Painting Place: The Life and Work of David B. Milne

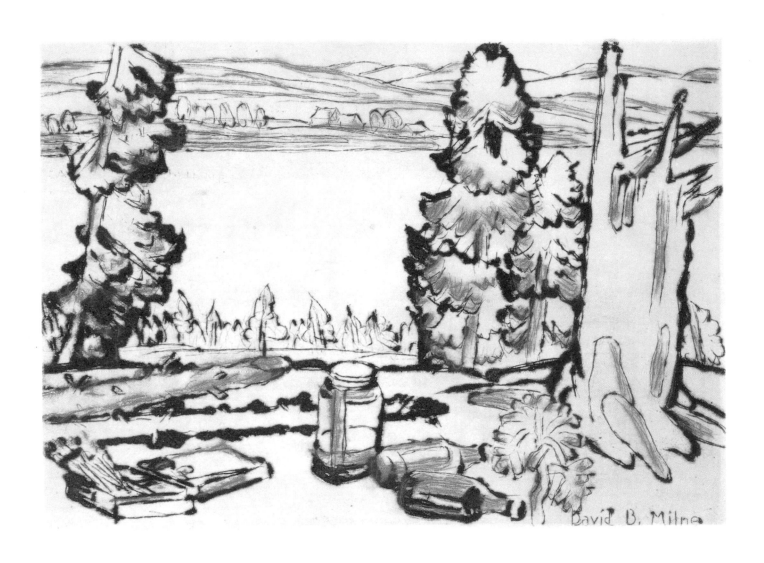

David B. Milne

Painting Place

The Life and Work of David B. Milne

DAVID P. SILCOX

UNIVERSITY OF TORONTO PRESS
Toronto Buffalo London

© DSLI Limited 1996
 Art and writings by David B. Milne © Estate of David B. Milne 1996

 Published by University of Toronto Press Incorporated
 Toronto Buffalo London

 Printed in Canada

 ISBN 0-8020-4095-0

 Printed on acid-free paper

Canadian Cataloguing in Publication Data

Silcox, David P., 1937–
 Painting place : the life and work of David B. Milne

 Includes bibliographical references and index.
 ISBN 0-8020-4095-0

 1. Milne, David, 1882–1953. 2. Artists – Canada –
 Biography. I. Milne, David, 1882–1953. II. Title.

 ND249.M5S55 1996 759.11 c96-931746-8

HALF-TITLE: Painting Place *(small plate), 1927, colour drypoint, 8.9×14.9 (3½×5¾)*

FRONTISPIECE: Painting Place *(the* Colophon *edition), 1930–1, colour drypoint in an edition of 3,000 copies, 12.3×17.6(4¾×6⅞)*

David Milne's words and images are reproduced in this volume with the kind permission of the Milne estate, which includes the Milne Family Collection and the Milne Study Collection. The owners – individuals and institutions – of works by Milne that are reproduced in this volume have graciously supplied photographs of the works or allowed us to take photographs for this project.

This book is part of a multi-volume project on the work of David B. Milne that also includes a two-volume *Catalogue Raisonné of the Paintings*, a CD-ROM version of the catalogue with all the works in colour, and a volume devoted to Milne's writings. Many individuals, corporations, foundations, and government agencies have contributed to this large undertaking. Their generous support of the project has made publication of this book and its companion volumes possible.

FOUNDERS: Anonymous, Fraser Elliott Foundation, Margaret and Jim Fleck, Gluskin Sheff + Associates Inc., Henry N.R. Jackman Foundation, Henry Luce Foundation Inc., McLean Foundation, Joseph S. Stauffer Foundation

BENEFACTORS: Anonymous, Arts and Communications Counsellors, Bank of Montreal, J.P. Bickell Foundation, Samuel and Saidye Bronfman Family Foundation, Eaton Foundation, Marvin Gelber Foundation, Imperial Oil Limited, Jarislowsky Foundation, Henry White Kinnear Foundation, Mr and Mrs John H. Moore, L.L. Odette, Power Corporation of Canada, Royal Bank of Canada, Charles and Noreen Taylor, Trimark Financial Corporation, R. Howard Webster Foundation

PATRONS: Atkinson Charitable Foundation, Birks Family Foundation, Black Family Foundation, du Maurier Foundation, Arthur Gelgoot and Associates, Audrey S. Hellyer Foundation, Ann and Lyman Henderson, Jackman Foundation, Norman and Dixie Jewison Foundation, Laidlaw Foundation, Philip B. Lind, Ruth McCuaig, Molson Family Foundation, Mimi and Sam Pollock Foundation, Robert Ramsay, Themadel Foundation, Norman and Pat Webster, W. Garfield Weston Foundation

FRIENDS: Anonymous, Bram and Bluma Appel Family Foundation, Cicely Bell, Davies Charitable Foundation, Edwards Charitable Foundation, Four Seasons Hotels and Resorts, Murray Frum, Bram Garber, George R. Gardiner Foundation, Margaret Godsoe, Senator Jerry S. Grafstein, Tim and Darka Griffin, H. Clifford Hatch Foundation, Paul W. Hellen, Richard and Beryl Ivey, Edward Jarmain, Michael and Sonja Koerner, John Labatt Foundation, James Laidlaw, Eva Miller, Mirvish Family Foundation, Joseph Louis Rotman Charitable Foundation, Joan Sutton Strauss

We also acknowledge the support of the Government of Canada, Department of Canadian Heritage; the Canada Council; and the Ontario Arts Council.

Contents

PREFACE ix

ONE **Mother's Garden** Burgoyne and Paisley, 1882–1903 3

TWO **The Defiant Maple** New York, 1903–1910 13

THREE **Billboards** New York, 1911–1916 35

FOUR **Village in the Valley** Boston Corners, 1916–1918 69

FIVE **The Road to Passchendaele** Canada, Britain, France, and Belgium, 1918–1919 89

SIX **White, the Waterfall** Boston Corners and Alander, 1919–1920 117

SEVEN **Across the Lake** Dart's Lake and Mount Riga, 1921–1923 139

EIGHT **Winter Carnival** Ottawa, 1923–1924 159

NINE **Black House** Big Moose Lake and Lake Placid, 1924–1929 169

TEN **Waterlilies and Etching Table** Temagami and Weston, 1929–1930 195

ELEVEN **Village Spread Out** Palgrave, 1930–1933 211

TWELVE **Earth, Sky, and Water** Six Mile Lake, 1933–1937 245

THIRTEEN **Stars over Bay Street** Six Mile Lake and Toronto, 1937–1940 281

FOURTEEN **Rites of Autumn** Uxbridge, 1940–1946 311

FIFTEEN **Leaves in the Wind** Baptiste Lake, 1947–1953 349

SIXTEEN **Epilogue** 1953 and after 371

NOTES 383
SELECTED BIBLIOGRAPHY 403
ILLUSTRATIONS 405
INDEX 411

Preface

D URING HIS CAREER, which spanned the first half of the twentieth century, David Brown Milne created three thousand paintings and as many colour drypoints, etchings, and drawings, and wrote over a million and a half words. His paintings and his writings made a major contribution to Canadian and American art of his time, yet neither are as well known as they deserve. This book, which is both a biography and an analysis of Milne's art, is an introduction to Milne the man, the painter, the printmaker, and the writer, and a tribute to his splendid gifts. I hope it will help to draw attention to him and give his particular genius the prominence it warrants.

In this study I have included as much detail about Milne and his work as good sense and curiosity, braced by admiration, allow. Artists and collectors are eager to know as much as possible about Milne, and their enthusiasm has persuaded me to think that more, not less, is better. Thus, I have quoted liberally from Milne's writings – his painting notes, letters, articles, diaries, and an unfinished autobiography – both because they illuminate his paintings and his ideas better than I can, and because, rare among painters, he is such a fine writer. One of Milne's unrealized ambitions was to collect his views and theories about art into a book so that his ideas, and the works that illustrate them, might be studied. His own revealing images and words have made it possible to draw a portrait of Milne's work and life. Few painters have documented their work so informally and candidly, and so profusely, as Milne and, at the same time, have been talented enough to engage our interest. The journals of Delacroix and van Gogh's letters come to mind: Milne is in this company.

Most of Milne's works were modest in size, and his method was intimate. His paintings reflect a sharp intelligence in organization and a rare sensibility of spirit in execution. They are meant to be seen and lived with privately; there are few weighty 'exhibition paintings,' such as many artists attempt, and by which they sometimes gain attention. Milne believed that large paintings were seldom successful, just as Edgar Allan Poe believed that there was no such thing as a long poem. Milne strove for power and simplicity, preferring to get a few elements absolutely right rather than a host of details almost right. 'In painting,' he wrote, 'I only count up to five.'[1] Milne admired the vitality of the new American art of the early twentieth century but, like John Marin, he was not in tune with the mid-century ambition for largeness of scale.

Milne also felt acutely that the painting tradition that he committed himself to serve demanded from him, in the twentieth century, pictures of immediate impact and rapid execution. The Old Masters created 'browsing' pictures that could be wandered through at leisure and whose secrets

and delights were only slowly divulged. For his times Milne thought that instant and total impact was called for. He considered painting 'the lightning art,' 'a drawing speeded up, intensified.'[2] He defined it best in a letter to a friend: 'The thing that makes a picture is the thing that makes dynamite – compression. It isn't a fire in the grass; it's an explosion. Everything must hit at once.'[3] Three-dimensional perspective, another established convention, was not 'a necessary element in picture making.' The convention was useful or important only if it contributed to the aesthetic effect. The same was true of colour: Milne thought that 'harmonizing and contrasting colours [were] a physical, not an aesthetic classification, of minor importance in painting.'[4] Milne saw in Cézanne's paintings that it was the shapes that were emphasized, not the colour, not the perspective, not the illusion of three dimensions. While the convention of perspective is 'sometimes used effectively,' Milne wrote, 'more often it has been not an inspiration but a dead weight dragging on the imagination. It has too often been used to create an illusion, not a reality.'[5]

Milne gave a higher priority to the processes of his imagination than to the products of it. Frequently he referred to his paintings, not as his first object or concern, but as the by-products of his aesthetic and imaginative life, the tangible record of mental and emotional experiences. His paintings flowed from living and working in accordance with his aesthetic beliefs, and they were both a record and a metaphor of these beliefs, rather than something separate. 'Painting,' Milne believed, 'isn't a matter of skill, a thing learned, but the outcome of one's life.'[6]

Milne also believed that art was like gold, or religion: it was there for those who took the trouble to find it. The search, with its rewards, was a lifetime's commitment, and depended upon one's 'conception of life.' 'Art is not a means of documenting or recording something other than itself, for art works from the known to the unknown ... it is a journey in an unknown land without an objective.'[7]

Milne was a man of both passion and intellect. For him thinking clearly and feeling deeply were both necessary to the production of great art. He had to get 'horsepower behind [his] emotion and intelligence,' he wrote. And he believed that the 'greatest qualities in art [were] courage, feeling, intelligence.'[8] His later work conveys a droll benevolence that is absent from his earlier work. He had a good sense of humour and he was a compelling conversationalist who dominated any discussion with original ideas and shrewd criticisms. His breadth of understanding was remarkable, and underneath his discourse ran a passion for life illuminated by art.

My own awareness of Milne began in 1957 or 1958. While I was still a student at the University of Toronto, I came to know Douglas Duncan and Alan Jarvis, two people central to Milne's reputation. Duncan was still Milne's agent and dealer and was then in the last decade of his life, a string-bean of a man, over six feet tall and thin, with wire-rimmed glasses and shaggy eyebrows. An unredeemable eccentric, his mail accumulated, unopened, in the back room of the Picture Loan Society, which he ran for most of his life, and lay over four feet deep across most of the room when he died. He encouraged me to write about Milne and to believe that I could help him finish his catalogue of Milne's work. Jarvis, often described as the most gifted and charming man of his generation, had just left his position as the director of the National Gallery of Canada, and he was unequivocal about Milne's superiority and durability – he was probably the

first person in Canada to recognize Milne's genius and appraise it accurately. He spoke of Milne's intelligence and passion, and he was no less enthusiastic about Milne's originality, toughness, and scope. Jarvis also encouraged me to write about Milne.

At Hart House at the University of Toronto in 1962 I administered a retrospective exhibition of Milne's paintings selected by Duncan. I was in charge of borrowing, insuring, advertising, hanging, and publicizing the exhibition. The show was stunning, and I spent hours, usually after the gallery was closed, basking in the aura of Milne's paintings. The enormous range of his work over nearly forty years of production was impressive, and all of it captivated me. Artists I was then getting to know were more enthusiastic about Milne's work than about any other painter of his generation, save, perhaps, Tom Thomson.

While I was working at the Canada Council in 1966, Ralph Allen, a fine painter and director of the Agnes Etherington Art Centre at Queen's University in Kingston, Ontario, invited me to write a substantial introduction for a travelling exhibition of Milne's work that the gallery was mounting to mark Canada's centenary in 1967. In the course of my research my appetite for further and deeper knowledge of Milne was whetted.

At the Canada Council between 1965 and 1970 I was in daily touch with Canada's best artists, who thought that Milne was the best painter Canada had ever produced (usually themselves excepted). Having one's opinion confirmed was pleasant, but their near-unanimity on this point was not lost on me. It wasn't only that Milne produced paintings that excited the people who painted professionally, but it was quite clear that, for painters, Milne was *the* great achiever, *the* great practitioner – he represented the essence of what it meant to be a painter. Always, even in his less than great works, Milne's line was energetic, his colours odd, but original and appropriate to the task at hand, and his purpose true. It was as if, had he been a singer, he had the clearest and most moving voice, the greatest musicality, and absolute pitch. His work appeals to artists because in it they recognize the quintessence of their craft and their art.

Duncan had mentioned my interest in Milne's work to the artist's son. After Duncan died in June 1968, David Milne Jr asked if I was still interested in completing Duncan's catalogue of Milne's work. We met to discuss the matter, and at the end of 1969 I started in, beginning with transcriptions of the letters and documents in the Milne family papers and those in the Dominion Archives (now the National Archives of Canada). But of course I was blissfully ignorant of the pitfalls and obstacles that lay ahead, to say nothing of the vast quantity of material available and the incredible complexity of the issues inherent in it. Before the next year was out, David Jr had become so interested in his father's work, an interest he had not been able to pursue while Duncan maintained firm control over the estate, that we agreed to throw out the earlier agreement and do the work on the catalogue raisonné together. He was just as blithe as I was about the extent of the mission we were launched upon: we confidently expected to complete it by 1972.

I began to write what eventually turned out to be this book in the summer of 1973, working with little more than a vague idea of what scope, level of detail, or interpretation of the material might be desirable. All I knew then was that Milne's life was an exemplary one for artists, and that how he developed and applied his aesthetic ideas was worth writing about. With a week or two of work here and there in the intervening years, I had

assembled a manuscript of fair proportions by 1980, but I wasn't at all happy with it. The late Alvin Balkind, Ronald Bloore, Shirley Gibson, John Newlove, and Craig Oliver, to all of whom I am indebted for comments about this earliest version of the manuscript, convinced me to throw out what I had and start again. I have received much editorial assistance in my work on this biography, beginning with that of Paula Goepfert in 1982 and Diane Mew in 1992.

My friend William Toye, retired Editorial Director of Oxford University Press Canada (who knew Douglas Duncan, from whom he bought a Milne watercolour and a drypoint in the 1950s), helped me greatly in the long, final stage of finishing this book. His suggestions were invaluable.

Over the last twenty-five years, on and off, David Milne Jr and I have worked together, gathering, analysing, and checking all the material to prepare the vast two-volume *Catalogue Raisonné* of Milne's paintings, the first such work for any Canadian artist. We are the first people to have gone through all the documents pertaining to Milne, most of it unpublished and generally unavailable, and to have seen nearly all the paintings. We have been able to correct mistakes in dates made by Milne himself and by Duncan, his agent and apologist for thirty years. In this book I have been at pains to indicate doubt when there is doubt, and to make assertions only when there is evidence. I have tried to compensate for my unabashed adulation of this fine artist, but like an earlier critic, Graham McInnes, I find it 'difficult to speak in moderation.'

The Milne family has been generous in making all the material left by Milne (over seventy-five big three-ring binders) available to me and to other researchers. They have insisted that any account of Milne's life be as truthful and direct as possible and have not asked to have any facts suppressed or interpretations changed. I wish to express my thanks to them for this freedom.

Hart Massey, who, when he was a boy of sixteen, was inspired by Milne, generously made the Massey family records available without restriction and he and his wife, Melody, encouraged me at every stage.

My students at York University, where I gave a seminar on Milne in 1976–7, were challenging and stimulating and I owe them more than they perhaps imagine they owe me: especially John O'Brian, who has since written perceptively about Milne and contributed substantially to my ideas about Milne's work; and Liz Wylie, who assisted with the *Catalogue Raisonné* for five years, and made myriad wise and useful suggestions.

Elizabeth Driver, who also laboured for years on the *Catalogue Raisonné*, was kind enough to add to her bibliographic and cataloguing duties by reading the biography, editing the notes, and making many corrections and helpful improvements.

I owe a debt larger than I can ever express or repay to cherished friends who, through their constant belief in, and encouragement of, my work on Milne, propelled me on, night after night, weekend after weekend, year after year: Iain and Louise Baxter, Hugh and Jane Faulkner, Douglas and Maudie Fullerton, Charles and Michiko Gagnon, Yves and Germaine Gaucher, Ted and Phyllis Godwin, George Anderson and Charlotte Gray, Peter Herrndorf and Eva Czigler, Joseph and Marie Intaschi, Tim and Susan Kotcheff, Ken and Joanne Lochhead, Gerd Mairandres, Neil and Laurie McPhail, Iris Nowell, Christopher Pratt, Mary Pratt, Rose Regal, Robert and Cecil Rabinovitch, Jack and Doris Shadbolt, Gordon and Marion Smith, Takao Tanabe, Shirley Cull Thomson, Irene Turrin, Don Wall,

Norman and Nina Wright; the late Joan Coleman, Betty Wall, and Johnny and Bea Wayne; and the many collectors, dealers, and art gallery officials who admire Milne almost as much as I do. I particularly want to thank Fraser Elliott, Arthur Gelber, Tim Griffin, Ruth McCuaig, Bill McLean, Robert Ramsay, Kathleen Richardson, and Gerry Sheff for their support, spiritual and material, when it was most needed. Stan Bevington of the irreplaceable Coach House was always there to discuss design issues and to make sure that my aim never dropped below the highest standards. Mimi Fullerton also helped set the ambition to do things the way Milne deserved. The Milne and Feheley families invited me to retreat to their summer cottages for periods of uninterrupted work.

I had my eyes opened further in discussing Milne's work with another great artist, a friend and colleague, the late Harold Town, who had as shrewd a critical eye as Milne, and as great a fondness for Milne's art as I have. Some of the observations on which I pride myself may have been stolen from him, and if he were here, he'd be sure to point them out – and claim a few others. Noting Milne's unequalled ability to leave things out of a picture and still have a powerful, animated composition with all essentials, Town called Milne 'the master of absence.'

I thank my employers at the Canada Council and York University, both of whom allowed me to carry out various parts of this huge project as part of my regular work. Over the years I was helped invaluably by my secretaries Paulette Charette, Margaret MacDonald, Judith John, and Sheila McDermott. I would also like to thank Jack Nichols of Toronto and John Boyle of Elsinore, Ontario (near Milne's birthplace), for permitting me to reproduce their portraits of Milne. The superb staff at the University of Toronto Press, Bill Harnum, Joan Bulger, Will Rueter, Peter Scaggs, and Cindy Hall, deserve my gratitude for their determination to make this a better book in every way. Their colleagues of much earlier days, Allan Fleming and Ian Montagnes, were also instrumental in coaxing the project toward a conclusion.

In a way, the long time that it has taken to complete this book (and its companion volumes) has allowed me to develop a deeper and more knowledgeable attitude to Milne and his art, tempered by greater experience and, I hope, wisdom. My admiration for his work is, if anything, more profound than ever.

My ambitions to scholarship are modest, but I would like to acknowledge the friendship and inspiration of three great Canadian teachers and scholars whom I came to know at Victoria College in Toronto: Northrop Frye, Kathleen Coburn, and John M. Robson, all, alas, now deceased. I like to think that this book is a witness to the fact that the many years they taught, guided, and encouraged students like me were not in vain. Perhaps partly because of their help years ago I eventually found myself at Massey College completing this task in the most conducive atmosphere imaginable. Professor Frye had agreed to write a foreword to this volume, and I regret that the length of time it has taken to complete the book has deprived readers of his comments on Milne's long career.

This book comes too late to offer to those I wanted most to please: my father, the Reverend A. Phillips Silcox; my mentor Peter Dwyer; and my friend Alan Jarvis, who first suggested that I write about his favourite artist, David Milne.

My wife, Linda Intaschi, a steadfast friend, spurred me on when I was flagging and inspired me if I became despondent. Her suggestions for

this volume made it much better and her help with the *Catalogue Raisonné* was also crucial. Without her constant support I would not have finished the whole task. This book is for her.

David P. Silcox
Massey College, Toronto, 1996

Painting Place 1, 28 August 1926, oil, 40.7 × 50.8 (16 × 20)

Feeling is the power that drives art. There doesn't seem to be a more understandable word for it, though there are others that give something of the idea: aesthetic emotion, quickening, bringing to life. Or call it love; not love of man or woman or home or country or any material thing, but love without an object – intransitive love.

David B. Milne, 'Feeling in Painting,' 1948

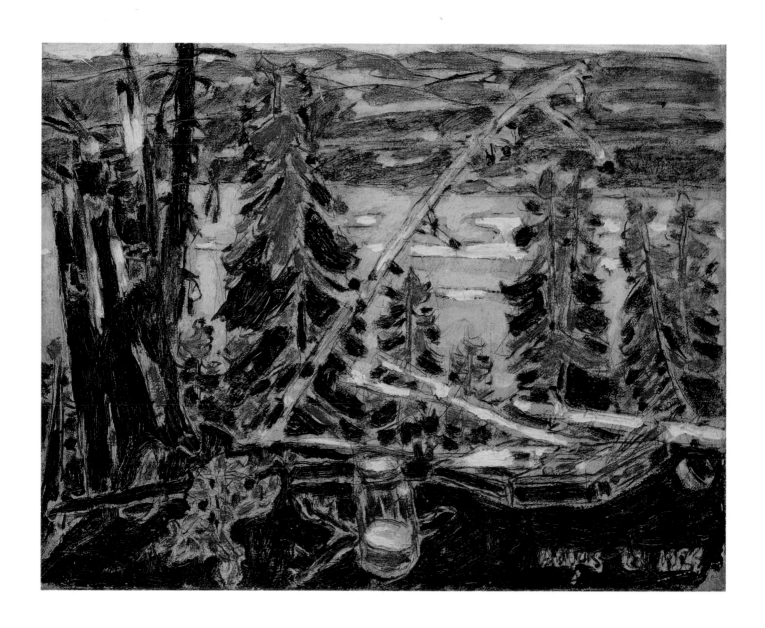

CHAPTER ONE

Mother's Garden

Burgoyne and Paisley
1882–1903

DAVID MILNE BELIEVED that a child's earliest experiences set lifelong patterns. When his friend Donald Buchanan wrote a book about the painter James Wilson Morrice in 1936, Milne chided him for not delving deeper into Morrice's childhood years.[1] Similarly, Milne wanted to know more about the early life of Tom Thomson, whose paintings he also admired.[2] He knew that the experiences of the child accounted in some way for the paths taken later in life. But Milne himself could not remember, or even guess, what in his own childhood pushed him along his adult track of discovery. 'There has never seemed to be any adequate explanation,' he wrote.[3] He felt that where one was born was probably insignificant, as he wrote later to Alice and Vincent Massey, but that 'race and family go very deep.'[4] Throughout his life he drew a parallel between his own Spartan aesthetic goals and his Scottish ancestry, pursuing what he called 'the Scotch motive' or 'economy of means,' by which he meant making the largest impact with the least material.

David Brown Milne was the tenth and last child of a poor family, and had the legendary advantage of beginning life in a log cabin. He was born on 8 January 1882 in a small log farmhouse near the hamlet of Burgoyne in Bruce County, Ontario. His parents had immigrated to Canada, via Boston, from Aberdeenshire, Scotland, in 1870.[5] They moved to Burgoyne after two years in Collingwood, Ontario. In Milne's memory his father William was a fleeting presence, 'coming in at noon on stormy days with icicles on his beard ... [with] waterproof boots and harness [treated] with melted tallow and lamp black.'[6] William's obituary, when he died in 1921 at the age of eighty-seven, noted that he was a devoted gardener, an avid reader, and had long been deaf. Perhaps his deafness or his work (he worked a nearby farm for an owner named Brown – from whom David's middle name came) kept him from having a determining role in his son's life. It was said that physically David strongly resembled his father, although the one drawing purporting to be of William does not show this. In any case, Milne's attachment to his mother was sovereign.

Mary Milne (née Divortay) was both stern and vivacious, taller than her husband and her son, intelligent, widely read, deeply religious, and, in her own domestic way, imaginative and creative. Her tableaux in dried leaves, flowers, and mosses always won prizes at local fairs, and Milne emulated her with his first paintings – 'on clam shells, and tin plates and maybe toadstools.'[7] To console herself, perhaps, for the early deaths of her two previous children, she kept David at home with her until he was nearly ten years old and well past the usual age for starting school. From her example Milne inherited the habit of hard work and an abiding love of flowers, qualities also credited to his father. When Mary Milne died in 1922, at the

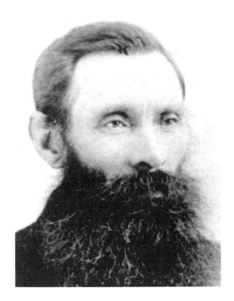

William Milne, Milne's father,
c. 1893

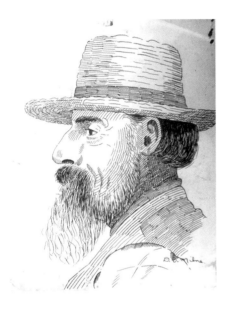

Profile of a Man in a Straw Hat,
c. 1902, ink drawing, 28.0×20.4
(11×8), possibly Milne's portrait of
his father

age of eighty-one, a year after her husband, the writer of her obituary commented: 'As a rule, lovers of flowers are lovers of humanity. She was no exception to this rule.'[8] Milne thought his mother also had a 'repressed leaning toward literature.' In her favourite stories, he recalled, 'material success did not figure': her heroes pursued spiritual ideals and goals and did not bother with such practical things as buying insurance or making money.

David's siblings were all much older than he. The senior Milnes came from neighbouring villages in Aberdeenshire, Udney and Fyvie (where they married). William (Willie), the first son, was born in Scotland in 1862; he was followed by James (Jim), Isabel (Belle), and Charles (Charlie). Four more brothers and a sister were born in Canada: John, Frank, Robert, Mary, and Arthur. The last two died in infancy, leaving Robert (Bob), the brother next to David in age, still eight years older. David's parents were already in their forties when he was born. The differences in age between David and his brothers and sister made him the family favourite, and the apple of his parents' eyes.

Milne's recollections of his childhood in the 'grey, weather-beaten farmhouse' on lot 19, concession 10, Saugeen Township,[9] were unusually specific. Sharply engraved in his mind were the images and contours of the countryside:

A nice place to be born in, at least to grow in, thrilling, mysterious, exciting place. On the back [of the farm], along the edge of Black's bush, there was a hill and from the top of a stump on that hill we could see mostly everything, our own fields and barn and part of the house, Finnie's pasture and berry patch, another farm, and then the valley through which the Saugeen River flowed, Brown's farm [where his father worked] very small and faint, and beyond it sand hills and a long, straight streak of blue, sometimes with a white moving speck on it, Lake Huron. From that stump for the first time, I was brought face to face with Infinity where anything might be and anything might happen.[10]

Glowing with colour, beds of flowers surrounded their house in thoughtful array. Milne's memory of them was

clear, vivid, scented and dewy. I remember where the red roses were and where the white, the paths and grass plots still hold their geometric precision. The new shoots of spiny roses and lilies of the valley push up through the ground with photographic clearness. Anything that had to do with flowers interested my mother, planting and digging and hoeing and weeding and watering. Since I did not often have other children to play with I followed my mother round a good part of the time and soon knew the flower garden well and soon found some of my mother's delight in it. I have never heard this love of flowers very satisfactorily explained. I think we go to flowers as we go to art, because both are useless. We do not reach out to either as an aid in our struggle for existence. Our devotion to either or both is a statement of faith, a declaration that for us there is more to life than mere continuance, it is good for itself, without purpose, that heaven is not far away and shadowy and unreal, but here, now and very real.[11]

These things – the house, the barn, the hills, the fields, the gardens, the bush, the orchard, and the creeks that made their way down to the Saugeen River – were the heart and shape of Milne's early life. Indeed, their imprint on his visual imagination lasted his whole life and moulded his way of seeing. When he was nearly sixty, and thinking and writing about his

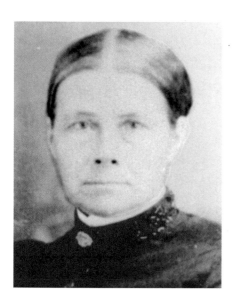

Mary Milne, Milne's mother, c. 1893

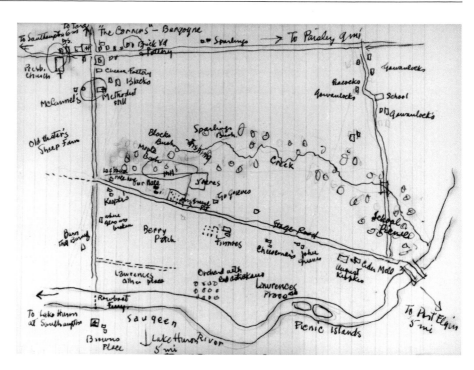

Milne's map of Burgoyne, drawn from memory in 1940

early life, he drew a map of Burgoyne with every detail of the places and buildings he had known as a boy.

In the winter, his favourite season, flowers were the patterns etched by frost on the window panes or the structure of snowflakes. David assisted nature by pressing pennies and keys against the panes to make his own compositions. At night when he was small, despite storms and cold, he slept, secure and warm, in a wooden box behind the stove. His strongest childhood memory was not of his landscape in summer, but of the long winter days that he spent at home with his mother, when he lived in a child's fantasy world, drawing and painting as children do:

I had the usual period of children's drawings, moons and stars and houses and Jerusalem cherry trees [they had one]. Done in watercolour on the blank ruled pages of a small almanac. They had only one remembered characteristic. They were heavy, the watercolour was applied as thick as it would go. Probably no more substantial moons and suns were ever painted.[12]

When Milne later looked back on these early expressions of intense emotion, he considered them to be 'the most truly personal things to be done for twenty years.'[13]

David received his early education from his family, and from the life around him. He listened raptly to his mother's stories of her life in Scotland, recounted in her Celtic accent. When the Milnes' Scots landlord at Burgoyne, Will Hogg, lodged with them for a while, he added his own yarns about Scotland. David recalled that Hogg taught him to read and write – although his mother must have had a hand in this. Each day David waited for the return from school or work of his brothers and sister. His speech imitated his mother's, and when he announced that 'the loons aire coomin' hame ta nicht' (the boys are coming home tonight), his brothers, who had learned North American inflections, teased him about his accent. From then on he spoke 'Canadian' English, charmed though he always

David Milne, about age eleven, c. 1893

was by the Scottish burr.[14] The local people pronounce the name 'Milne' as 'Mil´un,' but when he was in Scotland after the First World War, Milne noted that his name was pronounced 'Mill' or 'Mills' there, as it had been by the 'country folk in Canada.'

In the fields and woods David learned about flowers, mushrooms, and wild animals; he caught frogs and fish in Snake Creek or Burgoyne Creek, both nearby;[15] on the farm he watched calves, colts, and piglets being born and raised. Even the gravel pit was a museum where David saw 'more strange and interesting things' than when he later visited real museums. His brother Bob took him to a nearby tract where land clearing was going on, and

showed me about elm root smoking. There were great piles of logs and brush burning for days and he took me back to see them. Dried roots of the elm have pores running through them and smoke can be sucked through them. He picked a section of elm root about the length and thickness of a small cigar, lit it at the burning logs and set about some furious smoking. Me too. Very nice and very smoky and doesn't make anybody sick. I suppose he introduced me to other bits of childhood lore, though such things as basswood whistles, pea shooters and catapults seem to me to have come later, in school days. Anyway, there always seemed to be some trifling with the forbidden in Bob's leading.[16]

Bob was also blamed for taking David fishing on the Sabbath (a taboo) and setting him on a precarious log from which he fell into the creek, for which both were punished.

The neighbours on either side of the Milnes' rented farm near Burgoyne provided a dramatic contrast in living. The Scottish Finnies were church-going, stalwart, lawful, organized, and dull, but on the wall in their front room hung a Sir Edwin Landseer print of a stag and a depiction of the Battle of Waterloo – both of which piqued David's curiosity and provided one of his earliest encounters with art. The Low Dutch Koepke household, on the other side, was exotic and outlandish by Scottish Presbyterian stand-ards.[17] Alien foods – such as sauerkraut, schmeercase, stinkcase, and spicy wursts – could be sampled there. (What the Koepkes, being German, thought of porridge and haggis, or of the oatmeal bread Milne's mother made on top of the stove, is not known.)[18]

Games at the Keopkes' were more exciting and fearful [than at the Finnies']. Windows in vacant houses might be broken and cats were occasionally hanged over beams in the barn. These were thrilling adventures. There was no feeling of guilt or pity at the time, not until retribution caught up with us. I don't remember what my punishments for these affairs were when they became known, but the punishment of the Keopke boys made a deep impression on my mind. The offender was sent out to the orchard to cut a switch and with this he was whipped, while the rest of us looked on in delicious terror.[19]

From the Finnies David learned about conformity and regulation; from the Koepkes about freedom and danger. He sensed the value in both these approaches to life, and both guided him as an artist. Rules sometimes had to be broken, and in his childhood some form of punishment 'might al-ways be expected.'[20] He also knew about hard work and he remembered 'hoeing potatoes while other boys played lacrosse.'[21]

When he was ten, David began his formal education by attending the

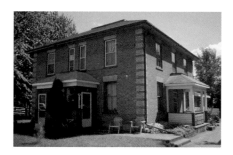

The Milne home on Orchard Avenue in Paisley, built c. 1893

Dove, c. 1902, ink drawing, 5.2×9.5 (3¾×2), in Milne's copy of the New Testament

Gowanlock school – or u.s.s. (Union School Section) No. 7 Saugeen and Arran to use the municipal nomenclature – about three kilometres (two miles) away. Although the building still stands close by lands owned by the Gowanlock family, its records have been lost and the length of David's attendance there cannot be verified. At that time the school year began in January, and in the wintertime David's feet were bundled into several pairs of socks, without shoes or boots – an odd but sensible protection against dry snow. On special occasions, and in warmer weather, he often wore a kilt. 'I have no reason to believe that I sprung into life as a full-fledged Scotchman,' he wrote later, 'though both my parents were Scotch and the first memory I have of myself I was wearing kilts and proud of them.'[22]

David could not have attended the rural school for long because his family soon moved a few miles south to the town of Paisley,[23] where his brother Jim had built a successful business as a painter and paperhanger. The older Milne sons built for their parents a commodious brick house with a small brick cottage or workshop behind it (where Jim Milne later lived), at what is now 315 Orchard Street at the corner of George Street on the edge of town, and on the west bank of Willow Creek, which is no longer in evidence. The house was split down the middle as a duplex so the senior Milnes could live on one side and earn rental income ($12 a month in 1912) from the adjoining half.[24]

The Milnes were rigorous Presbyterians. Stern discipline, hard work, moral uprightness, daily readings from the Bible, and mandatory attendance at three church services every Sunday were the family's staple diet at Burgoyne and later in Paisley. In 1889 David received as a Christmas gift from his brother Frank a copy of the New Testament, in which he drew a dove of peace.[25] As a young adult, Milne taught Sunday School and was also a leader of the Young People's Association in the congregation at Paisley. But, according to his wife Patsy, he 'wouldn't go near a church after he got to New York.'[26] Later he himself admitted: 'I never go to church and seldom vote.'[27] Nevertheless, the adult Milne was a profoundly religious man, with a slight penchant for the sterner justice of the Old Testament in his attitudes, although he linked the spirit of the New Testament to aesthetic excitement and in a late fantasy painting depicted Christ gazing (approvingly) at a Milne painting. Like his mother, Milne could recite Scripture freely and at great length. Out of this familiarity grew his staunch belief that the parables of the Bible were not meant to describe the past but to inform the present.

Milne had blunt, thick fingers, a snub nose, and the short stocky frame of his Scottish ancestors – his height was about 165 centimetres (five feet, five inches). His voice was soft and high in timbre. He thought of himself as timid and sensitive, and as a 'slow ripener,' but he was capable of being easy and gregarious.[28] From his family he inherited a keen sense of frugality and a stubborn grip on life at the precarious edge of poverty. Mary Milne's tales of her life in Scotland, no doubt recounted with detailed relish, stirred his interest in his origins. When Milne visited Aberdeenshire in 1919, he found himself (he said) as much at home as if he had lived there. He walked along footpaths his mother had taken and, as much for his own interest as his mother's, made notes on various Milnes and Divortays buried in the churchyards at Fyvie and Udney.

Perceiving exceptional qualities in her son, Mary Milne insisted that David receive a more extensive education than her other children. With financial assistance from his older brothers, especially Jim, he was able to

George A. Reid, The Berry Pickers,
c. 1890, oil, 167.6×127.0 (66×50)

The Model School class, Walkerton, 1900, David Milne in the back row

finish high school, he and his brother Charlie being the only ones to do so.
David quickly made up for lost time. His success at the junior high school
in Paisley was recorded in the *Paisley Advocate* on 26 August 1897:

Davy Milne, of Paisley, made a record of which any boy should be proud at the
late departmental examinations. He succeeded in capturing honors, notwith-
standing the fact that he has attended high school only six months. He received
his primary training at Paisley public school, and while there established a
reputation as a very clever student.[29]

At about the age of fifteen a 'desire to excel' became a mark of David's
character. The nearest senior high school was in Walkerton, about seventy
kilometres (forty miles) south of Paisley, and Milne enrolled there in 1897.
He boarded in Walkerton for $1.50 a week, returning home on weekends.
The science option he chose for his studies led him to fill pages and pages
with drawings of plants for his botany courses, an activity that rekindled
his love of drawing. Ironically he had once failed drawing in public school,
being unable, or unwilling, to maintain proper perspective.

In 1899, when he was seventeen and about to graduate from Walkerton
High School, Milne decided to enrol in the teachers' course in the Model
School at Walkerton, as Charlie had done. His class was predominantly
male, unusual at a time when many women were entering the profes-
sion.[30] On a visit with his class to the Normal School in Toronto Milne was
stirred by one of the first real paintings he ever saw. Of *The Berry Pickers* by
the Canadian painter George A. Reid (1860–1947) he later wrote: 'The
thing that impressed me ... was the vividness of the red raspberries re-
flected on the new tin pail. This was my first real kick from an oil painting
and my first enjoyment of texture in art.'[31] His attitude to art, which he
probably equated with illustrating, was still only casual, but he devoted his
leisure time to contributing to school yearbooks and making sketches of
people and places around Paisley. Milne's fascination with botany contin-

Milne and his pupils in front of their school north of Paisley, c. 1900–3

ued, for in the year or so after his graduation he exchanged plants and information with J.G. Wilton, one of his teachers.

Milne's principal at Walkerton, Joseph Morgan, wrote of him that he was 'a student of very exceptional ability. In all my experience, I have met very few to equal him in this respect.'[32] Coming from a man with decades of experience running one of the best schools in Ontario (and one that retained Latin and Greek on the curriculum longer than most), this was high commendation. When Charles Milne revisited the school thirty years after graduating, Morgan remembered him immediately and told him bluntly: 'You weren't the smartest one of your family to attend Walkerton High School. Your younger brother, Dave, was a better student than you in my opinion.'[33]

Milne accepted the post as teacher at the little school known as u.s.s. No. 7 Elderslie and South Saugeen, five kilometres (three miles) north of Paisley on what was then the Elora Road North, as the *Paisley Advocate* reported on 14 December 1899. He began teaching in January 1900, and was the master of a one-room schoolhouse for the next three-and-a-half years. He walked or cycled from his parental home each day, and sometimes trekked on snowshoes in the winter. Although he had in his care about forty-five children in all grades, if one judges from the photograph of Milne the teacher with his class, he enjoyed the work and had a natural and easy relationship with the children. Professionally, however, he was restless and unfulfilled, and later noted that he was only 'saved by interest in the children's performance.'[34] His later thoughts about the creativity of children, his interest in their development, and his belief that early influences are crucial to later achievements doubtless came from his experiences as a young teacher.

At this point Milne took his first hesitant step toward becoming an artist. 'I don't know what turned my thoughts in this direction,' he wrote; 'there never seemed to be any adequate explanation. I always liked pictures, and remember particularly the pictures in a book called *Picturesque*

David Bell's Cow, 1902, ink drawing, 28.7×39.5 (11⅛×15½)

Canada.'[35] In 1901 or 1902 he subscribed for a period of time to an American art course by correspondence – although he was later to claim that it took him years to unlearn the pedestrian habits this engrained in him. An example of his work for this course is preserved in *David Bell's Cow*, which is inscribed in the lower right corner: 'Lesson 8.' (Dave Bell's pasture was the site of the local swimming hole, which was inaugurated annually on the 24 May holiday weekend.)[36] At about the same time Milne sought out opportunities closer to home: he drew illustrations for a new publication from Guelph, Ontario, called *The Canadian Boy,* a slight periodical put out for a short time by the Turnbull-Wright Company, a printing firm which also published *The Confederate,* from Mount Forest. Milne submitted a cover drawing for *The Canadian Boy* in July 1901, but he had to redraw it when the format was changed.[37] He did artwork for different departments of the magazine. 'You seem to be quite useful with the pen,' O.E. Turnbull wrote to him. 'Would you please tell us something about yourself, how old you are, what business you are at present engaged in and if you would care to take up illustrating for us more extensively. We will have considerable illustrating to be done and if we knew what your special adaptations or choice in the creative world was, we could talk to you better. About remuneration, we will be willing to do what is right with you.'[38] A month later Turnbull was writing to ask for a photograph of Milne for publicity purposes; he enclosed a short story and asked for a 4"×5" illustration 'of the part of the story I have marked X, where the ghost appears to the boy in the graveyard.'[39] A.W. Wright, the publisher of *The Confederate,* wrote a year later that Milne's sketch and drawings of a battle scene were 'superb.'[40] In 1902 Milne contributed drawings and another cover design, and in 1903 two more drawings, to *The Canadian Boy.* The January 1903 issue, which came out late, touted the publication's virtues: 'Bright, Patriotic, Helpful, Entertaining.' Milne's contributions included two signed decorative panels of maple leaves and two beavers for the cover and, for a story, a drawing of 'a half-frenzied squaw' about to set fire to something with 'a burning brand' and another of a hunter named Joe 'gliding through the poplar bush' about to shoot something or somebody. The examples that exist of some of these first hesitant steps of Milne as an artist are now painful to look at.

A little sketchbook of Milne's, now preserved in the National Archives of Canada, shows how prolific and diverse his interests were at this time, for its sixty pages are crammed with drawings, often signed (an early indication of a strong ego), of trees, animals, birds, boats, occasional figures, later sketches for signs in New York, and notes for ideas and books to read. There are also several references to show that he experimented with photography, for he lists subjects, exposures, and chemicals needed for developing film, although no photographs from this time are known.[41] During the summers in these opening years of the new century Milne made extended sorties on his bicycle around southern Ontario, visiting Toronto several times. On one long summer trip in 1902 he made an elaborate drawing of the Niagara Gorge at Queenston. In addition, he did a number of portraits of people around Paisley, sketched in pencil. Although these are not of much interest in themselves, they indicate his ambition and the strong pull of the graphic arts. Milne was seen in his community as someone with a special talent. In the notes for his autobiography he cryptically mentions the excitement of 'all-night sessions.'[42]

A decade or so after Milne's death in 1953, a number of works from his

Dutch Woman in Clogs, *c. 1902–3*,
oil, 47.0×31.1 (18½×12¼)

adolescent years, along with letters to his mother and family from New York and Europe, were destroyed when new owners cleaned out the attic of the Milne home in Paisley.[43] The loss of the letters is especially unfortunate because of the light they might have shed on Milne's early career. But enough early drawings and paintings still exist to show an almost compulsive amateur, someone who was able to catch a crude likeness, and even sensed the mysteries of drawing, while lacking discipline, understanding, and skill. One or two of these drawings suggest that young David may have seen reproductions of Rembrandt drawings or etchings in a magazine, but most are unlike the work of artists Milne might have known and copied. His lack of sophistication was evident. 'Art was all one to me' then, he later candidly recalled.[44] These early works, however, foreshadow Milne's later insistence on originality.

Milne's youthful talent was his ability to 'see' with acumen and penetration, and almost everything he saw he retained as a visual image and stored for future use. Even at the age of sixty-five his memories were accurate, specific, and clear. When he looked over his old paintings, he could sometimes recall the weather, the temperature, the strength and direction of the breeze, patterns in the grass, and the whole look and feel of the place where he had painted.

From Milne's adolescent period two major efforts in oil have survived. The earlier one, *Irish Waterfall* (c. 1901), he copied from a book, although the model was in black and white and Milne supplied his own colour scheme. He mounted it in an extravagantly gilded frame and gave it to his mother, who hung it over the mantel in the livingroom, where it remained until her death. It is awkwardly done, but it shows ambition, and a predilection for a subject, a stream rushing over rocks, that would interest him periodically throughout his life. The other, a *grisaille* of a woman wearing clogs and carrying milk pails, *Dutch Woman in Clogs*, was either an exercise for the correspondence school or work from his earliest New York student days.[45] It shows that Milne had a delicate touch and a natural facil-

Irish Waterfall, *c. 1901, oil, 55.9×79.7 (22×31⅞)*

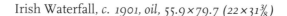

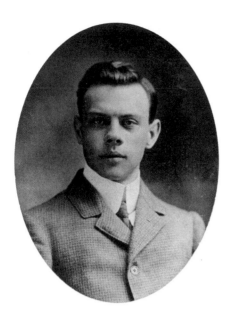

David Milne as a young man, c. 1903

ity for laying down paint, but otherwise the work is nothing more than one might expect from a beginner. That it is entirely in black, white, and gray is noteworthy, however, for a significant aspect of Milne's later art theory and practice hinged on his extensive use of these values, or 'non-colours.'

On 9 July 1903 the *Paisley Advocate* announced that David Milne had 'decided to abandon pedagogy and will take a course in art at a New York studio, to develop his natural talents in that line, for which there is nowadays a wide field for practical application.'

What led Milne to pursue his studies in New York, rather than Toronto or Chicago, or even somewhere in Europe? In a note for his autobiography he called it simply a 'jump in the dark.' However, one of his teachers may have urged him in this direction.[46] Moreover, the correspondence school, which had flattered him by reproducing one of his drawings in its magazine, had announced that it was going to open a school in New York.[47] Thinking that he was primarily interested in becoming an illustrator, Milne may have believed that New York, the mighty North American centre of the time, offered more scope. Or it may simply have been the magnetic tug of 'the periphery to the centre,'[48] as he wrote later. He set off in September 1903.[49]

Milne boarded the train to Toronto, sailed across Lake Ontario to Queenston, made his way by train to Buffalo and Albany, and then steamed down the Hudson River to Manhattan. His path seemed promising and fair, for Milne was young, doughty, and resolute. His mother, he sensed, knew that many difficulties would lie along his path, yet she did not attempt to dissuade him.[50] And he had behind him the support and encouragement of his little community. Much later he wrote that if he had been able to foresee the hardships ahead, he would have been too discouraged ever to begin his prodigious journey.[51]

CHAPTER TWO

The Defiant Maple
New York
1903–1910

To a young man of twenty-one from Paisley, Ontario, whose previous experiences of a city were two or three brief visits to Toronto, New York City in 1903 was a vast, noisy, and bewildering crucible. Milne fell into it, as he wrote later, 'knowing no more about my destination than if I had been plunging into the sun.' He also described his arrival as a less than irresistible force meeting an immovable object.[1] His first timorous but exciting night, after his arrival by steamer down the Hudson River, was spent at the Broadway Central Hotel on 11th Street, and the next day he visited the only people he knew in New York, John (Jack) and Jean Riddell. Jack Riddell was a brother-in-law of Milne's brother Charlie, and the son of a family the Milnes knew in Collingwood, Ontario. Milne was relieved when they spoke with the same Scottish lilt as his parents (they were more intelligible, at first, than their American children). The Riddells steered him to a boarding-house at 323 East 84th Street – the first of Milne's many addresses over his thirteen years in Manhattan and the Bronx – and invited him to family dinners on Sundays and to gatherings at Tammany Hall, the Democratic Party's Irish social club. They also provided occasional cigars, as Milne remembered.[2] He later repaid their kindnesses with the gift of *Pier on the Hudson*, an early oil painting done upriver near the Catskill Mountains.

Milne's track through these early years of artistic development and economic hardship is difficult to trace. A few facts, however, are known about his personal life, his formal training, his commercial work as an illustrator, and his first exhibitions. Milne's own brief, and much later, reminiscences about this period are sharp but not sequential: they tend to telescope the years and to collapse his experiences as student, illustrator, businessman, etcher, painter, and ardent suitor into one compact unit.[3]

For the first seven of the nearly thirteen years that he lived in New York, Milne was practically invisible among the legions of immigrants who pressed into the city during the first decade of the century, the period of highest immigration ever in America. He was poor, uncertain, and frequently dismayed by his lack of financial success. On nights and weekends he sought commissions as a window-dresser and poster or showcard maker – trudging down Second Avenue 'to the Battery and back,'[4] soliciting orders from shops. In the process he developed a prejudice against Jews, particularly Jewish tailors who, according to Milne, bargained hard and took undue advantage of his need to earn a living. Milne had no previous encounters with anyone Jewish and he did not pause to consider that this huge wave of immigrants was trying to cope with the same hard circumstances as he was. During the period he adopted some of the anti-semitic stereotypes so characteristic of the age, and later in his life this

prejudice occasionally surfaced in offhand comments that seem jarring today. Yet Jewishness was not an issue when it came to his admiration of the Jewish photographer and art dealer Alfred Stieglitz, and he included among his circle of close friends after 1911 the Jewish artist William Zorach and his wife Marguerite.[5]

Although Milne's first disappointment in New York, on the evening of his arrival, was the discovery that pretzels were not as sticky and sweet to the taste as they initially appeared to his wide and innocent eyes, 'just dry and seedy,'[6] a more serious disillusion came when the commercial school he had come to attend – the Arcade School, Milne called it, since it was in the Lincoln Arcade Building at Broadway and Columbus[7] – closed abruptly after a few weeks, swallowing up his and the other students' prepaid fees in the process.[8] Undaunted, and with either good advice or better luck, he transferred his allegiance to the Art Students' League of New York on West 57th Street, and was enrolled there for two years (he took night classes for a third year).[9] His brief tenure at the Arcade School gave him one advantage: the prerequisites for entry to the League were waived for him, and before he knew it, '[t]here I was in Frank DuMond's life class, portfolio propped between the legs of an upturned kitchen chair, a piece of charcoal in one hand and a "shammy skin" in the other, putting down on a sheet of Michelet paper my slightly distorted and feeble version of God's noblest work.'[10] Milne would, of course, have done this in the men's class; the women had separate classes, especially when there were models.

'I don't think my day was one of the Golden Periods of the League,' Milne wrote later, and indeed it was not.[11] None of those who attended with him achieved national or international prominence later as painters. Had he attended the League a few years later, he might have encountered Georgia O'Keeffe (1887–1986) or the precocious Stuart Davis (1894–1964). In retrospect, perhaps even at the time, Milne thought he might have been happier elsewhere – at the New York School of Art, for example, which he called the Chase School after its founder, William Merritt Chase, who still taught there with Robert Henri. Both were notable painters and inspiring teachers. At the New York School Milne might have trained with Edward Hopper (1882–1967), George Bellows (1882–1925), and Rockwell Kent (1882–1971): they were all born in the same year as Milne, and they all went to the Chase School. Hopper, from nearby Nyack, New York, started there in 1900 (and stayed for a lengthy six years), and Bellows and Kent arrived in 1904. Bellows, like Milne, started late after several years of college and after deciding against a career in sports in Columbus, Ohio; and Kent, already aware of his talent, had made a first start in architecture in the same Ohio college.

A block away from the League, at 6th Avenue and 57th Street, was the Chase school. I might have liked it better, I think, perhaps they even taught art there [Milne means rather than illustration or technique]. At least they taught a lusty way of drawing and painting, as limited maybe as the League's way, but more vigorous and inspiring. I have an idea – just an idea, and not based on any very intimate knowledge of the subject – that the Chase school was responsible for the most distinctively American art of that period and several succeeding decades. That was due, of course, to the teachers who had more of out-of-school accomplishment to their credit than the League teachers. The two leading ones – or at least the ones I knew about – were William M. Chase and Robert Henri. Both were well-known and accomplished painters – and inspiring teachers.

Chase was of the Sargent school. He had known both Whistler and Sargent and there had been some portrait painting back and forth. I am not sure now who painted whom, but I remember a very effective Sargent portrait of Chase and a rather less effective – but equally well-known – Chase portrait of Whistler, both probably seen at the Metropolitan Museum. Chase, I think, was an inspiring teacher. Once in a while he gave a demonstration – painted a quick portrait before his class and may, at other times, have painted a still life – fish. I am not sure about the fish, though they were among his favourite subjects. This practice may have had a tendency to keep his pupils trailing along behind him instead of travelling along paths of their own, but it was worth taking a chance on. He also gave talks – particularly about Whistler. These would be at the Chase school but League students were invited, because I remember hearing the Whistler lecture.[12]

Of Henri Milne also had recollections, for he was impressed by the spirit of adventure and independence that Henri championed:

Robert Henri was different [from William Chase], of the lusty school, a follower of Franz Hals. Slam it on and don't spare the subject. He could have organized a Salvation Army in paint, did I think, the Bellows-Luks-Glackens American school. I don't think I would have been much interested in the 'Hallelujah, I'm a Bum' side of this. I knew too much about poverty to be impressed by it – but I would have responded to Henri's drive and enthusiasm. There was nothing of all this at the League: there was a steady devotion to work without any promise of short cuts. That was alright for me but I would have liked something more exciting with it, and the faint Bohemian scent of the Paris schools that clung to the place didn't furnish it.[13]

Nevertheless, Milne learned the basics of his profession at the League, and was thrust into the company of others who were trying to become artists. He remembered fondly some of the cheerful camaraderie there:

Each student when he joined the men's life class was supposed to treat the class. Treats may have been doubled up sometimes but there were at least three or four each term, always following the same pattern. Work was stopped for a couple of hours, the model allowed to go home. A small keg of beer and sandwiches made of pumpernickel (very dark solid bread) and Swiss cheese were the refreshments. There was singing and talking and noise-making but I don't remember any particular hazing or roughhouse. It was entirely a men's affair. I don't remember, or maybe never knew, whether the women had any similar performance.[14]

And he also remembered that the city's commercial galleries, few as there were, provided an indispensable part of his education:

With other students at the Art Students' League in New York I used to visit all the Art Galleries – not many then, a dozen or less – these visits were made late in the afternoon and on Saturday mornings. I think we were less welcome in the afternoons when more important visitors were present than in the mornings when we had the galleries pretty much to ourselves.[15]

The companionship of these students and the art life of the city made up for any deficiency in the school. The discussions of art subjects – all of them, I think –

and the visits to museums and galleries were stimulating as well as informing
… We may have been a nuisance to the dealers, but they put up with it, they
never knew where their next crop of young artists might come from.[16]

The League shared its building with some art associations, including
the National Academy of Design. Milne also recalled

echoes from the National Academy School, haunted by the ghost of Kenyon Cox
– in flesh and blood. I remember seeing the lanky figure at an academy exhibi-
tion (downstairs). Even there he was a bit other-worldly – but he could talk –
was talking. He was standing with some other academy greats in front of
Winslow Homer's picture of the sea with a negro and some banana stalks on a
dismasted boat [*The Gulf Stream*]. He thought the reds in the lower left hand
corner (where the sharks were) was a bit overdone. So it was, even to me. To
Kenyon Cox it must have been a terrible shock.[17]

Cox was both an academic painter (he had painted classical murals for the
Library of Congress in Washington) and an ultra-conservative art critic,
and at different times an influential teacher, particularly at the Academy.
The exhibition spaces in the League building were used throughout much
of the year by various art associations and thus gave a broad view of cur-
rent American painting activities.

Milne's teachers at the League were well-known, if not particularly dis-
tinguished, painters: Henry Reuterdahl, George B. Bridgman, and Frank
V. DuMond (who also taught at the Chase School). Milne remembered
seeing Edwin Blashfield, another prominent artist, at work on large mu-
rals in one of the lower exhibition rooms. In retrospect, he thought little of
his teachers: 'From the work of the instructors at the league I learned
nothing of value to me in painting. The instructors were craftsmen, com-
petent, practical: art, to them, was [like] brick-laying, only more compli-
cated and difficult.'[18]

Some of the teachers were so popular and were there so long that they almost
came to symbolize the place. Yet they were purely school men with no marked
accomplishment outside the school. Admittedly they were there to teach us to
use the tools of the trade, to draw and paint. Craftsmanship was their concern
and I don't think they went much beyond that, were little concerned about art
itself. Students and teachers alike seemed to hold that view. But it doesn't seem
possible to teach people to paint without teaching them to paint in a certain way,
to teach craftsmanship without teaching art or some substitute.[19]

All Milne later claimed to have learned at the League was to smoke
cigarettes, while gazing out the window. The truth is that he received a
thorough grounding in all the basic skills needed by an artist: drawing,
design, etching, mixing paints, and colour theory. And despite all his ret-
rospective reservations, he also remembered the League affectionately:

For a year I attended a DuMond life class in the morning and a Henry Reuter-
dahl illustration class in the afternoon, and some days a half hour sketch class
without criticism after that. DuMond did some painting and illustration. What I
saw of it was conventional, fluent and slightly mannered, rather weak, not at all
like the teacher we saw, strong, alert, sympathetic and with a remarkable ability
to make the student brace up and tackle the thing all over again. I think in other

circumstances if I had spent longer with him, particularly in painting, I could have got hold of the thing, to my great advantage.

George Bridgman was a decorative mural painter. When I was in his class he did scene painting. I never saw any of his work. He lived, and maybe worked, in New Rochelle and came in evenings twice a week for the classes I attended – not in my first year, later when I worked days at the drug store. He was the anatomy man but didn't impress much of it on me. He was particularly popular, jolly, talkative, every once in a while breaking out into some jingle left over from his Paris art school days.

Henry Reuterdahl was an illustrator carried to fame by the Spanish-American War. His naval illustrations for *Colliers* probably were very good. He worked rapidly in oil or gouache with lots of freedom and fluency. Big, bluff, hearty, he looked like a sailor, and a rough one. In his own field, aside from the teaching, I think he outclassed the others. He was an illustrator and a good one.[20]

Friendly and helpful as these teachers may have been, what excited Milne most was a sketching class where quick, animated work was called for:

I was nearer coming to life in the half hour sketch class at the end of the day than in anything else. There wasn't time then to get mislaid in strange corners. Work was from models in street clothes and was usually done in charcoal, broadly treated and vigorous, put on in large areas, rubbed with the thumb, put in and taken out, marked with the point or with squeeze rubber. This was the nearest to picture making anyone got in the school.[21]

Above all, the League furnished a concentrated, creative ambience where students made art, saw art, and – most of all – talked about art incessantly. 'We saw everything, discussed everything, criticized everything.'[22] The ambition to become an artist would have taken root then, when hopes were high, impediments seemed small, and artists such as Monet and Whistler gave a young student a mark to aim at. The League's year-end exhibitions were exciting for Milne, and at the end of his third year he exhibited a work called (with a nod to Whistler, perhaps) *Opus 3*.[23]

Milne's savings from teaching and the money he had borrowed from his brother Jim to come to New York were soon depleted. With no regular source of income, Milne found the first two years in New York onerous and grinding. His work as a poster artist, however, soon brought him into contact with two people who were to be important in his life.

In 1906 Milne met his future wife, May Frances Hegarty, known to all as Patsy. She was sixteen, a cashier and the assistant bookkeeper who assembled the payroll for about thirty employees at Julius Jungman's two drugstores, one at 81st Street and Columbus Avenue on the West Side and the other across Central Park on Third Avenue – where Milne was earning $18 a week dressing the windows and making showcards in the fourth-floor storeroom on a long table. Patsy remembered their first meeting:

One day, when I was at the desk downstairs, a young man who came three times a week to make window 'displays' stopped at the desk and said 'Could I borrow a pencil?', and to my surprise he brought it back after a while (people sometimes forget to return them). That was the first time I spoke to Dave – but I did not pay much attention when he was busy in the window or upstairs. One afternoon, about 6 o'clock, on my way across 81st St. (just at the corner near the

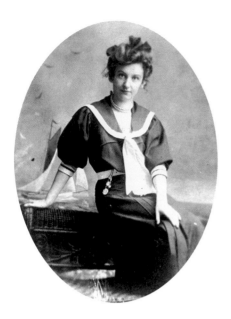

May Frances Hegarty, known as
'Patsy,' Milne's fiancée

store) to the Park to walk home, Dave came up and asked if he could walk with me – so we went through the Park. At first I was not overjoyed to have him come, but I soon felt quite at ease, because he was natural and quiet, and I thought he seemed very nice.

We walked home often after that ...[24]

With the ice broken, life at Jungman's drugstore took on a different rhythm:

We had endless fun up on the 3rd floor. Sometimes H. the photographer would shut the adjoining office door and roll the safe against it – and the only way I could get out was to open the window and go up the fire-escape to the 4th floor. Dave was the only one who figured that out (what I would do) so he went up the stairs – where he lifted me down – so I was beginning to know him much better by then. Walking along, a huge flag would suddenly drop on me from the 4th floor balcony – and I was all tangled up for a while, laughing and getting [out] from underneath, while people sat around laughing and enjoying it. There were so many things, and so much fun and laughter.[25]

One thing did bother her at first, however, and that was that 'the suit he [Dave] wore had at one time been a dark green. It was faded so badly, I wished he could have something better. After a while he did get a dark blue suit, and looked pretty nice.'[26] Patsy was also bemused by his heavy woollen socks, which his mother still knit for him, for she had never seen any like them.[27]

Milne courted Patsy for six years: the courtship ebbed and flowed with the usual ecstasies, vagaries, tears, and reconciliations that attend many an early relationship. The earliest correspondence between them dates from the summer of 1906 when Patsy was out of the city all summer, at Haines Falls, New York, at Asbury Park, New Jersey, in August, and at Stamford, Connecticut, in the fall. The other correspondence dates from 1908 and 1909, again when one or the other of them was out of New York – Patsy visiting relatives or working at resorts (Givens Park in Connecticut, the Grave House in Kaatskill Bay on Lake George, or at Haines Falls, near Saugerties, on the Hudson River), or Milne on a painting trip or visiting his family in Paisley.[28]

Patsy reported an early attempt by Milne to do a portrait of her: 'Dave started a full length sketch of me. After working on it for several weeks, he put it aside. I asked why he didn't finish it, and he said "I can't do it, I love you too much" and painted it out.'[29]

Patsy had been born of Irish parents in Brooklyn on 1 May 1889 or 1890.[30] Her Catholic father, Dennis F. Hegarty, was from County Cork and was well educated, but had immigrated to the United States because of a family quarrel. His business in New York was selling printing inks, but apparently he immersed himself rather more in alcohol and died in an accident a year or so before Milne and Patsy met. According to Patsy, her father was only 'interested in us [Patsy and her sister Maude] when he was normal.'[31] The family had lived first in Brooklyn near Tompkins Park; then in Lyndhurst, New Jersey; then back in Brooklyn, where the girls attended a Catholic school on De Kalb Avenue; and then near Bloomfield, New Jersey, in a large suburban house with an orchard. When success finally left Mr Hegarty for good, the house was lost – a humiliation for Patsy and her mother:

I often sat in the sun, when home from school, and tried very hard to think of

some way we could save the place. I was about fourteen then. Once I saw an advertisement in the paper for a girl to begin in an office in Newark. I walked there and found the position had been taken, and they said I wasn't old enough anyway, so I had to walk the five miles back, feeling very unhappy. My mother was so ashamed to think that we were losing our home, that she would not go anywhere.[32]

Patsy always seemed to prefer the country to the city, and already had spent a happy year at Ilion in upstate New York working as a cashier in a grocery store before returning to New York and Jungman's. Her recollections of rural living, both in her early letters and her later memoir, are nostalgic and constant.

Patsy's mother, Caroline Collins, was born in County Down, one of six daughters and two sons of a naval captain, and a Protestant. She was apparently a fetching beauty, with blue eyes, auburn hair, and 'a wonderful pink and white complexion' that Patsy inherited, but with a 'shy and quiet' disposition. When her husband died she moved to Manhattan. Mrs Hegarty seemed always to defer to Patsy's plethora of aunts when it came to questions about Patsy's life and prospects, and they were all opposed to Patsy's marriage to Milne, considering him a dubious choice as a husband.[33] This may have been, for the aunts especially, as much on religious grounds, Milne being thoroughly Presbyterian, as because of the doubtful likelihood of his providing a stable home and an adequate income.

Milne wrote reams of lovestruck letters to his 'little girl,' as he persistently called her during his courtship years. Those written in 1906, 1908, and 1909 are the only first-hand accounts of this period now extant. Although extremely saccharine, and revealing scant and mostly incidental information about Milne's work and habits, the letters offer the only authentic glimpses we have into his life and circumstances. Milne was hopelessly in love with Patsy. He worried constantly about her travelling alone and wondered about her competence to manage on her own. He called her 'Dear Little Girl,' 'Pats,' 'Sweet Little Girl,' 'Darling,' 'Dearie,' 'Dear Little Sweetheart,' and 'Patsy, Patsy, Patsy, darling.' He signed off one letter with: 'Patsy, you're the loveliest little girl in the whole world. Good-bye, darling, Dave.'

Of their New York years, Patsy remembered the excitement of attending the theatre and concerts, reading books together, and visiting exhibitions and other artists' studios. On Broadway they saw the celebrated performance of Maude Adams in *Peter Pan*, either soon after it opened in 1905 or more likely at the Empire Theatre revival in 1916; a revival of *If I Were King*; and numerous other plays. Milne read *Lorna Doone* aloud to her, and gave her copies of *Treasure Island, A Christmas Carol, David Balfour*, and Bret Harte's *His Letter and Her Letter*. Patsy's formal education, which had stopped when she was about fourteen, was extended by Milne's informal curriculum. Limited though it was, it gave her a degree of familiarity with things artistic, and it provided her throughout her life with the habit of using public libraries wherever she was – a habit that Milne shared with her.

The couple took day excursions up the Hudson River as far as Croton-on-Hudson, and had picnics at various sites in the New York City region. Patsy remembered some of these:

Then Dave asked me to go to Coney Island (on the boat) one evening. While we were sitting outside, looking at the sea, he said 'Have you any money with you?'

Amos W. Engle, Milne's painting and business partner, and Milne in New York, c. 1908

Wondering why he asked, I said 'No.' He slipped fifty cents in the pocket of my 'sailor-suit' and said 'Just to be sure that you will have the fare back in case we become separated in the crowd.' I remember the first dinner Dave and I had together – a small restaurant somewhere in the 40's, very nice, but with tables close together and crowded. Conscious of the people sitting so close to me (and probably shy) I was ill at ease, but felt like myself again when we got outside. Another time we had a fine dinner at Coney Island, steak, potatoes, vegetables and dessert. It cost one dollar each. Also I knew Dave better then, and enjoyed it greatly.

Our favorite place was 'Palisades Park.' On a Sunday morning, or a holiday, we took the small ferry from Yonkers across to the Palisades – brought our lunch along, walked to the top, and turned right for a mile or so until we came to the woods. There was a small stream running down to the Hudson [River]. We sometimes forgot the coffee pot and had to hunt a long time until we found an empty can to sterilize and boil water for coffee. We also made long sticks with a 'prong' for making the toast.[34]

Milne was very resourceful with his hands. On one trip, as Patsy recalled, 'it began to rain, and Dave and I were half way up the mountain, so he made a "shelter" with branches, and we sat there, enjoying the little place, while it poured rain outside.'[35]

The sorry state of Milne's finances was the usual excuse he proffered for postponing their marriage. The opposition of Patsy's family, or his own unspoken doubts about whether she really was the lifetime companion he was looking for, may also have accounted for the delay. Patsy recalled that her mother 'had a difficult time with my father in later years, and was not anxious to have me marry.'[36] The financial reason Milne offered was compelling enough, for on one occasion Milne tried, without success, to borrow money from one of his brothers in order to get married.[37] Patsy remembered that when they first met he was so poor that to prepare his dinner he stood on a chair to make toast and cook an egg over the gas jet that served as the light in his studio.[38]

The other key figure in Milne's life during the New York years was Amos W. Engle. He attended the Art Students' League at about the same time as Milne, although he was two or three years ahead, and he was interested in Milne's showcards. In 1906 he and Milne established a showcard studio at 8 (now 20) West 42nd Street, over Daley's Restaurant[39] – a commercial art enterprise that sustained both of them, precariously at times, until 1916. They ate at 'Cheap Charlie's' and 'Beefsteak John's,' took turns hocking their valuables when cash ran low, moved often, and sold their business to each other from time to time at a set price of $50. Occasionally they splurged at Charles and Company, a nearby gourmet store – 'Engle and I practically put them on their feet. Bought a pound of coffee every two weeks, butter once in a while, maybe only half a pound at a time, bread, good customers, paid cash, had to.'[40] Engle loved music and had a phonograph and a good collection of records; he also took up the concertina, which Milne had to be careful not to call an accordion. They lived at their studio illegally sometimes, sleeping in a little alcove on two cots, and for about two years they shared a front room in a boarding house at the edge of Hell's Kitchen in Manhattan's west midtown, near Ninth Avenue and 25th Street. Every Sunday their landlady, Miss Brady, cooked up 'two of the finest breakfasts [Milne had] ever set eyes on' before she went off to her Catholic mass. The

Engle Seated, *1908–11, ink drawing,*
33.1×22.3 (13×8¾)

breakfasts were consumed and the boarders were back in bed by the time she returned, 'confessed, penanced and absolved.'[41]

Engle was really Milne's intellectual, spiritual, and artistic guide during the crucial years of his artistic formation. He had already been to Europe and back on cattle boats, after getting himself thrown in jail for returning on a false passport. Two years older than Milne (who remembered him being two years younger), he was the son of Quaker parents whom Milne knew and visited in Masonville, New Jersey, near Philadelphia. No examples of his work have been found, and Milne (surprisingly) kept none. But the titles of his paintings, found in exhibition lists and catalogues, are evocative of the early work of the futurists or of Kandinsky: *Experiment in Movement, Rain Motif, Storm Pattern, Waterfall Pattern, Brook Pattern, Rainy Night, Sunlight,* and *Wind. Floral Pattern* was described by one critic as 'streamers and buttons of rich color.'[42] Another described Engle as practising 'a sort of onomatopean [*sic*] in his "Confetti," so much do his bright dots of color resemble the gay missiles.'[43] And yet another critic was enthralled by a work on black paper of a theatre interior, *Opening Overture, Century* [Theater], which was shown at the New York Water Color Club's exhibition in 1913.[44] Whatever the value of his technique and style may have been to Milne, Engle was a man of unusual mind, open to advanced ideas and to spiritual theories – he later had a strong interest in theosophy. He was one of the chief catalysts in Milne's transformation from a Sunday dauber into a profoundly committed painter. The two went off together on painting holidays: in 1907 and 1908 to Ashley in the Wilkes-Barre region of Pennsylvania, where Patsy joined them for two weeks; in 1913 and 1914 to West Saugerties, north of New York; and up the Hudson River valley after Milne was married. Many of the exhibitions to which Milne submitted also showed paintings by Engle.

An early but unidentified newpaper clipping (titled 'WHY SHOULDN'T A HALF MOON BE SKYED? And Then Again Are Not Autumnal Tints on the Line? What's the Answer?'), hand-dated 29 October 1910, sheds some light on Milne's status at that time. It is mostly the report of a trumped-up altercation between Milne and Engle as to who fared better in an exhibition: Milne, whose smaller picture *Autumnal Tints* was hung 'on the line,' as academy or salon pictures that were favoured then were, or Engle's *The Half Moon at Night*, which, while larger, was 'skyed' or hung high up on the wall. No reference to such an exhibition has been found. This tongue-in-cheek article was obviously an attempt on the part of the two artists to get some publicity. However, the reporter notes that their 'paintings have adorned most of the recent exhibitions.' Whether this is an exaggerated statement, coming so early in their exhibiting careers as it does, or whether they indeed exhibited earlier and more frequently than we now know, is an unanswered question. Milne later wrote that he had started exhibiting in 1907, but no record before 1909 can be found.[45]

The other piece of useful information in the article is that 'Milne and Engle share a studio in Forty-second street, and there they act as hosts to nightly gatherings of other artists and art "appreciators."'[46] Milne later refers to this salon-like activity of theirs nostagically: 'our shop came to be a meeting place,' where 'the battle of art raged, while my partner and myself feverishly plied the lettering brush, at the same time never failing to keep up our side – rather our two sides – of the aesthetic war.'[47] Issues of the day, art news, and gossip about other artists were no doubt as much part of the lively exchanges as aesthetics. One comment by Patsy confirms

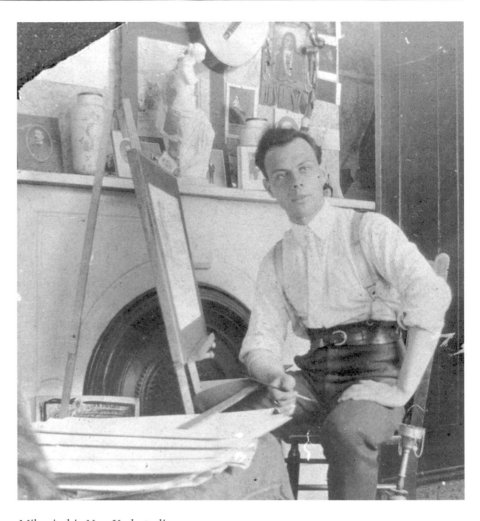

Milne in his New York studio, c. 1909

this: 'As a rule, Dave did not have much to say to people, but he would talk for hours about the painting and everything in regard to it.'[48]

A photograph of Milne in their 42nd Street studio at about this time, possibly taken by Engle, shows the aspiring illustrator in shirt, tie, and suspenders, surrounded by some of the objects of his trade: an easel, a plaster miniature of the Venus de Milo, a pair of Chinese vases *à la* van Gogh, reproductions of works of art stapled to the wall, photographs propped on the mantel of the fireplace, and a guitar.[49] At this time Milne still had hair, but it was rapidly beginning to recede at the temples, and within a short time he would be bald, except for a fringe around the sides of his head.

Milne later described Engle's odd combination of temperaments as 'Quaker, Yankee, Scotsman'[50] – a kind of Vincent van Gogh, who had his torments and talents in about equal proportions:

I am not a Van Gogh, though I can understand him. Engle *was* Van Gogh. Physically and spiritually the likeness was startling. Even in his life up to the time I lost touch with him, there were amazing parallels. Almost all of Vincent's self-portraits might have been painted from Engle, blond, gaunt, and with the same look in his eyes. He was a Quaker, at least the son of Quakers – with his mother he used the 'thee' and 'thy.'[51]

Some time after Milne left New York City in 1916, Engle seemed to lose a sense of purpose in his life. As soon as the Americans entered the First

New York Girders, *c. 1906–9, water-colour, 50.8×37.2 (20×14⅝), an early illustration by Milne*

An illustration for Uncle Sam's Magazine, *June 1909*

World War, in July 1917, he signed up and was off to Europe with the Engineers. After the war, in 1919, he drifted west to Seattle, San Francisco, Oakland, and Los Angeles – keeping in touch with Milne occasionally, and reporting that he was 'suffering from a slight or considerable dose of dog rot,' 'going through quite a bonehead period of my very mildly distinguished career,' and not doing much painting. He was delving more deeply into theosophy, working at the Lucky Jim silver mine, and proposing to study geology, chemistry, and mineralogy for three years to become a prospector.[52] Then correspondence between them faltered. Engle died a few years later, in 1926, at the age of forty-six. None of Milne's letters to him, nor any of his paintings, has surfaced as yet.

Milne left the Art Students' League in 1905 or more likely 1906. There is reason to believe that he was not very serious about his painting until about 1909 or 1910, despite his own later claims to the contrary. His primary objective in coming to New York was to be an illustrator for magazines, and it was this aim that absorbed his time in the years immediately after art school. In 1908 he wrote to Patsy: 'I haven't really been out painting for a good while.' A year later he wrote to her: 'I have been out painting just once – Sunday – in over a month.'[53] Painting was, apparently, only an incidental and recreational activity. And there are hardly any paintings, and no exhibition records, before 1909.

Almost none of Milne's commercial work has survived. Throughout the New York period, except for the summer excursions he took most years, Milne supported himself with his work either as an illustrator or as a sign letterer and showcard maker. What he actually did, what his work looked like, or how much he earned, is vague or is not known. A receipt for $75, dated 27 July 1908, is evidence of a sale to *Cosmopolitan Magazine*, although the acknowledged five illustrations of 'N.Y. scenes' were apparently never published. *New York Girders* is an example of the sort of work Milne probably did at this time, showing the deft creation of a striking image. A poster by Milne for *Cosmopolitan*, undated, was kept among his effects; it incorporates a proposed cover showing a speedboat at full throttle. The June 1909 issue of *Uncle Sam's Magazine* used three competent pen sketches to illustrate 'How the First Medal of Honor Was Won' in the series 'American Deeds of Valor.' No others are known, despite extensive searches, and although Douglas Duncan, Milne's agent and dealer many years later, wrote a note obviously based on a conversation with Milne saying that Milne's 'drawings appeared in Cosmopolitan & Pearsons Weekly about 1909–10.'[54]

In 1909 Milne also was busy for some time working on an illustration for the Hudson-Fulton celebration: the 300th anniversary of Henry Hudson's discovery of the river that bears his name, and the belated 100th anniversary of Robert Fulton's navigation of the Hudson River by steamboat in 1807. The celebrations went on all through 1909, culminating in the autumn of the year, with massive pageants and parades, a regatta of great sailing ships from round the world (including the arrival from Europe of a replica of Hudson's ship the *Half Moon*), and the unveiling of the Hudson Monument. Over a million visitors poured into New York to attend the festivities. But Milne's contribution, whatever it was, has not been found.

Nevertheless, Milne's letters to Patsy confirm that he stubbornly sought to make his reputation as an illustrator, sometimes against discouraging odds. Through the summer of 1909, for example, he toiled at nearly a

dozen different illustrating jobs for *Munsey's Magazine, Cavalier, Army and Navy Life* (later *Uncle Sam's*), and *Pearson's*. Capricious and fussy art directors hemmed and hawed, changed their minds, asked for changes. In August 1909 Milne wrote to Patsy: 'However, I do not want to get mixed up in commercial work [lettering and showcards] at all. One cannot do both, and I am going to stick to the magazines. I know I can make it go now and can make more money at that than anything else.'[55] A month later he reported stoically the collapse of one of his potential clients: 'The Uncle Sam's incident is closed. I got a letter from the collecting agency today saying that the magazine had gone out of business with assets of $50 and liabilities of $8,000 so that it was impossible to collect the claim.'[56]

Frank Munsey, the 'lonesome and frostbitten' publisher, commissioned a cover for *Cavalier*:

Munsey's sent me a letter asking me to call and I went down today. I have to make some important changes in the Cover yet. Mr Munsey wants it stronger, and he suggested the things to change. I shall try to get it done this week, as it must be done within two weeks. They want it for the February *Cavalier*. I suppose it will finally go through all right, but it has been a lot of bother. I am going to get at it tomorrow morning. In a sense it is a disappointment, and in a sense a relief. After all we won't worry so much if we finally get the thing through and get the money for it.[57]

Munsey never used the cover and Milne probably never got paid for it.[58]

Milne was first intrigued by illustrating, then challenged by it; when his ambition was thwarted, he was finally disgusted by it. He concluded that it interfered with his painting. One is left to wonder if he felt this way because he was less successful as an illustrator than some of his acquaintances: the off-hand treatment he received from his clients surely discouraged him. Later in life he was vehement about the separation of commercial and creative art, writing that 'there is more difference between commercial art and creative art than between a bishop and a burglar.'[59] When the two were too close, he wrote in 1951 to Donald Buchanan, who was then promoting industrial design at the National Gallery of Canada, people get cross-eyed.[60]

Nevertheless, it was during the winter of 1909–10 that Milne resolved to be a painter rather than an illustrator. Whether this conversion was prompted by one event, or was simply a moment of self-illumination, is not known. Engle's constant encouragement would have been persuasive, for his praise of Milne's work was always enthusiastic, and his belief in the higher calling of painting came to be shared by Milne. Ultimately Milne felt as if he were 'driving two horses in opposite directions,'[61] and he made the decision to follow the muse of painting rather than the siren of commerce.

Engle's memory of his and Milne's early years was nostalgic. Writing to Milne in the 1920s of earlier times and their adventures together, he recalled:

I surely have the most pleasant recollections of these – wondering whether they might not have been after all – very nearly our golden age – when hopes are high and our first nibbling at the art game gave us one of the few real thrills of life … Some of the those first sketches you made were corkers though … you turned out some beauties about that time – strange that you never realized on

Poster for the March Metropolitan
magazine, c. 1909–10, colour offset
lithograph, 56.0×35.3 (22×13⅞)

them – what you have done later are no doubt richer, rounder, deeper – and I can understand how the general run didn't quite get you.[62]

Sweeping changes were taking place in society and in art during Milne's formative years in New York. The world order changed fundamentally in those early years of the century. While Milne began to move toward his true stature as an artist, he witnessed both the crumbling recession of the old and the emergence of the new. After Queen Victoria died in 1901, the symbols and images of her age began rapidly to be replaced by those of the new century, as colossal industrial, social, and cultural changes occurred in relatively short order. Gas-driven taxis and buses began to replace horses in large cities; the Wright brothers flew an airplane in 1903; in 1904 the Americans embarked on building the Panama Canal; in 1905 Einstein published his special theory of relativity; plastics were invented in 1910; international wireless radio was a fact of life by 1913; and steel-reinforced concrete construction made possible 'skyscapers' that would reshape the twentieth-century city, especially in America. During this short period the way people saw and experienced the world was drastically and irrevocably altered.

In the arts the revolution was no less overwhelming. The first decade of the century saw major achievements by Giacomo Puccini, Richard Strauss, Gustav Mahler, Claude Debussy, and Maurice Ravel; by George Bernard Shaw, Joseph Conrad, H.G. Wells, Henry James, Anton Chekhov, Rudyard Kipling, and Thomas Mann. The influence of their works and ideas was inestimable. In 1903, in New York, the photographer and art dealer Alfred Stieglitz began his seminal magazine *Camera Work*. In 1905, reviewing the Salon d'Automne in Paris, the critic Louis Vauxcelles called the first major avant-garde painters of the new century *Les fauves* ('the wild beasts'). In the same year, when his career was nearing its end (although his influence was just emerging), Paul Cézanne finished *Les Grand Beigneuses*. In 1907 Pablo Picasso completed *Les Demoiselles d'Avignon*, achieving a departure from the forms of impressionism, much as the fauves departed from its colour. In 1908 Picasso and Georges Braque launched their adventures in cubism. In 1909 the futurists' manifesto blared out that the new age in art had begun. No one with sensitivity to the changing order, the *Zeitgeist*, could help being caught up by the dynamic possibilities of modernism. It was a heady time in the world of art, and Milne's arrival in New York could not have been better timed.

If Milne was naive and inexperienced, so was American art itself. New York was just beginning to ferment with the radical examples of modernism brought from Europe, especially from France. The close kinship between France and America during the political unheavals of the late eighteenth century was renewed as both countries entered upon the artistic revolutions of the twentieth. The bohemian reaches of Paris – where, in 1908, the New Society of American Artists in Paris was formed – were a spawning ground of new American art. At the same time the life and spirit of Europe migrated to the semi-bohemian but increasingly cosmopolitan setting of New York.

In 1903, the year of Milne's arrival in New York – the year J.A.M. Whistler, Camille Pissarro, and Paul Gauguin died, and Mark Rothko and Adolph Gottlieb were born – forces were already at work that would make New York a major world art centre. A great many aspiring or potential artists were gravitating to the market centre of American publishing – attracted,

like Milne, by the opportunities for illustrators. They formed a critical mass of creative people who attended lectures, organized exhibitions and societies, and helped to develop a responsive audience. The American painter Robert Henri (1865–1929), who taught at the New York School of Art, had studied under Alphonse Bouguereau in Paris, but he and his followers from Philadelphia – nearly all trained and experienced illustrators – abandoned French and American impressionism to paint real life as they found it in New York, where they were the most vocal and visible of the recent arrivals. As The Eight (they later were referred to as the Ashcan school),[63] they exhibited at the Macbeth Galleries with great *éclat* in 1908. Milne later exhibited with them at the N.E. Montross Gallery. The Montross Gallery, the Daniel Gallery, and the Macbeth Galleries, to which Milne later submitted work, were sympathetic to modernist work, as was the Whitney Studio, which opened in 1908. With Machiavellian strategy and unflagging energy Henri gave The Eight prominence by attacking the conservatism of the National Academy of Design, of which he was a member. Milne was impressed by The Eight's spirit of adventure and independence, although he did not think much of their painting. In a similar vein, although Milne thought Whistler's etchings and paintings had qualities to emulate, it was Whistler's attitude to life and art he found most admirable.

Also in 1908 Stieglitz began to show art as well as photography in the Little Galleries of the Photo-Secession, now commonly known as the 291 Gallery after its address on Fifth Avenue. Milne not only dropped in to see and study what Stieglitz was promoting, but he chatted with him and came to know him casually, especially later in the New York period when Milne had established a reputation.[64] Some of the most advanced art of Europe soon found its way there, and Milne later recalled the 291 with particular affection. 'For the first time we saw courage and imagination bare, not sweetened by sentiment and smothered in technical skill.'[65] In 1908 he would have seen the exhibitions of works by Henri Matisse and Auguste Rodin, and a year later by the American painters John Marin (1870–1953), Alfred Maurer (1868–1932), and Marsden Hartley (1877–1943), and by Henri de Toulouse-Lautrec.[66] In his notes for his autobiography Milne listed 'Exhibitions: Rockwell Kent, The Ten, Monet, Renoir, Cézanne (consider each in his place), John Marin.' The only one of these painters he wrote anything about was Monet, whose work he saw and admired at the Durand-Ruel Galleries in 1903,[67] although in a much later letter he admitted that Rockwell Kent's exhibition of Newfoundland landscapes in about 1905 'made a big impression on me and on most of the students [at the League].'[68]

The new wealth of America also made New York a Shangri-La for American portrait painters. John Singer Sargent (1856–1931), William Merritt Chase (1849–1916), and Childe Hassam (1859–1935) were then the darlings of a newly rich New York society that wanted to be immortalized in paint. The work of these artists, fine as it was, looked backward to the era that was passing, rather than forward. Even Henri, an apostle for the future, earned a comfortable living doing competent portraits, and painted for the most part in a safe and unadventurous way that was almost antithetical to his heated rhetoric. The Metropolitan Museum of Art added to the cultural richness of the burgeoning city by exhibiting non-Western art, especially Egyptian art, as well as Old Masters. Its grand expansion in 1902 not only allowed the public and artists alike to see a great deal more art, but made possible the mammoth exhibition of the popular Spanish painter

Joaquin Sorolla y Bastida (1863–1923) in 1909, and the large Whistler retrospective in 1910, which Milne undoubtedly saw but did not mention in later writing.

Art critics took note of the various new movements and helped to focus public attention on American initiatives. With the increase in exhibitions and the proliferation of artists' societies in the pre-war years, newspapers and magazines began to treat artistic events as news – and also as society affairs. For America art was becoming a way to display sophistication and urbanity. Who was exhibiting, who was buying, and whither art was going became subjects for journalists to grapple with; and, not surprisingly, they soon became aware of the rise of a distinctly American expression. Henri, particularly, spoke out forcefully for the native sons and daughters in art.

In the midst of all this Milne found the polar star to set his life's compass by: he first discovered Claude Monet's paintings in New York in 1903, when he was just beginning his studies at the Art Students' League. The experience was still vivid when he wrote about it in 1942:

I got my second thrill from painting [the first was in Toronto when he saw George A. Reid's *The Berry Pickers*] at the Durand-Ruel Galleries, then somewhere on 34th or 35th Sts. There was an exhibition of Monet's Haystack series – about half a dozen pictures I think. This was a new idea of painting to me, revolutionary. I had no particular interest in colour theories on which they were said to be based (I am not sure that I knew about these theories at the time) and none in the pointillist handling. It was the amazing unity of the pictures that impressed me, a unity gained by compression, by forcing all detail to work to one end. In all other pictures I was conscious of parts, in these I felt only the whole.

For a while they influenced my painting, directly; perhaps they still do very indirectly. I think it would be impossible for anyone to trace the influence by looking at my pictures. I soon found that Monet's way of achieving unity was Monet's way, and impossible for anyone else to follow directly. I still look for unity in painting, for singleness of purpose in painters above all things, but whatever efforts I have made in this direction have been along other lines than Monet's.[69]

In a later essay about Monet Milne gave a slightly different version of this critical encounter:

My introduction to Monet's pictures came shortly after I went to New York over forty years ago. Three, maybe more of his haystack series, were shown at Durand-Ruel's old gallery on Thirty-Fifth street near the Waldorf Astoria. I knew nothing of colour theories or pointillism or of Monet's contemporaries. I had heard of the impressionists but the word had no particular meaning for me. I didn't know whether Monet painted in the open air or in the studio. All of which was fortunate, for I had no misleading ideas about his work. I was thrilled by just one thing, his singleness of heart, the unity of his pictures. There was no straying into bypaths. He clearly aimed at one thing and one thing only. Later I saw one of the London series, and much later some of the Cathedrals, Cliffs, Rivers, Venice and the Waterlilies. The Cathedrals, Cliffs and Westminister Bridge seemed to me the high point in his painting. In these we got no return to the world around him, no story except the barest of recognition. We can tell they come from cathedrals or bridges or cliffs and that is about all. Their appeal is aesthetic.[70]

Although his recollection was that the influence of Monet was immediate and strong, it was not until five or six years later that any of Milne's paintings showed any influence of Monet. Only half a dozen from about 1909 or 1910 have the flickering brushstrokes and the closeness of hue (pea greens or blue-greens) that characterize Monet's canvases. 'Of all the painters of our time Claude Monet seems to me the most difficult,' Milne wrote. Monet was the one painter whose work was 'purely aesthetic, abstract,' and therefore the one closest to the heart of Milne's concerns.[71] The lesson Milne learned from Monet's example was structural and organizational, not technical. By contrast, Milne had little interest in Picasso's work, although later he had more interest in Matisse's, and a great deal in Cézanne's. Cézanne, he thought, was much less abstract than Monet, much more determined to get at the gritty reality of things, rather than at their aesthetic essence.[72]

The first recorded exhibition of Milne's art, apart from his participation in student shows, was in the 1909 American Water Color Society's spring exhibition, to which he submitted a pastel called *Classon Point Road* (now Clason Point, in the Bronx on the East River, between Winchester Creek and the Bronx River). The following year, 1910, Milne received his first critical notice from J. Nilsen Laurvick, who said of his entries in the New York Water Color Club exhibition:

the contributions by David B. Milne are deserving of special mention. Rather impressionistic in handling and brilliantly colorful, though somewhat lacking in that fundamental mastery which a synthetic treatment demands, this work is a welcome and refreshing note in the midst of so much that is commonplace.[73]

He was brought sharply to earth in the same year, however, by the critic of the *Philadelphia Public Ledger*, who gave a one-line review of one of his pastels: '*The Defiant Maple* of David Milne is clever, if bilious.'[74] Nevertheless, by the fall of 1911 his work had progressed sufficiently for him to be 'selected to be placed on the observation list' of the New York Water Color Club as a potential member.[75]

Up to 1910 it is possible to formulate only an approximate sequence of what Milne painted, and when. The stylistic leaps and shifts throughout these years are so erratic that any attempt at imposing order has to be arbitrary. Only two works in this early period, out of nearly a hundred that survive, are dated: one in 1904, the other in 1910. Those that are signed – an indication that Milne submitted them for exhibition – are few, and their titles, when known, do not correspond comfortably with those found in exhibition catalogues. But if the missing works for these years were found, they would probably not illuminate Milne's path much. One known work is marked, enigmatically, 'Second picture painted after art school'. Whatever its date, it merely proves Eugène Delacroix's sage dictum that every artist is first an amateur. Milne claimed, probably inaccurately, that he did not begin to paint until 1906 or 1907 and that he began to exhibit immediately.[76] The National Academy of Design was not easy for any young artist to get into, but the watercolour societies were both lenient and large enough to take nearly all submissions. Milne's nationality was usually irrelevant, but not always: 'being a Canadian didn't make any difference in these exhibitions, but the Carnegie Institute and Corcoran Gallery shows were barred to me.'[77]

Many years later Douglas Duncan (Milne's agent after 1938) went over

the New York paintings with Milne and made the following notes, which ultimately provide little help:

1st after art school gone; but 2nd is here, N[orth] of N.Y. City
Brownish ones most around Bronx Park
Waterfront, Erie Basin, at time when doing pencil & ink illustrations, Munsey's
 Mag. covers
Pale blue & green, Monet period, along Hudson, 129th St. & above.
More definite blue & green, a few, mostly winter ones, Jan. 1912.
Brown & green, sometimes lemon yellow, with broader strokes, spring 1912,
 mostly Spuyten Duyvil
Miscellaneous lot done below & above Harlem – between Wash. Hts &
 Yonkers[78]

In his earliest work Milne shows a heavy hand, a crudity in the handling of paint, and a choice of murky colours that was to persist for some time. A determination to illustrate is evident; but any burning ambition to paint for its own sake is not. Milne's hesitancy and awkwardness in oils can be seen in his attempts, as in *Van Cortlandt Park*, to try to create texture with the brush handle, and to use the palette knife to lay down a thick impasto of white as a central highlight. Colours range through brown, beige, gray, gray-blue, and dark green – but all are mixed with white. The effect, instead of giving definition and clarity, succeeds only in smothering everything with a dull and muddy tone. The earliest watercolours, however, point toward sharper definition and clearer form than the oils. The only attractive feature of the earliest paintings is a commitment to skies and clouds, trees and fields, water and reflections – the subjects of most of Milne's work, although they are treated tentatively.

The style of this earliest group of paintings follows the prevailing and pervasive examples of American impressionism. The giants of the day – Childe Hassam, J. Alden Weir (1852–1919), Willard Metcalf (1858–1929), and John Twatchman (1853–1902),[79] who were members of a group known as The American Ten – influenced Milne considerably, for the work he is known to have shown in 1909 and 1910 sometimes approaches their impastoed and fuzzy landscapes. His winter landscapes took something from Edward W. Redfield (1869–1965), a Philadelphia painter of note, with whom Milne soon served on juries for the Philadelphia Water Color Club. Decades later, in a letter to Alice and Vincent Massey, he mentioned Charles H. Davis (1856–1933) as a painter who was 'in the galleries' while he was a student. Weir was particularly close to Milne, and supportive of him and his work, certainly in Philadelphia where he had considerable influence, and probably in New York at the time of the Armory Show, when he was briefly the chairman of the organizing association. (In 1919 Milne felt no hesitation in asking him to write a letter of recommendation to the Canadian War Records.) Like the members of The Ten and those close in spirit to them, Milne worked in oils, pastels, watercolours, and etching. Pastels were also used extensively by Chase and Whistler, and in following them Milne was doggedly adopting the conventions of the day, and hoping for some sales and recognition. In 1910 or 1911 he gave up pastels and soon after jettisoned his etching, which perhaps had been an adjunct of his budding career as an illustrator and the focus of some of his early (and successful) creations. As a student he had been inspired by Whistler's etchings and was familiar with those of Joseph Pennell (1857–

Spuyten Duyvil Pastel, *c. 1909–10,*
pastel, 37.5 × 46.1 (14¾ × 18⅛)

1926), many of which had been published in *Munsey's Magazine* in 1907. In a letter of 1909 to Patsy he mentioned that Pennell's etchings, which were being exhibited at the Frederick A. Keppell Gallery that fall, were much like his own, except better and more expensive.[80] Only twenty-two single-copy examples of Milne's etchings of 1911 have survived, but they are indicative of his preoccupation with city subjects.[81]

Spuyten Duyvil Pastel, done in 1910 in the area immediately north of Manhattan, where the Harlem River meets the Hudson, is a good example of Milne's level of achievement at this time. Here, and in his painting, Milne shows a debt to the earlier generation of American impressionists in the way he provides a well-organized composition that is simplified into a few elements: a foreground, the house in the middle ground, the river reflecting the palisades in the background. The earlier tradition is there, too, in the way Milne diffuses and breaks up colours, creating an impression of atmospheric haze and vague definition. And he uses far more colours – nine or ten – than he would normally use throughout much of his later career. Yet he has put to work several effective techniques that would develop later in his work. The most obvious one is the use of vertical strokes, smudged a little to create a sense of texture. Another is the creation of fine and only slightly broken white lines running horizontally across the picture to divide it into the portions required by sky, palisades, reflection, river, and what may be the wake of a barge close to the near shore. Most important, this work shows a sense of freedom, a looseness, that Milne's earlier work did not have. It shows him on the verge of finding his own manner of expression.

The painters around Henri were also a source of encouragement to Milne in several ways. They, too, were essentially impressionists and some of them had fixed their gaze on the seedier side of New York rather than on pastoral uplands. Their subject matter, more than their style, was pounced upon by the critics, especially when they exhibited as The Eight in 1908. Two members – Canadian-born Ernest Lawson (1873–1939) and the Bostonian Maurice Prendergast (1859–1924, born on a yacht off Newfoundland) – attracted Milne's interest for brief periods.[82] Milne never mentions Lawson, but some of his early work suggests that they may have known each other and perhaps even painted together.[83] The same build-up of pigment and pulverizing of colour, and even the same stretch of the Harlem River (as well as the Hudson), can be seen in works by both artists at roughly the same time.[84] But it was the belligerent, rebellious stance of The Eight that attracted Milne, more than a specific style. How well he knew each of them he does not say, but for nearly a decade he showed with Newman Montross, who was their dealer, and he must have known them all to some degree. He definitely knew George Luks (1867–1933), with whom he served on a jury for the New York Water Color Club in 1915, and he records talking with Luks again in New York in 1917. The Armory Show of 1913 would have brought him together at least with Arthur B. Davies (1862–1928), Walt Kuhn (1880–1949), and William Glackens (1870–1938): Davies was its president; Kuhn a chief organizer (although he was not a member of The Eight, he exhibited at the Montross Gallery); and Glackens was chairman of the selection committee for all American participants (and Milne was represented far better than most American artists).

One skill Milne learned from, or had reinforced by, Henri and Chase was that of painting rapidly. Milne was impressed by Chase's annual lecture-demonstration of a quick still life or portrait.[85] Speedy execution became one of the hallmarks of Milne's painting; he usually, although not

Warehouse and Barge, *c. 1906–8,*
oil, 43.5×35.3 (17⅛×13⅞)

White Launch, *c. 1910, watercolour,*
50.8×38.1 (20×15)

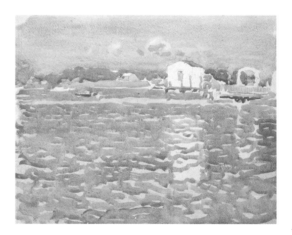

Autumn Tints, *c. 1909–11,*
watercolour, 35.3×26.7
(13⅞×10½)

Bath House, *c. 1910, watercolour, 26.1×31.5*
(10¼×12⅜)

always, strove to finish a work in one sitting. In 1908 he wrote of doing
two sketches in a day; a year later he did four in one afternoon.[86] Perhaps
a concommitant of this was his slashing, hurried way of applying paint, a
trait promoted by Henri, who derived it partly from the French impres-
sionists and partly from the work of Franz Hals. Much of Milne's early
work, in both oil and watercolour, came to life in such broad, rapid strokes.

Milne's own style begins to appear in the oil painting *Warehouse and
Barge* (c. 1906–8), which owes a debt to Henri's *Derricks on the North River*
(1902). The subject matter was then considered quite inappropriate for
art; the rather sombre cast of the whole painting, except for the brilliant
salmon colour, suggests Henri's influence. Milne extracted and empha-
sized the theme of reflections, and his painting here is much easier and
looser than it had been. Other works from these early years display ele-
ments of struggle: attempts to lighten the palette, or to gain sharper defini-
tion and greater clarity. Here began Milne's endless search for structured
definition, combined with simplicity.

During this time of concentrated searching Milne appears to have fixed

upon various combinations of colour at different times. In oils he did studies in greens, in whites and creams, and in blues; there are nearly a dozen watercolours in a greenish-blue sepia, such as *White Launch*, painted in the summer of 1910. Accompanying these forays in colour are watercolours done in a loose pointillist stipple, such as *Bath House*; and others painted with long, wide brush strokes, such as *Autumn Tints*.

Two works in particular mark the culmination from Milne's apprenticeship. *Van Cortlandt Park*, an oil painting from 1909 or early 1910 of Van Cortlandt Park in the Bronx, is executed in a gray-brown range, with the exception of a slather of white in the centre that, in a serpentine way, runs through the middle distance, linking foreground and background planes. The thick parallel ribs of brush strokes depicting the distant hills attempt to bridge the difference between a literal and a metaphoric rendition, an understanding that foreshadows Milne's later ability to render complicated visual information with a deft, simple brush stroke. Although the picture still has the muddiness that characterizes Milne's work before he learned to separate shapes with clear, unwhitened colour, the sharply marked bands of the planes declare the beginning of his understanding of how a picture can be organized. The row of trees acts as a barrier, and a focus, for what lies beyond. The horizontal slash across the near foreground, which has little inherent interest, compresses the composition from below and forces the central elements of the picture to push back down, and so to define themselves. Milne's slow evolution of this principle finally helped him to grasp the fact that the incidental parts of a painting were fully as important as the focal point in creating a sense of wholeness and drama.

The Defiant Maple, of 1909 or 1910, which is one of Milne's few pastels,

Van Cortlandt Park, c. 1908–10, oil, 44.5×50.8 (17⅝×19⅞)

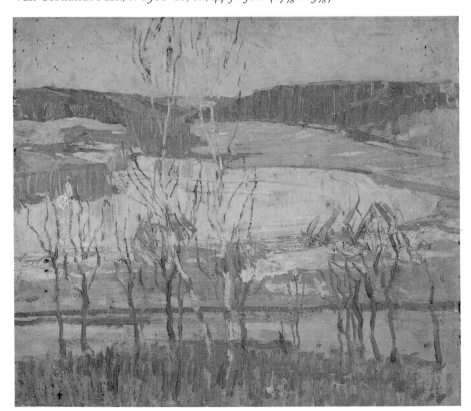

The Defiant Maple, *1909 or 1910, pastel, 57.8×45.8 (22¾×18)*

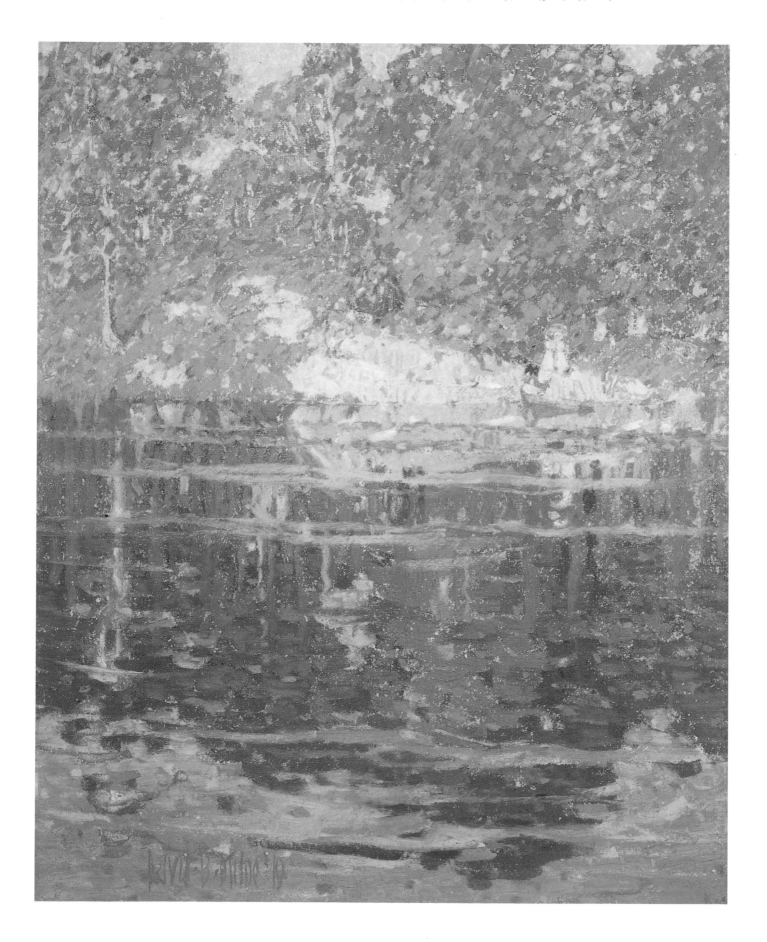

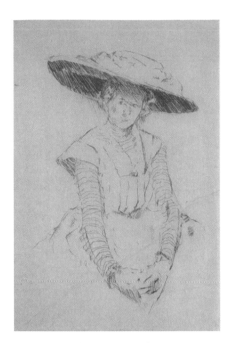

Patsy Seated, *c. 1911, etching,*
15.1 × 10.0 (6 × 4)

represents a radical departure in his use of colour and composition. Here, instead of receding planes and layered bands, is a circular pattern nearly all in the same plane. The eye is taken around the composition from left to right on the shore, down to the reflections, back up and around again. The colour intensity and overall patterning are even and uniform. Its forceful colour and effective flatness pointed Milne in a new direction. This work was symbolic for Milne, a Canadian in New York who was anxious to make an impact. When it was exhibited in 1910 – in his first appearance at the Philadelphia Water Color Club – he was undoubtedly more encouraged by its sale than cowed by the hostility of the reviewer who thought it bilious. Even an adverse notice was preferable to the snub of indifference. The fact that it was bought by a friend of Milne's friend and sketching partner, Andrew McHench, made the sale no less satisfying.[87]

In these very early works a fundamental characteristic of Milne's art was apparent, one that proved to be durable: his aesthetic creed clearly did not include a desire to shock or outrage in any moral or political sense. Painting, for Milne, was a purely aesthetic activity, not connected with social problems, and certainly not propagandistic; it was not even a process of recording or describing an object or a scene with fidelity or truth. Rather, a painting was a charged world of its own – created through its own laws and rules, and to be judged by them – balanced, integral, and evenly toned. The thrill that might be derived from painting was aesthetic: strictly confined to line, colour, and form – indeed to *seeing.* Holding this belief, Milne chose a path that was parallel to the one taken by the innovative French painters of the 1890s who called themselves the Nabis (and included Pierre Bonnard and Edouard Vuillard), and by Henri Matisse: a modernist path that avoided violent iconoclastic changes, shunned surrealism, and believed in abstraction in theory but not in practice. The visible world was always the starting point for inspiration; thereafter the creation of shapes and colours had its own life on canvas or paper.

By 1910, when at the age of twenty-eight he began to emerge as an artist in his own right, Milne had resolved two issues that were to define the rest of his life. First, he had exposed himself to the excitement and challenges of contemporary art and determined a direction for himself as a modernist painter; more specific influences sharpened his aim in the year or two following 1910, but his orientation was set. Second, he decided to give up his ambitions for a career as an illustrator. Commercial art, mostly lettering and poster work, provided his livelihood until he left Manhattan in 1916, and even for a short time after; but he inevitably found that it clashed with, and compromised, his new ideals in painting.[88]

Milne had not only weathered the physical and mental hardships of living in a sometimes callous and inhospitable city, and the demands of a strenuous apprenticeship, but he had been stimulated and tempered to a point where he believed that he could be a painter of note. He emerged from his first years in New York with a firm belief in his own talent and the beginnings of public acknowledgment of it. Seasoned by the rapidly changing cultural climate of the great city, Milne now felt prepared to confront New York and its art scene with confidence and determination. As they were sitting together on a small hill in Central Park one day, Milne told Patsy: 'I would rather be dead than not paint.'[89] She knew then that she would never be as important in his life as his art.

Billboards
New York
1911–1916

AFTER 1910 a spectacular transformation took place in Milne's art. As early as 1911 critical comments in newspapers and magazines recognized Milne as one of the most extreme and able of the avant-garde artists in New York. In the years that followed, his contributions to exhibitions were always noticed, usually quite prominently. Almost overnight the volume of his work swelled from a trickle to a torrent, his style changed from borrowed conventions to striking inventions of his own, its stance from reticence to a bold defiance. His paintings were hung in exhibitions at the Montross Gallery,[1] the North American dealer for Henri Matisse and Marcel Duchamp, and the home base for The Eight and for other major painters like Albert Pinkham Ryder and the Canadian Horatio Walker. In 1914, when Montross moved to new premises on Fifth Avenue, and throughout this period, Milne exhibited in special exhibitions there in the company of Henri, Glackens, Davies, Kuhn, Prendergast, Sheeler, and others, although Montross never paid Milne the compliment of a one-man show, presumably because he didn't sell well enough. For Milne, nevertheless, painting had now become an obsession to which all else was subservient. From 1911 to 1916 the body of his work contained, at least in embryonic form, nearly all the aesthetic concerns that would fill more than forty years of painting. The only cheerless omen, as Milne himself ruefully admitted later, was that he sold too few paintings to support himself as an artist.

Milne's basic source of livelihood continued to be the showcard and sign business he owned and operated with Amos Engle on 42nd Street, the shop where artists and their supporters frequently met. Maurice Landay, whose family owned a chain of record stores, visited the studio every week for many years to place and pick up orders for showcards, and was drawn into the whirl of excitement and enthusiastic discussion.[2] The sculptor Andrew McHench, who sometimes sketched with Milne and Engle, and whose influence was one that Milne acknowledged, was another regular visitor.[3] Other friends that Milne made in New York – such as commercial artists Arthur Vernon, James Clarke, and Howard Sherman – often dropped in for lunch and a chat.

Of the fairly large number of paintings Milne completed between 1911 and early 1916 (more than 350 still exist), only one in twenty is dated, fewer still can be identified as having been exhibited, and still other works that are known to have existed and that might have clarified our view of Milne's progress in this period were lost or destroyed.[4]

Milne's advancement in 1911 was exceptional, but hardly logical. With the energy of youth and the enthusiasm of discovery he hurled himself

Harlem Rocks, 27 February 1911,
watercolour, 43.8×36.2 (17¼×14¼)

John Marin, Weehawken Series, 1910,
watercolour, 41.0×34.0 (16⅛×13⅜)

impulsively from one idea to another. Some works are fruitless experiments, others contain ideas briefly pursued and then discarded; some indicate regression, others represent brave starts. Most intelligent, creative painters do not advance smoothly, but rather hop from one stepping-stone to another. By this time Milne's artistic affinity to Monet did not show in the painting itself, but only in Milne's desire to create a unified statement and reach a high level of accomplishment. Other artists now contributed to his thinking. While Milne's production for 1911 is both scattered and inconsistent, it had three key starting points: John Marin, Paul Cézanne, and James McNeill Whistler. But inexorably it evolved toward a style and an expression that were Milne's alone.

The first influential event was the exhibition of John Marin's paintings at Stieglitz's 291 gallery in February 1911. Milne had seen Marin's earlier exhibitions and had known and talked to him. Milne's *Harlem Rocks*, dated 27 February 1911, shows some debt to Marin in its freedom and muted colours. The long, tawny foreground, which takes up two-thirds of the picture space, recalls some of Marin's paintings of 1910, such as the *Weehawken Series*, which was exhibited at 291 in 1911. Even more closely related is Milne's *Spring Foliage*, which was painted three months later. Milne had already made considerable strides, but the example set by Marin's mature work may have spurred him on to a bolder use of colour and freer brushwork.

Even more important for Milne was the exhibition at the 291 gallery of twenty watercolours by the French painter Paul Cézanne – the artist's first showing in North America. Milne saw them in March 1911, just as Cézanne's importance was beginning to be recognized – five years after his death in 1906. Milne wrote later that we can only really see a tree because Cézanne 'split himself apart to see it.' Perhaps it was Cézanne's example that encouraged Milne to lay himself open to new and dangerous ideas, to 'split himself apart' by making something no one had made before, to see things as they had never been seen before. Although few of the Cézannes in the 291 exhibition have been identified, *Fountains (Le Parc)*, which was in the show, may have given Milne a new way of addressing the landscape, as in his *Blonde Rocks* of May 1911.[5] In this painting a certain daintiness and dullness still linger, but white space is used more effectively, and the pastel shades, while weak, are stronger than before. The long parallel brush strokes, which so boldly mark the hump of stone, leave out much detail and move the picture toward Milne's aesthetic goals of economy and simplicity, in which dominance/subordination become more clearly defined. Atmospheric effects are reduced to make way for form and shape. The strength in the work was beginning to show the raw power Milne was aiming for.

In the first half of 1911 Milne executed about twenty etchings that illustrate his debt to Whistler (and to Whistler's follower and biographer, Joseph Pennell). Whistler had been a model for Milne and his fellow students at the Art Students' League, and a massive retrospective exhibition was held at the Metropolitan Museum of Art in 1910. Of Milne's twenty etchings, five are dated in May, June, and July; and the rest are from this narrow time period, or very close to it. Only one impression of each of them exists. Four are of Patsy – one of them rather earlier (probably 1909) than all the others – and the rest are of sites in New York City: *The Plaza Hotel, Madison Square Gardens, Madison Square, The Whitehall Building, Ellis Island, The Claremont, Riverside Park,* and *Fifth Avenue and the New York Public*

Spring Foliage, *3 May 1911, water-colour, 44.8×37.5 (17⅝×14¾)*

Library Lions. This taste for city scenes represented a sharp shift in Milne's choice of subjects, for up to this time nearly all his paintings had been of landscapes in the suburbs: the Bronx, the Harlem River, Jackson Point, Canarsie Park on Jamaica Bay, Flushing Bay, Erie Basin, Van Cortlandt Park, Pelham Bay, Coney Island, and so on – all areas that were undeveloped bush or farm country. Suddenly Milne seems to have found the city itself a place of wonder and deserving of his attention as an artist. He may have started etching with the intention of producing a suite of etchings for commercial purposes. What is fascinating about Milne's subjects, from this point until his departure from New York five years later, is that as often as not he depicted new additions to the cityscape. The Plaza Hotel was new, the Public Library was new, the Metropolitan Life tower at Madison Square Gardens was new, and the buildings behind Trinity Church were new even if the church itself was not.

In 1908 and 1909 Milne had already done drypoint and etching in relation to his illustration work. He took his plates to a printer on Vescy Street to have them run off, and while there 'learned something about printing.'[6] *Ellis Island,* dated 8 July 1911, is a clear forerunner of one of Milne's recur-

Blonde Rocks, *c. 1911, watercolour, 38.1×31.8 (15×12½)*

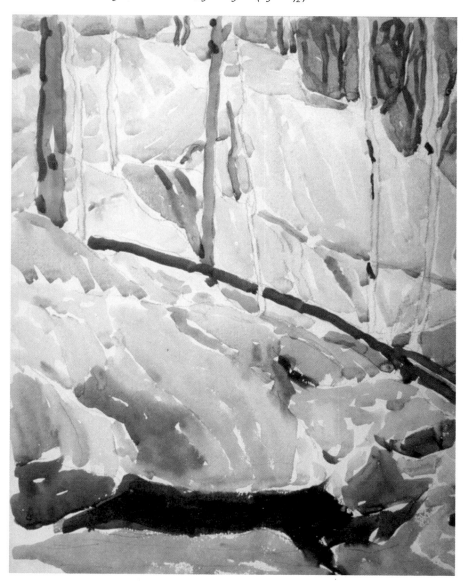

Apple Blossoms, c. 1911, watercolour,
47.7×38.1 (18¾×15)

Madison Square: Spring, 4 May 1911,
etching, 13.8×11.3 (5½×4½)

ring compositional motifs: a band detailing the far shore is placed high in the picture space, leaving a vast expanse of water untouched below, except for the textural qualities that wiping the zinc plate with the hand gives. Whistler often used this same compositional device in both his paintings and his etchings (*La Salute: Dawn* from the suite of Venetian subjects is an example). Milne used this division of the picture space (putting all the detail of the picture in one half only) for the rest of his life: it is in *Bronx Hillside in Spring* (1915), in *Across the Lake* (1921), in the *Bear Camp* series (1951), and in numerous other works. Turned upside down, it also accounts for the wide, empty skies of many of the Palgrave paintings of the early 1930s. These works are convincing evidence of what it was that Milne at first borrowed from Whistler, and then made his own.

Milne's concentration on the forms of the city affected him in ways that were profoundly significant for his art. His colours changed to reflect the boisterous images of New York streets, and in consequence affected his compositions in ways that he had never before considered. For example, he now began to paint in vertical formats – almost the only time in his life that he did this. Furthermore, the use of large empty spaces in the etchings led Milne to try the same thing in his painting: to open up larger white spaces in his watercolours. This reorientation in style occurred simultaneously with the shift in subject matter.

There were other influences in the air and around Milne's studio, such as primitive and Oriental art. His friends and colleagues – Engle and William and Marguerite Zorach, who had travelled to Asia – provided ideas and techniques that he at least considered. Chinese vases adorned the mantel of the 42nd Street studio, and African, Egyptian, Persian, Japanese, and other non-Western art was known to Milne through museums and commercial galleries. In his notes for his autobiography Milne mentions McHench, with whom he and Engle went out sketching. McHench's sculpture, a few examples of which are in the New York State Museum in Albany, was somewhat radical, for Milne mentions that it had holes in it – one thinks of the possible influence of Arp or Archipenko. In about 1914 McHench did a portrait of Milne in what looks like plaster. Milne 'didn't like it very much,'[7] according to Patsy, although he hung it on the wall and it appeared in Milne's paintings of interiors up to the late 1920s, when it was put into storage and never recovered.[8] McHench also was at work in 1915 on a controversial sculpture for a city square in New Rochelle to commemorate the American soldiers who had fallen in the Philippines. Milne continually sought out other contacts. Patsy reported that 'On Sundays, we often took our lunch and went for a trip or had some artist for dinner, if we could afford it.'[9]

In the watercolours executed during the spring and early summer of 1911 Milne strove to brighten his palette with more forceful colours, such as reds, pinks, and livelier greens. In *Apple Blossoms* he used for the first time unmixed colours: no longer reduced with white, they were vigorous and aggressive, and he set them down with enough separation to enhance their inherent strength. Milne's attempts in oils, such as *Blossoming Tree*, were considerably less convincing than his watercolours. In oil the need to fill the picture area completely seems initially to have confused and bewildered him: his explorations in oil did not catch up to his watercolours immediately.

In the summer of 1911 the meditation and exploration of the previous months and years suddenly coalesced into a succession of works that an-

New York Street, *c. 1911, oil,*
56.2×45.8 (22⅛×18)

nounced Milne's mastery of his own style, and on which he established his signature with precision and force. Milne's and Engle's studio was literally a hundred feet away from the New York Public Library, and Milne was able to watch it being built from a few months after the laying of the cornerstone (where the great Croton Reservoir had stood until that time) on 10 November 1902 through to its opening by President William Howard Taft, Governor John A. Dix, and Mayor William I. Gaynor on 23 May 1911. Milne would have been able to see Edward C. Potter, another Canadian artist working in New York, try out the plaster versions of his pair of lions on either side of the front steps before they were carved in marble by the Piccirilli brothers and then watch Potter supervise their installation. Milne would also have been impressed, as all New York was, by the extensive marble, walnut, and oak finishes of the halls, exhibition spaces, and reading rooms. (Indeed, the halls were the subject of at least two paintings that have been catalogued: *Library Interior*, and *42nd St. Library*.) In the fall he did two watercolours of the exterior of the library, *Black and White I* and *Black and White II*, that show how far he had travelled in a very short time.[10] He had discovered what for him was the right balance in the juxtaposition of near and far subjects, the right amount of white space for the amount of detail he wanted to convey, and the right strength for each of the colours. He knew, intellectually and emotionally, what he wanted to paint, and he also knew the right moment to stop. The first works in his new-found style struck him as being so important that he exhibited some of the 1911 paintings several times up to 1915. Later at least three works from 1911, out of a total of seventeen, were used to establish his bona fides to become a war artist with the Canadian War Records in England in 1918.

By 1912 Milne was also discovering that a new cohesion was possible in oils, as *New York Street* demonstrates. The fusion created by even tonal values and by simplified articulation – whereby a single brushstroke could indicate a window, a hat, or a figure – now gave him the freedom to accomplish in oil what he had already achieved in watercolour. Monet's 'singleness of heart,' which Milne sought to emulate, had finally begun to appear, for Milne's works now seem not only to bear his own imprint, but to stand as intelligent pictorial statements – coherent, strong, and unified.

Black and White I, *1911, watercolour, 46.0×58.0 (18×22¾)*

Black and White II, *1911, watercolour, 46.0×58.5 (18×23)*

Stylistically the paintings of 1912, 1913, and 1914 fit together more than those from any other period until Palgrave in the 1930s. The changes from year to year were subtle and tentative, although Milne's aggressive explo-

Fifth Avenue, *c. 1912, watercolour, 38.1×50.8 (15×20)*

Billboards, *c. 1912, oil, 51.2×56.5 (20⅛×22¼)*

rations, based on his discoveries of 1911, continued unabated. His colours were bold, saucy, and applied with bravado, yet these effects were increasingly achieved with sparer means, fewer colours, and more open or white space than previously. The assertiveness of Milne's style gives his paintings a high relief. The viewer is conscious of seeing not only the image but, simultaneously, the method by which it is depicted. This visibility of method becomes part of Milne's subject matter, drawing as much or more attention to the aesthetic aspect of a painting as to its physical subject: the real subject of the painting becomes the painting itself.

Two watercolours and an oil characterize Milne's work of 1912. *Fifth Avenue* reveals his acute powers of observation, for he caught with humour and ease the exact stance of the young toddler, the teenager, and the mother. He probably worked from a photograph for part of this painting, because it carries the mark of a carefully considered composition, despite its illusion of spontaneity. The same is true of *Billboards*, an oil that was one of the year's finest achievements, and the beginning of a series of works that made extensive use of billboards as subjects. Although he was

Three Hansoms, c. 1912, watercolour, 61.3 × 51.8 (24⅛ × 20)

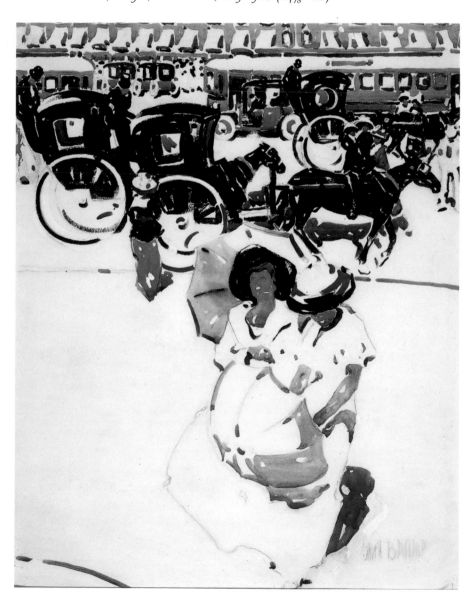

Lady of Leisure, *c. 1912, watercolour,*
28.3×38.1 (11⅛×15)

Woman with Brown Hat, *3 June*
1912, watercolour, 38.1×29.9 (15×11¾)

not the first to paint this kind of street furniture, Milne used billboards much more extensively than other artists. A third painting, *Three Hansoms*, was painted at least twice – providing convincing evidence that, even in his early years, not all of Milne's work was done quickly. If repainting a picture with a few modifications would improve it, then repainted it would be – so long as the inspiration of the original was still fresh.

In the spring of 1912 Milne began to work small, elongated oval shapes into his paintings as a textural base or filler. They figure prominently in the watercolours *Lady of Leisure* and *Woman with Brown Hat*. This was a trick Milne had discovered in 1911 while scratching his etchings. The little ovals had the advantage of being adaptable to his varying intentions: they could be left open, they could be dominant or unobtrusive, and they could be densely or sparsely used. Chiefly they had a quality of expansion in that they affected areas larger than the ones they occupied. In combination they created a powerful textural effect. In 1913 Milne added to his vocabulary spots of solid colour laid over a solid ground. His use of these devices to create a diffuse pattern, and to emphasize individual shapes, gave strength to the overall structure of his paintings.

An example of Milne's reponse to other art in 1912 can be seen in his taking inspiration from two of the five panels of Taddeo Gaddi's *Madonna and Child Enthroned with Saints*, which had been recently acquired by the Metropolitan Museum of Art. In *Madonna* and *St Lawrence* Milne was drawn to the heraldic colours of Italian primitive painting, and he translated them into the idiom of his day and into his personal style, while at the same time capturing the stained-glass boldness of Gaddi's painting.

In 1913, after a three-week holiday at West Saugerties in the Catskills, Milne's work took another leap forward with the discovery that white space

Bronx Park, *1913, 5 July, oil, 45.8×50.8 (18×20)*

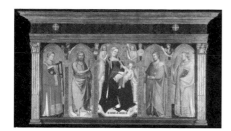

Taddeo Gaddi, Madonna and Child
Enthroned with Saints, *c. 1340,*
tempera on wood, gold ground,
109.8×228.9 (43¼×90⅛)

St Lawrence, *c. 1912–13, water-*
colour, 55.5×26.4 (19⅞×10⅜)

could be used to an even greater degree than he had yet dared to attempt.
On his return to New York he painted Patsy in *Bronx Park,* an oil in only
four colours with black and white. The limited palette and the simplifica-
tion of shape indicate his striving for economy of means. But the lively
colour in this work should not obscure the real intent behind it: an exer-
cise in reduction. Bright hues and high values were as susceptible to the
demands of simplicity as dark hues and low values. Another typical oil
painting of the summer of 1913 is *Sunlight,* in which the white paint func-
tions both as background and as a colour area. The application – in small,
rich licks – adds to the animation. But, despite the emphasis on colour
and surface texture, Milne did not forget the subtleties of establishing planes
securely, or of adding interest and tension by including the deeply recessed
area on the right. He now knew that the parts of a painting least observed
by a hurried viewer were critically important to the impression created by
the picture as a whole. The little spot of red in the middle of this painting,
characteristic of many works, also shows that he knew how to entice a
viewer's attention.

By the autumn of 1913 Milne had pushed his slow, sinuous stroke for-
ward to arrive at a new one that was rather sharper and more slashing. In
paintings of Patsy such as *Striped Dress* and *Reading* the contrast between
rough and gentle textures is extreme; colour areas are almost brutally filled,

Sunlight, *c. 1912, oil, 50.8×45.8 (20⅛×18¼)*

Striped Dress, *c. 1913, watercolour,*
47.7×36.5 (18¾×14⅜)

and yet the image is not threatened and the picture does not lose its balance. Indeed, the delicacy becomes more miraculous beside such strength. Dark and light colours are also poised in contrast. The figure in *Striped Dress* is complemented by the white stripe near the featureless wall that also serves as a subtle point of easy entry into the painting. In this case the white almost creates the illusion of a hole in the picture surface; the force of the blue and black, as well as the contrast between the rounded and the rectangular shapes, and the little touches of unexpected colour in the chair and clothing, help to reinforce this illusion.

The momentum of Milne's work carried through the fall and winter of 1913–14, and for the first time in his career he found that his painting in oil pulled ahead of his work in watercolour. Until 1912 Milne had done most of his thinking and practice in watercolour. His work in oil gave the impression of effort and strain. The first glimmer of a change can be seen in the paintings of 1911, with further progress evident in *Billboards* (1912) and *Bronx Park* (1913), but in the winter of 1913–14 Milne finally had a run of relaxed and successful works in oil that marked another phase in his swift development.

The evidence for this leap forward with oil is unequivocal in *Red* and *Black*, painted in the spring and summer of 1914. Both show the force and simplicity that Milne could now bring to bear when working in this medium. In a short time his touch had become lighter and much more deft. The restricted palette of *Bronx Park* was maintained; most of the paintings of the following winter were made with no more than four to seven colours, plus black and white. In some pictures white was used as a background, as it had been in *Sunlight*; in others it provided dramatic highlights, such as a window against which a figure is placed, as in *Red*, or as a focus for the composition. Black, which had been used only as a hue up to this point, was suddenly used to outline shapes and areas of colour, or to emphasize the drawing in key elements of the painting. These uses of black and white were nevertheless kept subservient to Milne's colour schemes and to his compositional patterns. As his work developed over these years, he became convinced that shape (or drawing) was more im-

Red, *1914, oil, 50.8×55.6 (20×21⅞)*

Black, *1914, oil, 51.9×61.9 (20⅜×24⅜)*

Evening Interior, *c. 1913–14, water-colour, 46.4×41.3 (18¼×16¼)*

portant than colour. Colour was emotional. But line, which defined shape, presented ideas; and Milne's chief aim was to present a strong, articulate thought. Reinforcing an idea with the emotional excitement that colour provides was certainly an objective, but it was a subsidiary one.

Many of the paintings of the winter of 1913–14 were of Patsy in the Milnes' apartment: *Evening Interior, The Yellow Rocker, 1914,* and *Striped Dress.* In *The Pantry* Milne used the time-tested compositional plan of looking through a doorway. Milne admired Velazquez's use of this device in *Las Maniñas (The Maids of Honour),* where the large, and in itself uninteresting, back of the painter's canvas counterbalances the rest of the composition. Vermeer also used the device frequently. In *The Pantry* an ample amount of space is allotted to the foreground door frame and walls and very little space given to the subject of the painting: the distant but central figure of Patsy, seen through the doorway, in front of the china cupboard in the background. This device succeeds because it focuses attention where it is intended.

Patsy is prominent – for good reason – in a large number of Milne's paintings beginning in 1912: after a courtship of six years Milne and Patsy finally married. Milne's showcard business with Engle was providing a modest but steady income. This, combined with his success at exhibiting (and occasionally selling) paintings, either gave Milne the impetus to propose or Patsy the confidence to accept. Disregarding Patsy's family's wishes,[11] they suddenly decided to get married on their way to Milne's home in Paisley for a holiday, and did so on 3 August 1912 in New Rochelle, just northwest of New York City, where McHench lived.[12] Engle bustled ahead of them and selected the addresses of two abandoned houses to serve as the necessary residences for their marriage licence. They bought

The Yellow Rocker, *1914, oil, 50.8×40.7 (20×16)*

The Pantry, *1914, oil, 51.2×46.1 (20⅛×18⅛)*

the licence at the city hall, were married in a minister's home, and after a celebratory lunch caught the night ferry from New York up the Hudson River to Albany. On board, Patsy remembered, they ate a sandwich supper in their stateroom. 'Then we went up on deck. It was a beautiful moonlight night, with the boat sliding gently along the quiet waters of the Hudson. The next morning, we had to get up at 4 a.m. to catch the train to Buffalo.'[13]

From Queenston they took another boat to Toronto, a part of the trip Patsy also remembered fondly:

It was a lovely trip up Lake Ontario, which I had never seen before (although Dave had), sunny and warm on deck. When we arrived in Toronto we went to the top of the City Hall Building, then had lunch. It was such a nice lunch, and very reasonable. Dave wanted me to see the stores, so we walked along the main street – we liked Ryrie Birks window with all the beautiful things in it. Dave said it was a fine Canadian store.[14]

The honeymoon at Paisley was a pleasant one, beginning with their arrival later that same day:

We arrived at Paisley about dark. Dave's sister, Belle, and Bob [his brother], who had come home for a visit, met us at the station. They had a lantern and we walked to the house. Dave's mother met us at the gate. She had a pleasant Scotch accent and was quite a tall woman. His father was small – like Dave in looks. Jim was there too. A man in a buggy stopped just then, and they told him who we were. He said 'So this is a Yankee.'[15]

The *Paisley Advocate* of 15 August 1912 noted that 'Mr. David Milne and his bride of New York are here on their wedding trip, visiting his parents and friends.' Mrs Milne senior gave her new daughter-in-law some stern advice. Patsy did not record it in her memoir, but after Milne died she told her friend the writer Blodwen Davies, who wrote it down in quotation marks: 'Dave will paint & paint & paint, & you will work & work & work.' Milne painted several excellent works during this pleasant interlude – of flowers, of the gardens around the family house, and of Patsy, who was to be the subject of a large number of paintings for the next two or three years, including one on 7 August, *Sleeping Woman*, of her asleep (but not undressed). The elder Mrs Milne's mandatory church services were attended on Sundays, but during the week picnics and walks along the Saugeen River were interspersed with visits with old friends:

We had a very nice time when Miss Miller and her sister invited us to go to their home, about a mile or so away (not far from the Paisley school). We got there about five o'clock – had some home-made raspberry vinegar first – then went down a back lane to the river. There was a place for a fire (made with stones) and Dave found plenty of wood, and made a great big fire. We had toast, coffee and cooked meat. The butter was made on their farm, and there was a wonderful home-made jelly roll. It was all pretty nice. We left about nine o'clock, and ran down the road, just having a good time.[16]

Milne took Patsy to see the school he had taught in: 'He lifted me up and I looked in the window of the one-room brick building, and tried to imagine what it was like when Dave was there.' Then 'we went back to New York after three weeks and sat up all night on the train, arriving in the morning

with only enough money to pay for two cups of coffee and car fare. I went home and Dave went to the Studio.'[17]

For the first two years of marriage they lived in an apartment in the Bronx, at 173rd Street and Park Avenue:

We had no furniture to start with, after we found the apartment, so Dave went to an auction, and made about six trips up from the City to the end of the 'Elevated ' Line (155th St.), carrying a chair or two each time – then walked to 173rd St. (he had to stand on the 'L' platform with the chair). He was very much pleased, as they were really nice chairs – 'rush' bottom, and cost $2.10 each, but had originally been a lot more expensive. Then he bought a rug for a dollar, also at the auction – about 12 by 14 feet, rather nice soft colours, but well worn – also a dresser (inside the top drawer was the name of the actor who had owned it). We left the dresser with the Burchs who had the grocery store at Boston Corners, as they wanted one, when we left B.C. Dave also bought a 'fumed oak' dining room table – some pieces of linoleum, a bed (a new mattress - six dollars) and a barrel of pots and pans and dishes. We forgot knives and forks – and for a few days had to use a pen knife to cut meat, etc., but were given some silver very shortly, also blankets. The furniture came up on a truck to the apartment.[18]

Milne thrived not only on the domestic stability of marriage but on the opportunity it now gave him to paint much more. Even though he was still a part-time painter and a part-time signmaker, his production shot up. Patsy's only comment about his work then was that he did 'oil in winter, water colour and pastel in summer' – a pattern that is clearly not true. She also said that Milne 'did not destroy any – either water colour or oil – and the difficulty of getting canvas etc. or water colour paper made him exceptionally careful – It was only on rare occasions that he painted any out – he never destroyed one.' This too is a fond memory, belied by the fact that Milne was a ruthless critic of his own work, and destroyed or painted out numerous works all his life. Nevertheless, Patsy is right in saying that 'after we were married the painting went on every day.' Milne did settle into a regular and productive routine. According to Patsy, 'Dave started right after breakfast, and painted until noon, mostly outdoors, but sometimes in the apartment or wherever we were living, working at a sketch he had made, sometimes for two or three days.' Then he 'usually went down to the 42nd St. studio about twelve o'clock, and came home about seven.'[19]

Patsy and Milne led a lively and varied life, while she continued to work for the Knickerbocker Chocolate Company. They went to the theatre, to concerts, and to exhibitions; they read novels and poetry together – Milne liked reading aloud. They kept a lively and full social calendar of simple dinners and parties with artists, either at their apartment or in the lofts or studios of others. Patsy and Milne entertained family and friends, as Patsy recalled:

My mother came once or twice to see us before she went to California, and my aunts came (they gave us heavy quilts, silver, etc., and Engle's people gave us a nice pair of woolen blankets, as his gift to us). Mr [Charles] Duncan, a young artist we knew, and Engle, also came to see us. I usually made a steamed apple pudding in a very nice pale blue crock I had. It only cost twenty cents, at a small store uptown. The artists seemed to enjoy the dinner, and the conversation was as usual about painting, which always made a happy evening.[20]

Other artists who frequented Milne's studio included William and Marguerite Zorach, J. Alden Weir (a judge for the Panama-Pacific Exposition), George Luks, Charles Duncan, Raymond Thayer, and Charles Lennox Wright. In 1913 Milne enjoyed a three-week holiday (Patsy took only two weeks, since she had a job) at West Saugerties, just west of the Hudson River across from Tivoli, where Patsy's relatives later had a summer place. The holiday was so salutary for Milne's painting that the following year the Milnes put their belongings into storage and moved there for three months. When they returned to the city, they moved to a large apartment, owned by one of Patsy's aunts, at 106 West 61st Street. Patsy then went to work as a clerk-typist for the General Electric Company. Milne could now walk, if he wanted to spare the time, to his showcard studio at 42nd Street and Fifth Avenue.

The years prior to 1913 saw an exhibition of The Eight at the Montross Gallery in 1908, followed by the Exhibition of Independent Artists in 1910 – exhibitions too early to include Milne, but a further stage in the advancement of the younger and more spirited artists of the period. Robert Henri, a staunch nationalist, was the moving spirit behind this latter large exhibition of, and for, Americans. Led by Henri, The Eight finally breached the impregnable wall of the stolid National Academy of Design, the bastion of the establishment and the refuge of academic adherents. By 1913 Milne had also infiltrated that conservative fortress with a work called *Blue-Green, Black-Green*; by referring only to abstract, aesthetic qualities, the title was provocative for the times.[21] Another exhibition, 'Younger American Artists,' was held at Stieglitz's 291 gallery in March 1910, following one-man exhibitions by John Marin and Henri Matisse. Rockwell Kent, an impetuous rebel, organized another Independent Exhibition in 1911, this time insisting that participants must resign from the Academy in order to be included. In 1913 the Armory Show stormed into New York.

The spirit of innovation was everywhere during these years, and the forms of art were being recreated at a frantic pace. The performance of Stravinsky's *Rite of Spring* shattered the old conventions of music and dance in 1913, the year Marcel Proust's *À la recherche du temps perdu* began to appear, the year of the first of Marcel Duchamp's 'readymades,' the year of the Armory Show in New York. In 1914 Wyndham Lewis – born in a yacht off Nova Scotia in the same year as Milne – edited the first issue of *Blast*, and a seminal book by Wassily Kandinsky was published in English as *Concerning the Spiritual in Art*.

At the 291 gallery alone the pace was energetic and the program innovative. Stieglitz gave John Marin his third exhibition early in 1911. This was followed by a show of twenty Cézanne watercolours and another of eighty-three drawings and watercolours by Picasso. In 1912, in addition to exhibiting paintings by the Americans Marsden Hartley and Arthur Dove, Stieglitz showed Matisse again (and, for the first time, work by children). Marin had another show in 1913 that would have been of interest to Milne. Later references confirm that Milne was impressed by the Brancusi sculptures displayed at 291 in 1914, the same year Stieglitz mounted an exhibition of African sculpture. Milne wrote later that at Stieglitz's little 'packing box' gallery, 'we met Cézanne, van Gogh, Gauguin, Matisse, Brancusi. For the first time, we saw courage and imagination bare, not sweetened by sentiment and smothered in technical skill.'[22] But Stieglitz was implacably opposed to, and contemptuous of, Montross and his stable of artists, which meant that he had little time for Milne, who – like other Montross

artists – was excluded from the important Forum Exhibition that Stieglitz enthusiastically organized in 1916.

Only the Matisse shows of 1908 and 1910 and the Cézanne and Marin exhibitions of 1911 were early enough to influence the course Milne had plotted for himself. By the time most of the major and influential exhibitions of the period came along Milne's artistic stance was almost set. Earlier he had tried to paint like Monet, but he quickly realized that only Monet could do that; and the lessons of the American Ten, albeit limited ones, had been absorbed. Milne had struck off on his own to find his own distinctive way of expressing himself. It is difficult to be sure about other painters who might have helped to determine his thinking: in later years Milne said that one might see a painting like Matisse's *The Red Studio* for just a second, through a crack in a door, and be influenced for one's whole life.[23]

Milne exhibited regularly during these years with the New York Water Color Club, the American Water Color Society, the Philadelphia Water Color Club, the Pennsylvania Academy of Arts, and other such associations in their annual exhibitions. These shows often toured to other American cities – Buffalo, New Orleans, St Louis, Newark, Washington, and so on. And in these tolerant associations emerging artists had ample opportunity to demonstrate what they were thinking and doing. Traditional critics carped that some young artists had warped the basic tenets of American impressionism, but other writers recognized their originality. As Milne rapidly became respected by his artistic peers, he was looked upon kindly by sympathetic and knowledgeable members of the press. His work rose well above the run-of-the-mill examples of painting that were shown, several hundreds at a time, in these clubs' annual exhibitions.

In 1912 Milne became a full-fledged member of the New York Water Color Club. He attended its meetings and was on the annual jury in 1915 with George Luks and Arthur Crisp, and again in 1916. By the time he left New York in 1916, he was a member of its executive committee or Board of Control.[24] He also served in 1915 as a juror – with the renowned etcher Joseph Pennell, and the locally popular painter Edward Redfield – for the annual show of the Philadelphia Water Color Club, of which he was also a member, having been elected (along with John Marin, Maurice Prendergast, and N.C. Wyeth) in January 1914.[25] Milne's friendly connections with Philadelphia no doubt grew out of the annual visits of Jerome Myers and George Dawson, officials of the club, who for many years called on Milne and Engle at their studio to select paintings for the club's exhibitions.

In New York a small Madison Gallery coterie, led by the painters Walt Kuhn and Arthur Davies, formed themselves into the Association of American Painters and Sculptors, and organized the International Exhibition of Modern Art of 1913 – now better known as the Armory Show, after the venue in which it was held: the new armory of the 69th Regiment, on Lexington Avenue between 25th and 26th Streets. The first president of the Association was the painter J. Alden Weir, an older man and a member of The Ten, who served on the executive committees of several artists' clubs and societies and was a good friend and supporter of Milne. The initial intention of the Association was to show their members' work beside a modest selection of contemporary European painting and sculpture. No one imagined, at the beginning, that more than 1300 works of art would be shown, that 50,000 catalogues would be printed, that over 75,000 people would attend – and that an artistic furor would ensue. But when

Distorted Tree, *1912, oil, 55.6×50.6 (21⅞×19⅞)*

OPPOSITE: Fifth Avenue, Easter Sunday, *7 April 1912, watercolour, 56.6×43.2 (22¼×17)*

Kuhn and Davies enthusiastically scoured Europe with Walter Pach, the number of European contributions mushroomed. To match the vast European component more equitably with American works, a Domestic Committee was struck, under the chairmanship of the painter William Glackens, to invite submissions from American artists who were not members of the Association. On the committee were D. Putnam Brinley, Sherry Fry, John Mowbray-Clarke, Frank Nankivell, Maurice Prendergast, Henry Fitch Taylor, and Allan Tucker. They invited certain painters to submit work in any medium, and clearly to state their order of preference, since only one or two works could be shown.

In January 1913 Milne submitted five works, two oil paintings and three watercolours. They were all accepted.[26] The oils were catalogued as 796, *Columbus Circle*; and 795, *Distorted Tree*. The watercolours were 794, *Little Figures*; 797, *The Garden*; and 798, *Reclining Figure*.[27] (The identity of these paintings is still uncertain, although *Distorted Tree* is probably now in the National Gallery of Canada, its Armory Show title restored, having surfaced from a New York source in the 1980s with a provenance going back to 1913.) They were soon hung in Gallery E of the Armory Show, with the paintings of Walt Kuhn, J. Alden Weir, Arthur Davies, and Bernard Gussow – rather distinguished company. Engle, Milne's friend and partner, had only two works accepted (*Windy Night* and *The Sprint*), and Marguerite and William Zorach, also friends of Milne's, had only one and two works, respectively, accepted. Alden Twatchman had two shown out of five submitted, Joseph Stella one of five, and Edward Hopper one of three. Mary Cassatt had two paintings hung and Maurice Prendergast three oils and four watercolours. Perhaps Milne's acquaintance with Jerome Myers, one of the founders of the Association, accounted for his generous

Cover and two pages from Milne's copy of the Armory Show catalogue, 1913

NEW YORK

1913

International Exhibition
of Modern Art

Association of American Painters
and Sculptors, Inc.

February Seventeenth to March Fifteenth

Catalogue 25 Cents

ZORACH, WM.
 78 West 55th St.
783 Portrait
784 An Arrangement

RASMUSSEN, BERTRAND.
 199A 33rd St., Brooklyn, N. Y.
785 The Tree of Knowledge

KARFIOL, B.
 Grantwood, N. J.
786 Men at Rest
787 George

DRESSER, AILEEN
 364 West 23rd St.
788 Quai de la Tournelle, Paris
789 Madame DuBois
790 Notre Dame Spring

ROGERS, MARY C.
 136 West 65th St.
791 Portrait

CRISP, ARTHUR
 147 Columbus Ave.
792 Panels for a Dining Room

DAVEY, RANDALL
 88 Washington Place
793 Girl in Blue

MILNE, DAVID B.
 8 East 42nd St.
794 Little Figures, Water Colour
795 Distorted Tree
796 Columbus Circle
797 The Garden, Water Colour
798 Reclining Figure, Water Colour
 55

MAURER, ALFRED
 Nos. 53, 54, 55

MAYRSHOFER, MAX
 Nos. 456, 457, 458, 459, 460, 461

MELTZER, CHARLOTTE
 Nos. 766, 767

MIESTCHAMNOFF, OSCAR
 No. 633

MILLER, KENNETH HAYES
 Nos. 49, 50, 51, 52

MILNE, DAVID B.
 Nos. 794, 795, 796, 797, 798

MONET, CLAUDE
 Nos. 494, 495, 496, 497

MOWBRAY-CLARKE, J.
 Nos. 696, 697, 698, 699, 700, 701, 702, 703,
 704, 705, 706

MUNCH, EDWARD
 Nos. 244, 245

MUHRMANN, HENRY
 No. 470

MURPHY, HERMAN DUDLEY
 No. 77

MYERS, ETHEL
 Nos. 662, 663, 664, 665, 666, 667, 668, 669,
 670
 87

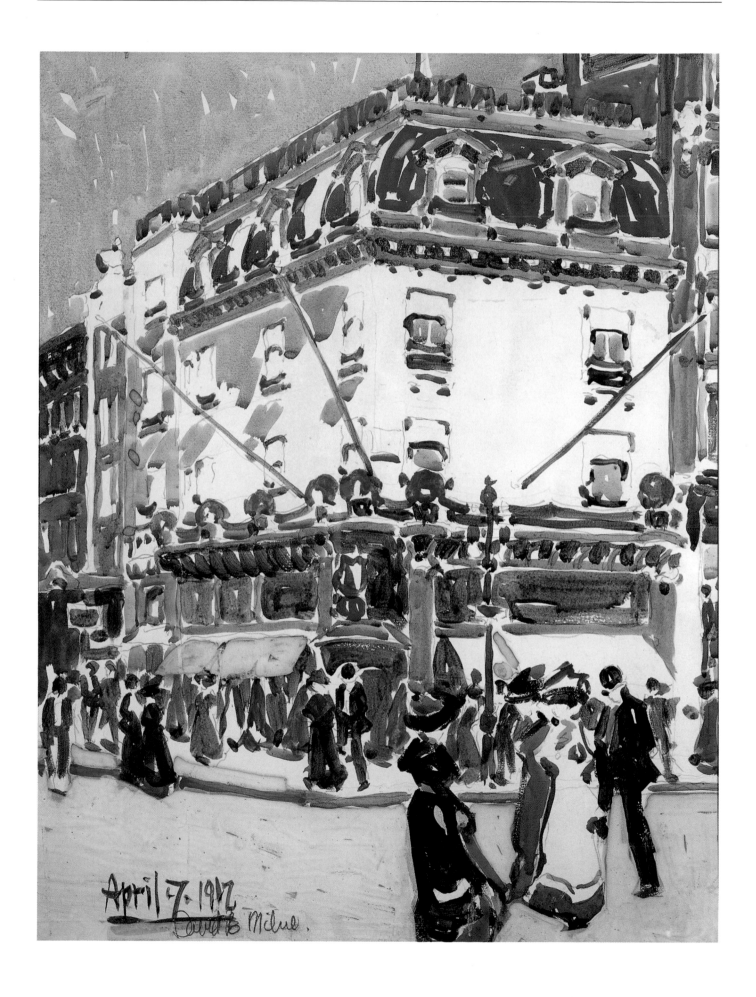

representation. Moreover, when a much-reduced version of the Armory Show was selected for showing in Chicago and Boston, only the original members' works accompanied those of the Europeans – with the sole exception of Milne's *Little Figures*, one of his watercolours.[28]

Patsy's recollection of the Armory Show was brief: 'We went to the Armory Show with the McHench's [*sic*]. It was greatly crowded – the "Nude Descending the Staircase" seemed to attract a crowd – Dave was delighted with it all. He was in it too.'[29] But there can be little doubt that this was a major event for Milne, as it was for all the North American artists involved. He called it 'this most thrilling of exhibitions.' Marcel Duchamp's famous *Nude Descending* sold for $324. Milne's work was priced at $60 and $70 for the small watercolours (comparable to Matisse's drawings – although his huge *Red Studio* sold for $4,000) to $200 for his oil paintings. These prices were comparable, for their size and medium, to the prices being charged by other American artists with established reputations, such as Maurice Prendergast and George Bellows, although not quite as high as those of the portraitists John Singer Sargent and Childe Hassam.

The strongest and largest representations at the Armory Show were works of Matisse, Redon, Gauguin, Cézanne, and van Gogh – all artists whom Milne admired, and from whose paintings he got ideas at one time or another. Although by this time his personal style had been set, what Milne saw at the Armory Show led to ideas for exploration that were soon followed up. Matisse's *Red Studio*, for example, certainly looms like a benevolent force behind paintings like *Red* and *Alcove*, works done in the following year or so.[30] Matisse received by far the most vicious of the negative criticism directed at the exhibition, since to conservative American eyes he seemed most to embody the decadence of Europe and the immorality of modernist expression. Others saw political danger and subversion. Common attacks described 'innuendoes of moral turpitude and mental instability.' Kenyon Cox described Gauguin as 'a decorator tainted with insanity,' and went on to portray van Gogh as 'too unskilled to give quality to an evenly laid coat of paint,' and Cézanne as 'absolutely without talent and absolutely cut off from tradition.'[31] No wonder that Milne, as a student and an artist, thought so little of Cox as a painter and critic.

The publicity surrounding the exhibition, while focused on the European paintings, nevertheless gave some attention to the American contributions, and especially to the radical, or 'extremist,' wing, of which Milne was part. One of the casualties of the exhibition was the realist movement led by Henri and The Eight; although it has since come back into vogue, it was for a time eclipsed by the well-represented modernists at the Armory Show. This undoubtedly gave a boost to Milne and others who thought and painted in his vein. As a consequence, after the Armory Show the tempo of Milne's exhibiting increased, and the Montross Gallery gave him more attention than previously. He also began to sell more. Although the records of the Armory Show do not indicate that Milne's pieces were sold at the time, they must all have been disposed of over the next few months, for none were left among Milne's New York hoard.

There is evidence that Milne's work was well regarded at the time. In his catalogue of the Armory Show Carl Zigrosser (1891–1975), then a young artist (who was later to write the 1969 catalogue of the etchings of John Marin), marked Milne's paintings as being outstanding, among the top few contributed by either American or European artists, and equal to the work of Edvard Munch in quality. Milne's *Distorted Tree*, in particular, he thought a 'most excellent design,' and he rated it among the top thirteen

paintings in the entire exhibition, putting Milne in the company of Albert Pinkham Ryder, Augustus John, Paul Gauguin, Paul Cézanne, and Henri Matisse.[32]

After this great exhibition Milne and his friends explored less formal venues in which to exhibit and sell their work. In January 1914 he and seven other artists – William and Marguerite Zorach, Amos Engle, Grace Latimer Wright, Lucy Wallace, Raymond Thayer, and Charles Lennox Wright – formed a group called The Contemporaries, and held an exhibition of their work in space rented or borrowed for the purpose at 18 West 37th Street.[33] Milne was the senior member of the group, and he showed ten works (out of a total of fifty), among them *Columbus Circle* just after it appeared in the Armory Show.[34]

A large Matisse exhibition at the Montross Gallery in January–February of 1915 must have been seen by Milne and have inspired him.[35] At the beginning of 1915 he seems to have paused, and then tried to simplify his forms and restrict his colours even more severely than ever before. One can only wonder whether he thought that his own work was as deserving as Matisse's of being exhibited and bought, or whether he took fresh inspiration from the work that was shown. But he would have agreed with Matisse that one always begins with the visible world and stops before abandoning the forms of that world altogether. In Milne's paintings, as in those of Matisse, one can always recognize the objects depicted.

Two contradictory experiences rounded out Milne's early exhibiting years. On the credit side of the ledger he had seven watercolours chosen for the Panama-Pacific International Exposition, a vast panoply of exhibits and objets d'art assembled in San Francisco in 1915 to mark the opening of the Panama Canal. The fine-arts section had over 4500 works, mostly American, since the war in Europe made extensive borrowing difficult or impossible. Artists such as Whistler, Chase, and Sargent were given their own exhibit rooms of thirty to forty paintings each, and Joseph Pennell had a room hung with 150 etchings. In this huge exhibition Milne's representation was by no means as grand as that of the great stars, but it was certainly not minimal. He was awarded a silver medal, a compliment enhanced by being equal to that of his former teacher Henry Reuterdahl, and by placing just behind Ernest Lawson, who earned a gold.

On the debit side was Milne's sole acceptance, and inauspicious debut, at the National Academy of Design. His *Blue-Green, Black-Green* sidled past the jury, but was 'skyed' – hung 'high up behind the door in the morgue,' a hanging that 'was considered an insult,' as Milne wrote later.[36] After the notices he had enjoyed, this slight probably rankled more than Milne ever acknowledged. He and his colleagues had often clashed in vehement debate about whether the secretary of the Academy, whose work each year looked exactly like that of the year before, actually painted a new canvas and used the frame from the year before, or simply changed the frame on the same painting. Cogent evidence was advanced on both sides. But despite this contempt, a warmer reception by the Academy would have been – for Milne, as for all other artists – the highest accolade.

In the spring of 1915 Milne decided to hold a large exhibition of his work in his own apartment. In order to present his paintings forcefully he painted the walls black, after agreeing with his landlord (Patsy's aunt, Geraldine Fitzgerald) to rehang wallpaper afterwards.[37] Milne mounted his pictures in wide gilt mats that set them off stunningly, if perhaps a little flamboyantly, against the black background. Perhaps the gold surround of the Taddeo Gaddi painting he had used a few years earlier as a

model for his *Madonna and Child* and *St Lawrence* was recalled in his mind. Patsy remembered that many people came (despite her fear that being above the ground floor would discourage visitors) and that Milne sold several paintings, netting more than $300.[38] This private exhibition appears not to have been reviewed.

In the fall of 1915 Milne was included in Montross's group show with an oil, *Ragged Shape*, and a watercolour, *Points and Full Curves*, neither of which has been identified. His work appeared in the company of thirty-three artists, most of them with two works each, including George Bellows, Thomas Benton, Joseph Stella, Walter Pach, and Charles Sheeler.

The press reactions to his work must have encouraged Milne, for he assiduously kept clippings of the attention he received, and noted that even a malicious notice was preferable to being overlooked.[39] Critical reaction to *Black and White* I and II (page 39), for example, and to another painting entitled *Tricolor* (not yet found) in the fall exhibition of the New York Water Color Club in 1911, made clear that Milne was a talent to be reckoned with. After commenting on the new vitality in American watercolours, Arthur Hoeber in the New York *Globe and Commercial Advertiser* drew particular attention to Milne, who, he felt, 'has caught the best of the new movement and spots his figures and architecture with great daring.'[40]

Other critics, however, were aghast. Joseph E. Chamberlin in the New York *Evening Mail*, after a brief eulogy to the sentimental attractions of work by Childe Hassam and other artists, refers to Milne's 'raw, poignant thoughts,' and then concludes feebly with the complaint that 'It is impossible to relate [Milne's paintings] to a gallery full of more conservative pictures.'[41] After the critic of another newspaper skipped through the works of ten or so known artists, including Hassam, he confronted the radical wing:

But the 'Incoherents' are here too, somewhat modified but still in evidence ... as in Stuart Davis's *The Booking Office* and *On a Rainy Night* ... And finally David B. Milne comes along with raw colors to take the place of drawing and everything else in *Tricolor* whose title might make a Frenchman fight in front of the picture, and *Black and White*, in which it is quite clear that Mr. Milne is, in his own artistic way, getting even with one of the Library lions of Fifth Avenue and Forty-Second which he pictures looking in the other direction.[42]

The reviewer of this exhibition for the *International Studio* was equally perplexed and indignant:

There were three rather amazing water colors by David B. Milne, which for bizarre technique should cause even the impressionists to pause. Only primary colors in their most vivid intensities seem to have been used, with no artifice of chiaroscuro other than sharp black shadows by way of delineation. That they may be said to be 'clever' is much more certain than that they may be said to be 'art.'[43]

The critic for the *New York Times*, however, after singling out only a few artists from the 400 exhibitors and, giving a nod to Hassam as an accomplished impressionist, devotes most of her review to Milne:

Then there is the Neo-Impressionist, or his successor, who divides his tones, uses pure color according to the laws of complementary hues and optics, and who limits his blots of pigment to a size definitely proportioned to the area of

42nd St. Library, c. 1911–13, water-colour, 42.9×36.5 (16⅞×14⅜)

the space he has to cover. Signac and Seurat were leaders in this school twenty years ago, and Mr. Milne and his companions in this particular art form owe much to their experiments. The 'Black and White' is a vivacious street scene with one of the lions of the Public Library on guard in the foreground and a motley group of people scattered over the sidewalks and steps of the Library entrance, and on the opposite side of Fifth Avenue the bright windows of shops. Although the picture depends upon the relation of the spots of flat color for its effect, Mr. Milne has not disregarded linear means. Some of his figures are boldly and richly outlined in color and the rhythm of these flexible lines contributes to the charm of the composition. The whole is very brilliant, very animated, conceived with vigor and executed with dexterity but not entirely free from the suggestion of separate effects brought together but not fused in one impression. Another picture by the same artist which he calls 'Tri-Color' is even more brilliant and direct with its childlike pattern of red and blue and white, but the cleverly varied touches of the brush, the play of the strong red and strong blue over the white ground, the finely suggested perspective make it a subtler performance despite its apparently primitive structure and drastic division of tones. Here the fusion takes place at a proper distance and the effect is one of artistic unity.[44]

With tributes like this, Milne's place in the art world of New York was enhanced, at least as far as his talent was concerned. And that was just the beginning of the notices he received.

Reviewing the annual exhibition of the Philadelphia Academy of Art, in which Milne showed *Marble House* and *Snow Shadows* (the first of which has not been identified), the *New York Daily Tribune* of 6 February 1912 noted that Milne's 'whites and greens and blacks, and his energetic and decorative line are symbols of alert perception.'[45] Milne's paintings were also singled out in a couple of unidentified reports:

The exhibition ... is rather better than some recent shows of the Society, though not an effectively inspiring affair. Much technical ability is in evidence. There is also no little variety. One may begin, for instance, with the deliberately radical water-line work of David B. Milne, pass on to the the single-touch but spotty character of Maurice Prendergast's paintings ...[46]

Milne was considered the prophet of 'ultra modernism' by the *New York Herald* for the same show. He was cited before Prendergast in the *New York Times,* which described Milne as employing 'a kind of telegraphic notation by dots and dashes of color and broken-up masses that results in dramatic force of description ... [His paintings] are quite violently alive, and send the pictures around them back into a shadowy and invalid region.'[47] By the autumn of 1912 the *Times'* leading critic was downright admiring of Milne's submissions in the New York Water Color Club's annual show, in which he showed *Three Hansoms, Fifth Avenue, The Roller Skater,* and *Black and Green*:

David Milne's extremely effective, intensely modern and competent blots and splashes of color ... leave poetry out of the question and get at once to science. They convey, that is, no special emotion, but they translate into the language of art certain forces of nature with a freshness of idiom that drives the matter home. Coleridge in his dream-haunted world made many an apt observation on human nature, as when he said that the truth haters of to-morrow would give the right name to the truth haters of to-day, 'for even such men the stream of

time bears onward.' We fancy that the truth lovers and truth haters of to-morrow will alike see in such pictures as these brisk little paintings by Mr. Milne a genuine effort toward individual research in the wide field of art, an effort toward cutting loose from formulas that have served for twenty or more years for the purpose of finding newer and more effective methods of reporting the forms of the natural world. Certainly he has found a way of suggesting movement almost too energetic to be applied to the leisurely hansom cab which he is inclined to feature.[48]

For the Armory Show, early in the next year, most critical attention naturally went to the European painters, and Milne's five paintings seem not to have received individual attention from any of the leading writers. The *Christian Science Monitor* of 24 February 1913, for example, merely added that 'the work of such American "extremists" as Zorach, Pach, Milne and Prendergast is shown.'[49] The *New York Times* of 2 March 1913, how-ever, commented as follows on the American submissions, including Milne's:

At the International Exhibition, in addition to the work of Mr Davies, we find many examples of this instinctive refinement modifying the influences that come from France with the true French genius for cheering on revolution. Glance for a moment at Walt Kuhn's 'Girl With a Red Cap,' at the nude figure by Robert Henri, at David Milne's water colors and those by John Marin, at Kathleen McEnery's nudes and the family group by Glackens – among these widely differing temperaments and talents we get one characteristic that marks them as belonging artistically to the same family, a sympathy between the artist and his subject that makes him respectful of its finer characteristics and suggests to him to show it, however unsentimentally, on its most agreeable side. If we outgrow these amenities of our young civilization we shall lose something that is not superficial but real and valuable. The present exhibition seems to us to indicate that we can plunge much deeper than we ever have done before into the relation between life and art without sacrificing our native instinct for decency.[50]

The Armory Show enabled that reviewer, at least, to see the possibility of a new maturity in American art – and among the few artists she thought could bring this about she included Milne. The idea that these painters could look at their subject on 'its most agreeable side' catches an aspect of Milne's approach to art that links him with Matisse and defines his aes-thetic stance with shrewd accuracy.

The exhibition of the New York Water Color Club in the fall of 1913 again elicited a strong response from the critics, with William B. McCormick in the *New York Press* noting:

David B. Milne's 'Hepaticas' and 'Jack in the Pulpit' shows that he is an eco-nomical young man with medium and also that his flowers must have been badly wilted when he set about painting them. Possibly wilted flowers are more artistic than perfect blooms such as Mr McRae has shown us in the outer room here. Milne also shows a 'Yellow Room' that is green.[51]

The *New York Sun* in unsigned coverage, but with the sub-headline 'BEST ESSAYS IN MODERNISM,' was trying to be complimentary:

The best essays in modernism ... were those of David B. Milne, whose color is

vivid, yet pleasing and whose decorative bent is pronounced. Whether it is a flower piece or a landscape the result has somewhat of the quality of good faience.

His best one, the 'Bronx Park,' is a daring arrangement of black trees, upon which the artist has amiably bestowed one or two touches of green, and a house that is white and blue and olive and purple, and which we don't recall having seen in Bronx Park, although that doesn't matter. It is excellent decoration, and any one who would enjoy a good tile would take pleasure in Mr. Milne's 'Bronx Park.'[52]

Again the *New York Times* of 9 November 1913 took particular note of Milne's contribution:

There are Mr. Milne's 'Hepaticas' next door [to Anne Goldthwaite, the first artist mentioned in the review]. What would a patient painter of the Ruskin period say to those hepaticas? Those dark blotches with queer, fat, juicy stems – when a man should paint hepaticas prayerfully, every vein showing and all a-tremble in the grip of the big March wind! But the Ruskinian hepatica was a poor anemic little thing compared to this lusty blossom. And the life in the swaying stem is, after all, the important thing, the marvelous power of bending before the wind and not breaking. This Mr. Milne gives us and also the richness in the color. It would be a fine thing to own such a healthy little drawing, just to remind us how strong one is in Spring and how full of life and fight.[53]

The three months that Milne and Patsy spent at West Saugerties in the summer of 1914 (June, July, and August) were decisive for Milne in several ways. They were there long enough to establish a steady routine for work and to schedule time for recreation. Milne went ahead to find a place, and Patsy followed a few days later, arriving at Saugerties by train just before a horrendous thunderstorm broke. Fearing for her own safety, and thinking that something had happened to Milne, who was not at the station to meet her, she began to cry. But Milne and an acquaintance soon arrived by horse and buggy, thoroughly drenched. On the trip to West Saugerties, which was eleven kilometres (seven miles), a wheel came off the buggy, landing them all in the ditch, shaken but unharmed. They walked to a farm, got another buggy, and although hungry and cold, continued on and were eventually harboured in West Saugerties and sat down to a hot meal.

West Saugerties is at the foot of the plunging hills of the Catskill Mountains, a sleepy little place that is still remote and rural. Apart from a few subsistence farms, the area is forested with hardwoods and watered by small mountain rivulets. The Milnes rented a small cottage for $3 a month from a Mrs Myers,[54] who lived across the street and whom Milne painted several times. The larger resort of Saugerties, on the Hudson River, with its substantial port and its odd three-storey lighthouse – painted by Milne from Tivoli in 1916 – made it a popular destination.[55] On Sundays Milne usually walked the eleven kilometres to Saugerties[56] for a hamburger, a bottle of sarsaparilla, and to get the weekend papers – and thus he learned of the outbreak of war in Europe.

This rural setting must have stimulated Milne's inborn impulses as a handyman, for he busied himself with various projects for recreation between his regular painting sessions. Their cottage was unheated and they lived mostly outside, cooking on a large stone fireplace that Milne made,

and taking shelter within only in the evenings and during storms or rain, and sleeping on a bed that Milne rigged up of cedar posts, rope, and cedar boughs. He also built a table by the stream, with shelves in the trees. To amuse himself he built a 150-centimetre (five-foot) waterwheel out of saplings and tin cans and installed it in the stream.

The neighbourhood provided him with all the painting subjects he could have wanted: from forest interiors, to a quarry, to women making colourful patchwork quilts in the village cottages, to Engle husking corn. Amos Engle lived with them for most of that summer, and he and Milne painted every day except Sunday.

Two good examples of the work Milne did that summer are *Red* and *The Black Couch*. Painted in the tiny store that the Milnes' landlady, Mrs Myers, had in the front room of her cottage where she sold candies and a few groceries, *Red* shows Patsy leaning against a chair and silhouetted against the windows, with shelves and a counter along the right side. The painting is nearly all in a brick red, supported with some tawny brown and a light electric blue. A little nile green defines the potted plants, and a few brilliant dots of crimson (flowers and labels) stand out against the white surfaces of the windows and counter and against the thin black outlines that emphasize the main planes of the painting, the window wall and the diagonal of the counter. Two spots of mauve bring the palette used to a total of six colours plus black and white. The brush strokes are very broad, the shapes painted inventively make up the figure and the objects we see. The whole is remarkably loose and easy, and one can understand why Montross chose to exhibit it; and why, with its graphic power and simplicity, the critic of the *New York Times* chose it to illustrate her review of the opening of the season at the Montross Gallery.

The Black Couch, *1914, oil, 50.8×55.3 (20×21¾)*

Battery Park, *1914, watercolour,*
33.1×39.7 (13×15⅝)

Brilliant Pattern, *1914, watercolour,*
50.8×45.8 (20×18)

The Black Couch is quite a different kind of picture, and its no less vibrant and eye-catching qualities were reached by different means. Again the palette is tightly restricted to six colours, with black and white; but instead of large areas of value (such as the white, or the brick colour in *Red*), this painting is in an all-over pattern – a treatment of the figure, couch, and room that unifies them by pulverizing each object into little shapes, meshing them into a consistent texture. Additional unity is achieved by allowing some lines, such as the carpet edge and the plate rail, to run almost unbroken across the whole width of the painting.

The lengthy stint of uninterrupted painting at West Saugerties fortified Milne's decision, two years later, to forsake commerce and devote himself solely to painting. Over the summer he produced nearly seventy paintings in oil and watercolour, nearly one a day. All convey an impression of wild and colourful excitement. It is not the colour, but his loose and flowing brush strokes, and his control of shapes, that create this impression, for he continued to work with a tightly restricted palette. For this summer only he used a strange, pale aquamarine blue that dominates many paintings, often because he lavishly used large quantities of it. (Milne used varying blues throughout his life, of which the tone and hue are so identifiable that they can often be used to date paintings reliably.) He also allowed his use of white to expand, as a method of accenting the quality of light. The white, breathing through his little ovals and V shapes, gives the effect of vibration and shimmer.

After such a productive summer, the city paintings done in the autumn of 1914, surprisingly, equalled the summer's stock. The overall patterns were tempered by the regularity of houses and blocks, and the bursts of little circles were confined within rectangles of slate, black, ochre, and rust. Recession was emphasized, and there was a new compactness to Milne's work, as *Stipple Pattern III* illustrates. The warring colours of the summer were held together by the compositional patterns imposed by the city itself: the stack of receding planes, the slash across the foreground that pushes up from the bottom and compresses the whole picture, the trees through which we see the nearer row of houses, then the distant hills, and finally the sky. In essence it is the same pattern, the same mental pattern, that Milne had used in 1909 in *Van Cortlandt Park*;[57] but how much more alive and sophisticated it is, and yet how unpretentious and deceptively formal.

The autumn colours in New York that year were exceptional, and Milne exploited them in a way he never had before. The reds, oranges, and yellows that surged from his paper – for he was working now mostly in watercolour – came from the early work of the summer of 1914. Now framed by outlines in black, or by the backdrop of the city, as in *Battery Park, Red Trees,* or *Brilliant Pattern,* they were concentrated and made significantly more powerful than they had been earlier. The gentle black outline was sometimes used to create a counterweight; but chiefly it added force, proving that the appearance of something contained is much more powerful than that which has no boundary.

In the fall, too, Milne learned another subtle trick. Rather than intermingling colours, as he had done in the summer, he now juggled masses of colour. This device made the fall's work – of which *Bronx Park, 1914* is an example – strong in a more complex way by paying attention to the balance in a picture, as a matter of colour, as well as of shapes and the weights of shapes. All the things that Milne had included in his work up to this point were brought into play: horizontal planes, the screen of trees, open white spaces, small brush patterns, and the rich, thick painting of

Posing, 1914, watercolour, 43.2×54.6
(17×21½)

Stipple Pattern III, 1914, watercolour,
55.9×45.7 (22×18)

massed areas. Wrapping all these together, usually, was a ribbon of blue across either the horizon or the foreground.

When the fall had burned its last display, Milne turned to landscapes – such as *Green House* and *Pink House in Snow* – in more sombre tones, with lowering skies, large, snowy spaces, and the spare silhouettes of trees and houses against an ascetic stage. The colours became softer and moved into a darker range. Somewhat unexpectedly, he began to use brown extensively and this continued throughout the winter. And, after a summer of roiling in a maelstrom of colour, Milne realized that he had to re-examine the powers of black and white to see what they now held for him – a journey that he repeated every few years. Throughout his life Milne continued to find new powers and properties in these two non-colours.

By 1914 Milne was firmly fixed as a 'regular' in the leading art societies, and he was regularly complimented:

The American Water Color Society, now holding its annual exhibition at the Knoedler Galleries, has many an agreeable thing to show, but none more invigorating than David B. Milne's red-haired woman in a garden with a parasol [possibly *Canadian Garden*]. Mr. Milne does his work as much with white spaces as with spots of color, and his work is so systematic that the word schematic comes into your mind, but he escapes the derogatory implication of the term. He governs his scheme instead of being governed by it, and his work is always brilliant and beautiful.[58]

The *New York Times* again had the most perceptive review of the 1914 New York Water Color Club exhibition, giving Milne's contributions this praise:

David Milne invariably manages an effect of modernity. His subjects are just the same pleasant old subjects – men reading, women sewing or peeling apples or having tea. It is all just the same, except that the work is dressed in the fashion of the moment, and well dressed. The artist has a genius for fashion. Not one in a thousand [artists] can spot a piece of paper as cleverly as he. It is amusing to note that in the little picture called 'Posing,' he goes back to the early Egyptian convention and paints the face of his man an arbitrary dark red and the face of his woman a lighter and equally arbitrary yellow. They look very nice, too.[59]

Posing is a picture of Engle and Mrs Myers at West Saugerties. The 'Egyptian convention' is clearly used, but the painting is a compact set of vibrant colours and shapes that makes it a fine exemplar of that summer's achievements.

Not all the reviews were complimentary, however. In a review of the New York Water Color Club exhibition that fall Milne was briefly mauled by Guy Pène du Bois, the conservative painter and dyspeptic reviewer for *Arts and Decoration,* when he turned to the members of 'the new Academy,' among whom he counted Milne: 'Mr. David B. Milne may scarcely be accused of advancing a step in five years. The despotism of his style may account for that just as it accounts for immobility in so many more academic painters.'[60] Edward F. Sanford Jr, writing in *International Studio*, was also hostile to Milne's paintings in the opening exhibition at Montross's new premises on Fifth Avenue in the fall of 1914:

the genial proprietor has taken yet another bold step into the realms of the very modern men and offers us at his Fifth Avenue rooms a group of advanced notions and strange performances – not, be it understood, without interest, but

New York Times, *18 October 1914,*
reproducing Milne's painting Red

still far away from his old standards. Other times other manners. It is unquestionably a day of art unrest, and here we have some of the revolutionary young men, with their strange manifestations. Tell us what does Mr. Milne mean by his *Black* and his *Red*, wherein are various spots indicating strangely two figures, women, with faces made not out of roses, but out of dreary pigment, black or red, as the case may be.[61]

But the *New York Times* had a different response to Montross's opening exhibition, and to Milne's contribution. From among all the paintings at Montross's, *Red* was reproduced on the front page of the arts section, with this commentary:

The Montross Gallery opens with an exhibition so vigorous and stimulating that one forgets the war. One forgets also the war between the new and the old that raged a year ago. There is much of the new in the galleries ... David B. Milne ... maps out his pattern with scientific accuracy. In the subjects shown at the present exhibition science is all that stands between the old and the new. How many times have we not seen that slim girl in a library, pots of flowers on the window bench, and the light falling in warm patches on the floor and furniture. But Mr. Milne has made himself master of the art of patterning and builds up his blocks of color as precisely as the modern doctor diagrams your heart action. The expressional force in his work is not great, but its aspect of high competency is exhilarating. Whatever he may have to say you feel that he makes no mistake in the form of his statement. [62]

Although Milne continued to receive critical attention from time to time after 1914, and continued to exhibit, the changes in the work that followed began to leave his critics behind. This slacking in the intensity of the attention he received may have been a factor in Milne's decision to leave New York (although Milne claimed that he never took press attention that seriously).

In his last sixteen months in New York City Milne made over fifty paintings and about forty fine ink drawings in black and white – but most of these, perhaps all but two, were done in 1915. Although this is a respectable showing, it represents a noticeable drop in his production compared with the previous three years, and the possibility is strong that Milne did no painting in 1916 until he moved out of New York. In 1915 Milne did most of his outdoor painting in the Bronx. The various views of Jerome Avenue, which in a tentative fashion represented his first 'series,' were made in oil in black, green, and white, and in watercolour in green and slate gray. All are superb. Black and white were used alternately to outline prominent forms, to create mass, or to provide little nodes of emphases.

The real discovery of the time was the combination of black and green.[63] Milne used black as a core for a mass, such as a tree, and used green to create a halo or to fill out the shape's outer profile. The largest run of these works came in the mid-summer of 1915. The drawing of the forms was so incisive, and the values of the two or three colours used were so carefully controlled, that these works can be read remarkably well in black-and-white photographs. The striking character of the green-and-black paintings is their compact, balanced, and almost abstract quality. In *Massive Design* Milne travelled to the very edge of his territory. Although he was not ready to offer up representation as a hostage to abstraction, he showed his understanding of a great principle of painting: the subject of a painting is the painting itself, first and foremost – the shape, line, hue, and value, nothing

more. The impact of *Massive Design*, with its few shapes strewn across the paper as if a landscape was being created that was remembered only in parts, is overwhelming in its concept and execution. It is pared and stark, although not uninviting. A prior version of *Massive Design*, also done in the summer of 1915, exists: *Black Cores*, executed in more detail, and with more attention to representation. A comparison of the two shows how Milne's process of reduction and simplification worked. Taking this process as far as Milne did in *Massive Design* must have contained an element of threat for him, because it pushed him closer to the edge of total abstraction than he ever came again. The works that followed were certainly as interesting, but for many years they were not as daring as this. Milne thought that *Black Cores* represented one of the most important things he had developed in his art up to that time:

The black 'cores' of the trees, a convention started in a watercolor made in 1915 from near Gun Hill Road looking across Webster Avenue to White Plains Avenue. This started from the need of a convention to represent trees looked at against the light where they showed a dark shadowed part surrounded by an illuminated part.[64]

In the summer of 1915 Milne also began a series of drawings in black India ink on tissue paper – a form of expression that lasted until May 1916 – that were further explorations of his concerns with abstraction, for they simplified and reduced all the compositional devices that he was using in his paintings. An example would be the way in which the lines of a landscape can be seen through trees and still be depicted effectively. Another example is the way basic units of form, such as the scallops and rectangles used in *Bronx Hillside in Spring*, can be manipulated collectively to create a dramatic, overall texture. Two or three of these drawings were translated into lithographic prints, of which multiple copies could easily be made. The process of printing was a sort of light-sensitive transfer of the drawing from the tissue paper to a litho plate, perhaps a 'planographic' method; but the process is now not used or even known.[65]

His work of 1915 and the early months of 1916 was later depreciated by Milne, who thought, in retrospect, that he had fallen into an 'unfortunate' manner:

Large Tree, *1 May 1915, ink drawing, 40.0×55.4 (15¾×21¾)*

Bronx Hillside in Spring, *31 May 1915, ink drawing, 38.1×53.3 (15×21)*

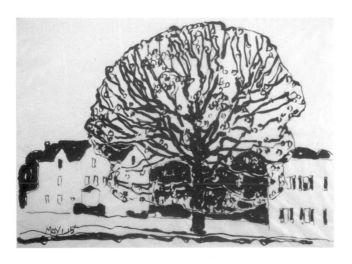

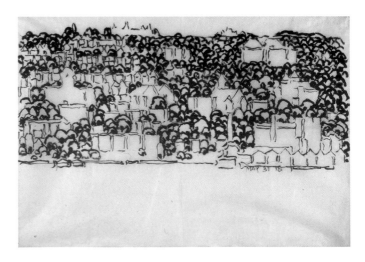

my painting, before I left New York, had taken an unfortunate turn, maybe reflecting a troubled frame of mind. The pictures were mannered, heavy, spotty and lacking any sensitiveness or subtlety. Very few were of any interest. The colours were mostly green, black and white and in some of the buildings a reddish brown. I worked in both oil and watercolour. The only explanation I can think of for this unfortunate style (or mannerism) which was carried over to Boston Corners, comes from some black and white brush drawings on thin paper done in the last New York winter. In doing show cards I used a process called litho printing. I made the design or lettering on thin paper and sent it to a printer and got back whatever number of prints I required, at a very low cost. I may have become interested in working with a brush on the thin paper and did some landscapes. I even had some printed, though I can't think why since there was no market for my pictures or drawings, certainly none for prints such as these. This was the only time my work at showcards seemed to have any effect on my painting, if it did have an effect. The two were far apart and deliberately kept that way. My window cards were the more ordinary kind. I never became highly skilled, as Engle did. That was the chief reason for keeping on with window cards as a part time job, and giving up any attempt to carry on with illustration – which would have paid better, but would have been too close to painting and had an effect on it.[66]

The real problem, he concluded later, was that he had become too fixated by black, although to judge from the pictures themselves he could be referring only to a tiny part of his production. Indeed, the heavy snows in the winter of 1915–16 drove Milne to paint a number of works that are predominantly white. And as he later identified his black-core discovery as being extremely important, surely this cannot be the 'unfortunate' turn that he imagined his work had taken. What is perhaps more noticeable than a supposed preoccupation with black is that the work of late 1915 (and possibly early 1916) seems scattered and unfocused in comparison with the cohesive nature of the work he had produced between 1912 and mid-1915.

The paintings of the latter part of the summer, and of the fall and early winter of 1915, continued the development of the idea of the cores, without

Black Cores, *31 July 1915, watercolour, 45.4×55.6 (17⅞×21⅞)*　　Massive Design, *1915, watercolour, 45.1×56.3 (17¾×22⅛)*

adding much of significance to it. In some other works of this period Milne experimented with textural effects by drawing with a dry brush and by creating a variety of serrated shapes in tight formations. These were the forerunners of ideas that Milne would soon exploit at Boston Corners. By December he had reverted to black and white in a pseudo-Japanese style, reinforced in a few drawings and watercolours by the use of rice paper. *Barge* and *106th St. Apartment* are examples. These are strong and beautiful, if uncharacteristic, works. In *Barge* Milne has lightly washed over the water area to create a subtle textural contrast. This technique gave him an idea that only came to fruition a little later at Boston Corners – an invention that he counted, along with the black cores, as one of the three most important developments in his work. These few oddities of late 1915 may indicate that Milne was groping a little at this time and could not quite find his bearings. He may therefore have blamed his 'unfortunate turn' on the fact that he was simply uncertain about which direction to follow when he had come so far in such a short time.

In 1915 Milne met James Arthur Clarke (1886–1969). In a taped recollection of May 1961 Clarke incorrectly remembered first meeting Milne in 1912, right after seeing at the old Montross Gallery at 38th Street and Fifth Avenue 'six canvases of such boldness, originality and simplicity that we knew that we had stumbled upon one of the great creative minds of the new century.' However, the two men did not meet until just before Milne had his exhibition in his 61st Street apartment, when he painted the walls black.[67] Clarke was introduced by a mutual friend, Arthur Vernon, whom the Milnes had met at West Saugerties the previous year, and who worked as a commercial artist with Clarke from time to time. Clarke had been a commerical artist (using the name René Clarke) for the firm of Calkins and Holden, with offices on 28th Street at Fifth Avenue, since 1912. He had innovative ideas and produced striking work, and his creative talent was responsible for building Calkins and Holden during these years into one of the top ten American advertising firms. Like most commercial artists, he kept an eye open for visual ideas among painters, and regularly went to the galleries that showed the more original and innovative artists. He had already seen paintings by Milne at Montross's old gallery and at the Armory Show, had read about him in the newspapers, and was much taken with his work. When he met Milne, Clarke was taken even more with the man, and he and Milne immediately struck up a close friendship. They found they had much in common: similar apprenticeships and early commercial work, a knowledge of the printing business, an irrepressible passion for painting, shared ideas about aesthetics, a similar outlook on life and business, a predilection for innovation, and a delight in hiking and camping. Certainly Clarke's purchase of some of Milne's paintings did not diminish Milne's regard for him. Clarke was soon visiting Milne's studio regularly and sharing activities with him. Together they made the rounds of the galleries, and they went on other missions as well: 'We used to go round to the second hand stores and buy these chromos. The pictures weren't worth anything but the frames were, so then Milne would paint over them – the frames – which were usually ornate, elaborate Victorian things, and then, of course, the sizes of the paintings were made to fit the frames that he had.'[68] Anne and Jim Clarke and Patsy and David Milne became a close foursome, and Milne's friendship with Clarke very soon became the most important one in his life. Clarke, in turn, later admitted that Milne was 'a big piece of my life.'[69]

Clarke was born in Florida but grew up in Springfield, Massachusetts,

Milne's friend James 'René' Clarke, advertising artist at Calkins and Holden, New York

and then went to Hartford, Connecticut, where he studied at the Connecticut League of Art Students before starting to work in New York. He was an immensely successful commercial artist, a founder of the Art Directors' Club of America, and the first member to be inducted into the American Advertising Hall of Fame – but all his life he was torn between commercial art and wanting to be what Milne was, a painter. His adoption of a half-pseudonym, René, is perhaps an indication of his uncertainty: he got the name from René Vincent, a French designer who worked for a time at Calkins and Holden, and from whom Clarke learned much. 'I talked so much about the man and his accomplishments and the new ideas that he had in advertising that they called me René, which stuck all my life.'[70] (Had Clarke known Milne earlier he might have been given a different moniker; instead, when their son was born shortly after Clarke and his wife Anne met Milne, they named him David in honour of Milne.)

At the time that Clarke was being pressured into becoming the art director of his firm in 1924, a position that would take him even further away from creative work, he offered Milne this apology, a mini-autobiography of his career:

I went into this business when, on graduating from high school, I was faced with the necessity to earn a living. All my attempts to get a job where I could draw were failures until I found a printer who would let me draw ornaments and initials if I would also act as shipping clerk, bill collector, errand boy and [printer's] devil. He consented to pay me six dollars a week, [and] as that was just six more than anyone else would pay, I went to work.

The compromise proved to be the key note of all my subsequent affairs. As long as I would do something for which my employers could derive a revenue, I could be as ornamental as I liked in the rest of the time.

It was not until 1909 four years later that I 'got religion.' I wanted to be a painter and I started making water colors around Pittsburgh and visiting the Carnegie Museum.

For some time after I was married the economic necessities rather blotted out the painting but at intervals it succeeded in coming to the surface and asking to be considered.

The economic pressure began soon to let up and as it did the painting came to take on more importance.

By 1921 I could begin to think of quitting the 'commercial' game and devoting my whole time to painting.

In the meanwhile I had met you and had been tremendously inspired and benefitted by you and your work.

But for you I should now be one of the mediocre painters forming the background against which your work stands forth so brilliantly.

I have through circumstances of my own choice been obliged to compare my painting with yours.

The conclusion that this comparison forced upon me was that I might perhaps by effort play Renoir to your Monet. In your own language 'a harvester not a sower.'

Without making any comparison between our temperaments and our mental equipments one cannot overlook the fact that through the years when I was making a spasmodic attempt to paint, you were steadily grinding away at it and developing slowly and progressively.

To overtake you would require an intensive effort of which I doubt I am capable, even if it were to be conceded (by charity) that I have the mentality necessary to the production of work equal to yours.

And only by the production of work of that merit could I justify leaving a field in which I have not yet exhausted the possibilities ... [71]

The possibilities for Clarke were enormous and he took full advantage of them. In a taped interview he told Blodwen Davies that there were two reasons why he took the direction he did in commercial art:

One was the increase in the number of publications, magazines and papers that used pictures. The reason for that, of course, was the tremendous improvement in reproductive processes ... as soon as we got color reproductions in magazines, well that opened up a tremendous field. For instance, in the particular field where I specialized, which was in food, the color factor was tremendously important, because your appetite appeal couldn't be rendered in black and white. It needed color.[72]

In 1926 Clarke designed the dust jacket and endpapers for Edna Ferber's new novel *Show Boat*, his first venture into the publishing field. Other examples of his work included ads for the jewellers Black, Starr & Frost, Hartford Fire Insurance, Wesson Salad Oil, Snowdrift cooking fat, Crane Paper, Martex Towels, and other products – all in their time quite innovative, and all drawing, to some degree, upon the discussions Milne and Clarke held regularly on basic aesthetic issues. One of Clarke's ads for Wesson Oil is not unlike *White Cabinet*, a Milne watercolour of the year before, 1922. In a retrospective description of Clarke's work a colleague said that in each job he did he 'introduced some special note that placed [his] work distinctly above the visual platitudes of his era.' In an apt phrase that not uncoincidentally caught Milne's vocabulary well, one of Clarke's advertising colleagues, Walter Geohegan, described him as 'aesthetically courageous.' In 1928 Harvard University awarded Clarke the Edward Bok medal for bringing 'dignity and excellence' to the field of advertising art, an achievement that, according to another colleague, helped raise this area of work to a profession.

The view of Milne's vivid pictures against a black background, as Clarke saw them when he met Milne in his black apartment, must have been as powerful as it was novel. Clarke thought that Milne's work was, simply, the best he had ever seen, and that its importance was a milestone in twentieth-century art. Clarke had seen the Armory Show and knew what he was comparing it with: 'It was astonishing,' he recounted later, 'the bold treatment, the originality, the technique, and the method of painting. There was nothing like it in America at all, or for that matter in Europe.'[73]

His paintings in those days were in a very high key. I think someone mentioned that they looked like stained glass windows ... and of course the thing that makes a stained glass window stand out is the factor of the light behind it and the room is dark. It [the black walls] had the same effect on his paintings, the brilliant colour stood out ... I recall seeing his exhibition in New York of his war watercolours; it was shown for the benefit of the Canadian war memorials and all his watercolours were matted with jet black mats and the effect when you came into the room was as if you were looking through holes or windows. It was astonishing.[74]

Milne's description of Clarke, in the Boston Corners chapter of his autobiography, was brief:

Clarke is a Yankee – that is, a New Englander. He came from Hartford, Connecticut. At that time he was a particularly successful commercial artist with a strong interest in the non-commercial side. Mrs Clarke had been a school teacher from Harrisburg, Pennsylvania and of Pennsylvania Dutch descent. Both the Clarkes had strong traces of their origin, some in expressions they used, a great deal in their thought and interests.[75]

Milne was soon discussing with Clarke the matter of giving up his part-time business as a sign painter and devoting all his time to painting. Clarke was also thinking, a little, about abandoning his life in commercial art for the life of the painter, although his family was about to increase and bring him new responsibility. Compounding both their decisions was the threat that the First World War increasingly imposed on everyone's life: the possibility that both Clarke and Milne might have to join up was something they seriously considered. In the meantime Milne decided to move out of New York City. Clarke was a part of this decision, and part of the process of deciding where to go.

Milne's reasons for leaving New York (the first of what turned out to be a succession of withdrawals over his lifetime) are not entirely clear. He wanted to abandon his showcard business because it interfered with his work as a painter. But he was also disconsolate about his 'unfortunate' preoccupation with black – or so he remembered later. One can now see, however, that after many New York works that were vertical in format, Milne was increasingly turning to the horizontal landscape format – noticeably so in 1915. Indeed, after he left New York, Milne's work, almost without exception, was horizontal. The vertical attraction of New York had ceased to inspire him.

Milne later gave a health condition – described by him as a nervous heart – as another reason for leaving New York. Nothing later in his life confirms a specific medical problem, except that a generally high-strung manner, or excitability, was part of his personality. Possibly his lack of financial success, either as an illustrator or as an artist, contributed to his anxiety. Certainly he and Patsy did not have the physical comforts that a stronger financial base might have supported, even though her work paid some of the bills. Being caught between two different part-time activities no doubt robbed Milne of both satisfaction and achievement. Moreover, Milne was not effective enough in looking after the business side of his career. Montross was not a determined agent (or at least seemed to be more preoccupied with Walker, Ryder, The Eight, Matisse, and other of his more lucrative stable of painters), and Milne's own promotional efforts were sporadic. If the pattern of his later life is any indication, his involvement with exhibiting his pictures doubtless preyed on his vulnerability and caused anxiety. Notwithstanding Milne's later recollection that his last year in New York was one of despondency and uncertainty, however, all six of the later years were highly productive, busy, and exhilarating.

Another reason for discounting Milne's self-deprecatory assessment of his last year or so in New York was that soon afterward, in 1920, he wrote that of the 'three of the most important things I have developed in my painting,' two were from the last sixteen months in New York. One was the black-cores convention he discovered in 1915, the halo effect with green over black when a tree or house is seen in profile against the light. Another was the clear water wash over a portion of a watercolour to change the

textural qualities between one half of a picture and the other. (The third discovery he noted was his unique 'coloured streaks' that he developed later during his tour of duty in France.)[76]

Whatever the reasons for leaving New York, Milne may simply have been caught up in a larger tide in the affairs of men. The First World War had begun for Britain and its dominions in August 1914. The disastrous Gallipoli campaign of 1915–16 was an appalling symbol of the horror that had seized Europe. In New York the Armory Show and its effects were now long past and the city no longer felt as buoyant or exciting as it had been. As a result, a number of artists – Milne included – drifted away to assess in solitude the capital they had stored up in New York during the previous decade. Georgia O'Keeffe, John Marin, Alfred Maurer, and Charles Sheeler were among those to do so, although each successfully kept a link with New York, their financial lifeline. It was a time to move. Stieglitz, 'the Ancient Mariner of 291,' closed his gallery in May 1917 (a month before the United States entered the war) with a show of Georgia O'Keeffe's paintings. A feeling of deflation followed.

Both Milne and his painting needed a change. Up to that time he had spent nearly all his adult life in New York – where he may never have intended to stay in the first place. He was yearning for simplicity in his work, and, being the kind of man he was, he could not inject simplicity into his painting before he first got it into his life. A move to the country was a necessary shift toward the centre of Milne's own psyche. The more he grew as an artist, the more he sought those things that had shaped him in early childhood.

CHAPTER FOUR

Village in the Valley
Boston Corners
1916–1918

THE PLACE Milne and his wife left Manhattan to go to was Boston Corners, a tiny village nestled in a valley in New York State on the western flank of the Taconic hills, the southern spur of the Berkshire mountain range. (The village lies right at the intersection of the New York, Massachusetts, and Connecticut state lines.)[1] The region was originally developed for mining iron ore, and some of the ponds that dot the area were once smelting or charcoal pits – charcoal was used as fuel in the iron-smelting process. Two rail lines ran through the cut of the valley floor: the Harlem division of the New York Central Railway and the Central New England Railway. Trains seldom stopped at Boston Corners, but four or five men in the village worked for the railways, and the station was the hub of a little cluster of service buildings. Charles Burch's store, the freight depot, and the boarding house Milne knew are now gone, and the white-and-blue clapboard Methodist church became a belfry-less house for many years until the belfry was recently restored. Little else has changed since Milne arrived there in 1916, except that trees have grown up, and a golf course has totally changed part of the valley floor north toward Copake.

Nor has the countryside around Boston Corners changed over the years. Little ponds, like Bishop's Pond (now Helck's Pond), Forge Pond, Rudd Pond, Kaye's Pond, Weed Mines, and Kelly Ore Bed still punctuate the landscape, hidden behind stands of maples, poplars, birches, and occasional pines and spruces. The Berkshires still tower above the valley in wooded mountains named Alander, Bashbish, Washburn, Brace, Frissell, Everett, and Ashley; the Bash Bish River still tumbles over Bash Bish Falls on its way to the valley floor at Copake, and Noster Creek (or Noster Kill, as it was called then) still winds down through Boston Corners to Ashley Brook. High in the hills to the southeast of Boston Corners are the Riga Lakes. The low hills west of the valley toward the Catskills – Fox Hill, Old Croken, and Tanner's – still carve their silhouettes across the sunsets.

Milne's decision to leave New York City was deliberate and, as he remembered it, so was his choice of a new painting territory. He and Clarke targeted the location by studying topographic maps of areas within 160 kilometres (100 miles) or so of New York City. Milne's memory of discovering Boston Corners was romantic:

It was more like finding a star or an element. Certain facts about it were known beforehand, or at least required. It had to be within reasonable distance of New York, yet beyond commuting range and it had to be suitable for painting, preferably with hills to sit on while painting other hills. If there were interesting things between the hills, such as a village or lakes or ponds, so much the better.[2]

*Under Mountain House, the Milnes'
home at Boston Corners, in the 1970s*

*Under Mountain House, viewed from
the east, in the 1970s*

Boston Corners, population 96, was indeed far enough away not to be infested by commuters – Milne was only the thirteenth person to buy a ticket to New York – and yet close enough for the Clarkes, who lived in Yonkers, to visit easily. That its location suited Milne is not really a surprise, for it was only forty kilometres (twenty-four miles) east of West Saugerties, where the Milnes had already holidayed in previous summers, and only thirty kilometres (eighteen miles) from Tivoli, across the Hudson River from Saugerties, where Patsy's aunt Geraldine Ryan had an elegant summer place called Meadowbrook – to which the Milnes, especially Patsy, repaired from time to time. Woodstock, nearby across the Hudson, was then (as it still largely is) 'a colony of artists,' as Clarke described it; although by 1961 he thought it had 'more screwballs than artists.'[3] The Art Students' League had a summer school at Saugerties, and Clarke often travelled through the area to visit his mother in Hartford, Connecticut.

To see if their hunch was valid, Milne and Clarke boarded a train to Boston Corners early in May 1916.[4] In spite of warm weather they still found snow in the bush. For three days they hiked around the area, finding such places as Forge Pond and Kelly Ore Bed, and spending a night or two at the White Hart Inn in nearby Salisbury, Connecticut. At first they were regarded warily by the folk at Boston Corners, who suspected them of being strikebreakers sent from New York to take over in the event of a threatened telegraphers' strike; no places were available for rent until their real intentions were accepted. After wandering over the Taconic Hills to the east and through the countryside, they found a small cottage hard against the west face of the mountain, a stone's throw from Boston Corners itself. It belonged to Joe Lee, dairy farmer and stationmaster, who was prepared to rent it, along with the twenty hectares (fifty acres) of pasture and bush that went with it, for $8 a month in summer and $6 in winter. Milne promptly moved into Under Mountain House, as it was called, and asked Patsy to come and to ship the furniture from their New York apartment. She arrived the next week. 'When I got off the train,' she wrote later, 'and looked up at the mountains, I thought it was a beautiful place to live.'[5]

Almost at once Milne fell in love with Boston Corners, and throughout his life it remained a symbol of the perfect painting place. After the grime, hurry, and anxiety of New York, he became reunited with his country origins. Here was his Walden, complete with ponds, a haven where he could live quietly and intensely, and where the chief purpose of his life could be pursued.

When he was preparing to leave New York, Milne confided to his friend and customer Maurice Landay that his intention was to get along with simple things, to tend a garden, and to sustain himself as best he could. He was determined to test Thoreau's example of self-sufficiency.[6]

The farm our house was on could never have been large enough to support a family. There were only two or three fields cleared, the rest was mountain and rock and bush. The frame house was old, more than a hundred years old, Joe Lee said. It had never been finished upstairs but was roughly divided into two rooms ... The finest thing about the place was the spring, running from under the roots of a big maple tree, fifty feet or so from the house. There seemed no change in it summer or winter. It never went dry, never froze over and was always cold. Speckled trout of seven or eight inches long were in the brook that ran from it and within a few feet of it. Smaller ones even got into it.[7]

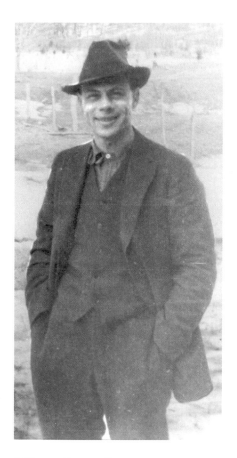

Milne at Boston Corners

Most of all, Milne's painting ripened because the locale made him feel at peace with himself. What put him at ease above all else was the gentle rhythm of the landscape, which he described in his 1947 autobiography:

Boston Corners seen from the rising ground behind Joe Lee's Under Mountain House was a string of coloured beads, with one end dangling into the cut that held the two railways, one road and one stream and was just wide enough to hold them. First, nearest the mountains, was the church, small, white, with a belfry. Across the road, a long gray house, sometimes occupied, sometimes vacant. Beside it an old log house, not habitable. Then Baldwin's house hidden by orchard trees so that its colour didn't matter. Then the red school. Next to the church on the other side was a white and yellow house that must have been lived in by different people at different times. I don't remember them. Beyond the school house was Joe Lee's imposing house, painted pale green with some other green or yellow in the trim, very fine for painting. Across the road Joe Lee's barns and silo, dark red. Beyond Joe Lee's house the small white one where Hiram and his wife lived. He worked at the milk station and later [in the day] on the [railway] section. Just where the road slipped down into the cut there was another small house, gray, and across from it on lower ground the milk station. In the railway cut were the station and water tank and boarding house, painted brown. Last of all, Chas. Burch's store, broad, white with an outside stairway. Further along was Burch's barn and at least one other house, practically out of town and out of sight from my painting place behind our house. In fact the railway buildings and Burch's store didn't appear in the panoramic picture.[8]

Milne and Patsy raised chickens and ducks – even though killing and eating them were traumatic events. 'There was one large rooster, and Dave suggested we have him for Christmas. We talked it over – but I regret to say I couldn't touch it when the dinner was cooked.'[9] Patsy recorded that one duck gave them an egg nearly every day all winter.[10] At Joe Lee's they got their milk at 5¢ a quart. They collected sap and made maple syrup in the spring of 1917 – a thirteen-litre (fourteen-quart) harvest. At one end of the house Milne built a cold frame to start plants early in the season, and from the spring he and Patsy watered their crops. Yellow roses grew along the front of the house.

Fruit was abundant. There were wild strawberries and raspberries, and all the huckleberries we cared to pick. We got a few pears at home, and more from the neighbours, plums, cherries, and apples too. One farmer just south of Boston Corners tried peaches, planted a whole hillside with peach trees. Never got any peaches. The valley had too many early frosts.[11]

In the fall they harvested barrels of apples and bushels of butternuts. They grew lima beans, muskmelons, and Swiss chard, along with all the other vegetables usually found in gardens. That first year the garden produced over a hundred big watermelons. Patsy preserved more than two hundred jars of fruits and pickles, enough to stock the cellar. On top of all this they sent the Clarkes two barrels of apples, onions, and celery. In return, the Clarkes sent the Milnes the first of what became an annual Christmas box, sent faithfully every year until 1947. Clarke made and painted the first crate inside and out, decorated it by hand, and packed it with small bottles, boxes, and crockery containers filled with various delights. Milne and Patsy were always thrilled with the exotic fruits, rich

Milne on the porch of Under Mountain House

cookies, crackers and cheeses, jars of condiments – and always pipe to-
bacco for Milne. In subsequent years Clarke had the yearly box packed by
Charles & Company, a gourmet supplier on 42nd Street where Milne and
Engle had shopped when they were occasionally flush.[12]

In horrible contrast to the idyllic calm of Boston Corners, the agonies
and shocks of the First World War reverberated. Milne's fascination with
the war was acute, and some eventual involvement seemed to loom ever
closer. Milne and Clarke debated what to do – should they enlist or wait?
For the time being Milne reconciled himself to waiting. Patsy too was con-
tent, for she naturally preferred having her husband with her.

In the first year, to earn a little money, Milne raised two hundred stalks
of celery. He later reported them all sold, but Patsy remembered that only
about a quarter of them were. Milne's strategy was to switch to onions the
following year. Still, he should have known from Thoreau's experience
with beans that hoeing onions would not give him time for reflection about
painting and its problems but only a deeper understanding of onions. The
enterprise failed to provide either restful contemplation or a reasonable
profit. Patsy's recollection was that none of the onions were sold until Milne
unloaded bags of them for $2 to Leon Baldwin, the baggage man at the
station and a neighbour.[13]

A more certain and tested method of making some money was launched
in the fall of 1916. Milne adapted his New York showcard letterhead to his
new address and began a mail-order showcard business. His idea was to
supply 'talking machine' stores with a poster announcing each month's
record releases, a chore he had done in New York for the Landay chain of
a dozen record stores, among others. He obtained a list of titles from the
Victor Phonograph Company, made up a poster, had it lithographed in
New York on cards in black and white, and then hurriedly coloured them,
sometimes with Patsy's help. He then mounted, boxed, and shipped them
to customers he had ferretted out in cities such as Providence, Hartford,
Boston, New York, Youngstown, and Akron. The enterprise, which took
about ten days, brought in about $30 monthly. But the day the boxes of
posters were carted to the station in a wheelbarrow and he could think
again about painting was always a blessing. Early in 1918, when he an-
nounced that he was closing his business to join the Canadian army, he

Stationery for Milne's poster business at Boston Corners

received good wishes from all his clients, but he was glad to stop.[14]

Throughout two summers the Milnes virtually lived outside, as they had at West Saugerties, regularly using a large stone fireplace that Milne built behind the house.

Life there was almost all in the open. We paid little attention to the house, except when it rained. Work, aside from painting and the usual daily chores, was mostly in the garden and up the hill behind the house getting wood. No one had lived in the house for a while so there was a lot of clearing up to do. When all the dead trees and branches nearby were gathered and cut up, all I had to do was to go up the hill a little to the edge of the bush for more. This was included in our $6 a month rent.[15]

They slept inside and took refuge there during storms and in the winter. That is when they discovered that their charming little two-storey cottage was not insulated and was immensely difficult to heat. The single-slabbed pine doors were impressive reminders of the trees that once could be found in the region, but they let snow and cold drift in. 'We weren't housekeeping,' Milne wrote, 'we were camping in a vacant house.'[16]

They proceeded to make renovations to the house, some of which were extensive: Clarke reported in 1961 to Blodwen Davies that originally the cottage had an open porch and no dormers; there was also 'a clearing [now grown in] behind the house that went quite a distance up the mountain, at the top of which Milne built his "painting privy."'[17] Milne also excavated a vegetable cellar under the floor so that things would not freeze while he was away on all-day hikes, or when he and Patsy were visiting in New York.

In the early spring of 1917 Milne and Clarke, for diversion, hiked the five kilometres (three miles) up to the Riga Lakes to camp overnight, a seemingly harmless activity that almost turned into a disaster. Snow had gone from the valley, and it was warm when they set out, but the air was bitterly cold by the time they arrived at the higher altitude. Nevertheless, they rowed an old scow through one lake and into another before deciding to make camp.

There was still some snow on the mountain so we pushed into a small bay and picked a sheltered place. It was very rough. We had to move stones to make a level area among scrub trees. We made a lean-to with Clarke's poncho stretched on some sticks, gathered wood, spread our blankets inside the shelter on some branches and prepared for a cold night.

The evening though, was alright. We kept a good fire going, prepared supper (with coffee) and with our shoes off and our feet dry we lay on our blankets. In the night it snowed and the weight of the snow pressed the poncho down on our faces. Without enough blankets and with a hard uneven bed we would have been very uncomfortable, even without the snow. We intended to go home next day, but the storm was still going on. The lake was rough, too rough for our flat-bottomed boat. After breakfast we explored a little, walked around in the snow, and tried to find out where we had got to, and what chance there was of getting home overland. There didn't seem to be any land route open. We were hedged in by thickets of scrub oak without any path or ridge of rock through them. It seemed we would have to camp out a second night. Our greatest worry was about food. That was getting scarce, though we did have plenty of sugar. This suggested jam, so we gathered wintergreen berries and made jam in a tin cup. Good thick jam, strongly flavoured with wintergreen. We liked it. Of course we

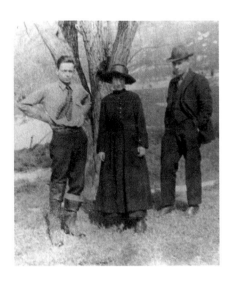

*James Clarke, Patsy Milne, and Milne
at Boston Corners*

would have liked almost anything we could force down our throats.

By the second morning the storm had passed, the lake was still and we set out early, driven by the discomforts behind us and pulled along by our hunger. From the top of the trail we could see the Boston Corners house, even, we thought, the cold frame at the end of it. That set us to worrying about whether anyone had thought of closing the window over the frame to keep the plants from freezing. On we went, again in bright sunshine and warmth. Our hardships didn't gain us much sympathy at home. It seemed the storm had pretty much by-passed the valley. Our sample of wintergreen jam didn't stir any interest at all – maybe our appetites had something to do with making it delicious.[18]

Clarke, in retrospect, had a different opinion of the matter:

It wasn't very good jam ... In fact, we went usually with too little. We didn't have enough food, we didn't have enough shelter, and we didn't have enough implements or anything of that sort. That was characteristic of Milne. He made do with very little. He was a great person for economy. He never used too much of anything. You can see that in his paintings ... economy of means ... was a characteristic of his whole being and his whole life. I think a person's technical methods and processes are a reflection of their own character, if they are sound. Of course a person that is imitating some other artist's methods and techniques, that's a reflection also on his own character. He is too weak to make his own methods. That wasn't true of Milne.[19]

Domestic chores, whether for food or funds, were leavened from time to time with picnics, hikes up the mountains, skating on Bishop's Pond, tobogganing down the hill behind their house (Milne made the toboggan), and occasional fishing jaunts. The Milnes sometimes visited or skated with the Roberts, who lived on the next farm (Phil Roberts was the night operator at the station). Other visitors were the Dennisons, artists who lived not far away at Old Croken and who later bought Under Mountain House from Joe Lee. Arthur and Cora Vernon visited sometimes and came at the end of 1917 for two weeks, just before Milne entered the army and just before diabetes, then untreatable, claimed Arthur, who died soon afterwards.

Once in a while the Milnes went to New York to visit the Clarkes and to see exhibitions. The Clarkes, when they visited Boston Corners, joined in the fishing, hiking, and other activities and stimulated long, animated discussions about art.

We always seemed to have a particularly fine and exciting time when the Clarkes were visiting.

Clarke and I had quite different backgrounds but many things in common. Both were fond of walking and camping, even the very primitive camping that was possible from Boston Corners. The Clarkes had a strong vein of economy so they didn't mind our simple, even primitive, way of life. One of Clarke's economies always seemed amusing to me. When they were ready to go home, usually on Sunday afternoon, they lingered a little for coffee, and the Clarke routine was not to make fresh coffee but to pour some boiling water on the grounds of the noon coffee and heat it over. We often talked over our differences of outlook, particularly about painting and the painting way of life. Clarke had foresight. He saw that painting couldn't possibly provide a way of making a living, yet he wanted to paint. First though, came the plan for living. This he

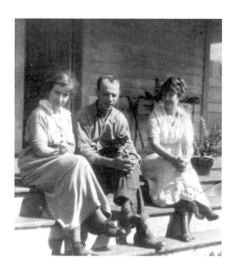

*Patsy Milne, Milne, and Anne Clarke
at Boston Corners*

managed with great success, with such great success that he had spare time for painting weekends and holidays, and on visits, and for long periods half time ... [Clarke] had to make a decision, and he made it. He decided that he wasn't prepared to sacrifice his family and his way of life and launch on an uncertain career as a painter. That decision wasn't made without a struggle, without some bitterness.

I too got my bitterness, but from the other side. I am not sure that I entirely lacked foresight. I had a pretty good idea by that time [1916–17] that painting offered very little in the way of security. But for me there was no decision to make. I had no other way of life. All I had to do was to follow the painting wherever it led, and trouble [myself] as little as possible about coming difficulties or sacrifices.[20]

Clarke's decision ten years later to accept executive responsibilities in his expanding firm and forgo his close connection with the artistic side of the advertising business, where he had made such a distinctive mark, was clearly one that pained him. He knew he was sacrificing something that was dear to him, and he envied Milne his single-minded devotion to his art. Milne, for his part, must have sensed that he was missing a lot from life as letters from Clarke dropped into his mailbox from across the United States, Europe, South America, from cruises in the Caribbean and winters in Florida, and from golf clubs hither and yon. Yet it was always Clarke who expressed regrets for the choice he had made, not Milne.

As far as painting was concerned, Boston Corners proved to be as good as Milne and Clarke had hoped:

Painting subjects were scattered all over the place but rarely were more than two miles away. All were painted on the spot, and then, good or bad, left alone; no attempt was made to develop or change or repaint after the original painting was done. I had to carry a wooden paint box, easel, stretched watercolour paper or canvas and, when I went to the limits of my painting territory, my lunch, cold tea or coffee in a jar, sandwiches, cake if it was to be had, even pie, when there was pie. The radius of my painting ground was determined by time, load and frame of mind. If my attention hadn't escaped from the round of day by day events and become fixed on painting subjects and painting methods within the leisurely two-mile walk, it wasn't apt to that day.[21]

Milne is misleading about leaving his work, good or bad, untouched after it was done at a sitting, for he not infrequently made substantial changes.

In all weathers the countryside was varied and agreeable for walking. Milne roamed from the steadfastness of Under Mountain House, sometimes in search of painting subjects, to the north, south, east, and west, often covering many kilometres a day. Rambling through the fields, over the hills, and past the ponds soon gave him an 'ease and steadiness' that, in turn, had a 'noticeable effect on the painting.' Many years later he wrote the following remarkable reminiscence of painting expeditions at Boston Corners, of which the memory was still vivid and warm. It is charged with minute and evocative descriptions as he searched for a painting place, and concludes with a wonderful account of the process of creation.

The pattern of these day-long painting trips was always pretty much the same ... The morning start, with my load, through the fence along the garden into Bishop's field, numbed by routine, with little interest in my surroundings. Then

the gradual quickening, sometimes slow, sometimes fast. At first only the half-conscious feel of the crispness of the grass with white frost on it. The familiar harsh scream of a blue jay or the chatter of a red squirrel might stir a comfortable, familiar feeling. A minute's pause to look at a garter snake stretched beside a rock to get the first warmth of the sun. On through the scattered maples in Bishop's pasture and to the top of a rise overlooking the valley. My load would be set down while I watched and listened to the morning train coming up from New York, a long trail of smoke and steam lying still on the air. This would be a possible painting place and subject. I had seen it many times and nothing had come of it. Now my mind was too sluggish to grasp anything of enough interest to start me painting. The quickening process [was] under way but still only partly. Up with the load and on my way, observing, with a little more interest, tree shapes and contours. At the side of Bishop's mill pond, another halt to look at the reflections in it, feeling some excitement stirred by the colour of the trees on the opposite bank, maples in scarlet and yellow, poplars in orange tinged with a little vermillion, the deep purple and green of ash. Some speculation about how nearly perfect the reflections in the still water are. A slight breeze springs up and the shapes in the water become less definite. A little more and they are changed to vertical waverings. Then the breeze increases and all are lost. This is not the place today. This pond with the low banks is too much exposed for my purpose. On again through Bishop's farm and across the next and the next. My thoughts now pretty much occupied with painting. The escape, the feeling of ease and well-being almost complete. There is more of purpose now, of search, as I make my way across creeks, along fences, through patches of bush and up and down hills. These reflections have had some attention recently, I know what do to about them, or at least what I want to try, and am busy with plans, based on what I have recently done, but with modifications based on past failures. I come to the Kelly Ore bed, a man-made pond about the size of Bishop's mill pond, but with steep banks round two sides and a small bush at the other. Not a thing remains to remind one that it has ever been anything but a quiet pool with grassy banks. Only a high wind will break its surface. This is the place. I unpack and set up my painting outfit. Quiet, leisurely, observant. I have no interest beyond what is in front of me, and what I am to do with it.

 I put a few pencil marks on paper, 'placing' what I want to include in the picture, moving it up and down or to either side, thinking not so much of what is there as about what I am to do with it. Then I start to draw in pencil, slowly, holding back rather than pressing on. Everything that is to go in the picture is marked in some way. The drawing is not to be followed closely; it is a sort of shorthand reminder made at leisure, to be used later when work is speeded up and there isn't time to travel back and forward from the scene to paper. What happens on the paper is not so important as what goes on in my mind. By the time the drawing is finished most of the painting problems of the picture are solved, even the colour and treatment determined. I get a tin of water from the pool, fix it on the easel, and set to work with colour. I work easily, rapidly now, the pool and its banks and the bush are gone, everything is on that rectangle of paper. The brush wanders over it, sometimes in great detail, sometimes broadly. I see not only what I have put down at the moment, but back to the solutions indicated in pencil and forward to what is still to be done. The pace quickens; on some rare days the painter can do no wrong (according to his own limited lights), things click into place without conscious thought [or] effort, problems solve themselves, the picture seems under its own power. Those days are infrequent. More often there is a break in the flow somewhere along the line. Some problems may have been overlooked in the process of pencil drawing, or

Weed Iron Mines, 1993

imperfectly solved, or shirked. Now there is a pause to consider it, an effort to grasp it. If the effort is not quickly successful, the thing fades away, power is lost like escaping steam, and another failure is added to the list. When it comes to putting on paint, speed, and with it, quickening, seems to be essential. An extreme concentration, a singleness of mind. The painter must come to life, must be quickened beyond his own normal possibilities – and that is the object of the walk and of all the preparations up to the hour or so of actual painting.[22]

The afternoon expeditions were somewhat different – they 'didn't often follow the same course as morning or all day ones.'

Setting out after lunch there didn't seem to be the same steady unrelenting movement to shed the cares of the day, and become absorbed in painting. Sometimes I seemed to make no progress, to find nothing to paint. In summer I got over that by lying down in a comfortable hollow and going to sleep – that was never difficult. When I woke, very often, particularly when the sun was low and the light different, I found things much more interesting and started to work at once, full speed. The return from these painting trips was something in itself. The return with my load, tired, relaxed, numb so far as feeling went, was a quiet enjoyment, whether the painting had turned out well or not. It was the effort that brought about the condition, not success or lack of it. Usually I knew pretty well what my luck had been without looking at the picture. I knew the feeling I had when I painted. There were sometimes surprises, pleasant or unpleasant. When I was in close pursuit of one particular thing I judged the merits of the picture by that only, losing the long-range viewpoint. There have been times when I have changed my opinion of the relative merit – and demerit – of my own pictures, mostly after twenty years or so without seeing them.[23]

Clarke remembers Milne coming home after a day's painting and looking at what he had done:

Milne would set up the day's painting up on a chair or something and study it and make notes and if there was someone there to talk about it, which he loved, why he would discuss why he did this, in what areas he thought it was successful, and which were not. And it was quite a treat to listen to him discuss the day's work.[24]

Milne's painting at Boston Corners from May 1916 to February 1918 falls easily into two distinct phases. Half the 134 paintings (38 oils and 96 watercolours) were executed during the first five months, as Milne threw himself excitedly, almost frantically, into his 'adventures in shape, colour, texture and space.'[25] A number of the early attempts to come to grips with the subject matter around Boston Corners were subsequently cancelled or had later works painted on the other side of the paper. Milne himself acknowledged this, although in retrospect he exaggerated his failures: 'painting was started quickly but for a long time was not good.'[26] Milne blamed this – perhaps logically, but not convincingly – on what he had been doing in New York, but many useful and exciting ideas were developed almost immediately. Not until the end of the first summer, however, did his work start to have a settled quality, despite many excellent paintings.

In the latter seventeen months that he lived at Under Mountain House Milne's paintings became relaxed and assured as he painted the hilly landscape around Boston Corners, and particularly variations of the little village as seen from the hill behind his house. After the summer of 1916,

during which Milne spun out one painting after another at a frenetic pace, it was almost as if he stopped, to absorb what he had learned.[27] Then – deliberately, almost casually – he produced the distilled wisdom he had gleaned from the new setting and his various confrontations with it. In New York he had invented a vocabulary and a grammar; in Boston Corners he articled them to the service of more profound thought and more deeply held conviction about the world he saw and painted. In New York he was an eager novice, apprentice, and then journeyman to painting; in Boston Corners he graduated to the rank of a master.

As if to mark this graduation, Milne regularly began to date, and then to sign and date, most of his work – something he had rarely done before, unless a painting was destined for an exhibition. Although he stated later that he was unable to exhibit his work while he lived at Boston Corners, correspondence with Clarke confirms that he continued to submit paintings to galleries and societies regularly and to have them accepted in New York, Philadelphia, and Boston.[28] Nevertheless, Milne's memory is essentially correct, for few paintings were sold except through Clarke:

So, at Boston Corners, the pictures were mostly set up on a chair and looked at on the evening of the day they were painted, then put away, unexhibited, and for the most part unseen, except maybe by Clarke. That wasn't a bad thing, so long as we could carry on. Painting developed naturally, without outside pressure, or any conflict in my mind between my own opinions and feelings and anything outside. Painting was almost entirely for the delight in doing it, and that seemed incentive enough. When we left Boston Corners for the army the pictures were packed away in Clarke's attic, and there they stayed for many years.[29]

The transition from New York subjects to Boston Corners subjects was not abrupt. Despite his new immersion in the forms of trees, barns, fields, and hills, Milne was still the same person and same painter he had been. Although he laid himself open to the process of discovering where his art might take him intellectually and aesthetically, he had to try out various ideas, test possible techniques, and experiment with different rhythms, patterns, and contrasts. Throughout the summer of 1916 his work jumped from one concern to another. Eventually he winnowed out those that proved

Joe Lee's Hill, *31 May 1916, watercolour, 38.5×56.3* (15⅛×22⅛)

Green and Mauve, *31 May 1916, watercolour, 39.1×52.1* (15⅜×20½)

Intersected Trees, *1916, oil, 50.8×55.9* *(20×22)*

useful or that could be adapted to his new purposes. Each of his devices has the effect of challenging expectation, of jolting the viewer by presenting an unusual structure, a jarring colour, a complicated texture, or a novel perception.

One important motif that was tentative in New York but important for Milne's later development was amplified and refined at Boston Corners. Milne often drew the lines of the horizon, or of hill contours, through the silhouetted shapes of trees, or traced telegraph lines or a fence across a landscape. His intention was to bisect the picture surface with a continuous, or nearly continuous, line. Initially this produced a certain stiffness, as if the idea were more important than its visual effect. But as Milne persisted, his treatment gradually became more subtle, and finally became submerged as a minor visual characteristic of a larger composition. Among the first paintings (in oil and watercolour) at Boston Corners, *Intersected Trees*, for example, shows a brutal insistence on this form. Later ones, like *Joe Lee's Hill* and *Green and Mauve*, convey a transparent delicacy that achieves the same visual effect without drawing undue attention to itself. Milne not only applied this idea horizontally to depict hills or horizons behind trees, but during the summer he used it as well in a number of oils and watercolours of trickling cascades that bisected the picture space vertically. *Drying Waterfall* and *Stream Bed in Dappled Sunlight* posed a visual puzzle where the illusion of two planes, distinctly separated, was set against the reality of the single plane of the painting surface. In the waterfall pictures, possibly more than in the open landscapes where he sometimes used a similar approach, Milne first became obliquely aware of the power that could be obtained by weighting one side of a picture against the other. An intersection upsets the normal rest and calm of a composition; it is naturally a place where forces concentrate or collide. Like other devices Milne was to develop later, it could animate a subject, give it an unexpected character, and thus force the viewer to look more sharply because normal expectation was not fulfilled.

Early in the summer of 1916 Milne first recognized a second device in his work that he called the 'interrupted vision' motif. Although he had used this idea tentatively in New York, in paintings like *Bronx Pattern* and *In the Bronx*, he was finally able to give it conscious definition. Years later Milne described this convention, and the act of *seeing* a painting, to Alice and Vincent Massey:

The most interesting series of motives I have ever used were developed in what might be called interrupted vision pictures. Though that sounds rather scientific, the motives came from the simplest and most common of occurrences. The novice photographer sidesteps and advances and retreats until he has a clear view of his subject, then snaps it. The result is often disappointing. The reason may be that he has left out what, unnoticed, gave the subject interest. He may have been standing in a sugar bush, interested in the bare ground with snow patches, the big sugar trees and little saplings, the figures and the sap buckets, but may have failed to notice the tree trunk at his side, cutting off part of his vision, or the branch in front of his face. Both were within his field of vision, though out of focus; and both had their effect; without them we miss the tantalizing mystery of the original view. Most of our everyday seeing is of this kind; we see past a man's shoulder, we get a momentary glimpse from a doorway; we seldom see things at leisure and clear-cut. Here is an opportunity for the painter, who is supposed to be an expert in seeing and on whom we depend for all our knowledge of appearances. He can get a kick out of this

Drying Waterfall, *1916, oil, 50.8×61.0 (20×24)*

Stream Bed in Dappled Sunlight, *1916, oil, 61.0×61.0 (24×24)*

Back Porch, the White Post, c. 1916, watercolour, 38.8×48.0 (15¼×18⅞)

Porch Post, 1934, ink drawing, 7.4×10.5 (3×4¼)

interrupted vision, and can reproduce his thrill on canvas for those capable of receiving it.

He went on to describe the origin of the watercolour *Back Porch, the White Post*:

I think my first interest in any of these themes, that have to do with natural seeing, was in 1916. We were living in an old farmhouse [Under Mountain House] in the lower Berkshires. The house had a kitchen extending behind one end of it, and the angle between the house and kitchen formed a porch. The roof of the porch was supported by one post, not one of those fancy turned affairs, but merely a two-by-eight painted white. In hot weather we had dinner, at noon, on this porch. One day, after dinner, my mind running on painting and painting possibilities, I noticed that the table with dishes, the chairs, the figures and the window behind, all low in black and white value, made a promising subject. Unfortunately the glaring, white post always got in the way, no matter how I sidestepped it always forced itself on my attention. I started to paint. I could have left the post out, but I didn't, I put it in, blank and glaring. The picture was interesting. Probably not at the time, but afterwards, I realized that it was good, not in spite of the aggressive post, but because of it. Later still, after pursuing the theme in several directions and on many canvases, I understood why the blank area of the post gave a kick. The requirements of such a motive are two – the blank area must be sharply in contrast with the rest of the picture, and it must be without interest in itself. Its purpose is to engage the attention quickly, and immediately release it in the detailed part of the picture. It is a transformer, it steps up the speed of grasping the picture and so increases the aesthetic kick; for speed, concentration, [are] the basis of aesthetic painting.[30]

As Milne says, the blank white slash, although of no interest in itself, was the catalyst that animated the whole picture, lifting it out of the ordinary and challenging the viewer's expectations. When part of an image is missing, the viewer has to supply it in his imagination; there is also a natural human curiosity to peer behind an obstruction. This formal motif, which had been gestating unnoticed for years, was finally recognized consciously as a useful and effective device that, through a subtle irritation, could heighten a viewer's interest. A characteristic of Milne's leisurely, circular development is that often he did not immediately recognize the importance of an accidental discovery; but once he saw its value and function he deliberately used it.

Two other devices, of relatively minor importance, were attempted at Boston Corners and would inform later work. One was an uncharacteristically bizarre palette, which shows in the shamrock green of the watercolour *Joe Lee's Hill* (Milne originally called it *Green Masses*), or the odd yellow-mauve in *Green and Mauve*. *Green and Black Tree Shapes* is another example. In such pictures the unexpected colour is accompanied by eccentric drawing: gaping holes in tree-forms – influenced by his friend Andrew McHench's sculpture, according to Milne – project an undertone of wildness and may remind viewers of the instability sometimes felt in a late van Gogh painting.[31] Milne certainly had no fear of trampling on established conventions if the effect he wanted required this. Indeed, strange and original colour combinations marked his work throughout his life.

Another of Milne's techniques was his use of little scratches in a painted area or small pellets of paint, mostly dots of white in oil, to distinguish different masses within a composition from each other. Milne called this

orchestration of small shape units 'texture.' In the works done in the summer of 1916, and again in the fall of 1917, the textural quality is characterized by jagged rather than smooth or rounded outlines, an abrasive edge that gives a number of the pictures – for example, *Pool and Birches* – a spooky and hurried look. This, in turn, emphasized the nervous, scattered appearance of work done in the first few months at Boston Corners, especially when compared with the serene, unruffled paintings that followed.

In the main, however, the work done in the summer of 1916 continued the restricted colour scope of the later New York period: primarily black and green with white highlighting and generous white space. A blue-gray slate colour that had first appeared briefly in 1914 at West Saugerties was reintroduced – used as a colour, as it had been in New York, not as a value as the later gray, without the blue or green tones, would be. When late that year Milne applied a wash of clear water over part of a watercolour drawn in black (as he had done once or twice in New York), he got a faint gray tone that seemed to infuse the painting with the quality he wanted. Still, his use of the slate-gray colour late in the summer was hesitant, and was perhaps only an unconscious groping toward the use of gray that he instinctively knew had to be grasped if he were to get anywhere at all. Gray is one of the most difficult of all colours to use successfully in paintings since, unlike any other colour, it immediately takes on aspects of all colours near it.[32] It is like a conductor: a little colour beside it is amplified many times; gray can even transport the effect of a little colour to an area in another part of the canvas. This is why Milne found it necessary to use sparing amounts of colour in conjunction with gray. Milne did not fully resolve this problem until the late 1920s in a few paintings of waterlilies at Lake Temagami, and then with great originality and freedom in his paintings of the village of Palgrave and the countryside nearby.

None of the paintings during this preliminary phase of Milne's life at Boston Corners provide a commanding view of the village as a whole, despite Milne's retrospectively stated reasons for choosing Boston Corners as a painting locale. Indeed, late in the summer Milne spent several weeks painting the interiors of sections of bush, boulders and lichens, moss and vines, as in *The Boulder*, an oil. Using only four or five colours, he tried to separate all the shapes and textures, to define the qualities of the objects while still investing the work with aesthetic vitality. Given the inventive and original ways in which he drew the shapes, the wonder is that these works are as quickly readable as they are. In several paintings – *Relaxation* is a good example – Milne's fascination with the events of the Great War in Europe show up in his references to camouflage, a convention of tricking the eye that Milne was often intrigued by.

In early September 1916 the Milnes holidayed with Patsy's aunt at Tivoli on the Hudson River.[33] This was a rather posh occasion for the Milnes, since Geraldine Ryan had, at Meadowbrook, a gardener, a chicken keeper, and a chauffeur, in addition to household help. Patsy regularly visited her aunt here over the years, although she never mentions the contrast between her aunt's well-to-do life and the life of uncertainty and poverty that became her lot when she married Milne. Particularly when she was young, she may have been swept up by the excitement, the freedom, and the idealistic rural life that she shared with Milne.

For Milne, still the avid botanist, the garden at Meadowbrook was a delight, filled as it was with wonderful flowers, vegetables, and exotic fruits. What also gave him much satisfaction was watching the river, with its

steady traffic of boats – sailboats and pleasure craft, steamers, ferries, and freighters – and the trains rushing up and down the river valley. Driving through the countryside in a touring car, a regular pastime, was not his cup of tea, although he might have been tempted to visit Olana, the famous estate of the American luminist painter Frederick Church, which was close by.

While he was at Tivoli, Milne painted *Entrance to Saugerties Harbour*, with its eccentric lighthouse, a splendid watercolour in which his invented, abstract shapes react dynamically to one another and yet do not obscure recognition of the subject. The upper and lower parts of the picture, which are sharply split by the shoreline, are welded together with three colours – aquamarine blue, jade green, and rusty brown, plus black and white – and fused by the interlocking shapes to form a forceful, comprehensive whole. Later that month, back at Boston Corners, Milne's first definitive 'reflection' pictures gave unequivocal voice to the dramatic dialogue between two parts of one picture, the same concern with which he had tentatively initiated the summer's work. The washed-over image in the water of *Reflections II* acts in contrapuntal rhythm to the unwashed image of the shore. In this and in subsequent works Milne began to orchestrate his slightly angular forms in more and more complicated ways, creating patterns within shapes and shapes within groups of shapes, but concentrating chiefly on the power and pulsation of the whole composition.

The second phase of this Boston Corners period began after the fall paintings of 1916 and carried through to February 1918, when Milne stopped painting and left in army uniform. No paintings exist for October and November 1916, presumably when Milne launched his mail-order record-poster business. A few unresolved oil paintings suggest that he may have had an interval of experiment; indeed, only about fifteen paintings were completed during the winter and spring of 1917. Yet while these were few in number, they finally portrayed the long, tranquil view of the village. In the few watercolours for these interim months the idea of using a wash over the upper half of the paintings, a hillside, say, to create a textural contrast with the lower half of the painting, was considerably advanced and may be seen in *Half and Half*. In oil progress was tentative and showed little of the control so evident in the watercolours. Milne's use of white

Entrance to Saugerties Harbour, *12 September 1916,* watercolour, *38.8×55.9 (15¼×22)*

Relaxation, *1916, watercolour, 38.5×46.7* *(15⅛×18⅜)*

paper as a positive, striking force in a watercolour composition did not find a parallel in oil: white paint was no substitute for white paper, since it always read too emphatically. When Milne did try to use the unsized canvas as a background, he found that its beige or creamy colour did not give him the effect he wanted either.[34] If later work patterns held true during this time, Milne probably painted some oils over each other several times and destroyed a good number of others.

The change that took place in Milne's painting during this period, however, was momentous. From a close-up involvement with his subject, Milne drew back to a dispassionate distance, but without loss of energy or immediacy. When he began to produce steadily again in the spring, his work showed so much assurance and objectivity that it is hard to believe the transformation could have taken place in so short a time.

Trees in Spring and *House among the Trees* illustrate the advance. In both oils Milne mastered the control and balance of colour; he made the white highlights (using white only to animate other colours, not as a matrix or value) fit more harmoniously with the whole work and, above all, he gave the drawing of the shapes a centre of gravity and a 'rightness' that the works of the previous year do not have in anything like the same degree. The June watercolour *Joe Lee's House*, for example, is brimming with invented shapes; it sits gently at rest, but seems charged with energy; it gives the appearance of spareness, yet is rich and full. The washed and dark areas create tensions between the upper and lower halves. The trees, in all their strange configurations, act as conductors or connectors that relieve the tension, as the eye tracks through the picture, and re-establish the charge as the eye moves on. Milne had learned that the drama he was creating could be more powerful when it was simply described. The strong predilection for line was given increased prominence and shows particularly in the drawn outline or silhouette. This is most obvious in the trees and buildings, but can also be noted in the horizon and the contour lines of the hill. In the fall of 1917, when Milne sent six watercolours (done in 1916 and 1917) to the Philadelphia Water Color Society, he gave them all similar but odd titles: *Drawing Made near the Catskill Mountains* or *Drawing Made at Boston Corners*, and so on. The linear and abstract qualities of these works, therefore, were uppermost in his mind. He was interested in the primacy of line or contour over colour or mass, a preoccupation that would recur often. On the back of these same paintings are Milne's other titles, probably inscribed a little later: *Half and Half, Soft Textures*, and in one instance, for a vibrant tangle of fall colours, *Coloured Spaghetti*. But his use of the word 'drawing' must have meant something specific to Milne, for his definition of a painting was simply that it was 'a drawing speeded up.' While the noun 'drawing' in art circles of the time generally implied a hasty, minor, and perhaps rather personal expression, to be viewed only as a means of getting from one stage of painting to another, Milne clearly believed that a drawing, at least as done by him, was an end in itself.

By late July and early August 1917 Milne had extended the intervals of space between shapes, most noticeably in the few black and green works of these months. *Road to the Church*, for example, further emphasized the importance of drawing. At this point Milne clearly believed that colour was an arbitrary tool and that the processes of thought were carried chiefly by line, although he did not articulate the idea until a few years later. Colour was still a major consideration; but it came after the structure was built up with line, and its purpose was to enhance and quicken the viewer's grasp of the composition. The sustained concentration and effort required

to establish this balance produced more assured works, and this was one unmistakable sign of Milne's deepening maturity.

The Milnes were at Meadowbrook in Tivoli again in August and September 1917 for a four-week holiday with Patsy's aunt. The watercolours *Sunburst over the Catskills* and *Reflected Forms* amply demonstrate, in their serenity and finish, the clarity, control, and opulence Milne could now achieve. In *Reflected Forms* shapes were stretched almost out of recognition, and Milne's extensive use of black shows a role for that colour that is greater than anything he had yet attempted. Throughout the fall he exploited the rich colours of the season with feverish excitement. In watercolour he pitted bold colours against pale washes, drew with great variety,

Trees in Spring, *c. 1917, oil, 55.9×66.1 (22×26)*

Joe Lee's House, *6 June 1917, watercolour, 39.4×56.6 (15½×22¼)*

Half and Half, *7 June 1917, watercolour, 38.8×56.6 (15¼×22¼)*

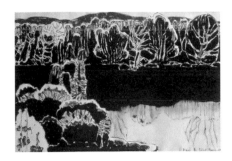

Reflected Forms, *1 November 1917,*
watercolour, 38.8×56.6 (15¼×22¼)

used white highlighting with a new skill, and introduced a crisp blue from time to time. In oil he tried painting directly onto the bare linen canvas without a primer or sizing base – *Pool and Birches* shows the result of this in its apparent spontaneity, its reliance on immediate drawing, and its limited colour range that manages, nonetheless, to convey the impression of a great variety of colour as well as shimmering activity.

The year 1917 concluded, happily and appropriately enough, with a series of paintings, in both oil and watercolour, of long views of Boston Corners as seen from the hill behind the Milnes' house. In picture after picture – *Black Hills, Boston Corners and Fox Hill, Village toward Evening, Fox Hill Berkshires, Afternoon Light II,* and *Snow Patches,* just to name a few – there is the little village, 'a string of coloured beads,' across the valley floor. The scoop of buildings traces a leisurely, rhythmic progression across the paper or canvas, and in a number of pictures, such as *Village toward Evening,* the curve is answered by the contour of Fox Hill in the background and by the hook of clouds in the sky. The natural effortlessness in these pictures is immediately striking. Milne worked up to this pitch of achievement after months of thought, analysis, and experiment – and of course years of preparation. But the result, so sparse and fragile in many ways, so unimposing, offers exquisite equilibrium and inherent strength.

The most important characteristic of these Boston Corners paintings is the truthfulness they have to qualities of light and atmosphere. During

Sunburst over the Catskills, *8 September 1917, watercolour, 38.5×55.3 (15⅛×21¾)*

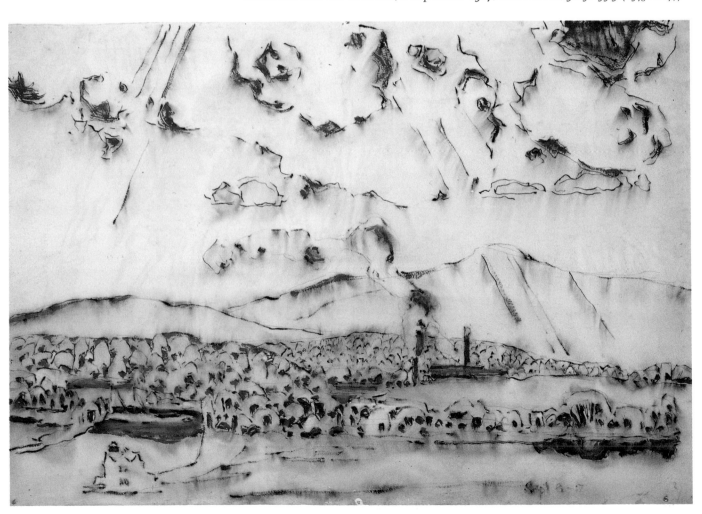

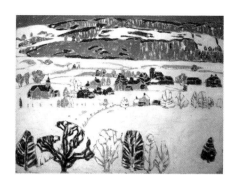

Boston Corners, *1917–18, oil,*
51.5×67.0 (20¼×26⅜)

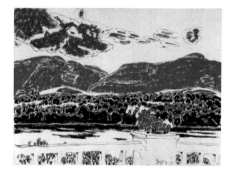

The Catskills, *9 September 1917,*
watercolour, 38.8×52.1 (15¼×20½)

this period Milne began to catch a specific and subtle feeling for weather conditions, the density of the air, and the fall of light across the landscape. His paintings even suggest the time of day they were painted. All of Milne's senses nourished his paintings: he not only cast a keen eye on the subject, but conveyed how the scene felt to his skin. The finely attuned sensibility he was able to express became a hallmark of his paintings from this point forward, and it is what gives his pictures their enduring qualities of freshness and vitality.

The views of Boston Corners, in many variations, were Milne's first sustained series on the same subject. His idea was akin to Monet's in his series of cathedrals, haystacks, and waterlilies, since both used a constant subject to explore the nature of painting and to vary the line and the colour

Kelly Ore Bed, *1917, watercolour, 36.5×54.3 (14⅜×21⅜)*

Village toward Evening, *10 November 1917, watercolour, 38.8×56.6 (15¼×22¼)*

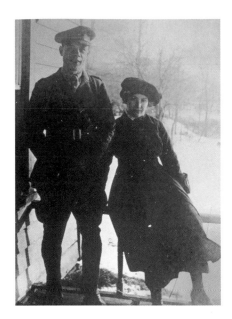

Milne in uniform with Patsy at Boston Corners, 1918

while holding to much the same theme. The tenderness with which Milne painted Boston Corners and its surroundings makes it easy to understand the lingering affection he felt for it. His time there, although relatively brief,[35] was one of intense tranquillity in which he became, as a painter, totally and wholly himself.

Milne's retirement from New York City and settlement at Boston Corners in May 1916 charged his art with a deep, full maturity. At the age of thirty-four Milne was already an acknowledged artist who had achieved much and created a distinct, personal style. But the solitude of the countryside inspired many fresh ideas and enabled him to express a breadth and resonance that were new in his painting. Had posterity known him through his New York work alone, he might be thought of as a provocative, meteoric talent whose originality seemed to shine in the reflected light of those around him. But by the time he left Boston Corners in early 1918 he had created a number of original devices in his work and developed a vision that was profound, gentle, and strong – and one whose light came not from others but from within himself.

Moreover, the act of withdrawal was itself important. This was the second example of a pattern that would occur over and over throughout his life. Every time Milne moved to a new location, he gave birth to exciting new works, invented new forms and techniques, and added strength to the sum of all his creations.

Fate intervened in this idyllic Boston Corners interlude when the thunder of war in Europe got closer and more insistent. The United States entered the fray in April 1917, and Amos Engle immediately joined up and was shipped to Europe with the Engineers. Canada instituted conscription and Milne wrote to Canada for information about enlisting. He went to New York when the British recruiting office opened there in December 1917 and volunteered. Patsy thought he would probably not pass the medical examination, since 'sometimes he had a little difficulty about breathing, which he thought might be caused by a slight heart condition.' When he did pass and announced his departure for training, she was shocked: 'That was quite a "blow" as I had not really expected it really – and I was frantic, thinking that something might happen to Dave. He was very patient (also unhappy) but probably understood that I would soon "carry on," like all the others, who had to go through with it too.'[36] Two months later Milne had packed his paintings and paint brushes away and was leaving Boston Corners in uniform, on his way to Toronto for basic training.

The Road to Passchendaele
Canada, Britain, France, and Belgium, 1918–1919

WHEN THE FIRST WORLD WAR erupted in Europe in 1914, Milne was perched safely above the Hudson River at Saugerties, reading the Sunday papers.[1] He had little incentive to volunteer. Europe was far away, the hostilities were expected to be short-lived, and in neutral United States he was not swept up into enlisting. Nevertheless, he was sufficiently enthralled by early reports of this momentous event to begin a scrapbook of news clippings and maps of the various campaigns and battle fronts. A common practice then was to paste mementoes into an obsolete book; in this instance Milne systematically obliterated Raymond Wyer's *An Art Museum: Its Concept and Conduct*.[2] The war occupied a larger place in his mind than that particular aspect of art.

Three years later, however, the situation had changed drastically. The early exhilaration North Americans felt while the drama unfolded overseas had fizzled into gloom; overconfidence had settled into grim determination. When the United States finally declared war in April 1917, the urgent need for reinforcements at the front tugged at Milne's patriotism. He wrote to Clarke in May that Canada had introduced conscription and that he was writing to Ottawa for instructions. The majority of the paintings of 1917, therefore, were done under the expectation of a sudden summons.

That Milne was by this time anxious to be involved may be inferred from a later letter to Clarke: 'The war loans used to ask people to "give till it hurt". Both of us I think did something much harder for quite a while – we stuck to our work till it hurt.'[3] Milne did not enlist, however, until the British recruiting office (Canada was still a loyal colony of the British Empire) opened in New York late in 1917. He then signed up, and early in the new year passed a physical examination, was issued a uniform, and given a month to settle his affairs. He returned to Boston Corners in uniform to make his farewells. The little school was let out to see him off on the train. Since he was the only person in the village to enter the war, a memorial plaque to those who served was never raised in Boston Corners, but his name is listed among the Americans on the cairn in the village of Ancram, six miles to the northwest, where once he had gone to sell his onions. Patsy stayed in New York and was employed by the British recruiting office as a typist.[4]

Milne's train arrived in Toronto on 1 March 1918. He was assigned to Company B of the 2nd Depot Battalion of the 1st Central Ontario Regiment, later part of the 8th Canadian Reserve Battalion. He executed a standard army will, leaving everything to Patsy, on 6 March 1918. After a few weeks Patsy came, with her cousin Geraldine, to visit for two days, staying at the King Edward Hotel, taking in theatre performances, and sightseeing around the city. After a month's training and drilling in Toronto at the

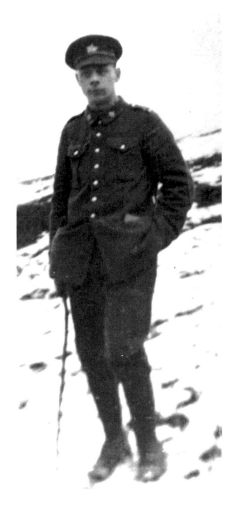

Milne with a walking stick, 1918

Canadian National Exhibition grounds – and, according to one later inter-view, shovelling coal at Western Hospital during a strike – Private Milne, D.B., 3232521, was hurriedly shipped, without his kit bag, to Quebec City as part of the forces sent to quell anti-conscription riots that had erupted there at Eastertime. This abrupt departure from Toronto permanently split the battalion, for some of the men were in the city on passes and did not go to Quebec. They were put on the overseas draft and sent to Europe almost immediately afterward.

Milne remained in Quebec City through the spring and summer of 1918. The army detailed him to night patrol in the Lower Town, to picket duty at the Citadel and at the fort at Lévis across the St Lawrence River, and to a host of other mundane military chores. He was trained in ma-chine-gun and rifle use, scoring a proficient 62 out of 70. With his fellow soldiers – an assortment of Americans, Irishmen, a Welsh black man, and other adventurers – he visited the Île d'Orléans and Montmorency Falls, swam in the St Lawrence River, played various sports, attended public events, and learned a smattering of French. He acquired a folding Brownie vp Kodak camera (it sank to the bottom of Dart's Lake in 1921), although few of his photographs remain. During the early summer Patsy came to Quebec with the Clarkes for a few days, and that prompted another round of sightseeing through the countryside nearby and more tearful goodbyes. In July and August Milne helped the Royal Canadian Mounted Police ('the Dominion Police,' as he called them) in rounding up deserters and con-scription evaders in Beauce and Wolfe counties.

I distinguished myself on one of these expeditions. It was the high point of my military career. We were armed and as we rattled along some of the men were busy loading their rifles, with the magazine filled and also a cartridge in the chamber. This looked like a good trick and I tried it too. Unfortunately some-thing went wrong. Still more unfortunately we were, at the time, passing a gang of Frenchmen doing road work. My rifle went off. It was pointed up so no one was killed, but the Frenchmen made one of the the quickest getaways you would want to see. Of course the whole cavalcade was stopped and the sergeant came back looking very serious. I felt bad too, but I had no stripes to lose, I was down as far as I could go.[5]

As the summer inclined toward autumn, and the events in Europe moved toward a dénouement, Milne began to fret that he might never be shipped overseas, a prospect that rather pleased Patsy. But orders finally came. On 10 September 1918 he boarded the ss *Ifernistolles,* of the Aberdeen-Austral-ian Line, in a fifteen-ship convoy that sailed for England three days later.

On 25 September Milne and his regiment debarked in the Thames River estuary at the Tilbury docks, and marched in the evening through north London amidst cheering Londoners – a sharp contrast to the cool indiffer-ence accorded the same troops in Quebec. His outfit entrained overnight to Kinmel Park Camp – 'just taken over by the Canadians' – near Rhyl in the north of Wales, where they were segregated for four weeks in an at-tempt to avoid the devastating epidemic of Spanish influenza then raging across Europe. The isolation was a failure, for the disease eventually reached the camp and killed a number of Canadian soldiers.

Life in Kinmel Park Camp was singularly uneventful. Daily parade and physical training were the only required activities, and each day became increasingly more monotonous than the last as four weeks stretched to six

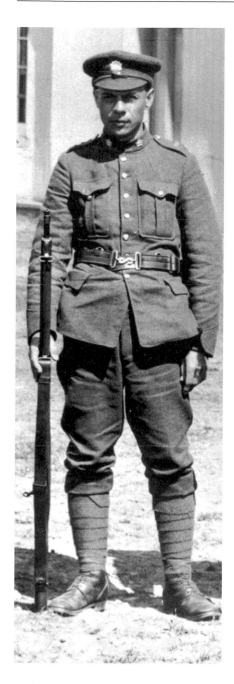

Milne at the Citadel, Quebec City, 1918

and then to eight. The men, Milne included, welcomed duty in the quartermaster's stores, the canteen, and the kitchen just to keep occupied. Contrary to his usual practice Milne even went to church several times. After the Armistice on 11 November discipline was relaxed even further. Not to succumb to boredom, Milne spent his days taking long hikes, nearly thirty-five kilometres (twenty-one miles) in a day, exploring and investigating the Welsh countryside he came to love, and sending postcards of picturesque scenes and historic monuments to Patsy, Clarke, and his family.[6] Everyone was anxiously anticipating discharges. Milne's unit particularly was congratulating itself on its good fortune: the rump of the battalion, stranded in Toronto the previous Easter, had been shipped directly to the front and been practically wiped out in its second attack against the enemy.[7]

Milne made only one close friend in the army, another private named Brown, a Welsh coal-miner who had immigrated to America just a year or so before the war began. The pair of them often walked together, ate together, and passed the time chatting. Brown was much younger than Milne and had not received much education. 'He used to write long letters home, always ending "This leaves me in the pink."' Milne helped him with spelling and wrote to Clarke that when Brown signed a letter he was far from finished:

When a man is writing a letter and gets as far as the signature you expect to see him get up from the table and come along almost any minute. Not Brown! He is fifteen minutes away from the end of the performance. He starts to read it over carefully, fishes into his pocket for his fountain pen, uncaps it, makes corrections, caps the pen, puts it back, and so on half a dozen times before he gets to the end. Then he chooses his envelope carefully, folds his letter, bends it over at the end ... to make it fit, seals it, gets out his little address note book and carefully puts the receiver's address and his own in full – then makes a record in his book, weighs the letter in his hand, puts on the stamp and is through. When I see Brown signing his letter I usually sit down and write a couple of my own.[8]

While for most men peace meant a return home, for Milne it also promised a return to painting. He had not painted for nearly a year, and in mid-October he wrote to Clarke: 'Once in a while I have a fleeting longing to sit down or stand up and paint, but life here swamps pretty much everything else including the war – for the present.'[9] Milne had a yearning, repeatedly mentioned in letters, to live and paint for a time in Europe after the war: 'I felt that the decided change would stimulate picture making and had some hope that my pictures (rather stiff and dry) might line up with English temperament.'[10] He hoped that he might be able to get his discharge in England (a possibility that the military would not allow) and that Patsy and the Clarkes would join him there. But during his weeks in Wales he did nothing to give substance to his daydreams.

In early December 1918, nearly a month after the fighting had ceased, Milne became aware of the Canadian War Memorials Fund, established in 1917 by Lord Beaverbrook and Lord Rothermere, in emulation of a similar British program, to record the Canadian presence in the war.[11] Beaverbrook's idea was an extension of the Canadian War Records, the main thrust of which was gritty propaganda – chiefly photographs used for telling effect in newspapers, documentary films, and newsreels. Beaverbrook, who was greatly attracted to paintings, thought to add a little

class and permanence to the venture by adding painters to the roster. He
sold the idea, which did not have much support from the military hierar-
chy, chiefly on the basis that the cost would be recouped through exhibi-
tion admissions. At first only British painters – such as Alfred Munnings,
Paul Nash, Augustus John, and Wyndham Lewis – were commissioned,
since Beaverbrook assumed that Canada had no painters worthy enough.
But after Paul G. Konody, art critic of the *Morning Chronicle*, one of his
newpapers, became an art adviser, Beaverbrook added Canadian artists
James Morrice, A.Y. Jackson, Frederick Varley, and Maurice Cullen. He
and Lord Rothermere agreed to cover the deficit, if any, and he anticipated
that Canada would build a fine memorial building to house the collection
after the war. Eric Brown, the director of the National Gallery of Canada,
and Sir Edmund Walker, a board member from Toronto, expanded the
program in Canada by commissioning artists to show the tremendous work
being done for the war effort by those at home.[12]

Milne was on the last day of a two-week furlough, wandering in Lon-
don's West End, when he discovered Beaverbrook's ambitious and far-
sighted program:

The war was slipping out from under me and my thoughts turned to the only
other thing I knew – painting. After lunch I wandered round in the streets
between Trafalgar Square and Piccadilly looking for some sign of a revival in art.
The National Gallery was still sandbagged, its collections not to be seen, and so
far I had seen no dealers' galleries that were open. Finally I came to one with a
single picture in the window. It was a painting of a troop ship, a camouflaged
CPR liner. On the frame was a small card saying 'purchased by Canadian War
Records for 200 guineas,' or some such unbelievable sum. I stood and looked at
it. It seemed something like my own work. Here was a painter not only back at
work but being paid for it. I had never heard of the Canadian War Records, and
if I had I wouldn't have connected it with painting. I was in a mood to gamble,
anyway I couldn't lose.[13]

The idea of someone's 'poaching in [his] aesthetic preserve' and being
paid for it snapped Milne to full alert, and he walked into the gallery to get
the address of the Canadian War Records. He quickly found his way into
Tudor Street and the War Records Office where he introduced himself to
Captain J.H. Watkins and Corporal S.W. Griffiths. Although the war was
over, an assignment was still a possibility, he learned, if he could establish
his credentials. He sped a cryptic note to Clarke on 6 December, asking
him to solicit two or three letters of reference from people who knew his
work, such as George W. Dawson, president of the Philadelphia Water
Color Club, or his dealer N.E. Montross, or the distinguished painter J.
Alden Weir.[14] Clarke was to send a selection of watercolours, 'possibly ten
in all,' that would show the range of Milne's capabilities and establish his
bona fides as an artist.

Watkins arranged to have Milne's leave extended for a few days, and
when Milne returned to the War Records Office he was told that he was to
go back to Kinmel Park Camp, where he would be relieved of all regular
duties, and begin painting. He received an interim carte blanche to stock
up on watercolour materials (for some reason, probably for ease and mo-
bility, he did no oil paintings during this tour of duty) at Winsor and New-
ton's, the artists' suppliers. He then returned promptly to Kinmel Park
Camp with elevated status. Although he was still technically a private until
the military bureaucracy could find a more formal niche for him, he moved

out of barracks and into his own requisitioned private room and studio, originally a laundry drying room. The War Records Office was short of paintings depicting the various camps where Canadians had been or were being billeted in Britain, and Milne's first task was to paint aspects of military life at Kinmel Park Camp.

Milne's probation lasted until after Christmas 1918. By that time he had painted a handful of new works and taken them to London. Clarke, for his part, had selected seventeen watercolours done between 1911 and 1917, which Patsy had mailed to Watkins. Both lots were vetted by Konody, who recommended that Milne be taken on strength.[15] A working visit by Milne to some of the war arenas in France was held out to him as a tantalizing if hazy possibility, for several of these had yet to be documented in paint. Milne was eager to go to France, not solely to see the battlefields, but also because he felt, rightly or wrongly, that the more he produced in Europe the better his chances of being discharged there would be. Milne's expectations were raised and reinforced by Konody's suggestion, based on his extremely positive reaction to Milne's paintings, that an exhibition of his paintings in London was a possibility after his War Records work was done. He did not learn until later that discharges in Europe were absolutely not permitted, and this dampened his prospects for exhibiting.

The army's (or Lord Beaverbrook's) purpose was to record where Canadian troops had been active or present during the war, and in Milne they found an ideal instrument. He was a shrewd and keen observer who could depict with accuracy and sympathy what was in front of him. Without interfering personally or morally, Milne could select the essential part of a subject and set it down, even relegating aesthetic considerations to second place if necessary. Also, he painted quickly, and his method was appropriate for the rapid and accurate kind of record that the army seemed to want. Milne was probably familiar with the British army's long tradition of topographic watercolour painting.

From his commercial-art days Milne knew what it meant to work 'for' someone. While the army seemed liberal enough in allowing him to decide what and how to paint, he must have been conscious of an unspoken obligation to document his subjects, to provide illustrations of a kind – especially since, for the first month or so, he was uncertain if he would be permitted to continue. For all he knew, his initial attempts might well tip the balance for or against his going to France. The thirteen watercolours of Kinmel Park Camp betray the conflict he must have felt: some, such as *Kinmel Park Camp No. 13 Looking toward Rhyl and the Irish Sea*, are calculated to win easy acceptance; while others, such as *Kinmel Park Camp: The Camp at Night* and *Kinmel Park Camp: The Middle Section of the Camp from the Hills above Kinmel Hall*, are daringly experimental in their treatment.

An early study of the camp at night was one of the experiments, painted on black paper and not very good in spite of its novelty. Two or three paintings are based on Milne's formal motif of interrupted vision, where a vista is seen past or through tree trunks. Others are done in intense and highly keyed colours; while still others are dashingly painted, with wet washes, free and generous in the handling. Most, however, whatever their style, are documentary in character, with an abundance of sharp detail and a skilled, perhaps too controlled, adherence to proper perspective and scale. Milne's letters hint that more works were painted than are now known. Possibly Milne held back some experimental works. For example, *The Hills behind Kinmel Park, Snow*, had nothing whatever to do with the army or Kinmel Park Camp. Some paintings were probably 'warm-ups' after a

forced sabbatical of more than ten months. As a group the Kinmel Park paintings give the impression that Milne went back to 1910 and rapidly recapitulated methods from his own development through to 1918 to ensure that all the techniques and devices in his artistic arsenal would be fresh in his mind and ready for service.

On 22 January 1919 Milne submitted ten watercolours to the War Records Office and they were immediately added to a large exhibition of Canadian War Memorial paintings that was then being shown, to great acclaim, at the Royal Academy in Burlington House, London.[16] Displaying some four hundred works – including paintings by A.Y. Jackson, Frederick Varley, Wyndham Lewis, Sir Arthur Munnings, Paul Nash, and Augustus John, among others – it was attended by two thousand people on 4 January, the opening day.[17]

Several of Milne's early war paintings were sent to New York for an exhibition at the Anderson Galleries in June 1919. In Milne's autobiography and in letters to Clarke, and in letters from Clarke who saw the paintings in New York, there are comments on a number of them.

Kinmel Park Camp: The Camp at Night I have been up on the hill behind the camp gathering material for a night drawing of the camp. A fine brilliant moonlit night, mild enough to sit on the ground and work. This is the second watercolor to date.

Kinmel Park Camp: Pte Brown Writes a Christmas Letter Brown is addressing his Christmas cards – a very serious business with him for he is one of the most

Kinmel Park Camp: Pte Brown Writes a Christmas Letter, *23 December 1918, watercolour, 28.8×29.9 (11⅜×11⅞)*

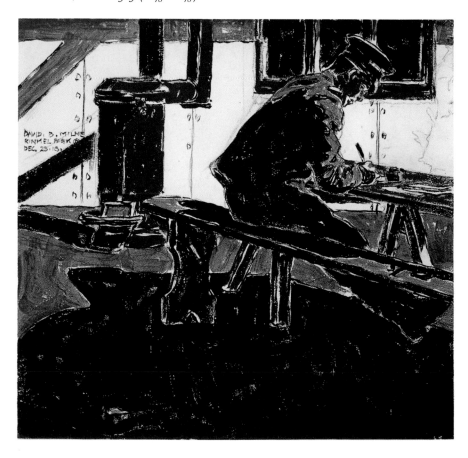

thorough human beings I have ever seen. He is trying to arrange the recipients to fit the ready-made mottos on the cards and has them all spread out as if he were playing solitaire.

Kinmel Park Camp No. 13, Looking toward Rhyl and the Irish Sea CLARKE: The one with the big cloud has a fine band of plain behind the Camp ... The cloud is a fine way to keep the picture from going to pieces at the top ...

Kinmel Park Camp: Dinner Is Served CLARKE: The cook house is a wonder ... The steam from the cooking was getting something out of nothing. Did you do it because you wanted to show Watkins you could draw and paint? Because it is one of the few Milnes I ever saw where the competent draughtsmanship and painting advertise themselves.

Kinmel Park Camp No. 13, Looking toward Rhyl and the Irish Sea, *14 December 1918, watercolour, 29.2 × 45.8 (11½ × 18)*

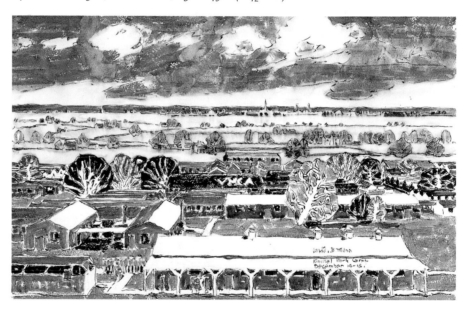

Kinmel Park Camp: Dinner Is Served, *1918–19, watercolour, 27.3 × 45.9 (10¾ × 18)*

Ripon in March, *5 March 1919,*
watercolour, 25.4 × 35.6 (10 × 14)

Kinmel Park Camp: The Middle Section of the Camp from the Hills above Kinmel
Hall I knew something of the scene before me. Away off when the haze lifted
I could see smoke from ships going to and from Liverpool. Nearer, the resort of
Rhyl and the hills of Flint. Between the hills and the camp was a wide plain ...
Toward the far side of this level ground ran the River Clwyd, and on its bank the
four towers and massive connecting walls of Rhuddlan Castle. We had visited
that too, even climbed the thick crumbling walls. Here, it seems, the Parliament
of England had once met, and here Edward I had made his promise to give the
Welsh a king who couldn't speak English. The impassable marsh must have put
him in a mood for appeasement.

Kinmel Park Camp Seen from the Old Roman Camp above St George On a
wooded hill behind the camp we were delighted to come on a Roman Camp
with a ditch and high earth ramparts and a level place within. If it weren't for
the large trees growing on it, the date of the buildings might have been 1900
instead of 400 or so.[18]

On 10 June 1919 Clarke wrote to Milne: 'What stops me is the way the
big subject has been reduced to lookable and paintable dimensions,' a ref-
erence to the several bird's-eye views Milne had done, such as the last two
mentioned.

Milne painted a few more watercolours of Kinmel Park, but on 5 Febru-
ary, in a letter to Patsy, he wrote that the War Records 'do not need any
more sketches of this camp.'

The 18 February edition of the *Canadian Daily Record*, a weekly news-
magazine for Canadian troops, contained a brief and flattering article on
Milne, undoubtedly written by Konody, titled 'A Private's Drawings.' Milne
was described as 'a provocative designer of the rarest distinction' and Vin-
cent van Gogh was invoked as a distant source of stylistic inspiration. Milne
may have been surprised to learn from this review that his work was 'highly
esteemed by connoisseurs in the United States' but he was delighted that

Ripon: South Camp from General Headquarters, *1 March 1919, watercolour,*
35.4 × 50.8 (14 × 20)

Konody and Watkins regarded the Kinmel paintings as different from the selection of New York works sent along a month earlier by Clarke and Patsy. In retrospect, however, Milne thought that the Kinmel Park paintings showed little new progress compared with those he later did in England – a just assessment.

Milne was next assigned to Ripon in Yorkshire, where he arrived on 24 February for what he thought would be a period of three weeks. He stayed for almost a month, but only eight dated works were completed and still exist. One of these, *Ripon in March*, a verso, echoes the broad, empty expanse of foreground found in some of the black-and-white ink studies of 1915 and foreshadows the crucial *Across the Lake I* of 1921, with its daring composition that leaves the lower half of the paper surface blank. Milne did not submit this work to the War Records Office. Perhaps he thought it

Ripon: High Street, 27 February 1919, watercolour, 50.8×35.6 (20×14)

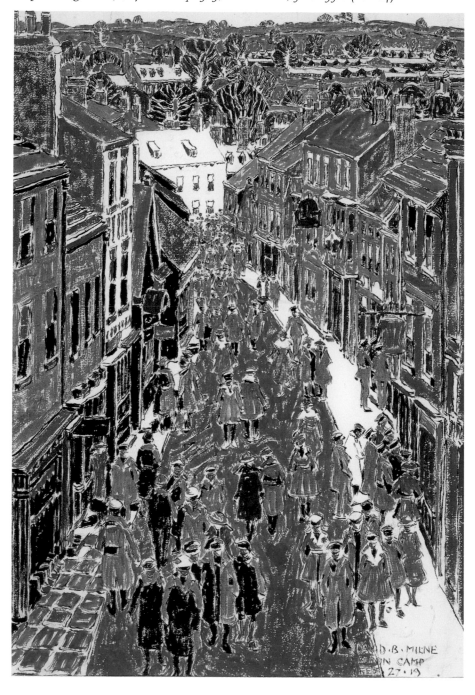

carried his principle of reduction too far, or at least too far for the army. Nevertheless, after packing an enormous amount of detail into his first army pictures, he was, he wrote to Clarke, back on the trail of the 'Scotch motive,' Milne's euphemism for doing more with less and demonstrating what he called 'economy of means' in his construction of a painting.[19] His first works had glittered like glass cases full of gems. Now he selected solemn and close-hued colours, where subtle rather than drastic shifts in colour defined the forms and the composition. *Ripon: South Camp from General Headquarters*, for example, makes use of five different grays, with sparing quantities of purple, cerulean, and green. The whites of the roofs bite into the detailed parts without threatening the poise of the whole – a remarkable effect achieved by the careful play of the various grays in relation to each white area. Like many of Milne's works, this one has a quality of contained, potential energy, like a taut slingshot.

In *Ripon: South Camp* Milne also begins to steer away from a direct head-on stance characterized by a well-defined foreground, middle ground, and background, often stacked one above the other, as in many of the paintings in early New York or Boston Corners – and in the recent paintings of Kinmel Park Camp. Instead, he was beginning to investigate more complex and subtle links between the various planes. The composition in this work, for example, is based on the sliding diagonal of the camp, rather than on a front, middle, and back. Scale reduces the importance of the distant planes; the foreground is dropped altogether. This new approach and format would be fully explored in France that summer (and culminate in his painting of the winding road at Passchendaele). Incidentally *Ripon: South Camp* shows the Cathedral at Ripon, from the towers of which Milne had a commanding view of the town and the camp for another painting, *Ripon: The Town and South Camp from the Cathedral Towers*.

At Ripon Milne began to abandon washes and to apply his watercolours dryly and thickly and with deliberation. Perhaps he hoped that with a drier application he could more easily achieve the even tonality required when using several colours within a narrow range. This technique was a characteristic of Milne's development in 1919 and was to be the basis for much of his work for half a decade thereafter. Milne's imagination was gripped not only by the idea of the prominence of line over colour, but also by the concept of outline, of a subject's essential profile in both its physical and psychological shape.

One of the works from Yorkshire, curiously not submitted to the War Records Office, is the often reproduced *Ripon: High Street*, which from a high lookout (a second-storey window in a building that still stands) depicts not High Street but the Skellsgate, another street. 'In the evenings and on holidays the town was thronged with soldiers,' Milne wrote. 'I was allowed to paint from a house at the head of Skell[s]gate, packing small soldiers in the narrow way between the houses. Afterwards I was invited for Sunday dinner by the family of this house.'[20] At the end of the street is a house that Milne left colourless, the first use in this period of his dazzle-area device. During his sojourn in Ripon Milne also painted from the three-storey General Headquarters building.

Milne moved from Ripon back to London and thence to Bramshott, Hampshire, a camp southwest of London near Guildford in Surrey, where he arrived on 20 March and stayed for about another month. Ten works date from this visit, although more were completed that did not survive his often severe selection process. The Bramshott paintings are more dramatic and vivacious than those of Ripon, even though the processes Milne

Bramshott from the Beacons,
29 March 1919, watercolour,
35.6×50.8 (14×20)

used were further extensions of his Ripon explorations. He wrote to Clarke that he was now in hot pursuit of the 'Scotch motive' and that most of the Ripon and Bramshott paintings were in keeping with the principle of economy of means: 'Of course I needn't remind you that all this theorizing is a post-mortem – not a plan. I started off with nothing more than that corny feeling that was I suppose bequeathed me by my ancestors.'[21] Dry colour and a narrow range of tones were part of being economical, as was the extensive use of contained white space without detail.

Two quite different works completed at Bramshott provide an instructive lesson in the formulation of Milne's aesthetic ideas. *Bramshott from the Beacons* divides into a lower part, which carries the burden of the picture's details in low tones, and an upper part, which has fewer engaging shapes and less interest. To compensate for the imbalance, Milne intensified the colours in the upper section considerably and raised the tone slightly. *Bramshott: Interior of the Wesleyan Hut*, Milne wrote to Clarke, was essentially the same kind of picture.

The *Wesleyan Hut Interior* is a duplicate, in motive, of the bird's eye view one [*Bramshott from the Beacons*] – the differences are pretty much due to minor things. The white paper plays a very slight part even in the upper half of this. The bright colors of the flags in this case are probably used to disguise a monotonous structural arrangement [rather] than to call attention to forms – the dazzle system I suppose. I rather like the keeping down of tone in the lower part.[22]

The lower section is tightly controlled in form, heavy in detail, and muted in tone. The upper half, where there is comparatively little detail, is accentuated by vivid colours in the bunting and flags that serve to balance the relative weights of the two parts. Milne's discoveries and explorations in other 'divided' pictures – such as the reflections and waterfalls painted at Boston Corners – had stood him in good stead.

The genesis of *Bramshott: The London-Portsmouth Road* provides another startling insight into Milne's painting methods. Milne mentioned in a letter to Clarke that he was thinking about this subject and described some of the minor details that were intriguing him, such as why the boot soles of an approaching soldier seemed so large proportionately, or how oddly the kilt swung on a marching man. Two weeks later he wrote again, this time stressing the work's basic black and white foundation and noting that the forms would be articulated with little haloes of yellow, khaki, and hospital blue. He concluded: 'This may look like theory before practice but it isn't. The picture is painted though it isn't on paper. These developments of plan arise from this picture, not from one that has gone before.'[23] Such an astonishing statement would be like a playwright announcing that his play was finished but that he had not yet written it down. Milne, similarly, painted many of his works in his head before he committed them to paper or canvas, and he could, had he wished to, repaint them from memory. Occasionally he resorted to a few shorthand pencil notations – we know from one sheet of studies on the back of a later watercolour that Milne did try out figures, horses, wagons, and so on to some degree during this time. Often these, although slight, were enough for him to retrieve all the aesthetic complexity of a problem he had shelved in the vault of his mind; often he did not need even that. *Bramshott: The London-Portsmouth Road*, when it was finally executed on paper, followed Milne's ideas closely.

This letter of Milne's to Clarke is in many respects the true progenitor of the long correspondence that would ensue between them over the next thirty years. Although Milne had already written often to Clarke, his letters to this point alluded only in passing to his painting and did not delve into an analysis of painting issues as this and subsequent ones would do. Perhaps Milne was prompted by Clarke's letter analysing the work he saw in New York. In any case, a pattern was set that drew from Milne some of his most fascinating explorations of aims and methods in his work. Instead of maintaining a diary (he kept only a little notebook in which he jotted expenses, a few place names, and addresses), Milne recorded his confessions and inner thoughts in letters to Clarke. Despite changes in formalities after the war, when people took to calling each other by their first rather than last names, Milne continued to use the 'Clarke-Milne' form. When Clarke suggested that they call each other 'Jim' and 'Dave,' Milne wrote: 'I don't seem to find it easy to discard the Clarke-Milne convention; came of a race living too far north to take easily or gracefully to any outward mark of inward feeling.'[24]

Milne's next posting took him in late April 1919 to Seaford, in Surrey, east of Bramshott, on England's south coast. Here he was closer to Folkestone and to France, but as far away as ever from knowing if he would be permitted to cross the English Channel. The uncertainty, the sense of marking time, may have affected his work, for the eight paintings completed over the next month are the least distinguished of the war group. The smooth, close-cropped downs of Surrey defied Milne's attempts to conquer them on paper, and he admitted to being 'rather "up against it" in painting these smooth hills.'[25] Even scenes in the camp were painted without any evident enthusiasm. He allowed himself distractions, such as painting a May snowstorm (*Seaford: North Camp in a May Snowstorm*) in a style reminiscent of the intersected trees of 1916. What he saw to paint at Seaford was evidently not right for his stylistic development.

Meanwhile, the military bureaucracy had been ruminating on whether

Bramshott: Interior of the Wesleyan Hut, 4 April 1919, watercolour, 35.5 × 50.8 (14 × 20)

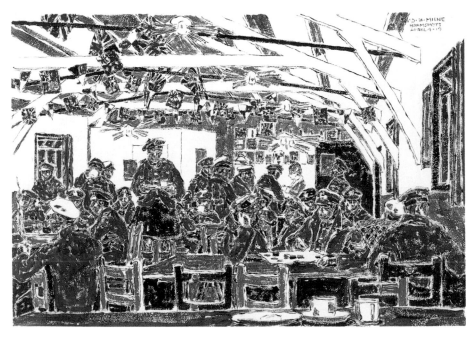

or not to send Milne to France. Once his work had been judged to be satisfactory – and he had filled out some forms and had another medical examination – Milne was recommended for a commission as an honorary lieutenant. War artists were routinely granted commissioned status so that they could travel with a minimum of fuss and bother and command the respect and the company they deserved. General Headquarters, however, refused to grant Milne's commission on the grounds that the war was over and that promotions, which entailed automatic pay raises, were no longer to be allowed, especially in the case of men shortly to be discharged. But for this ruling, Milne might have received his commission and been on his way to France in February.

The number of artists assigned to paint in France at any one time was also limited – and they were normally allotted only one month each. Milne believed that the quota was four and may have been told so, although the number of permits had been raised to six on 29 October 1918. GHQ pointed out to the War Records Office that Canadian forces had already vacated France and wondered if there would be anything left to paint. Nevertheless, a compromise was reached on 8 May 1919, and Milne was shortly sent to France in 'dress similar to that of a War Correspondent' with special shoulder flashes that declared 'Official Canadian War Artist.'[26] By his own account this seemed to work as well as anything else as far as saluting and deferential treatment were concerned:

Whatever rank I had was strictly honorary, and I never knew exactly what it was. On a later visit to London the sentry in the Tower (well, they should know but probably didn't) saluted but didn't present arms. There it was, something under a colonel. The indulgent said major, others contented themselves with captain, but never went lower. Very nice. It suited everyone.[27]

Milne was provided with a car and driver, given money for expenses, and letters to ensure that he would receive officers' privileges wherever he went.

Bramshott: The London-Portsmouth Road, *9 April 1919, watercolour, 35.4×50.8 (14×20)*

'All this stage management by the Records Office had a purpose: to make it possible for one of their very few workers to do his work without interferences from either the French or English or Canadians. It did that. They know their stuff, and so did Lord Beaverbrook.'[28] On Saturday, 17 May 1919, Milne had 'a very pleasant and sunny passage ... with lunch on board,' across the English Channel to Boulogne, where his driver, a Private Moore, was to have met him at the pier. He was not there. Unfazed, Milne set off in search of him 'by tramcar with a woman conductor, up the steep roadway to the top of the cliffs ... and on to Wimereux, British headquarters in France at the time.'[29] There he found Moore finishing his lunch in a local bar. The pair drove off in Milne's staff car, a Cadillac, and soon arrived at the Canadian field office at Camblain l'Abbé near Vimy, a commodious château that Milne used as his headquarters for a while (he painted it on 8 June). Moore gave him a tour of the area nearby on Sunday and on Monday Milne settled down to work.

Milne painted in northeastern France and Belgium until the end of August, beginning with the site of Canada's greatest military triumph in the Great War, Vimy Ridge. From the autumn of 1914 the ridge had been held by the Germans, forming a salient, or bulge, in the Allied lines. All Allied attempts to take it had failed. In early 1917 the Canadian Corps – after having engaged under British Lieutenant-General Sir Julian Byng in the Battle of the Somme, with huge losses – was sent to the Vimy sector. There, following extensive preparations, the battle for Vimy Ridge began on 9 April and was over in five days. It was a major victory for the Canadians, although at great cost: 3,598 men were killed and over 7,000 wounded.

After breakfast Moore took me up to the old front line past Villers-aux-Bois and round the bend and there a mile or so in front was a long, dusty-looking hill or ridge, showing a little green, but mostly marked and scarred with brown, gray and white. A few bare spikes of trees stood up from the crest at one end, Vimy

Vimy Ridge from Souchez, Estaminet among the Ruins, *19 May 1919, watercolour, 35.4×50.8 (14×20)*

On Vimy Ridge Looking over Givenchy to the Lens-Arras Road and Avion, *22 May 1919, water-colour, 35.5×50.8 (14×20)*

Wrecked Tanks outside Monchy-le-Preux, *24 May 1919, watercolour, 35.4×50.8 (14×20)*

Entrance to Cellar Shelter in Monchy-le-Preux, *26 May 1919, watercolour, 35.5×50.6 (14×19⅞)*

Ridge. We went through Carency, Souchez, now merely a map location, with one or two huts built by the French for the convenience of their transport drivers and returning natives, then up the Ridge by a road near the point at the low end. We didn't stay long or look round much but went back and up the road toward Lens as far as Liévin.

I had an idea where to start then, and I set to work beside the small Souchez River where there had once been a mill and a wood. The trunks of some of the trees were still standing with bullets and some small unexploded shells sticking in them. There were no branches on the ground. All had been long ago used for fires. Moore went back to camp and I settled down to painting my first view of Vimy Ridge.[30]

Milne had lunch at an *estaminet,* or tavern, in Souchez, a glass of wine and a sandwich. Moore came back for him at four o'clock – 'and the day's work was done. This was the usual pattern.' The painting for this day, 19 May, was *Vimy Ridge from Souchez, Estaminet among the Ruins.*

Despite the services he could call upon, Milne often preferred to travel about on his own. His painting equipment was light and unpretentious: 'My outfit consists of an easel, two sketching blocks turned face to face, a water bottle and a haversack. In the haversack, tubes of color loose in the bottom, watercolor palette, small flask of water with a wire round the neck to hang it on the easel, my sandwiches and two maps.'[31]

Milne was surprised by the mine craters throughout the area, 'big enough and deep enough to hold a house or even a church,' and with names: Montreal and The Twins (both of which he painted), and Kennedy. Milne remarked: 'Whatever damage [the mines] did, and it must have been great, they didn't drive the Germans out. They were still in German possession on April 9 [1918].'[32] His paintings *On Vimy Ridge Looking over Givenchy to the Lens-Arras Road and Avion, Entrance to Cellar Shelter in Monchy-le-Preux, Fresnoy,* and *Shell Holes and Wire at the Old German Line, Vimy Ridge* – all bleak depictions of wreckage and of nature defiled – can be linked to Milne's clear memory of the theatre of war as he found it:

The earth had been torn up and torn up and torn up again and from it at every step rifles and bayonets and twisted iron posts and wire projected. Shell hole merged with or overlapped shell hole, and everywhere was a litter of shell fragments, cartridges, shell cases and dud shells big and little, web equipment, helmets, German, British and even in some places French, water bottles of three nations, boots and uniforms, the boots often with socks and feet in them. Some shell holes even on top of the ridge had water in them and, over all, the sweet sickish, but not offensive, smell of death.[33]

He recorded Farbus and Oppy woods; at Thélus he sketched a sheet of studies of grave markers and, just to the east of Vimy, the pile of crumbled stone that had once been the proud church at Bailleul.

While Milne was painting and exploring, an officer from the War Records Office in London came to do some sightseeing and Moore drove him around. The next morning neither Milne's car nor his driver were to be found. After several days of searching, Milne learned that the car had been driven into a tree, not a common hazard then, near St Pol where Moore was in a military hospital, although 'not badly hurt.'

My transportation was gone, and there were troublesome enquiries from headquarters. The club at Camblain l'Abbé was closing up so I decided to move

further forward. I was invited to stay with the English captain in charge of a Chinese labour detachment near Mt. St. Eloi. This wasn't a camp made of junk but one of elephant iron huts with neat drives and flower gardens. I had a fine hut and a Chinese batman, tea on waking in the morning, baths, all that sort of thing. The Chinaman was particularly useful as a carrier. His pay was a shilling, or a franc, a day (I have forgotten which) and I doubled it. I was used to carrying my own painting outfit but my helper would have none of that. He insisted on taking the whole load. We went up to Vimy Ridge in the morning, taking our lunch and staying all day. I parked the Chinaman in a shell hole when there was much blowing up of dud shells and joined him when I thought it was advisable.[34]

Milne had to travel to London to solve the 'car difficulty' and finally acquired first a Vauxhall and then, a month later, a Sunbeam, and a corporal to drive it. From Vimy Ridge they motored through Arras to Monchy-le-Preux.

[Monchy] was a village on high ground; from a distance it looked like a saucer upside down on a table. Above ground it was completely wrecked but underground it was a maze of stone cellars, and the cellars were pretty well filled with wine bottles, all empty. These cellars made it easy to fortify and hold. There was an underground way from one side of the village to the other. It was attacked several times and finally taken by the Canadians. It was, in my time, a pleasant,

Shell Holes and Wire at the Old German Line, Vimy Ridge, 12 or 13 June 1919, watercolour, 35.3 × 50.7 (13⅞ × 19⅞)

silent place, good for painting and interesting to explore. On my visits I saw only two people there. One was a French soldier sitting on an ammunition dump nonchalantly knocking shells from shell cases, spilling the high explosive on the ground, souvenir hunter. The other, just as I was leaving at sunset, was an American soldier sitting on top of what had once been the church or town hall, looking over the darkening land, tourist.[35]

Eight and a half months earlier, beginning on 8 August 1918 with the four-day Battle of Amiens, the Canadian Corps had embarked on a series of victories, with much loss of life, that ended in the Battle of Mons and the silencing of guns on 11 November. The Canadian Corps had taken Monchy on 26 August – hence Milne's interest in the place. At the end of May he painted three works there, one of them the haunting *Wrecked Tanks outside Monchy-le-Preux.*

At this time there were no civilians in the forward areas except at Arras and Lens, and a few at such places as Souchez and Carency. There were no civilians and no soldiers except the men engaged in three tasks. First there was the Canadian graves detachment with three camps, one at Neuville St. Vaast on the Ridge. They were searching all the ground that Canadians had fought over for bodies known or unknown. They had detailed maps and diaries of the fighting and made a thorough search both above and below ground. I seldom came across them at their work but sometimes saw them at a distance and once or twice came across a body wrapped in a ground sheet and left in a shell hole overnight; they were neat and tidy in their work. When bodies were recovered they were buried in permanent cemeteries.[36]

The other civilians were German prisoners of war who, under British military direction, were searching for, gathering, and detonating unexploded shells:

Some of the shells were large and made a lot of noise, a tearing, splitting noise that seemed to last longer than anyone's endurance. That was unpleasant but there was little danger. The fragments didn't move horizontally. They went up in the air from the shell hole and curved and fell to the ground. But one day I had started to work at Kennedy Crater before I heard shells being exploded rather too close at hand. I didn't want to move so I set up a shelter with wooden

Panorama of Ypres from the Ramparts, July, August 1919, watercolour, two sheets: left 35.9 × 50.5 (14⅛ × 20⅛), right 35.6 × 50.2 (14 × 20)

dugout supports, thinking that would keep off any stray fragments. My shelter was scarcely up when another blast sent fragments as big as a football into the crater before me. That was too much. I moved to Montreal Crater a little further along. After all, one crater was very much like another.[37]

There were also Chinese labour battalions doing salvage work under British officers and NCOS:

They lived in camps of their own, some of them made of salvaged materials, mostly tin and sheet iron. One camp had a Chinese theatre, with very fine

Looking toward Thélus and Thélus Wood from a Nissen Hut under the Nine Elms, 26 June 1919, watercolour, 35.6×50.5 (14×19⅞)

Neuville-St-Vaast from the Poppy Fields, 5 July 1919, watercolour, 35.4×50.8 (14×20)

Milne on the battlefields of France or Belgium, contemplating a skull

entertainment and stage settings painted by some of their number. The same camp had a kitchen equipped with steam ovens, home-made, for cooking a light, soft, steamed bread. They seemed to enjoy the life, and had many amusements. They were fond of birds, small birds and magpies, that they caught in some way and kept in cages. When they went out to work in the morning they took the birds with them, hung them up with a cloth over the cage near where they were working and at lunchtime let them free. The birds don't try to escape, but hopped around beside and on their masters, even down their necks and up their coatsleeves.[38]

The War Records Office had requested paintings of Hill 70, Mount Kimmel, and Mount Sorrel.[39] Hill 70 stood over the destroyed coal town of Lens in France and was attacked successfully by two divisions of the Canadian Corps on 15 August 1917, although they had to withstand severe German counterattacks for another three days afterwards. The 2nd Canadian Division had almost been wiped out on 7 June 1916 at Mount Sorrel, although the next day the 1st Canadian Division under General Arthur Currie regained the position with few casualties. Milne reported, 'I never got to Mt. Sorrel – probably I did without being aware of it,'[40] but he did record Hill 70 in a pencil sketch that he made into a painting after his return home.

Apart from these three locations specified by the War Records Office, Milne was free to wander anywhere he wanted – informed, as he was, about Canadian battles. Yet the territory he staked out was tightly circumscribed. He painted extensively around Vimy Ridge, including all its suburbs up to Liévin and Loos in the north, where 10,000 Canadians had been killed, and south toward Arras, Monchy-le-Preux, and Courcelette. At the end of July, and again in August, he made short sorties to Belgium, where he painted in the Ypres salient, the St Eloi craters, Messines, and Passchendaele, all places that had a resonance for Canadians.

He also travelled from Arras to the Somme and left the train at Miraumont to set off on foot across the Somme battlefield, on a road that passed over the Regina Trench toward Courcelette, where the Canadians engaged in horrific battles in the fall of 1916.

When I stopped and looked closely I could see that fresh-looking earth, everywhere, had been torn up and thrown back again, cultivated by shell fire, not by plows. It wasn't just soil, it was a mixture of soil and metal, shell fragments, cartridges, bits of wire. And crosses, everywhere the small white wooden crosses, each one set up where a man had fallen. I stopped and made a mark on a paper for every cross I could see in the small space before me. There were forty-seven. On the crosses were small tablets of soft copper on which the man's name, rank and serial number were embossed with the point of a cartridge, or often simply 'Unknown Canadian Soldier,' sometimes 'Unknown German Soldier.' Later, tablets were made of aluminum stamped by some sort of hand machine.[41]

Before he reached Courcelette, he looked across a shallow valley and saw the ruins of the village, and beyond it the wreckage of a sugar refinery, which he painted a short time later.

I turned to the right and came to a small Canadian cemetery. New, muddy, with weeds growing in the earth and row on row of wooden crosses. A single wire on short posts surrounded it. The white fog was now close to earth and covered me like a white tent with only a small area visible before me. The bowl in which was

the ruin of Courcelette showed mistily beyond the crosses of the cemetery. I set to work, no sounds reached me. I was cut off from the world, only this little bit of the past concerned me.[42]

Milne painted *Courcelette from the Cemetery* on 26 July 1919, as a tribute to those who had died there. The experience he had during his painting of it was also recalled by him:

I had been working for a while when I became aware that I wasn't alone. A detachment of Canadian soldiers was entering the cemetery, a chaplain, and an officer with a firing party. They formed up opposite me. Whether they beckoned to me or whether I just joined them of my own accord I don't remember, but I stood at attention with them. The burial sevice was read, volleys were fired and the bugle sounded. The detachment consulted maps and hurried off in the direction of Regina Trench, for another such service I suppose.[43]

Three days later Milne was at Passchendaele, passing the long line of German pillboxes ('There must be thousands of them within the Ypres area') that still populated the battered landscape like so many malevolent toy blocks. He wrote to Clarke on 31 July 1919, two years to the very day after the start of the disastrous attack on Passchendaele began, one of the most costly of the war for Canadians – over 15,000 dead:

I cut across from the railway to the highroad. Here there are two pill boxes on opposite sides of the road, one in front, beside the punctured Zonnebeke gas tank, toward the railway, another quite close and on the other side of the road a whole line of them about ten yards apart with some scattered ones out in front ...
 Settled down to draw the curve of the road with stumps of trees and the two pill boxes.
 A few automobiles and a good many Belgian soldiers and civilians continu-

Courcelette from the Cemetery, 26 July 1919, watercolour, 35.6×50.5 (14×19⅞)

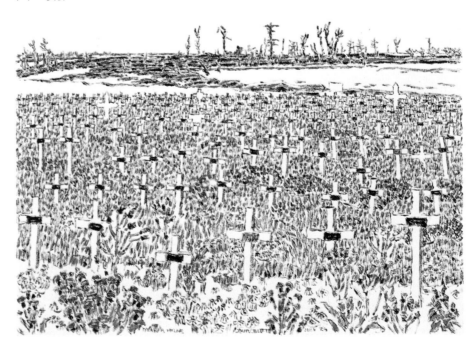

ally passing. A little convoy of Indian wagon drivers in Khaki turbans, a Canadian staff car with a sight-seeing colonel and two women came along. The driver had seen me at Wimereux and knew me. They stopped and chatted for a while.

Shortly after I heard singing up the road. A party of German P.O.W.s were coming from Passchendaele to their camp at Zonnebeke. I don't know what their song was, sounded like a hymn – may have been a hymn of hate for all I knew, they do sing that. At any rate it was beautifully done and sounded very sweet and rhythmical. At times you could hear it and then lose it. It wasn't very loud even when they were abreast of me. The thing was entirely governed by the marching – a sort of chant. They would sing a little, keeping time with the foot falls beautifully. Then for a few paces they stopped it and I could hear the heavy beat of the marching. Then away it went again. As they disappeared down the road the swing and ease of the thing was very moving.[44]

There, the day before he wrote this letter, Milne painted *The Road to Passchendaele*. By this time, in late July, the wiry linear style that had appeared in the first days in France had developed into a tough, ascetic way of painting. This, and other advances in colour and composition, suddenly fell into place, quietly and without much ado, and came to fruition in this painting; we can now see it as a culmination of the tendencies Milne's work had shown for some time and as a starting point for much of his work during the next few years. A few days later Milne decided to revisit Passchendaele simply because he had been so stirred by his experience there.

The Road to Passchendaele accomplished much that Milne had been striving for. The main objects, the tree stumps and the pillboxes, are deployed evenly yet asymmetrically throughout the painting area. The road serves not only as the blank area, or dazzle spot, but also reaches through the picture plane and, in a subtle, serpentine way, pulls together the foreground, the background, and the sky. The various parts fit into the whole like an interlocking puzzle, with each major component defined in outline. Milne

The Road to Passchendaele, *30 July 1919, watercolour, 35.4 × 50.5 (13⅞ × 19⅞)*

used only four colours, all of equal tone and value, scraped on lightly but with absolute sureness. It must have been painted on one of those magical days when Milne could do no wrong, when everything eased into its appointed place without struggle. The subject itself was not awesome or inspiring, so Milne's excitement must have come from his aesthetic vision, and the scene harmonized perfectly with his feelings. Certainly it gave him the opportunity to make something out of nothing, to take an 'inventory' of an empty road.

At nearby Gravenstafel, from which the valiant Princess Patricias of the Canadian Corps had launched their final assault in the battle of Passchendaele at the end of October 1917, Milne sketched a German pillbox, *Bellevue Spur and Passchendaele from Gravenstafel.* He imagined that the War Records Office would dislike his treatment of it, which he described, referring to the horizontal format and the heavy emphasis on linear elements, as a 'procession of coloured worms.' The colour is severely muted. Milne's work was also now beginning to have a coarse edge, a style that snubbed refinement in exchange for an aesthetic integrity that was not afraid of ugliness or distorted shapes. A smooth finish could no longer be true to the way he saw his subject. Two paintings, *Sugar Refinery, Courcelette I* and *II,* carried even further this spiky and awkward way of depicting subjects, and the formal qualities in each capture the essence of the paintings Milne subsequently did between 1919 and 1923.

Milne's production in France was both high and constant. During a period of three-and-a-half months he painted sixty-eight paintings, far more than any other Canadian war artist, and altogether about three times his annual lifetime average, which was itself impressive. In his 1947 autobiography Milne remembered having painted 'about sixty-five works in all' for the War Records, but in memory he confused the total, 112, with those done in France, which were numbered by him, with few irregularities or gaps, from 1 to 66.

While the hills of England and Wales had challenged Milne in some ways, their sweep and scale were not unlike those of Boston Corners. In contrast, the landscape of northern France – geographically a huge, almost featureless plain – was radically different. The war had contributed to this, of course, and in some panoramic views of the countryside Milne

German Machine Gun Posts in Thélus Cemetery, *12 or 13 June 1919, watercolour, 25.0×35.3 (9⅞×13⅞)*

Camouflaged Steel Observation Post on the Souchez-Arras Road, *14 June 1919, watercolour, 25.4×35.6 (10×14)*

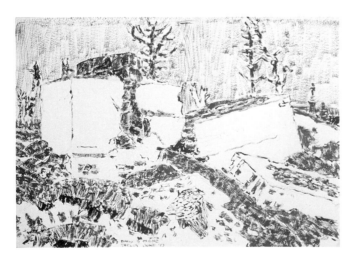

Bellevue Spur and Passchendaele from Gravenstafel, *7 August 1919, watercolour, 18.3×50.7 (7¼×20)*

The Sugar Refinery, Courcelette I, *1919, watercolour, 17.5×50.7 (6⅞×20)*

The Sugar Refinery, Courcelette II, *24 August 1919, watercolour, 18.1×50.8 (7⅛×20)*

detected only a faintly darker green where once a village had stood. The forests were demolished, there were piles of rubble everywhere, and the soil, in Milne's words, had been 'torn up and torn up and torn up again.'

This road has at one time been paved with brick. I could just trace the herring-bone formation in about two places ... I suppose I needn't mention that there are no fences or hedges, no trees either. From Miraumont to Courcelette there isn't the faintest trace of human occupation except these two patches of red brick a yard long in the road – not one tree stump or bush, no pile of bricks or stones that might indicate that there had once been a farm house, no trace of squares on the plain to indicate that there had once been fields.[45]

The subject matter Milne found on the deserted fields of battle was

bound to force a revision in his artistic thinking. Initially he retreated to the security of trusted formulas, using rich colours, high contrasts, dramatic dazzle spots, and the usual bands of near, middle, and far ground. Although he used these familiar techniques from time to time throughout the summer, they were eventually displaced by the other aesthetic concerns he had been nurturing, ones that rose out of his consideration of the material he was constantly looking at.

On 7 July near Vimy, Milne painted *Panorama of Lorette Ridge*, a large watercolour composed of two sheets end to end – a painting as scratchy, sparse, and bare as any he had ever attempted. Despite its oddity and probable uselessness to the War Records, it was the first painting in France that guided Milne directly to the heart of a new aesthetic territory. It did not lack colour (although the colours are extremely subtle) and was certainly not lacking in detail or in information about the subject; but it was pared to the skeleton of a scene.

The work had its precedents in an earlier one of charred crustacean-like tanks, *Wrecked Tanks outside Monchy-le-Preux*, and in a painting of a straggle of blasted trees that had once been the woods at Oppy, *Entrance to German Dugout in Oppy Wood*. In these two works, where only the outline is dominant, there are often lush and concentrated little gardens of colour and detail, like dazzle areas in reverse, where the eye is drawn to a restricted space of rich detail. But in *Panorama of Lorette Ridge* this is not the case. Here, with the least number of lines, Milne encompassed and defined the greatest amount of space and extracted the 'essential profile,' which included not only an object's silhouette, but its nature, its character, and its importance to the artist. His emerging style had found fit and adaptable subjects. The dryness and the increasing restraint in colour – not in brilliance always, but certainly in the number of colours used in one painting – can be noted throughout June. What began to predominate as the summer advanced was a new kind of calligraphic scratchiness that was suggested and accentuated by the shapes of torn and scarred trees, broken bottles, smashed concrete, twisted metal, tangled wires, and by all the scattered and abandoned military equipment. Milne realized later that for the first time in his life he was painting dead objects, particularly the shattered trees, rather than living things.

When his work in the Ypres salient was finished at Messines on 20 August, Milne returned to the Vimy area and spent the last days of the month painting in the monochromatic, rough, outline style he was coaxing forward. The vibrant colours of the earlier war paintings in England and Wales were set aside, except for the last painting on 30 August, which captured a rainbow glowing over the ruins of Wancourt.

Panorama of Lorette Ridge, *July 1919, watercolour, two sheets: left 18.0 × 50.5 (7 × 19⅞), right 17.9 × 50.6 (7 × 19⅞)*

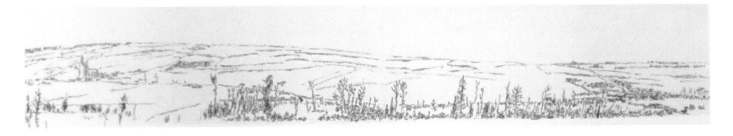

Wancourt, *30 August 1919, water-colour, 35.3 × 50.6 (14 × 20)*

Milne's immensely productive and creative time as a war artist ended: 'I just faded back to London and stayed there for a while, sightseeing most of the time.'[46] In October he took a leave to visit Aberdeenshire in Scotland to savour the places his mother had told him about when he was a boy. He spent a few days exploring Aberdeen ('I knew Aberdeen well, my mother had seen to that') and then set off by train, passing through 'towns and sights along the way [that] were as familar to me as Bruce County or New York.' One sunny afternoon he climbed Mount Benachie:

Almost everything I had heard about in my youngest years was spread out before me, from Aberdeen and the sea on one side to the Highlands on the other. Between the three peaks, called Taps, was a shallow valley and right before me in it was a square depression. It was the moss field where my mother had come to from a farm below to stack peat, fifty years or so before. I remembered her story of the great thunder and rain storms that overtook them on their way down the mountain, and on my way back I followed the dry ravine leading from the moss. I was down long before train time and had tea. I enjoyed the Scotch talk and baps and scones and cakes, white, crisp and light. Good, the baking and the talk and the sights, nothing failed me. I was still ahead of the train so I walked four or five miles in the twilight to another station on the line. Oldmeldrum had been the shopping town for my people, and Inverurie, perhaps the start of the railway then, was their point of departure for Canada.[47]

On another afternoon he went to Fyvie, where his father's people had come from. Familiar to him from his parents' talk were Fyvie Castle and Fyvie Church (where his mother and father were married) and 'even the names of the farms and the mills.'

The small well-tended churchyard was full of Milnes. I tried to sort out my particular branch of Milnes from the rest, wrote down the likely names on the stones, but had to give up, there were too many, and the first names were too much alike, too many Williams and Roberts and Charles! Here as with the old country folk in Canada Milne was spelt Milne but pronounced Mill or Mills.[48]

By late September Milne was on his way back to London and thence, in October, on the ss *Belgic,* to Halifax. When he arrived in Toronto, he wired Patsy. She had been anxiously watching the troop ships disgorging soldiers in New York, thinking that he might be on them, but when she received the wire she took the night train to Toronto.

When I got there the next day, sometime in the afternoon, I saw Dave on the platform – He said 'Hello Patsy,' and I said 'Hello Dave.' We couldn't say much – He held his hand up, and showed me a small wrist watch with a black strap – 'It's for you Patsy, I bought it in London.' It was the first one I had had, and I was very proud of it. We stayed at the Walker House for two days, then went to Paisley, to see Dave's mother, for a couple of weeks – Dave went to Eaton's, and sent a box of many different things she might like. His sister was not there, and his mother was having a great struggle to manage – His father was not able to do much. I felt very troubled about things. Dave paid the 'taxes', etc.[49]

On 14 October 1919 Milne was 'demobilized,' to use the delightful military oxymoron. Remembering this in 1947, without mentioning Patsy, he wrote:

I got my discharge at the Exhibition grounds in Toronto, just where I had started, with the same old sergeant major on hand too.

I had been given a package of pictures (my own) to take back [the War Records Office in Britain had closed] and had difficulty getting anyone to take them. I went from Toronto to Ottawa and then to Montreal before I unloaded. Then to New York for a visit with the Clarkes. Clarke and I made a few trips up the Hudson as far as Peekskill and Cornwall in search of a new place, but we were soon back in Boston Corners, from which I had set out, back in Joe Lee's Under Mountain House, and before Christmas up on the hillside behind, painting Fox Hill and Boston Corners, starting in about where I had left off.

There were some changes though in my way of working, a dry precision and more detail. This was evident without much development through the winter and summer at Boston Corners and the following winter at the Alander cabin.[50]

The nearly two years Milne served in the army had lasting repercussions for both his life and his art. Significantly, his was not a war experience so much as a personal and artistic one. He had arrived at the scenes of battle only after the tumult had died and the combatants had withdrawn. In many respects he was never closer to the war than he had been five years before on the banks of the Hudson River when he read about the opening salvos. Later he wrote that he could not tell whether he was 'the last soldier or the first tourist.'[51] In truth he was the latter, straying at will, chatting with anyone he ran into, taking photographs, and collecting postcards of places he visited or painted. But he was removed in time from the events that had created the subjects he painted. His vantage point allowed him to include some interesting contrasts in his work, particularly the images of the people who were beginning to reoccupy the torn land: a cyclist on the road winding down to Lens, a lone figure on the rim of Montreal Crater, people threading their way through the lamentable ruins of Arras and Ypres. In many of his paintings grass and weeds and flowers were beginning to hide the nasty relics of the war.

A photographic self-portrait of Milne shows him in uniform standing in the battlefields contemplating a human skull in his hand. Yet there is one (and only one) mention in his letters of his actually having recoiled from the grim horror of which he painted the aftermath, and that was when he peered into the burnt hulk of a tank:

The Menin Road was probably known to more British soldiers than any other place on the battlefields, and to many Canadians. Out the Menin Gate past Zellebeke Lake (now drained) past Hell Fire Corner and along the bare exposed mile around Hooge to the crest beyond. On the ridge was a tank graveyard, wrecked and burnt out British tanks, some bogged down in shell holes, some with their treads broken, some with holes in their armour, some with shells and gasoline tins inside, burnt and blackened. A look inside one of these places of cremation stirred about the only feeling of horror I felt.[52]

His apparent lack of concern about the brutality of war is perplexing but should not be overestimated. Milne seldom committed his personal feelings to paper, except in his paintings, which are moving testaments to the violence done to the landscape, urban and rural, that he saw in Europe. He wrote to Clarke that 'the evidence of endless and monotonous labour oppresses one, and of course, it must have been infinitely worse then.'[53] Referring to Vimy Ridge, he wrote: 'I had no feeling of sadness about the battles in this place, no feeling at all except of interest, and of amazement

A photographic self-portrait on the battlefields of France

at the effort. The fighting was too hard to grasp; the effort, the labor, was still evident at every step.'[54] He photographed a crashed and burned aeroplane and occasionally, as he wrote, glimpsed boots with feet still in them, or caught the stench of death from unburied bodies. Milne gazed at the chaotic debris dispassionately, with the detachment of one to whom only his art was of ultimate importance, knowing that nature would soon obliterate from the landscape the man-made chaos he saw and that the memories of it would soon fade. Milne could paint flowers among the ruins, and rainbows arching over a landscape in which only a few months earlier thousands of men had lost their lives, because that was what he saw there.

Army life had an overwhelming impact on Milne. In little more than eighteen months he was exposed to more experiences as a person and an artist than he could have imagined. Every minute of it thrilled him, he wrote. Gregariously he invited himself into people's homes and confidences to learn more about the history and manners of the many places he visited. He struck up discussions both inside and outside the army on subjects related to farming, architecture, machinery, botany, geography, and industry. In France he was invited to various officers' messes, treated with respect and deference, and given everything he wanted. In London he went to plays, museums, and exhibitions. He prowled through all the historic sites he could fit into his schedule, revealing in his letters a surprisingly wide knowledge of literature and social history. In contrast to his habitually marginal and precarious way of life, he suddenly had a regular pay cheque, with clothes, food, accommodation, and transportation provided. And all the art supplies he could use were gratis. The drilling, physical training, and constant hiking made him feel more fit than ever before. Despite occasional attacks of loneliness, for the first time in his adult life Milne enjoyed absolute psychological security. 'Never, before or since,' he wrote in 1934, 'have I been so conscious of health and strength, or so content.'[55]

How decisive Milne's brief military career was to him can be judged from the 'Army' and 'War Records' sections of his 1947 autobiography. Fully one-third of all he wrote in recounting his life is devoted to his army experiences, and he recalled minute details from each phase of them with great vividness. More importantly, his nine-month tour of duty as an artist had a salutary effect on the long-term development of his painting. The assignment could not have been more propitious. When he needed confirmation of his talent, a forward push, the army provided it. What the army needed was exactly what Milne could offer. He was encouraged to enlarge and extend what he had been doing, and what he wanted to do. The slight restriction needed for commissioned work was so incidental that Milne was at liberty to concentrate on the progress of his thought, style, and technique.

The aesthetic advances Milne made in his war paintings have been largely ignored by critics. The works were not initially considered to be 'painting' but merely 'sketching' or 'drawing,' a much lower order in the hierarchy of art than large-scale oil paintings or even military portraiture. In the catalogues of the War Records exhibitions, Milne's work was relegated at the end to the miscellany, and in one case a group of his works was catalogued simply as '429-441 Sketches of Military Camps.' Milne acknowledged this state of affairs and seemed resigned to it. Although his work always looks casual, easy, and spontaneous, he had spent seven intense hours one day working on small details in the painting *The Belfry, Hôtel de Ville, Arras*. Ironically, he easily could have done as many oil paint-

ings in the same time (and he did when he returned to Boston Corners) and earned greater acclaim for himself without sacrificing his intentions. His herculean achievement was not then, and has not been since, recognized for what it truly is.

The exhibitions of the War Records work in London, New York, and Toronto in 1919, and in Toronto and Montreal a year later, gave a brief exposure to some of Milne's contributions, although in the context of the hundreds of paintings and photographs and of the propagandistic basis of the program, it was perhaps not to be expected that much attention would be given to Milne's aesthetic explorations. But in the nearly eighty years since 1919 Milne's war paintings have been the object of only three or four small exhibitions, few of them have been published, and only a few have been included in other exhibitions of his work.[56]

Milne himself recognized that 'one can't go without painting for a year and then for nine months paint strange, unfamiliar subjects without showing it in paint. The man changes, and with that, the painting.'[57] Even in the 1930s and 1940s his work often harked back to the immense gains of this period, and the aesthetic discoveries of those few months gave him fuel for a lifetime. The finest examples of his later work, such as the drypoints with their incisive magic, are the direct descendants of the war pictures. Milne's career was once again set upon a new course.

CHAPTER SIX **White, the Waterfall**
Boston Corners and Alander
1919–1920

AFTER MILNE WAS REUNITED with Patsy in Toronto, and received his military discharge there, he and Patsy went to Ottawa and Montreal to hand in his last paintings for the War Records and to Paisley to visit his family and friends. Milne then had to decide what to do next, and where to live. He had some thought of living in Canada, and explored the opportunities for showing and selling his paintings, which proved to be meagre. In Toronto he saw the exhibition of Canadian domestic war art at the Art Gallery of Toronto, the result of the program, suggested by Eric Brown and carried out by Sir Edmund Walker, that was parallel to the War Records' program in the field.

Then Milne and Patsy returned to New York to visit her family and the Clarkes. As he talked to Clarke, it became obvious to Milne that his dream of painting in Europe again, with the Clarkes as company, was out of the question. The Milnes could not afford to do so, nor could the Clarkes, who by this time had young children. Instead, Milne and Clarke looked for a place for Milne to re-establish himself where he would be able to generate some income and still have time for painting. Building a summer place, as a part-time activity, would be compatible with painting; so might market gardening or raising chickens. He and Clarke took several trips up the Hudson River valley as far as Peekskill and Cornwall, looking for places and opportunities. Clarke was prepared to finance a small enterprise but nothing seemed to present itself.[1]

Instead, by 20 November 1919 Milne and Patsy were nestled back in Under Mountain House in Boston Corners, which Clarke had continued to rent for his family through 1918 and part of 1919 after the Milnes' departure.[2] In a flurry of domesticity Milne fixed and refurbished. He and Patsy puttied the windows, put on shutters, banked the foundations with sawdust, cleaned the stove pipes, repapered the living room, and 'hammered and tinkered round for three weeks, taking out nails wherever we found them and putting some in where there were none.'

On the hill behind the house he moved, enlarged (relatively), and refloored his painting shack (which he called the Painting House, or the P.H., in his notes and letters to Clarke) – a tiny shelter that did little more than keep wind, snow, and rain off his back.

I did a good many winter pictures ... most from a painting house I built in Joe Lee's field above the house where I could see the house, a row of trees to the right of it and the low hill in front, the thin street of Boston Corners with houses scattered along it, and beyond, the mass of Fox Hill. The painting house was a success. Made out of old boards, it was just big enough for me to crawl into, and to hold me and my equipment when I was sitting down. At first I had a window

in it and, I think, a small fire in a tin can. This didn't work, the window fogged
up. After that I had no fire and left the front open. The house just kept the
wind off.[3]

Despite the uprootings at regular intervals in his life Milne was by tem-
perament Thoreau's kind of voyager, who 'travelled a good deal in Con-
cord.' The strong pull of the Berkshire landscape soon displaced any lin-
gering thoughts of a painting sojourn in Europe. The Milnes had formerly
lived for less than two years in Boston Corners, but when he and Patsy
returned, he told Clarke about the homesickness they had both felt:

Patsy was homesick for her pots and dishes and I for an old axe and for a
hammer and nails – and both of us for this place which had made a deeper
impression on us than any other; was always what came to our mind when we
thought of home.
 When we got back here we realized what the trouble was. We felt all the old
thrill. No painting subject has ever hit me quite as hard as Boston Corners from
up the hill and no way of living has ever interested either of us as this secluded
way of life has. You don't get it in the same way, coming up once in a while for
a few days. You don't get the charm of our miniature secluded world behind our
low hill, don't have time to follow the changes of the weather, the coming snow,
the threatening storm.
 That is what we are doing now, simply getting our feet on earth, getting back
home.[4]

The winter of 1919–20 was one of the most productive periods of Milne's
life. In less than four months he completed ninety pictures – forty-three
canvases and forty-seven watercolours. His work through December was
entirely in oil, a medium he had not used for almost two years. He re-
ported to Clarke on 9 January 1920 that the return to 'oil hasn't given me
as much difficulty as I expected for the simple reason that I do it exactly as
I was doing the watercolors. It [the technique used in the War Records
watercolours] was derived from oil in the first place.'[5] His style, however,
was drier, more precise, and had greater detail than the pre-war oils. The
surviving paintings (Milne later painted out all but fourteen of the can-
vases) were, with few exceptions, of the highest quality. All were of Boston
Corners or the immediate vicinity. Milne travelled not more than four or
five kilometres (two or three miles) from home all winter and he had few
distractions.
 As if to signal this ambitious new phase of his life, he began to sign and
date all his paintings and to type up detailed notes for each one, with occa-
sional illustrations or handwritten glosses in the margin. He told Clarke
that the notes helped to 'crystallize [my] thoughts about the work a bit.'[6]
Over the next year he filled nearly a hundred typed, single-spaced, and
sometimes illustrated pages, dense with comments on what he set out to
do, how successful he thought he had been or why he had failed, and how
he would amend his next attempt. Most entries were made soon after each
painting was executed, although sometimes, like most diarists, Milne fell
behind and wrote up several days at a time. None of the 1920 paintings
were titled by Milne until years later, but most were dated at the time of
execution, making identification between the painting and the correct paint-
ing note virtually certain. The assiduous composition of these notes sug-
gests a larger, long-range purpose, as if Milne were making a record for
posterity.[7] When he began them, on the eve of turning thirty-eight, he was

in a buoyant and optimistic frame of mind. One cannot help but think that
the army had fortified his resolve, lifted his morale, and given him disci-
pline, because Milne's self-esteem at this time was probably at its height.

Ever since his student days, discussing paintings – his own or anyone
else's – had been Milne's favourite form of recreation. In long letters to
Clarke from England and France Milne had begun writing descriptions of
some of his war pictures. The painting notes, in a sense, extended this
exercise. Clarke was certainly the intended reader. Milne's own explana-
tion was typically modest: 'Painting has been going about as well as I ex-
pected, possibly a little better. I have been learning to crochet on the type-
writer and in doing that have used a sort of painting diary to practise on.'[8]
There was some truth to this, for in typing the notes Milne was merely
recording the thoughts he had on most painting days throughout his life.
It was his custom, after his evening meal, to prop up the day's painting
and, with his feet on the oven door and his pipe lit, analyse his work,
assess his successes, and plan his next explorations. If there was someone
present to share his thought, so much the better. If not, Milne would make
a few notes that he would then type up. Although he sometimes knew
what luck he had had, sometimes he surprised himself by what he had
created in the white heat of the actual painting process.[9]

Although the paintings of 1919–20 are nearly all well documented, we
do not have a comparable record of Milne's other activities. No letters from
9 January 1920 to 24 September 1920 have been found, and even the
painting notes stop after 5 April, not to resume until Milne began painting
regularly again on 9 August. Milne painted occasionally throughout the
rest of April and May, but no pictures have been found for June or July.[10]

Much of Milne's time during the early summer of 1920 was taken up
with a most unlikely and unprofitable activity: onion farming. Either
unmindful of his earlier defeats with celery and onions, or stubbornly buck-
ing the odds for success the second time around, Milne set about growing
onions in order to provide an income. He dug up the rich soil near the
small stream at Under Mountain House, planted onion sets, and started
weeding, hoping that onion growing would leave enough time for paint-
ing; and that, even while working in the garden, he could think about paint-
ing problems. Unfortunately, the weeds in the newly broken soil domi-
nated not only the onions but his thoughts about painting. While weeding
onions, Milne reported sadly, the only thing one could keep one's mind on
was onions – and weeds. By August he decided to let the weeds have their
way and harvest what onions he could – a wise decision, for painting re-
commenced and eventually the garden, without further help, yielded an
impressive crop. But there was not much of a market for onions in Boston
Corners or the nearby villages of Ancram, Copake, Irondale, and Millerton:
Milne tried them all. Not until the following March was he finally able to
rid himself of the last of the more than fifty bushels he had harvested.
They brought him a net profit of $27.50, which he reckoned at 20¢ a day
for his time.

After rehabilitating his little painting house upon his return to Boston
Corners, Milne used it constantly, particularly at the beginning of this new
phase in his career:

Some of these pictures, both oil and water colour, had curious textures of thin
lines, black and coloured. I thought of them as shirting. Many pictures were
painted from the same spot because there was a great variety of material in
front of me and the whole thing changed with changes in the seasons and the

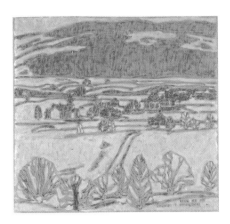

Track in the Fields, *21 December 1919,*
oil, 44.8×46.7 (17⅝×18⅜)

weather. Bare ground, snow, sunshine, falling snow, mist and cloud all made different pictures. The row of trees in front and near at hand made good material, particularly in shape. There were ashes and maples and one large old butternut that had lost most of the smaller branches. These went down on paper and canvas many times, though they couldn't always be identified without some effort.[11]

On 13 December 1919 Milne set to work at his painting again, but in oil on canvas. The first paintings were immediately, and perhaps not surprisingly, reminiscent of the last works done in Boston Corners in 1917 and 1918. The stacking of bands across the picture plane, the black outlining, the contrapuntal rhythms of different textures – all were evident in the earlier period. The paintings' softness and misty tonality also suggest a feeling of peace, of being 'home.' Milne was possibly recapitulating techniques and methods used before in this place, holding them in readiness for an ambitious program of activity and innovation.

Within a short time the chief painting characteristics of the earlier Boston Corners period merged with those of the war period. For example, the spiky dryness of the late war pictures was transmuted into the gentler and more rounded lines of the Boston Corners paintings. The wartime tendency to mark outlines or silhouettes with a scratchy, nervous, broad line can be seen in the January 1920 watercolours, and even more emphatically in those of February, but the confluence of the two styles really occurred in the oil paintings. In them, to convey the textural qualities of the sky or of Fox Hill, Milne scraped with a palette knife and produced an effect similar to the short, arid stroke of the dry watercolour brush he had used in France. This can be seen clearly in such works as *Two Cedars, Boston Corners* and *Gentle Snowfall*. Indeed, Milne himself said of the first two works of this period, *From the Painting House I* and *Track in the Fields*, both dated 21 December, that the 'treatment [was] exactly the same as in the French watercolours [the war paintings from France] derived originally from oil sketches made at Kelly Ore Bed, Autumn 1917.'[12]

But by mid-January 1920 the first flush of freedom and enthusiasm

Two Cedars, Boston Corners, *24 December 1919, oil,*
45.8×55.9 (18×22)

Gentle Snowfall, *30 December 1919, oil, 45.8×56.3*
(18×22⅛)

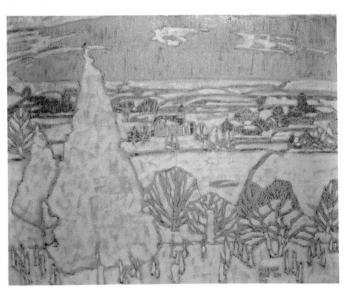

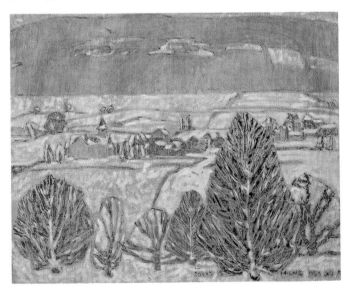

Seated Figure, *10 February 1920,*
watercolour, 56.2×38.8 (22⅛×15¼)

began to abate. For the best part of a month he had successfully completed two large oil paintings a day. He wrote to Clarke: 'One is rather inclined to feel a little stage-fright with oil, to yield to its slowness and work in a soggy, painstaking way ... I seem to do better when I use it more rapidly and freely, call it by its first name and slap it on the back.'[13] Although Milne attributed his hesitation to the medium, it is more likely that his diffidence heralded a change in his thinking. The paintings were coming rapidly, too easily, and Milne, in a fit of severity, destroyed over thirty of them. Would a more measured pace deepen his approach and make more substantive pictures possible? He resisted an answer to this question until the following winter and, in the meantime, concentrated his energies on the watercolour medium.

At this point Milne again delved into his aesthetic ideas about the primacy of line and shape. In his notes he drew attention to the lines he created in translating what he saw into what he painted. He was pleased when he invented a strong outline, or when an energetic combination of lines transposed the image from mind to paper with fidelity. Often his lines were extremely subtle, as may be seen in *Track in the Fields*: while the track itself is bold, the fence line running horizontally from side to side in the middle distance divides the picture almost invisibly. Of one destroyed work, Milne wrote: 'Either of the fence lines might be prolonged across the canvas as a crack or a half-invisible line, [and] would simplify by breaking the picture in two. This would make [the] picture easier to read.'[14] While these lines defined the composition of the painting, setting out its basic structure and legibility, the spots, dashes, nodules, and focal points that Milne consciously inserted gave his works further clarity and greater vitality.

The creation of shapes was Milne's most exciting challenge. He wrote of different shapes and their combinations: pyramids, fantails, spikes, ribbons, and streams. He often shuffled these around to suit his aesthetic purposes rather than match the landscape before him. In *Vapour Rising* he 'used a section of Fox Hill to [the] right rather than one immediately behind,'[15] and he sometimes erased trees in his search for the right balance and tension between shapes. When he failed, he confessed to having 'drawn too slavishly,' or to having 'copied' a tree or a hill without having 'acted on [it] enough.'[16] Things seen in nature might be the starting point of an image, but thought and action came between nature and the work of art.

Milne's gradual move toward a dominant use of line and shape – toward drawing as the major function of a painting – was an inevitable outgrowth of his wish to achieve clarity and simplicity. Colour has strong emotional associations, whereas line tends to emphasize thought or essence. Line is more metaphorical than colour, and a more direct conductor of energy, and conveys a message more forcefully than colour. To strip away unwanted ambiguity and achieve precision line must predominate. Milne was acutely conscious of this. About one painted-out image, which had three snowy hummocks in the foreground (a pattern he returned to a few years later), he wrote in his notes: 'It would seem that shape should be used wherever possible rather than colour because colour is the more arbitrary means, its use involves less thought.'[17] For the next few years colour was ancillary to line in Milne's work; he was preoccupied with colour only because he wanted to subordinate it to line.

The corollary of Milne's tentative theories about line and shape and the subordination of colour gave rise again to considerations about white as a

colour, as a value, and as a definer of shape. In the middle of January 1920 Milne tried to make a painting 'as white as possible.' This curious intention defeated him and he did not accomplish his goal until the following winter with *White, the Waterfall*. In this fresh engagement with white, white was not considered as a colour, as it might in identifying clouds or snow, but as a means of lightening the effect of the masses or shapes in a painting. What occurred to Milne was that by combining his passion for white with his emphasis on the use of line he might discover a more economical painting technique or convention. He started to think again in terms of 'white colours' and 'black colours,' as he had done hesitantly in 1911 and again in 1915. In his painting notes he first suggested to himself that he use three sets of colours:

1. White	2. Very light	3. Very dark
	Green	Black
	Violet	Deep brassy green
	and possibly	Cerulean and black
	Blue	Brown – viridian
	and	and light red
	Gray	with viridian predominating
		The purple equivalent of same
		possibly permanent violet and
		light red

The dark colours to be as near each other and black as possible, the light ones of the same tone and near white.[18]

Having selected a set of colours, Milne always had the option of altering the tone: for example, to give brilliance, as the use of 'black as a brilliant colour' had appeared in earlier work. Colour contrasts, however, were an incidental device, and less to be relied upon than getting the picture solidly founded on an arrangement that balanced white tones and black tones. For this Milne suggested the following line-up of adversaries:

Black colours –	White colours –
black	white (paper)
green (new blue and cadmium)	black
purple (new blue and indian red)	purple (cerulean and viridian)
red (viridian and light red)	blue (cobalt and black)
blue (cerulean and black)	green (cobalt green)
	red (vermillion and cerulean)[19]

In Milne's scheme of tonal relationships, black, by enclosing a white area, could thus be part of a white shape or white shape-group. Examples of this can be seen in such paintings as: *Sunny Morning, Kelly Ore Bed*; *Afternoon, Kelly Ore Bed*; *The Clearing above Boston Corners*; and even *Figure and Trees*. Colours, of course, had their equivalents in the gray scale between black and white. The equilibrium established by the two sets of colours ('black colours' and 'white colours') was the foundation, the *raison d'être*, of a painting. This mustering of two major forces gradually developed into Milne's convention of values, on which most of his work up to 1938 was based.

Still, sorting out the convention required a significant creative effort, and Milne had many subsequent thoughts about his solution and made

many revisions to it. His remarks to Clarke show both his intent and his difficulties:

My remarks about white in oil and watercolor were probably not very clear. I meant that in watercolor white pervades the whole picture [being on white paper] and so does not have much shock as a color, while in oil it is entirely different from the ground [of the canvas] and all the other colors (as I use them) and when used is violently noticeable.[20]

Milne continued to work at a remarkable pace through the first quarter of 1920. He regularly did a painting in the morning and another in the afternoon, alternating easily, despite later comments to the contrary, between oil and watercolour, and occasionally finishing as many as three or four paintings a day. This may be borne in mind when Milne later complained of not being able to deal with more than one medium at a time, or of the 'dark winter months' as being unproductive and depressing. Many of the winter's paintings – such as *Boston Corners in January, Village in the Valley, Black Cedars, Fox Hill on a Clear Day*, or *Snowfall, from the Painting House* – were of the long view of Boston Corners from the hill, with plunging gullies, ridged hillsides, and forest interiors, and they reveal the same sentient ability to read the air, light, and weather with accuracy, as do his paintings of 1917. Like the near or distant landscapes several paintings of Patsy, such as *Figure in the House I*, were studies of tonalities, shapes, and balances (she was no longer the obsessional object of eight years earlier). The choice of subject did not alter the vision of the painter greatly. Milne's explorations and experiments were numerous and thorough, and his failures, although instructive, mounted along with his successes: notes pecked out by Milne on his typewriter refer to far more paintings than now exist, and the handwritten postscript 'Painted Out' appears often.

The early winter of 1920 was replete with thought and work. Once Milne was settled into his little chalet, he immersed himself totally in his paint-

The Village in the Valley, Bare Trees, *20 February 1920, watercolour, 38.5×55.9 (15⅛×22)*

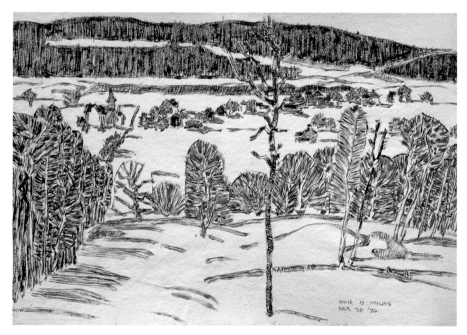

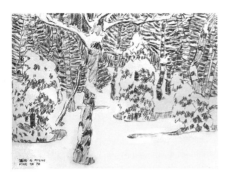

After Heavy Soft Snow, 20 March 1920, watercolour, 39.4×51.5 (15½×20¼)

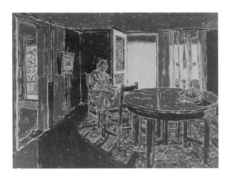

Interior with Table, 12 August and 9 September 1920, watercolour, 38.1×50.8 (15×20)

ing: planning, experimenting, analysing, reconsidering. In addition, as he wrote to Clarke, he had 'been reading quite a bit of Ruskin. Your remark that he is usually wrong but interesting hits him pretty well. I like his way of going at things. He doesn't side-step or generalize. He gets right down to facts stated in plain language.'[21] Milne's admiration for Ruskin, qualified though it was, is peculiar, given that Ruskin's aesthetic was quite at odds with the modernist canon that Milne espoused. One is led to ponder whether Milne was firmly committed to the modernist approach, or whether his understanding of it was at least tempered by some other strains of art theory that might have allowed him to accommodate forms of realism (or of fantasy, if one thinks ahead to the 1940s) that were the stock-in-trade of other streams of twentieth-century art.

Milne's attempts to exhibit his work during this time were sporadic and absorbed little of his energy. He took some paintings that spring to N.E. Montross, who exhibited several watercolours in 1920 and again in February 1921, but was unable to sell any. Three paintings were shown in Philadelphia in March 1920 at the annual 'Members Only' exhibition of the

Figure in the House II, 5 April 1920, watercolour, 49.9×38.5 (19⅝×15⅛)

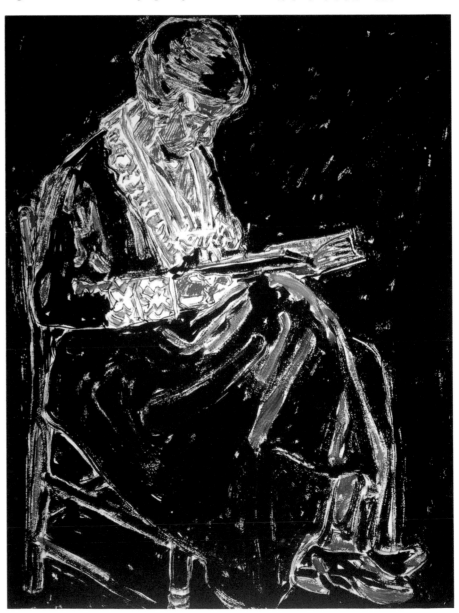

Pennsylvania Water Color Club, of which Milne was still a member;[22] in November Milne had seven paintings in the regular annual exhibition and all were illustrated in the exhibition catalogue, a substantial tribute. But apart from the few paintings taken by Montross, there was no other instance of Milne's work's being shown publicly at this time. During April and May he became rather dilatory, and his steady painting achievements of the winter came to an end: only fifteen works, which did little to advance the discoveries of the winter, were finished in the spring. His time for rumination was cut short by the need to do odd jobs for Clarke and a neighbouring artist, Howard Sherman, and thus make up for painting sales that had not materialized. Milne busied himself with the garden and growing onions.

In August 1920, however, painting and Milne's journal entries began again in earnest. Earlier in the summer Milne had visited his family in Paisley, the last time he would see his aging parents, and he stopped in Toronto at the Art Gallery to see the large war-paintings exhibition, in which a large number of his watercolours were included.[23] He had hoped that as a result of his success with the Canadian War Records he might find an outlet for his other paintings in Canada and in the United States, but in this he was disappointed. He and Patsy then had another brief holiday in Tivoli, at Patsy's Aunt Geraldine's summer place, before returning to Boston Corners. A few days later Milne was again working steadily and

Pink Reflections, Bishop's Pond, *24 August 1920, watercolour, 37.8×54.6 (14⅞×21½)*

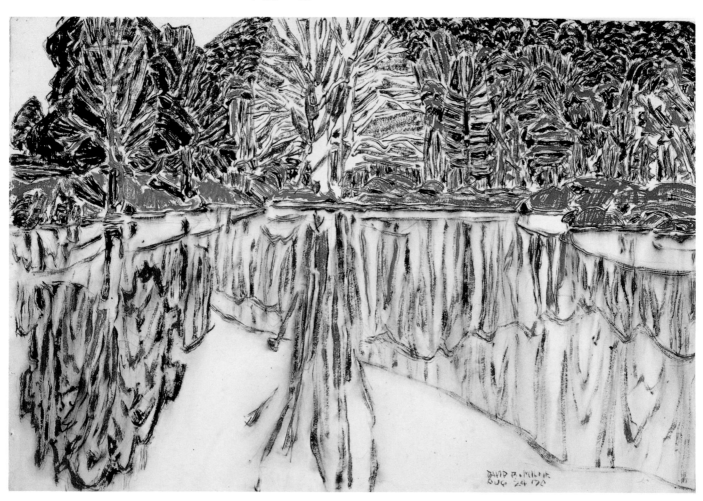

smoothly. By the last week of August he had built up such irrepressible momentum that he was able to produce half a dozen of the finest works of his entire life. So rich a store in a single year of an artist's life is unusual, but in the space of little more than a week it is rare indeed. When Milne was in full flight, he was truly prodigious.

Milne's work during August and September, bracketing this cluster of paintings, was mostly in watercolour; only two of six oils were retained. Milne began to move away from the direct influence of the War Records work, sacrificing some of the overriding detail to more openness, and providing greater readability. A series of stunning reflection pictures – beginning on 15 August with *Trees Reflected, Kelly Ore Bed* and pressing on with *Kelly Ore Bed* on 20 August, *Reflections, Bishop's Pond* on 22 August, *Pink Reflections, Bishop's Pond* and *Black Reflections, Bishop's Pond* on 24 August, and finally *Weed Iron Mines* and *Pool and Contours* on 27 August – brought to a successful culmination the experiments with wet wash that Milne had begun at Boston Corners before the war. Having reached this pinnacle of success, he then turned away from using a wash and did not return to this technique for almost twenty years. His watercolours for the next four years would be entirely in the dry-brush technique he had invented for himself during his army sevice.

Those magical late summer days of 1920 were spent at Bishop's Pond, Kelly Ore Bed, and Weed Iron Mines, sites of Milne's powerful reflection pictures before the war, and each a pleasant short hike from Under Mountain House. The two best of these outstanding reflection paintings were *Weed Iron Mines* and *Pool and Contours*. Together they comprise the high point, so far, in Milne's use of the thick dry line. The washed area in each is subtle, and barely distinguishes one area from the rest. Milne's ideal of being as economical as possible, of encompassing the most pictorial information with the least possible means, reached a new level. Colour was made wholly subordinate to line. While doing two paintings at Bishop's Pond, *Hill Reflected, Bishop's Pond* and *Dark Shore Reflected, Bishop's Pond*, Milne thought that he would like to do them again, reducing the colour in the reflections even more. He was very pleased with the drawing in each of these, except where he erred in setting the level of the waterline in *Dark Shore* and felt that the reflections at the left were 'stupidly drawn.'[24]

Pool and Contours, in Milne's estimation, combined 'three of the most

Trees Reflected, Kelly Ore Bed, *15 August 1920, water-colour, 38.5×56.9 (15⅛×22⅜)*

Black Reflections, Bishop's Pond, *24 August 1920, watercolour, 38.8×56.3 (15¼×22⅛)*

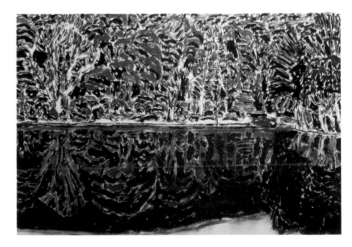

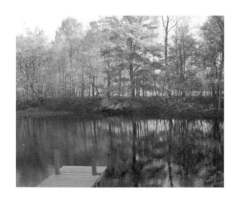

*Bishop's Pond (now Helck's Pond) at
Boston Corners, as it is today*

important things I have developed in my painting.' These were, first, the
black cores with green halos that were invented in 1915 in the Bronx; next,
'the clear water wash of late 1916' (which had actually first been used in
1915); and, finally, the 'coloured streaks to mark the boundaries of shapes
... used notably in the drawings from St. Eloi and Gravenstafel' in 1919.[25]
Pool and Contours is like one of those haunting portraits that reveals the
past and the future of the sitter, in this case Milne's own painting. Here
were planted the seeds of developments that were to germinate over many
years. For example, the row of trees across the horizon is an arrangement
peculiar to the Palgrave paintings of 1930–3 in shape and spacing. The
enclosures created with the drawn line alone and the interconnection be-
tween one closed space and another were the basis of most of the paint-
ings at Lake Placid and Big Moose Lake in the middle and later twenties.
The drawn line itself – dry, and actually a complicated sandwich of lines,
like a cable of multiple strands – attracted Milne's whole attention the
following summer at Dart's Lake and was the basis of much of his work
for ensuing years. In *Pool and Contours* Milne had achieved his aesthetic
goals of clarity, precision, and simplicity.

Milne's own assessment of the reflection pictures, when he looked back
over his life in 1947, was both informative and succinct:

The adventure in these pool pictures was one of texture, of contrast between the
harsh, clear-cut colour and line of trees and contours, and the intimate combina-
tion of the two in the reflections. I was still working in rather dry colour, not
using thin washes [as he was in 1947] but using colour as thick as it could be
applied, but usually sparsely to mark and emphasize shapes, mostly with a thin
but varying black outline. My method of dealing with the reflections was simple.
Most of the paper was left dry, harsh, but over the reflections I applied a wash
after the colour was applied and dry. Simple, but there were some difficulties
and surprises. At first I was confused by the colour of the pools. I applied a
blue-green wash over the underlying painting. That didn't work. The result was
muddy, confused, due to the division of interest. Then I eliminated the colour
from the wash, used pure water. That wouldn't have any effect over light washes
of colour, but over the thick dry colour I was using it gave a complete change of
texture. Every line in the area of reflection was intensified in colour, widened
and softened. The result was comparable to the contrast between a bitten

Dark Shore Reflected, Bishop's Pond, *1920, watercolour,*
38.8×55.6 (15¼×21⅞)

Bishop's Pond in Sunlight, *7 October 1920, watercolour,*
38.1×55.3 (15×21¾)

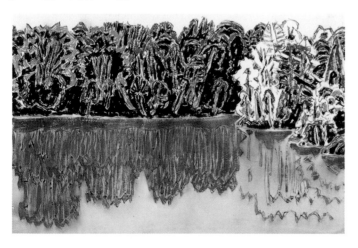

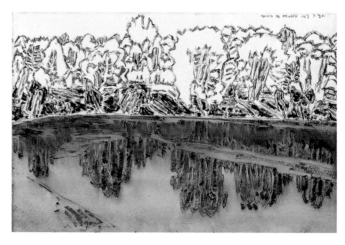

etching and a dry point. I was on the right track but had not yet arrived. The clear water wash widened the lines underneath, closing them up and leaving less blank paper between. The reflections area was overcrowded, without the spacious feeling of the rest of the picture. The solution was simple – to provide for this in the underneath painting. This I did, but it was a long time before I went far enough, eliminated enough. Even when I got that working, there wasn't an end to it. The washed-over area gathered a film of colour, gray, from the underneath painting, so that there was not only the desired difference in texture between washed-over and unwashed areas, there was an undesired difference of colour, like a gray woolen patch on a piece of bright patterned cotton. Finally I washed the reflections area over very rapidly with one or two movements of a large brush fully charged with clear water, allowing the surplus to run off at the side or into a blotter. That eliminated the patch – there was no difference in the two areas of the picture except one of texture. That was the peak of the adventure, but like most adventures this one ran past its peak, when the trees lost their leaves, and the brilliant, clear light of autumn had gone.[26]

The remarkable burst of activity that Milne displayed in creating his reflection paintings over six weeks in the late summer and early autumn of 1920 left him feeling drained, and uncertain about what to do next. The number of paintings he produced trickled off, his journal stops abruptly on 14 September 1920 in mid-sentence, and in October Milne stopped painting altogether. He had come to another moment of decision.

To meet his own immediate needs he went to New York at the end of September hoping 'to make $200 skinning the unsuspecting picture dealers and to make a get-away ... within two hours.'[27] This would have provided supplies and materials until the spring, when consideration might be given to travelling either to Canada or to Europe. However, the dealers – Montross, Daniel, Macbeth, and possibly others – would not be party to his scheme. Milne was unable to sell any work, even though George Luks tried to persuade Montross to make a modest purchase. Milne reported his failure to his friend Amos Engle, who was by this time frittering his

Weed Iron Mines, *27 August 1920, watercolour, 38.5×55.6 (15⅛×21⅞)*

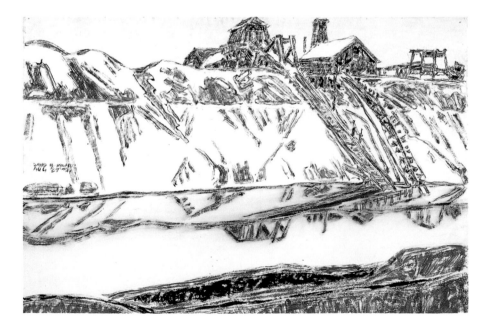

life away as a prospector on the West Coast. Engle replied in the last-known exchange between them:

But those miserable dealers – strange they can't see them. The Zorachs said that the war seemed to have a reactionary effect on the taste of buyers and dealers – they seemed to lack both discernment and courage. No doubt an improvement will be felt shortly along this line – people seem mentally thick these days – at least out here.[28]

And he closed his letter with the hope that Milne would be able 'to dynamite [his] way into some dealer's strong room.' In the circumstances Milne was forced into making frames for Clarke and his friends in order to earn some money. He had pictures accepted, but not sold, by the Philadelphia Water Color Club. Montross exhibited one or two works, but apparently neither bought nor sold any.

Henry David Thoreau was Milne's favourite American author and for years Milne had been committed to Thoreau's belief that one's life should be pared to essentials: making the most out of the least was Milne's ideal in both aesthetics and life. He found material possessions distracting and wanted only basic food and the opportunity to use whatever talents or resources he could find near at hand. His yearning for simplicity had prompted his move to Boston Corners in 1916. During the summer of 1920, however, he began to think of forsaking even its rustic comforts. A re-reading of Thoreau's *Walden* in the fall confirmed him in his plan to sequester himself in some hidden sanctuary, alone for the winter, and devote himself only to painting. Throughout the late fall Milne's only priority became the building of a retreat where he would be able to pursue this goal.

On 30 September Milne went on a day-long hike over the ridge to the east of Boston Corners and revisited a spot that he and Clarke had passed on a long hike earlier that summer – a high, sheltered dale, about five

Pool and Contours, *27 August 1920, watercolour, 28.3×39.1 (11⅛×15⅜)*

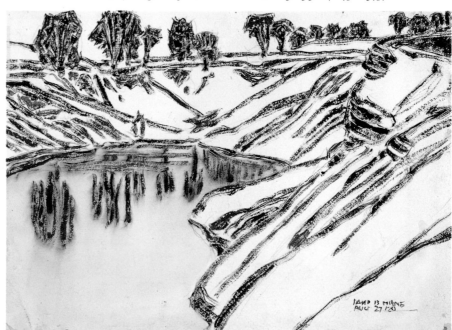

*Installation of Milne's paintings in the Philadelphia Water Color Club exhibition,
November–December 1920*

kilometres (three miles) to the northeast, on the flank of Alander Moun-
tain. There he decided to build a tiny shelter where he could spend time
only on those things that mattered most to him: thinking and painting.[29]
All other responsibilities were to be pushed to one side and ignored. He
seemed to have a strong intuition that he must concentrate for a time in
solitude in order to drive himself toward the next development in his work.
He got in touch with the owner of the land, a Mr Miles who lived at Twin
Lakes, Connecticut, and was allowed to proceed as long as he didn't cut
down any large trees. 'The venture itself has both Thoreau and Robinson
Crusoe gasping for breath,' he wrote to Clarke.[30]

Here is the story in Patsy's words:

We stayed [at Boston Corners] all Fall, Winter, Spring, and Summer, and when
the Fall [of 1920] came there was not much money left – the Army "checks" had
come in for several months, and I had saved about five hundred dollars while
Dave was away, but we had to use quite a bit, and get necessary things during
the year. I thought it would be a good plan to take a position for the coming
winter in the City, if Dave could keep on with the painting. He wrote to Clarke,
asking for a loan of fifty dollars, to get enough supplies etc. to do until Spring,
and decided to go to Alander and put up an Army hut, and keep the B.C. place,
and I would try to come up some week-ends. Clarke, as always, was good
enough to loan him the money. I went down and found a position in a Church
organization (in the office) near 23rd St., with a salary of twenty five dollars a
week.[31]

For the next three months all Milne's time went into preparations for the
winter. He did not begin painting regularly again until the Alander cabin
was completed at the end of 1920.

Milne was adamant about staying in the country, and it is clear that he
wanted to stay there alone, a decision that naturally put strains on the
Milnes' marriage. Patsy's going to work in New York City at the end of
1920 signalled that the bottom of the treasury had been reached, but it is
not entirely clear whether their separation and Milne's retreat were symp-
toms of problems in their marriage as well. Milne told Clarke that Patsy
wanted to work in Manhattan. Since she had always loved being in the

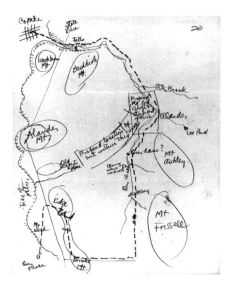

Milne's map of the Alander area, 1920, ink, 28.0×20.4 (11×8½)

Milne's construction drawings for the Alander cabin, 1920, ink, 28.0×20.4 (11×8½)

country, and Boston Corners in particular, and had never expressed any great liking for New York City, this separation, if such it was, may have marked the beginning of a long decline in their relationship. Milne had already shown some exasperation with Patsy in his letters from Europe. When he returned home he expected to find Patsy with a nest egg of his army pay on which they might live for a year or so; instead he thought that she had squandered it.[32] Milne had spent some of his army pay on himself, however, for he bought 'a very fine pair of shoes' in Ripon that 'lasted for years' and 'a new navy blue suit he had a London tailor make.'[33] In any case, whatever had knitted Milne and Patsy together in matrimony started to unravel at this time. Milne's ensuing letters to Patsy show cordiality rather than love, and his letters to Clarke mention her perfunctorily. The Milnes were nevertheless united still by social convention and economic necessity, and one imagines that they meant enough to each other to attempt to find a pattern that would be acceptable for both their lives.

The site of the cabin Milne built was only three kilometres (two miles) off the peak of Alander Mountain and not far from the highest reaches of the Bash Bish Brook. A tiny tributary nearby, Lee Pond Brook, provided Milne's water; he fetched his supplies from Boston Corners twice a week, travelling for the most part along what Milne called 'the Blowhole trail,' a path that led up from Boston Corners and through a saddle that was often immensely gusty.[34] Clarke remembered the trip as usually taking an hour and ten minutes.[35] The grove of enormous hemlocks surrounding Milne's chosen place was in the lee of the mountain winds and created a forest 'cathedral.' The heavy snowfall that year seemed to insulate him even further from the outside world, and he didn't even have to leave the cabin door to have painting subjects aplenty.

The cabin mimicked the architecture Milne had seen and painted in England and France: the durable army Nissen hut. His construction was a half-barrel shape, like a turtled boat, ribbed with maple saplings. Both ends of the barrel shape were planked with slabs of chestnut oak, with a small window in the rear and a door and two windows facing the valley. The windows came from an old chicken coop, according to Clarke.[36] The door and floor were also made of chestnut oak, and Milne was as proud as a cabinet-maker that the door hung perfectly from the moment he installed it – it didn't even need a latch. The whole structure was covered with tarpaper and insulated with moss. It measured approximately 3.3×4 metres (11×13 feet) and Milne described it to Clarke, who helped him to assemble the basic structure and visited him several times over the winter, as 'looking very much like a short elephant lying down in the bush.'[37] The stove, stove pipes, tools, window sashes, and a box of paintings and painting materials were transported, with some help from a horse and wagon, up an old trail to within a short distance of the cabin. All the lumber, including the slabs, was cut and split into planking at the site with only an axe and a handsaw. Milne hiked daily from Boston Corners and, as the fall progressed, had to contend with cold and snow. A primitive privy, designed by Milne, was built just behind: two poles nailed to two trees; the toilet seat, which spanned the two poles, was kept behind the stove and was at least warm whenever it was put to use.[38] The hut was finally habitable when Milne painted a small picture of it on Christmas Day 1920, although he did not paint there seriously until three weeks later.

Patsy wrote later that she visited Milne 'about once a month' – to 'make sure that he washed behind his ears,' as Milne put it to Clarke, euphemistically and in the third person. Milne, in fact, had brought up an old zinc

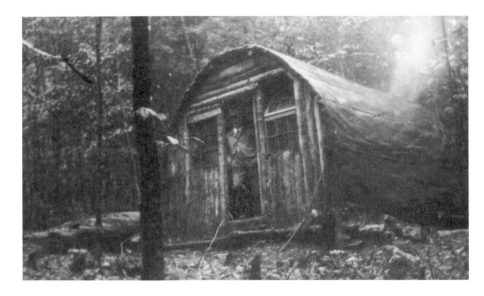

Milne in the doorway of the Alander cabin

The Alander cabin, ink drawing

bathtub, which was ritually used every Saturday night with water heated on the stove. Patsy remembered her visits to Alander:

It was a long trip, about eight or nine miles from Boston Corners [it was actually about three]. I went there [to Boston Corners] first, and the next morning early, we would pack the knapsacks and start, going up the mountain at B.C. through scrub oak for miles, then along the top to the cabin. I think we took a train from Copake once or twice coming back – but usually walked ... It was quite a long 'pull', up the mountain from the road below Alander ... and must have been two miles into the cabin.[39]

She wrote of Milne's shelter that it

was built of saplings – brought over the top, like an Army hut – then 'chinked' with moss – it had two bunks, and the floor and door were made of 'split' logs. Dave wrote that he had only just finished getting the door on when a big storm came. He also found an old stove at an abandoned lumber camp, and hauled it to the hut. A lamp, and some boxes to sit on, and a shelf, as a table, with other shelves for the painting material etc. around the wall, made it complete. It seemed so nice to get in, after the long walk, take our shoes off, after we had cooked dinner, and sit up on the bunks – opposite sides of the cabin, and read for a while.[40]

Although the purpose of this isolated shelter was to ensure economy and concentration, its location was chosen because it provided what Milne wanted to paint: 'an extremely new kind of material, closeup brook and tree stuff and wooded hillsides.'[41] What Milne thought was new about this – since he had painted similar subjects extensively during his first Boston Corners summer, and again the previous winter – is something he never explained; but he may have been anxious to reconsider this sort of material, particularly in its winter garb. Milne improved his vista from the doorway by cutting out the trees he thought were uninteresting. He was so charmed by those that were left that he gave them names such as Little Yacht Tree, Woodpecker Tree, and Flying Squirrel Tree. He referred to his little dell as 'the best bit of wood interior painting material the Good Lord

ever set out,'[42] and his paintings of the soaring hemlocks and feathery evergreens certainly have the air of having been divinely inspired.

Milne stopped writing painting notes during this retreat, although he wrote several long letters to Clarke in the fall. He went to New York at the end of January and took orders for picture frames for Clarke and his friends (and caught a bad cold), but this distraction can hardly account for the fact that four months of hard work produced only thirty paintings. A year earlier Milne had done as many in less than a month, although he destroyed many of them. He may have been particularly severe with himself at this time because he was trying to be exacting in his work.

As at other times in his life, Milne's need for money detracted from the time he could devote to painting. Since the New York dealers had been unwilling or unable to sell anything, his plans to float into 1921 with a semblance of financial buoyancy were scuttled. As an alternative, Milne decided that writing short articles for the hiking page of the New York *Evening Post* would be compatible with his monastic retreat, and might even be moderately lucrative. His first essay was sent to the *Post* in mid-January and returned to him in February without comment. Milne persisted in writing and sending other articles, and finally had the satisfaction of seeing at least one published more than a year later.[43] Altogether he wrote half a dozen short articles on hiking, topographical maps, squirrels, 'Trees – Friends o' Mine,' fishing, and one on the early history of Boston Corners, which had been the scene of major boxing matches. One aid in this enterprise was a big *Webster's Dictionary* from which, Milne declared, he derived enough enjoyment in the long winter evenings to compensate for the work of carrying it all the way up the mountain. His only light was daylight, or an old lantern that he used at night; the radio stayed in Boston Corners. The Milnes' cat was brought up from Boston Corners as his sole companion, but it disappeared one day when Milne stayed down in the valley overnight on a supply trip. Patsy was convinced that the cat was taken by a large owl they saw in the vicinity.

In the few Alander letters to Clarke Milne wrote of 'studying the shapes to the last notch and not catching them as they fly.'[44] He noted that he was 'beginning to get some thought out of [the new subject matter] and planning ways of getting at it, particularly in oil,'[45] but it was some time before he was productive at all. In watercolour, the more spontaneous medium,

James Clarke's watercolour of Milne painting in the doorway of the Alander cabin, 1921

In the Cabin on the Mountain I, c. 26 March 1921, watercolour, 38.5×56.3 (15⅛×22⅛)

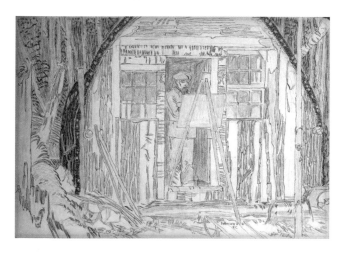

Doorway of the Painting House,
Alander, *16 January 1921, watercolour,
41.0×41.0 (16⅛×16⅛)*

he did less work, partly because he wanted to use oil, and partly because he could not use watercolour as successfully in the freezing weather; even when he started with boiling water, he found that it froze too quickly. Clarke's comment on Milne's seeming indifference to extreme weather conditions is telling: 'At the Mt Alander Cabin he painted nearly three hours standing at his easel in a foot of snow in freezing temperatures (I quit after an hour, too numbed to hold a brush or think).'[46]

The most important focus of his attention, one that Milne expanded upon at length in a letter to Clarke, was, again, the use of white paint. Milne had made considerable use of it in the previous year and now, perhaps because he was literally immersed in snow, he was conscious of the ways in which he might extend its use even further. He again delved vigorously into experiments with white. He wrote facetiously to Clarke that he had 'made a momentous discovery. Found out that for years and years Montross has been slipping an extra color [white] into my oil painting outfit – one that I have never made use of.'[47] He began to use white thinly as a colour to set in the shapes, and sometimes with a very slight tint so that it was really a near-white value, to use Milne's term. And he used it again to sharpen and to simplify; that is, he painted a richer, thicker white line along the outline of a shape or just up to the contour, thus giving it more emphasis. The early oils done from the doorway of the Alander hut, such as *Drift on the Stump*, show this device. A corollary of this use of white was a drastic reduction, almost an elimination, of the need for the black outline that had been Milne's mainstay in painting at Boston Corners and in Europe. He believed that while colour was emotive, line was the route to precision. When he was able to set aside his particular brand of black outline – whether thin and wispy or heavy and dramatic – he found to his surprise that the same definition and clarity could be obtained by using white in similar ways. Clarke later referred proudly to this invention of Milne's as the 'Great White Discovery.'[48]

In a painting note Milne summed up his aims for using the watercolour medium, and it was to be his credo for the next several years:

Starting with a clean sheet of paper, here are the two thoughts:
1. To cover the paper as slightly as possible, to remove it as slightly as possible from its original smooth whiteness, to put just enough labor and color on the paper to tell what is to be told.
2. To break the area up as little as possible, to leave to it as much as possible of its original – not whiteness in this case – but smoothness, unbrokenness, oneness.[49]

White is the equal of black in many ways, as well as its opposite, although in painting, unlike chess, black has a slight advantage, chiefly in weight and quick visibility. White fulfils the same role as black, in aesthetic terms, by acting as a counterweight, or foil, to black or to any value between black and white. It can be used as a gauge against which to measure colours and their values. Some people regard Milne's use of black as an indication of a mildly taciturn frame of mind, while others insist on seeing any use he made of white on the ground as snow, or in the sky as clouds. Yet both these views disregard the fact that, for Milne, black and white were aesthetic, not symbolic, agents, and they were not representational. Some of his summer landscapes with white in them are innocently given such titles as *Frozen Stream* or *Fields in Winter* by owners who do not

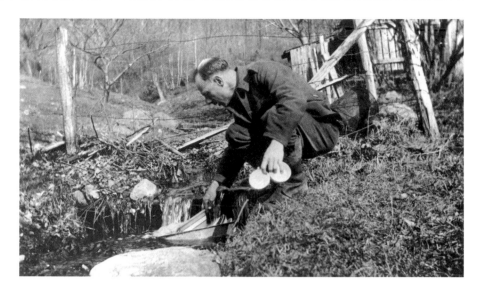

Milne at a stream, likely Ashley Brook, near the Alander cabin

realize that the whiteness has nothing whatever to do with the season. The indications of weather and time of year are often subtle and must be searched for; sometimes they are irrelevant to the aesthetic purpose and impossible to determine. But most of all one must accept the fact that form and drawing are what indicate snow or water or ice, not colour or its absence. Milne was often impatient with people who expected paintings to follow photographic colour schemes, for he knew that all systems of painting were only conventions. Some conventions were widely adopted, habitual, and literal; others were individually forged and shaped by each artist. In one of his painting notes Milne mentioned that the white in one painting represented brown fields, not snow, and that the only snow in the picture was a patch of purple under the trees.[50]

Drift on the Stump, *10 or 11 February 1921, oil, 35.9×46.1 (14⅛×18⅛)*

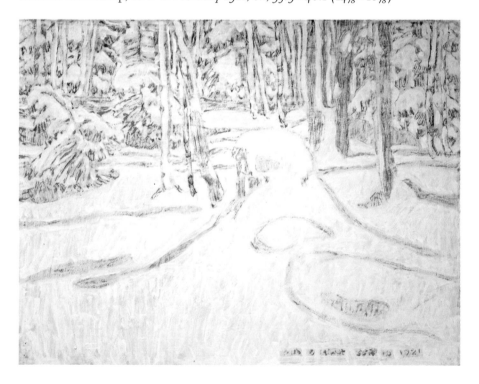

Because black values and white values were at the root of Milne's early training, the recurrence of experiments with them was perhaps to be expected. In later years family and friends who watched Milne work recalled that he would brush on some paint and then stand back and squint with half-closed eyes at his progress. Many painters squint at their work because this cuts down the strength of the hues and leaves a stronger impression of black and white values. Milne would do this to check what the balance of his composition was as he went along. The effect of a Milne painting is based on how he has organized and balanced the black and white values – whether it be one or more – in relation to the composition (or groups of shapes), and in relation to the hues or colours that mark the shapes.

In addition to using white rather than black pigment to draw an outline Milne also used white to separate shapes and shape groups from each other, emphasizing 'the shapes by painting in between with white.' When he did that, he found that the picture 'gained decision at every squeeze.' The discovery that white could enclose, separate, and simplify – in fact, do all the things that black could do – finally led Milne in March 1921 to one of the most important and successful of his works, appropriately titled *White, the Waterfall.*[51]

This oil painting absorbed Milne for more than a month of strenuous work, which may seem an extravagant commitment in time, given his usual practice of a painting or two a day. Yet the exercise comprised a rather ambitious agenda: to give prominence to line and shape, to subdue colour, to make extensive use of white, and to execute a painting slowly and fastidiously. Milne wanted to attempt 'long time pictures,' where shapes were 'ground and hammered into simplicity and order.'[52] He also worked slowly and carefully on other paintings that winter, *Black Waterfall,* for example, but *White, the Waterfall* was the season's touchstone. Its use of whites – one upon the other and around the little threads of colour – was truly 'a device of delicacy.'[53] Each carefully placed shape or stroke in this painting has a sense of inevitability, as rock and water and tree in turn succumb to the alchemy of the artist's vision and skill. Subject and vision mesh, and the technique and the treatment are brilliantly suited to both. There is a miraculous fusion of opposites: complete whiteness and also an enormous range of colour; brisk movement and tranquillity; myriad closed shapes that nevertheless produce a great sense of space and freedom; and ascetic simplicity despite the complex arrangement of forms.

White, the Waterfall was about as close as Milne ever came to meeting his own ideals for an attentively planned and rigorously worked painting that still had an air of improvisation, easiness, artlessness. In 1936, when he tried (unsuccessfully) to revive it as a subject for a drawing, he concluded that the original painting, 'has a "kick,"' and he had 'never been able to improve on it.'[54] This painting was also 'the father of all the summer of 1921 painting, and of many pictures since.'[55] His success gave him the courage to attempt 'long time' pictures regularly throughout his life, but it did not change his painting habits permanently. Milne continued to alternate between rapid, one-sitting paintings that came relatively easily, and worked-over paintings that came only with difficulty. Yet the impulse to find the most complete expression of an idea that drove him along the path toward *White, the Waterfall* was surely the genesis of the sustained themes and variations of the oil paintings done at Palgrave in the 1930s and the late watercolour series of the 1940s, such as the *Ascension* series, the playing cards, and the biblical and other fantasies.

White, the Waterfall was a giant leap forward in Milne's quest for a perfect picture. Because it was a pivot for many ideas, its problems and solutions were to haunt and frustrate him for years to come. Condensed into one small rectangle was a summary of all that he had done and thought for several years. All artists seek to create a work that conveys such richness, elegance, and simplicity that anyone can instantly recognize it as a masterpiece, a work that has power and striking force, subtlety, and lucidity, and that sums up most of what the artist has tried to reveal about his thought. Milne was no exception. He wanted to paint 'major' works, by which he meant thoroughly worked out oil paintings. He seemed to accede to the general view that watercolours were 'sketches' or 'drawings' and therefore something less than might be admitted into the pantheon of great painting. He was determined, however, not to be caught, as John Constable had been, in translating a sketch into a larger work, only to lose most of its vitality between the first draft and the finished version. Still, he was as equally determined to elaborate his ideas, to deal with larger issues, to introduce refinements, and to accomplish all this without losing what he sought most of all: economy and simplicity. It was a contradictory and almost impossible task. Each time Milne felt tantalizingly close to a way of

White, the Waterfall, *28 March 1921, oil, 45.8×56.3 (18×22⅛)*

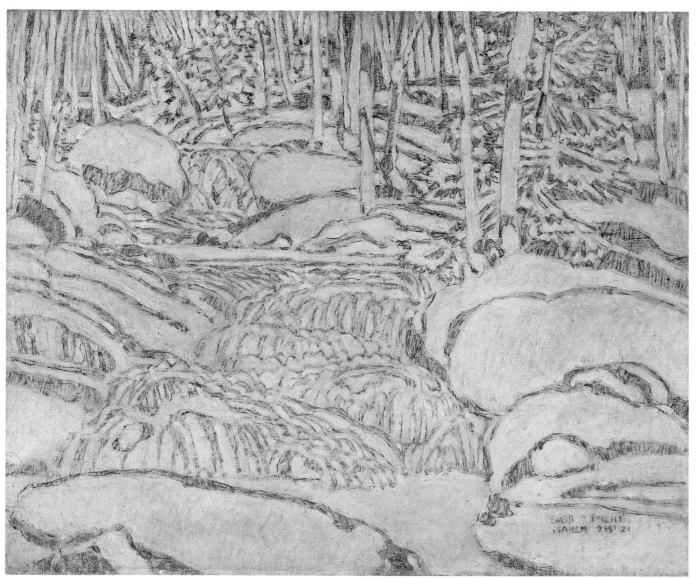

proceeding that would give him a masterpiece, and each time he was able to muster the concentration of intelligence and emotion, something unexpected always turned up, tripped him, or pulled him back. The dissatisfaction thus sown is perhaps what keeps the true artist moving on.

If Milne had clung longer to his mountain fastness, he might eventually have reached the centre of his personal aesthetic maze, but not even he with his abstemious habits could subsist on nothing. Patsy's income was insufficient; the literary enterprise eventually yielded only $21 in June; the onion business, which for a time made Milne the self-declared 'Onion King of Boston Corners,' finally netted an income of $27.50 in the spring, hardly enough to repay his time and expenses. Maple-syrup making produced only enough for personal use. Milne concocted a scheme, his 'Canadian venture,' to sell reproductions of his works, especially the war paintings, to Canadian corporations as 'memorials' for advertising. He drafted a letter, but never decided which companies to approach. Once again he sent pictures to the Philadelphia Water Color Club, and to the Montross Gallery, but none were sold. Financial necessity drove Milne back out into the world of working for money. He was forced to do further odd jobs for Sherman and Clarke and then take a summer job as a handyman at Dart's Lake in the Adirondacks. He left the Alander cabin on 9 May 1921, wishing he didn't have to go, but he never lived there again.

Clarke, who had been sceptical of Milne's Alander cabin experiment in the first place, supported his decision to abandon his secluded aerie by suggesting that 'the amount of time necessary to build the house, cook, wash and get fuel was not in good proportion to the leisure thus purchased for art.'[56] However, four months was barely time enough for Milne to establish himself, let alone give himself the leisure to do what he had set out to do. He expressed acute regret at having to break off his painting, and later counted this departure as one of the most painful dislocations of his life. He may have had plans for paintings that we don't know about, or he may simply have regretted that the world would not let him do what he wanted most to do, and what he did best.

Over the next year or so Milne visited the cabin site a few times and was there again for a nostalgic visit in 1928. In 1930 he wrote to Clarke that he had read of a fire near Mount Everett and 'wondered whether the cabin was burnt.' He continued: 'The little cabin keeps a very strong hold on my memory, the most vivid place memory I have – perhaps because it was so compact and I got to know it extremely well. Boston Corners – the place under the mountain, at least – is another very clear picture. Big Moose, even though I built the house, is dim compared with either of the others.'[57] Clarke wrote, in reply to Milne's query, that he was uncertain whether or not the cabin had survived; later he reported that it had burned.[58] Its exact site is now uncertain.

Across the Lake
Dart's Lake and Mount Riga
1921–1923

B Y THE EARLY SPRING OF 1921 it became clear that Milne and Patsy did not have enough money to continue living in Boston Corners without gainful employment, and that Milne would have to abandon the Alander cabin. So they packed up, stored their belongings, and left Under Mountain House, the place they loved so much. Patsy, who had spent the year working in New York City, took charge:

I wrote about twenty letters to places in the Adirondacks, to see if I could get a position in an office, at some summer resort.

I received two answers – one from Dart's Camp, at Big Moose, where they wanted someone in the Post Office, and to write letters etc. I talked it over with Dave, and he said to start, and he would come in a week or so, and see what work he could get ... They said Dave could make quite a few 'signs', and have his own time to paint – and would receive ten dollars a month, and board – I was to get thirty-five dollars a month with my board.[1]

Dart's Camp was a resort about 160 kilometres (100 miles) north of Utica, New York, in the southwestern corner of Adirondack Park. It was owned and operated by Mr and Mrs William Dart (Ma and Pa Dart, as Milne called them). Milne later wrote:

Most of these Adirondack camps were at that time still under the direction of the pioneers who had discovered them, made a small clearing and gradually built up a large camp and acquired a following of guests who came summer after summer. Dart's was on a lake half a mile across and a mile long. There was a main camp, a large dance hall with office and store below it, a winter house, numerous cottages, barns and stables, a boathouse, a large garden with a greenhouse and gardener. There was a piped water supply, an acetylene lighting plant, a laundry, shops, and ice houses. All the cottages had fireplaces with water pipes in them. It was the duty of two men to go round the cottages every morning before breakfast and light the fires, for warmth (Adirondack nights were always cool) and to heat the water for baths.[2]

The Dart's Lake camp, as such resorts were and are called, was practically self-sufficient and had a large staff that catered for the needs of two hundred guests.[3] Dart's was the largest cleared area in the whole region and had livestock for meat, milk, and other dairy products; teams of horses for lumbering, ice operations, and farm work; gardens for vegetables and flowers; and handymen who did everything from farming, construction, and carpentry, to cutting ice in winter, repairing furniture, boats, and canoes, and maintaining what few motors there were.

At first Milne and Patsy lived in the winter house, but as paying guests

arrived, the staff had to give up their rooms. Milne again showed his prac-
tical ingenuity by taking down a little tool shed and rebuilding it as a snug
little cabin beside the lake. He added a small porch, which gave him a
place where he could paint if it rained, although without a proper studio
he returned almost entirely to outdoor sketching in watercolour, as he had
done two years earlier in France.[4] His duties as a handyman and sign
painter usually occupied him from early morning to noon. He had his
afternoons and evenings free for his own work, as long as he could escape
being pressed into service by Ma Dart or being corralled by one of the
guests. He delighted people by painting little beavers on chips of wood
chewed by beavers, mounting these on pieces of cardboard, and selling
them as postcard souvenirs for 10¢ each.[5]

Surprisingly, after the travail of the winter, the reluctant departure from
Alander, and practically no painting activity in well over a month, Milne
immediately struck a productive new seam of inspiration that captured
the energy of the winter's work at Alander and coalesced with ideas ex-
plored in the 1919 war paintings. The drybrush paintings of the summer
of 1921, while perhaps unexpected, were a perfectly logical product of
Milne's previous work:

Work was steady at Dart's and so was painting. I worked in watercolour.
Changes forced by the war records work and partial development since began to
bear fruit there. The overburden of detail was lost and the precision was re-
tained. The Dart's pictures were all in the same vein. They might be described
as line drawings in colour. Shape was all important, colour was a mere agent in
simplifying the form. The chief means of simplification was form itself, a
contrast of open and worked over spaces – open and shut painting was Clarke's
name for it. Camp subjects were particularly suited to that way of painting.
Subjects that had little attraction if approached in another way became exciting.
A pig pen, a chicken house and yard made as good an arrangement as anything
else. The blankness of the camp water tank against a background of green trees.
The open lake, almost blank, and the tree-covered hills beyond. The sawmill
with its big saw and boards and machinery beyond it. The quiet, soft-textured
river with its log jams and rocks. Toward the end of the summer changes of
texture began to be used, the softness of shapes in reflections on the still water
against the harsher shapes of logs and trees.[6]

The first extant example of this series of drybrush paintings (others are
known to have been done), *Projecting Tree, Dart's Lake*, dated 1 June, shows
Milne already in full stride. His subject, a view of the hills across the lake
with driftwood outlined in the foreground, is similar in composition to
Pink Rock (1912) and the much later *Still Water* (1946). That fall Milne
started a similar painting, but in it he eliminated the foreground, leaving it
blank, to produce a major work, *Across the Lake I*.

Viewed from a distance, the Dart's Lake paintings seem to be drawings
done simply with thick, black lines in charcoal or other black pigment, but
with a dimension of richness and variety that is not explicable until close
examination reveals that the lines themselves are constituted of several
different colours, like strands in a piece of yarn, subtly interwoven and
intelligently articulated to suit the form. The impression that Milne's drawn
line gives of unevenness and coarseness is achieved by a constant and
carefully modulated series of shifts within a narrow brown-black-green
range. The monochromatic effect is achieved by keeping all colours ex-

Projecting Tree, Dart's Lake, *1 June 1921, watercolour, 27.6×38.1 (10⅞×15)*

actly equal in value. This was a natural development from the late war watercolours that had the same complex line, a lamination of strands with controlled variation in colour and no variation in tone. More importantly, the emphasis on line – with its function as an encloser of form – draws initial attention away from colour. Milne was amused when camp guests, who chanced upon him as he was finishing a painting, assumed they had arrived just in time to see him put on the colour.

Milne now readdressed a problem that had intrigued him during his last weeks in France: how to establish the essential profile of his subject. In France the barrenness of the ruined landscape had triggered his response, but at Dart's Lake he had to make a conscious choice to eliminate ruthlessly and he did. He thought he was giving himself a head start by 'selecting the least promising subject, the emptiest that I could find, and seeing what I could do with it.'[7] In *Projecting Tree, Dart's Lake* he chose a barren subject, but soon found that, for painting, empty subjects were as full as any others. To take the inventory of an empty landscape, Milne remarked to Clarke, was like taking the inventory of an empty house, a concept they had discussed before: when one's eyes are hard at work, an infinite amount of detail can be seen in something that at first appears to hold nothing. As a result Milne found it difficult to find empty subjects with 'no emphasis on anything, except what is given by crowding closer of detail.'[8] A later description of his inventory method applies here in part:

There is another method that has had a fascination for me – in theory; I haven't tried it – the inventory method. The thing as it pops up in my mind, is to limit one's range very much and go very exhaustively into what you have. A few illustrations. When I was painting the Squash Pond sketch [*Outlet of the Pond 1*], the dark one with the dead stick in the foreground, I had the feeling that I would like to go on down the quarter mile of dried up pond, painting every section of snag and stick in it – a hundred pictures of just about the same material. Then the one I have talked of before, the inventory of the empty house – observing the minutest details where details were few – and the old shell hole that I did make a try for, enumerating everything in it. The point of it is in the everything. Not merely things you would usually see but things so simple that you wouldn't ordinarily think of them ... To do it thoroughly you would spend a month in this one spot – or a year – working on the material here, either in paint or in words. Something of that method is what makes Robinson Crusoe and Walden the thrillers that they are for me. Then there is Marcel Proust's 'Swann's Way' that I have spoken to you about. They all have something of the expression that seems to tempt me – all based on the well known fact that if all the workings of one's mind for half an hour could be set down, they would fill a book bigger than the Encyclopedia. This is the biggest method, but probably, for me, would work better in painting than in writing.[9]

While this process of reduction and enumeration simmered in Milne's mind, another related painting development took place during the Dart's Lake summer – a tendency toward more radical compositions. Instead of level horizons and balanced forms Milne began to draw more lopsided works in which the weighting was off to the left, or to the right, or to the top, so that whatever aesthetic equilibrium was achieved had to be obtained by different equations than before. This skewing is especially seen in *Farm Yard, Leaning Gate,* and *Figure in Landscape,* but it also dominates works painted from the Milnes' little cottage, such as *Corner of the Porch,*

Figure in Landscape, *1921, water-colour, 38.1×54.0 (15×21¼)*

Milne and the man who posed for Figure in Landscape, *probably his friend Christian Midjo, Dart's Camp, 1921*

Dart's Camp, in which the porch frame in the immediate foreground controls the whole view. Arrangement in composition generally meant having a preconceived notion of balance, a sort of pre-editing that Milne wanted to avoid. He wrote to Clarke that he could not remember a picture 'where I ever got any first hand thought' out of balance or arrangement. He preferred to take subjects as they came, and believed that 'one subject [was] as good as another.'[10] It would be consistent with Milne's thinking to say that balance, or lack of balance, was not an issue of artistic dogma, but an aesthetic decision based on each individual case or requirement; and that, similarly, the use of complementary colours, or any matching colours, was irrelevant in itself: only the attainment of aesthetic goals, by almost any means, was what mattered.

Only ten of the nearly forty paintings completed at Dart's Lake were done in July and August. After Labour Day, when 'the big thaw started at the camp, [and] guests melted away,'[11] Milne had more time and fewer distractions, and his production increased markedly. Blank spaces were enlarged and detailed areas were further compressed. By this time Milne's outline was quite stark, as he pared away all extraneous material, but he felt that the weight of his lines needed to be still heavier. A touch of fall colour, which added a little heft, crept into some of the works, although even this was sparing and 'severely kept down.' The austerity of a painting such as *Point with Flag Pole* is reminiscent of the black-and-white drawings of 1915, with their ascetic severity and near abstraction.

The culmination of the summer's painting was the watercolour *Across the Lake I* of 4 October 1921. The upper third of the picture is a narrow band of Adirondack hills, enclosing the buildings of Dart's Camp seen from the opposite shore, and a thinner band of sky above. The lower two-thirds of the picture space is left completely blank (except for Milne's signature). A few days earlier Milne had sketched a similar work, *Little Reflections, Dart's Lake*, in which he drew a small band of reflections in the water area. In *Across the Lake I*, however, although he had drawn reflections very lightly in pencil and was going to paint them in, he made the courageous decision to omit

Pond, Low Water, *13 June 1921, watercolour, 38.1×54.5 (15×21½)*

Corner of the Porch, Dart's Camp,
*29 June 1921, watercolour, 27.3×38.8
(10¾×15¼)*

Point with Flag Pole, *20 September
1921, watercolour, 26.1×36.2 (10¼×14¼)*

Drawing of Reflections at Dart's
Lake I, *1921, 8.2×14.0 (3⅜×5½)*

them from the painting. In deliberately producing a state of imbalance between the open and closed spaces, Milne found the answer to his quest for utter simplicity and economy more successfully than in any of his previous pictures. *Across the Lake* has antecedents that go back as far as the etchings of 1911 and the black-and-white drawings of 1915; it built upon the dramatic contrast, or tension, between two major parts of a picture surface (in this case the upper third and lower two-thirds) that Milne had contended with in Boston Corners; and it recalled the last, tough watercolours done at Courcelette in France and at Gravenstafel in Belgium, where Milne had left large parts of the paper surface blank. Furthermore, it was a forerunner of many works to come.[12] When he saw it again many years later, Milne was still highly pleased with it. He thought it had less colour than he remembered but still delivered 'the kick of a particularly harsh mule.'[13]

As long as Milne's painting cantered along reasonably well, the camp work did not seem to distract him. He found that his talents as a handyman were in constant demand, and he enjoyed the work and was amused by the people. His recreation included boating, with Patsy or camp guests, and photographing beavers, using remote shutter controls – even trying to photograph them at night with a trigger and flash, but without success. One evening his camera fell out of the canoe and sank to the bottom and that was the end of that. He also took time to write a substantial article on the history and activities of the beaver in the Adirondacks – they were nearly exterminated at the end of the nineteenth century – for an unspecified publication, probably the New York Evening Post, which had published one of his articles earlier.

The patrons of Dart's Camp included a Norwegian named Christian Midjo, who was there with his wife on their honeymoon. A professor of painting in the School of Architecture at Cornell University, in Ithaca, New York, Midjo understood and admired Milne's work immediately and said he would arrange an exhibition of it at Cornell. After receiving this unexpected promise of support, and with his pay in his pocket and a thick sheaf

Reflections at Dart's Lake I, *19 September 1921, watercolour, 38.5×53.7 (15⅛×21⅛)*

*Milne's photograph of the hill across
Dart's Lake, 1921*

Little Reflections, Dart's Lake,
*29 September 1921, watercolour,
38.1×56.9 (15×22⅜)*

of successful paintings under his arm, Milne could count the summer at Dart's Lake as pleasant, easy, and productive.

Milne and Patsy left Dart's Lake in October to accept an offer from Milne's friend Howard Sherman, a commercial artist in New York, to stay in his place at Mount Riga – 'a small cottage,' in Patsy's words, with 'an acre or so of ground,' just south of Boston Corners on the Harlem Division of the New York Central Railway. The quid pro quo was for Milne to carry out some needed repairs on the house.

So I had part-time work. Very fine! Clarke and I together on weekends, rebuilt the porch, and the big chimney from the roof up. I patched and painted the plaster walls and ceilings, painted the woodwork and built a dumbwaiter between the kitchen and the cool cellar [to avoid going outside]. There was a spring in the cellar and always clear cold mountain water. No ice was needed. There was a station at Mt. Riga, but no store. We went to Millerton three or four miles away for supplies, either by train or on foot and to Sharon in New England for library books, partly by train and partly by walking, sometimes walking all the way. We got milk at [George and Mary] Kaye's farm and probably butter and eggs. Kaye's was a place of abundance, a large farm with a lot of cows, with big barns and automobiles and electric light. They had an orchard and prepared quantities of preserved food for winter. Even dandelion wine, but in smaller quantities and for special occasions. Mrs. Kaye had to keep it under her pillow at night. The hired man was addicted to it, or wanted to be.[14]

Across the Lake I, *4 October 1921, watercolour, 39.4×56.9 (15½×22⅜)*

Interior: Woman Reading,
20 October 1921, watercolour,
39.4×50.2 (15½×19¾)

The Sherman house was a small two-storey frame building with an internal pump in the basement well for running water – a welcome amenity compared to fetching water from a creek. The place was about 120 years old and had once been part of a sizeable mining village; the Kaye property immediately adjacent still had a row of old miners' cottages on it.[15] Other ruins and abandoned shacks dotted the area. To offset some of their expenses the Milnes took in as a boarder a young woman, Miss Guttman, whom they had met at Dart's Lake; she paid them $18 a week, which was a financial help, but her presence was a little distracting for Milne. More unsettling was a stray cat that wandered to the house in the dead of winter with frozen feet. They nursed it anxiously and named it Hop-along Cassidy, but it died, despite their ministrations, and was given a decent funeral complete with gravemarker.

Milne could quite easily, and often did, walk the six kilometres (three and a half miles) up to Boston Corners for painting subjects, but most were found nearby. For his first few paintings he simply applied the ideas and methods of the summer in watercolour, without any significant change: *House on the Railway, Interior: Woman Reading, Figure Sketching,* and *Ore Bed Pool* are all the result of using the Dart's Lake method of outline and enclosure with great effectiveness. But in November Milne made a fresh start when he began to type his Mount Riga painting journal and to number his paintings – MR 1, MR 2, and so on. He experimented, in oils, with forms, techniques, and colours: *Row of Trees, Mount Riga* of 29 October 1921 is quite unlike anything he had painted up to that time. The odd colours, the uncharacteristically wide range of the palette, and the thin, almost fluid way the paint is mixed (using linseed oil instead of kerosene) and applied, all point to a search for a new method of expression. Milne wanted to use oil paint because he thought it was potentially more powerful than watercolour, although he set himself the challenge of achieving as much simplicity in oil as he had in watercolour. There are notes for a dozen or so oils that were painted, but only two have survived: *Row of Trees* and *Orchard in the Brown Valley,* painted a few days later. Milne gave himself these instructions:

House on the Railway, *19 October 1921, watercolour, 38.8×56.3 (15¼×22⅛)*

Drawing related to Row of Trees,
Mount Riga, *1922, ink, 6.0×10.0
(2½×4)*

Aim at the following:

1. To use the differences between the pasty oil texture and water color. For this reason am using oil to thin colors instead of kerosene.

2. My present way of using water color is at its best when used lightly to emphasize line. I aim to make use of larger areas of color, in oil, for emphasizing shape. The present turning toward oil was caused partly by a desire – under the influence of the rich autumn colors – to give greater weight to the emphasis of shapes by marking them with areas of color. – See M.R. 22 [*Reflections at Dart's Lake II*].

3. To use the rubbing-out/painting-over feature of oil to give greater deliberation to the painting. This seems particularly important in view of the influence of last winter's oil painting (not, in itself, successful) on this summer's water color.

The scheme of values and colours is this –

buff
blue, gray – tints

red,
green,
violet – full colours

black

Still feel a distinct distaste for using the full colors in large areas, while content to use the black or tints freely. Is this a survival of the watercolor method or a deeper tendency having to do with economy of means?[16]

Although Milne's prescription was clear and his ambition strong, change was not evident in the few remaining works from this season. The drawing was excellent, but colours were kept on a tight leash, muted and subdued. In spite of his intention to concentrate on oils, most of Milne's attention was directed to watercolours, which for the most part merely applied the summer's lessons to Mount Riga subjects. The fact that a number of his oil paintings were destroyed may indicate that the complex ideas Milne was trying to untangle (chiefly how to apply oil in a way that empha-

Row of Trees, Mount Riga, *29 October 1921, oil, 25.4×35.6 (10×14)*

Clarke's House after Snow, *19 January 1922, oil, 30.5×40.7 (12×16)*

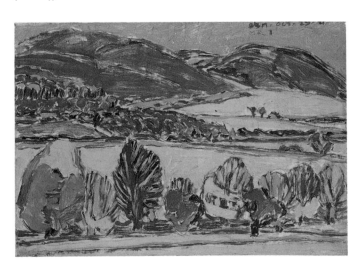

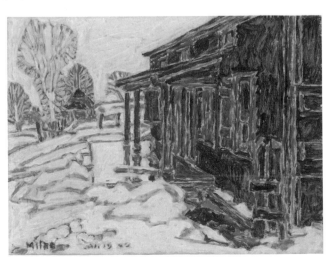

sized textural differences and how to enlarge his use of colour) needed time to float freely in his mind before they could be sorted out and applied – the usual, if occasionally frustrating, pattern in Milne's development.

As 1922 arrived, Milne's ability to articulate his ideas, or to achieve on canvas what he had in his mind, was at a stalemate. Since his return to Mount Riga he had managed about twenty successful works and another twenty that did not long withstand his critical scrutiny. January was devoted to diverse and absorbing experiments, but at the end of the month Milne obliterated most of these in a painting-out spree. He was using mostly 30.5×40.7-centimetre (12×16-inch) canvases and began to feel, as he wrote to Clarke, that he was using oil 'freely enough now to do a little thinking in the medium.'[17] In January he painted *Clarke's House after Snow*,[18] the first work in which the thrusting rectangle of the house butts in from the edge of the canvas. About this time Milne also started work on *Corner of the House II*, a painting that uses the same motif ('the bare, straight-lined side of the house intruding from the side of the picture'),[19] and that, like *White, the Waterfall*, was fussed over for a long time – Milne did not finish it until

Corner of the House II, begun January 1922 and completed January 1926, oil, 46.4×55.9 (18¼×22)

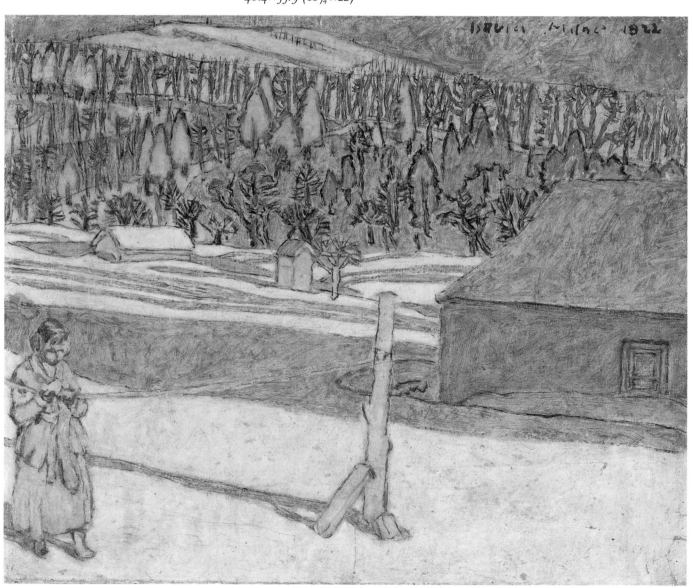

1926. *Corner of the House II* was another of Milne's deliberate attempts at a major painting that would contain a summary of his ideas, but much as it may fulfil or even exceed our expectations, it never fulfilled his.

One painting that did measure up to Milne's exacting standards was *The Hillock*. Milne wrote a long note about it and how he surmounted the cold of 23 January 1923 to paint it:

Have rarely felt colder when painting. Hands, feet, head and face cold. In spite of stamping, blowing, turning to the sun and frequent short jumping excursions I felt cold throughout. I finished just as the sun disappeared below the peak at my left. Gathered my tools, and though still uncomfortable, I didn't mind the stumbling home. I was cheered by the thought that, in finishing, I had at least conquered the cold, however I had fared in my tussle with art.

The picture may in a far-off, subconscious way be influenced by an old favourite of mine – the low relief, Return from the Land of Punt, in the Egyptian rooms of the Metropolitan Museum. The bands of shapes and the red colour as well as the line treatment possibly are what recall it. The drawing is decided, particularly in the two upward-bent bands. The smaller shapes are set down so that they are seen clearly, and are unusually varied. Differences in shapes and shape-groups are slight but decisively marked. This is one of the few drawings that I feel no desire to add to or subtract from.[20]

The Hillock rewards those who read it closely. It is not only the decisive brush work that is thrilling, but the drawing of the various shapes in trees, rocks, hills, and clouds. The invention of the shapes is Milne at his best; everything is 'acted on,' to use his phrase, and transformed from what it is to how he sees it without losing its identity. The hillock's profile echoed by the mountain's profile, the major divisions of the canvas, the rich yet restrained colour, the variety of the tree shapes – all are masterful. As one reads it, shape by shape, Milne's sensibility can be seen filtering the hieroglyphs of ancient Egypt. It was perhaps no coincidence that the tomb

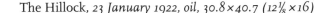

The Hillock, *23 January 1922, oil, 30.8×40.7 (12⅛×16)*

of Tutankhamen had been discovered two months earlier, precipitating a mania for things Egyptian throughout Europe and North America and recalling to Milne a favourite work of art.[21]

The fact that Milne produced several successful paintings in this period, works that satisfied even his critical eye, did not prevent him from experimenting with new techniques, nearly all fruitlessly, as it turned out. He drew in the paint with the handle of his brush, scraped and incised with his palette knife, laid his paint in layers to develop textures, rubbed tints into the paint while it was still wet, mixed new colours, and tried smearing watercolour into a fuzzy blur – all efforts to enlarge his vocabulary of expression, the sort of thing that many artists (J.M.W. Turner, for example) often revert to. These trials produced a few secondary pictures, but no durable ideas and no change in his methods that he could pursue.

Through this period of reassessment Milne continued to type up his painting notes. Clarke had encouraged his writing by suggesting that he undertake a book about art.

Is it not curious that with all the literature on painting there exists little or nothing about the actual doing of it[?] No catalogues of what so and so thinks as he proceeds to the place of business. No discussion of why he picks this particular spot instead of the thousands of others he has passed en route. No description of the unfolding of an idea as one develops the picture, nor the selection or rejection which goes into the making of a good one. There has been something of this in many of your letters to me, but in published literature little that I know of treats this, the best part of painting. There is a chance for David Milne, the writer.[22]

Clarke's urging must have inspired Milne, for his subsequent notes are bulky by Milne's usual standards: he began to write an outline for a book that covered the usual subjects, such as composition, colour, line, and texture, but with suggestions for defining them in his own unique way. On 1 March 1922 he wrote a long entry on his 'painting day,' the first of three such descriptions that he would write during his life. The painting described (not titled) has not been located, and was probably destroyed by Milne soon afterwards, although it may be *Mountain Road*, the only 30.5 × 40.7-centimetre (12 × 16-inch) canvas that even vaguely matches the description.

While I was stretching a canvas Patsy fixed up the knapsack with lunch, heavy mitts and felt boots. I fastened my canvas to the paint box, put on sweater and overcoat, and, with easel and paint box, started out. I walked slowly past the yellow house and up the mountain. My thoughts, mostly, were of everyday affairs, occasionally conscious of a momentary interest in the shapes of things that I passed, the trunks of three dead chestnuts and the snowy road at the top of the first slope, for instance. Occasionally I stopped to look over the valley, or back on my trail, then on again slowly, and the usual thoughts of people and things. Gradually began to bestow more attention on things I passed, thinking how the patches of snow with the tree-covered hillsides beyond would work out in painting. Began to be conscious of a working mood creeping over me, a concentration on painting problems, to the exclusion of wandering thoughts; conscious not only of an increase of attention but also of a growing will, a feeling of pressure within me that would lead me to unify the objects I was seeing, to reduce them to a common range, for instance to keep the canvas

Wet Gray Hill, *7 or 10 February 1922,*
watercolour, 28.6×39.4 (11¼ ×15½)

mostly black with slight markings of shapes with color, or to keep within a very narrow range of two-textured white, with accents of color.

Then I came on a subject that stirred rather more than the usual interest, stopped and set down the paint box to consider how it would work out, where it would lead to. I went over it pretty fully in my mind – patches of snow on bare ground, a large broken apple tree with violet, bronze, green and red in its trunk and limbs; behind it, at the edge of the snow patches, a row of alders, very irregular, and among them a farther apple tree, brown; beyond that a snowy tree-textured hillside.

Impressed with the prevalence of brown in the whole thing. Walked sidewise a bit to see whether the big apple tree would hide the peak beyond it. Stepped back to see a larger proportion of snow patches. Everything was promising except the irregular row of alders, which would require a lot of simplifying. I walked round a little, leaving my things in a heap on the ground; I wanted to see whether some of the other old apple trees were in a setting that did not include a monotonous row of alders. Where this was the case other things were missing, the snow patches, for instance. I went back to my first location and went into things a little farther. I studied how the scheme would join up with the work I have been doing during the past few weeks. I decided to use the heavy white texture for the big snow patches and the scratchy texture for the more detailed distant hillside, to make brown the prevailing color instead of black, and to interline it with the local colors.

Started to work, set up the easel, opened the paint box, rubbed a tint on the canvas then with pencil arranged the shapes on canvas partly to get them all on in order, partly as an aid to thought, to realize the shapes more fully.

After that I drew them in more detail with black. At this point difficulties began to crop up, shapes were becoming awkward, thoughtless. Warned by experience, I stopped work, left things standing, and went down the hill to a sheltered opening where I had had lunch before. I broke dead apple branches and made a small clear fire, went 200 yards away for water, made coffee and ate

Rocks in Spring, *7 March 1922, oil, 45.8×56.3 (18×22⅛)*

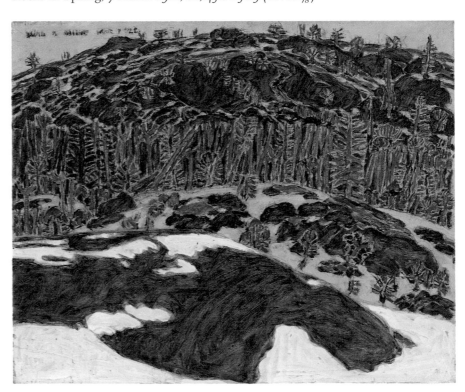

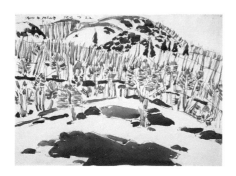

Melting Snow, *7 or 10 February 1922,*
watercolour and ink, 28.0 × 39.1
(11 × 15⅜)

my two meat sandwiches and a piece of cake. I held my feet toward the fire while I sat and ate, cold, overcast; my thoughts partly about painting and partly about trifling things. Scribbled a few painting thoughts on the margin of a piece of newspaper.

Went back to painting. Started to put on color. The grass around the snow patches appeared greenish yellow, but for simplicity I painted it in with the ground color red. Then rubbed it out and substituted the two white textures. The drawing with the color was rather fumbling so to make the shapes more decisive I scratched between the colors with a palette knife – suggested by previous uses of this palette knife texture. This led to the first creative thought of the day, a texture obtained by a broader scratched line than I had used before. The bands of trees on the hillside beyond soon suggested another new modification of the palette knife texture, thin scratched lines across bands of red. Went over the picture, simplifying, separating, binding together, no new developments. About 2:30 finished, packed up and started home slowly. Stimulated by painting, I thought of further painting developments, trees, particularly a dead chestnut, snow patches, suggested further texture explorations.[23]

Early in March, after a month's hard work, Milne finished *Rocks in Spring*, a superb and complicated painting. Milne first analysed the subject in several small works, studies in watercolour, in ink, and in oil, an almost unprecedented way for him to work. The large, definitive rendering in oil was, like *White, the Waterfall*, reworked many times, beginning on 8 February, before its difficulties were at last resolved. Milne completed it, finally, on a permanent easel of sticks he had erected at the site: 'spent a long, cold, continuously working day [9 March], finished about four o'clock.'[24]

Milne believed that these paintings that taxed his time and energy so heavily would, in the end, be more highly regarded than those he completed quickly. He was partly right, for those born of his extended worry do stand apart as direction markers along his path; but also partly wrong, because many of Milne's most memorable paintings, even from a formal point of view, were executed in a brief, concentrated hour or two, sometimes even in a few minutes. Both ways of painting had their place throughout Milne's life and career.

Milne's concluding paintings for the season were several versions of *New England House*, an abandoned yellow house that was once part of the old mining village up the hill from the Sherman place: Milne painted three watercolours and an oil. The simplicity of the subject – similar in composition to that of *Corner of the House* – suggested to Milne that this would be a good subject to try as a colour drypoint, a way of creating an image he had been thinking about for some time.

A drypoint is a sort of etching or intaglio print in which a needle or burin is used to scratch lines into a prepared metal plate (a smoked or waxed surface allows one to see what is being drawn), which is then printed by inking the plate and running it through an etching press, thus forcing the ink out of the scratched lines onto the paper. The only difference between drypoint and etching is that in etching the lines are given a different quality by being bitten into the metal by an acid bath (sulphuric acid), and the wax keeps the acid restricted to the drawn lines; in drypoint the line is ploughed out by the burin and throws up a burr or furrow that gives the inked image a softer, fuzzier quality. Milne had done both etching and drypoint work in New York, during or soon after his Art Students' League days, so he was thoroughly familiar with both processes. The gestation of Milne's colour-drypoint idea was slow, for putting 'colour' and 'drypoint'

House at Mount Riga, *23 March 1922,*
Milne's first colour drypoint, 9.6 × 14.6
(3¾ × 5¾), for which he used a
washing-machine wringer
as a press

together was something that no one had yet done, or even considered pos-
sible. Drypoint had always been a one-colour medium: black ink on white
paper. Not so for Milne. In a note of 1920 he had made a passing reference
to a soft reflection with a 'rich velvety line ... very much like a drypoint
line.'[25] Then, in his painting note of 3 November 1921, he wrote:

My present way of working in watercolor might possibly be developed into a
system of colour etching ... Scratch with dry point or etch the first plate as I
make the double line drawing in watercolor and print in black. On the second
scratch – keeping well within the black containing lines – what is to be done in
red, third yellow, fourth green, fifth violet. Suggest a scraped dry point line or a
dry, etched line for black plate and a wiped etched line for other plates.[26]

In the course of the next few months, Milne thought more about this
possibility and worked out in his mind the details of how he might do it.
Early in the new year he finally got ready to try out his invention. His
account of his first foray into colour drypoints is worth quoting in full:

We were at Clarke's place at least two winters. I think it was in the second
winter that the drypoints in colour were started. I had tried etching and drypoint
in black and white years before in New York so I had a little experience with the
medium, though I had never seen anyone make etchings. I had no press and
took my plates to a plate printer on Vescy Street, where I learned something
about printing. I have always had a strong interest in texture, that intimate
combination of form and colour. Even before this, at Boston Corners and at
Dart's Lake, I had some adventures in watercolour textures. It was, I think, the
possibility of further experiences with texture that drew me into the etching
enterprise. Drypoint particularly, because of its possibilities in soft and harsh
line, was an attractive field for experiment.

I had been thinking of it for several years and had talked it over with Clarke.
He didn't see much in the idea then, perhaps he thought it wasn't well to
venture into too many mediums, which was true, for me at least. A long quiet
winter at Mt. Riga seemed a good time to try my plan out. I got some pieces of
hardware store copper and zinc at Millerton and cut them into small plates.
From my earlier experiences I knew how to prepare a wax for coating the plates
and how to make them so I would have a dark smooth surface to scratch into. I
made a drawing and traced it on the dark surface of three plates. Then with a
large sewing needle fixed in a stick I scratched the first plate. I think the subject
was Clarke's house [it wasn't], probably done from an oil or watercolour. I had
no press but thought a clothes wringer would do for experiment. We had no
clothes wringer so I borrowed Mrs. Kaye's. I printed the first plate and with it as
[a] guide scratched some more detail on the second plate, to be printed in a
different colour. So with the third. I was now ready to try the printing in colour.
Each plate was heated, coated with colour, the surplus buffed off with a cloth
and printed, one over the other on the same paper. It worked. The result was
not unlike Dart's [Lake] watercolours, at least gave promise of something of that
kind. There were difficulties but most of them seemed to come from lack of
things to work with. The plates were not quite the same size and I had no way of
printing one exactly over the print made by the previous one. All I could do was
hold the paper in one hand and tip the plate as carefully as possible into the
slight depression made by the first one. It was a long time, several years, before
I worked out a way of registering the printing exactly. In the meantime the
difficulty wasn't without good results as well as bad. Since it was impossible to
make the colour from one plate lie over or parallel to those of another, I didn't

attempt it. I scratched the plates more freely so that lines of one colour crossed over others at a slight angle. This avoided the difficulty of registration and at the same time gave the prints a softer, more varied colour. I did a few more subjects but the process never went beyond the purely experimental stage at Mt. Riga.[27]

From this moment, until he got a press as a present from Clarke at the end of 1926, Milne spent no more time on drypoints, although he continued to think about them. Occasionally he took a prepared plate with him when he and Clarke went on sketching hikes. However, his serious work in the medium, even though the invention had now been proved, had to await a later moment in time when a press, fit subjects, and a refined technique could bring the idea to its full potential.

Milne laboured conscientiously at his painting in the winter of 1921–2, following the productive summer at Dart's Lake, but the results were mixed and showed some confusion. More than fifty works survive, a reasonable total in view of the many that were painted out, and considering that the drypoint trials occupied nearly a month. But those that remain are a strange assortment. A few are strong and courageous works; a few were painted in an established style, and therefore added no new thought; several are well below par. This was a season of proportionally more bad pictures than almost any other (or perhaps fewer were destroyed). The wild and irregular experiments Milne indulged in, although they later contributed to other works, created curious hybrids. The period as a whole has little cohesion. Everything seems disconnected as Milne jumped from one thing to the next and back again.

Perhaps one problem was that his relationship with Patsy may have deteriorated further, although he wrote nothing about it. What certainly did affect him was having two of his six submissions rejected by the Philadelphia Water Color Club; being rejected or 'fired' by the Montross Gallery and by the Daniel Gallery, presumably from group shows; and being excluded from an exhibition of the New York Water Color Club, an organization for which he had been on the Board of Control just six years earlier. After these multiple disappointments an exhibition organized by Professor Midjo at Cornell University in March 1922 was the more consoling. About sixty unframed watercolours, covering the span of Milne's work to that time, were shown.[28] Midjo undertook to sell what he could 'at real, not exhibition, prices,' which would have been $20 or $30 each at the most. Some good earlier works may still survive from the show, but efforts to trace them have been thwarted by a dean of the School of Architecture who, during the Second World War, donated all the school files to a paper drive.

Milne's later recollection was that a large number of paintings were sold at Cornell and that he had netted $700 or $800, but his memory may be more wishful than accurate. There is no contemporary reference to so many sales: at such modest prices, twenty or thirty paintings would have had to have been sold. Moreover, the total would have been enough to support the Milnes for a year at the level at which they were then living. The exhibition, however, did introduce Milne's work to a Buffalo architect named Robert North (who was lecturing at Cornell), and through him to a lawyer, Maulsby Kimball, of Buffalo, and to Spencer Kellogg, also of Buffalo.[29] The Kimballs, especially, bought work from time to time and became good friends of Milne. In 1923 North paid $105 for five paintings that he had selected at Cornell. The collective buying over the years by these patrons may have added up to the amount Milne remembered, but the fact that by

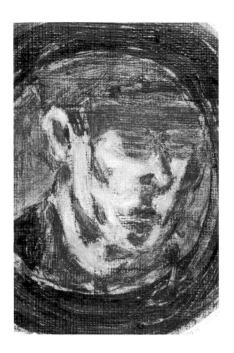

A detail from Mirror, *28 February 1922, oil, 30.5 × 40.7 (12 × 16)*

the middle of April 1922 Milne had stopped painting pictures and was in the Adirondacks painting signs and soliciting poster and stationery orders for van Harvey, a printer at Millerton, indicates that the Cornell exhibition had not been lucrative.

By May 1922 the Milnes were back near Dart's Lake, staying at Big Moose Station, three kilometres (two miles) from the lake, and scouting the possibilities of running a tearoom for the summer. They soon reached an agreement with people named Kinne to run the Little Tea House on Big Moose Lake, near the Glenmore Hotel. The cost of this particular concession was $300 (Patsy remembered $350), half of which Milne borrowed from Clarke. The tea-house, a five-room cottage on the lake, served refreshments – snacks, soft drinks, ice cream, and tea – and sold candy and souvenirs. Patsy made pennants. They hired Mrs Osterhout, a woman Patsy had known at Dart's Lake, to help with the cooking and baking. Ice cream came in from Utica. Patsy described the preparations and daily operations in her memoir:

Dave got several large packing boxes and cut them up – making small tables – painting them roughly, then putting the colour on (like a 'Roman' ribbon), waxing them etc. For legs, he used small birch trees, cut to fit. We had very little money and had to ask Clarkes for one hundred and fifty dollars to get started. He loaned it, for which we were very thankful ... [Dave] began making 'signs' (to match the tables) with white 'mats' and frames, and carried them all the way to Old Forge (14 miles) where he put them up in different places along the road, and in some stores. We worked hard to make it attractive. Kinnie [*sic*] loaned us a phonograph – and Dave took some yellow birch, about one and half inches thick, and made a frame-work about five feet high, on which he put several shelves for candy boxes etc. Clarke's sister in Springfield made delicious chocolates etc. and was willing to send some, to see how they would sell.

The first summer, a woman we had known at Dart's helped me. She made cakes and cookies, but the next season we could only afford to have one or two high-school girls, and I made the cakes etc. If we were very busy in the afternoon, Dave would help out. Ice cream had to be carried up from the dock – also kept well packed. There was plenty to do. Launches came to the dock from the hotels – there was no road in – only a 'trail.' We often had quite a crowd of people – also in the evening, and they seemed to like it all. It was quite a success, but the main trouble would be when it rained – and no one came, also the shortness of the season. We paid the rent, and expenses, and Clarkes, and had about two hundred dollars left.[30]

The tea-house provided living quarters for the Milnes and the help, and had a pleasant wide porch that overlooked the dock and lake. Presumably tea-house management was an acceptable occupation for Milne, since Patsy shared much of the work, and they repeated the venture a year later. However, given Milne's stubbornness in raising onions twice without financial success, there is no telling how successful this venture was. Patsy's reported net profit of $200 for the summer of 1922 may have been largely because, after arranging the Milne exhibition at Cornell University in March 1922, Professor Midjo and his wife stayed with the Milnes at the Little Tea House for the whole summer of 1922 as paying guests. Midjo painted every day and his wife practised the violin all day in a tent up the hill.[31]

The tea-house business, whatever responsibilities Milne shouldered, clearly interrupted his painting, because from mid-April until October 1922

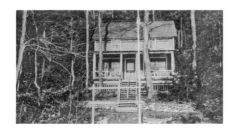

The Little Tea House at Big Moose Lake, run by the Milnes in the summers of 1922 and 1923

Stationery for the Little Tea House at Big Moose Lake

The Blue Dragon Tabletop, *1923, oil on wood, 72.3×105.1 (28⅜×41⅜)*

he painted only one watercolour, even though he told Clarke that he intended to get some work done during the summer. In May his mother died, an event that must have added to his sense of being derailed. She had been a strong influence on his life, and his reaction to her death could not have been casual. There is no record that he returned home for her funeral (or for that of his father a year earlier), although it is possible that he did so. What his thoughts or sentiments were about these emotional events in his life he did not record.

Milne may have expected that running a tea-house would give him time to paint, while Patsy poured tea and passed cookies. But there were signs to make, decorating to do, a garden to plant and tend, and other distracting chores. There is only one brief summer letter to Clarke, an indication that Milne's creative life was dormant. With the exception of his early army service, this was the longest break Milne had ever taken from painting.

By the beginning of October 1922 the Milnes were back at Biddiecott – the name Clarke gave to the house at Mount Riga when he bought it from Howard Sherman that March. For Clarke and his family the place drew them close to his New England roots and to his mother, who lived in Hartford, Connecticut. Clarke loved the area as Milne did, and his wife Anne started a garden there that soon became their pride and joy. Patsy wrote later: 'Mrs Clarke loved the garden and they had a great variety of vegetables and flowers – she worked at it all summer.'[32] The Clarke children needed a summer home to play in and at Biddiecott they got it. Clarke invited the Milnes to live in it during the winter on the same terms that Sherman had set out: free accommodation in exchange for repairs and upkeep. He also asked Milne to build a flat-bottomed rowboat that was used by the Clarke family on Rudd Pond, between Mount Riga and Millerton. Milne cheerfully obliged, although he was never able to test the craft on the water. He also found time to earn a little money building a garage for a woman at Copake.

Milne made a fresh resolve that fall and started immediately to work at his painting after the sabbatical summer, making an effort to be methodical and professional, as he had at earlier productive times. He began numbering his paintings (using exactly the same system and numbers as the previous year, causing the historian some frustration) and writing notes for them; then he began to leave a space to insert the number later; finally the chronology was abandoned altogether. No painting notes were written for the later 1922 paintings, and the little correspondence that exists does not chart Milne's progress through the winter. About forty works were finished before he returned to Big Moose Lake in May 1923, a significant slackening of the pace of previous years, even though many paintings may have been destroyed.

The paintings of October 1922 were solid and strong, spare in line, and rather more vivid in colour than Milne had allowed himself for some time. The first challenging new thought came when Milne painted *The Black Cabinet* in watercolour. Black had not been given such prominence in some time, except as an outline. Since 1920 most of Milne's attention had been focused on finding new purposes for white and light values. In fact, the watercolour *The White Cabinet*, of approximately the same time, may have sparked Milne's interest in this theme, and in the idea of dealing with it in the same way but with totally different means. The question now raised in his mind was whether he could get the same sort of delicacy, lightness, and well-articulated power out of black. He was slow to explore the issue at

The Black Cabinet, *1922, watercolour,*
35.3×42.9 (13⅞×16⅞)

The White Cabinet, *11 October 1922,*
watercolour, 35.3×50.5 (13⅞×19⅞)

this time, but whenever he worked with black through the 1920s his paintings were enriched and made more powerful.

Milne wrote to Clarke in November that he had a tendency 'to separate color and values, to use them as separate weapons ... in general to use changes of color for minor separations and changes of black and white [values] for major separations.'[33] In one of his oils in the fall of 1922, *Brown Hillside Reflected*, Milne introduced a new value, a soft, creamy brown. He planned to repaint the work but, as he wrote to Clarke, he wanted

to use instead of the brown color and value, a value halfway between the black and the white, but without its color. Then I would use the brown as a color in very small quantity and for minor differences. Values: white, light gray, dark new gray, black. Colors: (all one depth) violet, blue, red, brown and green. Sounds very simple and so it is but only arrived at after blundering into a great many difficulties.[34]

Milne then sketched in his letter a landscape with dark hills at the top, a band of fields in a second – or gray – value, and a row of trees in the immediate foreground in the lightest value. His commentary continued:

In the area of second value, the detail – roads, other contours, small trees and buildings – was marked with colors of the same value as used elsewhere, and these scrawly shapes showed too much detail for their importance, against the light ground. I was unwilling to paint in the ground in brown, following nature, because I felt it was an extravagant use of color – that is the amount of brown color used was out of all proportion to the amount of blues, purples, greens, reds and yellows. Now if I use a darker value (gray) instead of the second lightest, the detail will not be too prominently marked and at the same time will be done with economy of color. The last three sketches have been bordering on this but it took today's failure to make me conscious of the solution.[35]

The tints worked into the white during the previous winter were obviously not satisfactory to Milne, for they were neither colour nor value but something in between. In some pictures they had worked well enough, but as a principle, and as a means of continuing the development of his painting, they represented a cul-de-sac. The watercolours of the fall, such

Valley at Mount Riga, October, *25 October 1922, watercolour,*
38.1×55.9 (15×22)

Clarke's House, Late Afternoon, *2 February 1922, oil,*
30.2×40.7 (11⅞×16)

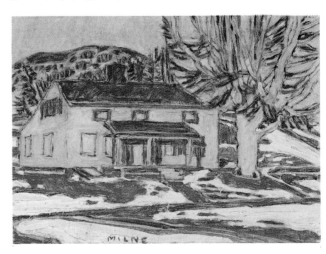

James Clarke, Biddiecott, *c. 1922, watercolour*

Brown Hillside Reflected, *1922, oil, 30.5 × 40.7 (12 × 16)*

as *Valley at Mount Riga*, although looser and more colourful than any since Boston Corners, did not suggest a new way either, except for reconsideration of the strong black value that perhaps prompted the use of a more forceful and deeper gray.

The advance Milne made that winter was, therefore, in elevating gray values to a major role in his work, and in suborning colour to a minor or supporting role. Where a colour was used as a value instead of a hue – as the rusty orange in *Clarke's House, Late Afternoon*, or the blue in *The Curtains* – it is always close to gray in effect, and to a middle value in its depth. Milne did not, or was not ready to try to, harness a bright colour as a value. That episode in his odyssey was still years away, at Six Mile Lake.

Once April 1923 arrived Milne again departed for the Adirondacks, seeking work as a sign maker and procuring orders for the printer van Harvey. By May the Milnes were back in the tea-house business at Big Moose Lake. To save money two high-school girls were hired in lieu of Mrs Osterhout, who had helped Patsy the previous year, but this meant that Patsy had to do all the baking. Patsy added decorated cushions to their stock of available merchandise, and Milne added charm to the place by decorating the tops of two tables, one with a running deer, which visitors dubbed a kicking mule, and the other with a pattern based on their blue dragon china. The Midjos visited in September.

But for all the Milnes' efforts, the holiday season was not good for business. Their profit was much less than they had hoped for, only about $40

Lanterns and Snowshoes, *4 September 1923, watercolour, 38.1 × 55.0 (15 × 21⅝)*

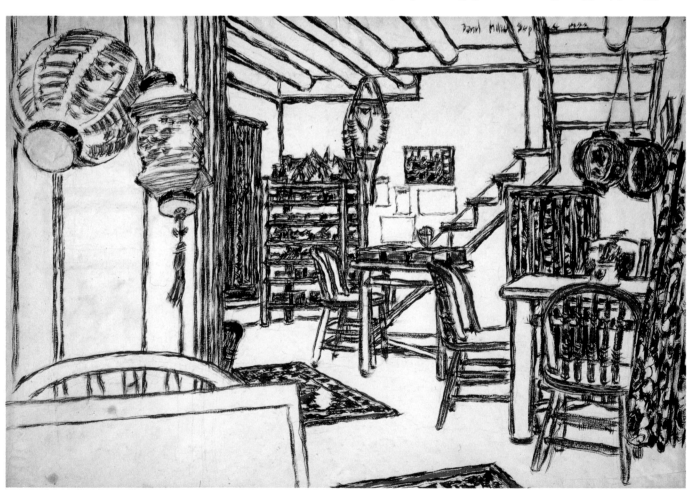

Verandah at Night II, *21 August 1923,*
watercolour, 38.5×54.3 (15⅛ ×21⅜)

Verandah at Night IV, *1923, water-*
colour, 38.8×56.6 (15¼ ×22¼)

after expenses, as Patsy recorded.[36] What irked Milne most of all was paying the concession fee. To escape it he could build his own tea-house, and he and Patsy would have a place to live in year-round as well. All he needed was to earn enough money for the project. With this in mind, Milne decided to 'go up to Ottawa early in October to see what [the] prospects [were], and try to get a start.'[37] His ambition was twofold: to make enough money to build a teahouse/cottage, and, using his war paintings, to introduce himself to the Canadian art community.

Unlike the summer of 1922, when he did no painting at all, the summer of 1923 at least saw Milne dabbling at it from time to time. By the end of September he had finished 'about 6 oils and 12 watercolors.' The most striking of the summer's works are the few night views from the verandah of the tea-house looking toward the dock and the lake, such as *Verandah at Night* II AND IV. The blackness of the night sparkles from the light of the Chinese lanterns suspended from the porch and strung down to the dock, and the porch poles and beams slice through the picture plane and the night. Another superb work from this period is *Lanterns and Snowshoes,* an interior of the Little Tea House. An exquisitely conceived, simply painted work, it is full of rich detail and carefully placed rhythms as one's eye moves from chair to chair, from table to table, from lantern to lantern. The way in which the space is divided and occupied is simple, complete, and faultless. The foreground chair, interestingly, holds Milne's easel, making this work one of his portraits of a painting place.

The rest of the works from this period, however, did not add much to Milne's stock of ideas or to his achievements. He was marking time, perhaps because he could get away only sporadically to paint. Beset by the anxiety of moving often and looking for work in 1922–3, of trying to make a meagre living by working when he wanted to be painting, Milne was constantly frustrated. And there was another factor: Milne and Patsy were growing further and further apart. Each went a different way in October.

Professionally there was more to worry about. The recognition and financial reward of the Cornell University exhibition could hardly compensate for the indifference Milne had met with elsewhere: he had been snubbed by a number of the societies and galleries where he had formerly exhibited. Clarke tried to shore him up by reporting that he, too, had been turfed out of the New York and American watercolour shows and joined 'the elect, the Paul Cézannes, Edward [sic] Manets, Claude Monets and David Milnes.'[38] But Clarke, increasingly busy with his own career and family, did not write often and failed to relieve Milne's creeping sense of frustration. Hobbled by poverty, indifference, and neglect, Milne didn't know what else to do except try to carry on and continue to give as much priority to his painting as he could, notwithstanding his failure to excite others with his accomplishments.

CHAPTER EIGHT

Winter Carnival
Ottawa
1923–1924

MILNE MOVED TO OTTAWA in early October 1923, without Patsy. The reasons he gave for this relocation, at different times or to different people, were various. But his underlying purpose was to gain a foothold as an artist in his native land and somehow earn some money, 'in the hope that a permanent return to Canada would be possible.'¹

On his arrival in 'the Land of Promise,' as he half hopefully and half sarcastically called Canada in his later memoir, Canadian customs officials impounded the packet of paintings he had brought with him ('I don't remember how many there were, maybe fifty, maybe a hundred, my treasure chest – hope chest really') and forwarded them in bond to Ottawa, where he was told he would have to pay several hundred dollars duty on them before they could be released.² This high-handed action was perhaps an omen that Milne should have heeded – nothing was going to be easy. Certainly it was a shock to the prodigal son who only four years earlier had been commissioned to do as many paintings for the Canadian War Records.

The collector was very nice about it though. He said he would let me have them to take down to the National Gallery – in trust. I took them down and met Mr. Eric Brown, the director, and Mr. McCurry, the secretary. They looked over the pictures, set them up on a chair and looked at them one after another. They were very pleasant and seemed interested. All they knew about me was that I had worked for the War Records. They offered to select a few and recommend that they be purchased for the Gallery. They would have to be approved by the Gallery Board. Unfortunately for me purchases for the National Gallery are not concluded off hand. I was to make many trips to the Gallery during the winter to see if the board had met. It hadn't, or at least didn't, pass on my pictures until early spring. Still, I have had a friendly feeling for the National Gallery ever since. They had done more than anyone else for me, except Midjo.³

As soon as he recovered his pictures, Milne matted six of them and took them back to the National Gallery to enter as candidates for the vast British Empire Exhibition scheduled for 1924. This was one of his stated reasons for going to Ottawa, although he might as easily have made his submission by mail. Another and more substantive motive for targeting Ottawa was to persuade Eric Brown (1877–1939) to buy a block of his paintings, possibly all the ones he had with him. This meeting actually took place in November, not immediately upon his arrival in October as Milne recalled in the passage quoted above.

When Milne first arrived in Ottawa, travelling with a friend – the Millerton printer van Harvey with whom he had hiked over Mount Marcy

at Lake Placid – he stayed at the old Queen's Hotel on Sussex Avenue, close to the market. Then, when van Harvey left a few days later, Milne moved into a $3-a-week room in Lower Town. By November he had found a studio/office/apartment in the Butterworth Building [4] at 197 Sparks Street near Bank; the rent for Room 36 was $16 a week.

This isn't a bad building even though there are artists on the top floor. Elevator. 3 storeys high. Pretty well finished, newly painted and varnished. My room faces the west, large window and two more large windows at the inner side, lighted from large skylight. My view is mostly rectangles with a glimpse of street at the bottom and a streak of distance at the tops of the rectangles. There ought to be fine sunsets above that.[5]

As usual Milne set about to adapt his new home for work. The janitor supplied some tools and boxes, and for $2 Milne bought the partitions in the office from the previous tenant, a soap-powder vendor, and built a durable easel that he subsequently used 'for many years' and a storage box that doubled as a seat during the day and a bed at night. Although theoretically no cooking was allowed, Milne had an electric hotplate and managed to cook simple meals (oatmeal was standard fare), supplemented by occasional visits to a cafeteria: 'The restaurants and cafeterias all advertise regular meals for 35¢ and seem to make good on it. So far as I can see food stuff at retail is just about half what they are at Big Moose. I wish I were ready to retire on my income.'[6] Money was tight and Milne was trying to eke out a small loan that Clarke had made to him at Big Moose. Patsy remembered their having netted a very small amount from the tea-house business: 'We divided the forty dollars and Dave went to Ottawa, while I took the train for Montreal.'[7]

Milne's new studio had neighbours other than artists:

Next to me was the office of the Ottawa Street Railway Employees Union. In the daytime there was a union organizer or secretary but most of the union meetings were at night, and I could follow proceedings in minutest detail in my room. There was a locked door between the two offices and that seemed no barrier to sound. In those evenings I formed a dim view of Street Railway unions. The members seemed to have unlimited faith in the power of words, at least loud words. The proceedings often seemed a sort of pompous play, talk in stilted forms without getting anywhere, to make the speaker feel important, part of something official. The organizer seemed to be a dictator, a tireless dictator concerned with the minutest details of squabbles with the Railway company. Every smallest incident led to scheming for advantage. They provided a kind of sour entertainment for my winter evenings.[8]

'This was one of the few periods when I had more time than I could use,' Milne wrote in his autobiography:

Daytimes were all right. I knew a few people in the building and a few outside it and there were always walks but evenings sometimes went slowly. There were moving pictures but I hadn't enough money to go more than once a week, sometimes not that often. I had good light and I probably got books at the Public Library; then there were the newspapers.[9]

He often took long winter walks of from five to twenty-five kilometres (three to fifteen miles), in the Gatineau hills on the Quebec side of the

Ottawa River and out to the government Experimental Farm, southwest of the city.

One Sunday, somewhere between Pointe Gatineau and Chelsea, a farmer in an old Ford overtook me and gave me a lift. He was on his way back home after taking Prime Minister King from his home at Kingsmere to Ottawa. I explored all the environs of the city and all of the city itself, sometimes half circling it in an afternoon's walk, from Rockcliffe to the Experimental Farm. Deflation after the war boom had left Ottawa looking shabby. There didn't seem to be enough paint to go round. Many new Government buildings were planned but not started and buildings on the ground where they were to stand were allowed to go without much attention, had the abandoned look of slums. There was a firm of architects in the [Butterworth] Building and the biggest job they had on hand was remodelling a store window.[10]

Of the other artists who had their studios in the Butterworth Building, one was the portrait painter Ernest Fosbery (1874–1960):

At that time he seemed to be doing portrait commissions only. His ideas about paintings were far away from mine, but we weren't too far apart for one to understand what the other was talking about. On other subjects we were closer than on art. He had been a major in the First World War, and I never tired of listening to his stories about his experiences and observations, all funny and all wonderfully told. He had an idea that the younger Ottawa painters considered him, as he expressed it, 'old hat.' Maybe they did, but I didn't classify my artists by hats. So far as I was concerned they could paint as they liked, but were they interesting? Fosbery was all of that, no matter what he chose to talk about.[11]

Graham Norwell (1901–67) also worked there. A widely exhibited landscape painter, who was then approaching the height of his career, he gave parties and was often in the company of the artist Harold Beament (1898–1984). They both worked for the government, colouring slides in the Natural Resources Branch of the Department of the Interior. Also working in the building was another artist, Yoshida Sekido, who painted in a traditional Japanese style on silk stretched on the floor or on rice paper with sumi ink.[12] Dressed in a traditional robe, he would demonstrate Japanese painting methods for visitors.

While he waited for his approach to Eric Brown to bring results, Milne tried to hatch other schemes. The first was to establish a school or a teaching studio, since Ottawa had none. In a letter to Clarke he pledged an immediate start, but the subject was never referred to again; a few pages of curriculum notes and a sequence for instruction are the only remnants of the idea.[13] Patsy remarked that 'Dave was having a difficult time in Ottawa – he could not seem to get a "class" started.'[14] Milne also hoped to earn income and recognition by persuading Canadian companies to use his war pictures, housed in the National Gallery, for reproduction in advertisements, but he never decided on any corporate prospects and so did nothing more. His approaches to both of the city's newspapers about publishing articles he thought of writing were not promising: 'Not much encouragement, but not actually forbidden to try,' as Milne wrote to Clarke.[15] Milne was eager to accommodate himself in any way that might give him some income and a tenuous toehold in his own country. But he started out alone, without contacts, knowing no one.

November, however, brought good news and modest encouragement. Two of Milne's six paintings were accepted for the Canadian section of the British Empire Exhibition, a huge assembly of Canadian painting that was going to be shown in Wembley, England, in 1924. One of them was *Across the Lake 1,* a watercolour of 1921 that Milne liked and considered to be one of his seminal works; the second was *In the Cabin on the Mountain 11* (the others submitted and rejected are unknown). Robert North in Buffalo had selected for purchase five paintings from the Cornell University exhibition the year before and Christian Midjo, who had arranged the show, now transmitted the money: $100. In addition, Brown at the National Gallery agreed to recommend a purchase of Milne's paintings to the board, although it was not going to meet for several months. The *Ottawa Evening Citizen* published, and paid $5 for, an article by Milne about the public's reading of war books, which he had researched by consulting lending records at the public library. The Ottawa Art Club invited Milne to give a 'three hour exhibition and a one hour lecture.' It was his first public lecture and he prepared for it carefully, as he wrote to Clarke, even to the point of writing out everything he wanted to say just in case his nerves or his memory failed him. His earlier experience as a teacher came to his aid, however, and although he was nervous at first, he was able to proceed without notes. He was flattered that the thirty-five chairs set out for the occasion were filled and that more than fifteen people had to stand.[16] He counted the evening a success, although no sales ensued.

Milne had begun to meet people. Brown liked him, and in addition to selecting his paintings for the Wembley Exhibition and for the National Gallery to purchase, he urged others to look at his work. Brown and H.O. McCurry (1889–1964), the secretary of the gallery, both made a point of mentioning Milne's virtues where it mattered; they had already helped with the Customs difficulty, and then they prepared the way for an exhibition of Milne's work at the Art Association of Montreal, an exhibit organized at the behest of the chairman of the board of the National Gallery, Dr F.J. Shepherd. They also both wrote letters of support so that Milne could sketch in the House of Commons and around the Parliament Buildings, and be considered for any employment that the government might find for him. Milne became friendly especially with McCurry, but also with other staff members. He met Lloyd Roberts, son of the writer Charles G.D. Roberts; the poet Duncan Campbell Scott and the painter Alfred Meister (1892–1959), whose pseudonym was Paul Alfred, both acquired paintings from Milne.[17]

Patsy visited twice, briefly. She had gone to Montreal, then Canada's largest city, to investigate the tea-house business but by accident ended up acting for a while as a governess for Mrs Hamil, whom she had met at Dart's Lake.[18] In December, however, she was offered work for the winter season at the Lake Placid Club – she had written to them from Big Moose earlier, offering her tea-house experience – and she had left for the Adirondacks by Christmas time.

Amid all these events and activities Milne's painting was stalled. He expected, not unnaturally, that the change of scene would start him off on a new path of exploration. He wrote to Clarke:

If I can stick it out here, I am anxious to see what the change of subject will do. It hasn't done anything yet but I have some inklings – particularly in the direction of night drawings – you remember the one of Patsy and the shack [*In*

the Cabin on the Mountain II] – I tried one at Big Moose [*Verandah at Night* series] but did not get it. I have some thought of doing it over.[19]

He began his working stint in Ottawa with two paintings of the Parliament Buildings and intended to pursue an ambitious program. His initial spurt of activity was promising:

I set about painting and, as long as the weather was good, that went very well. I worked mostly in watercolour. Did one from the roof of the King's Printer's building – with the King's Printer's permission. One of the back of the Mounted Police barracks from the [Butterworth] Building. Two (I think) from Hull – the Eddy pulp mills in the foreground and Parliament Hill in the background. These were in the manner of the Dart's pictures, very much line, with a pronounced use of open and shut spaces.[20]

These paintings were, respectively, *From an Upper Window, Ottawa* (two versions), *Old RCMP Barracks* (two versions), *Parliament Hill from Hull*, and *E.B. Eddy Mill, Hull*; Milne also did three versions of the *House of Commons*. But that was almost as far as he got. Much of what he did in Ottawa was simply tidying up from the summer, finishing some works and repainting others. Two repaintings of the Glenmore Hotel at Big Moose seen from across the lake, *Reflected Pattern I* and *II*, were done in Ottawa as part of a continuing impulse to paint a perfect reflection. These occupied much time, but did not lead to anything that could be developed further. Two small nocturnes of Patsy, *Figure in Black* and *Woman Reading by the Window*, done during one of her brief visits, were part of his intention to explore night pictures, but then he deferred that idea. The Ottawa subjects, such as the Parliament Buildings and the House of Commons, were done in the manner of the last work at Big Moose Lake, which was itself a variation on the Dart's Lake style. Milne's hope that the surroundings would produce a surge of new ideas, new approaches, rapidly diminished; pleasant and satisfying as the handful of Ottawa pictures are, subjects were not

Old RCMP Barracks II, *1924, watercolour, 38.5×56.9 (15⅛×22⅜)*

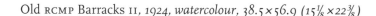

seen differently and so were not painted differently. Milne had reached an impasse, as he himself reluctantly acknowledged when he wrote to Clarke that 'painting has come second to striving for business.'[21]

On 18 December, while he was in Montreal at Eric Brown's suggestion, Milne was invited to exhibit his work in the galleries of the Art Association of Montreal (later the Montreal Museum of Fine Arts). This golden opportunity – burnished with the promise of future exhibitions in Toronto, Winnipeg, and Vancouver – was in fact a blandishment leading to disappointment. Milne threw his energy into the exhibition. He needed a hundred or more pictures, so he wrote to Clarke and Midjo to round up what they could to supplement those he already had on hand. Clarke was asked particularly to look for a large early painting of Broadway that Milne thought was colourful and might sell (this might be *White Matrix*). The Montreal exhibition of watercolours opened on 1 January 1924. Milne prayed for enough sales to teeter him into solvency. After twenty years of painting and exhibiting and his work for the Canadian War Records, he had some reason to be optimistic.

Of the 112 watercolours that Milne sent to Montreal, the Art Association's officers selected 95 for hanging, although Milne stressed that he wished to have even fewer shown and had given his suggested preferences.[22] The fact that only a few of the paintings were matted or framed and that the rest would simply be pinned to the wall may have influenced him. Milne wrote to J.B. Abbott, the Art Association's secretary, that he feared viewers would be surfeited and get pictorial indigestion: 'The more you cut down the number, the better it will please me.'[23] He prepared and sent extensive notes for a proposed talk – quite likely the same as, or a slightly revised version of, the one given earlier to the Ottawa Art Club. However, the lecture was never delivered and the notes were lost, although Milne asked for their return and was hoping to type them up and use them for some other purpose, perhaps as part of the book that Clarke was urging him to write. The only existing documents of the Montreal episode are a handwritten list of paintings from Milne, with titles and prices, and an exchange of brief letters between Milne and Abbott.

The exhibition included works from approximately 1912 to 1923. Prices ranged from $20 to $45 dollars, depending chiefly on size. Milne suggested to Abbott that anyone who purchased four or five works could ex-

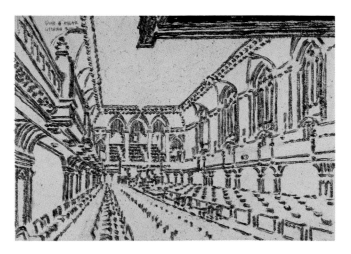

House of Commons, *7 November 1923, watercolour,* *38.8×55.6 (15¼×21⅞)*

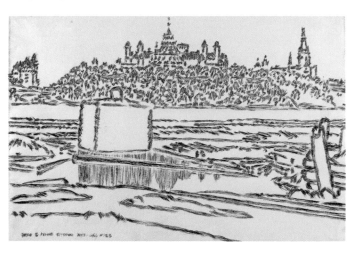

Parliament Hill from Hull, *1923, watercolour, 36.9×54.6* *(14½×21½)*

Figure in Black, *1923, watercolour,*
25.4×19.1 (10×7½)

Woman Reading by the Window,
1923, watercolour, 19.8×20.7
(7¾×8⅛)

pect a 20 per cent discount. According to Abbott, comments about the show were generally favourable, but he thought that 'any new method requires a lot of showing to the public before they finally appreciate it.' And Milne wrote to Abbott to correct one review that implied that the watercolour 'drawings' were studies for more conventional work in oil:

One criticism, or rather notice, has been called to my attention, in which it is stated that the drawings are something in the nature of studies to be used in more conventional things, presumably oil paintings. This is very far from their intention. My sketches for oil are made in oil, and on the spot. They concern themselves with quite different problems from those in these drawings, problems of colour in areas and different values, rather than with line.

On the other hand oil is a comparatively clumsy medium for the expression of line. That is what these, particularly the later ones, are intended to be – compositions in line, and complete in themselves. None of them have been or will be used in the making of other pictures. The simplicity of them is not the result of sketchy, hurried work, but deliberate simplifying, often by redrawing a number of times.[24]

Milne's watercolours – delicate, muted, and spare – did not generally lend themselves to easy acceptance. The Group of Seven's bold colours from post-impressionism and sinuous forms from art nouveau were rapidly becoming the new standards of the time. Even Milne's renditions of familiar sites in Ottawa – the Parliament Buildings and the interior of the House of Commons – found no favour with collectors of what was then contemporary. Canvases by Tom Thomson and A.Y. Jackson, which created a stir at Wembley that year, simply overwhelmed Milne's subtlety and finer sensibility with their flamboyance and size, although one English critic found Milne's work to be 'striking and powerful' and worthy of extended comment.[25] Nor did Milne share the Group's ultra-nationalistic point of view, finding it repugnant to the aesthetic concerns of art. Besides, watercolours were still considered to be inferior to oil paintings. In 1923 the $1000 to $1500 that the National Gallery was paying for major canvases by Canadian artists of Milne's generation was in sharp contrast to the $25 it paid Milne for each of the six of his masterpieces in watercolour; furthermore, Milne's works were purchased merely as 'drawings' – although doubtless with Milne's concurrence.[26]

The Montreal exhibition closed on 19 January 1924. Despite the attractive prices not one painting sold. Milne was crushed. He put on a stoic front to await the verdict of the Arts Club of Montreal, where his paintings were to be exhibited next, but two or three weeks later he learned that he had fared no better there.[27] Nor did he sell any in an exhibition he took part in with the Ottawa Group of Artists[28] held at Hart House, University of Toronto, from 30 January to 10 February, in which he had six works, each titled 'Watercolour Drawing.' Later in the year J.E.H. MacDonald arranged another Milne exhibition in Toronto.[29] He reported that 'there was considerable interest shown in the drawings, but a great deal of silent wondering from the critics.'[30] Nothing sold there either.

After the devastating results of the Montreal exhibitions were known, Milne practically stopped painting. He managed only two more paintings before he left Ottawa three months later, in March: one sketched quickly in oil in Montreal during the winter carnival, *Dominion Square I*, the other a repainting of it made in Ottawa, *Carnival Dress.* In half a year, from October to March, he had completed only sixteen paintings, a dismal record for

him. 'Ottawa developed nothing. Perhaps I felt too insecure, too much disturbed in mind,' he wrote later.[31] Before the end of the Montreal exhibition he wrote to Patsy: 'Painting a little again, but do not feel very settled at it. Too many breaks trying to work out some way of making something [i.e., money].'[32]

In February Milne had to go to New York and Tivoli to untangle some knots in the affairs of Patsy's relatives – another three-week break in his now haphazard schedule. Patsy's Aunt Geraldine, at Tivoli, had been financially plucked by a man she had hired to raise chickens for her, and in New York Aunt Emily, seriously ill, was expected to die. Milne declined to take a job as Geraldine's chief foreman, for he was apprehensive that complications would ensue and that he would not have enough time to devote to painting. His visit, however, allowed him to spend a few days with Clarke. They crossed from Tivoli to Saugerties on the frozen Hudson and hiked to West Saugerties. Milne was able to show Clarke the places where he had painted in 1913 and 1914.

Returning to Ottawa, Milne stopped for a day to visit Patsy at Lake Placid and learned that the Milnes could earn $150 a month (it turned out to be $120), with room and board, if they would run the tea-house at the Lake Placid Club's ski-jump the following winter. Since his own role would be part-time, Milne could continue painting. Further, Milne liked the area and thought it had potential as a painting site. But he had also received a promise, through either Norwell or Beament, of a position as a senior artist illustrating for the government in Ottawa, and he was determined to accept that. He had been interviewed for the job and Brown had written a letter on his behalf.

In a letter to Clarke of 17 March 1924, after describing the entanglements of his trip to Tivoli, Milne reported on his other prospects:

Then Ottawa. Worse still, the bottom had dropped out of my world. Parliament – without my knowledge or consent – had met while I was away and as soon as it met the public started throwing bricks, clamouring for economy. The Government lost its nerve, and threw the Departments, including the Dept. I had picked, into a panic. When I went round to see about my job I found that ... four of the staff ... had left or been fired within the month and the rating of senior staff artist had been abolished ... Final catastrophe, my chief backer – Mr. Brown – had left for the Wembley show.[33]

But Milne was persevering:

Been painting some again, oil, no wonderful results but at any rate it drags one out of the rather pessimistic attitude one drops into in the picture showing & selling and job-seeking business. I don't seem able to keep in a healthy frame of body and mind without two things, some steady current of painting thought to stabilize me, and a certain amount of manual labour or outdoor life to cool my nerves.[34]

Clarke immediately visited Milne in Ottawa to cheer him up and help him figure out what to do.

Clarke had an idea, a very generous one. This was that I go back to Big Moose and put up a building for a teahouse. Clarke offered to lend whatever money was needed to get it started. We went over the thing very thoroughly, even made some sketches for a building. I was allergic to teahouses and everything con-

nected with them but I knew Patsy would like it. I liked the building idea and the plan – three or four months teahouse and the rest of the year for painting was tempting. I decided to try it and that was the end of the Ottawa expedition and the beginning of three years or so [it was four] of Big Moose building.[35]

The fact is that Milne had thought of building a tea-house at Big Moose Lake nearly a year earlier. In his first letter to Clarke from Ottawa he spoke of being in Ottawa specifically to raise money for the tea-house project at Big Moose, and he expected to have the 'cornerstone laying' in early April. In retrospect Milne realized that this plan should have put him in a positive frame of mind, but as he left for Big Moose he was wistful. The Ottawa venture 'might have turned out all right if I had stuck to it. Spring was on the threshold and better days, particularly for painting. As I left I could see from the train window flooded fields and late snowbanks, and in the maple bush the blue smoke from syrup-making operations.'[36]

Milne's later excuses for failure in Ottawa – for his stay was in most ways a failure – are weak. He claimed, incorrectly as contemporary letters show, that poverty kept him from going to the movies, that lack of clothes kept him from working outside, that he did no work in the studio in those days, and that the weather inhibited him; that he was sometimes lonely is probably true. References to this period in his letters are almost as negative as he ever got in his writings, an indication that he was reaching a traumatic point in his life. He later reproached Clarke for not letting him stick it out in Ottawa a little longer, although in fact Clarke seems only to have supported, practically and financially, what Milne wanted to do. In the 'Ottawa' chapter of his autobiography he wrote defensively and regretfully:

Ottawa developed nothing. Perhaps I felt too insecure, too much disturbed in mind. Then, when cold weather came I didn't have clothes warm enough for

Carnival Dress, 1924, oil, 45.8×56.3 (18×22⅛)

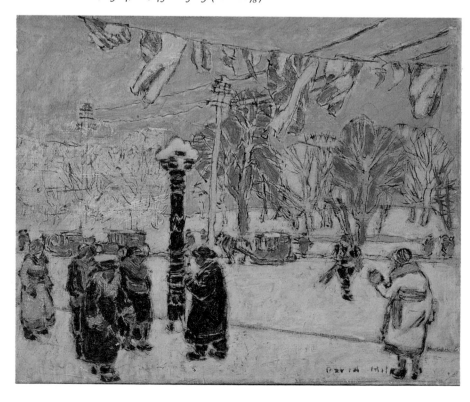

working outside and painting fell away. At the time I wasn't working inside from sketches, everything was done on the spot. Unfortunate. I could have done better with different painting habits. Altogether I showed little resourcefulness in this Ottawa interlude. I never seemed able to adapt myself to my surroundings and circumstances, in painting or in anything else.[37]

He was nostalgic for Boston Corners and Mount Riga, and in a letter to Clarke he wishes he were back there instead of in Ottawa grubbing for a livelihood:

Just the same, the thought of the little house at Mt. Riga gives a bit of a twinge, the yellow cat, the wood waiting for an axe in Kaye's swamps, the Clarke Friday nights, the high orchard corner, the stove in the lamp-lit dining room, the familiar tracks on the mountain, they all get a bit too real when they are dwelt on.[38]

The root cause of Milne's troubles at this time was clearly anxiety, combined with concern about the energy he expended in exhibiting and trying to sell his work. Selling paintings had distressed him in New York at the beginning of his career, and for most of his time in Ottawa he chafed at having to spend time on aspects of his profession that he would have preferred to ignore or to have someone else manage. Once March had slipped by and the winter season was practically over, he had to decide about the summer.

While Milne was living in Ottawa, his brief and infrequent meetings with Patsy – in addition to her two visits, he saw her in Montreal and at Lake Placid – are an indication of the deterioration of their relationship, although both must have felt the pressure to keep up appearances. They had already spent months apart from each other, and one would be hard pressed to conclude that they were forced to live separately, or that there was not a real estrangement. One senses that, even if they had previously been able to establish a home and an income, the result would have been the same. They managed to hold on to something for another few years, but the tension in their relationship was beginning to be destructive.

The board of the National Gallery finally met to approve Brown's recommendation to purchase, at a discounted $25 each, six 'drawings,' of Milne's, a clutch of masterpieces in watercolour: *Pool and Contours*; *Hillside, Autumn*; *The Mountains*; *Burnt Tree*; *Village in the Valley, Black Cedars*; and *Old RCMP Barracks*. Milne thanked Brown for his support with gifts in kind: Brown received *Fox Hill on a Clear Day* and *Pool and Posts* for his help and encouragement.[39]

During Milne's stay in Ottawa his work was exhibited and seen, and curators, artists, and others were friendly and curious. The National Gallery was supportive of Milne in a moral way if not a very generous financial way: the six paintings it purchased for what now seems like a breathtakingly low $150, just before Milne packed up and left, included several key works in his oeuvre. Although this reception of his work stimulated Milne and led him to think that success was imminent, he produced few new paintings. Moreover, his ego was badly bruised by the lacklustre reception in Montreal. On 27 March 1924 Milne entrained for Big Moose in the western Adirondacks and did not set foot in Canada again until he returned permanently, via Ottawa, in 1929.

Black House
Big Moose Lake and Lake Placid
1924–1929

WHEN HE ARRIVED at Big Moose Lake at the end of March,[1] Milne was forty-two years old, and was beginning to resent moving about and having to take on jobs that interfered with his painting. Nevertheless, he thought he could dispatch his proposed building project quickly, still keep up with his painting to some extent, and end with a financial asset that would support him and Patsy, one way or another, for the years ahead. Over the next five years he shuttled back and forth between Big Moose Lake and Lake Placid, spending each summer and fall until December at Big Moose, working mostly at building the cottage while Patsy ran the tea-house, and moving to Lake Placid until March or April to help Patsy run the tea-house at the Intervale Ski Jump for the Lake Placid Club, the Intervale Ski T (i.e., Ski-Tea). This pattern of activity, of course, interrupted Milne's painting time seriously; he found himself 'painting about half time.'[2] His production dropped drastically to a lower level than it had ever been, about one-fifth of normal, and this made him fretful and depressed.

When Milne and Clarke met in Ottawa in March 1924, they discussed the Big Moose Lake real-estate venture in minute detail, and refined the design of the project. Success seemed certain. Milne calculated, perhaps naively, that he could erect and complete his proposed structure in two summers. It would therefore be ready to sell, in a nearly finished state, as early as the summer of 1925; at the outside it would be ready to be occupied by the spring of 1926. He had Clarke's assurance that the bills would be met and that he could schedule construction work in such a way as to give some priority to his painting. The endeavour promised both fair painting and a major asset in real estate. Milne had done enough carpentry at various times in his life to know that he could do the actual work. Indeed, he liked to indulge his bent for working with his hands, for in small doses it proved a therapeutic change from painting.

Good roads were being built to Big Moose, and this enhanced Milne's options: sell the cottage for a handsome capital gain; rent it for the summer income; or run it as a tea-house to realize a steady annual profit for relatively little work. Milne's primary objective was to build and sell as quickly as possible. If the project worked out well, he thought, he could finance another lot and another cottage, perhaps one that he could build more slowly. In any case, it would be a place for him and Patsy to live and to earn money from the tearoom operation.

Within a day or two of his arrival at Big Moose Lake, Milne bought from Frank Day, a resident and owner of several lots, a waterfront lot for $1000, between the Days' cottage and that of the Kinnes, from whom the Milnes

had rented the Little Tea House the two preceding years, just along the shore from the Glenmore Hotel.[3] Romaine Kinne ran boat services at the Glenmore Hotel and on the lake, and he delivered the mail by boat. After a brief consultation with Clarke in New York Milne returned to Big Moose Lake to begin work.

The property he purchased, with Clarke's money, was a two-hectare (four-acre) lot with a thirty-one-metre (one-hundred-foot) shoreline. It stretched back up a steep, rocky hill for a kilometre (over half a mile) and encompassed both a large virgin stand of spruce and a high lookout called Billy's Bald Spot, where Milne thought he might later erect a tower from which tourists could scan the countryside. The large cottage was to be built near the lake, and in a structural sequence, so that a small living unit, as well as enough of the rest of the building to enable the tea-house concession to operate, would be available first. The rest was to be completed in easy, accommodating stages. The design was essentially a two-storey cottage attached to a bungalow, and included two upstairs bedrooms with bathroom and three commodious rooms on the main level – the living room, a dining room (or possibly a third bedroom), and the kitchen; there was to be a two-flight staircase between, and a large covered screened verandah along the front, with concrete steps at either end. The kitchen required a regular-sized chimney, but the one for the living-room fireplace was to be a large and impressive affair. The roof, with a large dormer window, was to be shingled, with tin sections around the chimneys and on the kitchen wing. Shingles would also provide siding for sections of the cottage. Other amenities included a woodshed and an icehouse, both sepa-

Milne's plans for the Big Moose Lake house, from a letter to Clarke, 1924

Milne's Big Moose Lake house as it stands today

rate structures, and a summer kitchen in the covered breezeway between the kitchen and the woodhouse. There was to be a back porch, and an outhouse was to be built until the indoor facility, complete with septic tank, was ready. A temporary kitchen for the tea-house was needed for the first year. Also included in the plans, for immediate construction, was a first-class dock to attract boating visitors. It called for a substantial log crib and tons of rock and earth, brought by wheelbarrow, as well as flotation barrels for the dock itself brought in from Old Forge or Utica.[4] Given the slope of the hill and the trees already on the lot, the landscaping requirements alone – the paths, grading, and planting – were rather daunting, but they did not deter Milne.

Milne first estimated that it would take him six months, part time, to complete the basic structure at a cost of about $700. When he proposed to trim a little here or there, or to make the cottage more compact, Clarke warned him about skimping: 'Word of caution from the bankers – don't try to figure it down *too* close. Must protect the investment by guaranteeing its ultimate value. Too much Scotch engineering might hurt its market value.'[5] The advice proved unnecessary, for right from the beginning Milne did everything to perfection, providing much more detail and quality than was necessary for the projected financial success of the project.

Throughout April 1924 Milne was busy cutting, clearing, burning stumps, shovelling earth, and moving it about. He started in by felling a large spruce tree onto the lake so that he could trim and cut it into lengths before the ice went out. He then cut trees high on the hill behind and skidded the logs down and out to his dock for sawing at the mill across the lake. Most of his lumber was thus provided, although special requirements were ordered locally. This was a huge task, complicated by the need to choose his trees astutely; fell, trim, and skid the logs to the bluff of Billy's Bald Spot; pitch them over the edge and down the bluff; retrieve them and sort them out at the bottom; and finally drag them along to the site or to the dock.[6] The weather that April was rainy and cold, which made all work difficult and unpleasant. Despite occasional snow flurries until the end of May the blackflies were abundant and ferocious. The hard and steady physical labour told on Milne; his hands, he wrote to Clarke, felt 'like two bags of cracked nuts.'[7] Patsy helped a great deal in the felling and trimming and became quite proficient at one end of the cross-cut saw. From time to time Milne also enlisted the help of neighbours like Frank Day by bartering his own labour in exchange. Day, for example, was particularly adept at selecting the timbers needed for sills, which he and Milne spent a week hewing and cutting to the required sizes. Milne hired Rodney Armsworth and his horse for a day or so for some of the heaviest dragging. In all, nearly eighty large spruce trees came down the hill and were hauled off by scow across the lake to the sawmill, to be made into studding and sheathing for the house, the icehouse, and the woodshed; in addition, many trees were felled and brought down the hill for the crib for the dock, and for all the sills and joists for the floors and walls. Milne even had to help out at the sawmill, first navigating his logs from the lake onto the conveyor belt for the big saw, and then raking sawdust out of the way.

In a fascinating process, detailed in a letter to Clarke, Milne split facing stones of granite for the fireplace. Patsy described these as

three pieces of black stone, with a salmon-pink streak through it. Dave sat on the side of the hill with a hammer and chisel, and for weeks worked to get the

Stone piers built by Milne

three sections out (without breaking) from the large boulder. The mantel was about five inches in thickness, and about ten or twelve inches in width.[8]

Milne began to make a slab by drilling (with a hand-drill) a series of strategic holes along the grain of a large stone and driving steel wedges into the holes until the wedges were taut. Then he waited, often for an hour or more, while the stone separated itself, a few millimetres at a time. The wedges were tapped in snugly once more, and again the waiting. Finally, after several repetitions of this, the stone separated (if he was lucky) into a usable slab. Contrary to Patsy's memory of weeks, Milne told Clarke it took only three days, but however long it really took, the whole process was numbingly slow.[9]

The building of the fireplace chimney was another time-consuming chore, for its foundations were deep, its width and thickness generous, the amount of concrete consumed inordinate, and the number of stones and bricks used astronomical. Instead of taking three days, the construction of the fireplace took ten; instead of twelve bags of cement, it needed twenty-three. The cottage itself, which had cement footings, themselves tricky to set, required twice the amount of concrete Milne had estimated.

In the end the house was wired throughout for electricity, a total of thirty-four outlets. For this Milne hired an electrician to do the basic work, and then did the finishing himself. He also hired a plumber, for the place had full running water with a toilet and septic tank. Inside walls were all wall-boarded, trimmed, and painted; the inside floors were stained and oiled, those of the porches painted. Milne lavished care on everything: he carved trilliums in wood around each light fixture and on the mantel of the fireplace, and on the staircase he decorated the balusters, handrail, and newel post. Every closet in the bedrooms had built-in cupboards and drawers. All in all, it was a tremendous undertaking for one man. As he finished the third building season, Milne was understandably almost overwhelmed. He wrote to Clarke: 'This thing was too big for us, as far as money goes, too long, even the actual work has been a bit too much, though I haven't got tired of that.'[10] Where the money was concerned, Milne could see that he was running over the budget he had set himself for the first season soon after he began. After a visit in the summer of 1924, to see what Milne had accomplished and to help him along, Clarke wrote to reassure him:

By the way, what you have done up there is tremendously to your credit. Without waste you have laid down a very fine foundation for your enterprise. It is only natural that after a long summer of work without painting you should chafe at the restrictions that a material enterprise imposes on one. Lord, how I do myself. I'm quite sure you can push through as originally planned.[11]

For the summer of 1924 the Milnes decided to run the tearoom in the basement of the Glenmore Hotel. This added to the roster of responsibilities and chores.

Dave painted window boxes etc, a bright orange – not just what we would have liked, but it had to be bright-looking as it was a rather dark basement and we had to hurry to get it in shape. We had three girls from Utica helping us, one a school-teacher. It was a very busy place after the dancing was over at eleven p.m. at the hotel. I went down in the morning at eight, and cooked ham, chicken, cake, etc., while Dave worked at the house, then he came down about six and

The stone fireplace of Milne's Big Moose Lake house

stayed until about twelve-thirty or later. I never liked to think of him on the 'trail' at that time of night, with the money from the tea-room.[12]

By the end of the second season, after a year of trying to run a tea-house operation at their unfinished location, building and tea-housing were predictably at odds with each other and both lost heavily. The noise of the carpentry interfered with running the tea-house, so that either work on the building was curtailed or customers were driven away and revenue was lost. By late 1927, when he was in the final stages of building, Milne calculated that the project had run to twice the original estimate Clarke had promised to cover. The financial worry drove Milne to accept jobs that he did not much relish: he went back to sign painting in the spring of 1925 to earn extra money, even lettering the trucks of the Big Moose Transportation Company ($4 a day), and searching out printing orders for van Harvey.

More seriously, however, all these activities interfered with Milne's efforts at painting. Through the summer and fall of 1924 Milne did virtually no painting at all, and for three months in the summer and fall of 1925 his paint-box lay unattended at Squash Pond, a quiet oasis at the end of a trail three kilometres (two miles) from the north end of the lake, while he toiled at his building. In October 1926, when he thought he could spend some time painting while Patsy visited her aunt at Tivoli, Milne had to devote five days of 'heavy wet work, digging, blasting and rolling stone'[13] with his neighbours, who suddenly decided to push through a road behind the row of cottages. He tried for a while to reserve part of each day for painting, but that didn't work. Then he reserved Sundays, but he found that they too slipped by. His discouragement was clear whenever he wrote to Clarke:

[20 April 1925] Painting. Stringing it along with fair results. Usually start in after dinner [lunch] and work at painting as long as it takes, then doing other work until near seven. Since I came back [to Big Moose Lake] have lapsed into water color. Ditching painting doesn't seem to work. Leaves nothing much in life. Have got a bit nervous again. Seem to need a bit of painting for a rudder. Also can't seem to do without this outside stuff [manual work in the open air].[14]

[Late October 1925] Cézanne is completely overshadowed in the art line. He left his pictures out in the field. My paint box and easel have been up at Squash Pond for a month, shot over by all the hunters in the woods. As soon as I finish, or stop work on, the fireplace I will have a go at picture making again.[15]

[3 June 1926] No painting these days except Sunday. Last Sunday added another Glenmore to the list. Free, vigorous and keeping to the value thing, but not a good deal more. However it is something to be getting over my fear of the medium, being scared into dumbness.[16]

When Milne did manage to pry some time out for himself, or force himself to paint, his relief was almost palpable:

[26 September 1926] I am in much better fettle than last year. The teahouse season hasn't been anything wonderful. The house isn't sold yet. I have no pants, none to speak of, and not much in the way of coat and shirt, but I still feel nearly human. The little trickle of painting has given me some feeling of life, the Sundays off and the two weeks' outing after the winter teahouse season have been so much precious ointment.[17]

[May 1927] Have been rather depressed this spring, in[side] too much, I
suppose, and the shortening of the end of the winter outing was a disaster. A
good many times I have set out to write but never could get there. Too much
grubbing about inside. No painting or etching since Lake Placid except one little
try. Have settled down to work the house off my chest.[18]

[July 1927] Not feeling very brisk – need a change badly and something to
think about. Will have to get away for a bit after we close, before we are all
finished. Recovering a little though as the jobs thin down.[19]

[July 1927] How did you puzzle out the long break in the Milne letters?
Probably by this time you are able to make a pretty good guess – just shiftless-
ness and emptyness – no painting, no writing, no thinking since Lake Placid.[20]

[25 June 1928] This is as near death as a human being ever gets short of the
real thing. One's whole attention is taken with hammering and sawing and
nailing. Such life as that allows in one's mind is as disconnected and aimless as
a dream.[21]

The tea-house side of the project, which seemed to have ignited Milne's
well-intentioned plans in the beginning, compounded matters further. In
1924 and 1928 the Milnes ran the tea-house concession at the Glenmore
Hotel where patrons were more certain, although this claimed a lot of
time. Much of the trade each day came after the dancing finished at the
Glenmore pavilion over the large boathouse. Milne did not relish staying
up for the extra hour or two after eleven o'clock, serving 'near beer' – a
feeble brew with a low alcohol content and therefore within the legal limits
of prohibition – to patrons who probably wanted the real thing. Patsy had
to go down at eight o'clock each morning to begin the day's cooking of
hams and chickens and to do the baking, cakes, cookies, and so on. The
three years of operating the tearoom in their house – 1925, 1926, and 1927
– were marginal at best. Whenever the weather turned in the least inclem-
ent, no one ventured out. In the first year at their own location, when they
were not known and competition from the Glenmore Hotel was sharp,
business sagged. Bad weather, limited advertising, and inadequate attrac-
tions – such as good lighting at night, music, and possibly a larger stock of
refreshments and souvenirs – were the chief reasons Milne cited for the
low income. By the time he realized these deficiencies, the summer was
practically over, and there was little he could do except plan more carefully
for the next year. Patsy made cushions and Milne carved souvenirs, as
Clarke described later:

Well, he did quite a bit of woodcarving. One of the things he did was to make
some garden stakes with birds, which he mounted on dowels and tried to sell
them to people that came to the teahouse. They were beautiful things, cardinals,
blue jays, all the native birds. And he painted them, of course he painted them,
with artists' colours – uneconomical.[22]

As the 1925 season wound to a close, the prospect of the books not
balancing in the Milnes' favour was inescapable: 'Labor Day, the saddest
of the year for teahouses. Then they stop guessing and are absolutely cer-
tain that in the contest between bills payable and bills receivable, the
payables have it.'[23] The following two years could not have been much
more profitable, for Milne had to borrow additional funds from Clarke to

Island in the Lake, *1925, watercolour,*
27.6×37.8 (10⅞×14⅞)

see him into and through the winter of 1928. Even their Glenmore conces-
sion with 'near beer' was perhaps a clear indication that the Roaring Twen-
ties were in full swing elsewhere, and that what the Milnes really needed,
if they wanted to make any money, was a tavern or a speakeasy.

In spite of all their travails Milne and Patsy were very much part of the
community at Big Moose Lake, trusted and respected, and living, to a large
extent, a normal life. Neighbours were friendly, and Milne reports on some
of their daily activities in his letters to Clarke. Mrs Day occasionally pro-
vided them with fish; Patsy reported that 'Mrs Day fished practically the
whole day for trout, in or out of season.'[24] Milne tried to schedule time to
read the newspapers and keep up with the news; he occasionally ventured
down to Mount Riga or New York; and he recorded having read, among
other things, Oscar Wilde's *The Importance of Being Earnest* and H.G. Wells's
The War of the Worlds. He and Patsy were known by the regular or perma-
nent residents of Big Moose from their earlier summers in the area, first
at Dart's Lake in 1921, and then running the Little Tea House in 1922 and
1923; and they bought their supplies locally and were in residence, for the
most part, from April until Christmas, although Patsy often stayed on later
at Lake Placid, visited with her relatives between seasons, and always re-
turned to Lake Placid a month or so earlier than Milne. Patsy struck up a
friendship with Florence Martin, a teacher from Yonkers, New York, who
had a place nearby and listened sympathetically to Patsy's concerns about
the Milnes' problems. In the early spring of 1926 Patsy was in New York
visiting her mother, who was in hospital for some weeks until she died in
May.

Milne struck up a friendship with Minnie Maddern Fiske, a famous
American actress, then in the much-acclaimed last period of her long act-
ing career, who owned the island in Big Moose Lake near Milne's house (it
appears in the painting *Island in the Lake*).[25] She had a splendid establish-
ment, with an elegant boathouse and an exotic gazebo, which still stands,
in a now-fragile state, on a point looking down the lake. The Milnes first
met her during the summer of 1922, when they were running the Little
Tea House. Milne had made a sign for the place in which the 'a' in 'tea'
seemed more like a 'd' to Mrs Fiske, who insisted on calling their enter-
prise the Little Ted House. From time to time she invited the Milnes to
dinner at her home, although there are no recorded accounts of these eve-
nings. She had recently adopted a little boy in Colorado, whom she there-
fore called Boulder or Bouldy, and she coaxed Milne into taking them both
hiking and camping for a night – a not wholly successful adventure, to
judge from Milne's and Patsy's later comments. Mrs Fiske wanted many
pillows and a cuisine suitable to her station and reputation, which im-
posed additional and distracting responsibilities on Milne; but after din-
ner she paid for these services by entertaining the Milnes and Bouldy,
seated around the campfire, by declaiming Lady Macbeth's soliloquies.
Milne was disappointed that she did not have as much interest in painting
as she had in the theatre, especially his painting, one surmises. In 1926 he
complained that he was 'starved for any kind of discussion of art or kin-
dred subjects. Occasionally try a little assault on the ideas of neighbours or
visitors. Nothing – even Mrs. Fiske presents a blank wall.'[26]

Milne no longer submitted work to annual exhibitions, so that his con-
nection with the outside art world had ceased to exist. Whether he simply
could not afford to exhibit, or thought it not worthwhile, is hard to deter-
mine. His efforts in relation to his career were neither ambitious nor regu-
lar. Occasionally, however, he was happily surprised: for example, when

Robert North in Buffalo sold five more paintings for him; or when Clarke held a show of his work at the Calkins and Holden office in New York at the end of 1926 and a dozen works were sold.[27] But for the most part his painting was done solely for his own interest, benefit, and self-respect.

Milne's painting sorties at Big Moose Lake took him either up the hill to Billy's Bald Spot or to locations in bays up the lake, reached in the Adirondack guide boat that he had bought for himself in 1924. In one or other of the various bays of the lake the noise and thoughts of the resort world were left behind and he could let painting, etching, and other things exercise his mind and sensibilities more than construction.

After the frantic summers of heavy labour and worry at Big Moose Lake came the relatively calm few months each year at the Lake Placid Club, where winters, with lighter responsibilities and fewer scheduled daily chores, were leisurely by comparison, and more productive for Milne's painting.

[The Ski-T] was at the foot (about three hundred feet [away]) from the 'Jump' and was originally an old farm house. The Club had fixed it up with a furnace, fireplace, bathroom and a large stove in a big sunny kitchen. It was on Club property two miles from the Lake Placid Club itself. Handmade tables and chairs of hickory, with handwoven table 'runners' and blue candles, made it attractive. We were asked to look after it and live there for the season. Club members came down on days there was a 'Jump.' From the kitchen window we could see the 'Grandstand' for about a thousand people.[28]

Despite the relative comfort of his and Patsy's employment, Milne's initial reaction when he arrived at Lake Placid late in 1924 was hostile. He hated having to 'break off the painting' again to take up yet another task in yet another place: 'Bitter words and sour feelings. I dislike fitting myself into new jobs with a very thorough going dislike ... The mountains not white, just dusty. Marcy and Whiteface show a bit more character, but not much. A bunch of 5 and 10 cent store hills they seemed this morning.'[29]

The Milnes received $120 a month for their work. The tea-house was not just a tea-and-cookies operation, however, for they were expected to keep the place warm and clean and to provide full breakfasts, lunches, and dinners for members of the club whenever needed. They were especially busy on weekends, or on days when there were meets at the jump; only when the weather was inclement did they have the luxury of idleness. Once they were strained to capacity because a film crew descended on the club for several days to shoot scenes for a forgettable romantic comedy, *Fascinating Youth*, a showcase for Paramount Studio's School for Stars, which had just graduated its first class. Several times a week, when the season was busy, Milne would shuttle between the tea-house and the club's main lodge on Saranac Lake, fetching supplies in a packsack or on a toboggan or sled. The club and the tea-house both had good libraries, which gave the Milnes all the reading material they needed. As long as the members' or visitors' stomachs were satisfied, Milne could spend whatever time he wanted reading, hiking, looking at the mountains, doing his painting, or anything else. He subtly tried to interest his employers and the guests in his paintings:

Occasionally I hung a picture in the tea house, but no one was interested. I think they classed them as modernist, and in some strange way linked with

political revolution, Bolshevism. How that came about with people above the average in intelligence, and, presumably, in culture, I don't know.[30]

One of the personal benefits of the winters at Lake Placid was that both Milne and Patsy learned to ski, both downhill and cross-country. Although Milne also hiked on foot or on snowshoes, it was skiing that allowed him to explore the countryside thoroughly and to find the rhythm of looking and exploring that would stimulate his painting eye, just as hiking had done at Boston Corners. His proficiency on skis was such that in 1926 he skied from Lake Placid to Big Moose Lake in the early spring, covering the 150 kilometres (90 miles) in five days.[31] Once he climbed Mount Marcy with an acquaintance and skied down, a feat that experienced skiers would find a challenge. Patsy reported that 'sometimes Dave would "guide" people to the Adirondack Lodge – one of the large over-night lodges, 18 miles from where we were ... and he would then ski back.'[32] Milne met, and occasionally skied with, 'Jackrabbit' Johannsen (1875–1987), the Norwegian who brought cross-country skiing to such popular prominence in eastern North America, and who lived in Canada and skied until he was 109 years old. Patsy remembered him: 'One of the best skiers was a Mr Johannsen, who would come down with a large police dog hitched to a sled piled high with camping things. He usually camped for three days about twenty-five miles away. He was seventy and a fine skier.'[33]

The farmhouse at North Elba where the Milnes lived was close to the farm of John Brown, the nineteenth-century abolitionist. On one of his hikes Milne came to the site of this early settlement of freed and runaway slaves, known during its brief existence as 'Timbucto.' Just before Milne went to Ottawa in 1923 he had passed by it with van Harvey en route to their Mount Marcy hike, and he wrote of this in 1947:

In the morning we started on over North Elba, a bare and windswept bit of country, with a post office and a few farm buildings scattered over it. We were in John Brown's country. North Elba was a negro settlement in his day. There was nothing left of it now, except one negro at Lake Placid, and a few battered tin wash-tubs scattered round what had once been a place of hope. I am not sure that we knew anything about that when we passed through that first time. There were many other things about the country that we didn't know – they were still to come. I was, in a few years, to push slowly along this North Elba road in a wild blizzard after climbing to the timber line of Marcy on skis, very tired but cheered by the glow in the sky over Lake Placid showing occasionally through the driving snow. All this country was to be painted, hills, levels and mountains. The old farmhouse that we passed near the ski jump was to be home for three [five] winters, and the way from there to Lake Placid was to be as familiar as a garden walk.[34]

In a 1928 letter to Clarke Milne described an outing that took him over the same ground:

On over the crest of the North Elba plateau, where the road is sunken for a mile or so. Why, I don't know, probably just wore down and the dust blew away.
 Stood on the strands of fence wire to look over the bare fields toward the swamp. Miss Wood – Woods' farm – once told me that in civil war times or before there had been a negro settlement in that place, freed or runaway slaves brought from the sunny south and settled in the bleak almost paved field. All gone, and all descendants except one. An amazing incident.

I crawled over the wire and went across the field searching for traces of the settlement. Still traceable. Rough foundation walls, two cellar holes, one fenced in to keep the cows from breaking their legs in it. Bits of sleigh runners, battered tin, some boards, part of a framed building. There were traces of at least six houses in the first field and another across the fence. All of this was on the long slope towards the river – to the left of where I slid ahead on skis when we went to the Adirondack Lodge. At the last cellar hole I thought I had made a find. It looked like a weathered wooden grave marker. No! the reading on it – raised, the painted letters had resisted the weather better than the unpainted wood – was 'Terris Perfection Washer, patented May 31, 1889.'[35]

As the mountains became more familiar, Milne's reservations about the suitability of the landscape for painting waned, and he learned to like the eastern Adirondacks, as indeed he had when he had first viewed the region in the fall of 1923, and when he was visiting Patsy in early 1924. Soon after his annual arrival at Lake Placid, his inspiration for painting would flutter to life again. And in 1927, 1928, and 1929 his plunge into the drypoint medium gave him enough activity to keep his creative mind alive. Once in 1925, and again in 1926, he even restarted his practice of making notes on each of his paintings, but his resolve was shaky and did not last long on either occasion. In 1925 he wrote only one letter to Clarke from Lake Placid: it was full of pen sketches of ideas for paintings, although few of those sketched and discussed were ever painted, and the rest were probably never begun.

Clarke was at a critical point in his own career; he was working hard and was unable to visit Milne as often as either would have liked. Besides, both Lake Placid and Big Moose were much farther away from Yonkers than the Clarkes' own place at Mount Riga. Constant business travel and family matters also reduced the number of Clarke's letters, which in the past had seemed to help to keep Milne on an even keel. Still, Clarke tried to push Milne into an optimistic frame of mind, and to provide him with incidental goals that might be helpful. He suggested, once more, that Milne write a book about art, since he wrote so often and so well about his own work. Milne replied:

Your other suggestion though is a fine one – the book idea. Not for the sake of the product but for the thought and interest that would come in the making of it. I am going to get at it ... The thing is that while I write or paint with one hand I have to have someone – nature mostly – hold the other. I have to have a person to debate with, or an object to paint from or write about. In the notes I have the sketch or incidents and places of the day to start from. It would be hopeless for me to change that, clearly a very strong, fixed habit, in trying the book.[36]

Milne's eye for painting subjects, the ability to see something in a way that excited his aesthetic sense, was constantly stimulated at Lake Placid – rather more than at Big Moose Lake. On a few occasions he described scenes to Clarke that might easily have become paintings:

Patsy's time off. I am storekeeping. Sitting at the kitchen window, looking toward the woolly caterpillar hill. It is the morning after the storm and a bit of flesh color is beginning to creep into the dull sky. After the closed-in skyless country of Big Moose you are always conscious of the skies here. Even on dull days they have variety. At the beginning of this storm two days ago I went up

over the hill behind the house just before dark. All the air was gray and solid with snow except on the Saranac side, there it was bottle green, brilliant, transparent – and shiveringly cold.[37]

Here is a silk pattern (the stove) for you. Circles and squares and uninventable combinations of the two worked out in freckled masses of black, black and red, black and purple, outlined by the streaks of blue gray smoke and with a gay rectangle of vermilion and ashy white in the middle.[38]

This brought me to the top of the rise by the corner of the wood just before sunset. The top of the world – a world all brilliant color, Boulderwood farm buildings were blood red and burnt purple, Post office farm lemon, scarlet and lavender – even the little abandoned-looking farm house was gay with every-thing from red to black and the road was a streak of lemon yellow and orange – even scarlet where the snow fence was, running through the blues of the snow shadows then beyond Placid and the mountains were a soup of lighter purples, roses and blues.[39]

During these years Lake Placid and its surroundings provoked a scatter of fresh ideas for Milne's paintings. And Big Moose Lake was the site of *Painting Place*, and several other masterpieces (*Sparkle of Glass*, *Early Morning*, the *Outlet of the Pond* series, and *Cottage after Snowfall I* come to mind) in which Milne seemed to skip ahead in his development, despite his sporadic attentions to his art. In 1925, a year after his grumpy arrival at Lake Placid, Milne set to work after nearly a year of painting inactivity – he had hardly set brush to canvas at Big Moose in 1924. Apart from the Catskills, the Adirondacks were the first mountains Milne had painted. The sense of scale and grandeur that one associates with mountains – even tame ones like those at Lake Placid – is absent from his Adirondack paintings. The broad sweep of the valley floors and the contours of the hills are deftly painted, but as they never held Milne in awe, he never painted them to convey that feeling to the viewer. Rather than evoking a sense of the sublime or the perilous, paintings such as the series *Saranac Hills* and *Whiteface* suggest that, in Milne's eyes, these mountains were reduced to the dimensions of a bowl of fruit or a vase of flowers. Milne did not like a place he could not know intimately. He had the eyes and mind of a botanist, not an

Whiteface, *1925, oil, 40.7×50.8 (16×20)*

Valley, Lake Placid III, *1925, oil, 40.7×50.8 (16×20)*

adventurer, and he sought first-hand knowledge rather than wild-eyed experience. What Milne did do, however, was paint the mountains accurately, for those who know the area well see these paintings as portraits.

Milne did not respond easily to Lake Placid's world of winter and mountains. His uncertainty is indicated by the four watercolours called *Ski-Jump Hills with Radiating Clouds*, in which he appears to be *feeling* his way toward an aesthetic solution rather than having found it. But his interest was piqued, for during the first six months of 1925 he painted some thirty watercolours (ten of them at Lake Placid) and the same number of oils, not counting those that were scrapped then or later. Compared with other periods in his career, this was a respectable showing, and it proved to be a high point in his production at the time.

Whiteface is typical of many of the oil paintings. In a passage reflecting the uncertainty that governed his work during this five-year period of painting doldrums Milne made this comment:

> The picture at present, in spite of its good material, is in disgrace, after a week or so, inside and out, spent on it. It lacks unity, simplicity, compression – it is a thing of parts. I have an inkling of how I may fuse it by doing great violence to Lake Placid scenery, but don't know how it may work out.[40]

Milne reached a solution by sometimes rearranging the Lake Placid landscape. And his system of values underwent a subtle change. He began to use values in a slightly different way, building *Whiteface*, for example, on three values instead of two: a black, a white, and a mid-value (gray), 'each one given a compartment to itself.' But this use of values created too much separation among the sections of the painting, as Milne was aware: 'I want to make them a bit more sociable – use one of the values for a ground and set the others against it.'[41] He finally used the values in such a way as to create a powerful image without resorting to tricky effects of scale or colour. Although success seemed to come to Milne only hesitantly and fitfully, *Whiteface* shows that when it did come it was unequivocal.

The weather at Lake Placid often inhibited anything more than a quick

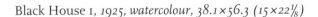

Black House I, *1925, watercolour, 38.1×56.3 (15×22⅛)*

pencil sketch or a few scratches that guided later refinements. Nonetheless, Milne painted outdoors frequently, while also referring to 'the increasing freedom in working at these things inside – still uphill work though. All these things that are such efforts for me are only 16 by 20.'[42] But many of the paintings Milne laboured over so diligently at this time were even smaller, only 12×16 inches.

Among the last watercolours Milne painted in the United States were *Black House I* and *II*, two versions of a neighbouring cottage at Big Moose Lake, the Gambles'. These paintings are both subtle, dry, and delicate in details, yet rich and powerful in their simple composition. But one is tempted to think of them as symbols of Milne's despairing state of mind, as though he were looking at the finished version of the cottage he was building for himself, while regretting that his construction work was dragging him away from his painting.

In the spring of 1925, after painting in watercolour all of his professional life, Milne suddenly and unaccountably stopped. *Tribute to Spring* left his easel early in June, and he did not paint another watercolour until twelve years later in the early summer of 1937. This valedictory painting, oddly, seemed to foreshadow the loose and colourful style that Milne would turn to more than a decade later. 'As a tribute to Spring,' he wrote, 'I made a speckled (spattered) water color. Spring didn't deserve any such tribute ... Rained, snowed and showed a little feeble sunshine in between.'[43]

Tribute to Spring, 1925, watercolour, 28.3×38.5 (11⅛×15⅛)

Milne's decision to abandon watercolour was a conscious one, for in November 1925 he wrote to Clarke that his thoughts were 'turning a bit to etching as a running mate for the oil and succession to the watercolour, particularly my scheme of colored etching.' If Clarke could find a press, Milne wrote suggestively, he would 'hock the new fireplace' to get it.[44] One might have expected such a radical step as forsaking watercolour, the mainstay of Milne's forms of expression up to that time, to have been clarified or mentioned or rationalized. Was it really to make room for etching or drypoint? Hardly that, since he had no press, and in fact made no beginning on drypoints for another year and a half – although in the spring of 1926 he again prodded Clarke to send him a press. But whether it was that he wanted to avoid the spontaneity of watercolour and reserve himself for more measured work in oil, or whether he was putting a part of himself into a state of hibernation, or whether his abandonment of watercolour had to do with his depression, after *Tribute to Spring* he did no painting at all through the rest of the spring of 1925 and most of the summer.

Clarke had seen Milne's painting of *Whiteface* in January 1925 and resolved to encourage him by arranging for Calkins and Holden to buy it; he also commissioned him to create another painting of the Lake Placid area to hang with it. This may have been Clarke's roundabout way of spurring a listless Milne into activity, and supporting him financially at the same time. Milne took up his palette and oils with determination in August 1925, anxious to complete his task and collect his money. But almost a month later he was still fussing with Clarke's pictures, especially the second one, *Valley, Lake Placid III*. Until well into September he was, as he put it, still 'tickling up a few accidentals.'[45]

'Start painting tomorrow afternoon,' he wrote to Clarke with fresh determination toward the end of July 1925. 'This is the resurrection and the life. The housebuilding as an all-day job is rest, sleep or death, very irritating to me. However, it is a fine soothing half day enterprise. Much better than tea-housing.'[46] The 'resurrection' was a hopeful allusion to the revival of his creative impulse, the one thing that gave him a sense of pur-

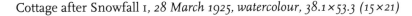

Cottage after Snowfall 1, *28 March 1925, watercolour, 38.1×53.3 (15×21)*

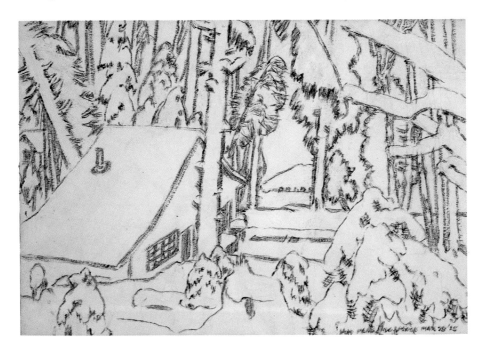

pose and worth. But tremendous energy was required – concentration and courage, as well as imagination – to chart new paths of thought and to admit new ideas.

How easy these things come up to a certain point, and then what effort it takes to carry them the last quarter of the way to readability, and all the time there is nothing in it except working yourself up to the sticking point. To force yourself to see, that is, to admit things. One will persist in saying there is no such animal.[47]

At this time Milne had pulled out *Corner of the House II*, the large, arresting blue Mount Riga subject he had started four years earlier, and thought he might repaint it. He wanted to substitute a gray value for the blue, but he was unable to reconcile himself to a gray snow shadow: 'You may put down your purple cows and green pigs and get away with it, pigs and cows come in almost any colour, but deep shadows on snow come in only one, and it goes against the grain to lose it.'[48] He offered the following commentary on his method, and on this painting, although it will be noted that, in the end, the blue value was not eliminated:

When you get a thing all hammered out and mauled around, searched in every corner but the thing doesn't look like anything at all because there is so much debris lying around, so many of the changes are fumbled or only suggested, or muddy or greasy, then you decide to take a clean slate and put it all down as it should be. But if all the interest had been squeezed out and nothing else is left to do but mark things down, it is apt to be rather sluggish work, not enough to warm you into violent activity. On the other hand if all the plodding has been done through days and weeks until it is all familiar, settled, uninteresting, and at that moment you decide on a sweeping change, something that will either put life into all your plodding work or waste it, then you can start in your repainting

Outlet of the Pond, Morning, *1928, oil, 41.0×51.1 (16⅛×20⅛)*

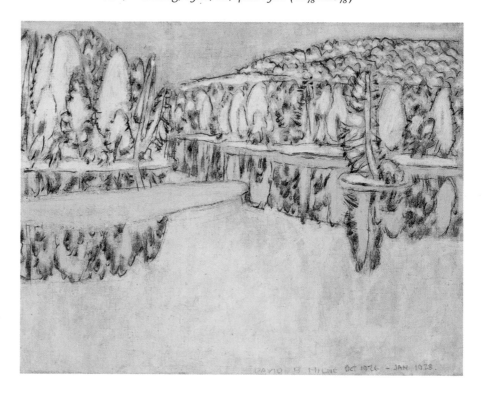

with enough fury to make you think, things are apt to go supremely well, difficulties melt and the thing simplifies into a unit.

The decision to eliminate the color from the mid-value of the Mt. Riga blue-shadow picture is one of these bringing to life events – at least has that possibility. Unfortunately visitors have come for lunch both yesterday and today just when I had got my sleeves rolled up and started the slaughter. When I start in again tomorrow morning I may have cooled down and lost some of the valuable gory-mindedness. I think though I have it where it will itself stir up a bit of fever when I look at it again.[49]

This was one of Milne's last paintings of Patsy. She had posed for him very little after 1921–2, and this appearance in 1926 and one in 1927 (*Interior of the Kitchen with Patsy I*) were to be her last.

Another picture that Milne repainted at about this time was *Outlet of the Pond*, first painted in the fall at Big Moose. It went through the same process as *Across the Lake I*. Milne told Clarke later that he

had some junk in the foreground, but it had no connection with the rest so I took it out. The shape groups of the thing are rather good, and marked with great economy – these *were* the picture. About the only excuse for anything in the foreground would be a dazzle spot or band such as I spoke of in the last [letter], a bank in shadow or something of the kind. That would allow vigorous treatment in the upper part, and at the same time retain the feeling of softness, slightness, economy. However it doesn't need anything of the kind if I can handle it decently. I am not much on delicacy.[50]

This process was one that formed a familiar pattern in Milne's work. The simplification of a visual idea, so that it read more quickly, and thus had more immediate impact, was a constant aim when Milne altered his paintings. By pruning down and concentrating on the essential characteristics of a painting, Milne was able to give it greater legibility – and power.

The latter part of the winter of 1926 was devoid of painting. It wasn't for lack of time, since Milne confessed that he had been rising uncharacteristically early: 'I have seen more sunrises this winter than I did in all the rest of my life.'[51] The fact was that he was troubled and unsettled. His performance was no more encouraging in the summer of 1926. The few paintings, less than twenty, that remain from this time, including *Box on the Porch* and *A Landing among Rocks* (which exists as a small painting and in a larger unfinished version, *Guide Boat and Reflections I*), are not nearly as exciting as those he had done just a few months earlier, with the exception of a run of gems at the end of August that included *Waterlilies and Indian Pipes*, *Sparkle of Glass*, and the first versions of *Painting Place*. Still, the concepts in his value system continued to grow. More and more he was using mid-value or gray. Even when his impulse was stimulated by a colour, he found that only a value would answer. For example, he wrote to Clarke that 'mostly in spring when the first full green foliage comes out, I have a desire to plunge into it and sort it out … the light voluptuous green seems to call out for the two light values [white and near-white].'[52]

One thing about the Sunday sketch was interesting – comes up often but was particularly marked Sunday. Did you ever try to break out of your channel & overflow your banks – override your artistic convictions?

The economy principle – in the present place the mid-value idea – has been

growing round me very strongly for a long time. Now I find it impossible to jump out of it. I sometimes find myself trying. The principle of course, is that where a color ceases to work, eliminate it, use a value. That is, if a great patch of red marks a form that has little interest, where it is not necessary for emphasis, do not use it.

Sunday, the first green grass made a big hit with me. Felt it tingling in me when I was drawing. So when I came to put on color I gayly slammed in a nice big patch of it, in a shapeless mass. As soon as it was on I was horrified, it was like physical pain. I couldn't get it off and mid-value in its place quick enough, but, that done, all was well.[53]

Milne tried to force discipline upon himself by analysing how to get launched into making a painting. In July 1926 he wrote to Clarke that there were two ways for him to choose a subject: one was to 'wander around, gradually warming up until something definitely connects with the painting chapter you are in at the time – at present the three values – and sets off the fuse. That gives you an initial velocity that will carry you into the thick of the work, when you can generate your own power as you go.' The other approach was simply to plunge into any subject and battle a way out. He was painting, he claimed, only on Sundays, and on one Sunday he could not 'muster enough interest to paint or write or even go for a long walk.' Then, in the same letter, he expanded on the challenges he faced on his painting days:

I imagine the Clarke disease is very much like the Milne disease. The patient goes along beautifully for a while, two o'clock going fine. Three o'clock fine, four o'clock, all's well. But at four-[forty]-five the patient realizes that the day is over. The moment has arrived when the jug is full, that is all. Everything is all right except the nerves, they are tired. Comes I think from too much scattering, giving attention to too many things. Will have to simplify – sacrifice; simplifying that doesn't cut off anything we seem to need or value probably wouldn't do.[54]

Six weeks earlier he had described to Clarke his responses to his good and bad days:

Yesterday I had an all day painting session. Rainy and very dark. When I got through and looked at the picture I was – not pained or disappointed – but amazed that any human being could do work so bad. You are of course used to days when the last hair in the brush seems to get your idea and follows fluently and with no effort in spite of all difficulties, high winds, snow storms, cold. Also with other days when it isn't under control at all – skips a couple of inches then makes a shapeless blotch. This seems to be particularly noticeable in oil. Well, yesterday was one of the last. Still, now that I look it over again ... it isn't all bad. Some problems are solved in principle, if not in completeness and it makes a nice tempting starting point for another try. It is one of the Lake Placid ones [possibly the *Little Spruce Tree* series] that I have worked a month on at one time or another, a light value one. Seemingly when I get a dash of black to anchor to I can ride through, but when I get into the treacherous delicacy of light values I sink. Getting it though. I still take the oil a bit too seriously, am too heavy handed, too close and too painstaking in detail, without enough grasp of the whole. Working in small dark rooms is partly responsible – only partly. Now I am beginning to swing it through without plumbing the sides of the houses and

numbering the trees, Frank Day's principle – nobody will notice the difference, not even me. Still, up to date, I don't know of anybody's work that is more full of promise and less of performance.[55]

In August 1926 he wrote: 'Painting hasn't been entirely barren, but a lot of work has left little to show.'[56] Milne's letters, which dwindled in number as time went on, were chiefly a litany of sad frustration and despair. Then, miraculously, two fine works appeared, like surprising late flowers in a garden. The first was a still life, *Waterlilies and Indian Pipes*, with waterlilies, bowls, and Indian pipes, all sparkling and vibrant.

Then without apparent effort I managed another little still life, mushrooms (or toadstools) and indian pipes in white bowls and clear glasses. Chosen of course for their lack of strong color. A problem in three near-together light values. A little spice was added to it on the way by the use of black in very small quantities, marking or calling attention to shapes. The black was suggested by the little bits of soil sticking to the subject.[57]

Immediately after came *Sparkle of Glass*. Both were clear forerunners of the 1929 Temagami and 1934–6 Six Mile Lake paintings of like subjects.
 Next was *Painting Place I*, painted on a height of land called Gamble's cliff, adjacent to Billy's Bald Spot. Milne had taken an afternoon nap in a little hollow; when he woke the light had changed and he suddenly 'saw' the striking shape of what became, eventually, one of his finest paintings:

There is no lack of things to weave into my tapestry, sun and wind and birds ... Bleached blue sky with wiped clouds above and moulded clouds below. Blue velvet hills beyond and green velvet hills near.
 The moving scene within is passable, but it is the frame of the mirror that grips your heart. I didn't notice that there was a frame at first, not until I had curled up on the raincoat for an hour's nap in the hot sun. The first blink on waking, before I lifted my head, introduced the frame. Black prongs of spruce branches lying on the ground, thick black trunks of standing spruce, and

Waterlilies and Indian Pipes, *1926 or 1927, oil, 42.0×52.7 (16½×20¾)*

Sparkle of Glass, *1926 or 1927, oil, 41.3×51.1 (16¼×20⅛)*

First drawing for Painting Place,
*August 1926, pencil, 12.0×15.5
(4⅝×6¼)*

beyond black and green feathers of spruce trees. I saw the thing when I woke rather than when I came because the sun had crept round to the side and marked things much more vigorously than before. It is often hard to tell what leads one to see a picture. In this case it was undoubtedly the vigor of the shapes – rather the vigorous marking of them with black ... I have added to the picture, nestled along the lower edge among the black sticks, a 2 quart jar with coffee, a cup, some papers and a writing pad. They give a fine brilliant sparkle to the foreground, and the rounded shapes are tremendously effective among the prongs. In the effort to save escaping steam I have been trying weekend painting instead of afternoon painting, so I think I will travel up here tomorrow and try brushes and color on this subject.[58]

The description in the letter, accompanied by a pencil sketch, was the starting point for what turned out to be a fruitful idea for a painting and a long period of gestation. When Milne painted the subject the next day, he left

Painting Place I, *28 August 1926, oil, 40.7×50.8 (16×20)*

Painting Place II, *1926–30, oil, 40.7×50.5 (16×19⅞)*

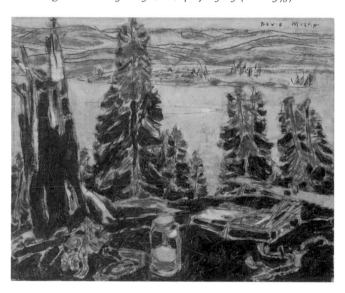

Painting Place: Brown and Black, *c. 1926, oil, 31.1×41.0
(12¼×16⅛)*

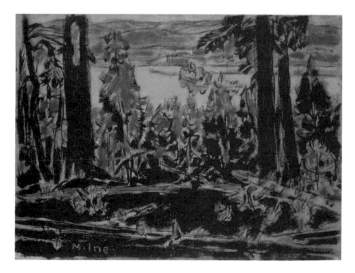

Painting Place III, *1930, oil, 51.5×56.4
(20¼×26⅛)*

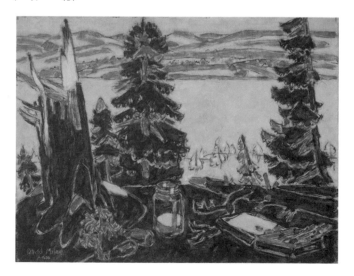

out the cup and substituted an open paint box for the writing pad and papers. Now he had the idea firmly planted in his mind. He took a larger canvas and made another attempt. This time he could not resolve the detail of the distant shore to his satisfaction, and his initial impulse behind the painting was checked.

When Milne went off to Lake Placid in December, however, he was full of ideas to use the etching press that Clarke had purchased for him, and his first drypoint subject was *Painting Place* (Tovell 32), of which only two impressions in two states are known. The drypoint sets out the basic elements of Milne's composition: the artist's materials are strewn across the foreground – a painting box, a jar, tubes of paint. The large spruce stump is prominent on the right (the image is reversed from the painting, of course), but the other trees do not create the 'frame' that Milne had described so vividly at first. The far shoreline is confused by the weak transition between the shore and the hills in the farthest distance. In 1927, a year later, Milne tackled another oil painting of the subject, but again he was unable to resolve what to do with the far shore; it remained an unresolved issue until the winter of 1929–30 in Weston, when Milne probably finished this second version, and then painted the third version in its entirety (see pp. 208–9).

We recall Milne's experimental attempts at drypoint in 1922, when he printed a prototype at Mount Riga, using his neighbour Mrs Kaye's washing-machine wringer. In early 1926 he bought some zinc and copper plates and began scratching preparatory sketches on them. He also reread Maxime Lalanne's *A Treatise on Etching* (1880), a standard primer that he owned. Initially Clarke, according to Milne, was not wholly enthusiastic about this direction in his development, but Clarke finally went along with it. In response to Milne's comment in November 1925 about turning to etching to replace watercolour, Clarke wrote back in early 1926:

I had Jim Herbert post a notice at the Art Students' League offering to buy a press and he called up Joe Pennell to see if he had any on his list. Joe crabbed all over the world and then suggested that as presses were scarce and high, you etch your plates up there and send them to me to be printed. I can however get a small new hand press from $75 to $125 according to plate size. I think the $75 one takes an 8×10.[59]

By the spring Clarke had moved a little closer to a solution:

I think I have found the answer to the etching press. Enclosed is a circular about an inexpensive outfit. If this would do – you see it is fairly light and transportable – I will make you this offer. I will buy the press and we will keep it at the Milne headquarters – wherever they are. In return for this unprecedented altruism I will exact as my pound of flesh one good pull of every etching which you make. By this neat piece of bargaining I stand to acquire several thousand dollars worth of real art by the meagre outlay of a few dollars. Thus does capital grind talent. How about it?[60]

Milne's reply, presumably enthusiastic, was made in person when Clarke visited soon after he wrote. Finally, at the end of 1926, Clarke sent Milne a new Gorr Portable Etching Press, Model A, which he had bought from Pallette Art, a New York supplier.[61] It was lacking accessories, so Clarke asked Milne to order up such things as acid and trays (as though Milne

were going to do etching instead of drypoint), tools, plates, and so on. 'We can order larger supplies as soon as you have experimented and found the deficiency of present outfit. I will be fully repaid for the outlay in proofs. Forget that part and go to it. You will have enough to worry about with the handling of the medium without worrying about finances.'[62]

Milne was determined to produce a lot of 'high grade merchandise'[63] that could be sold and thus ease his financial woes, or so he wrote to Clarke, but his real excitement lay in creating something new and strikingly original. At Lake Placid in early January 1927, nearly five years after he began to think about drypoints, Milne made a start:

Finally got the etching press set up and a little preliminary work started. Merely process and the result painful to look at. Haven't tried a plate yet and won't until I solve a few more difficulties. Have just scratched on some hardware store zinc. Made the mistake of breaking in the new pants and the new press on the same day, succeeded with the pants all right.

Have been trying the drypoint, and that is probably a mistake, etching would be a bit easier, because I have a little more practice in it behind me. I haven't been able to scratch with any sureness, sometimes I throw up a burr and sometimes I make a slippery skid. That, of course, will take care of itself with practice.

So far I have noticed a little difficulty in registering the color exactly where it is to go. Plate or paper seems to travel an eighth of an inch or so. That can be corrected, I have no doubt. Then using color in very small streaks and patches as I did in watercolor, it is lost in the black, probably because of the light value of colors. Remedy, of course, is to use larger areas of color.

I have a good subject picked out for the first plate [this was probably the first version of *Hilltop* or *Painting Place*, Tovell 32], but suppose it will be better to scratch round a bit first to see what happens when you press various buttons.[64]

By scratching with a needle into a copper plate Milne created a line with a tiny burr of metal beside it. The plate was then inked with pigment and wiped. A little pigment would lodge in the furrow of the line, and in the burr or rough edge beside it, and would be imprinted onto the damp paper when the plate was run through the press under great pressure. The usual drypoint process uses a single plate with black ink only, but Milne's inventive variation was to scratch a plate for each colour he wanted and superimpose them one upon the other.

The first trials of the coloured drypoints were tentative and the results, as Milne reported, were 'painful to look at.' Nevertheless, he began to see the world in terms of what would adapt itself to his drypoint ambitions:

[The] flesh-colored sky soon turned to full sunlight. Now there is a blazing landscape of black, white and blue. It looks like the thing to try the larger patches of color on, so I have made a pencil sketch of the white jump and as soon as I get a plate ready I will scratch it – not a real plate, a piece of hardware store zinc.[65]

By the middle of January 1927 Milne was able to report that he was 'now a lap ahead of Mrs. Kaye's wringer.' Over the next few months he experimented with various technical aspects of the process. Scratching into the plates exactly as he intended clearly took considerable practice, just as making corrections needed some experience, and registering the different

Milne's early drypoint trials, 1928

plates required patient, fussy adjustments. Milne discovered that much larger areas of colour were needed than he had anticipated, since the values were all so light. He soon found, too, that copper plates worked best for drypoints and that he could use heavy oil pigments. The subjects that were done at this time were *Power Lines, Lake Placid* (Tovell 34), *Ski Jump, Lake Placid* (Tovell 35), *Little Spruce Tree* (Tovell 36), *The Pond* (Tovell 38), and *North Elba* in two versions (Tovell 33 and 37). An example of Milne's 'scratching round a bit'[66] is a unique piece of experimentation that includes forms used in the North Elba subjects. When the artist André Bieler, who had come down from Kingston, Ontario, visited, they spent half a day excitedly testing different methods.

No drypoints can be definitely tied to the winter of 1928–9, but some further tinkering with techniques or modifications of various subjects can be presumed. At this time Milne carried small prepared plates with him whenever he went sketching: he was as likely to scratch a plate as sketch a canvas. In January 1929 he informed Clarke that he was doing 'no painting this winter' and only 'working a bit at the etching,'[67] a euphemism, perhaps, for a good deal of effort.

Still bothered some by the mechanical end – and not trying for much else just yet. The printing doesn't give much trouble but the drypoint is a ticklish tool, very much like skis – infinite possibilities but hard to control. I never seem to know when it is going to take and when it isn't. However the last few days have been better. I am getting less afraid of it. For one thing you never need to be hopeless about the first scratching. You can reduce or even take out the scraper and rescratch, without losing the intention of the thing. Today I took advantage of that in scratching a plate. Cut all the lines lightly and of the same depth – as far as I could tell. After taking a print of this I will recut some of them deeply. Where you put a heavy line over the light one you can do it quite freely because the light one will be swamped by the burr.[68]

He applied himself to a second version, on a larger plate, of *Painting Place* (Tovell 52),[69] a Lake Placid subject, and *Across the Lake* (Tovell 53 and 56), works that he had already done as paintings. He had tried a fairly traditional version of the *Painting Place* subject as one of his first attempts at a whole print; now he tackled a more ambitious version, as he wrote to Clarke in February 1929:

Do you remember a black and green oil – unfinished – done at Big Moose. A tree stub, spruces, a paint box, two gingerale bottles, a jar of coffee, etc. Heavy black with a little green and couple of specks of purple and brown[?]

I had been trying to see what I could get in drypoint out of the heavy black.

I scratched one plate, cutting in very strongly the first time, but the proof didn't look like anything, no start, no idea, nothing to go ahead with. Then I went completely off my head and filled in the ground – like a pen and ink drawing – trying to imitate the black background of the painting. I knew this was wrong when I was doing it. Well, I scratched another plate – not heavily enough to interfere with freedom in drawing. That seemed to work fairly well, but I didn't know what to do next – where to cut in heavier to get something out of the heavy black, or even what to do with the green. That was where I was today, had the black plate lightly scratched, and a transfer made for the green one.

Since I was driven to it, I started in emphasizing important shapes – such as the outside lines of the stub – with deeply cut lines. Then as a minor emphasis

North Elba (fourth version), *1929,*
colour drypoint, 13.3 × 17.6 (5½ × 6⅞)

– where the black lines were left light – I scratched the green plate. All of this with very little faith.

The double inking [was] still running in my mind, so I inked the black plate with black, wiped it with blue, wiped it and then printed it. The result was rather close to what was ordered. No sign of the black and blue as distinct colors ... but a heavy lined print that looked as if it had been done with writing ink. I could see that it solved the heavy black problem. Then I inked the green plate with yellow ochre and viridian and printed over the black. Rather pleased with it when I glanced at it and I hastened to stop work for fear I should do worse. It pleased me rather more, probably, than it would you. You might consider it sloppy. However, it is a drypoint – could not be got so directly from anything else.[70]

Milne was enthralled by the possibilities of the drypoint medium. Five years earlier he had stumbled upon the idea of using drypoint in a way that he could now put to a practical test. He thought that he could create the same magic in drypoint as he could in paint; even though it meant running a gauntlet of technical hazards, he wanted to produce a surprise at the end. 'In the etching there is one breathless moment – when you run the print through for the last color and lift it up to see it. A thrill – usually disgust. Today though there were two little thrills that pleased, so a good day.'[71]

The creation of drypoints was good indoor work for Milne on stormy days while he was at Lake Placid, but he still liked foraging through the region in search of subjects to paint. While at Big Moose, whenever he managed to escape the demands of his building project, he turned to painting only, since his press stayed at Lake Placid. Three or four of the Big Moose paintings of 1927, of which there are less than a dozen, are of such quality that they rise easily above Milne's standard for that time. Views of the Glenmore Hotel, such as *Hotel across the Way,* with its extensive use of gray, or mid-value, push to an extreme the boundary of this convention that Milne had developed. The handling of the outlines of the objects in the painting and the background against which they are set are contrasted with the condensed, tight (and small) areas of colour. Not unlike the views of the hotel are *Outlet of the Lake* and *Boulders in the Bush,* both scintillating works, alive, fresh, and powerful. More than that, they all extend the use of Milne's value system, particularly the use of mid-value (gray) or the light values (white or near-white), far beyond anything that he had done before; and they contain the least amount of colour – other than white, gray, and black – of any of Milne's paintings thus far. If the colours in each painting were gathered into a solid area, barely a hundredth part of the surface would be covered. Yet miraculously, these paintings seem immensely colourful. Colour is used as a catalyst, animating areas much larger than the space over which it is spread. Nevertheless *Attic,* an oil of early 1928, showing paintings strewn about the Lake Placid painting room, is perhaps a visual metaphor for Milne's feeling of desperation in trying to find a direction or strategy. His occasional successes, although brilliant, were offset by a dwindling production.

Throughout this period Clarke's loyalty and support were about the only things that consoled and sustained him: 'From one year's end to another,' Milne wrote, 'I see no one even mildly interested in the things I think about except Clarke.'[72] About Milne's Big Moose Lake enterprise, however, Clarke must have been disappointed. In retrospect he was harsh: 'They had chosen a very poor thing from a business standpoint. It was a

wonderful place, but for running a tea room in competition with a hotel ... which had all the facilities for amusing people and feeding them ... it was a bad choice.'[73] Clarke thought that after five years Milne had probably 'painted the place out,' and that 'he'd have wanted to move on to some other place' in any event.[74] Clarke also thought that 'at Big Moose his life was interlaced with a great many people who interrupted his painting and his thinking and his work ... [At] Alander and Boston Corners ... he had no interruptions, but at Big Moose, with the tea room and all the activities, the people, he felt that was an intrusion.'[75] Milne's spotty production and his discontent rather prove Clarke's point.

As the years wore on, Patsy's role in Milne's life as a painter sadly began to turn into a problem for him, on the same plane as other things that interfered with his work. Although Patsy was lively, competent, and a hard worker, she was neither intellectual nor artistic, and no sounding-board when Milne needed to discuss professional matters. Further, Patsy came to love the Big Moose cottage and wanted to live there forever. 'It was a lovely place, and I would have been very happy if we could have kept it, because Dave had built it, and I loved the lake and the trees, and the fine air.'[76] She always regretted its eventual sale and resented having to move away from the area where she had friends and a pleasant and varied way of life. But once he had finished building it, Milne could hardly wait to sell it.

During the three summers of 1926, 1927, and 1928 Milne had the house up for sale, regardless (at first) of its unfinished state. He tried advertising, showed people around, and even tried to enlist the aid of neighbours in finding suitable potential buyers. Mrs Fiske had been co-opted as a scout for potential buyers. Milne's 1928 notice, posted at the site and elsewhere, said:

THIS CAMP FOR SALE $6500. COMPLETED
Land – 100 feet frontage on Big Moose Lake,
runs back to State land, about four acres.
Spruce, pine, hemlock and hard wood,
includes part of the observation point Billy's Bald Spot.
Private Dock, wood and ice house, spring water.
Unusually dry and healthy location.
Substantial house, six rooms and bath, fireplace,
wired for electric light, craftex finished walls.[77]

The prospects were few, and their negative or indifferent reactions added further to the stress Milne felt in carrying responsibility for the place.

In the late summer of 1928 a real-estate agent at Old Forge finally found a buyer for the house at the asking price of $6500, a man named Byron H. Collins, of Leonia, New Jersey, and his family. Milne and Clarke received a down payment of $1,000, a further $1000 on closing, and for the balance took back a three-year mortgage that began on 1 November 1928. At last Milne was free of his obligations at Big Moose, and was able to move on. He had promised to do some carpentry for Clarke at his Mount Riga house that fall,[78] but after that, and after the 1928–9 winter season at Lake Placid, his last obligation, he departed. Patsy stayed at Utica for a month in the summer of 1929, then went back to Lake Placid for a while, and may have spent part of the summer with one of her cousins. She did not rejoin Milne until they met in Toronto in the fall of 1929, four or five months later.

In his autobiography, written over twenty-five years later, Milne wrote

not a word about Big Moose Lake or about the house that he built there with such care and effort (it still stands in good condition, having passed through several owners, and with the addition of a boathouse added by the Collins in 1929) nor about Lake Placid, where he developed his drypoints and did many fine paintings.[79] In the context of his painting career the five-year period at Big Moose Lake and Lake Placid was a cruel disappointment. Milne had produced only about thirty watercolours and eighty-five oil paintings, a tally he had regularly reached in a year up to that point in his career. Even if one makes generous allowance for his usual destruction of paintings, and for the time devoted to his drypoint initiative, the total is still markedly below Milne's usual production. But one must set against this the distractions that pulled at him from every side, both at Big Moose Lake and at Lake Placid. That he produced as much as he did during this period is evidence of his determination, and of the deep roots of his experience and dedication. The few weeks he had devoted to drypoint experiments prepared him for work that would occur a little later, but this flicker of excitement only emphasized the dreary pall that almost smothered his creative life. In January 1929 he wrote to Clarke: 'I don't thrive well on the fare of the last few years, particularly the inside part. I will have to get out as much as possible – all day for a while. Painting is the best and only cure.'[80]

Milne's twenty-six years in the United States had been momentous – with highs and lows, both extreme. He had been acclaimed and he had been forgotten. His work had poured forth (until the later years) despite the lack of commercial success and recognition. Much later, when the painter Carl Schaefer (1903–95) wrote to him about exhibiting in the United States, Milne replied:

My own exhibition experience in the States was almost unbelievably discouraging, constant exhibiting up to the summer of 1915 [1916] and no sales. Then I had to give up the city and move to the country. For years I didn't even try to exhibit. During all the time the Berkshire and Adirondack pictures were being painted, none were shown anywhere except some watercolors (unframed) at Cornell University in 1922. That was partly due to my circumstances and partly due to my lack of enterprise. I think sales have less to do with the quality of the pictures than with the personality of the painter.[81]

Milne later commented that if Clarke's money had not been tied up in the Big Moose cottage, he 'would have walked away and left it, unfinished,' just to get away from the interference to his painting that it represented from the beginning. Ironically, the income from the mortgage on it, which he and Clarke held equally when it was sold, although often hard to collect, provided a modest income for Milne and Patsy for more than a decade.

At the end of April or early in May 1929 Milne took most of his paintings down to Clarke's new house in Yonkers, where 'two large boxes of Milne water colors and oils and about twenty framed Milnes' were already in storage.[82] After he had packed most of his and Patsy's other belongings and put them into Florence Martin's boathouse at Big Moose Lake, he turned his back on the cottage, on the Adirondacks, and on the United States, and never returned.

His last act, as he headed home to Canada, was to go off on a three-day hike with Clarke up over Mount Marcy. It was the last time they were ever together.[83] Clarke had written just a year earlier:

I have always contended that painting is an intellectual process but I am beginning to feel that it is after all a most highly emotional process and that success can be best obtained by letting the senses reign. I ask this as a question because I think you hold the opposite view. I am showing you a map of the battlefield so that you can pick yourself a nice hill to fortify, when we get stretched out in the sun to straighten out the world.[84]

How Milne and Clarke resolved the issue of the senses versus the intellect is not recorded, but Milne doubtless would have held that both were necessary for good painting, with the art talk heavy, of course. Clarke remembered that 'Painting along side of Milne, talking to him, evenings and other times, why I learned more than I had ever learned in any other place that I know of, '[85] and that Milne 'talked so much about painting that he would have bored a layman to death in a few days.'[86] One principle that Clarke recalled about Milne was his sense of priorities among competing impulses or diversions:

He didn't discuss it [a painter's life] very much, excepting we always discussed the economy of a painter's life and he felt that painting came first and you could have any modicum of luxury or well-being or comfort or anything – that was just an accident that came along with it. But the painting was the first thing and the only thing.[87]

When their hike was over, Milne said good-bye to Clarke and turned his footsteps toward Canada. At the age of forty-seven his aim was to rededicate himself as a painter. And he was going home at last.

Waterlilies and Etching Table
Temagami and Weston
1929–1930

MILNE'S FIVE YEARS OF SERVITUDE to his Big Moose Lake project had reduced him to a Sunday painter and left him despondent. His 'nervous heart,' as he called it, affected by too much sawing and hammering, nudged him with intimations of mortality; and his relationship with Patsy was increasingly strained. Milne saw that he either had to reclaim his life as an artist or forfeit it. His prescription for survival was a simple one: solitude. He fled to Northern Ontario to set himself a crucial test – perhaps the most consequential of his career. Isolation, fortified by his Scottish stubbornness, helped him to work constantly and exclusively as an artist, and thus nurse himself and his professional pride back to health. 'I was so pleased to find that I could still work at all,' he wrote with relief to Clarke at the end of the year, 'that I didn't worry much about results.'[1]

Early in May 1929 Milne started out for the north. His first stop was Ottawa, where for a few days he visited his acquaintances of five years earlier, especially those at the National Gallery, surrendered himself to a dentist, and was fitted for new glasses. After Ottawa Milne entrained for Cobalt, a small mining town about 140 kilometres (85 miles) north of North Bay, Ontario. His reason for choosing that destination is unknown, although with the recent collapse of the mining business there, Milne may have imagined that cheap housing could be found.[2] When he got off the train for a day's sightseeing in the village of Temagami, fifty kilometres (thirty miles) south of Cobalt, he liked it so much that he decided to spend the summer there instead. He visited Cobalt for one day later on.

Temagami had been accessible only by rail until a rough road was put through a year before Milne's arrival. But the railway service had made the region a popular place for summer holidays. From the beginning of the century hotels and luxury camps had been built around the lake. The largest of these, the Temagami Inn, was still thriving (the most luxurious, the Lady Evelyn Hotel, had burned in 1914). Like Algonquin Park northeast of Toronto, Lake Temagami catered to well-to-do summer vacationers in its early days, and in 1929 it was still popular with cottagers and summer visitors and sometimes attracted Hollywood's rich and famous.[3] Several large boats serviced the huge lake, including the *Belle of Temagami*, which was put into service in 1908 and still plied a daily schedule in 1929. She had been built and was operated – as several of the hotels were – by Dan O'Connor, who early in the century turned his entrepreneurial skills to developing tourist, mining, shipping, and lumber businesses in the region, mostly on Lake Temagami.

In early to mid-May 1929, while snow still lay in the bush, Milne struck camp about half a kilometre (a quarter-mile) up the lake from the village.

Temagami in 1929

Temagami in 1930

He pitched his tent, built a wooden floor for it, and rented a boat while he repaired an old canoe he had bought, probably from the Temagami Canoe Company, which had recently established itself there. He explored Lake Temagami as far as Bear Island, just five kilometres (three miles) or so away from the village at the other end of a long, thin bay. Milne liked what he saw. He wrote to the Government of Ontario to enquire about purchasing part of Island 27, which was quite close to the village and looked up the long arm of the lake through which all water traffic ran. Despite delays in this negotiation Milne moved to his proposed new home site on 30 June and began preliminary clearing. Before he could assume title, however, he was informed that he had to submit and pay for an expensive land survey 'in triplicate, on linen.'[4] He therefore cancelled his application, and at the end of July or early in August he relocated his camp 'farther up the lake' to enjoy a better view of headlands and sunsets. Eight terse and perfunctory letters to Patsy, rather blandly signed off 'good bye dear' after he had told her for the third time how tame the Canada jays were, and one to Clarke reveal that the whole summer was reserved for thinking and painting. Apart from his one-day excursion to Cobalt, Milne travelled not more than five kilometres (three miles) from his base camp.

Milne's serious intent to get himself back on track was evident immediately. As when he had sequestered himself at Alander eight years before, Milne confronted the basic premises of his art and his methods. On 24 May 1929, in a draft of a letter to Clarke, he wrote that he was working on the sixth repainting, in four days, of a view of the village of Temagami. This change in habit from his usual practice of completing a work in one short, intense session seems to have been a conscious one, for Milne wrote to Clarke later that year that it was 'only in the last few years' that he felt 'any desire to work over and over on the same thing, [and] only this summer and fall that I have done it to any extent.'[5] He had previously toiled over several paintings – such as *White, the Waterfall, Corner of the House II*, and *Rocks in Spring* – but their revisions and repaintings had been the exception rather than the rule. In mid-summer he wrote to Patsy that he was 'working over things on a little larger canvas.' At this time, 'larger' meant up to 50.8 × 61.0 centimetres (20 × 24 inches), not as large a canvas as he had used at Boston Corners, but larger than most paintings of the previous decade; this change was perhaps a sign of warming ambition.

The summer's paintings do not appear to have followed any clear sequence of stylistic development, but they fall into four categories by subject: Temagami village; a flooded mine shaft; general landscapes; and flowers. Unfortunately Milne's notes and letters are few, and not particularly helpful in sorting out the sequence of paintings. Later, however, he mentioned casually that he had spent 'a third' of the summer (he was at Temagami for at least four months) painting waterlilies, and the last six weeks of his stay painting the flooded mine shaft.[6] Much of the reconsideration and repainting took place, not on site, but at his tent – and possibly some paintings were completed or done in the autumn, after he had left Temagami.

There are only five known paintings of the village of Temagami, all 40.7 × 50.8-centimetre (16 × 20-inch) canvases. If the number of recorded works is any indication, the village subject held the least interest, for there are more paintings of the mine shaft, of flowers, and of general landscapes. However, the first subject planned and painted in May was a distant view of the village, and it was repainted at least six times, according to Milne's illustrated letter.[7] Curiously, none of the extant paintings, of which *North-*

*Drawing of village of Temagami,
25 May 1929, ink, 8.5×11.0 (3¼×4½)*

Northern Village, *1929, oil, 40.7×50.8
(16×20)*

ern Village is a typical example, at all resemble his tiny pen sketch in the draft letter; probably more paintings were executed than now survive as Milne strove to stimulate his flow of creative adrenalin.

In the village pictures Milne tried at first to depict Temagami as a thin band of buildings between an empty foreground and an empty sky. He scrapped this plan because the sky kept filling itself with 'slight zeppelin-shaped clouds,' and because he found that the arrangement did not address the idea he had when he began, which was that the sky should be a 'flat light value, merely a foil for the rest.'[8] The 'foil,' as Milne was later to explain it, was like the 'dazzle spot' in purpose, except that it worked in the opposite way. The dazzle spot first forcibly snagged the viewer's attention, then released his gaze to wander around the picture; it launched the viewer with a jolt; the foil, however, was a resting place to which the viewer's eye, after it had jogged along the tracks of detailed and compressed forms, could move for relief; once rested, the eye could again journey into the complicated parts of the painting.

Often in Milne's work the sky is the foil and the earth is the repository of heavier, more fragmented forms. But as though to show that the device has only an aesthetic purpose, Milne sometimes reversed the pattern, making a cloudy sky the busy area and the darker but simpler earth the foil – as he frequently did later at Palgrave. The contrast between the two parts of the canvas had its antecedent in the dramatic conflict first seen in the reflection pictures first developed at Boston Corners. These paintings – which depend so much on the tension or division between washed-over and unwashed parts, between sky and earth, water and shore, and, above all, between dark and light – were the distilled essence or expression of a moving aesthetic experience, after moments of insight so intense that they make Milne's painting endlessly fascinating – and ultimately impossible to understand on an entirely rational basis.

In the surviving paintings of Temagami village Milne made a start on a new understanding of the way in which the principle of opposing powers could be brought into equilibrium. But this concept was not fully realized, perhaps because the subject matter was not appropriate to the thought. Milne perhaps needed a simpler division of elements than the Temagami landscape provided.

The paintings of the village refer back to the work of a few years earlier more than they prefigure the later work of the summer. They are brilliant, and in the disposition of shapes and shape groups are extremely easy to read. This is partly the result of Milne's rendering of clouds, which in some cases echo the radiating clouds in the Lake Placid paintings, and in others fill the sky area with the recurring 'zeppelins.' Partly, too, the brilliance is attributable to the very light values used throughout. But compared with the paintings of the abandoned mine shaft that followed, these works lack bite. When he knuckled down to the more complicated subject of the mine shaft, Milne set aside light and middle values and called on dark values and black with regularity.

What the paintings of the village and of the mine shaft have in common, however, is a concern for faceting everything in the painting, as in a work by Cézanne. All the elements in the subject – clouds, buildings, trees, water surfaces, and rocks – have a jewel-like radiance, enhanced by a thin contour lining that separates one element from another. Yet the unity of each work is important, and the mine-shaft paintings, particularly, are tightly organized around one central image.

By the second week in May Milne had discovered one of O'Connor's

abandoned mine shafts – Milne reported that O'Connor's brother 'says it's an iron mine – iron, copper, silver, gold, arsenic, sulphur, molasses – well, anyway, it looks like a collision between Winsor and Newton's and a coal mine, good for painting.'[9] In his notes he described the mine as having been left at an exploratory stage:

To the miner it may be a disappointment, but to the painter in search of color it is a find. Everything in the way of color that there is and in all possible intensities and combinations. The pits are filled with water, some apple green (milky) in the middle with yellow in the shallower parts. Another one is bottle green in the middle (clear) bordered with golden leaves. The sulphur in the water coats everything with a film of yellow.[10]

On 25 May, the day after his sixth repainting of the village, Milne did his first painting of the flooded mine shaft. This subject posed a problem that he had not met before: the piles of rocks and the blasted rock faces presented a panorama full of angularity – spiky, ridged, and jagged – that may have been somewhat reminiscent of the war-torn ruins of France in 1919. He approached the old mine workings gingerly – with, as usual, his three values. After an initial trial he saw that he would fare better using black 'as a colour merely,' and the light value or near-white as a 'contrast spot, a dazzle spot, throwing the rest of the picture together by its contrasting shock.'[11] The result was satisfactory, but further simplicity seemed possible.

In the pools of *Flooded Prospect Shaft* I and II, where the division between colour areas is so much softer than among the rocks and trees, Milne omitted the black line he often used to draw shapes, allowing the colour areas to abut each other without drawing an outline. This is a new and unusual characteristic in Milne's work. He wrote about it in a letter to Clarke:

The shapes in the pool of water are angular as in the rocks, but there is a softness about them. This suggests leaving out the black line used in drawing the shapes and running the colors together. I have used something of the kind in skies – sometimes outlining very slightly and then keeping the colors or

Flooded Prospect Shaft I, 1929, oil, 31.0×41.0 (12⅛×16⅜)

Flooded Prospect Shaft II, 1929, oil, 46.4×56.3 (18¼×22⅛)

values farther apart than usual & leaving the canvas showing. This is a very simple & powerful means of simplification. When I paint this subject again I will try it [i.e., 'leaving out the black line'] in the pool.[12]

Like many of Milne's discoveries, this one grew gradually and steadily over the next few years and emerged finally in a powerful and indomitable way when he returned to watercolour in 1937. It may have contributed to his expanded use of colour in the fall of 1929 and to his overlapping of colours in the drypoints of this period.

In spite of his admiration for the colours in O'Connor's mine, Milne adhered doggedly to a palette of black, white, and gray values with small touches of basil green, chrome yellow, and mauve hues. The toothy shapes and the concentration of colour patches in the central pool give the hues a strength out of proportion to the area they occupy. As Milne pursued the visual secrets of O'Connor's abandoned venture throughout the summer, he also made increasing use of black. In a majority of the thirteen known paintings of the mine bed Milne not only used black extensively, but he also used it to paint in the actual shapes: instead of outlining the shapes in black, he painted them black and left outlines of primed but unpainted canvas. Dramatically reinforced by occasional drifts of colour reminiscent of developments in the drypoints, the effect was immensely strong, almost brutal. The whole process reversed what Milne had been doing most of his life. Instead of concentrating attention on the drawing, he was now throwing the spotlight on the painting by exposing the actual process of scrubbing or brushing on pigment.

This absorption with the method of painting through the faceting of the shapes themselves is similar in some respects to Milne's narrow focus on white pigment at Alander in 1921, when he was also occupied with 'close-up stuff.' As he had been then, Milne was again drawn toward abstraction, with the result that some of the Temagami works have a complexity that requires time and intelligence to read correctly.[13] Milne did not traffic directly with abstraction, but his flirtation with colours and shapes once- or twice-removed from the subject matter was an indication that he was again reconsidering the fundamentals of his art as he had in 1914 and 1921, and as he would again in the 1940s.

Riches, the Flooded Shaft, *1929, oil, 51.5×61.6* (20¼×24¼)

Prospect Shaft, *1931, colour drypoint, 17.5×22.5* (6⅞×8⅞)

Milne did not reject either the theory or the idea of abstraction. Indeed, he knew more consciously than most artists that painting was abstract in and of itself. But he was concerned that the viewer, no matter how visually untrained, would have something to grasp while the picture was making its impact. Milne's lines, colours, and shapes were to his painting what T.S. Eliot's 'objective correlatives' were to poetry: the sensory prods that conveyed a formula for a particular experience, whether that experience was consciously perceived or not. Milne's experiences began with what he saw before him. His most abstract works always have some link with natural phenomena, even though the link is sometimes not recognizable. In Milne's work, abstraction is chiefly in the method and only partly in the subject.

The primary focus of the mine-shaft paintings, as can be seen in the spectacular *Riches, the Flooded Shaft*, lay in the differences in texture between rock faces and pool surfaces. Milne had always been captivated by textural contrasts, by which he meant changes not in the way the paint was applied, but in the way the different groups of shapes were related to one another. In the secondary matter of style something new in Milne's trunkful of techniques can be seen: a definite, if minor, attempt to ignore 'finish,' to leave the picture with a slight edge of roughness, as if the paint in some areas had been rapidly, almost carelessly, applied and not brushed neatly up to the border of the area it was intended to fill. This appearance of calculated spontaneity became even more pronounced in the years that followed. However, when Milne looked over the Temagami paintings in 1934 before he sold them to the Masseys, he counted them all as failures: 'a losing battle with the prospect holes of Temagami' is how he described three of them then. Of five more he wrote: 'All failures. Some are attempts, some seem to be just nothing.' And he added as a postscript: 'These failures would reveal just as much as the successes – the other side of the slate. They are necessary to a complete judgement of the whole.'[14]

Eight small landscape paintings of lakes, trees, islands, and sunsets were probably done on the spot while Milne was making day trips by canoe. In most of them the emphasis is on the wedges of distant shores prying their way between water and sky, on points and island headlands jutting into earth and sky, both separating them and joining them together. These paintings appear not to have held much residual interest for Milne, and their importance is better seen against later developments, particularly in paintings of Six Mile Lake near Georgian Bay, where Milne's subjects were once again points and islands pressed between air and water. In the evolution of Milne's work it was more usual than not for a problem to emerge tentatively and then be submerged until circumstances were right for it to be given full attention.

The reappearance of flower paintings at this time heralded Milne's return to an inspiring stream of work. Usually Milne painted a flower picture each spring when he was moved by early blossoms in the gardens or the woods. In the only letter he wrote to Clarke from Temagami Milne recalled the dismal history of the annual flower picture for the previous year. He claimed it was the only painting he had begun at Big Moose Lake in 1928, and he described how it had languished, unfinished, until the arranged flowers had died and become dusty relics, a source of embarrassment and fear to him. With this precedent Milne was naturally hesitant about his ability to paint another bowl of flowers. But in Temagami, toward the end of June, he rallied and gathered blossoms for a start. His account of the painting of *Tin Basin, Flowers in a Prospector's Cabin ı* in the

Drawing of White Waterlilies in a Prospector's Cabin, *1934, ink,* 11.0×16.5 (4⅞×6½)

letter to Clarke is a marvellous description of the beginning of his recovery as a painter:

I have just been painting the annual flower picture ... Every year at a certain stage in the season, the flower painting impulse is sure to come. This year yesterday was the day. The day before that I had been up the lake painting and, on my way home, I landed on an island to look it over for whatever it might offer – in painting, geography, history or anything else. Not much but flowers and few of them. Beside an open fireplace I picked a delicate kind of what we used to call bleeding heart – like a string of pink earrings. It seems to grow mostly where there has been fire. This, with a small lily of the valley-like plant and yellow and green wood lilies, was all.

I brought them home in a tin can of water, and yesterday morning I arranged them on the packing box table in the tent. On the home grounds I found wild roses and some small white laurel, possibly labrador tea.

I fixed an awning over the entrance to the tent, stood outside with the easel and subject matter inside. Terrifically hot. Even under the awning I could feel the heat striking up from the ground to my face. I shifted the awning with the sun, and all went well until the last half hour. Then the sun outdistanced the awning and changed the light so that my shapes – mostly reflections and shadows – went out on me and I fumbled. I hesitated about black and white values and was lost. The result wasn't bad, but short of what I had got keyed up to.

I decided to get up early and paint it over ... No chance to make the thing under the same conditions so I packed up the painting material and properties and started up the lake. Very much depressed! I landed on the same island and got more flowers, taking them with the ones from the home island in the water pail. I thought of tackling my job in the open, but the shifting light was too threatening, so I paddled across the lake to a prospector's camp that I had visited before. It has a table and a bench.

Tin Basin, Flowers in a Prospector's Cabin I, *20–3 June 1929, oil, 41.3×51.5* (16¼×20¼)

There I started in arranging things, a shiny tin plate – one from my dining set of two – half filled with water, a couple of wild roses floating in it; rising from the plate a Heinz pickle bottle – clear, the label scraped off – in that some wood lilies in water. Beside the plate a bowl – from a Quaker Oats package – this half filled with water but no flowers. So far the same arrangement as yesterday. In the cabin I found two greenish beer bottles. In one I put a spray of twin flowers – a necklace of small rounded leaves and trumpet-like twin flowers on long stems, lavender. This took the place of yesterday's bleeding heart – out of stock ...

I started in – measuring, the coldest start possible. The gloom still unbroken. No feeling at all, purely observation and reason. I got things placed fairly well and marks made to remind me of characteristic detail when I came to drawing with the brush ... Very restless but getting a little interested. Still tramping round and thinking of other things. I ate my dinner [lunch], cold coffee and four fruit crackers – light dinner to keep me from getting sleepy and lazy. Then I sat against the wall of the house in the shade for a few minutes.

Tackled the drawing. Very fumbly. The brushes – never washed when I paint every day – had dried a little too much in the hot dry air and scratched uncertainly. However, I kept on going. Mind active enough now but very restless. Went once or twice and lay on my back on the bench to quiet down.

Came to the color. Brushed in the dark value – the lightest of my blacks, about half way between mid-value and the black of black paint. This came from yesterday. Then put in a little brick red, clumsily and heavily where it should have been slight. Bad! Warmed up enough now to feel a shock at this lack of control, to have a sinking feeling that I was on the slide again. However, I recovered and caught the scheme of things with the next few bits of color, green, yellow-green, purple and what goes with me for rose. Fully stirred up now and all in a fever to push it along. Working fast and pretty surely. Able to see on the canvas now, how things are coming out. Putting in the last values, a light and mid-value. This was where I went to pieces yesterday. Not today! I brushed in a middle value – a reducing value to subdue and unite shapes, then a high value, almost white, a defining value to emphasize shapes. That was all. One hasty glance showed it pretty good. I went out and down to the lake where I lay on my back on a board for a few minutes. Then back to add and subtract a little – to cut out accidentals. Pretty fair ... Packed up and set the cabin in order ... A fine serene feeling. Tired a little, hungry. Soothed, not because the picture was a little better than usual but because I had been away for a holiday, carried into the swing of the thing so that everything else was crowded out. Very rare in the last few years and even in the last month but coming back again.

Back to the tent before six ... Kept the smudge going until the blackflies quieted ... Just dark, a dog on the mainland is barking, slowly, as if his mind weren't on it. A frog just behind me echoes him with careless muffled croaks that sound like subdued barks. A few chirps from the birds that put in an eighteen hour day here. A loon calls, not wild and startling, softly this time and forgets himself in the middle. Has something quieted the beasts – or is the serenity in me tonight?[15]

With this success behind him Milne found other flowers and still lifes attractive as painting subjects. At first he could find no trilliums, and then only yellow waterlilies, but before long he had both these and white waterlilies too, not in 'their wild and dangerous state, as Monet did, but captured and tamed, stuck in pickle bottles, fruit jars and whisky flasks.'[16] And soon there were daisies, wild roses, lady slippers, fireweed, raspberries, labrador tea, and bleeding hearts.

Milne's claim that he spent about a third of his time at Temagami paint-ing flower pictures may be a fairly accurate guess, but the number of ex-tant paintings is disappointing. Only five are known to exist, although clearly a greater number were painted and then rubbed or painted out. The sum-mer saw a great deal of repainting, and the flower pictures may have fallen victim to Milne's editing process more than the other subjects.

With one exception the five works are dominated by magnificent white waterlilies, a flower that has long typified the essence of Milne's work for many people. Yet Milne, in his self-effacing and contrary way, insisted that the waterlilies 'weren't important, they were just an excuse for having the bottles of water around to diffuse and refract the light.'[17] This statement is a key to a truth about Milne's methods and ideas. Flowers were not subjects in themselves – indeed, nothing was – yet they excited Milne's imagination. The same thrill might come from a pickle jar or, as happened once, from a green smear on a two-by-four piece of lumber, but Milne liked to have flow-ers around and inevitably they ended up in his paintings. They coaxed out of him a complicated and colourful solution to an aesthetic problem. Underly-ing all was Milne's belief, renewed again, that flowers were akin to artists, for both were useless and glorious. Milne's flower paintings were, in one sense, all meditations on himself – floral self-portraits.

In *Flowers and Easel*, set in a prospector's cabin, Milne made the paint-ing of the subject the subject of a painting. The conceit of a painting within a painting was a visual enigma Milne liked to play with. From time to time he made visual puns and allusions, sometimes seriously and sometimes with tongue in cheek. And often the artist's studio was a part of these paintings, a traditional subject with painters from Vermeer to Matisse. The same sort of preoccupation happens frequently in other arts too: mov-ies are made about movie-making, poems are written about writing po-etry. Milne extended the concept in his own way: his 'painting places' are views of his studio, of painting sites, and of paintings themselves. He found

Flowers and Easel, *1929, oil, 51.1×61.6 (20⅛×24¼)*

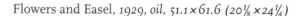

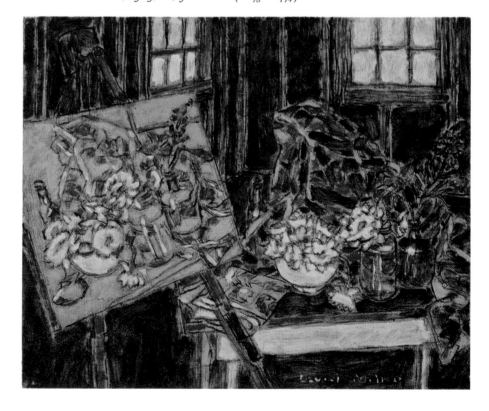

that paintings, like flowers, were near at hand, and once paintings were finished, they could themselves be considered as subjects.

Flowers and Easel and the other interior still lifes also draw on the inventory method to which Milne, like Thoreau, was addicted. It was a process he urged upon others: he suggested to Patsy that she simply describe in her letters what was on the writing table, or to Clarke that he give an inventory of what he could see from where he was sitting. This was Milne's way of looking at the world around him, gathering everything into an encompassing vision, endowing all with unity and completeness, and avoiding a straggle of separate and unrelated things.

One of the best-known of the Temagami paintings, indeed of all Milne's works, is *Waterlilies and the Sunday Paper*, known for years as *Waterlilies, Temagami*. The restoration of Milne's title points to an aspect of his work that is instructive and typical of much that was to come: the delicacy of the flowers set against the trite scramble of the weekend comics. The comic pages are irrelevant and incongruous, yet the inappropriate disturbance they cause in the viewer's expectation is what makes the picture perpetually satisfying. Milne had often created viewer discomfort, as one might call it, mostly in aesthetic ways, but here for perhaps the first time he chose a subject with inherent as well as aesthetic contradictions. It is not a message received and then recognized, but a conundrum that Milne has posed, a visual sleight of hand, and the painting refreshes the viewer each time it is considered because there is no end in it.

In juxtaposing two disparate subjects this picture is the first example of a trend that now began to develop in Milne's work. Odd objects that would not normally be found in a painting – such as tins, beer bottles and pickle bottles, and other pieces of flotsam that Milne painted in the summer of 1929 – began to crop up his paintings over the next few years. His use of these objects encouraged him to paint even odder subjects and later to invent subjects to paint. By the end of the 1930s Milne had developed a pronounced streak of fantasy that can be traced, in part at least, back to this summer.

Nearly all the paintings of the summer of 1929 have a sparkle, a glinting brilliance, that is new in Milne's work, and they are more intense than much of his earlier work. The extensive use of black contributes to this intensity; the faceted rocks of the mine shaft are given the character of rough diamonds; the trees seem to shimmer with interior light; and the tremulous delicacy of the flowers lends a breath of magic to these canvases. Even the ordinary bottles and bowls seem almost sacramental and are made to look like jewels through the prism of Milne's vision. Milne shared with the biblical prophets, and with Blake and van Gogh, a view of the world that saw the source of life in all things. The light of Milne's subjects is the same that glowed in the bush Moses saw, that made St John's vision of the heavenly city one of glittering gold and gems. In medieval paintings the Holy Ghost, depicted as a dove, is often engulfed in fire, and when God resides in objects they appear to be burning with a clear light. Milne's Christian vision was tutored by these metaphors, and it was this vision that informed Milne's paintings of this summer.

The thirty-odd paintings done at Temagami in the four months before Milne moved to the Toronto area in the fall of 1929 are eclectic, but they contain the crux of his aesthetic thought for the next decade. The immediate and spontaneous thrill of a subject no longer wholly satisfied Milne. Now he wanted, as he had at Alander, to create, carefully and deliberately, pictures

that had weight, presence, and complexity but that retained the appearance of sponteneity. During the summer at Temagami Milne was searching for a new vein of inspiration to replace the one that had slowly petered out over the previous few years. Constant reworking and repainting closely matched his state of mind. Most of all he wanted to prove to himself that he could return to work as a professional painter. What pleased him most of all about the summer, as he told Clarke, was discovering that he could think and paint again after his long digression. Milne was forty-seven and, had he known it, he was only at the mid-point of his lifetime production.

Milne left Temagami in the fall of 1929, and went to the village of Weston, seven kilometres (four miles) northwest of Toronto, barely a month before the Great Depression descended. He had managed to keep Patsy away for the summer by describing the vicious blackflies and mosquitoes and the stark isolation of his island camp at Temagami. He did this not insistently, but suggestively, leaving the final decision up to her: if she could accept the conditions and promise not to interfere with his work, she was welcome, but otherwise not. She chose to heed Milne's none-too-subtle hints and stayed at her work in the Adirondacks. She joined him, however, in Weston.

Milne's purpose in moving close to Toronto was, as it had been when he went to Ottawa six years before, to establish himself in the Canadian art world and to make at last his 'long-contemplated' return from exile.[18] From Weston he took stock of his prospects and found few grounds for optimism. Opportunities for exhibiting were limited, and for selling there were practically none. Canadian art circles were small and clubby. 'We hibernated in Weston,' he wrote later to Alice Massey.[19] Milne did not 'make friends easily now,' although what he 'missed most since leaving New York long ago [was] the contact with other people, the play of opposition and agreement, the

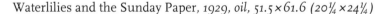

Waterlilies and the Sunday Paper, *1929, oil, 51.5 × 61.6 (20¼ × 24¼)*

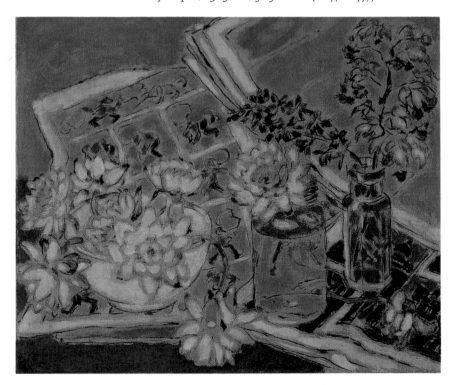

arguments down on 42nd Street [at his studio], the meetings, exhibitions, etc.'[20] No matter how distinctive his painting was, there was no vacuum in Canada for him to fill, and few artists or curators even knew who he was.

The Depression, Milne wrote ironically to Clarke, did little to alter his 'regular brand of prosperity,'[21] but certainly it accentuated his parlous circumstances. Canadian art institutions were marking time until better days returned, but the arts ranked low and signs of vitality were fitful and minor. In addition, the visual arts in Canada were entering a depression of their own. The views promulgated by the Group of Seven had created excitement in the early 1920s and had then subsided into the new academy by 1930. Affiliation with various social causes affected much art of the 1930s, but such alliances were totally outside Milne's aesthetic canon and therefore of no interest or assistance to him. The debate between the proponents of national art and those who spoke for international art was also distant from Milne's philosophic and aesthetic concerns. For Milne art was either good or bad, no matter where it was done.

In thinking about political and social matters, however, Milne was a staunch nationalist. Despite his lengthy absence from Canada, he was still a Canadian citizen, a proud Canadian war veteran, and a devout monarchist. In deference to Clarke he conceded on the spelling 'color' instead of 'colour,' and doubtless other American habits had been ingrained over a quarter of a century, yet he never regarded himself as an American. In fact he was beginning to consider depositing his substantial cache of pictures somewhere in Canada if he could realize a modest return that would allow him to go on working.

At current Toronto exhibitions Milne was disheartened by much of what he saw. At the large department stores, Eaton's and Simpson's, he found what he described as 'trade art' or 'beads for the Indians.' The Art Gallery of Toronto he thought much improved from his memory of visits as a soldier in 1918 and 1919, and again in 1920; but its exhibitions of Otto Jacobi (1812–1901), Tom Stone (1894–1978), Austrian and Czechoslovakian prints, and travelling shows of the American, New York, and Cleveland watercolour societies 'were of no interest.' In the latter two societies he detected work that was 'a bit reminiscent of my own stuff shown fifteen years ago.' More stimulating were exhibitions of the work of the Americans Leon Kroll (1884–1974) and Ernest Lawson, who was Canadian-born, and the Ontario Society of Artists exhibition of March 1930, particularly works by A.Y. Jackson, J.E.H. MacDonald, Lawren Harris, and 'the best piece of work in the show,' Emily Carr's *Indian Church* (at the time Milne remembered only that it was by a 'B.C. woman'). Among the paintings in the gallery's permanent collection, Milne thought Tom Thomson's *The West Wind* was 'thrilling.'

But what to do with his own work? Should he, Milne asked H.O. McCurry at the National Gallery, follow Cézanne's example and leave his paintings standing in the fields?[22] McCurry sent information about some exhibiting possibilities, and Milne reciprocated with a selection of watercolours: he invited McCurry and the director, Eric Brown, to make a choice, but it seems likely that they did not, having already received paintings in 1924. Fred Haines, the curator at the Art Gallery of Toronto, was neither enthusiastic enough to purchase any of Milne's paintings nor impolite enough not to see him briefly. Milne was informed in 1929 that the annual exhibition of the Group of Seven – by then a fairly broad forum, since there were now ten members and a number of associates – was a 'private show' open only to the Group and their invited friends, although it was held in a public gallery.

The Weston railway bridge as it stands today

Milne submitted six works (three paintings and three drypoints) to the Ontario Society of Artists in 1930 and had two accepted and shown, one oil painting and one drypoint, which naturally pleased him, but neither was purchased. The only salvation came in March 1930 when Clarke placed an order with Milne for eighteen drypoints at $10 each – doubtless the result of pressure by Clarke on his business associates.

Without resolving the problem of how to promote his paintings in Canada, Milne settled into his house and studio and became absorbed in his work. His studio was a small area, only 2.4 × 3.3 metres (8 × 10 feet), in an old factory building called the Longstaff Pump Works,[23] and there he spent much of his time. He found the landscape uninspiring for painting, even though he hiked as much as thirty-three or more kilometres at a time (twenty miles) through the surrounding countryside. Their house, at 49 St Alban's Avenue, in what Patsy described as a 'poor district,'[24] was furnished and comfortable and the Milnes rented it for $18 a month for six months, October to March. Patsy detested Weston. They survived on what was left of the Big Moose Lake cottage sale and the $200 Patsy had earned at Lake Placid that summer, but she had wanted to stay at Big Moose Lake and was doubtless beginning to resent the persistent hardship of their lives. Canada was foreign territory to her. She used the public library frequently and took weekly weaving lessons in Toronto with a Miss Turner – a pursuit she thought might be turned into a money-making hobby if she could buy a loom.

Most of Milne's work in the winter of 1929–30 was devoted either to repainting earlier subjects or to creating and refining the techniques for his drypoints. From the previous year he brought forward for finishing the drypoints *Painting Place* (Tovell 52), which he considered 'the best of the lot,'[25] *Across the Lake* (Tovell 56), and *Haystack* (Tovell 54). He probably finished them before Christmas, and he then did at least preliminary states for *Waterfall* (Tovell 60) and *Stream in the Woods* (Tovell 55). In painting Milne did a few landscapes that grafted the angularity of the flooded mineshaft series from Temagami to the trees, clouds, and fields of Weston. The

The Pump, 1929, oil, 31.1×41.3 (12¼×16¼)

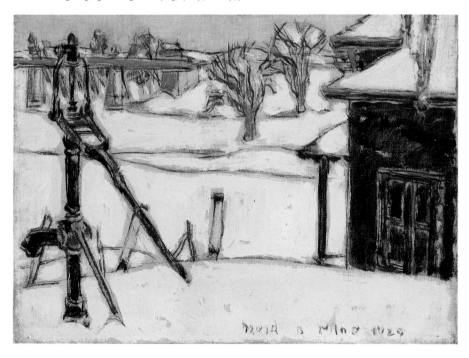

colours, as before, were the three values with touches of brown and a new slaty blue-gray. *The Pump*, looking up the Humber valley from the site of what is now the Weston Golf and Country Club, recalls the motif of *New England House* and *Corner of the House II*: the house shape pushes in from the right side of the painting, the railway bridge abbreviates the distant view, and the pump in the foreground contrives to slew the picture into sharp perspective.

Five years later Milne remembered that most of his work at Weston was 'plodding, heavy and without kick,'[26] and that he spent most of his time finishing and repainting. He was undoubtedly referring to his re-working of the summer's painting. Some versions of the mine shaft may well have been done in their entirety in Weston, because Milne now needed to be in front of the subject much less than before.

One major work that was definitely repainted in the winter of 1930 is one of the two later versions of *Painting Place*. Both paintings point to aesthetic developments that the southern Ontario landscape inspired in Milne: a softer, gentler curve of hill than at Big Moose Lake; a deeper distance than he found in Boston Corners; and, for the first time, a cultivated landscape of rolling hills, like those of his native Bruce County. One version, *Painting Place II*, had been started at Big Moose in 1926 and partly reworked in 1927. The distant shoreline, left unresolved in 1926, was probably finished in Weston, for the character of the landscape is much closer to that of southern Ontario than that of the Adirondacks. Another version, *Painting Place III,* reproduced on the jacket of this book, was painted in its entirety in February 1930, as Milne wrote to Clarke:

I have got a lot of work in this year, particularly working inside carrying things along a bit. I find I have a great number of things on which I have put anywhere from a week to a month without getting clear of them, and some of these I have pushed along. One was a picture [*Painting Place*] with a spruce stub and spruce trees on top of a cliff at Big Moose – two bottles and a quart jar with a painting

Corner of the Etching Table, *1930, oil, 41.3 × 51.5 (16¼ × 20¼)*

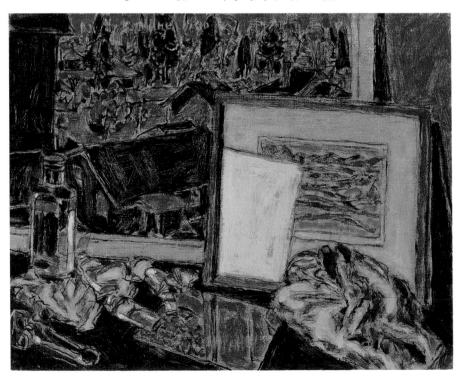

box in the foreground. We once discussed the shore across the lake, I remember. This I have worked on a lot and finished up last week, a bit larger in size. A few others have been finished and many carried along nearer a finish. I have painted very few small sketches, hardly at all outside this winter. I will try to work more outside now though.[27]

All of Milne's paintings are comments on the human condition, in one way or another, but those paintings that show the artist's tools and his studio are of a particular kind, because they also comment on the nature of art and its part in the drama of daily life. Milne's painting-place pictures are in a sense all self-portraits. Alan Jarvis wrote:

the story of Milne's life is the story of a life-long search for the perfect painting place and the passionate desire to confront the perfect site with the total concentration of creative energies [that] would result in the perfect expression of this unique moment in time. Milne found these moments far more often than has been given to any of his other Canadian contemporaries, perhaps never more felicitously than when he set down *Painting Place III*, first in the Adirondacks, then in tranquillity in Palgrave [*sic*].

Painting Place III, 1930, oil, 51.5 × 56.4 (20¼ × 26⅛)

There is the close-up foreground still life of the materials of the artist's trade set against trees and stumps which almost overwhelm the viewer with the power and immediacy of their pattern; there is the middle distance of calm, blank space, and a far-distance of rhythmic shoreline pattern. What was a perfect painting place for Milne has been captured, fixed with an exquisite sensibility and an inexorable visual logic, the whole transfused with love in an act of creative imagination. Here, I believe, was Milne at his happiest and best.[28]

Jarvis captures Milne's odyssey perfectly. From the *Painting Place* paintings one gets an unequivocal sense that, as Milne himself wrote, 'feeling is the power that drives art.'[29] In this case Milne had been seized by an idea which he lived with for several years before he gave it final form.

In the winter of 1930 it is also likely that Milne worked again on the painting and drypoint of the tennis courts of the Glenmore Hotel. *Roofs, Glenmore Hotel* appears in *Corner of the Etching Table*, a Weston subject that also has a prepared and polished drypoint plate reflected in it to make a startling dazzle spot. The drypoint *Lake Placid, Winter Sunset* (Tovell 50) was also completed at this time.

Milne was not content with his winter's achievement and may have destroyed a good deal; he told Clarke, matter-of-factly, that he had worked very hard. Before embarking on a productive spring, however, he had to cope with the expiration of his leases at the end of March and with the stark reality that the money from Patsy's savings and from the sale of the Big Moose cottage was running out. He decided that they would move farther away from Toronto to the country where they could plant a garden and pay less rent. He scoured the Caledon hills, fifty kilometres (thirty miles) northwest of Toronto, and in the middle of April Milne withdrew from what he called the 'Old Testament city' of Toronto and its suburbs, and he and Patsy moved to the little village of Palgrave. There he had hills to paint and to paint from, a garden to tend, and the sights, sounds, and smells of farming – all the familiar scenes and senses of his boyhood.

CHAPTER ELEVEN

Village Spread Out
Palgrave
1930–1933

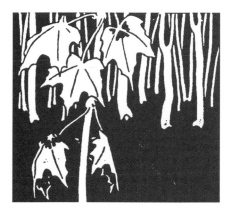

PALGRAVE IS A VILLAGE beside the Humber River in the Caledon hills, sixty kilometres (thirty-five miles) northwest of Toronto. In 1930 it had a population of less than a hundred. Its relation to Toronto was not unlike that of Boston Corners to New York, and when Milne moved to Palgrave with Patsy at the end of March 1930, he went with the expectation that it would, like Boston Corners, offer less expensive accommodation in a rural community beyond commuter range of the metropolis, and hills to paint from. He was looking forward to planting and tending a garden again – he had not had one since Boston Corners, ten years earlier – not just for practical reasons, but because he wanted to be close to country and farming. He also thought that the Palgrave landscape, with its hills and woods and ponds and streams, would be as congenial for his painting as Boston Corners had been. His production of over two hundred paintings and many fine drypoints in the ensuing three years proved that his instinct was sure.

At the top of its watershed the Humber River runs through terrain that in the 1930s was a patchwork of wooded and open country; clearing for subsistence farming in the rocky soil had cut down all but a few isolated stands of the original hardwood forest. The trees that were left were chiefly sugar maples, pines, and cedars, with a few beeches and birches. From fence lines and roadsides stately elms presided over the stony fields and rolling hills. Many of the hills were of sand or gravel, and some of them had their tops scalloped by wind and rain, as can be seen in Milne's *Hills at Seeding Time* and *Blind Road, Plowed Ground*, among other paintings. Cedar swamps were common in low-lying areas, stagnant ponds dotted the region, and little creeks wriggled their way down the larger ravines. Gibson Lake, a pond on Hiram Gibson's farm, a fifteen-minute walk east of the village along Albion Sideroad 25, presented Milne with the subject for such memorable paintings as *Splendour Touches Hiram's Farm*. Everything Milne chose to paint at Palgrave, as at Boston Corners and Lake Placid, was within easy walking distance of his doorstep.

In earlier times the Palgrave area had been the home of Huron and Mississauga Indians, and Milne occasionally found arrowheads and shards of their pots throughout the area.[1] Settlers in the early nineteenth century were chiefly Protestant Irish and their main occupation was farming. The village of Palgrave grew up around a grist mill that was built on the Humber River, once a fine salmon stream, and at the north end of the village was a large mill pond; the dam for the mill race provided a bridge to the country north of the village. In the few years before Milne's arrival and during his time there ginseng root was grown under shaded shed-like structures and then dug up every seven years and shipped to the Orient. This speculative crop made a modest fortune for a few astute men, including

both Dr Albert F. Reynar, the town's first and only doctor, and the town's barber.[2] Reynar had also been the most persuasive proponent of the drive to bring electricity to Palgrave in 1927, a refinement that was initially resisted by most of the residents, probably because of the cost.[3] Consequently Milne's second studio in Palgrave, to which he and Patsy moved at the end of 1932, had the advantage of electric light.[4] The Canadian National Railway line cut a great arc through the village, and the railway's grain elevator and potato shed stood beside the track at the end of Wallace Street, west of Main Street, where the Milnes first lived.[5] A branch line of the Canadian Pacific Railway ran through the countryside three kilometres (two miles) east of Palgrave, where a flag station with an elevator, water tank, and a siding, called Palgrave Station, were built.

Palgrave has almost as much character as B.C.[Boston Corners]. It isn't a necklace of colored beads, more like a nest of Easter eggs. It is about as populous as Copake but doesn't cover as much ground. It has a railway station – about a dollar fare to Toronto – two hotels – two very small churches and an Orange hall – three stores in one of which is the post office – a harness-maker's shop – two garages – a little flour mill – one doctor – a school and very few – perhaps 20 – houses, three or four of them farmhouses – at least four houses are vacant. It is a police village – whatever that may be – and has cement sidewalks and electric light, even on our little back street there is a sidewalk and an electric light in front of the house.

 Our house has had no one in it for two years. It has six rooms, a very good cellar. There is a well 40 feet deep, a little barn, and a good garden, with some plum trees, a patch of berry bushes and innumerable black and red currant bushes, in addition to the two apple trees and the rhubarb. In front we get quite an extensive view – fifteen or twenty miles – toward the west.[6]

Wallace Street was a short street of half a dozen houses parallel to Main Street and a block west of it. The Milnes' house – for which they paid a monthly rent of $7.50 – still stands, much as it was then: a small, two-storey frame structure with modest rooms, no porch, a tiny summer kitchen, and a small shed. There was scant luxury in it, even for unassuming folks. Patsy disliked it with reason enough, for it had no furniture,

Hills at Seeding Time, *1930, oil, 40.7×55.9*
(16×22)

Blind Road, Plowed Ground, *1930, oil, 41.3×56.6*
(16¼×22¼)

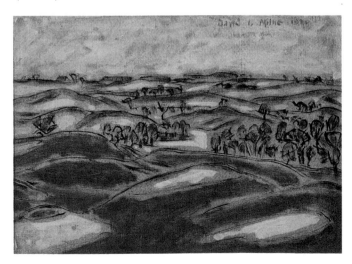

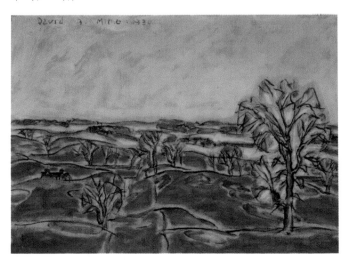

The Milnes' house in Palgrave, in 1973

save an old wooden bed.[7] The few crates and boxes the Milnes had brought with them served as tables and chairs for a while, and they were given an old wood-burning kitchen stove. At an auction a year later Milne bought two tables, five chairs, and some other basic household furnishings. Patsy disliked being closely hemmed in by neighbours on either side; the house also backed hard on the stable and rear yard of the Queen's Hotel, where electric lights kept the horseshoe pitch thudding and clinking long into the summer evenings. Milne fitted out the small upstairs front room as his studio; it had a little stove of its own for heat, his easel, his drypoint press and accessory equipment, and 'shelves all round' to hold paints and canvases.

Ollie Matson's house, so often painted from the studio's upstairs front window (e.g., *Ollie Matson's House in Snow, The House Is a Square Red Cloud*), is still across the way, although shielded now by mature trees.[8] From the upper rear window Milne looked out over their kitchen chimney and through the yard between the Queen's Hotel[9] and the service station toward the main street of the village (this is the view in *Window*, among others). He could see Ed Young's house and butcher shop, which faced the hotel across the street; the back of the service station; over it the flat roof of the Imperial Bank, the town's only bank; and behind the bank the modest steeples of the Anglican and United churches. A short distance to the southeast Milne could sit on a knoll and look north over the railway tracks toward the village. Milne painted this view countless times, using the same basic composition as in *Serenity* and *Rooftops*. Gazing west, he would have seen Dr Reynar's imposing red-brick house with its flat-topped hip roof, another painting subject (*Brick House and Stormy Sky* I and II). Although the hotel, the train station, and the grain elevator are now gone, and Ed Young's house has been replaced by a fire station, many sites remain that are easy to identify in Milne's paintings.

Milne planted his garden at Palgrave almost as soon as he arrived, and he thought again of raising vegetables to earn money. Fortunately, he decided to forgo a repetition of the experience of growing celery and onions at Boston Corners, since prices had dropped; this not only saved him and

Splendour Touches Hiram's Farm, *1932, oil, 51.1×61.3 (20⅛×24⅛)*

The Cold and Rain Grip Hiram's Farm, *1932, oil, 51.1×61.6 (20⅛×24¼)*

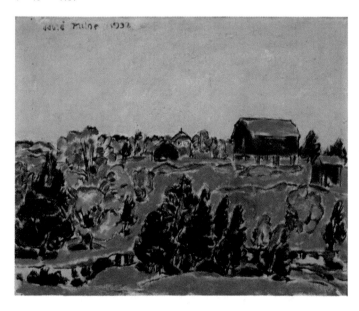

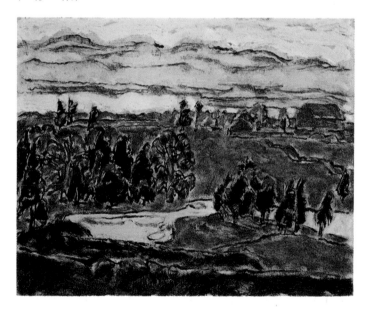

Patsy great labour, but allowed him more time to paint. The small garden they did plant gave them an ample supply of produce for their own larder and took little time from his chief pursuit.[10] It even provided some things that he *was* able to sell – corn, beans, onions, and currants.[11] Milk and other dairy products were available 'almost next door,' and Patsy also raised a few hens.

Although Palgrave nearly met the ideal of Boston Corners for Milne's painting, two things gave the place, with its eerie name, unpleasant associations for the Milnes: first, the Depression and their poverty; and then the fact that their marriage came to a sad and acrid end there. 'Artists stand depressions quite well,' Milne wrote in a letter of 1932, 'depressions look so much like their regular brand of prosperity.'[12] But this was the most trying period of his and Patsy's life together, ending in their being legally separated. These final three years of their marriage were acrimonious.

Another disaster threatened when the purchasers of the Big Moose cottage, the Collins family, began to default on their mortgage payments with more than half the principal still to pay – just when the Milnes' fortunes were lower than usual and their needs greater. For Clarke, who shared the mortgage with Milne, this default was merely one small loss among many others; for Milne, as Clarke knew, 'it is everything.' Foreclosing on the mortgage was only a theoretical possibility: who would buy the cottage? The hope that the Collinses would pay at least the interest on what they owed postponed a confrontation, and led Milne and Clarke to agree to try and get what they could, when they could, assuming that matters could be resolved in a reasonable time.[13]

The Depression only deepened the cut that poverty had always made in Milne's and Patsy's daily livelihood. Paintings were not selling. Because of the loss of income from the Big Moose cottage money for food and clothing was reduced to a pittance, and needed dental care had to be put off.

Window, *27 May 1930, oil, 56.3 × 71.8 (22⅛ × 28¼)*

Milne bartered his labour at harvest time for permission to cut the winter's wood – for the first winter in Allie Bible's bush, and then in Dave Matson's. He dug up and bagged 350 sacks of potatoes for Bible. Although the Milnes grew their own fruit and vegetables, life for them then was at the edge of survival. 'The third year,' Patsy wrote, 'we were very short of money. We paid the rent, and had wood for the winter, but not very much for food.'[14] Milne had but one pair of pants and one shirt, although Clarke sent an old suit that, with a tuck here and there, served for a time. 'The good days seem to be over,' Milne wrote to Clarke in 1930, although he noted stoically the following year that 'hard times are our regular dish, and present day fare with us doesn't differ so much from regular fare.'[15] Milne made frames for his paintings (only one or two are still in a Milne original), and in 1932 a new palette.[16] His stock of painting supplies was limited, and many pictures that might have survived in less austere times were scraped off or painted over. Many canvases from the Palgrave years are painted on both sides.

Yet Milne was determined that his professional life, his painting, would have priority over everything else. The little available money was used first for pigments, canvas, brushes, paper for drypoints, burins, and other supplies – and for glasses (his eyes were giving him trouble again). These expenditures, when so much else was urgent, put great strain on his marriage. Milne and Patsy lived in hostile solitude for much of the time, he out in the countryside painting or working alone in his studio – often having his dinner there, with only the cat for company. There was nothing for Patsy to do at Palgrave – not even furniture to dust – and she was naturally fretful and unhappy. At Weston she had taken lessons in weaving, but even that occasional diversion was impossible in Palgrave. Skiing offered some recreation in the winters, but by and large it was a sour time in which mutual resentment and recrimination were rife. Palgrave was a misery for both the Milnes. For three whole years they spoke hardly a civil word to each other.[17]

As usual, Milne wrote practically nothing about his personal feelings, except to complain that he was 'too much around the house, not enough contact with people interested in all the things that interest me, no pictures, books, music or chatter.'[18] Occasionally he sallied over to the Queen's Hotel in the evening to gossip with the neighbours and listen to the radio with them. But this contact, welcome as it was, was no substitute for the marathon discussions about art he had once had with friends and colleagues in New York, or with Clarke and Engle. The art world he had known seemed remote and unreal, and Milne must have wondered – for example, when Henri Matisse had a large retrospective in New York in 1932 – why no interest in his own work, which he knew to be good, had been shown by galleries and curators.

Despite the domestic tension, the Milnes were neighbourly and approachable, as they had been at Boston Corners and Big Moose. Milne knew about farming, he was easy with children, and he was still curious about people and things, although he claimed not to be able to make friends easily any more and there seemed to be no one in Palgrave who shared his interests. The fact that neighbours helped them out from time to time, and that Patsy was able to find a place to stay when the final separation occurred in 1933, indicates that they were accepted. Barring a few day excursions to Toronto, Milne never left the village except for hiking and skiing sorties into the nearby countryside for painting, activities that at least kept him fit. Working steadily, almost compulsively, kept him sane. His

long letters to Clarke were replete with information about his painting, without a hint of the looming rift between himself and Patsy. The contrast between the body of great work Milne achieved in Palgrave and the dire and unhappy circumstances of his personal life there could hardly be sharper.

Milne's eyes had long been a source of anxiety to him. When he wrote to Clarke from Palgrave about the trouble he was having with them, he traced the original damage, he thought, to the days when he made showcards in New York and did close-up work that caused eyestrain. He also cited finishing the inside of the Big Moose house and scratching drypoint plates as further aggravations. While he was in Palgrave he spent $75 on fees to an optometrist, Dr James McCallum, in Toronto, and on new glasses. (Fifteen years earlier McCallum had been Tom Thomson's generous patron, but either he was not interested in Milne's work or Milne was too reticent to offer payment by barter. Since he and Milne disagreed on aesthetic matters, as Milne told H.O. McCurry in a letter, the former is more likely.)[19] McCallum prescribed a series of exercises for Milne's eyes, which included looking into the distance frequently, and suggested that Milne not do an excessive amount of meticulous, detailed work or reading. 'Painting outside is the medicine,' Milne wrote to Clarke.[20]

In the official history of Palgrave the former owner of the Queen's Hotel credits Milne with introducing cross-country skiing to the town – thus, as the *Brampton Conservator* reported on 19 February 1931, making it a tourist mecca for the sport. Milne may have been something of an oddity when he first appeared there on skis, but he certainly did not think of himself as a pioneer of the boards. His only mention of skiing – apart from noting that he travelled about on skis whenever the weather permitted – was that he had made ski-poles for Patsy and a friend of hers and that he was going to make a pair of skis for himself, but decided instead to buy a pair for $4.50 because the price was so low.[21]

Milne perhaps compensated for his solitary life at Palgrave, where no one shared his artistic interests, with a steady outpouring of letters to those people he missed. The volume of writing he did during the Palgrave years is astounding, much increased over the late 1920s, and seems related directly to the volume of painting activity and his general state of artistic well-being. 'A natural craving for intercourse with others interested in the things that interest me has been suppressed, its only outlet has been in letters,' Milne confessed later.[22] His letters continued to be mostly to Clarke, but now he occasionally included McCurry of the National Gallery among his correspondents – perhaps with a shrewd eye to his professional position, but also simply because in McCurry he found someone in the Canadian art world who was sympathetic. He also wrote to Maulsby Kimball and his wife in Buffalo; they had already purchased some paintings and were proposing to arrange for exhibitions of Milne's work in Buffalo and New York. Milne's various drafts and letters and notes were, perhaps, paper versions of the verbal battles on art and aesthetics that had so engaged him during his years with Engle in New York, and with Clarke in Boston Corners and Mount Riga. Often Milne would write a draft (in one case nearly fifty pages long) of analysis and commentary on his work, or on that of others, and then copy it over as a final letter.

In these writings Milne showed himself to be an astute critic not just of his own painting but also of painting in general. Milne's verbal agility and facility astonished Clarke, and no doubt impressed McCurry, for not only were Milne's opinions just, but his reasoning and observations were shrewd

and clear. He seldom complained about his circumstances, or confessed what he felt about things personally, as opposed to professionally. He indirectly acknowledged this when he wrote to Clarke that 'literary efforts with me follow the plan of the sundial and record only the sunny hours.'[23] He expressed to others a cheerfulness that was in striking contrast to the poverty and stress in his life. Here he is writing to Clarke in 1932:

Sunday morning again! Here am I, one of the kings of the earth – and that's higher than any heaven I have ever seen described. If I were asked to name anything to be added to this morning's possessions or conditions I would be hard driven to do it. The mohammedan idol, perhaps, some houris. No houris here, but, since they would destroy most of the joys already in my possession, I am just as well off this way.

I am sitting on a woolen sweater with my back against the fortunately shaped butt of a maple tree at the edge of a little patch of bush.[24]

The surge in writing at Palgrave, which Clarke encouraged, came at a time in Milne's life when he felt that he had thought things through and had ordered his 'little field pretty thoroughly and [that] it wouldn't seem so difficult to set it down.'[25] In response to Clarke's renewed urging, he scratched out a spare outline for a book about art – showing how he would introduce people to the subject and then expand upon art's intricasies and subtleties. This armature was to be fleshed out with reproductions, painting notes, the narrative of a painting day (which he had already written out for Clarke in a letter – pp. 75–7), art criticism, and other such matters. The beginnings of his autobiography came next, with notes to himself about what to write about: the first painting he ever did on a cigar box lid; the influence of Andrew McHench, his New York sculptor friend, whose work encouraged him to try to paint holes in his trees as McHench had put holes in his sculpture; the first work he exhibited; his first use of white paper and the conventions it inspired – such as the outline or black-core convention, or the dazzle area; the importance of texture, contours, colours; and so on.[26]

The ideas for the book spilled over into Milne's draft letters of 1930 to Maulsby Kimball, since he was preparing to send a shipment of paintings to Kimball for exhibition and wanted to arm him with some aesthetic propaganda.[27] Emotion in painting is one subject that he touched on; he wrote that an aesthetic thrill is as necessary for a viewer to appreciate a work as it is for the artist to paint it creatively. He defined creative painting as that which the painter sees for himself, through his own conventions rather than some other artist's, separating it from the mechanical or technical part of painting. Most painters, he noted, see only what previous painters have seen; they are indebted to Constable or Cézanne, and are unlikely to add much that is original to what they have borrowed. 'Most of us walk along a well-trodden path in a great company, no courage needed. A few follow a path by themselves, against the voice of their fellows. The creative men kept on when all paths ended.'[28] Milne's draft notes also included definitions of line, colour, hue, value, the dazzle area, and contours. In defining line, for example, Milne is brilliant:

All painting, etching and drawing is considered as a use of line and color – both in all cases. Line is mostly one particular way of looking at a shape, the abstract view of shape. It may be insignificant in length, the spots of blue in the elm tree in the 'Blind Road' drypoint [Tovell 59] are considered as lines. It may or may

not enclose an area. It may be emphasized or reduced in importance in innumerable ways. In the 'Waterfall' drypoint [Tovell 60] the lines that mark the rock shapes are emphasized – quite aside from their color – by making them heavier; the ones that mark most of the tree and water shapes are reduced by being thin ... There is no limit to the ways and degrees in which line may be emphasized, but in general the more emphasis it gets the more fully considered it should be – the more intentional and decided. Only in the case of some dazzle spots and areas is this reversed. Then the value is used for its effect on the picture as a whole or parts of it – not for the sake of the line that contains it.[29]

Milne's style of writing is easy, deferential, and imaginative. He uses imagery with telling effect, and draws the reader gently and suggestively into a position of agreement on some very contentious issues. His explanations are succinct and persuasive; he coaxes the reader toward an attitude of openness, pointing out ways of seeing and appreciating a painting, and correcting habits of viewing that are prejudicial to a fresh appraisal. Milne disarms the reader with pithy aphorisms: for example, art needs to be simple and fast, and needs therefore to avoid obstacles, just as the hundred-yard dash can't have obstacles; or art is like dynamite and needs compression. Milne the writer was essentially as intelligent, perceptive, stylish, sensitive, and acute as Milne the painter and Milne the printmaker. One cannot avoid the conclusion that in his writing Milne kept one eye on posterity, hoping that eventually his commentaries would reach a wider readership, and perhaps help others to see and appreciate his paintings more easily.

Just before Christmas 1929, and again early in 1931, Milne saw exhibitions of works by the Group of Seven at the Art Gallery of Toronto – the later one being the last formal Group of Seven exhibition. Both exhibitions included works by the ten members of the expanded group and a number of their friends, such as Bertram Brooker, Fred Brigden, George Reid, George Pepper, Lilias Torrance-Newton, LeMoine FitzGerald, and Emily Carr. Milne drafted a letter to McCurry about the 1929 exhibition, which he never finished, but which he obviously had in mind two years later when he did send McCurry his comments. Commenting on the 1929 exhibition, Milne first had a few things to say about the friends and associates of the Group. Milne felt that they had

never got down to the tremendous labour that is necessary to get anywhere in painting. Perhaps too much teaching & societies & art politics ... All of the Seven are evidently competent craftsmen and so are [their associates] ... But craftsmanship alone provides no thrill, & is a means not an end. There must be more. For me, at least, there must be something creative, either accomplished as in [A.Y.] Jackson or promising, as in Emily Carr. There must be something seen by the artist at first hand, something put down on his own authority.[30]

Applying these standards, Milne had qualified regard for Emily Carr and Arthur Lismer, and only technical praise for Edwin Holgate and Lilias Torrance-Newton. He thought that A.J. Casson and Frank Carmichael were tragic examples in the exhibition: 'No fault can be found with their craftsmanship but they haven't a thing to say for themselves. Practically everything in their pictures comes from either Harris or Jackson. Harris's pitchfork trees are lifted bodily and Jackson's flowing contours are repeated to the point of deadly monotony.' Of J.E.H. MacDonald Milne remembered having seen much better work previously. He concluded by describing

Lawren Harris and A.Y. Jackson as the only two of the Group with truly creative qualities, although he added as a codicil:

Your Canadian art apparently, for now at least, went down in Canoe Lake. Tom Thomson still stands as *the* Canadian painter, harsh, brilliant, brittle, uncouth, not only most Canadian but most creative. How the few things of his stick in one's mind.[31]

In his letter to McCurry about the 1931 exhibition Milne again started with a general introductory comment:

All of the Seven proper are extremely proficient, so differing from most of the older school, Reid, Beatty, and those of that period who never seemed to quite master the thing they set out to do. I always feel some clumsiness, fumbling in their work. All of the seven are master craftsmen. Have they more than this? After all, craftsmanship is a low measure to judge artists by. Have they courage – that highest quality of the human race, creative courage? Have they anything to say in their own authority or is it all borrowed? This is the highest of standards and I rather think at least two of them measure up to it. This courage business is important because I think that we as a people, even more than the Americans, lack it. We are clever, imitative, but we seem to wait for someone else to show us the way, then we follow him instead of carving out a path for ourselves. Just at the moment I can't think of a single creative work that can be credited to a Canadian – in architecture, literature, engineering or anything else. No doubt there are some, but nothing sticks out very strongly when measured by the old country, Europe or even the United States.[32]

His comments on the individual artists, most of whom were by then past their prime and a decade past their formation as a group, were perceptive and astute:

A.Y. JACKSON The finest thing about Jackson is his consistency, his steady, gradual progress from the earliest things of his I have seen to the latest. Strong! No sudden breaks due to outside influence. At the moment, I would say, at the top of Canadian Art and with something of his own, something great.

LAWREN HARRIS I would place [him] as your other creative man. The opposite of Jackson in almost every way. He, so far as I can see, has had his periods, his sharp changes in style, which suggests a giving way to outside influences. Superficially he owes much to the modernists of twenty years ago – who in turn borrowed it from African sculpture. The extreme simplification got by leaving out and the extreme emphasis got by the exaggerated modelling comes from the Africans by way of Brancusi's sculpture. In spite of this leaning on someone else's authority, there is something running through all Harris's work that I think is creative. In all his stages he is not only simple, but extremely simple, and I think that is his own.

ARTHUR LISMER He has a sensitive, beautiful line in contrast with Jackson's & Harris's brutal, unfeeling drawing.

J.E.H. MACDONALD At present making no progress. Apparently his painting is swamped by other activities.

A.J. CASSON and FRANK CARMICHAEL The two finest draughtsmen you have.

Extremely clever ... Artists to their fingertips but not creative. Never will be. No one who has reached so high a point technically will ever be more than a craftsman – but what craftsmen!

EDWIN HOLGATE Doesn't fit, not so far, fine craftsmanship but conventional.

BERTRAM BROOKER My magnificent Brooker! What a splendid crash he makes. His craftsmanship and cleverness make it worse. He is not working at anything of his own, always imitative and always with a new god. Your first art appreciator.

LEMOINE FITZGERALD Remarkable in this show in that he isn't dogging either Jackson's or Harris's footsteps. A craftsman. In fact, that is his trouble. He has got too far along in craftsmanship, without saying anything of his own, to be hopeful. If they had never been done by anyone else his pictures would be masterpieces. But that is the point: if they lack creative courage, they lack all.

EMILY CARR There are no great women artists, no women creators. Too much cleverness and no courage. I am not going to be fooled any more. But she makes a good bid. Struggles. Nothing here equal to her little Indian church. [Milne had seen Carr's *Indian Church* in March 1930 in an Ontario Society of Artists exhibition, and commented, 'the best piece of work, to me ... was a little white church in a green forest by a B.C. woman. Without seeing more of her work I couldn't say whether she has added anything of her own to the modern techniques; but her picture was extremely well done.']

Summing up his views of this 1931 exhibition, Milne wrote: 'A good show. Whatever the value of the Group of Seven in Art, there is no doubt about their value to Canada. Mr Bennett [the prime minister] could very nicely vote the seven a million dollars each, and the country would still be in their debt.'[33]

About a year later, in April 1932, Milne corresponded again with McCurry, who had sent him a set of coloured reproductions of paintings by the Group of Seven. Although Milne had high praise for J.E.H. MacDonald's *The Solemn Land*, Frederick Varley's *Stormy Weather, Georgian Bay*, and Arthur Lismer's *September Gale*, his highest praise was again for Tom Thomson's work, in this case *The Jack Pine, Northern River*, and *Spring Ice*.

Though Thomson built [*The Jack Pine*] on Gauguin, I feel that he got something of his own out of it. Varley's and Lismer's pines are pretty much conventional pines, well done, but quite familiar, you don't feel any opposition, neither do you feel much enthusiasm, you admire their proficiency, that's all. But with Thomson's trees it is different. You can't be indifferent. These few patches with knotted strings are powerful, there was strong emotion behind their making and they stir the same now.[34]

Looking at the reproduction of *Northern River*, Milne was equally thrilled:

Just plain impossible, but he has done it, it stirs you. Any painter who has ever worked on this overlying pattern motive will realize at once that this is tackling a complication beyond all reason. A great point in Thomson's favour this, and his lack of perfection. I am wary of craftsmanship. It is nothing in itself, neither emotion nor creation.[35]

And Milne concludes with a reference to Thomson's sadly premature death by drowning in 1917, before he was forty: 'I rather think it would have been wiser to have taken your ten most prominent Canadians and sunk them in Canoe Lake – and saved Tom Thomson.'[36]

Milne also made a point of seeing an exhibition of paintings by J.W. Morrice (1865–1924), in whom he had considerable interest. Although resident in France, Morrice was a Canadian, and, like Milne, painted for the Canadian War Records. Older than Milne by nearly twenty years, he had been deeply influenced by a tradition parallel to impressionism – that of Edouard Vuillard, Pierre Bonnard, and the other painters who were known as the Nabis, whose work had also influenced Milne in his earlier New York days. Their intimate, evenly toned, and aesthetically based paintings were also an early influence on Henri Matisse, who was a close friend of Morrice's for a time (they had painted together in Tangiers in 1912 and 1913). Matisse described Morrice as 'the painter with the delicate eye.'[37] Morrice was a brilliant painter, able to evoke a mood or atmosphere and, above all, to maintain an even tonality in his work – a skill that Milne could equal. His subjects were often exotic (circuses, resorts, tropical islands, Arabian bazaars), and there was a distinctive poetry in his expression – accentuated, some thought, when he drank excessively, which was often. Somerset Maugham portrayed him as Warren in his novel *The Magician* ('very nearly a great painter ... [with] the most fascinating sense of colour in the world'). Milne had probably encountered Morrice's work earlier in Ottawa and Montreal, but this Toronto showing disappointed him; he called it 'studio sweepings' and thought that advantage was being taken of Morrice's recent death by the executors of his estate and by an unprincipled dealer. Milne thought that in Morrice's work 'everything [is] subordinated to aesthetic emotion, which he gets almost by color and line in the later more successful ones ... He is weakest in his creative side – pure painting but not great painting. Nothing much you can put your finger on and say this is Morrice.'[38]

Milne's attempts to sell or exhibit his paintings during the Palgrave years met with only modest success. A few drypoints were accepted in annual exhibitions, both in Canada and the United States; but there were almost no sales, apart from Clarke's enterprising sales of drypoints to his friends and associates. Clarke had made a passing reference to having a New York gallery handle Milne's paintings, but the plan never materialized.[39] Milne baulked at sending oil paintings to exhibitions because, given their larger size, the cost of framing, crating, and shipping them was beyond his purse. For the few he did send – to the Independent Art Association in Montreal and the Ontario Society of Artists – he made his own frames; but he was always disappointed when only one of his three or four submissions was accepted. In Cleveland and Chicago he had drypoints accepted for annual exhibitions, but the only major sale was of *Window*, purchased in Ottawa in 1932 from a national touring exhibition by Alice and Vincent Massey for $175.[40] The National Gallery (Brown and McCurry, who had urged this purchase on the Masseys) at the same time purchased a drypoint, *Waterfall* (Tovell 60), which was also in the exhibition, for $18.50.[41]

More interest in Milne's work came from Maulsby Kimball and Robert North in Buffalo. North, who liked and wanted to buy Milne's work, wrote to say that he was approaching William M. Hekking, the director of the Albright Art Gallery (now the Albright-Knox Art Gallery) in Buffalo about an exhibition.[42] At the end of 1930 Milne sent Kimball, from the stock of

canvases he had with him at Palgrave, a large box with a selection of his best work from the previous five years (forty-six oils, eight watercolours, and some drypoints). Kimball helped North make arrangements for an exhibition (or possibly two), but the plans never seem to have crystallized.[43] An influential friend of North's, Spencer Kellogg, was supposed to arrange for the show, once it was organized, to go on to the International Exhibition Center of the Roerich Museum in New York, where he was vice-president; but this plan also fell through.[44] Kellogg also suggested that the Sterner Gallery in New York would be a good place for Milne to show and sell his paintings, but nothing seems to have come of that suggestion.[45] Of the paintings they had in their care for the next four years, the Kimballs purchased several before sending the rest back to Milne in 1934.

One event that drew Milne out of his Palgrave retreat, figuratively at least, was his involvement in a controversy over the National Gallery of Canada at the end of 1932. A petition had been submitted to the government by a number of artists, organized by Wyly Grier, then president of the Royal Canadian Academy, calling for an investigation into the gallery because its policies, they claimed, unduly favoured the avant garde. This was odd, because the avant garde in Canada was then represented by the Group of Seven (their average age nearing fifty), a waning force in political terms and not a strong factor in creative terms. When Milne entered the fray, the academy was questioning the competence of the director and the curators of the National Gallery. Milne wrote vigorously in the interests of the gallery to the prime minister, R.B. Bennett; to the gallery's chairman, H.S. Southam; to the director, Eric Brown, and to McCurry, assistant director; and to various newspapers. Southam had Milne's letter printed in all newspapers in the Southam chain in Canada. Milne's letter to the editor of the Toronto *Mail and Empire*, published on 6 January 1933, applauded the fine work of the gallery staff in representing all aspects of art fairly, then flayed the academy:

No such self-perpetuating body, after its initial years, can escape becoming tradition-bound, an association of followers of the past rather than leaders of the present. The perfect academy would be one in which nothing ever changed, even its membership. It may have been an impatient associate who remarked that academicians rarely die and never change their minds, but there is truth in the statement. No academic body, after twenty years of existence, has any part in the creative art of its day; it has joined the dead waters below the mill. [46]

Milne argued that artists should leave matters in the hands of the curatorial and administrative staff of the National Gallery, who had proved themselves capable and objective. They were 'laymen' who, since they devoted all their time to art, were the best judges. 'Every artist sees art from the standpoint of his own work,' Milne wrote, 'and to everything outside that he is indifferent or opposed.'[47] An artist can represent only his own work or his own opinions, and should not therefore claim to be either catholic or dictatorial. This view angered Grier. In response he asked scornfully if theology, law, and medicine should be practised by laymen. Milne countered by pointing out that the word 'layman' had originated in the church and applied to legal juries.[48] The National Gallery survived the attack largely unscathed, although in a letter to Toronto sculptor Elizabeth Wyn Wood, who had offered support to the gallery on behalf of the Ontario Society of Artists, Milne noted: 'One phase of this agitation is unfortunate even though

Cover of the Colophon, *part 5, 1931*

no action is taken by the government, there will still be pressure on the National Gallery, enough to interfere with its freedom.'[49]

Just after Milne moved to Palgrave, Clarke showed some of Milne's drypoints to Elmer Adler, a New York man of letters and the founder and editor of a new periodical called *The Colophon: A Book Collectors' Quarterly*. Dedicated to fine printing, typographic design, and beautiful books, the journal was itself exquisitely set and printed, often on various handmade papers, and it included facsimiles and sometimes original artwork – wood-block prints, etchings, and so on. Clarke, now one of the leading advertising artists in New York, had become interested in typography and book design. (He had designed the dust-jacket and endpapers for Edna Ferber's 1926 novel, *Show Boat*.) He approached Adler, who immediately liked Milne's drypoint prints and saw that one would be suitable for his publication. In August 1930, therefore, Clarke sounded Milne out on the possibility of doing a drypoint to be published in the journal. By September he was more specific: he anticipated an order from Adler for 2,000 original signed drypoints to be bound into the fourth issue. The magazine would pay Milne $400 (20¢ a print), supply good Italian paper (Fabriano) to print them on, and reface the plates in steel as necessary.

Milne seized the opportunity happily. The prestige was alluring, given the calibre and interests of the subscribers. As well, the exposure might conceivably lead to the sale of paintings. The technical challenge was a little more daunting. He wrote to Clarke:

Your word of the big etching order was a little bewildering but welcome. I think I can manage if they allow time enough – I don't suppose they would be apt to underestimate the time required for that sort of work.

I am going to be stuck though for money to provide materials – color [ink], wiping rags, kerosene for heater, blotters for flattening prints, rollers for inking (I am making two), an extra set of blankets, repairing the press (this I am getting done today). Color [ink] of course is the big one but I think I can get by on these plates a little easier than my estimate in last letter of $100, 5¢ per print. My guess was based on a 3 plate subject. Can you loan me $60 to be repaid out of the [Big Moose Lake] house money (if they make a payment), if not, out of the etching money? I don't like to ask this when the Clarkes have done so much, but neither do I like to let this fine chance of a good job go by. Insurance and rent which come [due at] the end of this month will stretch us out so we can't carry through until the house interest comes.[50]

In making his drypoints Milne had used expensive artist's pigments instead of printer's ink, which he estimated as 10¢ worth of pigment for each three-colour print – a large sum for a large edition. For the *Colophon* job Milne at first thought that, while maintaining his usual high standards, he could run twenty three-colour prints a day, at a cost of 5¢ each, and maybe even more two-colour prints. This was of course a guess at both quantity and expense, since he had never run a full edition; but he had some idea of how fast he could work. Simple mathematics, however, should have told Milne and Adler that at this rate the task would take more than three months, including Sundays, and the publication deadline would still be missed by ten days at least. Nevertheless an agreement was concluded. The subject chosen was the print based on the painting *Painting Place*; the drypoint was to be in two colours, green and black, and it was to be called

Hilltop. The project got under way on 6 October 1930, and the $60 Milne asked Clarke for was quickly sent to him.

Milne managed to produce works of high and consistent quality at a rate that was surprising. Sets of plates (one for green and one for black) were steel-faced for him in Toronto and New York, and he simplified his colour requirements as he went along.[51] After working through Christmas and the New Year, he reported to Clarke on his progress:

The job itself is going slowly but steadily – rather better and more uniform prints, and four sets of new plates untouched yet. Time is always the trying thing. I have 500 here which still leaves me short of the half way mark. The light plates I am using won't print more than 40 a day – too light to wipe quickly, don't hold heat well and curl a little in the press. The heavy ones, sent to New York, will be along very soon now. Their limit is about 60 a day – and that's a real day. Very hard on the eyes – because they leave no time for any compensating outside seeing. More etchings than most people do in a lifetime.[52]

Even so, he was not producing fast enough to meet the schedule. Then, with the deadline rapidly approaching, Milne's first shipment of 250 finished prints struck an unexpected reef: American customs officials levied a duty that threatened to scupper the whole commission. No allowance had been made for this, and Adler could not, or would not, pay the duty. Following Adler's suggestion, Milne sent smaller packages of prints to friends of Adler in Chicago, Detroit, and Buffalo, as well as New York. This skirted the customs issue successfully, but the publication date sailed past and part 4 of the *Colophon* was issued without Milne's drypoint.

Adler reassured Milne that he wanted him to continue, and he duly rescheduled Milne's print for the next issue. This was all very well, but to confound matters Adler then decided that, with the success the *Colophon* was enjoying, he would print 3,000 copies of the fifth number rather than 2,000. Accordingly, he increased Milne's fee to $600 for 3,000 copies, and Milne had to work for another three weeks or so. He toiled on until the end of March or early April 1931, by which time he was probably black and green himself and quite fed up with his 'painting place.' As he had written earlier to Clarke, the 'biblical character who mourned about hope deferred making the heart sick must have been dabbling in color drypoint methods.'[53] Finally the task was complete, including a hundred spare copies of the print sent by Milne in case of problems during the binding process, and that spring the print was bound into the *Colophon*, part 5, 1931, as *Hilltop: A Drypoint in Two Colours* ('Printed by the artist at Palgrave, Ontario') (Tovell 63).

A few months later Adler sent Milne a copy of a commemorative birthday book he had helped to publish on Rockwell Kent – who had been born in 1882, the same year as Milne. This elicited from Milne a short but fine reminiscence of the importance that Kent had for him and his fellow students while they were at the Art Students' League, when Kent was making his first sharp impression as an artist in New York with his stark shore-and-ocean images from Maine, and later from Newfoundland. Milne sent the book to the National Gallery of Canada for its library.[54]

By trial and error Milne had learned a great deal about his drypoint equipment and was now able to guide his unique process of making colour drypoints toward richer possibilities. At Lake Placid during 1927, 1928,

Waterfall, *1930, colour drypoint,*
17.5×22.6 (6⅞×8⅞)

Lines of Earth, *1930, colour drypoint,*
12.6×17.6 (5×7)

Outlet of the Pond, *1930, colour*
drypoint, 17.6×22.6 (7×8⅞)

Blind Road, *1930, colour drypoint,*
12.6×17.6 (5×7)

and 1929 he had worked at twenty-five different subjects. At Weston he had reworked some of these, and refined technical aspects of the process. His first drypoints at Palgrave in the summer of 1930 were of two Big Moose Lake subjects, *Waterfall* (Tovell 60) and *Outlet of the Pond* (Tovell 61), and two Palgrave subjects, *Blind Road* (Tovell 59) and *Lines of Earth* (Tovell 58). While these were wonderfully rich and delicate, they did not satisfy Milne entirely. He had now learned ways of applying ink to the plates, experimented with various wipings (whether with rags or with the hand), improved registration, and tried using different papers and differing degrees of moisture and temperature. The mixing and overlapping of colours from different plates created especially thrilling aesthetic effects and informed important aspects of Milne's painting during the Palgrave years and later.

These drypoints were luminous and magical fulfilments of Milne's aim to create works so delicate that the pigment seems to be wished onto the paper by some act of the mind or the imagination rather than by brush or press roller. The prints have such a sense of casual spontaneity, such lightness, it hardly seems possible that they are the result of an arduous and complex technical process. The images are exotic but they seem familiar; the lines are definite but soft; the colours are pleasing but not representational; and although the prints are tiny, they unfold worlds of immense space and airiness before our eyes.

The secretary of the Chicago Society of Etchers, Bertha E. Jaques, one of the leading American authorities on etching, put her finger on the originality in Milne's colour drypoints when Milne sent three of them along for Chicago's annual graphic art exhibition in 1930. Jaques replied: 'Here is something unlike any of the thousands of prints received – drypoint – line in more than one colour – must be printing for each colour – do you care to explain to me? Questions will be asked.'[55] Jaques knew about the etching process and was startled by Milne's virtuosity: he had invented something that brought freshness and delight to a medium that had become tradition-bound and monotonous. Etching had lost its connection to contemporary expression and Milne had recovered that. But Jaques's interest and admiration were lost on the Chicago jury. As Milne reported to Clarke, the jury 'took the Blind Road and rejected the Waterfall & Outlet of the Pond.'[56]

In the late summer and early fall of 1931, soon after he finished the *Colophon* task, Milne produced another batch of outstanding drypoints: *Prospect Shaft* (Tovell 64), a Temagami subject of Dan O'Connor's mine shaft; and four Palgrave subjects: *Barns* (Tovell 66), *Blue Sky, Palgrave* in two versions (Tovell 67 and 68), *Queen's Hotel* (Tovell 65), and *The Village (Palgrave)* (Tovell 69). These were followed shortly after by *John Brown's Farm* (Tovell 70), a Lake Placid subject developed from Milne's 1928 painting of the famous abolitionist's home at North Elba.[57] In all of these drypoints Milne finally resolved what had been a recurring dilemma: how to treat large, open areas in a way that would give them vitality without destroying their essential blankness. He found that wiping with a rag instead of the hand left an uneven and heavier residue of ink on the unworked sections of the plate, so that a mottled tint dampened down the otherwise stark whiteness of the paper. The degree of wiping was critical for each of the three or four plates Milne usually used. He found the wiping process exciting when it worked and disastrous when it failed. When it was successful, the effect was equivalent to that of the rough-scrubbed skies in his paintings, which Milne accomplished

*Self-portrait, partly painted out, on
verso of* Red Elevator and Blue Sky,
c. 1930, oil

with an off-white or gray value: the effect was a purely visual expression, totally abstract, not representational, and yet balanced, interesting, modulated, and variable. In a purely painterly way Milne subverted the fundamental premise of printmaking, which is to provide uniform copies through a whole edition, by producing copies that are nearly all different from each other in ways either small or significant.

Despite all the time Milne committed to the drypoints his greatest achievement at Palgrave was his painting. He was able to accomplish in oils what he had done in watercolour at Boston Corners: to create a major body of work that is cohesive, intricate, and energetic. The Palgrave countryside had many of the attributes Milne had found inspiring for his painting in Boston Corners, chief among them the rhythm of shapes of the buildings in the village and in the surrounding terrain, the serenity of the blue skies and the dramatic parade of clouds, the undulating hills, the dense swamps, rich in colour and foliage, and the fluctuations of light, weather, and season. Often he painted the view from the south, looking at the village across the track; or the view out his studio window toward Ollie Matson's house, with the distant horizon behind it to the west; the view up Main Street; the grain elevator; and differing versions of sideroads, or of the rail lines slicing through the country hills. The aesthetic issues Milne addressed in his paintings during these three years were like related strands of development gathered into a single braid: an emphasis on drawing; an elaboration of his value system – one that pitted dark values against bright hues; a preference for rough brushwork that gave an appearance of spontaneity; and a fresh consideration of space divisions or equilibrium among well-defined areas of a subject. Underlying all of these was a sense of severe restraint. Although not sparing in paint, Milne wanted to express an ascetic idea – one that was simple, tough, skeletal, and direct. Stringency, rather than plenitude, became his watchword, and serenity his goal, an expression in his painting of peace, equilibrium, stasis, where before his objective had been conflict and drama.

One obvious omission in Milne's production at Palgrave was still lifes. The still-life genre had been a staple for him throughout his career, yet in the three years at Palgrave he did but half a dozen, three of them variations on an arrangement with a blue bottle, one of a rocking chair, one of tiger lilies, and one of petunias. Only the last of these held any vital interest for him, and it changed and changed and was never satisfactorily finished. Milne's overwhelming emphasis at Palgrave on the outdoors, or on landscapes, is unusual in his career. It was as if he did not want to be indoors, even though he spent long hours working in his studio alone, or that his preoccupation with the landscape sucked all his attention away from his immediate surroundings.

Another unusual attempt by Milne at Palgrave was to paint a self-portrait. This was the only time that Milne set out to paint a self-portrait rather than just including his own image as an incidental element in a larger painting.[58] Yet this self-portrait, showing Milne with a pipe, was painted out by him, and the other side of the canvas was used for another picture, a landscape. Perhaps his facility at catching detailed facial expressions, which he had shown in New York, had left him through lack of practice. Yet he was drawn at this time to looking at himself critically.

The great diversity of subject matter, other than still lifes, was matched by Milne's remarkable productivity during the Palgrave years. The oil paintings poured forth: thirty in 1930, a short year and one truncated further by

the *Colophon* commission; seventy in 1931; a hundred in 1932; and a number more in the early months of 1933. To these must be added the drypoints and a stack of drawings on the backs of cancelled *Hilltop* sheets or other paper. This output was prodigious, especially considering Milne's frail financial and emotional circumstances.

Milne's work in oils was often in a large format for him – anything up to 65×80 centimetres (26×32 inches) – despite his straitened circumstances. He wrote to Clarke that when he was putting $3 worth of paint on a $3 canvas, he found it difficult not to be nervous and cautious, even though he knew that the way to paint was 'to swing it by the tail.'[59] Yet he never hesitated to scrape off the pictures that displeased him, and the possibility of returning to the less expensive watercolour medium was not mentioned in his letters or notes. Instead, he painted both sides of many canvases.

While a good number of the Palgrave paintings are dated either on the canvas or in documents, the progression in Milne's work from year to year is not easily discernible. During the three years in Palgrave Milne was obsessed by continuing concerns for aesthetic solutions, and in some cases he worried a single subject along over many months, clinging like a burr to an idea that he thought needed fuller expression. By 1933 one can see a tendency toward more angular and less finished work: he was finding rough and awkward brushwork vigorous and compelling. And although he applied himself with astonishing diligence, inspiration was not always there when he needed it: he was often frustrated when he could not resolve some of the aesthetic issues he confronted. He said in a letter to Clarke that he had painted the same painting once every day for a week and was still unable to come to a resolution that satisfied him. Milne's overall achievement in this period, however, is impressive by any standards.

Whether he was painting the fields, the mill pond, the grain elevator, the village, or his house and those of his neighbours, Milne was dealing with the aesthetics of land and sky and their relation to each other. A natural concomitant of that, and a natural subject for Milne's sensibility, was the atmosphere and character of weather and of light falling across the land. In landscapes Milne was enthralled, first and foremost, with the relationship between earth and sky, with finding the balance between fussy earth shapes and an empty sky, or between a clouded sky and sparse rolling fields, using one as a foil or counterpoint for the other. The proportion of each to the other became a major preoccupation. The play of light, whether the glare of noon or the oblique rays of dusk, set the depth of the values to be used; the tilt or complexity of the horizon determined the contrast between them.

For Milne a connection with the land was instinctive, fundamental, essential. It embodied a reaction to the human condition in a telling way, for he believed that seeing *where* we are is one way of knowing *who* we are. An aesthetic response to the environment distinguishes the human response from the animal. Mere existence is easy enough, Milne wrote to Clarke, but it hardly provides the sort of thrill that one can obtain from a complex, sensitive work of art. Milne even saw an intimate connection between the human form and the landscape: he wrote to Maulsby Kimball that 'the flowing lines of earth have a close resemblance to the lines of the figure – as they often have,'[60] a point he made even more explicitly to Clarke.[61]

During his first winter in Palgrave Milne wrote to Kimball about his need to start a painting from nature and his equally strong need to differentiate between art and nature:

The third day of the biggest snow storm of the season! I suppose all artists who work much outside have a strong interest in the weather and all natural phenomena. Yet love of nature and art are – at least with me – quite separate feelings. I have enjoyed the big storm but am conscious of only one bit of aesthetic feeling during its three days: Sunday afternoon as we were skiing along the railway track I got a fine texture thrill out of the granulated old snowbanks and the fluffy new ones – even decided how I would paint it.

The painting of your little 'Farm Across the River' furnishes an example of the working of the two interests side by side – yet scarcely related. All the time I was working on it I was quite conscious of what Nature was doing, yet I can trace no connection between that and what was going on in a painting way. In one channel were the observations and feelings about the weather – the discomfort from the cold, irritation at the vibrating of the easel in the gusts of wind, the observation that the wind came up from the river valley and not across it, the

Serenity, 1931, oil, 46.4×51.5 (18¼×20¼)

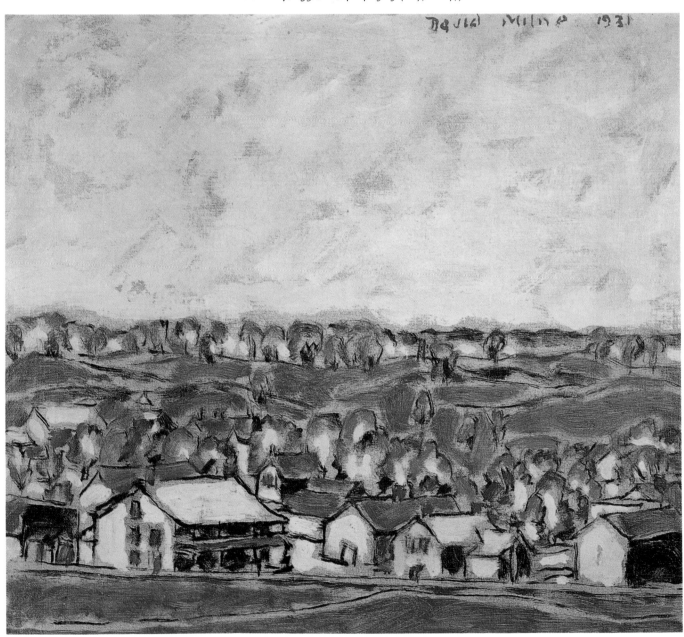

threat of snow in the cold sky. In quite a separate channel the translation of the distance into a flat combination of gray and red, the stepping up of this arrangement into black and red in the tree shapes of the river slopes, the emphasizing of some shapes in the farm buildings and nearer trees by a very slight use of a brighter color, the marking of the contours, the strong but sensitive line of the tree drawing. On occasion I have been conscious of a third line of thought carried on at the same time, not related in any way to the immediate surroundings – memories. One thing I do find difficult though – to keep a pipe lit and paint.[62]

Milne devoted weeks of concentrated work to, and painted untold versions of, what he called the serenity motive, a depiction of a particular relation between sky and earth that held them in a charged equilibrium. This idea spilled into all of Milne's views of Palgrave, affecting his approach to his redefinition of space and volume, changes to his value system, and his sense of appearing to express his images with spontaneity. Here is how he explained the motif in a letter to Alice and Vincent Massey:

On a bright day you go out and stand for a moment: a burden falls from you, you are refreshed, stimulated, uplifted. Why? Just exactly what, in nature, has stimulated you: the fresh air, the sunshine, the beauty of the landscape? No, none of these! The painter gets this feeling of serenity, just as anyone else does: then something, some timing of his particular art interest at the period, moves him to search out the mystery by painting. In the end he knows that his feeling came from just one thing, the great, restful space above the horizon. He can reproduce his emotion aesthetically by placing on the lower part of the canvas an area of detailed shapes – varied enough to engage and tire the eye quickly – and above this a larger, dominating area, perfectly blank, no detail, no gradation, unteased, unnoticed, without interest in itself, merely an area of rest, a refuge.[63]

The blank sky, he wrote to Clarke, was a device that worked differently from the dazzle spot that he had frequently used:

It is interesting to examine this use of blank space with that other one – the dazzle spot or area. They are quite different. The dazzle area is violent, a sharp

Drawing of Light *(initially titled* Fair Weather*), 17 March 1932, ink, 11.5×14.5 (4½×5¾)*

Drawing of Serenity, *20 August 1934, ink, 12.5×15.5 (5×6⅛)*

Village Spread Out, *1931, oil, 46.1×61.6 (18⅛×24¼)*

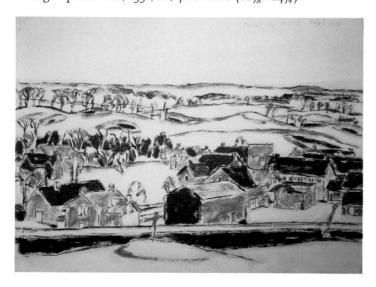

Village in the Sun I, *1931, oil, 51.5×61.6 (20¼×24¼)*

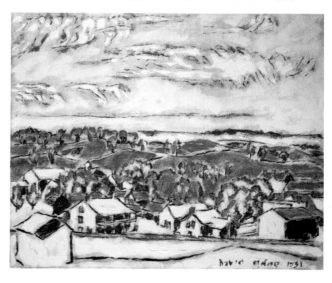

contrast in value. It is the first thing to engage the eye, throws you violently and quickly into the detailed part. This rest area is different. It isn't violent, it isn't the first thing to attract the attention.[64]

Milne introduced blank skies often in his many studies of the village of Palgrave seen from the knoll to the south, with the railway embankment and track slicing on an angle across the bottom portion of the canvas, cutting off the Queen's Hotel on the left and Ed Young's butcher shop to the right of it. Past the village is the countryside to the northwest, and above is the over-arching sky. *Serenity* is one of the versions of this subject that glows with the sense of peace and stillness that Milne was seeking to capture, although the same may be said of *Village in the Sun, The Village in White,* and *Village and Country.* A comparison of these different views of Palgrave make it evident that while Milne kept to one basic composition, he was willing to omit or shift a tree or two, a building, or whatever else was necessary to balance all the shapes, and particularly to keep the busy earth shapes from overwhelming the viewer's attention: maintaining aesthetic poise was his goal. The most interesting aspect of this group of paintings is the scrubbed-in skies. Here is Milne's painting as pure as it gets, usually a middle value (of gray) or a light value (of near-white or creamy white) without clouds or any other sense of representation. The texture of the scrubbed-in skies – whether the paint is evenly applied or patterned irregularly, thin or thick – is what ultimately makes the impact, and balances the more definite representational forms of the village buildings, trees, and distant hills. Milne painted and retained at least twenty-five versions of this subject, each one different in emphasis, and each an attempt to resolve the same basic aesthetic problem in a slightly different way.

One of Milne's problems in balancing sky against earth shapes was resolved by allowing some of the earth shapes to butt up into the sky area. *Kitchen Chimney* is an obvious example; but the same was true of his country landscapes, where tree shapes on the horizon complicated the relationship between the two main masses, upper and lower, and provided a means of welding them together forcefully. Sometimes Milne allowed a line of clouds on the horizon to achieve the same effect, as in *Clouds at the Horizon.*

Kitchen Chimney, *1931, oil, 51.1×71.5 (20⅛×28⅛)*

Chimney on Wallace Street, *1932, oil, 50.8×71.8 (20×28¼)*

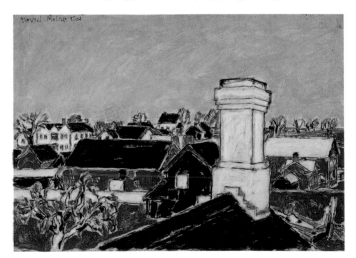

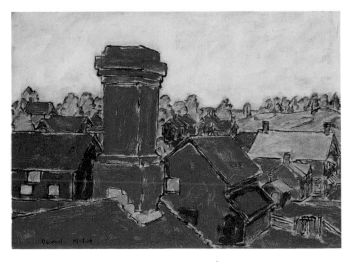

A motive is rarely worked to a conclusion and then dropped, it becomes part of the painter's life, it may be reproduced in varying detail later, or it may merge into another motive. This blank sky theme appeared many times in my work after I had arrived at its simplest form. One slight but distinct development of it was a series of 'clouds on the horizon' pictures.[65]

Another much-painted subject (thirteen versions remain) was Ollie Matson's house, which stood on Wallace Street across from the Milnes' and was observed daily by Milne from his upstairs studio window. His numerous portraits of Matson's house again dealt with the same aesthetic interest, but this time using transpositions to achieve equilibrium. The brick-red colour of the house was sometimes transferred to the shadows or to the clouds, the blue of the sky was transposed with the clouds or with the green of the grass or trees. One of Milne's titles, *Ollie Matson's House Is Just a Square Red Cloud*,[66] suggests that in Milne's aesthetic universe the shape-groups he conceived often encompassed incongruously coloured details, and that, as we are enabled to take them in easily and quickly, we make allowance for transpositions because first we read the shape, and then the colour. And in all this, because it defines shapes and shape groups, line is supreme.

Among the early paintings Milne did in Palgrave, *Window* is as good an indicator of his renewed optimism and aesthetic direction as one could find. His annual spring flower painting for 1930, this picture strikes a note that is decidedly ambitious. In a large format, and using his value system with unrelenting determination, Milne combined his spring bouquet of flowers with a rough, dark, out-of-focus frame and a compressed and complex distant view of Palgrave's buildings as seen from his upper rear window past the kitchen roof and chimney (producing a cubist-like

The House Is a Square Red Cloud, *1931, oil, 46.4×56.3 (18¼×22⅛)*

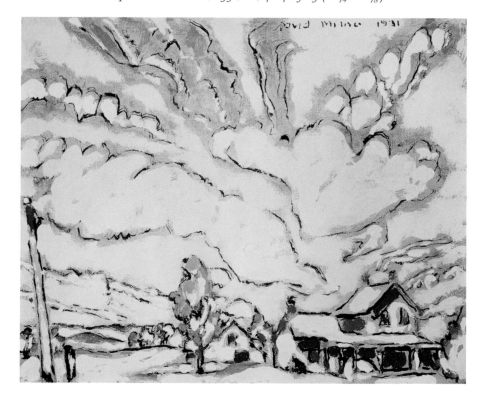

composition of facets and intersections in monochromatic values).

Not long afterward Milne tackled the same scene in a wholly different key in *Kitchen Chimney*. The stark white chimney is set off by the village in the background, this time in highly contrasting values of black and white that change the impact of the scene totally. The chimney, in Milne's assessment, was a simple point of entrance into the detail of the painting, and the composition is dependent on the arrangement of complex shape groups that are either predominantly white or black.

Framed Etching (or *Lilies from the Bush*, as Milne first titled it) was the annual flower picture for 1931. In this superb still life trilliums are set up in front of one of Milne's framed drypoints, and the reflection of a window in the glass of the drypoint provides a natural dazzle spot, one that, in Milne's words, 'steps up the speed of seeing' and experiencing the picture.[67] The drawing Milne made of this painting in a letter to McCurry shows emphatically, and elegantly, the way he used his value system – three values in this case – to provide a sense of taut balance.

From the latter part of the Palgrave period is *Dark Hills and Glowing Maple*,[68] a painting that incorporates many of the discoveries Milne made during his aesthetic explorations. It is a summation of the idea of putting bright hues and dark values into a tight relationship. Milne recognized that this painting had antecedents and successors, but he was

surprised to find that so many of the later Palgrave pictures deal with the theme of this one. It was entirely unplanned, and evidently came very naturally from the dull days and bright color of fall. The peculiar dark glow of these pictures comes from the use of bright hues with dark values. The motive can be traced in the earlier ... [*Kitchen Chimney, Two Maples, Storm Passes Over*], and the later ... [*Ice Melts on the Pond, Clouds over the Village, Splendour Touches Hiram's Farm, Ice Melting on the Pond, The Cold and Rain Grip Hiram's Farm*], and others.[69]

Milne's use of values, and the dark values particularly, gave immense power and brilliance to his work. The origin of this tendency can be traced back to his night paintings (in New York, West Saugerties, Boston Corners, Alander, and Big Moose), and the device is evident in the mine-shaft paintings at Temagami, although Milne was not necessarily conscious of this.

Of the four major aesthetic interests of Milne's Palgrave years – using drawing more regularly, adjusting his value system, finding ways to achieve a sense of spontaneity, and defining new space relationships – drawing served a fundamental purpose. The fact that Milne took up drawing with such enthusiasm in Palgrave heralds his return to the fundamentals of his art and a change in his working methods. Although occasionally he made pencil drawings for their own sake, or as notes for paintings, nearly all his drawings were preparations for paintings. He did none, or very few, through the 1920s, when he used the slightest of pencil sketches on his paper or canvas and painted over them. Now he filled sheet after sheet with pencil drawings of clouds and landscapes, working out details for such components of his paintings as a car sitting in the yard of the Queen's Hotel, the spacing of elm trees across the fields, the calligraphic shapes of individual trees he would use in his compositions, and of barns nestled in the hills.[70]

For Milne, as for all artists, drawing was not only a way of analysing and recording, but above all a way of 'seeing' with mind and hand. He recorded what and how he saw in a cryptic personal shorthand: often his drawings are little more than three or four lines marking the large con-

Drawing of Framed Etching, *17 March
1932, ink, 13.0×15.5 (5×6)*

tours or indicating the essence of what he wanted to convey in his painting. Yet these unassuming little sketches have the nervous energy and all the lean, sinewy strength of the paintings. They are spare but incisive. Relationships between or among groups of shapes, which is chiefly what is explored in them, are proposed and resolved with grace and sureness. Occasionally Milne added a colour notation or two to remind himself where the emphasis of the hues should go. From these apparently simple drawings Milne could reconstruct what he had seen and how he was going to paint it. Drawing allowed him to concentrate on seeing rather than on painting, and freed him from inclement weather and the seasons, from always having to work directly in front of the subject. He could take his notes home and work inside. Sometimes he drew for the joy of drawing

Framed Etching, *1931, oil, 66.1×71.1 (26×28)*

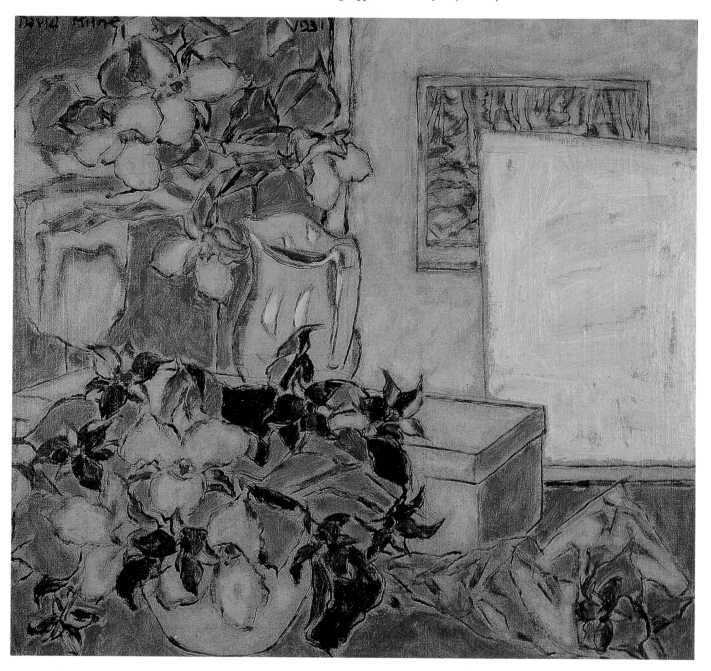

itself, just to catch a fleeting impression of clouds before they moved on, or of light against a hill before it changed; but usually he had a secondary objective in mind – to capture something he would use in a painting.

Drawing also adds to an artist's stock of images, and exercises the faculty of sifting and comparing imagery. By this time in his life Milne had an enormous wealth of images stored in the vault of his mind and most of it was readily accessible. As he explained to Clarke, when a shape was wanted for a flower picture at Temagami, '[I] searched my mind for something to use there and hadn't to search long. I remembered the treatment of foliage in a picture of an old stove at Big Moose. The loop-like shapes would work in harmony with the shapes here.'[71] In Palgrave he added greatly to his already ample store. The fortuitous shapes of clouds, particularly, opened his mind to possibilities, as Leonardo da Vinci had found inspiration for shape-creation in clouds or the embers of a fire. This attention to things that came so mysteriously, and accidentally, was in some ways the most important development of the Palgrave years, for eventually it changed Milne's approach to painting for the rest of his life. The possibility of making purely fanciful images comes from just such sources.

Milne's value system, another concern of the Palgrave years, evolved primarily as an extension and a refinement of what he had already worked out during the 1920s. The paintings of Lake Placid and Temagami had already led him to experiment with gray, black, and white in unusual proportions; in Palgrave these pigments were part of his basic arsenal. His refinement of this aspect of his unique approach to painting was to develop the use of two dark, two middle, and two light values, thereby allowing himself room for more complicated relationships of shapes and colours. By the end of the Palgrave period he had delved deeply into considerations of bright hues set against dark values; more than a dozen important pictures, for example, *Dark Hills and Glowing Maple*, show his pursuit of this idea. The dramatic contrast he thus set up between parts of the canvas was almost the antithesis of the serenity motif, and even recalled,

Dark Hills and Glowing Maple, *1932, oil, 40.7×52.1 (16×20½)*

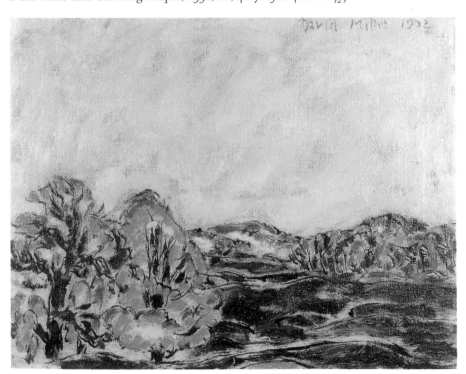

in a different form, the dramatic opposition that some of the earlier Boston Corners paintings had expressed.

But though values are powerful they lack variety. There is the one supreme contrast, black & white. Contrasts of black, white and middle value are still strong. In my own painting I have found great use for a further contrast of two light values and with less success of two middle values. I have used, but so far without much success, two dark values, black and near black – I look forward to being able to use that contrast in time. But that is as far as I go – six values at the most.

Black
 Near black
Middle value
 Near middle value
White
 Near white.[72]

Milne had always divided his canvases into black groups of shapes and white groups of shapes; colour was used only to add emphasis and to speed along the reading of a painting. At Palgrave, however, perhaps under the influence of the landscape there, Milne began regularly to use a creamy beige colour ('a near-white value,' as he called it) as well as a soft dove-gray colour (a mid-value) to fill out most of the surface of the painting – the fields, or the areas below the horizon line. Sometimes he used subtle and complicated variants of this: a white value and a nearly white value, a dark value and a nearly dark value, and a mid-value. The hues, or colours (other than white/cream, black/nearly black, and gray), only sharpened the edges of certain shapes – the edge of a bush, the lines in a field, the awnings on the Queen's Hotel, the corners of houses or barns, and so on. Milne devoted most of his last year or so at Palgrave to working out the implications

Flag Station, *1931, oil, 45.8×56.3 (18×22⅛)*

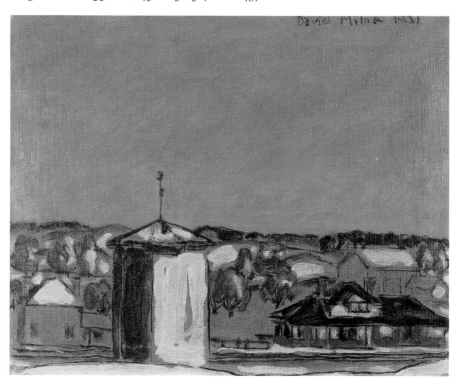

of the bright-hues/dark-values idea in various subjects, such as *Cloud Curtain*, *Splendour Touches Hiram's Farm*, and *Clouds over the Village*.

Milne also took a daring step forward in his value system by using a bold red to cover a large area instead of a gray or other neutral tone. This startling innovation, seen for the first time in *Flag Station*, made him realize that the simple transposition of colours could have profound implications; that, theoretically at least, virtually any colour – red, brown, blue, or green – might be used as a value if it were properly supported by the hues and shape groups of the rest of the composition. Milne did not use this discovery much at Palgrave, but it started him thinking. The potential of red or blue as a value poked at him, and continued to be a subject for his meditation until he proved what could be done with this convention in the wonderful *Nasturtiums and Carton* of 1935–6.

In his Palgrave paintings Milne was also pursuing the appearance of casualness and spontaneity, which he achieved by loose drawing, roughly applied or scrubbed-on paint, and leaving areas of coarse canvas showing through. He wanted a sketchy quality to be a dominant feature of much of his work at this time. The earliest example of this characteristic can be found in an embryonic form in the last paintings done in France for the War Records, such as *The Sugar Refinery, Courcelette I* and *II*. The first conscious manifestations of it were the drybrush paintings of the early 1920s; but in these paintings Milne was looking not for casualness so much as for economy of means, even although the appearance of spontaneity seems critical to their success. His lifelong concern with economy of means surfaced again in Palgrave, but with a slightly different rationale: it was used now to achieve a different reaction in the viewer. Milne was hoping to draw more attention to the speed at which a painting can be read, to let the viewer get to the aesthetic thrill of a painting faster and more directly. Refinement, therefore, had to be avoided. Milne praised Tom Thomson's 'lack of perfection' in *Northern River* and admired its compulsive image, 'complex beyond reason,' which pulled everything else in the picture with it. Milne knew that skill with pen or brush was not enough to compel attention or to carry a work: 'I am wary of craftsmanship. It is nothing in itself, neither emotion nor creation.'[73] He chose coarser canvas and sometimes larger brushes as an aid to achieving the sketchy appearance he increasingly wanted. He wrote to Clarke:

The speed with which the sketch is done may breed concentration, compression ... the very sketchy treatment ... avoids the appearance of effort and so gives power. I make no effort now to avoid the sketchy look, no matter how often a thing is done over or how rigidly considered it is.[74]

Anything that distracted or delayed the aesthetic impact meant failure, he wrote to McCurry in 1931:

Everything in a picture must work; if it doesn't, it is a weakness, just as much as mounds or rocks or corners to turn in the course for the 100 yards dash would be, it slows you up and so exhausts your emotion.

And in a letter to Clarke he wrote:

This quickness of execution is important – for me at least. Plod as much as you like but when the time comes to set down what you have in mind, drive into it.

If you don't, you are not quickened enough and get lost in detail, you scatter your emphasis and get some very worthy parts but no whole.[75]

An impression of artlessness in his art was what Milne sought. At the Morrice exhibition at the Art Gallery of Toronto Milne fell into conversation with a gentleman who maintained that a painting should be sturdily constructed, and Milne wrote to Clarke about it:

He felt that the solidly painted picture had more decision or success than the more loosely painted one. Nothing in it, I would say. A carrying over of the standards of material things to aesthetics. A solidly built house is more valuable than a slightly built one – but in aesthetics it is the thought that must be sure rather than the paint.[76]

This idea was quite compatible with one of the basic premises of modernist art: to make a strong and unified impact. In his letter to McCurry, Milne described how he tried to get

right to the heart of what a picture is. I would say it is merely (in principle) a drawing made readable. And since art is aesthetic emotion, exhausting, to be sustained only a short time, the more quickly readable a picture is the more its emotional effect is compressed and the greater its power.[77]

The corollary of Milne's drive toward an unfinished look was a greater mental preparation – his thoughtful involvement with the idea of a picture prior to the actual painting of it. Milne had always been fairly cerebral in his work, thinking intensely about what he was doing or how to change what he had already done. But now he wrote to Clarke of a painting planned at leisure but executed with speed:

I sat down on the side of a hill partly sheltered and looked at it for an hour or so. Figured it all out, even to the details of the foliage in the two big maples that were the main part of the picture, even the values planned and exactly the way of applying the paint. Then I painted it quickly.[78]

Milne could easily dispatch the physical part of making a painting in an hour or so. The consideration before and after was what took time. Clarke recounted how Milne 'never sat down and started to paint right away. He looked at the subject and he sorted it all out in his mind, the various things he was going to do, before he put any marks on the canvas or on the paper. He would sit in front of the subject maybe forty-five minutes, or more sometimes, just looking at it, before he made a mark. I'd have mine half done by that time!'[79] Milne mentioned this studiousness frequently in his letters: 'most of my painting is done off the canvas anyway, evenings, mealtimes.' Another passage gives an even clearer description of this:

All week spent inside and on one picture [Queen's Hotel, Palgrave] – one that has been going off and on since last summer. I rubbed it out and painted it over once for every day except Saturday and haven't got rid of it yet. As soon as I can I will get a bigger room for pictures of this size, not for the painting, but for the seeing them in between times.[80]

A final idea that Milne developed further during the Palgrave years was

one he referred to as 'space divisions.' He cited the painting *Barns* as the work in which he pre-eminently addressed this theme. To some extent this idea was a reworking of an earlier concern, the open-and-shut spaces of the Dart's Lake paintings of 1921. At Dart's camp Milne had composed his paintings out of the silhouettes or outlines of elements of a domestic landscape, similar to the way he treated the tanks, pillboxes, and piled debris of the abandoned battlefields of France. Now he was after something different. Instead of a simple outline, he tried to achieve an equilibrium among a number of spaces of different sizes and shapes, and in some instances of different tonality or value as well – full spaces rather than empty ones. *Barns* achieves these aims with compelling bravado. The balance among the different components of the composition, the weight of the lines that separate and unite them, and the way everything sits within the picture space are just about perfect. Every line, every space, is both charged with energy and standing at rest. Colour, although not at all representational, fulfils the role that Milne assigns to it, enhancing the rest of the composition, speeding up the legibility of the painting, and adding emphasis where needed. Here is Milne's account of the making one of the later (and probably destroyed) versions of this painting:

It is about the simplest picture I have ever tackled – the least lines, the least color, the least detail. Space – or maybe spaces. Very little black outline, the most prominent use of it is in the flagpole on the building at the left. In other places it is used as spots at corners and ends. The roof of the barn, the roof of the building with the flagpole and a couple of telephone poles, white. A few contours and a few parts of lines on the barn touched with two reds, two purples, and a yellow-green. The strongest value and the most color in the house on the ridge, black, two reds and a reddish purple. An open and shut

Barns, *1930, oil, 40.7 × 50.8 (16 × 20)*

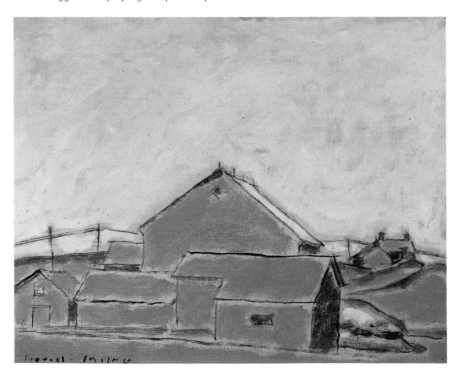

Barns, *1931, 1936, colour drypoint,
17.5×22.5 (6⅞×8⅞)*

Drawing of Barns, *14 June 1934,
11.0×15.5 (4⅜×6)*

picture, the ground shapes hold together against the sky merely because the sky is absolutely blank.

I painted it first at Palgrave – probably the first summer [1930], after harvest – I went round to it several times later and made pencil sketches, never got anything as good in the way of spaces. Two winters ago I made a drypoint of it [*Barns*, Tovell 66] (very much like the picture is now – this is the one I said I would send you, but haven't sent yet). I often thought of doing something more with it. A couple of months ago I drew it on a 26×32 canvas. The day before yesterday late in the day, after I had painted in another one, I painted it, sticking pretty well to the original plan. In it everything but the sky was middle value – to emphasize the rather good sky line. Not bad, but I decided that the open and shut plan would emphasize the sky line enough, since the sky was blank. Anyway the space dimensions in the barn and ground were fully as interesting as the sky line. The problem was merely to emphasize or reduce these few spaces so that they would hit all at once, so that you wouldn't travel over every detail before getting the whole, to order it so that one flash would carry you through it all. Yesterday I painted it again with that idea. Much better, faster, hit harder. Some weakness in the contours and in the house. The color remained just paint, and the eye was slow in leaving the interesting spaces of the barns and taking in the house, because of its small size. I hadn't used any black in it, and it was flat, lacked sparkle, kick. This morning I took it out and hung it on the side of the house and sat and thought over it until noon. Had absolutely everything decided on. Then I rubbed it out (the ground stays) and drew it in again and painted it this afternoon. Pretty good, the contours too heavy with color, interfered with the house, which from the start was planned for the strongest color. I rubbed out the contours and did them again. Right, but just a trace of fumbling here and there. I may do them or part of them over tomorrow. Where there is so little in the thing, you haven't much leeway, you have to have what is there do something.[81]

Line, value, and space are also masterfully used in *Queen's Hotel, Palgrave* of 1930, another of Milne's most satisfying works. The rhythm established by the roof shapes and gable points as one's eye roves across the painting is immensely satisfying. The tone of the paint is even and cautious, reassuring. The way in which the paint is laid on is sensuous and vigorous in every respect, but gentle to the point of quietude. Even the colours – a tangy mauve, a hot tangerine, and the vanilla sky, so familiar from Milne's other paintings – seem more compatible than usual. The whole painting breathes a magnanimity of purpose that traps the feeling of an empty, rural hotel yard baking in the sun on a hot, still, summer afternoon. Milne wrote, as usual, to Clarke about his many explorations on the way toward painting this major work. In fact, of all the versions he did, the only one he retained was this early one, which was a model for many later ones, none of which survived Milne's harsh scrutiny:

This picture ... is just about the simplest thing conceivable to look at but is more complicated in origin and plan. I had used the Queen's often in pictures before but always seemed to miss some thrill I got when looking at it. I usually see it from the yard, past stables, sheds or garage – blank areas uninteresting in themselves but looming very large in any casual view of the hotel. In other pictures I left these out – and lost the thrill, which seems to come from the open spacious setting. This picture has to do with that. The blank corner of the stable changes the scale of the whole thing, compressing the detailed part into a small

Yard of the Queen's Hotel, *1937,*
colour drypoint, 17.6×22.3 (6⅞×8¾)

Drawing of Queen's Hotel, Palgrave,
17 April 1932, ink, 13.0×17.0 (5×6¾)

Queen's Hotel, *1931, colour drypoint,*
17.6×22.3 (6⅞×8¾)

area and leaving a blank sky area – for rest. That's it, concentrated, spacious, restful. Not as much serenity as the landscapes with the upper two thirds blank but much the same idea That is the arrangement, but it isn't the motive of this particular picture. A red brick hotel in sunshine, pronounced shadows on the walls from awnings and cornices. As usual, I split my hues from my values. The hotel becomes a middle value, merely gray scrubbed over the area to kill it, the hue is used as orange to mark detail in sunshine, as purple to mark the shadows. A little more complicated than that. As a rule all my hues are middle value. In this [painting] the purple is a dark value [that] goes with black [i.e., goes in place of black] and the orange is a middle. Doesn't sound like anything, does it? But kind of interesting in practice.[82]

Milne's working method also underwent revision in the course of the Palgrave years. He described to Clarke in detail, because it mattered, the sequence in which he painted at Palgrave. He always began, he wrote, with a slight pencil sketch, setting the primary divisions of, say, horizon, building, or tree placement. Next came drawing in black paint, again on the slight side, but with more detail. The minor hues were put in next. At this point, with the picture's skeleton in place, came the flesh in the form of, first, the middle value and, second, the light values. Milne was not sure why this was the necessary order, but for him it was mandatory and it worked. There was, he wrote, 'a vision or a feeling behind it all but it would take some delving to uncover it. All I know is that there was much agony endured in forming this painting habit.'[83]

The order was one thing, but treatment or technique at each stage could change things even more. A difference in the touch of a brush, for example, or the size of the brush, could alter the effect of a value or hue significantly, so that there were numerous options for subtle contrasts with each stroke. 'The lightest is applied with more of a pulling dab – to make the heavier pigment stick – but stick irregularly,' Milne wrote to Clarke.[84] He continued his analysis in another letter:

The reason for this way of putting on the paint is a feeling for economy – of aesthetic means ... a hankering to do things by the slightest touch on the canvas, the brush meeting it and no more ... Some feeling of economy prevents me from varying hues in the same picture (by adding white or less white). This is so strong that I sacrifice economy of touch ... to economy of value in the hues. These things are slight when put in words but they are very strong and control you pretty completely.[85]

Milne backed up his report on his brush strokes by describing to Clarke the different brushing methods and touches in the works of Velazquez, Rubens, van Gogh, Constable, Turner, Cézanne, and Titian. His appreciation of their work clearly rested on their technical accomplishments, their ability with the brush. They were painters' painters above all else. While the narrative content of their paintings was important, the way it was achieved and conveyed – the imaginative spark – first of all, and most importantly, rested in their technique. The narrative content and the general appearance of their paintings might engage those who knew little of the painter's creative process, yet their impact and enduring worth ultimately came from the collective force of individual brush strokes, thoughtfully and inspiringly applied.

In the 1930s, when many North American painters were dedicated to

social realism, Milne might have treated Palgrave's simple homes, deteriorating barns, and unpretentious hotel from this point of view to produce narrative paintings of his own. But Milne never considered giving in to work that was even remotely sentimental, or political. Adhering to his aesthetic beliefs, he treated his Palgrave subjects straightforwardly. But he saw them so intensely and so personally that he was able to endow them with radiance, with glory, while also giving them instrinsic dignity. He seems to have possessed them, portraying them as not bigger than life but true to life. The paintings of Ollie Matson's house, for example, do not disguise its plainness but rather celebrate its ordinariness in rich, reverberating tones. Milne saw his Palgrave subjects with the same intensity that van Gogh saw the furniture in his cramped room in Arles. In Milne's vision humble subjects were subsumed and elevated.

In November 1932 the Milnes learned that their rented house had been sold, and on 1 December they moved around the corner to the basement

Queen's Hotel, Palgrave, *1931, oil, 51.1×61.3 (20⅛×24⅛)*

apartment of a store at the corner of Wallace and Main streets where Milne also rented a large, electrically lit studio on the upper floor. He wrote to Clarke that he was looking forward to painting larger pictures there, but he left Palgrave before he could realize this ambition.

Milne once remarked to McCurry that he had enough subject matter in Palgrave to last him a lifetime. But the Palgrave interlude came to an abrupt halt when the Milnes' marriage ended with a legal separation. In 1933 a separation was a powerful measure, one that carried with it a great deal of social opprobrium, no matter the reasons. Next to divorce, which was difficult to obtain, as well as expensive and time-consuming, separation was the best resort for couples with severe incompatibilities. On 24 April 1933 Milne and Patsy signed a short document that stated that, as a result of 'unhappy differences' that had arisen, they agreed 'notwithstanding their marriage and coverture' to reside separately 'and be separate as to bed and board.' Patsy undertook not to 'institute any legal proceedings' or to try 'to resume the marriage relationship, or bring any action for alimony' so long as Milne met a schedule of payments that were spelled out as $7.50 a month for the balance of 1933 and then a lump sum of $767.50 in January 1934, when the balance of the Big Moose mortgage was expected. Payment was conditional upon payment of the mortgage. Marley Beckett, a neighbour and a particular friend of Patsy's, witnessed the separation document.[86] In 1940 Milne's lawyer referred to Patsy's 'infidelity,' but no mention was made of infidelity in 1933.

This sad, legally formalized end to their marriage raises questions about the Milnes' relationship that are now, perhaps, unanswerable. Neither Milne's nor Patsy's writings shed any light on this, except to imply that whatever affection they had for each other had evaporated through the 1920s. Milne's moon-struck billets-doux of his courting days suggest that their initial attraction was physical, enhanced perhaps by Patsy's professed interest in art, even though her understanding and practice of it were shallow. The young man at mating time, Milne wrote to Clarke in 1934, 'just buys a ticket and takes what the lottery shakes up.'[87] The Milnes appear to have had few mutual intellectual interests, for Milne never wrote to Patsy about painting problems or aesthetic ideas. He had made it abundantly clear at the outset of their relationship that his painting came first and Patsy second. Patsy always remembered the day in Central Park, before they married, when Milne had said to her that he had to be a painter or die, and she knew that she was, and would always be, less important to him than his art. In spite of the mutual attraction and affection that had brought them together and kept them in marriage, Milne's compulsive and determined nature and his obvious priorities made it impossible for him to provide the security and stability that Patsy needed. About their third year in Palgrave Patsy wrote: 'There was a great feeling of insecurity. I often thought, if we had stayed in New York, where we knew people and places, things might not have happened as they did.'[88] Neither Milne nor Patsy wrote anything about their not having children, but given the norms of the age, their childlessness may well have been a factor in their eventual unhappiness with each other.

Patsy had not had an easy time of it. She was left to fend for herself for months, beginning with Milne's war service in 1918. She had laboured at menial tasks, often alone, to contribute to their financial needs. Although she wanted Milne to be successful, she must have resented the time and concentration he devoted to his painting and printmaking. This was espe-

cially true at Palgrave, where Milne's painting was a full-time pursuit and the first priority for any money the Milnes had, and there was nothing whatever for Patsy to do, not much of a house to keep, not much of a kitchen to work in, no friends except the few that she was able to make on her own. Nevertheless, the ties and obligations they had developed together over more than twenty-five years could not be set aside easily. After brief periods apart, they had tried to live together, perhaps unwillingly, first at Weston and then at Palgrave.

For Patsy the shock of the separation, when it finally came, was disorienting and she tended to blame Milne. When she wrote her patchy memoir many years later, this is all she said about it, even getting the year wrong:

(Around 1934) A brief period of upheaval, impossible to explain, (alien and far removed from other years). Endless worry and despair. If, later ... there had been a desire for forgiveness, there would have been little hesitation on my part, at least.[89]

In later years Patsy tried to suppress the fact of the legal separation. She refused to request, or consent to, a divorce and continued to imagine that amity could be restored eventually. But for Milne it emphatically could not. He tried to be kind to Patsy by writing occasionally and sending a little money, and to be rid of her at the same time by refusing to see her if at all possible.

Milne and Patsy were happy enough at the beginning of their marriage, for Patsy was Milne's model in many of his paintings for over fifteen years. Making a home, first in New York and then later in Boston Corners, seems to have given both of them a high degree of fulfilment. Patsy was a proficient housekeeper and a capable cook, to judge from the preserving she did and her work managing tea rooms. She was practical and, although perhaps in a limited way, imaginative. She had an interest in art as a result of her association with Milne, and she occasionally tried her hand at drawing or painting. At Weston she had taken up weaving, although she did not work very diligently at it. She seems to have had a sprightly temperament, but no one credited her with a sense of humour or shrewd ambition, both of which Milne did have and probably needed in a mate early in his career. The unpublished memoir she wrote late in her life, just after Milne's death, reveals her as pleasant and mildly distracted, which she may have been by then, but conscientiously dedicated to his memory, and quite unaware of the dimensions of his achievement. Her writing is not in the least intellectual, or even fluently articulate. She was simply incapable of following Milne as he hewed his way through the thickets of his late painting years. Milne was a man with a large ego, which he hid behind the mask of his self-effacing Scottishness. He was doubtless not easy to live with, and as naturally self-centred as many artists are bound to be. If his muse was not diligently served, he was readily capable of being ruthless. As Clarke commented, Milne felt that 'painting was the first thing and the only thing.'[90]

The ghost of penury and the breakdown of his marriage did not deter Milne the painter. The steady, concentrated work of the three years in Palgrave gave him a chance not only to recapitulate his theories and practices as an artist but also to suppress any lingering doubts he may have had about himself, brought on by the fractured life of the Adirondack years.

Artistically the Palgrave years were superb, productive, exciting, self-satis-
fying: 'three happy, peaceful, fruitful (in painting) years,' Milne wrote later.[91]
Over two hundred worthy pictures testify to that, and so might many of
those that were painted out or destroyed. He emerged with a personal
freedom and self-confidence unequalled since the First World War. Yet
the critical difference was that during his military service Milne's confi-
dence was built on external supports. In Palgrave the assurance he gained
was much deeper, much surer, for it was garnered from the resources of
his own will and an indomitable determination to paint – no matter what
else might happen. Milne had become a painter reborn.

Earth, Sky, and Water

Six Mile Lake

1933–1937

AFTER THEIR SEPARATION in April 1933 Patsy intended to return to the Adirondacks to work in a tea-house and Milne was to remain in Palgrave. Patsy's plans fell through, however, and she stayed in Palgrave. Milne felt obliged to leave, although he had said that Palgrave was a place where he would have painted happily for the rest of his days. He bitterly resented the upheaval because it meant that painting had to be 'broken off,' a wrenching experience, particularly at 'the peak of spring and fall,' as he complained to Clarke.[1] He described this particular rupture as 'a calamity.' Resettling at the age of fifty-one would not be easy, even for one as nomadic as Milne. The strain of his departure, no matter what the reasons, doubtless affected his opinion of other things, especially his painting.

At first Patsy stayed with Marley Beckett and her father, Peter, where she raised chickens and did some gardening – chiefly growing potatoes. Milne had agreed to pay her $7.50 a month through to the end of the year, when he thought the Big Moose mortgage would be paid off in a lump sum and she would get half their share and be able to buy a small place and settle down. Since only the interest on the mortgage continued to be paid after 1933, and occasional small amounts of capital, Milne remitted to her half their share of the income as it was received. Patsy spent a short part of the summer working at Windermere, a resort on Lake Rosseau, in Muskoka (where she was employed the next three summers), and then she returned to Palgrave. She seemed to assume that the separation was temporary and that soon Milne would allow her, in her words, to live with him again, to cook for him and mend his clothes.[2] Conscientiously she clipped art items she thought would interest him: 'I sent him a "subscription" to *Blackwoods' Magazine*, and all the art criticisms I could find – *Saturday Night, The Globe and Mail* were especially good, and I watched for them regularly.'[3] Her loneliness was almost palpable: 'There was a little hollow, some distance from the [Beckett] house, and I stood there for a while, and imagined how wonderful it would be to see Dave again.'[4] Whatever she subsequently tried to do to mend their relationship, such as sending him food, clothing, and household goods, was at first tolerated by Milne; then he became resentful of her persistence and wrote to her sharply to stop trying to be helpful and let him get on with his work.

As usual Milne disguised the whole truth about his domestic situation when writing to Clarke. In June he reported only that things were 'disturbed and uncertain,' and that 'Patsy and I had decided to make some change this summer. Both, particularly Patsy, getting very much worn and dangerously nervous.'[5]

Milne left Palgrave in early May 1933 and went first to Bracebridge,

Milne's map of Six Mile Lake, in a letter of c. 8–12 October 1933

about 160 kilometres (100 miles) north of Toronto, where he found nothing that pleased him, then doubled back to Orillia, where he bought a canoe and supplies. Slowly, as if he were wounded, he paddled his way north and west along the shore of Lake Couchiching and then along the Severn River until he arrived at a campsite near Port Severn, the last lock on the waterway before Georgian Bay, where he pitched his tent amid clouds of mosquitoes and blackflies. He grumbled to Clarke in mid-June that he was 'not content at all,' for he had not yet started to paint. Changing his painting ground from the 'open skies of Palgrave to the closed-in material of the bush' was intimidating and a poor use of precious time. 'So far it looks to me like a month unpleasantly wasted. I don't like these sharp breaks now, the continuous thing suits me better.' Although he had to 'make everything from the beginning, even the thinking,' he decided that at least this break would test his theory that 'anything is good painting material when you get to know it.'[6] Despite his disclaimer, Milne managed to get some exciting painting material out of the area, of which *Waterlilies in the Bush*, which he drew again about a year later, is a fine example.

Milne's initial idea in poking around the Severn River area, as it had been at Bracebridge, was to find a place where he could build a cabin to live in and paint in, and then possibly sell. His only caveat was that the new building would be considerably smaller than the one at Big Moose. A road to Severn Falls was being constructed, land values seemed about to rise, and he thought he could build a cottage in his spare time. In spite of his Big Moose experience he still saw cottage building as a way of earning money without interfering with his painting time.

Milne's enthusiasm for the Port Severn area waned, however. On an exploratory trip with Don and Florence Houston, artist friends he had recently met, they found their way into Six Mile Lake, in Baxter Township, near the southern end of Georgian Bay. To Milne the terrain there seemed open and congenial, unlike the constricted and less inspiring landscape of the Severn River. The shore and bays were littered with driftwood, pine stumps and logs mostly, the result of earlier logging of the area and a much earlier (1915) major forest fire. The only drawback, which Milne later counted as a virtue, was the isolation of the place: contact with civilization entailed a twelve-kilometre (seven-mile) trip by land or water. As Milne visited the lake several more times to paint for a few days, the distance seemed worth the painting subjects he found, his painting improved, and his mood turned to cautious optimism. In the late summer he moved to Six Mile Lake to stay.

I don't know why the lake is called Six Mile ... Perhaps it is because you can travel in a straight line on it in several directions for about that distance. Something like this [see above]. You can't see more than two miles across it except by carefully picking your stand. Too many points and islands. Good canoe water. It is in Muskoka, in the township of Baxter. Baxter must be about the most thinly populated township this side of the north pole. So far as I know I am the only permanent resident. From here you can hear the train whistles at Bala and the steamboat whistles on Georgian Bay. No railways touch Six Mile and no highways. There is one rough wagon road from Honey Harbour and Port Severn, branching off to touch Six Mile at White's. You can't get to it by canoe without a portage. Barring that it is accessible.[7]

He had previously written to Clarke that, although his painting was im-

Waterlilies in the Bush, *1933, oil,
46.1×56.6 (18⅜×22¼)*

Drawing of Waterlilies in the Bush,
*20 August 1934, ink, 12.5×17.0
(5×6¾)*

proving, 'so far health seems to be the only gainer this summer. I feel stronger and healthier than I have since the war. Eyes, too, have had a rest, I haven't been reading or doing close work at all ... Some day I hope to have a radio, that will keep me from reading too much.'[8]

At first, as if unwilling to give up his initial purpose, he proposed to buy two hectares (five acres) on a point and build a cottage on it. Milne eventually dropped that idea and instead rented a two-hectare lot from the government at $5 a year and decided to put up a modest cabin for his own use. During September he mooched planks, boards, and poles from driftwood piles around the lake. He then ordered from the sawmill at Big Chute an additional 700 board feet of lumber to complete his little cabin. The shipment was delivered part way, but so late in the fall that Milne finally had to ferry it in himself in his canoe, battling ice all day in a tricky and dangerous passage between Hungry Bay, where a neighbour had brought the load by boat and barge, and his own point.

Patsy, back in Palgrave, sent by rail freight to Big Chute six big boxes of paintings and equipment that Milne had packed earlier. She also sent other supplies – plucked chickens, sacks of vegetables, and about 'twenty five or thirty jars of fruit.'[9] These he buried deep in the ground, to keep them from freezing, and used throughout the winter. By late November Milne had finished the roof in a snowstorm and closed the cabin in, but he still had not installed a door by Christmas. Yet he was happy. In fact he was to stay here for six years, longer than anywhere in his adult life.

Despite the restrictions imposed by an abode of such modest dimensions, 3.7×4.8 metres (12×16 feet), Milne felt that it was 'about the best painting place' he had ever had. He gathered moss to insulate the cabin and covered it with tarpaper, just as he had the little cabin at Alander. It stood out on a promontory of granite facing west over the lake. 'The cabin on the point was like the bridge of a ship, right out in the light – and the weather.' A little bay with a sand beach was to the north and another larger bay to the south.

The cabin was built at the neck of the rocky point which was flat on top with a shallow marsh in the middle. The rock ledge I had slept under [on his first trip] partly sheltered the west side. It was twelve by sixteen with a door at the back, a blank south wall, two horizontal casement windows on the west side looking out on the lake and two upright casement windows on hinges in the north end towards Lost Channel. Two more [windows] were added later.[10]

The windows had been ordered from Eaton's, a vertical one for the east end by the door and two double ones for the west wall. Milne found a stove at an abandoned lumber camp and had it ferried to the cabin site by Onesime Mayer, a friendly lumberman who lived a few kilometres away up Jesus Creek, as the locals referred to Mayer's stream in deference to his Catholicism. Milne built shelves along the cabin's east wall. He later described his new home as 'just as near heaven as you can get ... [I'm] like a chipmunk in his cave.' It had cost him '$40 and a lot of misery,' but he was content there and thought that it was 'good enough for a Velazquez.'[11] He stocked the cabin with painting and etching supplies and enough food to see him through the winter:

Bringing home the winter supplies always seemed like a great event, like threshing day on the farm. I got them from Eaton's and Herman Cadieux brought them as far as Scotty's bunk house at the top of the marine railway.

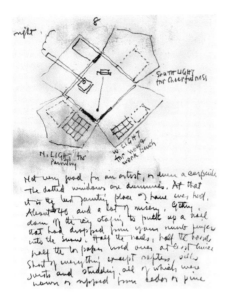

Milne's cabin at Six Mile Lake, as
illustrated in a letter to James Clarke,
23 December 1933

There they would stay until I found time and suitable weather to get them home. Scotty brought them down to the railway for me and I carried them in the canoe to the portage. There the heavy boxes and bags and the canoe had to be carried over a hundred yard portage and loaded again on the lake. The possibility of rain was the deciding factor in deciding on a day. I disregarded the wind. On a fine autumn afternoon, otherwise suitable, there was apt to be a strong wind blowing down the lake, a head wind. I could have waited until after sunset when the day wind would die down, but I was always anxious to get home, didn't like waiting around. So I balanced the load carefully and set out. When I got toward the point the water was rough and all I could do was keep headed into the wind and move along very slowly. I steered close to the point, then turned on the crest of a wave and ran easily into the harbour at the sand beach. Then more carrying up to the cabin. One or two of the boxes were opened in search for some special luxury for supper. The rest were left outside to be opened later. There were lots of things ... If there had been more, or more of some kinds, I wouldn't have been so well pleased. I never liked to be faced with too much food.[12]

Milne's supplies were tantalizingly and proudly enumerated in a letter to Clarke: '30 lbs. bacon, 10 lbs. brown sugar, 10 lbs. white sugar, 25 lbs. flour, 15 lbs. oatmeal, two small bags salt, 5 lbs. coffee, 2 lbs. tea ... 3 lbs. cheese, a little beef and some salt or smoked fish,' a sack each of potatoes and apples, beans and some other vegetables, two cases of tinned evaporated milk, some honey, syrup, as well as tapioca, pepper, matches, canned fruit, spaghetti, corn syrup, peanut butter, biscuits, and soda crackers. In addition there were wax and thread to sew shoes, cork insoles, laces, leather soap, Epsom salts, pens, pencils, envelopes, towels, shaving soap, toothpaste, and a new toothbrush.[13] Patsy supplemented all this with her provender from Palgrave, although Milne chided her for doing so and wrote that she should not send things that he did not ask for. He tried to be

Winter Sky, 1 January 1935, oil, 30.5×41.0 (12×16⅛)

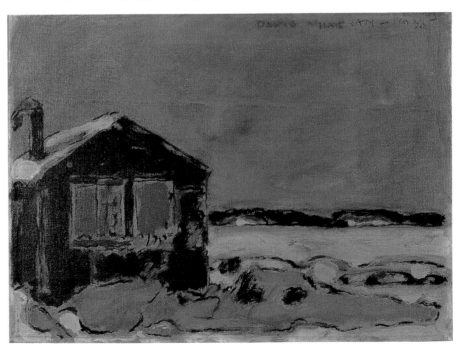

reassuring about money for her sake, but he was unable to be convincing.

Milne decided to make maple syrup in the spring of 1934, an occupation that he thought would be compatible with his painting. He entered into a partnership with Scotty Angus, the manager of the marine railway that ran between the canal system and the river at Big Chute,[14] and trekked daily to Rattlesnake Pete's sugar bush to gather sap and make the syrup, using equipment that Angus owned.

I loaded up the sled with an axe, tub and tin cans ... and started down the ice and then inland to start sugar making. I had no auger or brace and bit to make holes so I made a V-shaped cut with a chisel and set in a small trough of tin to run the sap into the can. Then I built a stone fireplace against a rock at the edge of the bush and started syrup-making on quite a large scale. Very nice work, one of the few occupations that can be combined with painting ... The trees and sap cans and the saplings, the rocks and logs covered with snow, the fireplace and supply of firewood, even the smoke from the fire and the vapour from the boiling sap went into the painting.[15]

The venture benefited his painting more than his syrup making: the operation was modest in scale, since it provided only enough syrup for Milne's personal use and four or five litres (a gallon) for Angus.

At about the same time, in the early spring of 1934, Milne got a taste of an experience that he soon came to dislike intensely: Patsy showed up at the cabin, unannounced, having skied in from Big Chute behind Angus and his Newfoundland dog pulling a toboggan with her luggage and two pails of honey. She later wrote that she 'stayed about five days, and hated to leave ... Dave said "don't be afraid, we will see each other again."'[16] According to another report, Milne made her leave almost as soon as she arrived.[17] But there was no doubt about Patsy's pleasure: 'I did not feel tense and unhappy as soon as I saw Dave again, and the world seemed wonderfully bright.'[18] Patsy had spent the winter of 1933–4 in Clarkson, west of Toronto, where she took more weaving lessons from Miss Turner, with whom she had studied when she lived in Weston. The next winter, 1934–5, she stayed in a little room at the Woman's Art Association on Prince Arthur Avenue in Toronto. She visited Milne again in the spring of 1936 and once more in September – in the spring canning wild strawberries they picked, and in the fall about twenty pints of peaches for him to add to 'the bushel of apples I dried the winter before.'[19] Milne encouraged her to find a place for herself and get settled in it, but Patsy seemed unable to confront such a definitive move. She kept hoping they might live together again, although for Milne this was impossible.

Milne's first year at Six Mile Lake was affected by the sorry state of his finances. The failure of the Collinses to repay the mortgage capital on the Big Moose house on schedule at the beginning of 1934 – because of the closing of their New Hampshire bank, and then their New Jersey bank in Leonia – put a severe strain on Milne's finances, and on his nerves. The interest payments and occasional small chips off the principal gave him some income: without it he and Patsy would have had none. However, he was left without the means to get the full dental and eye care he needed, and with a dwindling supply of painting materials. To pay his life-insurance premiums Milne borrowed money from Clarke. In the summer of 1933 he often used small canvases, perhaps to save money, and he could not afford to send his paintings to exhibitions. Insolvency made

Two pages of Milne's letter to the
Masseys of 20 August 1934

him profoundly uneasy, but he persevered. By the summer of 1934, with good progress in his painting, he was feeling sanguine about his artistic direction.

This increased self-confidence and enthusiasm stiffened Milne's resolve to advance an earlier plan he had set aside: to try to sell all his work in a single transaction. The proceeds would buy him financial security for many future painting years. The serial nature of his paintings seemed to Milne to make them attractive as a cohesive and continuous documentation of one artist's struggles, failures, and successes. Storage was looming as a worry, especially with the possibility of Clarke's moving house after the death of his wife Anne in 1934. Clarke had three big boxes of Milne's paintings, the Kimballs another in Buffalo, a number of paintings were among the effects left in Florence Martin's boathouse at Big Moose Lake, and Milne had five or six crates of paintings with him at the lake. The danger of a cabin fire was always at the back of Milne's mind. And a forest fire that might destroy the cabin while he was off on a trip was also a constant worry: in the summer of 1933 one or two forest fires broke out nearby, close enough for Milne to paddle over to watch one at first hand. His accumulated work represented a huge asset, but the longer he did nothing about selling it, the more it became a potential liability.

Milne confided to Clarke that he had decided to sell his entire lifetime's production. Although he identified the idea as a museum project, Milne decided that his 'first attempted victim' would be Vincent Massey, who was known to be wealthy, an acknowledged patron of the arts, and a member of the board of the National Gallery. Massey and his wife Alice had already bought one of Milne's paintings from a travelling show at the National Gallery for $175. During July 1934 Milne drafted his proposal and finally typed it and sent it to Mr and Mrs Massey on 20 August. The letter precipitated a convulsion in Milne's life that was far from what he expected.

This unusual and fascinating epistle is surely one of the most remarkable documents of twentieth-century art. In twenty-nine pages – most of them typed, single-spaced – that included nine brilliant ink drawings Milne told the story of his life and work. He gave a short account of his training and progress as an artist, from his first hesitant steps in New York and his acceptance in the exciting Armory Show, to his work for the War Records, and his life up to his Six Mile Lake retreat. He described the most important characteristics of his aesthetic practices: his value system, the dazzle spot, the foil, interrupted vision, and open-and-shut spaces. He stressed the importance of the relationship of his paintings to each other and his wish to keep them all together and in Canada. And he concluded by asking the Masseys if they would like to look at the pictures and consider his proposal:

To set some sort of bounds to my proposal, I have put a price of five dollars each on them, good or bad, as they come, possibly five thousand dollars in all. This is purely arbitrary. It isn't large enough to have made their painting a profitable, or even possible, enterprise; yet it is enough to ensure years of continuous, undisturbed painting for the artist with simple tastes. The aim is to trade twenty-five years of painting that is past for five or ten years in the future. It may seem an unusual way of going about things, but it is in just some such way that much of the art which has influenced our time has passed from the hands of its makers. The best work of Cezanne, Degas, Renoir, Pissarro and

[Henri] Rousseau went to helpful and discerning patrons, often at prices well under a hundred dollars. Yet those transactions are the ones that have to do with the making of art. All the millions spent on Holbeins, El Grecos, Rembrandts and the work of other masters after their death did nothing except to move their pictures round a bit.[20]

In response to Milne's proposal, Alice Massey replied, briefly and courteously, that she and her husband were intrigued: they would give his request more thought, and they would indeed like to see the pictures. Alice Massey, rather than Vincent, had written to Milne about the painting they had already purchased, and all the ensuing letters to Milne, with one exception, were from her. She offered to send her driver to pick the paintings up. Milne estimated that he had about three hundred with him at Six Mile Lake, done since his return to Canada in 1929. He sent what he had by rail express prepaid (ignoring her offer) on 13 September and followed

An illustrated page of Milne's letter to the Masseys of 20 August 1934

that with a long 'rough list or catalog' that set the number of paintings at
243, plus six that needed further work. The fifty-five paintings (Milne
thought about forty) stored with the Kimball family in Buffalo were to be
retrieved and added in; they were mostly Palgrave and Temagami oil paint-
ings, but included a small number done in the Adirondacks before 1929
and eight watercolours of the early 1920s.

The Masseys were genuinely excited when they opened the boxes. They
set about seeking opinions about Milne's offer from friends, and espe-
cially from the staff of the National Gallery. H.O. McCurry, the assistant
director, made a trip to Batterwood, the Masseys' home at Port Hope, on 3
October to make an assessment and a recommendation and found that
the Masseys had spread the paintings all over their indoor badminton court.
Alice Massey then wrote again to ask if Milne would sell them only the
three hundred paintings.[21] They did not seem interested – or at least did
not say they were interested – in seeing the earlier paintings. Milne was
reluctant to change his purpose, which was to keep all his work together
and to realize enough money to support his life as a painter for several
years. So, rather than bargain or resist, and perhaps with an eye to a future
sale, he wrote back that if those he had already sent and those with the
Kimballs in Buffalo were 'kept together, they would make a record of the
last five years,' and that he would accept $1,500.[22] This made the rate the
same, approximately $5 a painting. Milne sensed that the Masseys might
be unwilling to accept, or pay for, the seven hundred additional paintings
stored with Clarke, and that there might be stiff custom duties. The Masseys
agreed to this on 3 October, after getting McCurry's positive recommenda-
tion, and paid half the amount then and the balance on 23 November when
the Buffalo shipment arrived and Milne forwarded some of the six paint-
ings he had held back to finish.[23]

Thus began – rather easily and enthusiastically on the part of the Masseys
– a relationship that lasted for four years, despite Vincent Massey's ap-
pointment as High Commissioner to the United Kingdom less than a year
later. Milne met the Masseys briefly in their Toronto apartment in March
1935, when he agreed to sign a stack of the paintings they had acquired.
Milne was able to thank Mrs Massey, in particular, for thoughtfully buffer-
ing his isolation with magazines and books, an occasional sweater, pro-
duce from her garden, and culinary delights from the Batterwood kitchen.
Alice and Vincent Massey, in turn, told him how much they and their
sons, Lionel and Hart, loved his work. Alice Massey wanted Milne to talk
about art with sixteen-year-old Hart, who had already shown remarkable
talent as a painter, and during Milne's visit they did discuss painting, for
Hart remembers vividly the odd palette that Milne set – only 'four or five
little volcanoes of colour.'[24]

Although Milne had expressed himself plainly about why he was sell-
ing his work in a block at such a favourable price, and been explicit about
not wanting to disperse his paintings, the Masseys had different ideas,
which they happily conveyed to Milne. They decided, first of all, to select 'a
number ... for our own collection'; and, indeed, fourteen works were in-
cluded almost immediately in an exhibition of the Masseys' private collec-
tion that opened at the Art Gallery of Toronto in November 1934. A few
friends and relatives received Milne paintings as Christmas gifts that year,[25]
and Alice and Vincent also proposed to give some to public galleries, al-
though only three were given to the National Gallery of Canada in 1935:
The Water Tank, *Contours and Elm Trees*, and *Ollie Matson's House in Snow*.

Had they stopped there, no difficulties would have ensued. But the fi-

nal part of the Masseys' plan was to resell most of the rest of the paintings through commercial galleries in Toronto, Ottawa, and Montreal. They said they were going to take 'very careful advice as to the prices,' but they did not say what the prices would be. The revenues, however, were to serve a larger purpose: the development of Canadian art. After the Masseys' purchase price and the costs of exhibiting had been recouped, the surplus proceeds, or net profits, referred to as 'the fund,' would be used to purchase 'further examples of Canadian art.'[26] And Milne was to receive an additional benefit: the Masseys proposed that he would 'share in the appreciated value of the canvases' as they were sold. This was a sufficiently major consideration that Vincent Massey made a special point of it in his memoirs: he recalled that the amount they paid was so modest, even though it was Milne's asking price, that they would sell some paintings and set aside 'a proportion of the proceeds to accumulate in a fund that would be Milne's own,' thus 'securing for the artist a fair return on his work.'[27] However, 'the fund' was not a discrete entity kept in an account: it existed only in the minds of Alice and Vincent Massey. Practically considered, it was fully integrated with their 'Picture Account,' which recorded all their art, artifact, and fine furniture expenses, including purchases, insurance, framing, shipping, catalogues, and other miscellaneous payments, at the National Trust Company in Toronto. Alice Massey wrote to her son Lionel that 'the most exciting part of the whole transaction' was selling the Milne paintings through Mellors Galleries.[28]

Milne was shocked by the Massey plan to break apart the body of paintings that he had sold at a nominal price specifically in order to keep them together. He had made a weak financial proposal because he was ultimately more concerned about his paintings than about money. Had he been thinking in pecuniary terms only, he might, for example, have offered a selection of attractive paintings at reasonable but commercial prices, probably with an enticing discount. The Masseys had recently paid $175 for one of Milne's paintings, so they must have been well aware of the bargain they were being offered. They had been purchasing individual canvases by J.W. Morrice, and by members of the Group of Seven and their contemporaries, for up to $1,500. In light of the price Milne asked, one might have expected the Masseys to be more sensitive to the painter's wishes to keep the works together, even though Milne's proposal was an unrealistic one for almost any collector. Since the paintings were now no longer his, Milne had little room to negotiate. He complained awkwardly to the Masseys that their plans 'seemed to demolish my pet theory of the interrelation of the pictures,' but then conceded that an exception might be made 'at least for the period of the exhibition' – the first sale show that was scheduled immediately for the Mellors Galleries in Toronto.[29] Milne suggested a thoughtful installation for this exhibition, a plan that grouped works to reinforce the paramount issue for him: their interrelation. He was completely unaware that plans for other exhibitions were afoot and would have been alarmed if he had learned of them. As to sharing the 'appreciated value,' Milne modestly demurred (he thought that a sale was a sale), although the Masseys were insistent that this must and would be done. At the Masseys' request, however, he did consent to give them first refusal on future work. Vincent Massey's reply to Milne's letter objecting to their plans (the only time Vincent wrote to Milne) interprets Milne's wishes oddly: 'both my wife and I are very glad that you approve of the plan which we have for the pictures,' he wrote, and added in a postscript: 'I think you will agree that it would be better all round if no mention were

Mellors Galleries, 1934 exhibition catalogue

made to Buchanan or anyone else of the actual terms of our transaction.' In a stark denial of Milne's objections to the way they were proceeding, Massey added: 'I make no mention of the charming way in which you wrote about our plans for the pictures. Your letters have greatly added to the pleasure of this little effort on behalf of Canadian art.'[30] Milne had not only *not* approved of the Masseys' plans; he had completely disagreed, albeit charmingly. And he had then reiterated his purpose and the conditions he had envisaged in making the sale in the first place. Not surprisingly Milne had a sense of foreboding about further misunderstandings. He flattered the Masseys by referring to their 'self-sacrificing plan of art patronage,' although he was the one making the biggest sacrifice.[31] He went further and suggested that 'if any arrangement, similar to the one we have had, could be made, it would be a very great pleasure to me, and a relief, and a practical advantage as well.'[32] He was hinting, of course, that the Masseys should purchase all of his work every year, and keep it together, but he was not explicit about how much he thought they should pay him for future work; and they did not ask for clarification or interpret his suggestion as Milne thought they might.

The first sale show of Milne paintings owned by the Masseys opened on 20 November 1934 at the Mellors Galleries at 759 Yonge Street, just north of Bloor Street. The gallery – managed by Robert Mellors but effectively owned by Arthur R. Laing – touted the exhibition as 'a fresh, buoyant and mature interpretation of Modern Art in Canada.' Milne's suggestions for hanging the show were not followed at all, nor were any of the works he recommended included. The foreword to the catalogue was written by Donald Buchanan, a young scholar and curator at the National Gallery, who had visited Milne earlier in November at the Masseys' request (his travel expenses were drawn against 'the fund'). A 'hundred or more' people attended on opening day and sales, at $20 to $60 a painting, were brisk.[33] The Masseys told their friends and their political and business associates about Milne and his work, and sent them along to the Mellors Galleries; since the Masseys were known to be collectors, people naturally paid attention. Milne was sceptical about this exposure and the good it might do him. He travelled to Toronto to have a look at the show for himself – darting into the gallery for a few minutes without telling anyone who he was – but he spent most of his time (and some of his money) at a dentist's.

Advertisements in all the newspapers made Milne's name and his work known in art circles, and the critics were enthusiastic, acclaiming a fully formed and exceptionally talented new star in the Canadian art firmament. Kenneth Wells, journalist and critic at the Toronto *Telegram*, called Milne's work 'the greatest contribution to Canadian art since the advent of Tom Thomson,' and in his year-end review referred to 'the most exciting, significant, and exhilarating exhibition of the year – the work of David B. Milne.'[34] This high praise was echoed by Pearl McCarthy in *The Mail and Empire*, who wrote that the power of Milne's canvases was 'a force to be reckoned with in Canadian art.'[35]

Word of the exhibition and Milne's acclaim soon reached Patsy, who imagined that it was a portent of better times. Milne swiftly disabused her:

Do what you think best about going to any exhibitions, but the best thing you can do is nothing. I was at the Mellor[s] Gallery for less than fifteen minutes and didn't tell them who I was. I haven't seen any of these people. You still

Paper Bag, *in the February 1935 issue of* Canadian Forum

don't seem able to leave things alone. You have talked to the people you speak of but you haven't told them the real reason why we are not together. I don't like having to write these letters, and get to dread seeing your letters, because there always seems to be some new difficulty. Just remember the last years we were together – or even before that and let things alone for a while.

Paying the insurance loans, Clarke's loans and the teeth and getting back to where I was when I left Palgrave has taken almost exactly half of what I got for the pictures and there is no more in sight until I get more painted.[36]

Milne's reversal of fortune allowed him only a thin cushion of luxury. He got new glasses, some new clothes, and a battery radio, and he stocked up on painting supplies. But he had not bought himself the years of freedom from financial worry that he had intended, and a good third of his large stock of paintings, virtually all the oils (which were more valuable in market terms), was used up in the process.

By the end of 1934 Milne had received $1,500. Sales of $825 had netted the Masseys $543 after expenses – their two-thirds share of the proceeds (Mellors Galleries got one-third) – and fourteen paintings had been sold to accomplish this. The Masseys gave small paintings to Robert Mellors and to Kenneth Wells for their solicitous attentions. Before the year was out Buchanan and McCurry had both received little Milne paintings for their assistance, and Graham McInnes, after his astute but effusive articles in *Saturday Night*,[37] was given one in 1935. Laing proposed, and the Masseys accepted, an exclusive contract for Milne's future work at 50 per cent of net proceeds, rather than the usual 33 per cent. This was done without consulting Milne, whose work was the object of the agreement; yet the Masseys did have Milne's promise to give them first refusal on new work.[38] Mellors and Laing also convinced Alice Massey that Milne should sign all his pictures, thus making them easier to sell, and Milne did sign a number of them in 1935, although somewhat grudgingly. His terse comment was: 'Dates, useful, signatures not of much importance; pictures are supposed to be signatures.'[39] Both Mellors and Alice Massey also expressed their wish that Milne paint more waterlilies and canoes, since they were attractive to people and sold well.

The Mellors exhibition, or most of it, minus the pictures that had been sold, was transferred in early 1935 to James Wilson and Company, a gallery in Ottawa, and opened there on 29 January. Nine works were sold for a total of $525. On behalf of the Department of External Affairs Buchanan chose two superb paintings for the Canadian Legation in Paris, *Framed Etching* and *Ground Contours*.[40] From 18 to 28 March the show was installed at Scott and Sons, a gallery in Montreal, where only one small work was sold. Later in 1935 William Watson, a respected Montreal dealer, declined an offer to take any of Milne's paintings on consignment from Mellors/Massey, citing as his reasons Montreal's apparent indifference to Milne's work, and the cul-de-sac of modernism that he thought Milne was in.[41]

In May 1935 Mellors Galleries held an informal exhibition without a catalogue and organized another show in Ottawa. Sales totalled a further $975. Yet another exhibition of the Massey Milnes at Mellors Galleries was arranged for November 1935. Milne was persuaded to attend in person, daily for a week, from four to six in the afternoon, to help with promotion. He protested meekly to Alice Massey that the show had too little new work in it, and that holding one exhibition on the heels of another was not

wise. Nevertheless, he enjoyed meeting other artists and chatting with the critics. In reply to Milne's mild criticisms, the Masseys asked Milne to propose business terms. He responded vaguely, agreeing only to let the Masseys see new work as it was produced, and hoping, perhaps, that they would propose a more generous arrangement than any he might suggest. Accordingly, in the fall of 1935, he sent another sixty-five paintings to them for their perusal – all his 1935 work.

Upon receipt of these new paintings Alice Massey sent Milne $250, confident that she and her husband had just bought a further sixty-five paintings – at less than $4 each.[42] Milne wrote back that such an arrangement could not be made for current work and that what they had paid for his entire 1935 production could be considered only as an advance: 'Of course, to continue the price arrangement we made for the accumulation [the three hundred paintings] and apply it to current painting could be no more than an emergency plan to get the fund on its feet; it would soon produce a [financial] crash on Six Mile Lake and an interruption of painting.'[43] The Masseys seem not to have considered that their payment of $250 represented Milne's entire annual income, and not to have recognized the financial consequences for Milne if he continued to sell his paintings at $4 or $5 each? They flatly ignored his statement that he and they did not yet have an agreement about the new paintings and simply reiterated that when the fund soared into the black, as it would surely and shortly do, he would receive ample share of the appreciated value. In the meantime they 'so deeply appreciate[d]' his putting his new paintings in with the others.[44]

Thus by the end of 1935, barely a year after this unique experiment in patronage had begun, the Masseys had paid Milne $1,750 but had received over $1,200 in net profit from sales. All the Milne pictures they hung at Batterwood and in their Toronto apartment had been framed and shipped as part of the expenses charged to the fund. Mellors Galleries had been reimbursed for all its expenses and cleared nearly $700 in profit. In addition the Masseys had possession of, and believed they owned, 351 paintings, less the 40 or so that had been sold or given away to relatives or people who had been helpful.[45] There had been three commercial exhibitions in Toronto, two in Ottawa, and one in Montreal, as well as further exposure in the Massey Collection exhibition at the Art Gallery of Toronto.

Milne suspected that something was wrong when he learned that the miraculous fund was still moribund at the end of 1935, despite the rather bullish market in his work. When the Masseys returned to Canada briefly at the end of 1936, they renewed their agreement with Mellors Galleries (of which Milne was not informed – Vincent Massey had asked Mellors and Laing to keep it secret[46]), and suggested to Mellors that prices be kept 'extremely low' to encourage sales; they also pulled more paintings out of storage to take back to London with them, bringing their London stock up to 175 pictures. Milne's work was still selling at $20 to $25 for small canvases and $60 to $100 for larger ones, whereas they had sold at up to $150 two years earlier (and the Masseys had purchased one for $175 four years earlier). By the end of 1936 – after another exhibition at the Mellors Galleries, as well as the inclusion of Milnes in an exhibition at Hart House[47] – the Masseys had recovered virtually all the money they had paid Milne.

Milne, credulous as always, unwittingly compounded matters by sending all his 1936 paintings to Mellors Galleries in the fall of that year. Mellors acknowledged receipt of these, but to the Masseys, not to Milne. On learning of the new shipment to Mellors, Alice Massey sent Milne a further

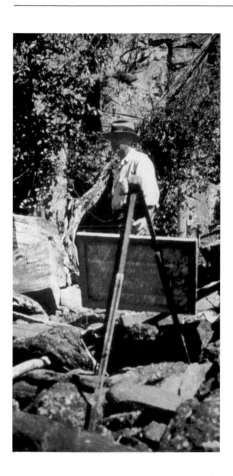

Milne at his easel at Gloucester Pool,
Six Mile Lake, 1936

$250 on 9 September 1936, noting at the bottom of her copy of the letter: 'For 50 pictures [actually 40] from Mr. Milne in September 1936 to add to the original lot.'[48] Given that Milne was still contending that the 1935 pictures had not been adequately paid for, he would have been astounded to learn that Mrs Massey thought she had bought these new paintings on the same terms as before. Mellors naturally assumed the paintings were the Masseys'.

In March 1937 Alice Massey sent Milne $100 and a further $200 in November. For the Masseys these advances were gestures of good will – perhaps supplements to the token amounts paid for the 1935 and 1936 paintings, or harbingers of the time, not too distant, when the fund would turn from lead to gold. In gross terms it had already done so, but with the low prices, the second and third 'purchases,' and the recent advances, it was still lagging in net terms: 'the pictures are beginning to be sold,' Alice Massey wrote to Milne on 15 March 1937, 'but have not yet reached the point where in each sale you were to share regularly.'[49] According to the Massey formula each $100 advance required *net* sales of $250 to offset it. With the Masseys still to receive some of their initial outlay, it was going to take some time and a lot of sales before Milne would get his often promised share. Furthermore, the Masseys had been busy selling works from the batch of paintings they had taken with them to London. Vincent Massey's staff were encouraged to buy one or two each (Lester Pearson, Frederic Hudd, and Michael Wright all did), and even to sell what they could discreetly (Pearson did). The Masseys did not calculate the sale in England of at least fifteen paintings in determining whether 'the fund' was in the black yet, an oversight that might have altered matters, although with framing deducted, perhaps not much.

Another exhibition was probably held at Mellors Galleries in the spring of 1937, and Milne's works were also hung in the lobby of Massey Hall, the Toronto concert hall, at the end of 1937. In January 1938 Mellors held an exhibition of the work of 1937. Momentum was now working well on Milne's behalf, and Mellors and Laing estimated that sales would exceed $1,000: more people seemed interested in buying Milne's work, and the critical response had again been immensely favourable.[50] During the exhibition Mellors wrote to the Masseys that he and Laing found Milne 'simple, in the best sense of the word' and, somewhat patronizingly: 'Back of Milne's work, there is, we believe, truth and honesty of purpose, and at least a trace of original personal expression.'[51] This kind of verbal cotton wool, so lacking in insight, typified an attitude that eventually made a working relationship between Milne and Mellors/Laing an impossibility.

Milne was invited to attend the 1938 exhibition, and either Laing or Mellors insisted on paying Milne's train fare and expenses, a small and innocent gesture that was, in Milne's words, 'the brick that started [the] riot.'[52] Milne quickly, and correctly, surmised that this cost was not coming out of the Mellors commission, and he suddenly understood why the fund was so anaemic. He wrote to Clarke that he thought he and the Masseys were being duped by Laing and Mellors, and that 'most of the pictures would have to be sold to pay for the cost of selling them. There isn't any Santa Claus.'[53] He told Alice Massey that he thought Mellors was 'confiscating paintings instead of selling them.'[54] 'I had supposed,' he wrote to Mrs Massey, 'that the Massey-Mellors arrangement was on a purely commission basis.'[55] In his calculations Milne assumed a 20 to 25 per cent commission, with only framing at a set cost included; or, since his works were hard to sell, perhaps a 33 per cent commission for the gallery (the

very arrangement the Masseys had at first, but then changed to a 50 per cent commission), *including* all normal gallery expenses – framing, advertising and promotion, catalogues, and overheads. He did not know, of course, about the arrangement that allowed a commission of 50 per cent *plus* expenses.

In a letter of 24 February 1938 to the Masseys Milne set out clearly his view of the unhappy circumstances he was in and his plans for dealing with them. He reminded them that the second lot of paintings, the 1935 paintings, had not been paid for and that he had received a down payment only. This issue was again glossed over by the Masseys, who took it for granted that the second lot was an outright sale of the same kind as the first, and at an even lower price set by them, not by Milne. Milne did not know that they assumed that the 1936 paintings were theirs also; he thought they, at least, were his. In an attempt to put matters right Milne suggested that the 1935 paintings be considered as the Masseys', and that he receive proceeds only from 1936 onward. Even so, he wrote, it would be 'something of a disaster for me, since the only tangible thing left of the last nine years' work would be the pictures of the last two years – minus whatever charges (substantial I am afraid) Mellors may have against them.'[56] This was a little unfair, since Milne had set, and the Masseys had accepted, the selling price of the first lot of paintings in his initial proposal, although not the resale price. However, he had not agreed to a price for the lot in 1935 nor for the ones that followed in 1936 and 1937. As an alternative Milne asked if the Masseys would take all his paintings and pay him an adequate return in a short time.[57] This was really a reiteration of his original proposal, but the Masseys did not nibble.

Months drifted by. Finally in June 1936 Mrs Massey wrote to Milne that he should conclude their 'joint arrangement' with Mellors Galleries – Milne emphatically denied that the arrangement was 'joint,' since he had never been a party to it, nor had he even known of it – and have Mellors ship to the Masseys the paintings that belonged to them.[58] In August 1938 Milne asked Mellors Galleries for an accounting and a summary of their transactions, and again time elapsed. Laing's first report was vague and inconclusive. Milne finally ordered Mellors to stop all sales.

Milne then made another proposal to the Masseys: he and they together would form a study collection of his work, with the Masseys contributing many of the pictures they held and with Milne tripling that number with his earlier work stored at Clarke's, the whole to be donated to the National Gallery of Canada as a gift without strings and beyond the pale of the commercial market.[59] The Masseys never responded to this suggestion, although it emphasized strongly the terms upon which Milne's initial appeal to them was based: he was still trying to hold his works together.

Mellors Galleries' failure to comply fully with Milne's request for an accounting may have been a ploy to shield the Masseys, but it incensed Milne, who realized that the Masseys had not given Laing the authorization to prepare and send him a statement of sales. In August 1938 Milne wrote to Alice Massey, addressing her both in the third and second persons: 'In other words – Mrs Massey will extend her wrists for a mild slapping – you haven't sent [Laing] the instructions I suggested six months or more ago.'[60] And when Milne finally got a statement, and discovered that it did not include four sales that he knew to have been made, he wrote again to Mrs Massey that 'we must get out of this fog' and that she was 'in the dog-house.'[61] Alice Massey, however, had wired Mellors from Switzerland in the summer, and wrote later from London, that 'all should be done

Milne, Douglas Duncan, and Alan Jarvis at Six Mile Lake, 2 September 1936

Alan Jarvis and Milne at Six Mile Lake, c. 1936

as Mr. Milne wishes about the pictures.'[62] She too asked for statements and lists, and Vincent Massey wrote to the National Trust Company requesting them to sort the matter out on his and his wife's behalf with Vera Parsons, a Toronto lawyer whom Milne, in his anger and frustration, had now brought into the fray.

Vincent Massey wrote to the National Trust again on 5 October 1938, noting that the statement he had just received from Laing 'makes it quite clear that pictures belonging to Milne [presumably the 1936 paintings] have been treated in the same way as have pictures belonging to my wife and myself. He should, of course, have received all proceeds of such sales, and the statement confirms my fears that this had not been done.' This declaration is odd in light of the secret agreement between the Masseys and Mellors Galleries (the gallery naturally assumed the paintings were Massey property), and was contrary to Alice Massey's assumption that she had bought both the 1935 and 1936 lots of paintings outright. In his letters to the National Trust Vincent Massey also assumed that he and his wife owned the 1935 paintings, but he seems to have realized that he would be on thin ice in claiming ownership of the 1936 paintings.

The final settlement did not undo the injustice of the purchase of the 1935 paintings, although it did, finally, draw the whole matter to a close. Milne received $354 from the National Trust, and twenty-five of his 1936 paintings were returned to him. Parsons, however, had to pay $69 to release these works from Mellors, reporting that the atmosphere was 'bristling with hostility' and that the expenses incurred by the gallery, which she thought were suspiciously high, were not supported by vouchers for many items. 'Artists have to take what they can get without getting noisy,' Milne wrote to Clarke.[63] The Masseys still promised to pay Milne a share of any proceeds from subsequent sales of their Milnes.[64]

Around this time a crucial, if unlikely, silent player entered the drama. This was Douglas Duncan, a lanky, bespectacled, thirty-four-year-old aesthete and bookbinder. Duncan was born in Kalamazoo, Michigan, in 1902, and moved to Canada with his parents when he was a child. His father was the president of Provincial Paper Limited in Toronto. Duncan attended the University of Toronto Schools and then Victoria College in the University of Toronto. His sister Frances, who married J.P. Barwick, an Ottawa lawyer, was Canada's finest harpsichordist in her day. Duncan had no idea of following his father into business, and enjoyed doing esoteric things in the arts. In his twenties he had started to collect prints and drawings when he was in Paris learning to become a bookbinder, and he had a large collection of rare books and classical records. Uncertain about what to do with his life, and assuming that he might not have to make a decision in that regard, he had been offering bookbinding services to the literati of Toronto since 1928, when he returned from his long stint in France learning the craft. Bookbinding was not a brisk business, but his income was ensured by his father, so that he did not have to have a well-paid occupation if he didn't want one. He still lived with his mother and father in a large house in the elite Forest Hill district of Toronto.[65]

Duncan had heard about Milne's work from his young friend Alan Jarvis, then a philosophy student at the University of Toronto, who had seen and written about the Milne exhibition at the Mellors Galleries in November 1934. Although Duncan had not seen that show, he bought work from the 1935 exhibition. In January 1935 he and Jarvis travelled to Six Mile Lake to seek Milne out, and then visited him again in 1936. Milne affectionately called them 'the twins.' After their second visit they left with gifts of paint-

ings and drypoints, in return for their gifts of an Aladdin lamp (an improvement over Milne's dim old lantern and a boon to his degenerating eyes), a comfortable chair (Milne had no chairs and usually sat on a box),[66] and Meier-Graefe's recently published *Vincent van Gogh*[67] ('too close to home sometimes to be comfortable,' Milne wrote, although he was so deeply touched by Theo's letters to his brother Vincent that he thought that such love was not surpassed in the four gospels).[68] Duncan, who became good friends with Milne on their first meeting, was knowledgeable about artists in France, enthusiastic about Monet, knew a good deal about Canadian artists and their dealers, and was himself a collector. He was instantly an avid admirer of Milne's work, especially the drypoints:

Douglas Duncan and Alan Jarvis came to visit me, bearing gifts – the Aladdin lamp and a camp chair. I remember that we went exploring to Pretty Channel and Hungry Bay, and away over toward the outlet of the lake. I remember the picnics particularly because we always seemed to forget to take some important item of food or of cooking equipment, baked beans without a can-opener, and tea without anything to make it in except plates. In spite of that the days went very well, but we felt we should be doing a bit of picture viewing. Again the cabin was almost bare of pictures. Again the drypoints came to light. I didn't know it before that time, but this almost complete collection with innumerable states and variations was to Douglas like fishworms to a fish – many, many fishworms. I learned a lot I hadn't known before about my own etchings. Douglas took some with him, and later I sent them all on, with ones that were done later ... That exhibition lasting a few evenings in the cabin was by far the most successful I have had.[69]

Not long after this 1936 visit Duncan became Milne's confidant in both personal and artistic matters. He enquired about the arrangement with Mellors Galleries only because he wanted to organize an exhibition of drypoints, which he did in 1938. Milne later began to give some thought to taking his business to Duncan, if he could extract himself from the Massey/Mellors confusion, for he regarded him as 'following in the steps of [Ambroise] Vollard,' the Parisian dealer for Renoir, Cézanne, Picasso, and other artists.[70] In June 1937 Milne had all the paintings stored with Clarke shipped to Duncan.

In 1936 Duncan joined two friends, H.G. (Rik) Kettle and Norah MacCullough, to found the Picture Loan Society; they had the assistance of four others, Erma Lennox and the artists Gordon MacNamara, Gordon Webber, and Pegi Nicol McLeod, serving as the Organizing Committee. At the end of 1936 the society moved into third-floor premises at 3 Charles Street West at the corner of Yonge Street in Toronto.[71] The society was patterned after an English organization, Picture Hire Limited; its purpose was to exhibit paintings by contemporary artists and lend them out to members, who subscribed for $2 a year, at a rental of 2 per cent of their value per month. If, after living with a painting for a while, the member wanted to purchase it, the rental fee could be converted toward the acquisition of the work, and payment in ten monthly instalments was possible. The society took a modest 10 per cent commission on any sales, considerably less than regular dealers who took 33 per cent, thus returning more of the selling price to the artists. Soon after the Picture Loan Society was formed, Duncan became its moving spirit and chief administrator. It was incorporated as a non-profit organization and so it remained as long as Duncan lived: it was associated with him alone for the rest of his life.[72]

Milne's painting outfit, 1936

The society remained at 3 Charles Street West in four modest rooms on the top floor until Duncan died in 1968.

Milne kept Duncan fully informed of the final spasms of the Milne-Massey-Mellors arrangement, even while Duncan was gallivanting around France with Alan Jarvis in the summer of 1938. Milne wished that Duncan had been in Canada so he could discuss the situation with him. However, when Duncan returned in the fall, Milne warned his lawyer, Vera Parsons (to whom Duncan had introduced him), to keep Duncan out of the negotiations with Mellors and the National Trust. Although Milne had evidently made up his mind to change dealers, he waited to do so until he was free of Mellors Galleries in order to ensure that Duncan would not be put in a position of conflict.

Duncan was ready to offer Milne what neither the Masseys nor Mellors and Laing seemed able to provide: a reasonable income that would allow him to paint and to live without worry. Duncan also had a sensitive understanding of Milne's work and purpose. He was able to propose the sale of some paintings but he also understood Milne's desire to create a critical mass of work for future study. More to the point, Duncan was prepared to give Milne a far greater share of proceeds from sales.

For Milne, and particularly for Alice Massey, the end of the Milne-Massey arrangement was sad. In most respects both had aimed, from differing perspectives, at a unique kind of patronage. Milne had been naive at the outset; his often obsequious way of addressing the Masseys, nearly always in the third person, was quite different from the way he addressed anyone else. The Masseys were not as generous or as sensitive as they might have been about the financial arrangements, although Mrs Massey was thoughtful in nearly every other respect. They apparently did not fully understand Milne's initial purpose in seeking their patronage, which was to consolidate his work, not scatter it. While they did him an incredible service, lifting him out of obscurity and into contact with those who were to befriend and support him for the rest of his life, a fact that he much appreciated then and later, and making him financially solvent for a time, the service they did themselves was certainly as great or greater. At the end of it all Milne presented them with another painting, a fine watercolour called *Candy Box* (which has disappeared without a trace), and he bequeathed two more paintings to them in his will in return for their 'great kindness and help.'[73]

The tenor of Milne's life at Six Mile Lake was not unlike the routine of his Alander Mountain retreat above Boston Corners. After the daily chores of cutting wood, cooking, cleaning, and carrying water, Milne had the rest of his time for painting, which was 'over on most days by four o'clock,' and for thinking about, and looking at, his painting.

After supper I often sat on a box outside overlooking the lake, sometimes doing eye exercises or drawing sunset clouds in pencil, and often watching the performance on the stage before me, a fast-moving play, particularly from half an hour before sunset to dark ... The approach of thunder storms was particularly exciting. There was a slow, soundless beginning, flashes and rumblings of thunder, crashing into full power before the final rush of wind and rain. After a hot day it was refreshing to wait on my box and get splashed by the first big cool drops, leaving just time to get inside before the curtain of water swept over.[74]

Living virtually in the open, surrounded by nature in the raw and prac-

tically out of sight and sound of other humans, Milne found himself submerged in the natural world. It provided inspiration, dramatic excitement, aesthetic stimulation, and ready material for his meditations. Whether he was preparing his meals, getting water, cutting wood, or drawing or painting, he was happily in its thrall:

Life on the point was ruled by the almanac. Changes in the weather and in the seasons governed my comings and goings in the affairs of daily life, and often made my painting too. All was exciting. I saw spring come, as on a moving picture screen ... From day to day I watched the budding leafing of the trees across the lake from the first slow softening of stem and branches, then a faint touch of green, and at last, between sunrise and sunset, the rush that hid the branches and changed the far shore from fine lace to substantial fabric.[75]

Winter was particularly exciting, and sometimes dangerous. Milne once slipped on a bit of ice and fell when he was walking down his rock to get water from the lake: the water pail fell in and was lost, and he nearly went in himself. Heating his cabin was a constant battle, and even the resiny pine roots he found scattered around the lake on driftwood stumps did not always make heating an easy task. As a torch for night forays he used these pine roots, hammered into a fibrous and sticky mass. His instincts for simple survival were sharpened in nearly everything he did. He was constantly wary and observant as he made his way on foot, skis, snowshoes, or by canoe – he had to be.

In winter, particularly when there wasn't much snow, there was an almost continuous booming and crackling of the ice. I could trace the forming of a crack right across the lake by the sound, sometimes as loud as the bursting of a shell. This was mostly at night but in hard frost in daytime too. When I was walking on the lake I used to speculate on the effect of a big crack underneath my feet but nothing impressive ever happened that way.[76]

Wildlife played a large part in his day-to-day routines. In September 1933 Milne wrote in his diary:

In the morning the gulls had a feast across my little harbor, with a bit of fighting. Not vicious, but genuine battles. Several times another gull challenged the eater and tried to drive him away. The idea seems to be to work with the wings. To strike with or grab the elbows (or would it be wrists?) with the bill. Gulls appetites can not be so big. They have been working at one fish, not more than 14 inches long, since yesterday afternoon. While I was sunning at the cabin a frog hopped across the rock in front of me. That was unusual, but there was a reason. He was followed by a garter snake. I caught the snake on a stick and heaved him into a tree from which he slid, apparently without damage. On the way back in the afternoon I saw – and heard – a deer, the first I have seen this summer. Last night just at dusk I heard a noise and looked out, to see a skunk just disappearing into my fireplace, which must still have been warm. He was looking at the egg shells I had thrown in, hoping there would be eggs left in them. Partridges are plentiful and tame. When I was eating my supper one was going to roost in the trees just below me, not bothered at all by me or my fire.[77]

He also contended with porcupines, Massassauga rattlesnakes, puff-adders (which at first he mistook for rattlers), and he occasionally saw a wolf.

Canoeing and skiing were other regular activities, since Milne was often on the move:

[the country was] fine for travelling and exploring and I made many long trips, sometimes with the sled and painting outfit. I went beyond the far end of Crooked Lake, up to Lone Lake, over toward Honey Harbour.[78]

On one of his day-long canoe trips he visited a young artist, Cleeve Horne, and his wife Jean, who were building a cottage on an island in Crooked Lake. In the summer he swam frequently, often up to 'half a dozen times a day.'[79] In his second winter, after the Massey sale, he enjoyed 'some exciting programs' on his new radio, while also hearing 'some terrifying ones' featuring the 'brutal voices' of Hitler and the (Canadian-born) American Roman Catholic priest Father Coughlin, whose fascist sympathies were broadcast in notorious radio addresses.

For twice-weekly supplies, such as bread and meat, or to collect his mail, or whenever he wanted company, Milne trekked out to Big Chute. There the wily curmudgeon Scotty Angus lived with his wife Nan and their numerous family. Milne became quite fond of them. The Anguses not only held his mail and parcels but generally kept an eye on people coming and going, tried to spot and recommend potential customers to buy Milne's paintings, and watched over his cabin whenever he was away. Milne sometimes spent evenings there en route to or from Toronto. Angus was mentioned frequently in Milne's correspondence and in the Six Mile Lake section of his autobiography Milne elaborated on Angus's past in the far north, on his forest lore, his love of hockey broadcasts, and his trenchant, though shallow, assessment of national politics.

During his years at Six Mile Lake, Milne usually spent Christmas with the Angus family.

Christmas day was as exciting in the cabin as anywhere. Clarkes for years had sent me a Christmas box from Charles in New York. This had almost everything you could think of in the way of luxuries. Figs, dates and candied fruit. Nuts and fancy biscuits and Christmas cake and plum pudding and always an Edam cheese.[80]

Taking a treat or two from the box, Milne put on his 'Sunday clothes' and skied through the bush to reach the Angus homestead before dark, and usually stayed there overnight. After the children were in bed, he enjoyed hearing about Scotty's early days in Canada as the head packer for the surveyors mapping the Hudson Bay Railway. They even talked about art. Scotty, who had been a picture framer as a youth in Glasgow, 'liked to see something recognizable in his pictures, the clearer the better':

My pictures didn't supply much of that so he was sometimes driven to figures in clouds and such things, where I had intended nothing but clouds or at least shapes based on clouds. Mrs. Angus was more sympathetic or at least tolerant of the modern point of view. She didn't ask much of her pictures.[81]

Milne was a frequent user of the library service at Big Chute. Every week two boxes of books arrived at the school, one for adults and one for children, and Milne usually took two or three volumes back to his cabin. The school was a simple log structure, 4.8×7.3 metres (16×24 feet), built in 1932 by the residents, and the teacher while Milne was there was Eliza-

beth (Betty) Cowan. Milne made friends with her and they shared discussions about music, art, and teaching; he also helped her with her skiing. Milne was both sympathetic and knowledgeable about her responsibilities at the school, having taught young children himself for three years. Most of the community activities at Big Chute, the Christmas parties and plays at the school, were attended by Milne. He was fascinated by the murals the children drew on the blackboard: 'After seeing these, my own efforts were apt to seem a little flat. I sometimes tackled unusual subjects but the children in their smaller pictures went away beyond me.'[82] He also enjoyed the children's flower gardens at the front door of the school and around the base of the oak tree along the path leading up to the school.[83]

The first summer he made a garden at his cabin, gathering 'enough earth to fill a small hollow in the rocks not more than twenty feet across.' He didn't have a spade, and his hoe was a 'bent piece of sheet iron fastened on a stick.' The next year he made a larger garden 'at the foot of the rocks beside the bush.'

Stones and rocks and roots had to be taken out and soil brought from the swamp. The garden was enlarged year by year and must have been all of twenty feet long. It was a vegetable garden, carrots, beets, tomatoes, lettuce, and beans, all the fresh vegetables I could use when they were in season.[84]

He put a brush fence around it to discourage rabbits and groundhogs, and it was a substantial and productive operation.

Although Milne lived almost as a child of nature, he was, ironically, more involved in contemporary activities than he had been in many years. Reading and the radio, conversations and letters, all kept him informed and aware of what was happening in the world, the world of art in particular. And although he was geographically isolated, he had more contact with people who were interested in what interested him during these years than in all the previous decade. The presence of his paintings in exhibitions of the period had given his name a degree of currency among members of the art world, and visitors sought him out. A visit by two clergymen, Dr Thomas H. Cotton and a friend of his, Canon John E. Ward, led to talk about art and religion.

Most people find my pictures just blank but my visiting churchmen found little difficulty in grasping their essentials. They should. I would say that there could be no better introduction to the study of art than a reading of the four gospels where singleness of heart is taught and lived. Singleness of heart, sincerity beyond anything possible in daily life, is essential in painting.[85]

In addition to visits by Jarvis and Duncan, Milne was host to others who were interested in his work. One spring Norman Endicott, professor of English at the University of Toronto, and his wife, Elizabeth, visited. Donald Buchanan, the young art critic and curator at the National Gallery of Canada, who wrote an article about Milne for *Canadian Forum* and sold Milne's drypoints to his friends and to the gallery, was an occasional visitor, and he was once accompanied by Jane Smart of Ottawa.[86] So was the writer and critic Graham McInnes,[87] who also wrote laudatory articles about Milne for *Saturday Night* and *Canadian Forum*. His enthusiasm for Milne's painting was both intelligent and passionate: 'Of Mr Milne I find it difficult to speak with moderation.' He thought Milne's work had achieved 'an excellence past comment,' and that 'his later work [this in 1936] is so conceptual that it almost vibrates in space like music.' McInnes rated him as

Drawing for the Undergraduate, *1936,
ink, printed dimensions 12.7×16.6
(5×6½)*

probably the 'greatest artist at work in Canada today.'[88] McInnes's shrewd assessments of other painters give additional weight to his judgment of Milne. In a 1935 article McInnes compared him, in a way that Milne would have appreciated, to one of the most celebrated of French painters:

It is perhaps not fanciful to see in Mr Milne, buried deep in the Ontario back-woods, steeping himself in the trees, rocks and lakes, and moving more and more towards the expression in sparing line and dry punctilious brush-stroke of their variety and underlying unity, a parallel with Cézanne, buried deep in Provence, and doing much the same sort of thing. In both cases the artists have, implicit in their almost ascetic austerity, a depth and a breadth of vision that strains to their limits the conditions imposed by paint and canvas.[89]

While he was a student at the University of Toronto, Jarvis also wrote glowingly about Milne in the 1936 *Undergraduate* (University College's literary magazine), about a year after he had first discovered Milne's work at Mellors Galleries. He and Milne exchanged letters, and Jarvis put up a small exhibition of Milne's work when he convened a first meeting of the University Art Association in early 1938. His article in the *Undergraduate*, although short, deals effectively with Milne's value system and his restricted palette: six or seven hues, created from eleven raw pigments. Jarvis also drew attention to Milne's concern to rouse an aesthetic emotion in both painter and viewer and to simplify so that the 'visual pattern' can be 'grasped ... quickly and easily.' The drawing Milne provided to accompany this brief article is of waterlilies in a bowl.[90]

One winter the Toronto sculptor Emanuel Hahn (1881–1957) came up with Milne from the city and they made their way to the cabin, Hahn on snowshoes and Milne on skis. 'Manny was a seasoned camper and liked it, liked cooking and working around the cabin. He fixed everything he could get his hands on, whether I thought it needed fixing or not, and then made a note of materials needed for more fixing so he could send them to me.'[91] Even Alan Plaunt, a wealthy collector (and one of the founders of public broadcasting in Canada), and his wife, made their way to Milne's humble cabin, led in by Angus. During this period Milne also came to know the young Douglas McAgy, later a curator at the Montreal Museum of Fine Arts, and still later Joseph Hirshhorn's private curator; Robert Hunter, then a curator at the Montreal Museum; and J. Burgon Bickersteth, Warden of Hart House in the Univeristy of Toronto, who invited Milne to Hart House to talk to students and arranged an exhibition of his work. And tourists dropped in, sent along by Scotty Angus. Milne travelled to see his exhibitions, to visit his brother Jim in Paisley twice, to stay with the Kimballs in Buffalo in the spring of 1935 – meeting for the first time Robert North and Spencer Kellogg, who had both bought Milne's paintings in the twenties and had tried to exhibit them in 1930. The three Kimball sons travelled over from Buffalo and camped with Milne in the fall of 1935, taking the 1935 paintings down to the Masseys at Port Hope on their way back. Stockton Kimball, Maulsby's eldest son and a medical student, wrote notes on Milne's conversations and opinions, and sketched Milne, the cabin interior, and one of the paintings that Milne had on the easel: *Black and White, 1935.*

With all his socializing, one might expect that time for reflection and work would naturally be curtailed, but the stimulation seemed to inspire Milne to paint. He was canny enough not to allow his life to be derailed. Only occasionally in letters to the Masseys and to Clarke does he complain about depressions and an inability to work with vigour and purpose.

The confidence Milne felt as a result of the Massey purchase gave him a new lease on life, despite the frustrations that ensued. The people he met, the trips he could now take, the amenities he could now enjoy, although modest, were in striking contrast to the constrained years at Palgrave. The relative ease that had entered his life showed in Milne's constant and high production during his years at Six Mile Lake: his experiments were fruitful and exciting, his evolution was fairly rapid and purposeful, and his range of subjects and his ways of expressing them were broad and confident. He was as expressive during this phase of his career as he had ever been.

As he slowly made his way north from Palgrave and Orillia in the spring of 1933, Milne fussed for over a month before his painting, still in oils only, lurched to a 'wobbly start' on 20 June, 'the first flicker of anything at all this hot day.'[92] Then slowly, as the summer progressed, his inspiration gathered momentum. By late summer he was able to write to Clarke from Six Mile Lake: 'I still yearn for Palgrave, both as a place to live and a place to paint, but am beginning to see something to tie to here, at least in a painting way.'[93] Initially he had only minimal painting equipment and small canvases – a format that he used constantly at Six Mile Lake. He reported to Patsy that some of the larger canvases had blown out of the canoe and sank with the weight of the paint.[94] His first works were similar to his last efforts in Palgrave in two obvious ways: the lusty, crude brushwork was retained in many works, even exaggerated; and the same warm, carnelian ground, probably from canvases prepared at Palgrave, was frequently used. But the landscape was drastically different, and Milne's approach to it had to be reconceived entirely. Although the topography of Six Mile Lake, with its lakes and islands, its conifers and deciduous hardwoods, and its outcroppings of the Precambrian rock of the Canadian Shield, was similar in many ways to the landscapes of the Adirondacks and Temagami, it was subtly different in layout and shape. And besides, Milne's sensibility had changed in the intervening years. Milne found inspiration in the landscape in all seasons and did not shy away from the undifferentiating greens of full summer, as the Group of Seven and their associates did. With one exception, *Black and White, 1935*, all the canvases at Palgrave and Six Mile Lake are horizontal but, unlike Palgrave, where there was only earth and sky, and the canvas was divided into two horizontal elements, the river or the lake had to be taken into account at Six Mile Lake. The line of sight was generally cut off by the far shore or by trees nearby, rather than fading to an infinity of hills or a distant horizon. No matter how much more open Six Mile Lake was than Severn River, it was still a closed landscape. In composition Milne was driven, as he himself admitted, 'closer to the Dart's Lake' paintings, with their open-and-shut motifs, than to 'anything else.'[95] Further, where the Palgrave landscape was soft and rolling, the bush country at Six Mile Lake had sharp points of land and islands, irregular rocks, and jagged driftwood. Bristling pines and spruces replaced the lyre-shaped elms. Six Mile Lake undoubtedly recalled to Milne's mind the Temagami landscape of four years earlier. Compared with his Palgrave paintings, those done at Six Mile Lake in the first year or two were edgy, brittle, and coarse.

Milne's system of values also had to undergo a revision. He wrote to Clarke:

Painting material at Six Mile Lake is mostly rocks, worn and whitened by the

Rock Pool, *1933, oil, 29.5×34.8
(11⅝×13¾)*

water, bleached driftwood and in the channels, chutes and rapids and pools. Very fine, and I can get something out [of] it if I work long enough at it. The plan I have been working on is to use a color where I usually use a value – in this case [perhaps *Rock Pool* or *Pool in the Rocks*] I used blue in the water and sky areas, and black and white values with detail in color in the rock and land areas. Nothing much has come of it yet – it is still merely a plan, applied without developing into anything. At Palgrave I used the blue of the sky to mark cloud shapes and a value for the blue sky. This transposition gave something. Here the problem is a little different – no detail in the blue areas. What will come of it I don't know – possibly it will be abandoned – that has its uses too. No one need be afraid of going too far or making mistakes in painting.[96]

This idea of using a vivid colour, such as red or blue, as a value, was considerably advanced during the Six Mile Lake period (Milne had tried it only once at Palgrave in *The Water Tank*), and it was soon to become a major factor in Milne's painting.

'I have been greatly tempted ... to tackle something from firelight at night,' he wrote to Clarke in the summer of 1933.[97] This temptation, to which Milne yielded, also meant a change in procedure, for he could not paint at night. Instead, he memorized a subject, as Whistler used to do, or prompted his memory with a swift pencil sketch or notes, and painted it the next day. (Once he tried to simulate darkness 'with the cabin darkened and the lamp lit. From time to time I let in the daylight to see how the colour was.'[98] This experiment, which sounds comical, was not a success and he did not repeat it.) Milne saw the memory method as simply an extension, over a slightly longer period, of drawing cloud sketches for use in painting, as he had done at Palgrave. But exciting as some of the paintings were, he was wary of using this method often: 'I am a pretty slow progressor, and time has made me wary of little excursions up blind alleys.'[99]

By September 1933 Milne felt that he was beginning to produce something of interest that showed 'a general widening or enriching of method.'[100] More variety in the use of the black outline, with an emphasis on a thin line, he thought, was a good development. More importantly, he started to use a colour instead of black for an outline, and to paint up to the edge of it with a value; a variation on this was to use the ground colour itself to establish the outline of a shape. In a letter to Clarke he wrote:

The ways of indicating a shape open to me would be the following:
1. Black outline on the ground (usually a sort of flesh color).
2. Black outline [on the ground] emphasized.
3. No black outline – colored outline on the ground.
4. Black outline, either with or without hues, and worked up to
& 5. with a value, white, black or middle value.
6. No black outline, colored outline worked up to with a value.
7. The ground making the outline, worked up to with a value.
The first three I have never used. I cover the ground more or less though I have had plans for using it and hope to get at it.
(6) and (7) are the things that give the peculiar kick at present. Surprising the range they give when combined with (4) and (5).[101]

Increasingly Milne's choice of colours tended away from mundane representation and often invoked a transposition that tricked the eye at first glance. For example, in *Rowboat on Shore I* Milne painted the bottom

Rowboat on Shore I, *1933, oil,*
30.8×36.9 (12⅛×14½)

of an overturned canoe blue, trees black and white, a bit of rock green, and the water and other elements a value of gray, black, or white. The colours and shapes can be read instantly, but only on reflection does one see that some of their expected hues have been interchanged.

The stunningly beautiful *Alder Branch* is one of the early works from Six Mile Lake that uses a device that Milne called interrupted vision. In it a close black branch is set against a backdrop of crimson, mauve, and ochre autumn trees and their reflections along a river or lake shore – the whole enriched with creamy-white and gray values. The daily trips to the sugar bush in the spring of 1934 prompted a further use of this idea in *Sugar Bush*:

These pictures were the first at Six Mile Lake that greatly interested me and that are still clear in my mind. Passing among the big trees and the saplings on sunny mornings I sometimes stopped to consider what was before me, trying to translate the exciting mystery of the bare trees and branches into painting language. At first I used the photographer's method when making sketches, moving about until I got an uninterrupted view of whatever seemed important in the mass of detail in front of me. This didn't seem to work, the mystery and thrill was gone. Then I noticed that usually, when I was moved by a scene, before I changed my position to get a clearer view there was often a branch or sapling right in front of my eyes, vague and out of focus and hiding a part of the material beyond. I tried using these almost formless shapes, not of interest in themselves, but merely distracting the attention from what was beyond. It worked. The effect of these obstructions to a clear view was as exciting in the picture as in nature. There was not only the obscuring of shapes, the interrupted vision that stirred the picture maker as well as the syrup maker to effort, there was also a change in texture from the scarcely defined very near shapes to the clear-cut farther ones. This plan of things was used repeatedly at Six Mile Lake, particularly with flowers.[102]

Alder Branch, *1933, oil, 45.8×56.5 (18×22¼)*

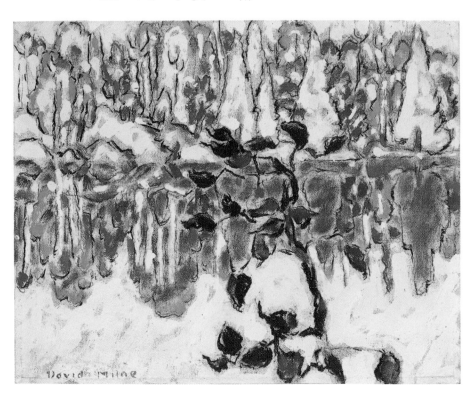

Drawing of Sugar Bush, *20 August 1934, ink, 10.5×16.0 (4¼×6¼)*

Another impulse Milne had with certain subjects was an extension of his Palgrave 'indirect' or repainting method: he tended to work longer and more deliberately on a larger canvas, 'and to work at it inside – away from the material.'[103] Milne ordered larger canvases with this initiative in mind.[104] Through the winter months of 1933–4 especially, when Milne found that he painted sluggishly in the feeble light and cold weather, he thought again about this method of working 'inside,' and devoted a good deal of his time to repainting some of the Palgrave works (a few of which are actually dated 1932–1934). He even determined to repaint *White, the Waterfall* of 1921 and *Corner of the House II* of 1922–6 that spring. What prompted his renewed desire to 'get something out of a bigger canvas and longer hammering'[105] he did not say. Perhaps he thought that reworking these paintings in a different setting, supported by his accomplishments at Palgrave and the developments of his value system, would help launch him on a new track at Six Mile Lake. As a warm-up for the *Waterfall*, he did a number of pencil studies of a small creek in Angus's sugar bush. His strategy was clear: he 'deliberately fought away from the innumerable small pictures done at a single sitting.' Hence his return to *White, the Waterfall*; it had come 'close to the end of the barren Alander winter, and I am hoping for something of the kind at the end of this trying and barren one.'[106] His sour memory of Alander aside, Milne believed that if he could do only two pictures in succession this way – by 'hammering' his way through – he could do any number. Perhaps he was thinking of Tom Thomson's *The West Wind*, which had been transformed from a spritely little sketch into a painting with implacable sureness and magisterial scale. But in the end, whatever he may have painted, nothing now remains.

Milne's writing is so supportive of his 'direct' method of painting, it is difficult to imagine why he was pulled so strongly away from it:

why has the apparently easy and careless canvas life and thrill, when the carefully wrought and painfully conscientious picture may be cold and dead[?]

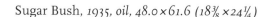

Sugar Bush, *1935, oil, 48.0×61.6 (18⅜×24¼)*

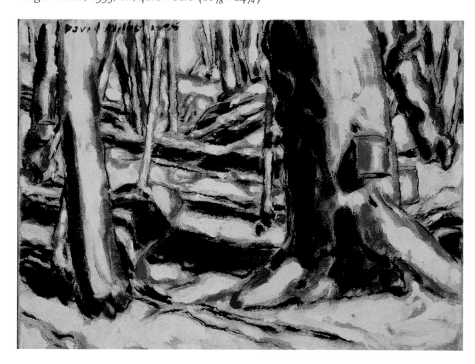

Bag of Sugar, *1934, oil, 45.8×55.9 (18×22)*

Of course the answer is that the painter was live, quickened, when he painted the first, and whatever he put down would carry that quickening, and reveal it to the spectator. How? Feeling drove his intelligence. His thought was at its clearest, his courage (or whatever approach to courage he was capable of) at its highest. Everything he had was concentrated on that rectangle of canvas. His feeling made him eager, impatient; no wandering into side paths, he went straight for the one thing he saw. If his feeling was strong enough he could override doubt and tradition and accepted theory.[107]

Milne was a painter who was not naturally inclined to proceed steadily toward a single large work. His methods of thinking and painting were matters of insight and swift reaction, of intellect and emotion combined, of process and aesthetic rightness, of variations with continuity. Yet that did not keep him from wanting to attempt more ambitious kinds of work, perhaps because he sensed a need for a radical reorientation in his development. If Milne wanted to change, his only way of making it happen was to put himself in a position as close as possible to whatever state he had been in when, once or twice before, he had seemed nearest his goal of producing 'a major work.' Two paintings had the qualities Milne thought he was after: 'The Alander one [*White, the Waterfall*] and the Biddiecot[t] one [*Corner of the House II*] both have kick, even when I look at them now, but in each case I had to break off [stop painting] and went back to the other [direct] way.'[108]

Can a sonneteer or a lyricist suddenly work in a larger, more complex mode? For Milne the die had been cast years before when he developed the habit of painting quickly and intensely, even though his urge to change was persistent, and he felt that he had the ability and intelligence to paint in another way. To Clarke he wrote:

This winter I have made some progress, a little, but I haven't clinched it, I am not sure of it. In spite of all the agony I haven't a thing to show for it. And it seems the simplest thing in the world. All you have to do is paint a picture over on the same or larger scale and make such changes as you may feel will improve it. You can work that way, practically every painter works that way all the time, but so far I can't ... Of course, the difficulty is habit, long formed habit. I know what to do, but can't get the emotions going, can't get thrill or kick out of it, so can't put kick into it. The light and thrilling line is gone, the delight and ease and sureness, but as soon as I go back to the more direct method I find it is still there. This winter I have come close to it at times, have had the tantalizing feeling of just having it within reach ... I didn't think there would be any difficulty. Have a good picture the first day, a damned good one the second and a masterpiece by the third. I was amazed; it didn't work.[109]

In May 1934 Milne set about to paint his annual spring flower picture with the aim of being slow and thoughtful, rather than fast and intuitive. The flowers quickly disappeared, however, in *Bag of Sugar, 1934,* a still life at night, which Milne painted from memory, using a few hurried notations in pencil to capture an image that had moved him. His eagerness to plan and develop a composition with care and deliberation took over at that point and, despite the painting's obvious success as a work, it is nevertheless rather starchy and posed: it does not pulse with the vibrancy of an intensely experienced subject. But Milne did not see this. He wrote to Clarke: 'I think I have got the repainting inside method going at last.' Its advantages, he explained, were that he could tackle larger canvases, vary

Frost on the Window *(detail)*

his subjects more by including night subjects, and allow greater latitude in creating the effects of light. It was a matter of considerable convenience that he now felt he could be independent of the weather.[110] 'This winter and spring I have managed to keep away from the direct work and stick to my job, but it's been close to suicide,' he admitted to Clarke.[111] Milne's satisfaction did not last long. After thinking he had achieved a breakthrough, upon reflection he decided that he had failed utterly.

Because of the ebb and flow in his struggle to establish his repainting method, Milne vacillated between optimism and pessimism for the first half of 1934. As often as he felt that he had not quite 'clinched things,' just as frequently he felt that he had overcome difficulties and no longer had that 'lost, scared feeling,' that he knew 'better what [he] was doing and what to do next.' The technical and aesthetic skirmishes he won gradually gave him a more positive outlook and this stiffened his resolve to arrange his life differently. It was then that he decided that, instead of building another cottage, he would trade his accumulated stock of paintings to support him for five or so more years of painting. So while Clarke the widower courted his secretary, whom he married in 1935 with Milne's full approval ('You could marry Mae West and it wouldn't alter things a bit so far as I am concerned'),[112] Milne stalked the Masseys, with results that have already been described. The business of sorting and packing paintings and writing lists for the Masseys, as well as finishing up some paintings for them and straightening out his affairs once he had some money, left little time for painting during the rest of 1934.

Milne began 1935 with fresh determination and a New Year's Day portrait of his cabin, *Winter Sky*. Shortly after that, in *Frost on the Window*, he limned its frosted windows against which he had propped a mirror that reflected his own face, the last self-portrait he was to do. Milne had not often done a self-portrait – once or twice at West Saugerties, once at Mount Riga, once again at Palgrave, and now. None of these, save the one at Palgrave, are introspective works in the tradition of, say, Rembrandt's self-analysing pictures. Rather, Milne's self-portraits seem almost incidental

Frost on the Window, *1935, oil, 31.0×41.6 (12⅛ ×16⅜)*

Drawing of Northern Lights, *1935,*
ink, 11.8×14.8 (4¾×6)

inclusions in other works. It may be that faces did not interest Milne as much as other objects, or that the anecdotal reference a face always makes was remote from the primary concerns of his modernist painting principles. As reflections Milne's self-portraits are at one remove from himself: his painting place pictures are his real self-portraits.

Many of the works done in 1935 – and it was a productive year with more than fifty paintings completed – were what Milne called 'memory pictures.' For these Milne would try to fix a particularly strong image in his mind, perhaps make a few pencil notations, and then set about the painting of it the following day or the next week or, in some instances, much later. *The Big Dipper* of 1936 was first conceived when Milne saw the constellation through the window just as he was going to bed one evening in March 1935. He made a quick pencil sketch by flashlight, painted it the next day in the sugar bush, and then painted it twice more over the next few days. Eventually he did a final painting a year later. The same pattern occurred with *Lightning*, which was also tried in 1935, but not finished until a year later. 'The idea,' Milne wrote to Clarke, 'is to get a strong kick from the subject, and let the putting of it on canvas take care of itself. Have the thing strongly enough fixed in your mind, then grab your brushes and just fall over the canvas. Faith, that's what it is.'[113] At about the same time, and inspired by the pyrotechnics of a night sky, he did a related painting, *Northern Lights*, which was the subject of a long letter to Clarke:

I have done a dozen or twenty very small pictures – 12×14 or 12×16 – from memory. The method is pretty much the same in all – a very quick observation, usually when doing something else, a slight pencil sketch at the time or sometimes later, then the actual painting done next day or later, in some, months later. They are mostly extremely simple – answers to the old conundrum, how little does it take to make a picture. Poor reproduction [see above]. Northern lights, and that's Cassiopeia showing through. This is the first one done, and still the most thrilling to me. I was going to bed when I looked out of the window and saw a passable display of northern lights. I felt some painting in it, so I got a piece of paper and the flashlight and made a slight drawing like this, but better, and with a shooting star in it too. At that time I was painting and making maple syrup down at the sugar bush. There, next day, I painted in the northern lights, rubbed it out and painted it in again, again rubbed it out and finally painted it in to my satisfaction. I think its kick comes mainly from the use of values – my standard values convention. The land shapes are black, the water and blank area of the sky are dark gray, the arc and rays of the lights are near-white with a slight use of hues, two reds, yellow and blue, the over-stuffed stars are high white. The whole thing is warm. In the second painting I tried a more literal set of blue-grayed values, but I am so used to using the straight gray, black and white that I had to discard the blue tinge. This would be the prescription – a second to get it, 2 minutes to make a drawing, a quarter of an hour to paint it in (painting over would not come in the plan). The things get their kick from singleness of purpose.[114]

Milne's interest in still lifes, almost dormant at Palgrave, returned at Six Mile Lake. He had painted only a few at Palgrave, and a few in 1933–4; thereafter they were a staple of his production. The objects in his cabin – the shelves, the dishes, the potato pot, the lantern, his food, the easel, flowers in season, the interior of the tiny cabin itself – were the pawns in his exploration of this genre. Milne's ability to see something where most of us would see little or nothing is evident in his still-life paintings, for after

Mellors Galleries, cover of 1936 exhibition catalogue with Milne's drawing of his painting Lightning

an object had caught his attention, he was able to lift it out of its ordinariness into a vision that was often enchanting. Yet it was an aesthetic vision, not a sentimental one:

For me sentiment has no place in paintings. The only feeling understandable is aesthetic feeling, no bearing on our struggle for survival. Painting has no purpose; it is intransitive, has no object. Coming from the world around us it does not return to it. Call it abstract, though it need not be non-representational. It is quite natural that it should retain traces of its origin. I would have no interest either in representation or in eliminating representation. A loaf of bread, a jar of jam, a bunch of flowers and an apple on a table would be to me merely a collection of shapes to be ordered by arrangement, and colour, with no concern about whether the result suggested the objects they came from or not. Representation would largely vanish through lack of interest in it, sentiment would vanish entirely for the same reason. Still lifes make good subjects for eliminating sentiment.[115]

Through the early winter of 1935 Milne painted several interiors of his cabin in which flour bags, the cabin shelves, or his easel were the chief subjects. These direct paintings were easy, sure, and accomplished. And when the spring came, Milne forgot about his drive to hammer away at one painting over a long period of time, and painted sumacs, wild roses, rocks, canoes, and 'hepaticas, adders' tongues, ladies slippers, hare bells, white waterlilies, cardinal flowers, water hyancinths, petunias.'[116] In a letter to Buchanan Milne wrote of his ritual of the annual flower picture in terms so lucid and descriptive that the letter was later revised and printed as an article entitled 'Spring Fever' in *Canadian Art*:

In the morning I went back to the bush and gathered some hepaticas and adders tongues. I set them in a bowl on the table, looked them over and painted them. It took all day, one way or another. I have forgotten just how they were arranged or what was with them and what the point of it was, but it wasn't bad. Next morning I got more flowers, put them in the same bowl, rubbed out the picture, and started all over again, looking at them, changing things round,

Northern Lights, 1935, oil, 31.0×35.9 (12⅛×14⅛)

Lightning, 1936, oil, 31.1×36.5 (12¼×14⅜)

working arrangements on the canvas, then rubbing them out. By four o'clock I
had things placed satisfactorily and everything planned but there didn't seem to
be enough kick left to start me painting. So I changed the whole arrangement
and managed to start. I was through in time to have supper before dark, and I
got quite a thrill out of the picture.[117]

Another subject that Milne fretted over during the winter of 1934–5,
and repainted several times into the late summer, was the cabin shelves:

After some hesitation, I have got the painting going fairly well again. I got two
or three canvases out of the more subdued side of autumn colors; and, this
week, have renewed the battle with that stubborn subject, the *Cabin Shelves*. I
have painted it in twice this week – and rubbed it out twice. Still it is progress-
ing. It is larger than usual and has a multitude of detail, so painting it in one day
leaves me rather limp. This is the inventory (don't read it, just notice the length)
– a wind-breaker, a box of matches, the red flour bag (naturally), a small jar of
boiled salad dressing, a bottle of ink, a square tin box, the lamp, a gallon pickle
jar with a branch of maple leaves sticking in it, a box of writing paper and a box
of envelopes, a cloth bag half full of sugar, a honey pail, a towel, three gem jars,
a package of cornstarch, bowls and plates, a gallon jug of vinegar, a package of
stretcher pieces, (opened but still in the wrapper), and the Shelves themselves.
Wouldn't that make anyone tired? The problem is to combine these ingredients
into one dish, and a dish easy to take.[118]

Whether the dark winter weather and solitude were beginning to affect
him more during 1935–6, Milne began to complain about depressions.
He never, in his writings, unbandaged his depressions so that we could
see what they were like. It was part of his general philosophy of life not to
complain too much or to reveal personal anguish. Was his work at an

Summer Colours, *1936, oil, 30.8×36.2 (12⅛ ×14¼)*

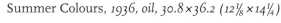

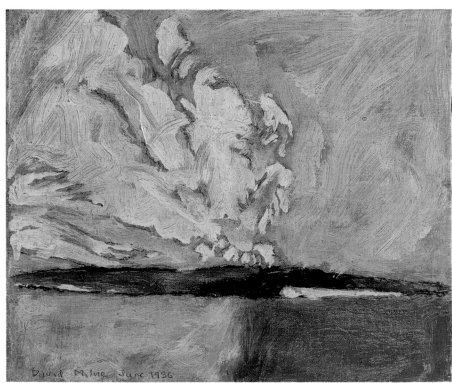

impasse? He referred to it as 'plodding,' and as if he could find no excitement in it. Were there simply too many interruptions in his life, so that his concentration was scattered? Had he made himself melancholy by wondering if he would be alone forever? Was he suffering from cabin fever?

Milne's laments over the slump in painting are to be found mostly, almost exclusively (the exception being in a few letters to Patsy), in his letters to the Masseys: 'Painting has been on strike and writing has been out in sympathy ... The winter [of 1935–6] has been completely barren, nothing survives'[119] (yet he had been quite productive, no matter what he said). By the summer of 1936 Milne noticed a slight improvement, but 'still there is no escaping the conclusion that this has been a bad period.'[120] In his letters to others the period was not half so gloomy as it must have appeared to the Masseys. Did he want the Masseys to think that things were worse than they were? The number of paintings done during the year was quite respectable – indeed, somewhat higher than average. He may have wanted them to think that he needed extra encouragement and support.

Despite his protestations, and the doldrums and difficulties at the beginning of 1936, this was another prolific year when Milne produced more than thirty-five fine works. The paintings summarized the search that he had been conducting during the three previous years, and perhaps made possible the move into new aesthetic territory that was to follow. The 1936 paintings are easy, dignified, and absolutely 'right' in nearly every respect. *Summer Colours*, for example, is utterly simple, and yet there is great power in the contrast of colours, and in the division of the composition into a dramatic and tense equilibrium; it is both a sample and a symbol of the year's work.

Bare Rock Begins to Show, which started off the year, is an excellent example of how Milne could let black values and full hues sit, in starkness

The Time of Forest Fires, *1936, oil, 31.1×36.2 (12¼×14¼)*

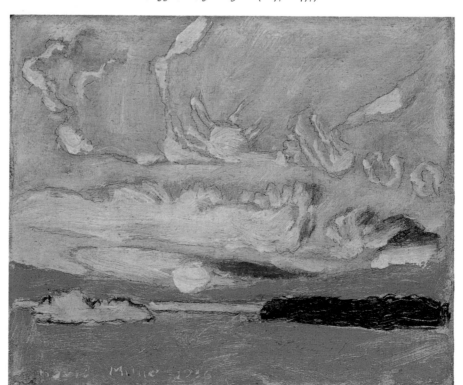

and richness, upon a white ground. The hues by themselves are a minuscule portion of the surface of the canvas, yet they animate the whole upper section and counterbalance the larger shapes below. The shapes in the upper band are also strikingly original, and they flow from one to the other with astonishing sureness and variety. Referring to the lacy bands of trees, Milne wrote that this picture might be called 'embroidery among patches.'[121]

Milne continued to work over paintings, and one of his worries in doing this was that in the process of strengthening and improving each part he tended to lose the one powerful impulse that drove the image into existence in the first place. In January 1936 he wrote to Clarke that at the end of

Bare Rock Begins to Show, *1936, oil, 51.4×61.6 (20¼×24¼)*

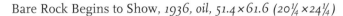

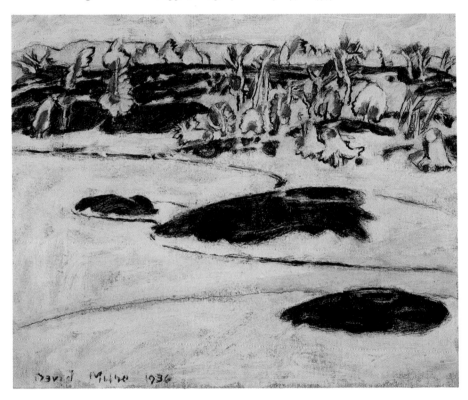

Cabin Shelves, *1934, oil, 46.1×56.3 (18⅛×22⅛)*

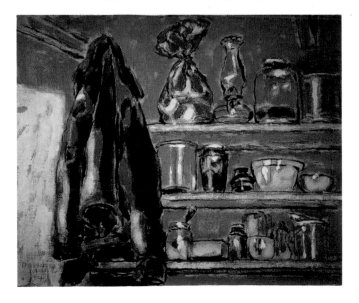

Yellow Coat and Shelves, *1936, oil, 61.3×76.2 (24⅛×30)*

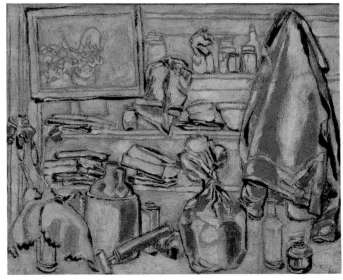

a week of working at parts, he had a dozen good pictures but not a whole one:

There is no singleness. We read them, we follow all the detail and lose the picture as a whole. Our feeling is dissipated, not concentrated. And it is the depth of feeling that counts. A rifle bullet will knock us over, but the same force spread over two or three minutes can be withstood.[122]

The quality that Milne admired in both Claude Monet and the American painter Albert Pinkham Ryder was that they never lost sight of the whole, even while working out the details of their paintings. Ryder tended to eliminate detail; Monet 'pulverized' it to keep the viewer from being side-tracked or lost. The vital part of any picture or sculpture or building, Milne wrote to Jarvis, 'is very small and can be quickly noted or easily remembered.'[123] Painting for Milne was an explosive art, one that hit the spectator instantly, with a blow. The details had to contribute to the first wallop, not detract from or supplant it.

Salmon Can, *1936, oil, 31.5×36.2 (12⅜×14¼)*

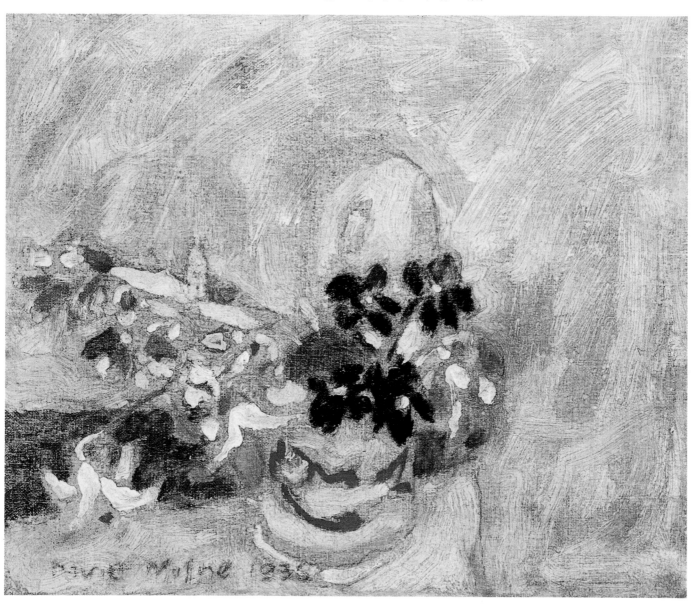

Nasturtiums and Carton II, *1937,*
oil, 47.0×66.7 (18½×26¼)

One painting from 1936 that Milne thought measured up to his ideals of singleness and power was *Salmon Can,* which he wanted Stockton Kimball to have as a wedding present. If it was already sold, Milne wrote to him, he would paint him another one, since he knew its structure and details well enough to do so easily. The painting itself, (depicted in *Yellow Coat and Shelves* of the same year) is marvellously askew and not easy to read; but its close-toned, creamy pigments are as abstract and pure as Milne was able to make them. The relation of the detail of the flowers to the large blank area is in equilibrium, yet full of tension.

In the course of 1936 Milne's painting again shifted noticeably to the out of doors and to his direct method of pictures painted in one sitting. In a note he wrote for *The Time of Forest Fires* he described his method:

To do these sunsets, you go out after supper, and sit on a packing box above the water. You smell the smoke from forest fires and listen to the loons calling from the middle of the lake. You watch the changes in the western sky as the sun nears the horizon and, perhaps, make a few pencil drawings of clouds and headlands and islands. At the same time you notice the colours, not as they are, but as they would be in your own assortment of black and white values and hues. Then the mosquito[e]s start to hum in the bush behind you and you go back to the cabin. The drawings are put away and, usually, forgotten. But the next day, or some other day, as you go over the stack of sketches, you come to one that brings back with unusual vividness, the picture you saw as you sat on the packing box above the still lake. The one that you paint, once maybe, more likely twice or three times, you work at it until your canvas gives the same 'kick' the sunset gave you – or until you get tired of rubbing out and doing over.[124]

One of Milne's important innovations of 1936 was using a bold colour as a value: he had started, tentatively, with blue upon his arrival at Six Mile Lake in 1933. In *Nasturtiums and Carton II* he used red as a value and wrote a long,

Raspberry Jam, *1936, oil, 46.1×56.3 (18⅛×22⅛)*

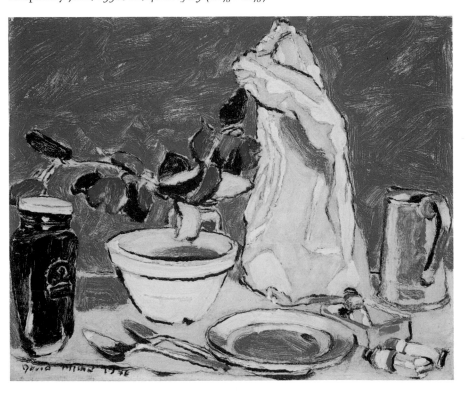

careful analysis in a letter to Buchanan. The inescapable presence of blue in everything Milne looked at from his rocky point had been provoking him. Normally, in his system of values and hues, he would paint the blue water white, gray, or black. The problem he set himself in *Nasturtiums and Carton II* was how to use a huge area of strong and aggressive red where he would normally use a value. In a painting with blue, Milne explained to Buchanan, the problem would be the same. The dominating red, then, became a foil for the smaller areas of black and white, a complete reversal of Milne's normal procedure, but one that succeeded and became an important factor in the watercolours that were soon to follow.[125] The first indication of this use of colour in lieu of values was in *Trilliums and Trilliums* painted earlier in 1936. The other painting that held the seeds of future development was *Raspberry Jam*, in which Milne began to think consciously of a progression of colours across the picture plane.

The first one [*Raspberry Jam*] was in Mellors exhibition last fall – Mellors sold it to Douglas Duncan, for sixty-five dollars. Heavens, I worked a month on it. It went from black to light blue without passing through reds very much. You

Trilliums and Columbines, 1937, oil, 46.1×56.3 (18⅛×22⅛)

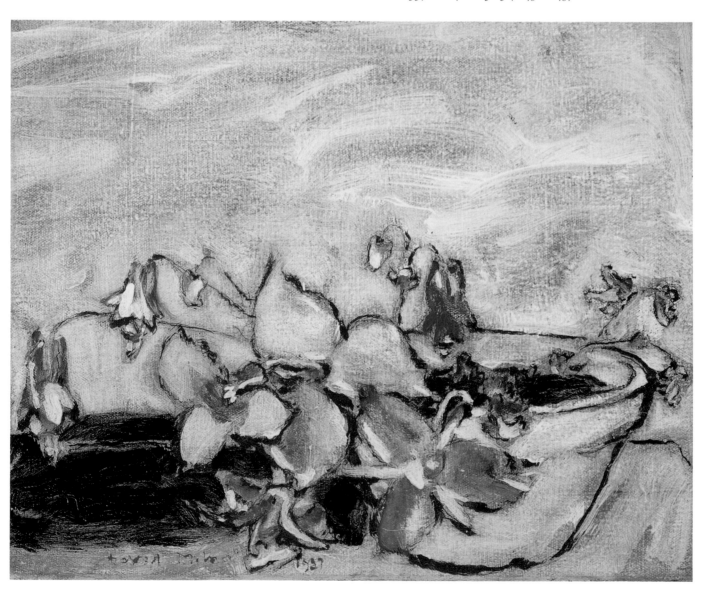

wouldn't notice this progression thing. I wasn't conscious of it until it was done, or in the way in the first one. Yet I can't remember that I have used the composition before. Usually my compositions are not a progress across the canvas, they are more apt to be a crossing over, a concentration at one point. I was thinking of this composition as a symphony but I asked [Graham] McInnes and he looked it up in the encyclopaedia, and a symphony is something else. Well, progression does better. The point of it is that there is a strong accent at both ends of the picture, though one end, of course, is a little stronger than the other. Sounds silly, doesn't it?[126]

The oil paintings of the first part of 1937 – when Milne's winter depression again set in, but with less severity, according to his letters to the Masseys – were essentially extensions or applications of the ideas developed earlier. *Nasturtiums and Carton* was painted again, and such fine canvases as *New Shelf, Flowers of the Maple*, and *Winter Clouds* can be counted among those of that year. *Trilliums and Columbines*, which in structure harks back to the Palgrave landscapes, was perhaps one of the most felicitous, with its rich, luxurious pigments and its freely painted abstract background. Milne was always capable, it seems, of a poetic response to flowers, and his treatment of such familiar subjects occupied his attention while his sensibility tuned itself to a new wavelength.

Mid-way through 1937, however, Milne's painting veered in a different direction, when he again took up the watercolour medium after a twelve-year break. The focus of his thoughts shifted to watercolour. The alchemy of this profound two- to three-year change was the prelude to the last great period of Milne's art, when he moved into a realm of expression that had been totally foreign to his production up to this time: fantasy.

Stars over Bay Street
Six Mile Lake and Toronto
1937–1940

IN THE MIDDLE OF 1937 Milne's life began to change in several dramatic and fundamental ways. At fifty-five, when many men are sliding toward retirement, Milne was manoeuvring himself, perhaps unconsciously, toward another beginning. Events in his art, and in 1938 in his personal life, conspired to jostle him out of what had become, for five years, a fairly stable routine, at least as far as painting was concerned. The miraculous event of 1937 was the resuscitation of his dormant skill and interest in watercolour, which gave an urgent momentum to this new phase of his life; so much so, indeed, that shortly his interest in oils was displaced and his production in that medium plummeted. He painted no oils at all in 1938, and by 1940 he was concentrating on watercolours almost exclusively. During this time his productivity rose sharply. Letter and journal writing, often a barometer of his state of mind, rose to an all-time high. The recognition he was receiving as a result of the whirlwind into which the Masseys had thrust him was leading Milne to assess his position and his future. In the years following 1935 he found the stimulation of new friends and artistic debate intoxicating after years of relative silence and private meditation. The idea of leaving Six Mile Lake began to have appeal.

Almost the last of Milne's significant paintings in oil were springboards for what were to become the unexpected fantasy pictures of his late years. These were *Picture on the Blackboard* and *Margaret's Picture of Wimpy and the Birthday Cake*, two rather odd subjects that started him thinking along lines that led him from the real to the imaginary. The first was inspired by an Easter picture that six-year-olds Kathleen Angus and Norma Collins had drawn on the blackboard at the Big Chute school. It showed their own school, with trees, a sunset, a sailboat, and three pupils walking along the path to class. The second of Milne's paintings was inspired by Margaret Smith, the six-year-old daughter of Doug Smith, the local storekeeper and postmaster. Her painting shows her birthday cake and her dog, Wimpy, appearing to stand on the cake. In Milne's painting, which is luscious and creamy and mostly abstract, Margaret's picture is lying on the card folder in which Milne brought the picture home. The charm and inspiration of the children's drawings pulled Milne back to his own childhood and to his memories of his first paintings of suns and moons, done with the utter dedication of a child.

Just as he abandoned watercolour inexplicably in 1925, so Milne offered no explanation when it again became the main focus of his painting ideas and expression. Unlike his last watercolours in 1925, which were rich, reserved, and austere (except for *Tribute to Spring*), the new ones were fluid, reminiscent of the most vigorous and experimental excursions of Milne's New York years and recalling his wide, bright palette of that time in their splashy variety of colours.

Milne's production in watercolour began, a little unsteadily, in small formats, in the early summer with a view of Pretty Channel and then a few sunsets. Other subjects, such as reflections or landscapes, harked back to the Boston Corners' concerns of 1916, when Milne had mastered both technical and aesthetic aspects of this medium. Soon Milne addressed more complex subjects in larger sizes as both his technique and his enthusiasm revived. With his habitual reticence, spiced with a pinch of irony, he wrote to Clarke in November that he had 'tried a few water colors. At first I was completely lost, but after spoiling a lot of paper I have got some freedom in it, but still without much to show.'[1] By the end of the year he had quite a lot to show: more than thirty watercolours (in addition to the thirty-five oils from the early part of the year). As the reference to spoiled paper suggests, many more works were certainly rejected and destroyed.

After several trial watercolours in the early summer Milne finally tackled a major subject in July: *Vinegar Bottle*, a still life of a jar of blueberries, a vinegar bottle, a paper bag, and other objects set out on a table. The genesis of the arrangement was a combination of two still lifes, the 1934 *Flour Bag* and the 1936 *Raspberry Jam*. There was one enormous difference, however: Milne was no longer aiming at a picture in which everything hit at once; rather, he was striving to compose a work in which, in addition to the initial impact, there was a progression across the sheet, a rhythm established by jumping from point to point to point and from colour to colour to colour. Milne described *Vinegar Bottle* to Alice Massey:

I am working just now on a still life – a two-quart jar of blueberries, an empty cardboard box, dark red, an empty vinegar bottle, a plate with two tomatoes on it, a paper bag, a couple of nasturtiums, the Massey bowl, the usual thing. Why just these things? Well, they make a progression, a progression in red – deep red, almost black, a full deep red, almost purple, a pink, nearly white, a full warm red, then a series of light warm reds ranging from yellow to rose, more small speckles of bright red and white or almost white. The idea seems to be a definite progress from black to white by way of red.[2]

This change in approach opened up many novel possibilities. Instead of a concentration of focus, there were now several points of focus; instead of

Picture on the Blackboard, *1937, oil, 46.7 × 68.3 (18⅜ × 26⅞)*

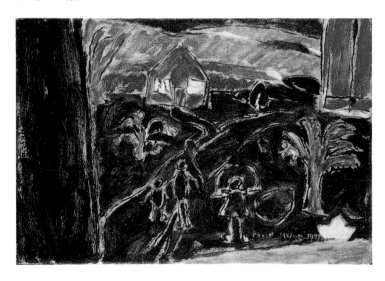

Margaret's Picture of Wimpy and the Birthday Cake, *1937, oil, 31.1 × 36.2 (12¼ × 14¼)*

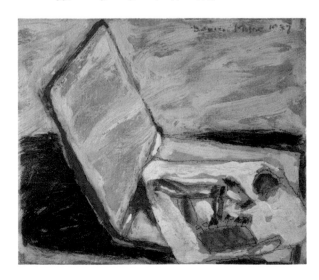

making a single immediate impact, the painting invited the viewer to read through from one cluster of details to another. What Milne referred to as a blank area was increased in size but, instead of being gathered at the upper or lower part of the composition or to the side, it was split up and deployed around and through the various objects. An indication of Milne's excitement with this change was that he did a number of versions of *Vinegar Bottle*, finally retaining only three in watercolour and one in oil, *Bag of Sugar, 1937*.

In the same letter to Alice Massey Milne pointed out a key characteristic of his creative process: the fact that he was not aware of what he had done until after he had done it.[3] In fact, this way of working had been constant throughout much of his painting life, from as early as Boston Corners and the war service. Something in the process of painting – the excited involvement once he had launched himself, the inspiration of creation in the white heat of execution – always seemed both to surprise and to delight Milne when he was painting well. After he had time to reflect on what he had done, to see why a particular impulse had created an effect that worked, he was then in a position to use that invention consciously rather than intuitively. A new technique or effect always led to other sets of problems and solutions that posed further challenges. If a painter already knew everything that was going to go into a work or what was going to happen during the painting of it, the purpose in doing it was already lost. That sort of painting, for Milne, was reminiscent of the sort taught by his teachers at the Art Students' League, whom he described as approaching art as if it were bricklaying: one predictable action after another, with a totally predictable result. For Milne the real purpose and the excitement of painting were the discovery and exploration of something previously unknown, the invention of original effects, the creation of new conventions, and the raising of an aesthetic thrill in the process. The result, if he was lucky and his aesthetic emotion was running high, would astonish him and be alive for others.

The boldness with which Milne had attacked paintings in oil up to this time was shortly evident in the watercolours. *Yellow Shoe Box* is a good example. The bravura treatment of this work showed that Milne had few inhibitions in watercolour, either in his methods of application or in how far he

Vinegar Bottle III, 1937, watercolour, 40.7×54.0 (16×21¼)

Bag of Sugar, 1937, oil, 51.1×61.6 (20⅛×24¼)

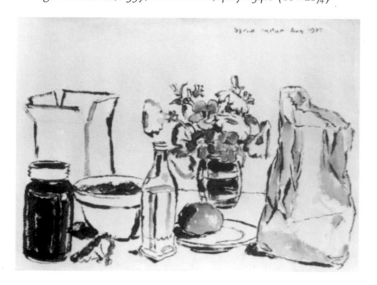
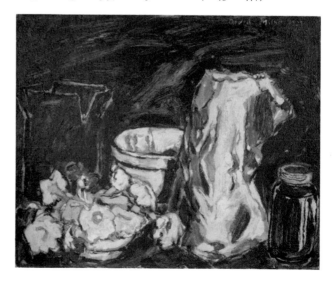

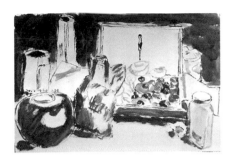

Edam Cheese, *1938, watercolour,
38.1×55.9 (15×22)*

could go in using one colour, such as yellow or black. In oils Milne had
worried excessively about using bright, full colours where he had normally
used a value; his *Nasturtiums and Carton* paintings show the extent to
which he wanted to go with this idea, but the fact that it is an isolated ex-
ample indicates his hesitation in doing so. In watercolour the paper itself
acted as a value, giving a very different quality of colour. Milne used a gray
value in some watercolours, but, while it was elegant, he achieved only minor
success with it. In other works, in total contrast to those in which he used
bold colours, Milne painted with a touch that could be as gentle and delicate
as one could imagine, as, for example, in *White Shoe Box.*

With the idea of using a large area of bright colour as a value instead of
gray, black, or white still beckoning him, Milne returned to the *Nasturti-
ums and Carton* subject from the year before, and repainted it in both oil
and watercolour. He must have seen that using strong and vivid colour in
large areas could best be achieved in watercolour, not because the tech-
nique did not work in oil (it did rather well in the few instances that Milne
followed the impulse to a conclusion), but because in watercolour it has a
freshness, a smack as irresistible as a sea breeze. Milne must have been
lured by the brashness and versatility of working in watercolour, the speed
of execution, and the ability to present a coarse and rough appearance.

When Milne saw his new watercolours framed and hung at the Mellors
Galleries for an exhibition of 15–29 January 1938, he thought they were
'rather better than the oils,'[4] and they struck his admirers as both power-
ful and sensitive. He now 'thought' in watercolour. Most of his paintings
in oil (they were fewer and fewer until he stopped working in oil altogether
in 1946)[5] were primarily translations of what he had already thought out
in watercolour. In the five years after he started painting watercolours again,
Milne painted only a dozen or so oils. Although there are some exceptions,
most of his masterworks after 1938 are watercolours.

The speed of watercolour was so much greater both in execution and in
the impact on the viewer that the watercolours seemed to Milne's sensibil-
ity to represent the spirit of the times with much greater power and appro-
priateness. This may have been rationalization after the fact, but as early
as the New York years Milne's leaning seemed to be toward watercolour –
at least as far as its immediacy was concerned. In a letter to Carl Schaefer,
himself an accomplished painter in watercolour, Milne wrote that he was

surprised that the watercolour [had not] been used more by the modernists. It is
so direct and when the white paper convention is accepted, so powerful, even

Yellow Shoe Box, *1937, watercolour, 27.3×44.5 (10¾×17½)* White Shoe Box, *1937, watercolour, 29.2×45.1 (11½×17¾)*

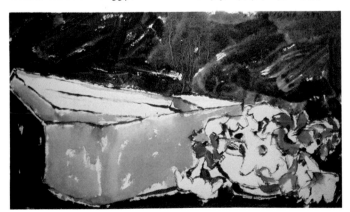

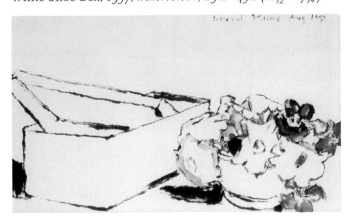

Milne in his cabin at Six Mile Lake, with a version of Cabin at Night *on the easel*

brutal, that it would seem an ideal medium. Theoretically, it should be *the* painting medium because it is faster, and painting is the instantaneous art.[6]

Milne wrote to Graham McInnes about premodernist works as 'browsing' pictures, ones in which there was such a degree of complication and detail 'that they couldn't be completely grasped at one glance, a bit of further exploration was invited and rewarded.'[7] In contrast, he wrote, most modern works can be visually captured all at once, whether in one quick vertical or horizontal sweep of the eye, or in a gentle arc, or even one rapid wave. Milne's variation on these possibilities was the 'progression' in which the movement was across the picture in a rhythm established by the various objects, a series of measured, but not necessarily regular, beats. To illustrate his point, Milne referred to his painting *Edam Cheese*. Like most of the paintings of 1938, it is based on the same principle as the *Vinegar Bottle* series of 1937.

You start at the cheese, black and white, strong but with little detail, not emphasized. Then up through the two cardboard containers, without holes or much detail. Down and then up through the more detailed bag of nuts in which there is more colour. Then across, more slowly by way of the box and its contents, full of colour and detail – the high point of the progression. Then down by way of the marmalade jar of clear honey, which is pale yellow.[8]

The principle of a 'progression – that is, a movement from one side of

Cabin at Night 11, *1938, watercolour, 42.0 × 61.6 (16½ × 24¼)*

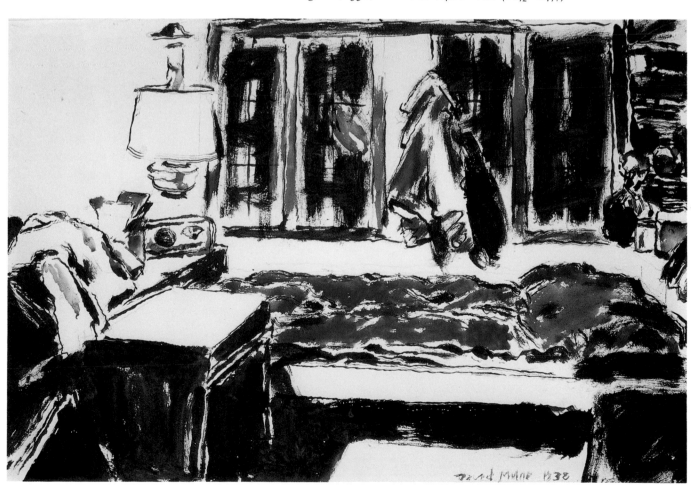

the picture to the other by steps or beats rather than by a smooth-flowing progress'[9] – had often informed Milne's painting. It is there, even if not identified as such, in the church, barns, and houses of Boston Corners, which are stepped across the canvas in a series of calculated beats. There is also a pronounced visual rhythm in the Palgrave paintings *Barns* and *Queen's Hotel, Palgrave*, as one moves across them from space to space, from gable to gable, from rooftop to rooftop. And while most of Milne's pictures make a sharp and undeniable impact when first seen, many do require or invite a 'reading' at greater leisure. Nevertheless, there was now more detailed planning in the application of this idea, and the rhythm was variable, more staccato than pulsing, and emphatic in a new and insistent

Brook in the Sugar Bush, *1938, watercolour, 35.6×50.8 (14×20)*

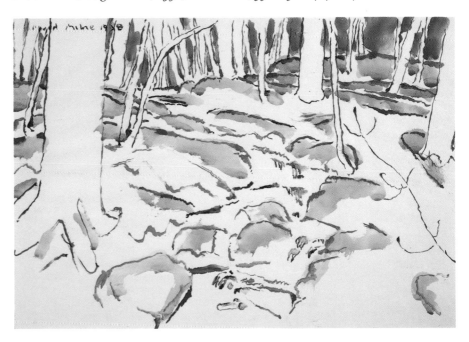

Lighted Lamp, *1937, watercolour, 35.3×49.9 (13⅞×19⅝)*

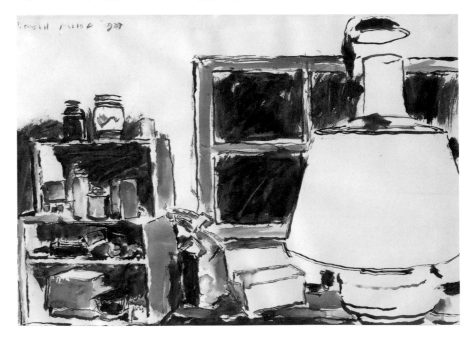

The Pole Line, *1938, watercolour,*
37.2 × 54.6 (14⅝ × 21½)

way. Whether or not Milne's painting had been influenced by Igor Stravinsky's music, with its rapid shifts of tempi, cannot be known; but in fact he had been listening to it with admiration. He had also been reading poems by T.S. Eliot and Ezra Pound, with their abrupt juxtapositions of images and changes of metre.[10] During the January 1938 exhibition of his paintings at the Mellors Galleries he gave an interview to a young reporter, a student at the University of Toronto, for the *Varsity*:

For Mr Milne there is not much difference between painting and music. 'Music is an arrangement of sounds against time, whereas painting is an arrangement of lines, hues and values against flat space.' He then went on to point out the similarity of feeling between the formless patches of black in one of this own paintings and certain massive chords in a Stravinsky concerto.[11]

He was also quoted as saying that 'All art has the play element. It is a delight in itself and for itself,' and he was said to have 'a keen sense of order that is related, he says, to his fondness for mathematics.'[12] This is the first documented reference to this interest on Milne's part; it may have been rekindled by his friendship about this time with Carson Mark, a brilliant young student in nuclear physics at the University of Toronto (who was to become the head of theoretical nuclear physics at Los Alamos, New Mexico). Milne met Carson and Kay Mark when he first camped on the Severn River, where Kay's parents had a property on which they camped every summer.

Before the end of 1937 Milne adopted in watercolour his idea of memory pictures: ones sketched or noted at night and then painted the next day or so. *Lighted Lamp* and *Cabin at Night II* are two of the first of these. They are excellent examples of Milne's ability to use the paper as a positive force and as a value. While in *Lighted Lamp* it would be normal to imagine that the lamp (the one given to Milne by Duncan and Jarvis) would be left white, the real surprise of the picture is that the walls of the cabin are also left white rather than darkened as they would have to be in actuality, with dark window panes. In *Cabin at Night II*, which he repainted 'many times,' the white paper indicates the lamp's illumination of the whole middle area, with a black foreground and black windows. But *Supper by Lamplight*, a study of his food-laden table, is predominantly black.

The idea of the progression was varied again a year later, in 1938, when

Red Lily, *1938, watercolour, 36.9 × 53.7 (14¼ × 21⅛)*

Zinnias to Paint, *1938, watercolour, 36.6 × 54.9 (14⅜ × 21⅝)*

Drawing of Cracks in the New Ice,
15 January 1939, 6.5×10.0 (2¾×4)

Milne painted *Breakfast with Flowers*. Here the progression moves, through space and colour, from the dark, opaque background on the left through the objects on the table to the blank white space on the right. Hence, two systems of rhythms, one of shapes and one of colours, are syncopated across the sheet at the same time. A variation of this is found in *The Pole Line*, an often painted landscape, where the central strip, through which the double row of poles marches over the hill, is in black and white values, and coloured curtains of trees are draped on either side. Here is Milne's description of the work:

I go along this rather rough way when I walk to the Big Chute. The right-of-way is kept free of trees. The most interesting thing about this is its simplicity and the arrangement, the peculiar concentration on the poles which are very slight – that is, a concentration on almost nothing.[13]

By the beginning of May 1938 Milne had completed a large number of still lifes and landscapes, and he wrote to Mrs Massey: 'I think the present pictures are freer, looser, have more unity, give more attention to the whole and less to the parts ... in many of them detail is deliberately lost or killed to avoid a scattering of interest.'[14] A month later, however, Milne admitted to McInnes that there were only 'half-a-dozen that I like fairly well and a bale of spoilt paper.'[15] Milne's ruthless self-criticism never left him.

In the same letter to McInnes Milne drew attention to another concern: the deliberate use of contrasting colours and their application. Its origin can be seen in the work of 1937, but Milne concentrated on it in 1938. Dark, opaque colours – maroon, black, and tawny brown – were generally scrubbed rather than washed on. This difference in application meant that they would be vague in form and be given considerable weight, but without definition. Set against them were light, transparent colours – scarlet, carmine, amber, sky-blue – always washed or flowed on. Generally, the light colours went over an outline or contour in a complementary colour that had been drawn in pencil or charcoal. The transparency of the wash

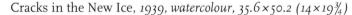

Cracks in the New Ice, *1939, watercolour, 35.6×50.2 (14×19¾)*

Milne in his cabin, with The Yellow Coat *on the easel*

was important, and can be vividly seen, for example, in the light-coloured and luminous *Brook in the Sugar Bush* of 1938, where the technique of washing over the confining lines of the underlying shapes is particularly noticeable. He described painting this subject:

the hepaticas are out and the bush has an over-all brown or red look. These clear trickles of snow water in spring are always thrilling to me. This is about the first use of the transparent color used in this way – transparent wash to bind together detail of the same or near the same colour – which has marked most of the spring and summer work.[16]

Many paintings from 1938 show the chief characteristics of this period: power, elegance, and variety. *Zinnias to Paint*, for example, is a charming subject (the painter's studio again), and a work that shows the dark colour scrubbed in, the transparent colours washed in, and a circular progression of reds. *Red Lily* is another in which the shelves, with their different objects, make a double progression in counterpoint to each other. And, with his usual wry humour, Milne's red lily in this painting is not the trillium in the middle but the paper bag on the right: 'In my philosophy a paper bag is in exactly the same class [as flowers] as painting material.'[17] Beginning with *Cracks in the New Ice*, a most successful use of a gray value in watercolour, Milne pursued the idea of using a large expanse of bolder colour, like red or blue, as a value in a series of paintings using the bays on either side of his rocky point as subjects. *Spring Comes to the Bay* ('One of the few pictures I have made dominated by blue')[18] and *Across the Bay in Spring* are two typical examples in their colour and their composition; they led Milne to other similar landscape treatments during the summer of 1938.

Rounding the year off are two paintings that take a step or two down the path that Milne was moving inexorably along. Milne's direction had begun to show itself in *Picture on the Blackboard* and *Margaret's Picture of Wimpy and the Birthday Cake*, paintings in which he began to move toward a light-hearted world of childlike fantasy. In November he was prompted by the sight of one of Mrs Angus's figurines to paint *The Hula Dancer*, another odd subject. When he had worked out a version that he liked, he gave it to her. A gift for Elizabeth Cowan, who was departing as the teacher at the local school at Big Chute, was appropriately called *Goodbye to a Teacher*. The gifts, framed at Milne's expense, were an uncharacteristic gesture, since Milne seldom gave, or even tried to give, his work to anyone. Milne's instructions to Duncan about Miss Cowan's painting reveal the generous and personable side of his character:

I wrote to Miss Cowan at Coniston and told her about it, sent the card with your name, told her you would arrange everything. This is important. Miss Cowan may be a little timid, but I want her to have the picture if she likes it. If she doesn't and would rather have something else, then show her a good many (good ones) of the Mellors ones (oils or watercolours) and the recent watercolours. She is to have anything she chooses. Then frame it for her and, if she has gone back before it is done, send it by express prepaid. I knew Miss Cowan for five years, she and her school were the source of a lot of inspiration, so there mustn't be any half way about it.[19]

Milne had begun to think about *Goodbye to a Teacher* in June 1938, but he was still painting versions of it more than six months later, into early

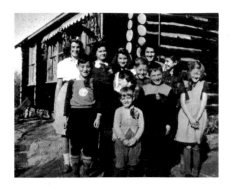

Teacher Elizabeth Cowan and her students, 1938

Drawing of Goodbye to a Teacher, *15 January 1939, ink, 10.0×15.0 (4×6)*

1939. Six versions still survive, although many more were made. The work embodies an intricate concept in the creation of two colour progressions running in close parallel, one in the children's clothes, the other in the flesh colours of their faces. Milne committed a great deal of time to this work: he juggled the various abstract elements of the painting to make them fit together properly, trying different colour combinations and methods of applying the paint. He went out of his way to paint the children's faces without expression or character, since that didn't matter to him. Nevertheless, Miss Cowan could still identify each of the twelve children nearly forty years later.[20] Milne started with a snapshot from which he imaginatively re-created this simple image, garnishing it with ideas taken from the children's own drawings: tame and wild animals, exotic trees and birds, and very large worms. He 'had a lot of fun with it':

In it there are eleven scholars and one teacher, one porcupine, one white rat, one robin mistaking the white rat's tail for a worm, one small green snake, one small yellow bird (kind unknown), one ant, part of one large tree, several large evergreens, assorted landscape and the school as the children draw it. It isn't funny, more nearly quaint, there is a minimum of illustration, no portraiture. It is mostly a painting problem ... Do you remember the transparent colors in some of the spring ones, usually with sharply defined detail in outline underneath? Well, the flesh is treated that way – probably a large part of the temptation to make the picture. The teacher has been a problem. Bare arms and face

Goodbye to a Teacher IV, *1939, watercolour, 38.1×55.9 (15×22)*

decided on – transparent color over changing outline and detail – but her dress hasn't been satisfactory. I wanted it to have simplicity and at the same time some distinction. I think this new color will do it. It is almost exactly the same as the transparent painting of the arms in hue and black and white value, the difference will be the texture.

All the way along this picture has been interesting to me, in composition, detail, way it developed, everything. No attempt at realism is made in it.[21]

The whole of 1938 was an exciting and momentous one for Milne. His production was high, with over eighty paintings completed, and the exhibition in January 1938 at Mellors Galleries had been both a critical and a financial success. He spent a week in Toronto for the exhibition and described his socializing in a letter to Mrs Massey, including his meeting with the young reporter for the *Varsity*:

She said she was a cub reporter and didn't know much about art. I think she was spoofing me. Alan [Jarvis] brought in her column next day and it was particularly well done. If she didn't know about art she had a fine basis for it. She was trying to get some broad idea of my definition of art and I was attempting to explain the thrilling, illuminating effect of it – you know, 'a presence in the room' – 'making it bright and like a lily in bloom.' So I asked her if she had ever been in love. The infant looked me square in the eye and solemnly said, 'Yes'. So she understands the comparison. Miss Proctor, don't know her first name.

Well, Miss Proctor was scarcely out of the door when Barker Fairley came in – you probably know him – head of the German department in University College. Paints, too. He was going to get [A.Y.] Jackson for lunch. Said he would bring him down and all go to lunch. He did and we had a very long talk. I met Jackson before many years ago but particularly enjoyed this longer talk. He looked older than I thought him, which just means that I look older than I thought too. Very pleasant, Jackson, and has been particularly helpful to the younger painters at the Picture Loan Society.[22]

There was a dinner with Duncan, Jarvis, and the painter Will Ogilvie. Norman and Elizabeth Endicott, who had visited Milne at Six Mile Lake, appeared, along with the art critics Pearl McCarthy and Graham McInnes. Robert Hunter, a curator from Montreal, met Milne and over the next few years bought a number of paintings and later arranged exhibits of Milne's paintings in Florida. Arthur Lismer came to the exhibition and spent hours chatting with Milne. As a favour to Alice Massey, Milne saw a young sculptor, Sheila Wherry. He was 'interviewed' on radio station CFRB by Blair Laing, the young son of the owner of Mellors Galleries, following a script Milne had written out to make sure the right questions were asked.[23] All in all, Milne was at last being seen, being sold, being paid attention to, and thinking about a wider range of ideas in his painting than he had for a very long time. In all the years in the Adirondacks, at Temagami and Palgrave, and for long periods at Six Mile Lake, Milne had been, except for supportive letters from Clarke, essentially alone as far as his art was concerned. Now he was returning to an atmosphere more like his early days in New York, with their debate and stimulation. In October 1938 his work was shown in the large exhibition of Canadian art organized by the National Gallery for the Tate Gallery in London. Milne was prominently represented by the Masseys' large *Window*, by *Painting Place III*, and by two watercolours, *Candy Box* and *The Cross Chute*, which were sent over for the

occasion. The English were not much interested in Canadian art and for the most part the reviews of the exhibition were 'inadequate and slovenly' according to Northrop Frye, then at Oxford University, who reviewed the exhibition for *Canadian Forum*.[24] In a letter to his wife Frye wrote that Milne's oils were 'average Milnes,' but he put Milne – 'water-colours especially' – among those half-dozen artists he thought were Canada's 'best bets.'[25] Milne was chosen for special mention by *The Observer* and lauded, to A.Y. Jackson's displeasure, by the critic for *The Manchester Guardian*, Eric Newton. Since English opinion was thought to have prestige in Canada, the *Canadian Forum* wanted to publish an English critic's point of view, and asked Newton for a review:

Onto a scaffolding of severe yet sensitive line he imposes a colour scheme that is always rigid, always simple, never obvious and often quite unexpected. His inventiveness seems inexhaustible: his chief limitation is that he works best on a diminutive scale. 'Window' and 'Painting Place' are typical examples of his art.[26]

Milne was also stimulated by his letter writing (and by the letters he received). Of the more than sixty letters he wrote in 1938, twelve are restrained but not unfriendly ones to Patsy; there are numerous long letters to Alice Massey, often up to ten or twenty pages, reflecting on his painting and recounting daily trivialities; and long letters to Duncan and Jarvis (and to 'Douglas and Alan' jointly). Others were written to Clarke, Schaefer, McInnes, his lawyer, Vera Parsons, McCurry, Mac MacKenzie (a cottager not far away), Mellors and Laing, and to a new friend, Kathleen Pavey. One thinks of the hours Milne must have spent alone in his cabin writing these by hand, yet they seemed an easy and natural mode of expression for him. Alway vivid, interesting, and readable, his letters reveal the skills of a true writer.

Milne journeyed several times to Toronto, and in June 1939 he again visited the Kimballs in Buffalo, spending about a week at their country place at East Aurora. He also visited his family home in Paisley and tried to find a retirement place for his only remaining sibling, his brother Jim, who needed care. When the King and Queen visited Toronto in the summer of 1939, two years after George VI's coronation, Milne the monarchist was on hand to cheer them.[27]

The changes in Milne's life prodded him into behaviour that was relatively new for him. In addition to the gifts to Mrs Angus and Miss Cowan, Milne gave paintings to Duncan, Jarvis, McInnes, and Parsons; early in 1939 two were given to a fund-raising exhibition in aid of Spanish refugee children. In August 1938 Milne submitted ten watercolours to the National Gallery to be considered for the Tate Gallery exhibition. Though only two were chosen, Milne asked that all ten be sent to the Masseys in London so that they might choose one as a gift for all the kindness and support they had given him.

At the end of 1938 Milne invited Duncan, after a three-year acquaintance, to become his agent and dealer. The terms were much more favourable for Milne than those with the Masseys and the Mellors Galleries: two-thirds of gross sales for Milne, with Duncan paying for advertising, framing, and other costs out of his share. Duncan was still green as a businessman – he was certainly no Vollard – but his connections and initiative ensured that sales were steady despite the war. He was allowed to dip into the boxes of Milne's paintings that Clarke had shipped up a year earlier

after keeping them for so many years. A shrewd collector, Duncan was bowled over by what he saw, and made a substantial purchase for himself. As Milne's agent, he ferreted out J.S. McLean, the head of Canada Packers Ltd, a large meat-packing firm, and persuaded him to add to the Milne paintings he had already purchased from Mellors Galleries. Both Duncan and McLean, who was beginning to be a discriminating collector, purchased a generous number of the early watercolours: Duncan took twenty and McLean twenty-two. At prices set by Duncan (between $65 and $100), McLean's purchase, which he considered an initial selection only, exceeded the amount that the Masseys had paid Milne for ten times that number of oil paintings only four years earlier – $1,600.[28] While this purchase made Milne's financial status measurably more secure, it did not make him rich. It did, however, make him eligible to pay income tax for the first time, a task that his new agent busied himself with. But Milne had found two well-to-do people who liked his work and would ensure that he was able to continue to devote himself to it without worry. Milne met McLean soon after the initial purchase. McLean immediately and thereafter was Milne's most substantial benefactor, with a good eye and a genuine interest in Milne and his work. Duncan often visited McLean's house, the magnificent Bay View, overlooking the Don Valley in Toronto, bearing examples of Milne's work and spreading it out on the living-room floor for McLean and his wife to see and to choose from, or going over works that McLean had on approval from him.

In February 1939 Milne went to Ottawa with Duncan to meet with Eric Brown, director of the National Gallery. The purpose of their visit was to offer the gallery a study collection of Milne's work, an idea that Milne had hoped to entice the Masseys into sharing but now offered on his own. His intention was to donate, without condition, about 450 of his early watercolours and oil paintings.[29] Brown accepted the gift provisionally, noting that the offer had yet to be submitted to, and approved by, the Board of Trustees. Nevertheless, he liked Milne's work a great deal and probably expected no difficulty with the proposal. Unfortunately, Brown died before the offer could be presented to the board and no one, not even his successor, McCurry, carried the matter forward. The only legacy of the trip was Milne's bad cold, his first in years. On the way home Milne stopped off to visit Patsy at the Lake of Bays, where she was staying temporarily, to see if he could persuade her to buy a place and get herself settled.

On his way to Ottawa Milne went to Toronto, where he visited A.Y. Jackson in his studio. Jackson wrote about this visit rather jealously to Arthur Lismer:

Milne dropped in yesterday. He's a nice chap, quite unaware of all the machinery the boys are using to keep the limelight on him. At least it looks queer. This slippery bird [the English art critic Eric] Newton had several articles in English papers on the Tate show. The ones I saw had no mention of Milne, nor did any others, save the article of Jan Gordon's, which sounded like an answer to someone trying to shove Milne down his throat. About all he says is 'Could one still be interested in say about thirty works in his style' but Newton has an article in the Can. Forum [February 1939] in which he calls Milne 'the most individual of the Canadian painters, both in his vision and in his method.' Why did he not state this in his articles for the English press[?] I feel he was primed to write the Forum article. It was necesssary for the same people here to find endorsement of their estimate of Milne in the British press, and when it was not

forthcoming, they had it made to order. This may be all surmise, but it's a little queer.[30]

There is no evidence to support Jackson's sour interpretation. Jackson returned to his envy after Milne's death, and used to say that the trouble with Milne was that 'he didn't use enough paint.'[31]

Although J.S. McLean's major purchases of works from the Picture Loan Society were important to the society's health, Duncan was able to sustain, modestly, a sizeable coterie of artists, Milne among them, from his own private resources. He insisted that Milne become a member of both the Canadian Group of Painters (he was elected in November 1939) and the Canadian Society of Painters in Water Colour, so that whatever avenues for sales and exposure as then existed would be open to him. Given Milne's aversion to artists' societies – his own earlier and doubtless enthusiastic membership in them in New York notwithstanding – getting him to sign up was something of an achievement for Duncan. Pearl McCarthy, the art critic for the *Globe and Mail*, was bewildered to learn in December 1939 that Milne had only just then become a member of the Canadian Society of Painters in Water Colour.[32] Although Milne's and Duncan's relationship began well and lasted as long as Milne lived, Duncan's dithering and procrastination were soon evident and became a sore point between them. Once, early in their association, exasperated by Duncan's fussing, Milne wrote him a sharp letter telling him to get himself organized: 'You are trying to do too much for me. Calm down. Only painting and my life here is important.'[33] Yet Milne trusted Duncan implicitly because Duncan understood painting and aesthetics, and told Milne he was a superb painter, despite reservations he expressed to others. Helen Frye, who was a docent at the Art Gallery of Toronto and among Duncan's circle of friends, wrote to her husband, Northrop Frye, at Oxford on 1 October 1938, just prior to Duncan's becoming Milne's agent and dealer, that '[Duncan] has just seen a lot of recent Milnes and thinks they're very poor, that Milne is over-doing his lone-genius act living in the wilderness.'[34] Milne was, of course, about to move to Toronto, and he was unaware of Duncan's dislike of his current production; perhaps Duncan emphasized his enthusiasm for the work of the 1920s without discussing the new work candidly with Milne.

Duncan soon got an opportunity to winnow the chaff out of Milne's work. Before Milne left Six Mile Lake, he, Duncan, and Jarvis reviewed and assessed all the paintings Milne had on hand. The purpose was to make certain that indifferent work was not allowed to exist – a point Duncan was always emphatic about – since it would dilute the value of the rest: only the best works should be kept, the remainder burned. Milne described the funeral pyre as 'thousands of dollars worth of oils, a million of watercolours and some chicken feed of etching ... Douglas is having a grand time sorting and resorting and tearing up and wishing he hadn't torn up – pictures.'[35] Jarvis related later that two votes could either grant a picture a reprieve or send it to oblivion.[36] As photographs show all too sadly, it was indeed a pyre, with Jarvis in his beret committing Milne canvases back to the elements. Given how important even scraps of works can be, it makes one wince to think of whole canvases, and promising ones at that, being destroyed.

The war years were rather stultifying for art activities. Milne had to ask the National Gallery of Canada for a letter saying who he was, so that the police would stop questioning him as he sketched around Toronto (and a

Alan Jarvis burning Milne paintings at Six Mile Lake, 1939

year later in the countryside around Uxbridge). But Duncan was able to mount several exhibitions of Milne's work, including one in March 1940 of early paintings in oil that was well received by critics and visitors. The Art Gallery of Toronto bought its first Milne, *Green Cedars*, for $175, although not until the director, Martin Baldwin, in Robert Hunter's words, had been 'cudgelled' into seeing the exhibition. This was not, in Milne's opinion, a great example of his work, at least compared with what else was then available. He wrote to his friends the Marks:

Don't know exactly what luck [Duncan] had with the exhibition which is nearly over, only that the worst picture in the exhibition (my rating, not theirs) was bought by the Toronto Art Gallery. A sale, a sale, anyway which is something in these hard times – or what are you having out in Winnipeg?'[37]

Sales were few indeed, and Milne's total income in 1939 was only $816.66; the following year it dropped to $687.94. Other exhibitions at the Art Gallery of Toronto in April 1940 gave Milne scope to exercise his critical faculties. He was more excited by the work of children than, for example, by American government art projects for federal buildings that Milne found 'dead and dull.' Worse, in his eyes, was the patriotic American school:

This painting – Grant Woods' and others' – is not based on colour, line and arrangement, but in sentiment – in Grant Woods' case a sort of provincial homesickness, Americana.[38]

Picasso also came into Milne's critical sights after he was offered an expense-paid trip to New York in January 1940 to see a large exhibition of Picasso's work.[39] Milne decided not to go, but this didn't stop him from expressing his views:

Picasso is a puzzle, very interesting and very capable. The clear-cut and apparently sudden changes in his work are hard to explain. Unless they come from within they would indicate a weakness, that he is unduly influenced by outside sources ... [His ideas were] developed with more force and concentration by others, notably Braque. The Spanish pictures seem to me pretty much junk, inspired by hate rather than love. I am very doubtful about the creative power of hate. No one can deny however that Picasso is extremely clever and a first class workman.'[40]

Milne was much more sympathetic to the work of Matisse, whose paintings had the aesthetic play of forces that Milne himself aimed for, than to Picasso's anecdotal portrayal of emotions. For Milne private anguish and raw feelings were not aesthetic subjects. He much preferred Giotto and El Greco, and among the moderns he admired Modigliani, Gauguin, and van Gogh.

In the midst of this major transformation in his life and habits Milne fell in love again – with Kathleen Pavey, who was twenty-eight, exactly half Milne's age. Kathleen, known to her family as Wyb, shared an apartment with Kay and Carson Mark at 13 Eaton Avenue in Toronto. She met Milne when she was visiting the Marks, who usually camped not far from Milne's cabin. One day soon after, when out alone in a small forty-five-pound trapper canoe with no keel, she was caught in a squall and forced to take refuge in Milne's bay. Milne invited her into his little cabin till the storm

Red Dress II, *1939, watercolour, 35.6×50.8 (14×20)*

abated. As they chatted and got to know each other, a mutual attraction developed. This is how she described it years later:

I went up camping alone, and I was going past his place. It was a terrible day and I had never been out on the lake, [but] I managed to turn the canoe and went into a bay past his place. He was there waving his arms, directing me, and of course you couldn't hear a word with the wind blowing. But then that night we had supper and he just went right off. He paced up and down his little cabin, just bursting with talk. He'd sit beside me and hold my hand and then he'd up and off again. Then he finally wound down and put up my tent and I got him some hot cocoa and got him to bed. Then it seemed to me that I'd no more got to sleep than he was out prowling around. And so I couldn't go on with the camping trip. I couldn't go and leave him. So I stayed. I don't know how long I stayed – I don't remember. But that's how we got together, really.[41]

Kathleen thought Milne was suffering acutely from cabin fever, and she was probably right.

Kathleen Pavey was born in Bristol, England, on 10 October 1910. Her brother John, known as Jack, was two-and-a-half years older. Her parents, Alfred and Bessie Louise Pavey,[42] were Unitarians, and a liberal atmosphere of curiosity and openness characterized the family. Her mother was spirited and lively and had a great fondness for travel. Her father was a fisherman in Bristol, but his business failed and they moved to Canada in 1914. Alfred Pavey worked in Toronto for City Dairy delivering milk, and the family lived in accommodations provided by the dairy. In 1916 he went off to war and was wounded at Vimy Ridge. He returned to Toronto and worked for a time for the College of Pharmacy; then, in 1936, he and his wife went back to England, where he worked for Butlin's holiday camps. Kathleen's mother came back to Canada for an extended visit in 1938, which was prolonged by the advent of the Second World War. Kathleen's father also returned to Canada then, settling in Montreal.

Kathleen's first attended school on Gould Street in Toronto, where Ryerson Polytechnic University is today. There her best friend was Kay Abbott, and together they went on to Central Technical School. In 1926 Kathleen was sent for a year to a girls' school near Stroud in Gloucestershire, England. She came back to Toronto, studied nursing, and when she was nearly nineteen began to work as a nurse at Western Hospital. She stayed there three years before becoming a private-duty nurse, working in both homes and hospitals. She was in the first class of nurses in Toronto to be trained with a psychiatric specialty, and she later took a postgraduate course in nursing psychiatry. Her knowledge of art was limited; but she had an open mind, native wit, and a curiosity that sought to be tutored. Like the Marks, she was interested in poetry, literature, and music, and when she met Milne, she found someone who shared many of her interests and could add to them with perception and experience.

By the time Kathleen returned to Toronto from Six Mile Lake in October 1938, a month or so after meeting Milne, the die had been cast. Their letters flew back and forth. Duncan said they spent 'more than a month at the Tudor Hotel on Sherbourne Street' that fall (recommended by him because it was cheap). Milne visited Kathleen in Toronto again in January 1939, and in February, when he stayed at the Carls-Rite Hotel before and after his trip to Ottawa with Duncan to see Brown. In March Kathleen and her mother moved for a month or more to Tea Lake near Big Chute, where they rented a place from a Mrs Gill. Mrs Pavey herself had a quick mind

Reading in the Cabin, *a portrait of Kathleen Pavey shortly after Milne met her, 1939, watercolour, 35.6×25.4 (14×10)*

and keen sensitivity. While she was herself five years younger than Milne, she seemed to understand how real and intense her daughter's relationship with him was. Writing to Kathleen, Milne was almost rapturous about a letter he had received from Mrs Pavey:

There is one passage in it that says practically nothing at all and yet is about the nicest thing I've ever seen in a letter. It tells – without telling – something of what was in the wonderful mother's mind on some occasions last winter. We wondered – perhaps you knew – I know now too that there was nothing but sympathy and understanding. Heavens, what a kick that gives me.[43]

To maintain the necessary formalities and yet be familiar, Milne suggested they call him 'Divortay,' his mother's maiden name, so they would not have to call him Mr Milne. The three went on winter hiking trips on snowshoes or skis and, as they visited back and forth, the relationship between Milne and Kathleen was cemented. The visit of the Paveys, mother and daughter, naturally stirred a certain amount of local gossip. This became especially speculative when Patsy appeared, uninvited, on a couple of occasions – although, fortunately for Milne, not when the Paveys were there. In May 1939 Milne visited Kathleen in Toronto; in June Kathleen was at Six Mile Lake; in July, August, and September Milne was in Toronto, living with Kathleen, first in her small apartment in the Sunnyside district and then at the Pellatt House Hotel on Sherbourne Street near Wellesley. On 1 August 1939 they moved into a second-floor apartment in the Sheldrake Apartments, 1 Homewood Avenue, at the corner of Carlton Street, overlooking Allan Gardens.[44] In mid-October Milne returned to Six Mile Lake for a brief period, with the intention of closing his cabin for the season and then spending the winter in Toronto with Kathleen. He went to the trouble of putting on a new roof, making a few other repairs, and burying the tinned food in the ground. He left in early November 1939 and never returned.

Milne's brief courtship of Kathleen Pavey, so unlike his first prolonged engagement, was based on a profound mutual respect and, as Kathleen later described it, 'a spiritual union.' To outward appearances their relationship seemed to fly in the face of all the social conventions of the day, but it was easily accepted by friends who knew them both. Milne found in Kathleen someone with whom he could talk intelligently, who could engage him in conversation, and with whom he could share his interests in the arts. She also brought keen common sense and practicality to their life together. While they were together at the Tudor Hotel for about a month in the autumn of 1939 (waiting for their landlord at 1 Homewood to make some repairs),[45] they made vows to each other and agreed that a marriage ceremony had taken place. Although at this time Milne's new 'wife' was sometimes still referred to as Kathleen Pavey, by Milne and others, she began regularly to use the name Kathleen Milne. Milne wrote to her in October: 'Impressed by your new signature & flattered. By the way, I have just remembered that I omitted the 'obey' in the little ceremony at the Tudor. Please insert it. Thanks!'[46] Her Unitarian upbringing made it easy for her to accept what she perceived to be an honest and vital union of two people who were married in every sense they both thought important.

On 28 December 1939 Milne wrote a long letter to Carson and Kay Mark as from 'Wyb and Milne,' in which he described their life as a fully domesticated couple – they had prepared and shared Christmas dinner

with friends, probably George and Dorothy McVicar (Dorothy was another school friend of Kathleen's and George was a bright young biochemist at Connaught Laboratories). A much later addition to the letter (20 March) describes

Wyb ironing again, she has had so many acute attacks of ironing that it is probably chronic now. She is also working in the daytime and has to be at the Western Hospital at eight o'clock, which means up at 6:15. Douglas is to call up at 9:30 – just five minutes ago – and to follow his call with a visit, pledged to go home at 10:30, come what may, lucky or not, coffee or no coffee. I don't believe it though. [Duncan was unreliable about appointments.][47]

Milne's and Kathleen's life together in Toronto, through 1939 and 1940, combined hard work and pleasant recreation. Kathleen appeared either as the central element or as an incidental figure in more than thirty paintings (although she does not figure in them after they moved to Uxbridge in the fall of 1940). Kathleen continued with her nursing, which often meant long hours for days at a time, but there were times when she did not have assignments. Milne painted steadily nearly every day. Both kept diaries. Their recreation included a full schedule of exhibitions, concerts, movies, and other events, and a great deal of reading – mostly books borrowed from the public library. At Hart House – in those years a crackling market place of ideas and activities, where Milne found stimulating discussion and an openness of mind – he was asked to gives talks from time to time. They made friends with several people, and frequently had dinner with the McVicars, either at the Milnes' or at the McVicars' apartment at 219 College Street, near St George, where Milne sketched the dishes that are used in *Red Dishes* and *Red Plate*.

Another favourite form of recreation for the Milnes was hiking and picnicking: day-long treks up the Don Valley, along the Scarborough Bluffs, through the eastern Beaches district, and weekend sorties into the countryside toward Uxbridge to the northeast, and toward Palgrave and Cookstown to the northwest.

Kathleen, nevertheless, remembered the first year of their living together as difficult. Milne was, she recalled, 'in poor shape. He'd been in the bush too long alone ... he was emotionally and mentally and every way in a very upset state which lasted quite a long time. Certainly that [first] year was very difficult. He needed someone with him.'[48]

The real need, I think, came out in that first year in this litttle apartment we had ... I went off to get washed one night and when I came out he was standing in the middle of the room, and he was in a state of shock – his lips were blue and he was in a cold sweat. I got him to bed and treated him for shock, and he finally got [it] out that he thought I'd gone. He'd looked around and I wasn't there.[49]

It is possible, of course, that Milne had for long been in, or close to, an 'upset state,' and that the intensity of his life and the way he drove himself so relentlessly for his art were quite novel and inexplicable for Kathleen. Her support and understanding were nonetheless a boon to Milne, and he was able to take his new life in stride and maintain his momentum and inspiration as a painter. Duncan and his circle of friends, which included other artists, such as Caven Atkins, Will Ogilvie, and Carl Schaefer, musi-

cians, writers, academics, and others interested in the arts, also gave Milne support and encouragement.

Milne's liaison with Kathleen naturally intensified the problem with Milne's wife. Patsy and Milne had been legally separated for six years. Patsy had managed to eke out a modest living by working for summer resorts in Muskoka and receiving some support from Milne, who always sent her half their share of the Big Moose Lake mortgage payments and occasionally other amounts. For some time he had been urging her to find herself a place where she could settle and offering to pay for it and furnish it when she found it. His attempts to persuade her to take responsibility for her own affairs, however, had little effect, for Patsy wanted to live with him again – a possibility that Milne had emphatically and explicitly re-fused to consider. Allowing her to visit him at Six Mile Lake now and again were, for him, acts of kindness, but they only prolonged Patsy's agony – and Milne's. In the summer of 1939, with Duncan, Milne scoured the Lake of Bays area searching for a place for her. Then he thought that Jim Milne, by then his only immediate family member, and Patsy might look after each other; but this did not work out. No place could be found in Paisley, although both he and Patsy went there separately to investigate the possibilities. Milne began to dread Patsy's showing up by chance at his cabin and the possibility of her embarrassing him when he was with Kathleen. So in November 1939, when he and Kathleen were living to-gether permanently, he wrote to Patsy and told her, rather bluntly, where matters stood:

In your letter from Elgin Street you ask what I think of your going to Paisley and other plans. I can't tell you more than I have already. All you have to do is to make up your own mind.

These letters have been coming every few weeks for years and I have an-swered them, but they have accomplished nothing, have done only harm to both of us, and for me have become periodically repeated irritation. If this were continued it would make nervous wrecks of both of us. I couldn't make a living and we both would soon be in want. You have asked what I couldn't give instead of accepting a situation already in existence and making the best of it for both of us. I have been willing to send you what money you needed when I had it, and last spring felt I could help you to get a little place in the country so you could settle down. You could be reasonably comfortable and safe. But the livelihood of both of us depends on my being able to lead a peaceable, healthy, normal life and that is all I can or will do. I will not live with you or see you or keep writing to you. There never was any chance in the last ten years that we could live happily together. This summer I have been living in Toronto with another woman. She works and provides for herself, but of course you could get a divorce. It is only fair that you should know this but I won't talk to you about it or write to you. If you want to know anything more about it you can call up Douglas Duncan (Kingsdale 0739). He knows something of our difficulties and of this situation and also knows my circumstances, and will tell you what he can.

<div align="center">Dave [50]</div>

In the spring of 1938 Patsy had been feeling distinctly uneasy, even before Milne and Kathleen Pavey met: 'When April came, I was feeling very nervous, and had lost about twenty-five pounds in weight – I could not do much cooking, because of restrictions [where she was staying], and

the added worry about Dave, and not having a home.'[51] Milne was by this time urging her to buy a place and fit it up. One can imagine Patsy's reaction to Milne's letter when it arrived in the fall of 1939. Here is how she described it years later in her memoir:

For some reason I cannot explain I felt greatly worried. Dave wrote, saying he was feeling nervous. Then there came a lapse between letters, and I was frantic – walking down to the Post Office at Windermere every day – hoping to hear. After three or four weeks, there was a note from Dave, in which he enclosed fifty dollars. I felt that something was wrong, and decided to go again, and see what I could do about Jim ... [I] came back to [Toronto and] found a letter from Dave, and wondered why, instead of putting a 'return' address on the envelope, with his name as he always did, it only said 'From David B. Milne' – There were only a few lines, but the shock was so terrific, I could not think clearly. After a while I began to pack the suit-case, and I told Mrs. E[vans] I was leaving in the morning. (I did not explain why).

I left for the Lake of Bays ... Each morning I walked for miles (I could not stay inside). Over and over again, I asked myself why Dave, whose life had been perfectly normal all those years, could have changed to that extent. Perhaps he found it impossible to explain to the friends who knew him so well (or even to himself) the manner in which he was living.[52]

Milne's letter was followed by one from Duncan, who sent Patsy an undisclosed amount of money on behalf of Milne, on 4 December 1939. Patsy responded two weeks later with an anguished letter that read in part:

Mr Duncan, I will not accept the money at all, thank you ...

Last March, my husband came up to a place near this where I was working, and trying to weave, after he left Ottawa. He seemed very glad to see me, and I felt proud of him. It made me very happy and I thought of it often in the summer.

Toward August, I asked him if there could be some way I could have a little house not too far away from him and if I could go down to the cabin for a few days. I had no house. He always seemed contented and pleased when we were with each other, and I loved mending his clothes, and cooking for him, and the lovely 'trips' when we cooked outside; but more than all the rest, to know that he was painting.

He wrote that he was very nervous, and then he went to Toronto. His letters were irritable and I was fearfully worried. I could not sleep well, and I prayed there would be some way I could be with him and help.

Then he wrote about an affair with a strong woman (evidently of a 'certain type').

The shock of his letter was too much. I had taken a room at Mrs Evans on Elgin Avenue [in Toronto] and was looking for a position, but could not stay [in Toronto] after that for very long. No one must know the foolish way he is acting, because it would hurt the painting.

I love my husband more than anything on earth – perhaps too much ... It has been the finest thing in my life to go through everything for him, to work and love the painting, because I loved him.

The old lady who has this cottage will be back in about five weeks. I am getting my own food and after she comes I cannot stay here.

I have four dollars left, and I have not paid the dentist, but before I take the money to live on, that my husband might have to give up painting to earn, I would rather 'beg.'

I am afraid too, the 'woman' he is 'keeping' would not let him send any money to his wife ...

Goodbye Mr Duncan. I think you will be a good friend to my husband while he is acting like a 'fool'.

If at some time he is alone and ill, I pray you more than anything else, to send for me and let me wait on him and care for him, if I am still alive.

Please do not write any more letters for him. It is pretty hard for me when you do that ...[53]

There is little doubt that Patsy *was* helpless and had a weak grasp on the reality of the situation. Milne's frank letter to her of the previous month, according to Patsy's account, was like a thunderbolt. She thought her world had collapsed, for she had always assumed that Milne was simply and temporarily in need of solitude, and that soon they would resume their lives together. Although their legal separation had now been in effect for six years, she acted as if it had never been signed.

Florence Martin – Patsy's mentor and friend from Big Moose Lake – writing with astrological conviction from Yonkers, apparently suggested, in Patsy's words, that Milne was 'under the influence (for a while) of erratic planets.'[54] Her other suggestions were not particularly helpful either, although Patsy drew a good deal of solace and comfort from the simple fact that somebody was sympathetic to her point of view and her plight. Florence Martin wrote to Patsy:

Don't trust him [Duncan] or V.P. [Vera Parsons]. If they had sympathy with you they would have seen you had some income every year ...

Don't say anything to Mrs Robinson [Patsy's neighbour at Dorset where she was living] about Kathleen Pavey's numerology as her name is Kathleen and she might not like it...

It is natural that you are shocked and upset. Dave was a man and sexual intercourse means a lot to them and they consider it no more harm than eating or any bodily function. It seems to me that Scotchmen are the worst.[55]

Patsy at first rejected all entreaties from Milne's emissaries, and she continued to refuse any monies from Parsons, as well as from Duncan, even though both wanted to see that she was regularly provided for. In January 1940, replying to Patsy's letter of 17 December 1939, Duncan tried to conclude matters with her:

I need hardly assure you that I have had no eagerness to be involved in your affairs. But, as you know, I have enjoyed Mr. Milne's friendship and confidence for the last four years; and for more than a year have been doing my best to look after his interests. I have unintentionally become mixed up in this both as his friend and as agent for his pictures.

I can scarcely in a letter discuss the questions raised by your letter, except to point out that you are completely wrong as to the character of the lady; and equally wrong in your assumption that the relationship is not permanent.

I again enclose a cheque for $25.00. And I would urge you most strongly to come and see me, as soon as you can. For I feel that some permanent arrangement should be made as soon as possible. Your remarks on the subject of the earlier cheques are quite unjustifiable, since the other woman is earning her own living; and since even Mr. Milne's row with Mellors [the severance from the Mellors Galleries in 1938] was due to a desire to provide you with a place of your own. We both spent many days last June hunting for a suitable place in this

vicinity. I can assure you that your support is a major concern with him, and one that I approve and share.

I see no financial difficulties ahead, provided that something is done about the whole business very soon – that would remove you from the somewhat ambiguous position you are in, and that would restore to Mr. Milne enough peace of mind to paint. That is why I am willing to try to help straighten out the situation and (since you profess a concern for the painting) to try for your help in the matter. For if the strain of the last ten months or so continues to affect the painting, there is no telling what financial difficulties may be ahead for each of you.[56]

This was followed by another letter in March:

Dear Mrs. Milne –

At Mr. Milne's request, I enclosed your first letter to him in my letter that you sent back, unopened. The second registered one he irritatedly signed for and removed from the post office, but did not open; and the third he re-addressed to you in his own hand. You will see that he is determined not to correspond with you, and that any communication will have to be with me.

You have a completely wrong idea of the character of the other woman; and have certainly no basis for your hope that it is not a permanent relationship.

As Mr. Milne wrote you, he wishes to make an arrangement to provide for your support. The sentence you attribute to him is obviously distorted from its context: but if the strain of the last seven years – still more impossible to bear now – continues, his work will suffer and he will be in fact 'hard driven to support you both.' If, however, the present situation can be clarified without delay, there will continue to be enough money for him and for your support in a home of your own. Mr. Milne feels there is no necessity for borrowing on his insurance; and that there is, apparently, a curious confusion in your mind in thinking that that money comes less from him than any other.

I have written you three letters in an attempt to be helpful, to you as well as to him, in this difficult affair; and I have sent you three cheques from Mr. Milne that you have returned. I don't see that I can do anything more now than repeat that I should be willing to talk over the situation any time most sypathetically with you; and state that there is adequate money for you here when you wish to accept it.[57]

Patsy's response is evident from Duncan's note to her a few weeks later:

Dear Mrs. Milne –

I really don't see how you expect me to be able to 'straighten out the tangled "skein"' when you won't even open my letters.[58]

Patsy wrote frantically back to him: 'You say "his mind is not in good shape." How could a man of his type, live with a strange woman (since before November) and be able to paint well[?]'[59] As Milne's representative, Duncan held the position of power, and Patsy, understandably, did not like him at all – he was, after all, an ally of her husband's. Even in her much later memoir Patsy retained her unpleasant impression of Duncan:

Douglas Duncan came up [to the Lake of Bays] about three times, and wanted me to take money that Dave gave him for me – I refused, while Dave continued

in the same way [i.e., living with Kathleen]. I did not know he was coming – he just arrived – Cynical, and a very different type of person from Dave or Clarke.[60]

In February 1940 Duncan approached a Mrs Hornell, who was an acquaintance of Patsy's at the Women's Art Association in Toronto, to get her help in persuading Patsy to accept an arrangement for her support:

Dear Mrs. Hornel[l] –

I enclose the cheque ($50) for Mrs. Milne. It is very kind of you to try to help, too, in this unhappy tangle. Mr. Milne wants to provide for her, permanently – but as you know he also wants a final winding up of the last seven years, and he will have no further direct communication with her.

I return a letter addressed to him, enclosed in my letter to Mrs. Milne. She returns unopened my letter in a registered letter to him, which he calls for at the Post Office and coldly turns over to me. It is a nonsensical situation, since my letter was certainly an attempt to be helpful.

Certainly I see no solution unless Mrs. Milne is willing to come down and discuss things with you and me. Let us hope she will not continue to shut her mind to the facts.[61]

Not surprisingly, this action offended Patsy:

Dear Mr Duncan –

I am returning the check my husband asked you to send me – and registering it to make it safe.

I am greatly annoyed with Mrs. Hornell to think she has interfered in any way against my wishes – I am writing her today.

She is the only person in Toronto I have spoken to in regard to my husband. I was ill for several days after I received the letter and Mrs Hornell was very kind. I did not want her and Mrs Evans where I was staying – to know what the trouble was – and she came down during that time.

She mentions only one paragraph in your letter which says 'that my husband wants to forget the last few years.'

Why – Mr. Duncan, did he come up here last March [1939] to see me and stay at Mrs. Irwin's where I was? He brought me many nice things too, and I was so happy to see him even for two days.

Can you explain this in the face of what he has done lately [?][62]

Milne was, of course, in an anomalous position. Married to one woman, he was living with another. Naturally Patsy and those who sided with her took a dim view of this, while Milne's friends rallied round him and found his arrangement acceptable, if not exactly comfortable.

Parsons's attempts to communicate with Patsy were even blunter than Milne's and Duncan's, and were also rebuffed or ignored:

Mr. Milne desires to make it quite clear that having regard to what has taken place in the past there is no possible chance of his ever living with you again. He states that he considered and has always considered the fact that you were unfaithful to him an insuperable obstacle to any future cohabitation, and that your visits to the cabin and constant letter writing were not only a breach of the separation agreement dated the 24th of April, 1933, but entirely unwelcome.

Mr. Milne has now formed an unalterable decision in regard to his future so far as you are concerned. He does not desire to, nor will he, see, write you nor

open your letters. He is however prepared to maintain you properly having
regard to his circumstances.[63]

After valiantly resisting the advances sent by Duncan and Parsons on
Milne's behalf for some time, in April 1940 Patsy reluctantly accepted a
regular monthly stipend from Milne through Duncan and Parsons. Duncan
wrote to Patsy:

Dear Mrs Milne
As I wrote before, since you will not read my letters, I can do nothing further on
this side. There is sufficient money from the paintings to support you both. I
have turned over to Miss Vera Parsons, Solicitor, 372 Bay Street, Toronto, ample
funds for your maintenance, which she will send on your request.
Sincerely,
DD[64]

Once it became clear that Milne would not see her again or write to her,
and she realized that she could not even find out where he lived, Patsy
finally found herself a tiny place near Dorset, Ontario, on the Lake of Bays
in Muskoka, and bought and fixed it up with money from Florence Mar-
tin, who visited her at some point in the late 1930s.[65]

Milne's relationship with Clarke was affected by the breakdown of his
marriage to Patsy. Clarke may have sensed that Milne was unhappy in his
marriage, but nothing was said until 23 May 1940 when Milne finally gave
him an explicit account of the situation – without, however, mentioning
the fact that he was living with Kathleen and that he intended to continue
to live with her:

I think I should tell you the exact situation in regard to Patsy, not that you
could do anything for either of us. Anything that you, in the goodness of your
heart, might feel inclined to do, would, I think, be apt to do serious harm.
However this is how things stand.

There never was any chance of our living happily together since Lake Placid,
which is a long, long time ago[;] six or seven years ago, before leaving Palgrave,
we signed a separation agreement. At that time Patsy was as willing as I was.
Afterwards she changed her mind and ever since at longer or shorter intervals
has tried to bring back the old relations. That was hopeless, and its only effect
was to make it more difficult for me, both in nerves and in making a living out
of painting. Since last fall I have refused to see her or to deal directly with her.
She has sent back checks three times and a fourth time refused money sent by a
friend of hers. There is enough money for her needs just now and all she has to
do is to go or send for it. She has been notified about it by the lawyers who have
it. I am willing to make an agreement providing for her so far as I can. Douglas
thinks $500 or so a year could be managed. That would be more than either of
us ever had. In return I would have to be free to live a normal undisturbed life.

Sorry to trouble you with this, but you should have some idea of things.[66]

Clarke's response was short, but apparently sympathetic to both:

I am sorry about Patsy. Of course we would like to help but don't know what we
could do for either of you. Perhaps, too, it is better as it is. Anyway, one cannot
sit away off here and have any opinion which is worthwhile. If, however, there is
anything which you think of that you want me to do please feel free to call on
me. I can't see how there is anything else for me to say.[67]

As he prepared later that year to ship his Christmas package to the Milnes, he was still sorrowful, but understanding:

After much hesitation I also sent a small box to Patsy. The Christmas wishes are mostly for old time sake and no matter what has happen[ed] to you or me or Patsy. There is still a wish that she would also remember the Clarkes as they were in those pleasant days. I sent it to Baysville, Ontario. If that is wrong will you correct it with a postcard to the Postmaster there.

The same goes to you. I would like so much to be with you and make a trip such as we used to do. But now I am hemmed in with obligations to so many persons I cannot do what I would like to do most.[68]

Milne and Kathleen had talked about going to England in the fall of 1939 for an extended visit, but the outbreak of the Second World War late that summer deferred those plans. As Milne was a veteran with distinguished, though non-combatant, service in the First World War, the moment that war was declared he wrote to the Masseys, who were still in London and were to remain there throughout the war, offering to serve under the same terms as before: as a war artist recording and commemorating where Canadian troops were and what they were doing. Vincent Massey's reply by wire, nearly a year later, was not with a firm offer; rather he suggested that Milne 'come to England and paint war pictures through private arrangement with us. [I]f so what remuneration would you suggest[?]'[69] Milne's response was neither enthusiastic nor cold, just vague. Between his offer and Massey's reply Milne had established his new life with Kathleen, and the discovery in the fall of 1940 that she was pregnant added weight to his desire to stay in Canada. The idea of going back into the army at the age of fifty-eight could not have been appealing.

In September 1940 Milne and Kathleen had a six-week camping holiday near Sturgeon Lake in Haliburton. The trip began with difficulty: 'too much moving, too many portages,' according to Milne. And because of 'Wyb's delicate condition' she could not carry her load, so they settled down in one place for a while. Eventually they set off again into what they thought was a stream but what turned out to be a river with powerful rapids that capsized them. Milne described the experience to Carson Mark:

We came to in the water. We both kept hold of our paddles. Wyb kept hold of the canoe and tried to drag it up the rapids by brute strength. I kept my hat on – and dry, though I am sure I was under water. Before we could discuss things and fix the blame we were washed up against the bank at the edge of a swift eddy. The canoe was upside down and began to shed its load, but Wyb got up the steep bank and I began tossing what I could get hold of up the bank to her. We didn't lose very much after all.[70]

Milne also wrote that fishermen along the river caught most of their things. But in her letter to the same friends Wyb contradicted his version of the story:

Accidents in icy water do not, as I have always supposed, inspire one with fear for loss of life. On the contrary such an event never enters one's head. But loss of 'stuff' does pack a wallop, particularly when the weather had been going from bad to downright lousy for several weeks and the stuff contains nice warm woolly blankets. And when one's feet land on a rock, one (all right me) hangs on to that stuff with the grim determination not to see it float away, come hell or

high water. And it didn't as D.B.M. has told you, we floated with it. Any that got away when we were salvaging continued in that efficient eddy and we caught it on the second or third trip around – except for a few things including the easel and apples which we recovered a couple of days later.[71]

Despite this initial calamity camping was something they both enjoyed, and an excursion to Haliburton became an annual family fall event for the next six years.

In 1939 Milne introduced into his work a colour that he became excessively addicted to and that came to be known, after Duncan's scornful description of it, as 'the hellish colour.' It was an 'imperfect mixture' of permanent violet with yellow ochre that found its way into everything, beginning early in 1939 and persisting well into 1941. Milne liked it because 'besides the changing look it has the feeling of being transparent and at the same time opaque. It is brushed, not flowed on and so does not define, merely emphasizes a shape. Though everything from yellow to magenta shows in it, the effect is rose, a peculiar opaque rose.'[72] In some works, such as *Canopy Bed* and *Palgrave, 1939*, it seems appropriate; set off with black and brilliant red, as in *United Church*, it is stunning. When it had the look of an unsettling shade of mustardy purple, it was not, however, suitable for everything, and it began to nauseate after a while – even Milne got sick of it quickly. He wanted to let it go but, as if he were holding an electric wire, he could not.

One of the more interesting early uses of the hellish colour is in *Stars over Bay Street, 1939*, where it is used as a ground in the first version of this series. The subject is the view looking south on Bay Street just above College, with Eaton's College Street store (now a retail/office complex) on the left and the Ford Hotel at Bay and Dundas (now demolished) visible in the distance. Over the next two years Milne painted numerous variations on this subject (eight paintings, all watercolours except one, and a drypoint, survive), and more while he lived in Uxbridge and visited Toronto from time to time. The hellish colour certainly helped to get this first major series on a single theme off to a dramatic start. The ground is broadly worked, giving the odd amalgam of colours ample scope to set off the detailed drawing of the buildings underneath. Even when he attempted a

United Church, *1939, watercolour, 37.8×48.0 (14⅞×18⅞)*

Firehall, *1939, watercolour, 37.8×50.8 (14⅞×20)*

version in oil, or decided to drape a dramatic night sky over his subject, the peculiar aura conveyed by the hellish colour still suffused the composition. With its odd, otherworldly quality, the colour created an atmosphere that was in a way equivalent to the strange fantasies that Milne was beginning to paint. Both were a comparable distance from the reality they referred back to.

Most of the paintings done in Toronto were not innovative in any major way; it was rather a time for using the gains and discoveries of the two previous years in a wider variety of subjects and compositions. Dramatic contrasts of white space, producing a sort of dazzle spot, recurred frequently. The use of transparent colour lightly washed over a richer colour and often set in contrast to darker, vaguer shapes and colours, continued without significant change. This can be seen most spectactularly in *Firehall*, where the dark shapes hang ominously at the top of the picture. Milne found Toronto stimulating, and indeed it provided him with inspiration for much of the rest of his painting life. Apartment living, his first experience of it since leaving New York in 1916, brought back an interest in looking through a doorway into another room, or of having one's range of vision cut off on either, or both sides, by an arch or door frame. In *Hyacinths in the Window* this device tends to accentuate and focus one's attention; it was also used, in part, in *United Church* of 1939. Occasionally Milne reverted to his trusted system of black and white values. In his first painting of the Ontario legislative building, *Parliament Buildings*, he used a gray wash and little colour. Like many of Milne's Toronto paintings – *Brewery at Night, Embassy Club, Night on Dundas Street*, and the *Stars over Bay Street* series – it was a night picture.

As fall gave way to Christmas 1939 and winter to spring, Milne's painting production did not abate. In 1940 he produced a good deal more than a hundred paintings, of which nearly ninety remain. Only five of these were in oil (*Parliament Buildings at Queen's Park, Chocolates and Flowers, Chickens on Lace*, and two unfinished). The watercolours, which were now carrying all the freight of Milne's thought, not only had to survive Milne's severe editing and repainting process, but also had to run the gauntlet of Duncan's fussy critical eye and his commercial concerns. Indeed, Duncan increasingly took onto himself the role of final arbiter of Milne's work. On

Stars over Bay Street, 1939, *watercolour, 28.6×35.6* (*11¼×14*)

Stars over Bay Street, 1941, *8 March, watercolour, 38.5×51.8* (*15⅛×20⅜*)

Allan Gardens Drawing, *1940, pencil,*
38.9×51.5 (15¼×20¼)

28 October 1940 he recorded that he had taken home a bundle of water-colours and 'destroyed 68 (mostly inferior versions).'[73] Given the sorting and burning of paintings that had taken place a year earlier with Milne and Jarvis at Six Mile Lake, it is likely that the sixty-eight victims were paintings of 1939–40, rather than of earlier periods.

In 1940, as in 1939, few significant changes mark Milne's working methods or techniques, but a new note of fluency and ease is sounded. Milne was working with happy inspiration, and what came out in the paintings was his sense of joy, playfulness, and good nature. One of his diary entries in 1940 is a long commentary on the subject of children's art – seen at the Art Gallery of Toronto in April – which continued to enthral him:

What makes these children's pictures so delightful is clear enough ... there is no confusing of purposes, no battle between what they want to do and what they

St Michael's Cathedral II, *1940, watercolour, 37.8×43.5 (14⅞×17⅛)*

Parliament Buildings, *1939, water-
colour, 37.8×48.6 (14⅞×19⅛)*

Brewery at Night, *1939, watercolour,
37.2×50.8 (14⅝×20)*

have to do. There is complete freedom. This is art for delight in it, not art for
use ... there is nothing to check their invention, they are completely in control of
what they put in or leave out and how they do it. This gives them a tremendous
one-direction drive. They never attempt anything they cannot do.[74]

The subjects Milne painted are for the most part commonplace, but the
aesthetic issues he dealt with were increasingly complex, subtle, and ab-
stract. He continued to develop the idea of painting in a series, nearly
always doing further exploration of a subject by repainting it. While he
often did numerous versions of some works, he kept but few, as the dia-
ries that both Milne and Kathleen began to keep this year testify.[75]

Allan Gardens, which Milne's and Kathleen's apartment on Homewood
Avenue overlooked, went through half-a-dozen versions. Milne also left a
finished pencil drawing of it, a habit that was now running strongly in
him and had been growing since he had begun to use up the spoiled or
rejected *Colophon* sheets for pencil sketching in Palgrave. Increasingly
Milne pondered options and worked out details in pencil sketches.

The paintings of subjects found along Toronto's waterfront mark the
beginning of a new device that carried through to the end of Milne's paint-
ing life: a veil-like wash that floods across the picture plane and either
provides a rich background for figures and objects or in some paintings
becomes a major element in the composition, like some great snake or
waving banner. In conjunction with empty space and a few critically placed
details, the wash makes for a dramatic picture, as in *Coal*: a progression of
piles of coal, tanks, cranes, and elevators squats low on the sheet and a veil
of intense blue drops out of a vast, empty sky. The blacks and whites in the
works of this time are stark, and the hellish colour is often grating and
dominant. Simultaneously, however, Milne painted several works that are
essentially monochromatic – such as *Eggs and Milk* and *Kitchen* – where a
soft and gentle cream colour suffuses everything and there is little con-
trasting force except for the sharp colour of the flowers. But usually very
little is soft or delicate. This fitted in with Milne's ideas about the watercol-
our medium, which he saw as being capable of great power, even brutal,
through the use of colour and form. Milne also believed that framing a
watercolour in the same way as an oil painting – that is, without a mat –

Kitchen, *31 March 1940, watercolour, 38.1×51.1
(15×20¼)*

Eggs and Milk, *24 March 1940, watercolour, 36.6×49.5
(14¼×19½)*

Hyacinths in the Window, *1940*,
watercolour, 37.8×50.8 (14⅞×20)

would give it strength. Many of his works of this time are marked in his hand 'NO MAT.'

However remarkable Milne's return to watercolours was, and however surprising and happy the changes in his personal life, the most profound development in this period was the birth of Milne's fantasy pictures – a stream of paintings that were an entirely unpredictable and astonishing departure from his modernist roots. At first this unorthodox idea was expressed only in ideas for painting, not in any paintings themselves. Milne was about to embark on an odyssey where few were able to accompany him. He was raising insoluble contradictions for his modernist tenets when he began to harbour thoughts for fantasy paintings that had both religious and secular, but idiosyncratic and humorous, imagery. Prompted by the children's art at the school at Big Chute, Milne accepted the idea of fantasy as a valid point of approach: in *Picture on the Blackboard* and *Margaret's Picture of Wimpy and the Birthday Cake* Milne painted from a child's vision. In March 1939 Milne wrote to Alice Massey to tell her about plans for future paintings. One was going to be of Noah checking the animals into the ark, to be called *Passenger List* or *Bill of Lading*. He was just beginning to work out the details of this one, he noted, and by June he was able to provide Kathleen with a little sketch and a description of the queue of boarding animals at the bottom of the picture with only their ears sticking up to identify them; in 1940 he mentioned the 'Ark inventory' again in a letter to the Masseys. This concept, however, was never realized in a painting, although the subject of Noah emerged four years later in the series of paintings of *Noah and the Ark* that portray the animals spreading out over the land after the Ark has come to ground on Mount Ararat. Another fantasy subject Milne described to Alice Massey was to be called *Christ in the Wilderness* – the wilderness being the bush of Six Mile Lake. He was also planning one on the subject of St Francis of Assisi. Although Milne gave no details, this idea evolved into *The Saint*, which Milne finally painted in 1943. The next chapter explores this strange and wonderful development in Milne's work during the final phases of his career.

Rites of Autumn
Uxbridge
1940–1946

O N 31 OCTOBER 1940, when Kathleen was in her third month of
pregnancy, the Milnes left Toronto for Uxbridge, a quiet town of
about 1400 people, sixty-five kilometres (forty miles) to the north-
east. They rented a house at 185 Brock Street, at the corner of Cedar, for
$12 monthly; and for another $2 Milne rented a studio from people named
Peck a hundred yards or so away on Brock Street, over Gray's Bakery –
'the painting place' or simply 'the place,' as he called it.[1] After they had
settled, Kathleen wrote to their friends the Marks: 'We chose Uxbridge
because it offered easy transportation to the city, not too easy transporta-
tion for trippers (e.g. friends and relatives) and good skiing. The choice
has been quite a success ... We skied nearly every day from November
until the beginning of April.' She reported that they had an 'adequate house,
fairly large garden, & a mile of sidewalk ... a great asset as it affords D.B.M.
many pleasant perspiring hours of snow shovelling.'[2]

After visiting them in December with Vera Parsons, Douglas Duncan
wrote to Milne:

The house appears satisfactory, and the surroundings of Uxbridge look as
though they might provide good material for the future. And most of all the
major watercolour in the dining room [*Window on Main Street*] was very encour-
aging: it is very lovely and promises well for the future if you can stop stewing
while this miserable situation [concerning Patsy Milne] drags on.[3]

Milne, apparently enjoying his new domestic state thoroughly, wrote back:

Last night Wyb and I had a picnic in the studio – that is, Wyb brought our
supper over, and by sitting on boxes or the floor and spreading our eatables on
newspaper, letting the stove smoke and arranging a draft on one side and a
scorching on the other, we got about the picnic effect. Very nice and we saw a
couple of painting subjects, one from the window with Christmas effects and
one inside, mainly the gorgeous window which is a very nice assembly of brown
and blue and black by lamplight. That will probably be painted some of these
days.[4]

Picnics outdoors were equally enjoyable:

Last Sunday Wyb and I went out to some long hills and had some fine skiing. It
was clear and sunny and we had our lunch in the bush beside a little fire. We
took it easy and had a very fine day. Bring your skis up when you come. You
may just as well leave them here, you probably won't use them anywhere else.

Monday ... A boy brought us a fine Christmas tree Saturday night. Sunday
afternoon I set it up and Wyb trimmed it. We expect to spend Christmas alone

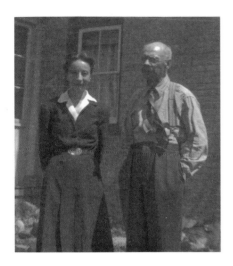

Kathleen and David Milne in front of
their Franklin Street home in
Uxbridge, c. 1943

except for the tree and a chicken. Wyb's father and mother are coming up a week from today and Mrs. Pavey at least will stay a week or so.

Merry Christmas from both. Come up when you can. [5]

The Milnes also found the town library to be well stocked with books of interest to them, and additional reading material was brought along by Duncan and other friends.

Kathleen's diaries, which she began again on 19 February 1941 and continued until 15 October (and sporadically thereafter), give faithful though brief accounts of Milne's painting each day, sometimes with his ideas on what had been, or was to be, revised, and occasionally longer, more conventional entries relating mostly to domestic matters. The first entry reads: 'No painting – Drew Stars over Bay St. 9th version. Small changes made.' One of her long entries included the following references to their domestic life:

Home at 12:30 & puttered around cracking ice on the top verandah & heaving it overboard. Got it all clear & that will be the end of it for this winter. Had a little lunch (sandwiches & tea) then rested for a while. Did the chores, listened to the [New York] Philharmonic – just fair to middling, but Deems Taylor quite interesting – got dinner & have just completed a bonnet, now have 5 coats, 4 pr. booties & 3 bonnets done.[6]

The war seemed remote to the Milnes in Uxbridge. For Milne, who referred to the war in his letters only occasionally and indirectly, this was perhaps because his link to the Great War so many years earlier had pushed the progress of the Second World War to the back of his mind. But they listened to news reports on the radio. For the much younger Kathleen the unfolding of events, although far away, was more gripping. She seldom failed to make a brief summary in her diary of the current war situation – always followed by some domestic item that revealed her current interest:

Wed. March 26, 1941. Yugo-Slavia has joined the Axis. Not a popular move among the people according to reports. No air raids of importance over Britain for several days & no sign of Spring offensive. Greeks & British in Middle East still seem to be progressing favourably. Navy has had some success sinking enemy ships but still losing large numbers themselves. Made a sponge cake today & and didn't mind it at all though it still seems to be about the least interesting form of cake.

Thurs. Mar. 27/41. Yugo-Slavia has revolted against the gov. which signed up with the Axis yesterday. Peter (17 years old) has ascended the throne & formed a new and apparently pro-ally gov. Hanar in Abyssinia & Cheren in Eritrea both captured by Br. today. Had steamed raisin pudding made with suet instead of butter. Worked quite well. Going to prepare fruit for marmalade now.

Fri. Mar. 28/41. Still no air raids of importance over Britain. Both sides claim a few ships sunk – Yugo-Slavia settling down. No official statement from the new gov. but it seems unlikely they will co-operate with Nazis in an attack on Greece. Made 3 quarts marmalade. D.B.M. still working at etching [drypoint] 'Reflections' [*Still Water and Fish*]. Printed 9 or 10 of the black plates.

Ap. 11/41. Last Sunday (Ap. 6) went for a picnic a mile or so along the rlwy tracks then into a cedar swamp. Found a fairly dry hummock. Pruned a few

*Kathleen Milne with David Jr,
November 1941*

Milne, Kathleen, and David Jr

trees & laid the branches on the ground to sit on. Very comfortable & really hot. Both got tanned & I got a fine crop of freckles. Lots of birds about but we didn't see any new ones.

Lunch – pilchard sandwiches, cake, tea & apples. Stayed out for 7 hours & got a good sunning & airing. Germany invaded Yugo-Slavia.

The imminent arrival of their baby is never mentioned by Milne in writing – nor by Kathleen, apart from the references in her diary to her knitting. But her entry for 30 April 1941 reports that she and Milne are staying at the Tudor Hotel in Toronto, 'waiting.' Although in late pregnancy, she did not appear to be in any great anxiety. On the previous Sunday, back in Uxbridge, she and Milne had gone on a picnic, and when they got home, Duncan and Vera Parsons came for a visit. Two other Toronto friends, George and Dorothy McVicar, who were to be designated the child's guardians, showed up, and Kathleen served them dinner ('roast beef, potatoes, spinach, rhubarb ... custard and cake'). Afterwards she and Milne were driven to the Tudor Hotel on Sherbourne Street in Toronto, where they arrived around 10:30 p.m. They spent the next day, Monday, 'resting & getting oriented. D.B.M. went downtown in the a.m. & came back complaining bitterly of sore feet & rough Italian watercolour paper – all he was able to get. The English paper factory has been partially destroyed by bombs.' The next day they went for a walk before breakfast: 'Over the Sherbourne St. bridge, through Rosedale to Castle Frank & back via Bloor [Street]. Heard and saw what we think was a cardinal ... After breakfast D.B.M. drew the backyards & backs of houses from our window. Painted it in the p.m., thin lines, black, warm red, yellow, a little green ... This afternoon D.B.M. did his picture over, varying a little, both detail & colour [*Roofs I* and *II*]. We shall go out for a walk in the evening when it is cooler.'

David Milne Jr was born the next Sunday, 4 May – an event that Kathleen reports in her diary, finally, on 27 May: 'Went to the hospital Friday May 2 to have Nancy. David 2nd arrived Sunday a.m. May 4. Nancy has not appeared yet.'[7]

Milne returned home alone to Uxbridge on Sunday, 11 May, and on Monday morning wrote a note to Kathleen, who was still in the hospital, that concluded: 'Kiss little David for me – if he isn't too scrubby looking. I will write tonight. I love you and I miss you very much.' That evening he wrote her a long letter describing his trip home, how he found the garden, and his mundane daily activities. He found the house damp and cheerless: 'This place is too big and barren for me but, anyway, it's better than wandering round Toronto.'[8]

A characteristic of some new fathers who are older – Milne was fifty-nine when his son was born – is not to be playful, and to lack the energy and interest to tend a baby. But Milne, although he was steeped in his work, adjusted enthusiastically to the new family situation. In his letters to Duncan he seldom failed to mention little David, with wry humour that barely masked his enjoyment and pride. (One can imagine what the bachelor aesthete and art dealer thought on receiving these baby anecdotes.) On 31 July 1941 Milne wrote: 'Wyb got a Brownie camera for mother's day but did not get a good photographer with it. So, if you can bring your camera David will smile for you – we hope.' And a few days later:

This has been a day of rest. We have not been further away than the garden. David cooperated pretty well except after lunch when Wyb and I thought we would get a little siesta, leaving David asleep in his buggy in the back yard. It

Milne with his son

didn't work. Wyb just managed to get to sleep when there were reports from David, so I had to try to keep him quiet. I tried wheeling him round the house. That always works, sightseeing. Finally he went to sleep on my shoulder, so we went in to listen to some music on the radio. When I sat down he woke again. Then we both went to sleep, David slung over my shoulder still. All was peace for a while until we began to topple over.[9]

And on 2 September, in a letter to the Marks:

Give David a shoulder to ride and a back to spit down and keep them moving and nothing else matters very much – except food … Milk … orange juice, pablum and cod liver oil is the menu – oh yes and water. Of these water is the least liked, except perhaps in hot weather. Cod liver oil isn't so much but it does make a stirring smell through the house, and round the house. Any day now I expect some housewife to stop me on the street – women I never saw before – but that's to talk baby … After a short introduction devoted to David, they rush into long reminiscences of their own baby experiences with their own nauseating children. They finally return to David, remarking, 'He does cry a lot doesn't he.' The cats. Of course I explain that he never cries at night and, in the daytime only when people are passing. Anyway, Wyb and I think he's wonderful, mostly.[10]

The only feared disruption to the Milnes' retreat in Uxbridge would have been a visit from Patsy. By this time Milne was not only avoiding her, he was hiding from her. The first precaution was to give their address only to trusted friends. Except for Kathleen's family and a few others, all correspondence, whether coming or going, was handled by and through Duncan at the Picture Loan Society. Even Clarke had to write in care of Duncan. Milne's cheques were endorsed and sent to Duncan for deposit in a Toronto bank. Art stores sent supplies to Duncan, who rerouted them. Milne and Duncan disguised Milne's whereabouts by giving the name 'Main Street' to the numerous paintings he did of Brock Street, the chief thoroughfare in Uxbridge. This screen of secrecy, behind which Duncan smugly exulted, no doubt fed the perception of Milne as a recluse, but in truth it was merely his way of protecting himself and his new family from the constricting morality of the time. Milne's parents, had they been alive, would certainly not have approved of his domestic circumstances, and his friend Clarke had been left to guess about the matter until 23 May 1940, when Milne finally told him that he and Patsy had separated, but not that he was living with Kathleen. When Alan Jarvis was visiting Canada briefly at Christmastime in 1941 and wanted to see Milne, Duncan wrote to Milne: 'I didn't mention David Jr, nervously thinking that he [Jarvis] might accidentally let it out somewhere – and it could, of course, have very unpleasant repercussions.'[11]

Milne never freed himself from anxiety about Patsy or the fear of social opprobrium. He sent Patsy payments of varying amounts at irregular intervals, conscious of his obligation to send her *something* without overlong hiatuses, and always hoping she would never come to expect more money than his fluctuating means allowed. He was prepared, as he once wrote her, to provide the money if she ever decided to buy a place of her own and settle down in it – so long as she would leave him alone. He always remitted to her half the Big Moose mortgage money, but it was forthcoming even less regularly than his own income. On 15 March 1941 Milne sent

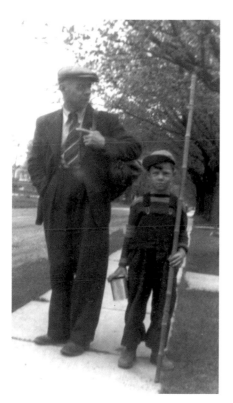

Vera Parsons a cheque for $65 for Patsy, noting that since the previous September he had paid out a total of $250 to her or to Duncan 'on my wife's behalf.' He added: 'Clearly one may end for the present all efforts to obtain a divorce, there is no money to put one through, even if my wife wanted it and there is no reserve to make a guarantee of a fixed income for her possible.' Nevertheless, according to Kathleen Milne, Milne later blamed Duncan and Parsons for not pushing the matter of a divorce with greater determination. Patsy, however, would probably have refused to grant one, and certainly would not have sought one. She was reluctant to appear in court and in any case she wanted a reconciliation. She was far from a passive recipient of Milne's payments. On 8 May, four days after his son was born, Milne wrote to Duncan: 'So long as my wife can sidestep Miss Parsons and reach me through you, she will do just that. The very best thing you can do for me – or for her either – is to tear up her enclosures and, if you answer her letters at all, merely refer her to Miss Parsons and leave it at that ... The last thing we want just now is to keep in touch.'[12]

The effect of this, ironically, was to create a closer bond between Clarke and Patsy. Clarke sympathized with Patsy's plight, and wrote consolingly to her: 'Never mind about the letter. I know how you felt and one must say those things to some one. I wish I might do something.'[13] In 1942 he wrote again:

I read your letter with some concern, it is not pleasant to know that old friends have not found the happiness they deserve. We are reaching the time in life when these things of the heart bear more heavily on us. When we are young we can forget them or work them out.

I, of course, would like to do something to help you with Dave. Since I first learned about it, I have thought many times about it. Perhaps if I could see Dave and talk to him it would be different but to convey such thoughts in a letter is very differcult [sic, a Clarkeism], in fact, I fear impossible.

So I can only hope that you and he find some way to be together again as you were before.

Dave sent my share of the Collins payment last month although it was late. Perhaps you will hear from him soon now.

In the meantime I am sending you a small check to help tide you over until you do hear from him. You do not need to regard this as a loan. Shall we call it a dividend on the delightful days when we were all together?

Keep up your courage, Patsy, and do not doubt that what you want will come to pass even though today the prospect is a little dark.[14]

Clarke also took some responsibility for Patsy's financial well-being, to the extent that he could without appearing to be condescending:

I wrote to Dave this summer and told him that I felt that I had had my share of the money from the Big Moose house and that from here on he was to keep all the Collins checks. But of course I stipulated that he was to share them with you. I hope that he has done so because I am sure that he promised to in his acknowledgement.[15]

A month or two later he reinforced his support:

It goes without saying that I would like to help you in your present perplexities.

However it is a little differcult [sic] for me to advise intelligently as I do not

know what arrangements you have with Dave in the matter of money.

It is, of course, Dave's duty, legal and spiritual, to provide for your mainte-
nance and by the same token you do not need to feel that you are accepting
anything which is not your due in accepting moneys from him.[16]

He wrote to her again in 1944:

Tomorrow I'm going to be married again, I hope for the last time. A year and a
half of this [bachelorhood] is enough for me. I cannot live alone.

You know the children have grown up and flown the nest.[17]

Although Clarke cared about Patsy, he continued, as far as Milne was
concerned, not to comment or interfere in any way. But the correspond-
ence between Milne and Clarke diminished in frequency and enthusiasm
through these years. Once the need to correspond about the mortgage had
disappeared, Milne's and Clarke's letters dwindled to a perfunctory one or
two a year.

Whatever reputation Milne had as a painter by this time, six years after
the sale to the Masseys and two years after Duncan became his agent, his
work was far from lucrative: his total earnings in 1940 were $647 – not a
sum to banish financial worry from his mind. Even Duncan, usually an
optimist, wrote: 'I doubt whether any good painter since [Tom] Thomson
has had a smaller number of admirers than you have.'[18] Although a select
circle had bought Milne's 1930s work, few people, perhaps only half a
dozen, had seen any of his paintings from before 1929 (except the War
Records works, which were exhibited briefly in 1920 and 1935 and then
locked in storage) – a period of twenty mostly productive years. At this
point any possibility that Milne might receive some acclaim for his work
was stifled by the direction his art suddenly took, and by the choice he had
made to live out of most people's sight and mind. In addition, the con-
strained atmosphere of wartime subdued the arts scene considerably.

Each period of Milne's life had distinct tensions, but in the 1940s Milne
had responsibilities that he had not experienced before. Patsy had nearly
always contributed to their family income, as had Kathleen before 1940.
Now the fact that he had a son and a wife who was not earning brought
about a complete change in Milne's pattern of living, and he felt driven to
work beyond his normal determination and habit.

Finances therefore must have put a strain on Milne's relationship
with Kathleen. His income in 1939 had been only $817. During their
first year in Uxbridge it rose to $904. 'It was a tough couple of years,'
Kathleen recalled in an interview, referring to the first years of their being
together, 'but I think part of it was a reaction to his years of solitude at Six
Mile Lake. He simply had lost the ability to live comfortably with another
person.'[19] She found Milne full of jealousy, fear, and uncertainty, and felt
that he had transferred to her the deeply embedded mistrust he had felt
for Patsy:

The difficulties with [his] personality were of course the depressions and the
anxieties and jealousies, which I found very difficult, and the mistrust ... I think
he was giving me all the faults he'd found in his first wife, real or imaginary.[20]

The bouts of melancholy that Milne had complained of at Six Mile Lake in
the mid-1930s returned at Uxbridge, and Kathleen recalled 'long periods
of depression' and his often eating alone. For all that, the years from 1940

to 1946 were marked, for the most part, by domestic contentment and steady productivity:

I wasn't expecting it to be easy. It wasn't. But [it was] rewarding ... we had a marvellous time. He had a tremendous sense of humour, a great wit. And we liked doing the same things: our walks, we were out every day walking, or skiing, gardening, reading together. As far as I was concerned, marriage was a job. That was my job. His painting was his job. And I did what I could to make a go of it, you know.[21]

Milne's home with Kathleen and little David and visits from knowledgeable and supportive friends were a source of joy, inspiration, and stability. Weekend visits from Toronto by Duncan, Vera Parsons, and George and Dorothy McVicar were always welcomed. From time to time Kathleen's parents came from Montreal for a week or so. Trips to Toronto, although not frequent for lack of what Milne considered suitable clothes to be seen in, were occasions for further socializing, and for seeing exhibitions and meeting other artists. Milne was now accepted by the Canadian art establishment, small though it was. As the years went by, and David Jr grew, Milne delighted in sharing with his family various celebrations and activities: Thanksgiving, Christmas, Easter, birthdays, camping, picnics, hiking, and skiing. Kathleen thought that he was 'wonderful with his son because he was a natural teacher. He was good with *all* children, really, but it made him easy with young David.'[22]

One particular enjoyment each fall (from 1940 to 1946, 1941 excepted) was the family camping trip of two or three weeks to the wilderness near Coboconk, in Haliburton County, 165 kilometres (100 miles) northeast of Toronto. The attraction of the fall colours was a lure for many Canadian artists and made a fall trip a necessity in their lives. Milne easily adopted this routine, particularly as the garden in Uxbridge could be left to its own devices in September. Usually the Milnes set up a base camp and settled into a routine that allowed Milne to work every morning. Kathleen and David Jr made periodic trips to Coboconk for supplies. Even after David was old enough to attend school, he was taken out of school for the period of this family ritual. Milne usually stayed on after the family holiday for an extra two or three weeks to paint.

Window on Main Street, *1940, watercolour, 37.8×50.8* *(14⅞×20)*

First Snow, *1940, watercolour, 38.1×55.9* *(15×22)*

Uxbridge United Church, 1970s

When Kathleen took young David to visit friends in Toronto, Milne wrote fond letters to his son, illustrated with drawings and signed 'Love from Daddy.' Even his most anxious moments could not diminish the warmth and joy Milne derived from family life. While he increasingly felt the need to withdraw, and to wrestle alone with his demons and angels, the attachment to his family was strong. Kathleen was very much aware of the conflict that the opposing demands of work and family created in Milne:

I would like to make [it] clear about [his] selfishness. Now to me self-centredness I would find very difficult to put up with, but that wasn't his kind of selfishness. His was a devotion to what he'd spent his life doing. And that takes a lot of courage [because it may] make hardships for the people you love – that takes an awful lot of courage, much more than just putting up with things yourself. And there's nothing self-centred about that ... there's nothing innately selfish [about it].[23]

New surroundings and new circumstances had often renewed Milne's determination to paint, and within a month or so the move to Uxbridge proved to be congenial. His work poured forth in watercolours, colour drypoints, and an occasional oil. His production for 1941 was close to ninety paintings: for both quantity and quality it was a year with few equals. But the change to the tranquil small-town life of Uxbridge, so different from the wilderness of Six Mile Lake and the Methodist bustle of Toronto, did not manifest itself immediately in his painting. Not until the house and studio were settled did the work flow with regularity. Milne painted new subjects, such as his house, the grain elevator, and the main street from his studio. His first work was in oil and, in anticipation of doing more drypoints, he ordered plates, pigments, and other supplies.

In the cold weather of late 1940 Milne painted the landscape that confronted him from his studio window, or nearby: plain and simple buildings were composed and painted to produce works of singular calm and

Red Church IV, *1941, watercolour, 38.8 × 52.7 (15¼ × 20¾)*

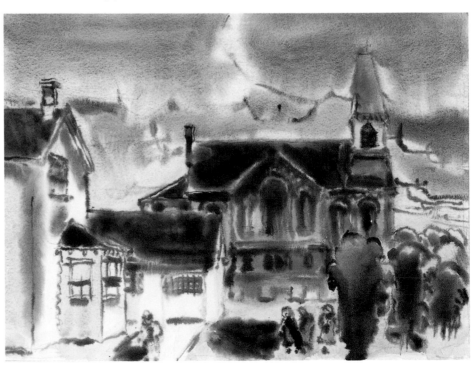

respect. The watercolour *Window on Main Street*, of which he did a dozen different versions, is a view of Brock Street, a scene that was painted again in *First Snow on Main Street I* and *II, Gentle Winter,* and *Snow from the North.* Early in 1941 Milne painted *Our House and the Neighbours', Uxbridge* in five versions, the *Free Methodist Church* in three, and the United Church (*Red Church*) in six. But he also returned to former subjects: Toronto waterfront paintings were redone; *Outlet of the Pond,* which dated back to 1926, and had been briefly exhumed at Six Mile Lake, was reworked as *Still Water and Fish* in watercolour, and also as a drypoint (Tovell 77) with eighteen varied impressions in a month. *Stars over Bay Street* was painted again, for each small change in technique opened new possibilities for the resolution of earlier problems, or the application of the new technique to an earlier subject. Milne wrote to Clarke that considerably more than half his work of this time was painted not from the subject but from previous paintings, with or without changes in composition and point of view.[24] Milne again became interested in contrasts in texture, as he had been at Boston Corners, and he experimented with thin and thick lines playing against each other, and with soft and harsh areas in counterpoint, but with the emphasis on the soft. These contrasts were restrained, and the once dramatic use of black and white was now muted. In some oils, such as *Grain Elevators I,* the stiff oil was brushed into the wet, thin underpainting, thus 'softening the edges of the colors.'[25] The watercolour of the same subject showed how Milne could exploit the idea in a different medium, for when he was in top form he could work in both oil and watercolour more or less at the same time with equal facility.

One characteristic of many paintings from this period was a dulcet pink wash, which was sometimes contained in one area or sometimes suffused the whole work. It is the colour key to *Window on Main Street,* to the Main Street snow scenes, to some of the landscapes done around Uxbridge, such as *Our House and the Neighbours',* and to Milne's new repaintings of *Stars over Bay Street.* The pinkish hue purged the white of starkness; when it was combined with a contrasting deep brown-gray instead of black, Milne's pictures suddenly developed a gentler brilliance, but they still had explosive power. An increasing range of colours began to show in subsequent paintings. The flower pictures painted in the summer of 1941, such as the

Poppies, *1941, watercolour, 37.5×54.6 (14¾×21½)*

Zinnias and Poppies I, *26 August 1941, watercolour, 38.1×51.1 (15×16⅞)*

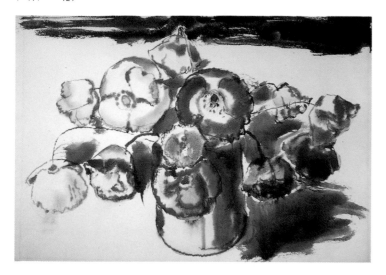

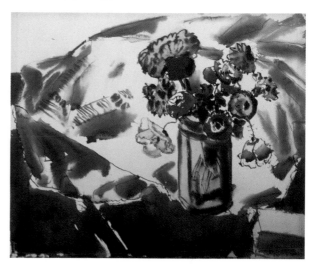

numerous paintings of poppies – *Poppies, Zinnias and Poppies I, Poppies in a Tin Can, Poppies and Nasturtiums, Poppies and Glass* – all have a scarlet richness that saturated the paper in a way that was new in Milne's work, and that he would exploit over the next few years. He also began to fill out his pictures with more detail, thus detaining the viewer for longer and more complicated journeys within the picture space. *White Clouds in a Blue Sky III* is an excellent example. Had the sky been left blank or washed in one tint, the viewer might sweep through the different earth shapes very rapidly; but with the cloud outlines drawn in blue, and the blue scrubbed areas among them standing for the whole blue sky, the eye is deliberately held up, or back, by what Milne called 'an area of confusion.'[26] Consequently one reads the painting much more slowly, as the eye moves up into the sky area at each interval between major focal points on the lower band of shapes: the piles of coal, the fuel tanks, the freighter.

Because he was more often working from other paintings and from his imagination rather than directly from nature, Milne worked increasingly without strict regard for the seasons. Until the late 1930s it can reasonably be assumed that Milne's spring flower paintings were painted in the spring. After that one must be cautious, for Milne's practice of painting at first hand, especially anything seasonal, was ignored as he aged.

In early May 1941, while he was in Toronto awaiting news from the maternity ward, Milne whiled away a few hours in the Central Reference Library reading W. Gurney Benham's *Playing Cards, A History of the Pack and Explanations of Its Many Secrets* (London, 1931), and W.A. Bentley and W.J. Humphreys's *Snow Crystals* (New York, 1931), a vast collection of Bentley's photographs of snowflakes.[27] The sketches that Milne jotted down from these books became the impulse for some of his work over the next three years. But with the excitement and disruption that the new child caused in the household, painting was 'in a slump' until July.[28] Another push with oils did not lead to success, but in watercolour Milne painted *Lemon Lilies*, a glorious still life of flowers, two bricks, and a baby's bottle.

White Clouds in a Blue Sky III, *21 February 1941, watercolour, 37.8×54.0 (14⅞×21¼)*

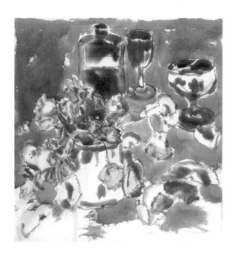

Poppies and Nasturtiums, *1941,*
watercolour, 41.3×38.8 (16¼×15¼)

Milne liked the picture so much that he framed it and hung it in their dining room, and its unusual yellow-ochre wash became a touchstone for many subsequent works. He wrote to Clarke that all the drawing in it had been done in colour rather than in black, an important departure for him.[29] The effect softened and enriched the texture, and created more subtle contrasts to black areas and to white paper, characteristics that appear again in later paintings.

Milne then returned to what he called his 'subject' paintings – those unusual fantasies that he had been thinking about in 1939 and 1940. The range of the fantasy pictures, when Milne finally gave them full rein, was impressive: the *Ascension* and *Resurrection* series, which ran to more than fifty works; the *Return from the Voyage* series; the *Fruit of the Tree* series; *Mary and Martha* (the *Supper at Bethany* series); the *Noah and the Ark* series; the playing card series of kings, queens, and jokers, sometimes with angels; snow flakes in Bethlehem; Judgment Day; angels and tempters; and other pictures that also alluded to the theme of transfiguration: catalogue mannequins brought to life; depictions of cemeteries, funerals, and grieving widows; a convoy of chicks and a hen crossing a table at Easter; and stuffed animals and other toys posed with flowers.

Milne's eventual departure from landscapes and domestic still lifes into overt subject matter was crucial. It carried him through to the end of his life: the last work on his easel was one of a tempter seducing angels with cosmetics. From 1938 onwards, Milne had a choice between direct painting, which was how he referred to his landscapes or still lifes, and subject painting, which was his term for the unusual subjects – mostly religious in inspiration, subjects that he thought up almost as if he were illustrating a biblical comic strip. Sometimes, especially later, he himself felt a tremendous tension between the two kinds of painting, but initially the flow of his work incorporated both quite easily.

One of the key tenets of modernist painting, and particularly Milne's branch of it, is that subject matter is secondary to the relations of colour, tone, and shape. Milne's decision, or series of decisions, to step outside

Lemon Lilies, *1941, watercolour, 35.9×53.3 (14⅛×21)*

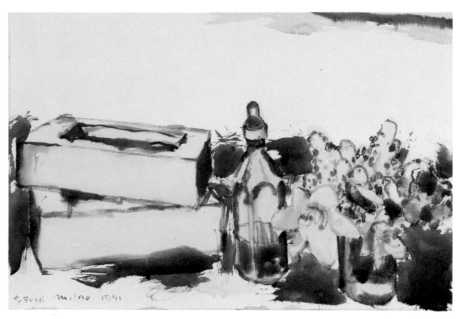

Poppies and Lilies III, *1946, watercolour, 54.0×36.9 (21¼×14½)*

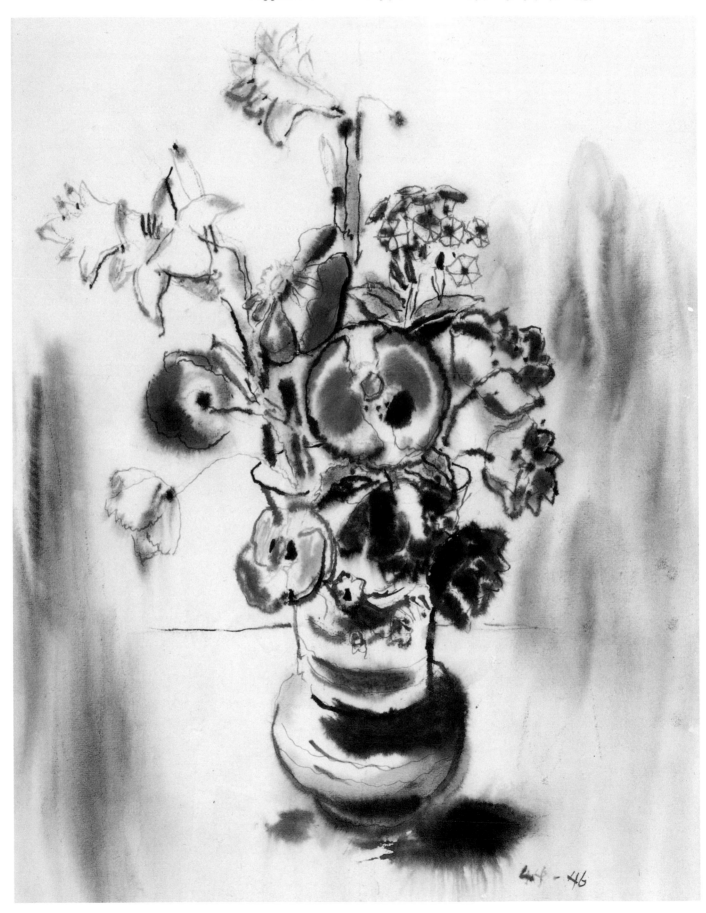

A page from Bentley and Humphreys's book on snow crystals, from which Milne made sketches

the canon of modernism into an odd, personal kind of fantasy world that had echoes of the iconography of art history, combined with symbols of the realities of life, is largely inexplicable. He may have ignored or suppressed the significance of these subjects, but we can hardly do so. Clarke was taken aback when Milne described to him what he was up to:

What started you on the subject matter thing and how do you justify it with your old practice of getting compositions from nature[?] You used to say nobody could dope up composition better than the real thing (i.e. nature). Of course I've been doing that right along, but the best ones I ever did were inspired by ones made from nature. I'll bet if you check back so are yours too.[30]

Milne's insistence on the subject paintings was an eccentric compulsion in Duncan's eyes too, and others found it disquieting. The new paintings were bewildering and difficult for people who were used to Milne's landscapes and still lifes. In Milne this reaction instilled a grumpy determination to work on the new ideas that were possessing him rather than on paintings that were more obviously saleable. He was driven to endless repaintings in an almost fanatical search for perfection in execution: more than fifty exploratory variants of the Ascension series provide numerous proofs of this. Milne continued his fantasy paintings until late in 1946, when, after working on them for eight years or so, he unaccountably dropped them for about five years. He may have been brought up short by their great divergence from the canon of modernism, his own root and tradition, or he may simply have needed to shake himself free of them in order to give other ideas attention.

The snowflake sketches made in May 1941 metamorphosed into the painting *Snow in Bethlehem* in August. Milne attempted it first in oil, then painted three versions in watercolour in five days. The first two watercolours depicted two little angels carrying a snowflake, but this idea was too cute; it tended to weaken and confuse the composition and by the third version the angels were banished. The first two versions were themselves

Snow in Bethlehem II, *11 August 1941, watercolour, 39.1×55.9 (15⅜×22)*

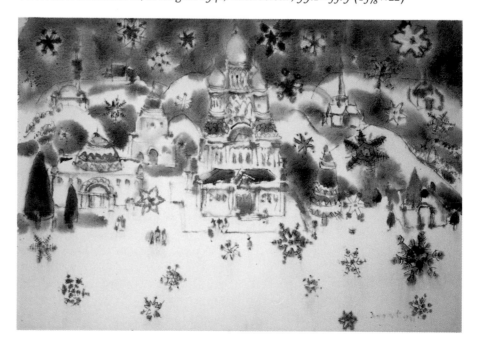

eliminated when, with Milne's permission, Duncan cut up one to use as
Christmas cards in 1945, and the other was presumably destroyed. In the
only surviving version (*Snow in Bethlehem II*) Milne painted one of the
angels with its skirt blown up, 'to keep from being sentimental.'[31] In his
later paintings with angels Milne was careful not to lead his viewers into
stereotyped responses by painting saccharine winged figures, and in some
works he dressed his angels in bowler hats for the same reason. The other
elements of this powerful and delicate painting, so perfect in its evocation
of a Canadian Christmas, came together accidentally: the central church
was purloined from a newspaper photograph of a church in Tallinn, Esto-
nia; the fenced evergreen began as a Turkish cemetery; minarets and domes
suggest the East, and the spire the West. 'I had embarked on a fantasy,
where any resemblance to the things of the world around us was little
more than coincidental.'[32]

In spite of shifting from one medium to another, from direct painting
to indirect, from inventing new subjects to reviving old ones, and painting
indoors and out all at the same time, Milne did not permit his work to
become an eclectic scramble. Each painting benefited from, and contrib-
uted to, the others. Aesthetic continuity was the real core of his achieve-
ment. Even when he moved to a completely different subject, there was a
steady rhythmic advance in Milne's artistic thinking. And his thought, as
well as the changes in technique, bound the works together: his way of
applying paint a little differently each time, a little wetter or a little dryer;
the painting over when still wet, or partly dry, or almost dry; the discovery
of new colours, sometimes accidentally; the varying of a composition slightly
to improve the balance of colour to black-and-white values; the winnowing
out of awkward details to make the internal movement smoother – these
daily concerns were constant throughout the painting of diverse subjects
and numerous treatments. Milne trusted his sense of continuity and feared
the loss of momentum. He did his best work when there was a 'flow from
one picture to another. Pictures are not entirely separate units but are closely
related, like members of a family, with characteristics of one coming from
some previous one ... When this stream is flowing painting is most direct,
comes from within, from the painting itself, rather than from outside in-
fluences.'[33] It was his need to have immediate ancestors constantly at hand
to establish the lineage of his work that induced Milne to release his paint-
ings slowly.

There is one sense in which the fantasies were completely consistent
with Milne's painting canon, even if they appeared to represent a radically
new direction. Aesthetically they advanced his painting of the moment in
their colours, their values and combinations of them, the progressions
and paths for the eye to follow, and their compositional balance or imbal-
ance. In these technical ways they referred back to the direct paintings of
landscapes and still lifes. But the fantasies also fell within the framework
of Milne's early belief (mentioned to Clarke in 1921) that anything that
went into the artist's mind could be used for painting. For most of his life
this had meant immediately visible subject matter; but beginning in 1937
a greater imaginative range is evident in *The Hula Dancer, Goodbye to a
Teacher*, and *Picture on the Blackboard*. One might even trace the origin of
the fantasies back to the 1929 painting *Waterlilies and the Sunday Paper,*
with its incongruous juxtaposition of flowers against the weekend paper's
comic pages. In the 1940s many of Milne's subjects were not appropriated
from nature but were discovered in his flinty mind, where odd subjects
and painting problems bumped into each other and then coalesced. This

departure from his usual way of proceeding pulled Milne outside his normal and traditional pictorial concerns as an artist.

Snow in Bethlehem, The Mass in the Forest, Return from the Voyage, Mary and Martha, Noah's Ark, and the *Ascension* series – in fact most of Milne's fantasy pictures – have a biblical reference, although little traditional biblical imagery. Angels inhabit some of them, as they also infiltrate secular themes. Milne knew his Bible well and believed deeply in its symbolic truth and its pertinence to contemporary life. In *Mary and Martha,* for example, painted in 1945, Lazarus, Mary, Martha, and the disciples have gathered for what Milne thought of as an ordinary supper among friends. As bread and wine were the staples of a supper in the biblical story's time and place, so Milne presented the staples of his time and place: supply boxes, flour bags, cheeses, and various bottles were the sacraments of his daily spiritual life. Milne did not dredge up arcane or obscure material for his fantasies, but used the thoughts and objects of everyday life in order to make his abstractions concrete. His saints are alive and walking among us, his biblical landscape is southern Ontario, his *Ascensions* rise over Uxbridge and Palgrave, and Jonah returns from his voyage via train and Union Station in Toronto. In Milne's mind local settings connected profound and ancient truths to contemporary experience. People who had never trod the shores of Galilee might pace the shores of Six Mile Lake with Milne's saint. The past was intelligently present in Milne, and the charming rituals of the day or season were elevated by him into universal pictorial truths. His new fantastic landscapes became landscapes of the mind, and thus served to enlarge, and underlie, other images and ideas in his work.

Milne believed that the Bible was relevant today and that the true understanding of art, the emotional thrill that it instilled, was paralleled in the rebirth symbolized in the life of Christ. Milne once quoted Christ's answer to Nicodemus, that a man must be born again to enter the kingdom of heaven: he must be as a child again. An understanding of art depended upon one's ability to enter a world of innocence. This is one reason why children's art, with its singleness of heart and its direct and immediate translation of perception to image, always fascinated Milne.

The humour and light-hearted charm of many of the fantasies have led some people to believe that they were painted for the nursery and not meant to be taken seriously by adults (except as investments). But for Milne the humour was simply a means of attracting the viewer's attention, of expressing the joy in the idea of the work. The delicate whimsy was intended to have a subtle effect on the willing and knowledgeable viewer, and it was not easily achieved. After the initial inspiration there was a great deal of careful and prolonged thought, and much painting and repainting. No sudden burst of revelation created these works. Like the drypoints, they were imbued with a spirit of joyful and spontaneous inspiration, but they were arrived at only by an arduous process of intellectual and emotional effort that drew upon Milne as a whole man, his life, his beliefs, his technical abilities, and his imagination. They are to Milne's work, perhaps, what Blake's *Songs of Innocence* and *Songs of Experience* were to his: a culmination of ideas that are at once simple, direct, and beautiful.

In September 1941 the playing-card drawings sketched in May were pressed into service for what was to be a quick and simple work. Such is the unpredictability of the imagination that this subject was fertile enough to suggest variations and to demand repaintings over three years before its attractions were finally exhausted. Milne had a sheaf of sixteen little

A page from Benham's book on the history of playing cards, from which Milne made sketches

drawings and some notes to remind him of shapes and figures and some of the characteristics of the different suits and their members. For example, he noted that the King of Hearts wore ermine, the Queen of Clubs was stout, only the Queen of Spades held a sceptre, the Knave of Clubs held an arrow, and the King of Diamonds did not wear a sword. The degree of Milne's indebtedness to Benham's book is obvious from a comparison of the sketches with Benham's illustrations. Yet for Milne the source was, as he had always maintained, only a means of getting started, and anything that took an artist's fancy could serve that purpose, be it an idea, an object, a theory, a story, a mathematical formula, or another painting.

Once Milne was launched into this series of fantasies, the ideas generated by the paintings themselves took on an ebullient life of their own. Of the numerous versions he did, nearly twenty still exist, although several are only in fragments. The first version, *King, Queen, and Jokers I*, is particularly striking for its bold colours and intricate structure. Doubtless it had been carefully mulled over before it was first drawn on 3 September. Then Milne meditated on it for a few more days, during which time he worked on another subject. On 7 and 8 September he drew it again, and he finally painted it on 9 September.[34] Its colours were derived from the paintings immediately preceding it: *United Church, Zinnias and Poppies,* and *Lemon Lilies* – the yellow-beige wash from the latter, the rich brown from the church, and the brilliant reds from the poppy studies. One difference, as Kathleen noted in her diary, was that it was an 'all over design,' one that did not have large areas of black or white but employed much smaller areas throughout the work.[35] Areas of complicated detail and areas of vagueness are contrasted so that as one scans the painting the rhythms are varied: 'There seems to be a rather uneven beat,' Kathleen wrote, 'slow, quicker, quick, slow, quicker, slow. Waltz time with hesitation at the central figures.'[36]

But *King, Queen, and Jokers I* is also compositionally an exciting work – perhaps somewhat obvious, but as precise and thoughtful as a Raphael. The king, in his regal and awesome confidence, is the focal point, despite his placement slightly to the left of centre to counterbalance the large portrait on the right. He is flanked by three knaves on the left, and three ladies on the right, the queen and two ladies-in-waiting. Both of these groups form a shallow V-shape, which accents the position of the king. Above him are three angel-jokers, forming an upside-down V, with the bowler-hatted joker in the absolute middle of the picture. Three portraits on the wall, along with the slightly drawn doorway, provide a different rhythm with their irregular spacing, although they are of equal value in their weight of colour and total size. The whole is flanked by two more knaves holding pikes. The rich colours, particularly the royal blues and the brilliant reds, the precision of the drawing down to the most minute detail, and the relation of groups and spaces are perfection itself.

Although Milne always disclaimed any moral or symbolic intention for his work, it is difficult not to see this painting as a set of symbols issuing from a poetic mind. There are the ancestral portraits on the walls. Milne, particularly as a new father, was conscious of ancestry, both as it had formed him and as his earlier pictures had formed his later ones. There are the angels, irreverently costumed, representing the spiritual part of his inspiration – and his humour. One angel is in contemporary dress, if only to emphasize, in a mildly satiric way, Milne's conviction that genuine believers in angels (or in the spiritual order) would not conceive of them as

beings from another age but as creatures from their own time and place, something that is real, here and now. There stands the monarch, richly robed, holding his sword and orb, gazing to his right piercingly and with kingly righteousness. As ruler of the imagination he is powerful, insistent, decisive, even something of a tyrant. One can imagine that he expects to be deferred to, that he has great knowledge and energy, a high regard for exact ritual, and an Old Testament sense of justice, and that he is also capable of fearful anger. How much of him is Milne?

The succeeding nine paintings on this theme – and probably more (although only five remain) – were executed in September and October 1941. They were chiefly of knaves in a portrait gallery, with an emphasis on the portraits. Milne attempted one version in oil that may have prompted a reconsideration of his old value system, for it is painted in gray, black, white, and red. In any case, it encouraged him to seek another solution to the *Stars over Bay Street* subject, which he had been fretting about since 1939 and was still painting in 1942. The softer and wetter method he had developed earlier in 1941 – although sparingly used in the playing-card paintings, which are dryly and stiffly painted – seemed to offer a better

King, Queen, and Jokers I, *9 September 1941, watercolour, 38.5×56.6 (15⅛×22¼)*

King, Queen, and Jokers IV: It's a Democratic Age, *c. 22 January 1942, watercolour 55.3×76.7 (21¾×30¼)*

King, Queen, and Jokers V: It's a Democratic Age, *1943–4, watercolour, 55.6×76.7 (21⅞×30¼)*

King, Queen, and Jokers VIII: It's a Democratic Age, *1943–4, watercolour, 55.9×76.2 (22×30)*

solution for *Stars over Bay Street*. The watercolour versions of it were delivered painlessly; but the oil version thwarted Milne day after day until he finally abandoned it, unfinished.

Milne was sufficiently preoccupied with these subjects that he ignored the outdoors and the fall colours. Instead, after a brief pause, probably for thinking and planning, he painted the first version of *Noah* (*Noah and the Ark and Mount Ararat I*) in late November 1941. Duncan claimed that there were 'perhaps 30 variations' of this subject, but judging from the notes and diary entries this is improbable.[37] Only eight versions now exist, along with a small drawing for another version in which Noah himself stands beside his ark with monkeys on his shoulders and animals gathered about.

None of these were the same Noah that Milne had conceived, planned, and sketched in 1938, with the pairs of animals boarding the ark four ears at a time. The subject he now chose was of the animals streaming out across the land after the flood, with the ark, Noah, and Mount Ararat in the distance. It was what Milne called, against his own earlier definition of a painting's having to be able to be grasped in a flash, a 'browsing picture,' for it takes time to read through it and to recognize, with surprise and

Noah and the Ark and Mount Ararat I, *c. 1 December 1941,* watercolour, 37.2×54.6 (14⅝×21½)

Noah and the Ark and Mount Ararat III, *15 December 1941,* watercolour, 33.8×55.9 (15¼×22)

Noah and the Ark and Mount Ararat IV, *10 January 1942,* watercolour, 38.5×56.6 (15⅛×22¼)

Noah and the Ark and Mount Ararat V, *13 January 1942,* watercolour, 38.1×55.3 (15×21¾)

Drawing of Noah, 11 June 1939, ink, 12.1×17.9 (4¾×7)

delight, what constitutes each cluster of animals. There is humour and irony in the lion with a baby's bottle, the mouse on wheels, the monkeys on a ladder. But the purpose of the picture was to offer the viewer an opportunity for discovery. The scrubbed-in areas of wash, as Milne pointed out, give the composition its movement and structure.[38] The animals simply reside within this matrix. The Noah series of paintings is consistent in colour, drawing, and feeling with the Main Street subjects done at this time. In some the drawing is in black and the colour restrained, but in others the drawing is also in colour and the splotches of wash are a value. What is remarkable about the Noah paintings, when closely viewed, is how powerful and sharp identification is and how improbably, magically, the wavy lines and little dabs of colour create an image. Incidentally, the first version of Noah has the animals rushing from right to left across the sheet, but in all subsequent variants they are galloping eastward.

In the midst of unburdening himself of Noah's ark (the subject carried through to April 1942) Milne found the playing-card series suddenly taking an astonishing turn. In place of one of the attendant knaves and one of the ladies-in-waiting Milne introduced a contemporary couple, a bowler-hatted, cigar-chomping man and a rather demure shy woman. The working title was *In a Democratic Age.* Milne explained to Clarke that the presence of Mr and Mrs John Doe in the picture was really for the aesthetic purpose of introducing 'plain figures (for contrast) with the playing card ones, rather than to make a satire.'[39] Whatever Milne intended, the 'plain men' featured in this series bear remarkable likenesses to Mackenzie King, Winston Churchill, and other public figures of the day. While he obviously painted these with tongue in cheek, Milne disapproved of the gradual severance of Canada from the British Empire. He was both a monarchist and a nationalist, and in Canada's drift away from Britain Milne foresaw an automatic drift toward American cultural standards, for which he cared little.

The year 1942 was launched with two versions of Noah done in a speckled manner like stage sets, further variants of the playing-card subjects, and several of Brock Street in a snowstorm, with a tow truck as a prominent feature in one of them. Milne began work on a drypoint of the latter

Prints, 1942, watercolour, 37.5×55.9 (14¾×22)

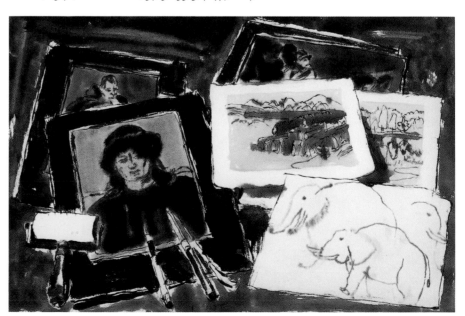

subject, *Main Street* (Tovell 80), without the truck, and he pecked away at various inkings and compositions until he found a definitive colour scheme and drawing pattern in mid-February. The drypoint of *Grain Elevator* (Tovell 81) followed immediately and was subjected to the same clarifying process with four plates, endless colour trials, and wholesale revisions of the composition. Clouds that were initially drawn in were eventually erased. The yellow used in this drypoint, and in the watercolour *Lemon Lilies*, prompted another watercolour attempt at the Noah. This was followed a month later by yet another Noah with a yellow wash base and with the addition of a rainbow and a goose.

In the course of ordering more drypoint supplies, Milne asked Duncan to lend him a few reproductions of Old Masters, preferably in colour. The upshot was *Prints*, a splendid watercolour of disarming simplicity that was subject to several repaintings. It shows reproductions of works by Raphael and El Greco alongside Milne's own drypoints and a drawing of elephants for one of the Noah paintings. It is an exquisite testament to Milne's abiding sense of tradition, and an intrepid statement of his own worth as a painter.

Flower subjects arrived with the spring of 1942, superimposed on the Main Street motif in two vibrant watercolours, *Wild Flowers on the Window Ledge* I and II. These succeeded brilliantly, especially in the interplay between the far and near detail. In June 1942, preparatory to an attempt in oil, Milne did four watercolours of *The Saint*, a subject that he had mentioned to Mrs Massey three years earlier, using the title *Christ in the Wilderness*. He described it briefly as depicting 'the wilderness ... right round Six Mile Lake with a canoe and a campfire and smoke and stars – and maybe northern lights.'[40] Later versions, especially with the addition of all the animals, changed the subject to a variation on St Francis, although Milne's saint fattened into a jolly friar, quite unlike Giovanni Bellini's austere St Francis.

The saint started out as St. Francis until I discovered that St. Francis was ascetic and mainly interested in birds, my saint is fat and interested in animals in

Wild Flowers on the Window Ledge I, *2 May 1942, watercolour, 36.9 × 55.9 (14½ × 22)*

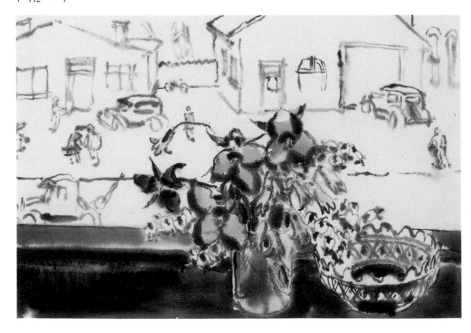

general, from elephants down to porcupines. He might be St. Jerome, but I don't know enough about St. Jerome so mine will have to be an Unknown Saint.[41]

Two versions are built upon a strange verdigris colour that was used again in *Shrine and Saints* a year later. One version was cut up by Duncan to decorate young David's nursery; another became one of Milne's most reproduced pictures.

During the course of the summer a few other flower pictures were completed in watercolour, and Milne then did a series of watercolours (ten or so) of lighthouses on Toronto's waterfront, with its necklace of islands; the city is in the background of several of them. This series – soft, gray, and elegant – included variants with seagulls caught in magnificent contortions of flight. In the fall of 1942 Milne spent a month alone in the Coboconk area, and the trip produced a good crop of pictures. For *Cedar Swamp* Milne used the green wash of *The Saint* to excellent effect; but in the majority of the fall pictures, such as *Yellow House,* he again used the ochre wash from *Lemon Lilies,* with the bonus of a soft persimmon red to accent the season's colour against saffron. Milne concluded the year with at least two further trials of *Stars over Bay Street* (*Eaton's College Street* and *Evening on Bay Street II*) that profited from the misty gray wash carried over from *Gulls and Lighthouse.*

While the watercolours proceeded without undue fuss throughout 1942, from the early spring on much of Milne's time and energy was devoted to painting in oil. The attempts frequently fell short of his target. Milne resorted to an unusual procedure then, and over the next few years, which was to use watercolour as a means of investigating and blocking in compositions for subjects intended for oil. A watercolour would seem to him 'to give a pretty good chance to develop a way of working in oil,'[42] but then he would be sidetracked by further implications in the watercolour. Somewhere in the back of Milne's mind was the thought, perhaps planted by Duncan with his marketing problems, that oils were a more desirable goal. In the spring of 1942 Milne stretched eight 40.7×50.8-centimetre (16×20-

The Saint III, *17 June 1942, watercolour, 37.8×55.6 (14⅞×21⅞)*

inch) canvases and determined to complete definitive versions of *Stars over Bay Street*, *Noah and the Ark*, and *The Saint*. After laying siege to them all summer, he ended with only a respectable painting of the first and several unfinished remnants of the others. Up to 1947, when he abandoned oils altogether, Milne tackled them 'without seeming to get anywhere in particular' – a familiar litany through his late years. Some were charming, others quite strong; but after Six Mile Lake the power, originality, and freshness in Milne's paintings are found in his watercolours, not in his oils.

In 1942, at the age of sixty, with over thirty-five years of experience and accomplishment behind him, Milne knew exactly what he was doing. In the face of oppressive financial circumstances he worked doggedly, day after day. In spite of Duncan's reservations about some work – Milne wrote to Carl Schaefer that Duncan particularly disliked the playing-card series and *White Clouds in a Blue Sky* – he stubbornly tacked his way against the winds of fashion and acceptance, and against the currents of misunderstanding that constantly threatened. But the watercolours of this period are rich, elegant, and confident. They soar with inspiration and glow with a gentle incandescence.

In the first half of 1943 Milne coasted on the momentum of previous discoveries. *Immortality in Queen's Park* and *Shrine and Saints II*, depicting the statues in front of the Ontario legislature, jocular political satires, used the verdigris wash of the previous year, when the subject had first been contemplated. At the same time Milne did five versions of *Park Plaza*, drawn at night from the roof of the Picture Loan Society building, a few blocks away, where he stayed on a visit to Toronto in March. In both these subjects the tint was applied first. When it was dry, parts of the painting were wetted again and the darker colours put on quickly and decisively, and then more detail was worked in. To take full advantage of the diffuse blur created by the wetness meant working with great rapidity and concentration. This, in turn, meant knowing in advance what colours were to be used and what their shape would be, whether they were to be drawn with a large or small brush, fully or partly charged, and with thick or thin medium.

Park Plaza offered the option of transposing tones to show dark stars against a light sky or vice versa. Since the same dilemma had arisen in *Stars over Bay Street*, Milne's attention was again drawn to that subject and

Gulls and Lighthouse II, *1942, watercolour, 37.5×54.9* (14¾×21⅝)

Gulls, *1942, watercolour, 37.5×55.3* (14¾×21¾)

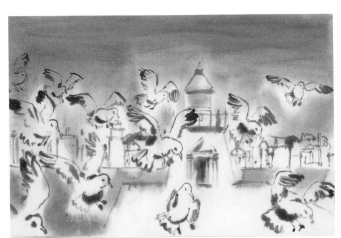

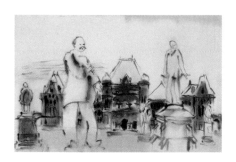

Shrine and Saints II, *11 March 1943, watercolour, 36.9×54.6 (14½×21½)*

he experimented with, but never printed, a four-plate drypoint. The drypoint *St Michael's Cathedral* (Tovell 82), finished by the end of May, roused Milne to a rendering in oil, which was much less successful than the two watercolours of three years earlier on which it was based. The few spring landscapes were mostly unnoteworthy, but the flower paintings that followed were back up to a high standard, particularly the splendid series of poppies, beginning with *Poppies in a Paper* and *Poppies and Lilies* (which he continued into the next year). Their fragile butterfly beauty, perfectly drawn and breathing spontaneity, places them among Milne's finest works. They seem to fulfil his statement that he would like to have 'wished' his images onto the paper.[43]

An exception to these successes, which carried through from early 1943 into the next year, was a subject picture derived from Eaton's catalogue, the one publication that was probably read nearly as often in Canada as the Bible. In February 1943 Milne painted the first versions of *Portraits from a Catalogue* and *Sizes and Colours* – a title inspired by the exhortation on the catalogue order form to state these clearly. The subject was not so far removed from *Goodbye to a Teacher* and the first of the playing-card paintings. The row of catalogue models in dresses, suits, underwear, coats, and hats was, pictorially, a progression of shapes, colours, and textures. In Milne's mind the line of figures was a pleasant fiction on which to hang his real concern for lines, forms, and colours. But he never brought this subject to a final conclusion, abandoning it in a half-developed state.

By midsummer Milne's idea of painting a line-up of figures had transferred itself in his mind to a line-up of angels accompanied by a larger figure (the common man) taken from the playing-card series. This new subject picture, initially called *Trumpets*, then retitled *Resurrection Day*, depicts a contemporary man hovering in a dark cloud over a faintly drawn cemetery. On his left are three large and four small angels blowing their horns. (But on the verso Milne made a rough sketch, a forerunner of the *Ascension* series, in which the man is flanked by angels on either side.) Two further steps toward a definitive and articulate treatment of this theme were a painting that combines a levitating figure above a street scene (*Day*

Resurrection III, *1943, watercolour, 38.1×55.9 (15×22), irregular*

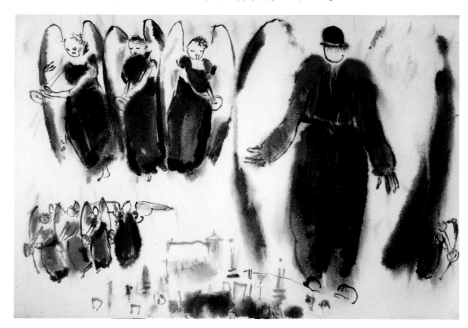

Day of Judgment VI, *1947, watercolour, 54.6×36.5 (21½×14⅜)*

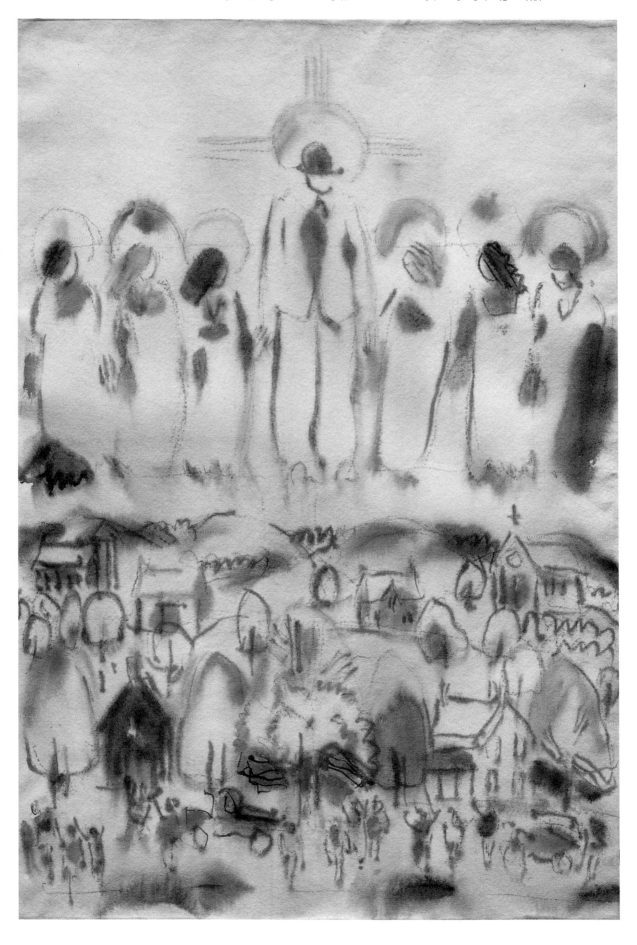

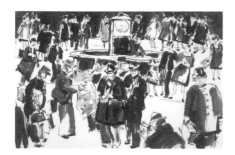

Return from the Voyage II, *1944,*
watercolour, 37.8×55.9 (14⅞×22)

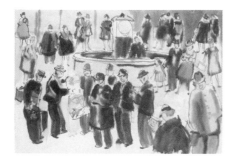

Return from the Voyage III, *1944,*
watercolour, 43.9×63.5 (17¼×25)

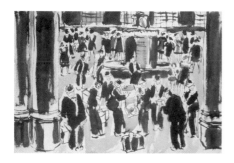

Return from the Voyage IV, *1944,*
watercolour, 38.1×55.6 (15×21⅞)

of Judgment II), and the two versions of *Signs and Symbols*, which, for the first time, clarify the division of the picture space by placing an angel on either side of the ascending Christ.

While this theme of Resurrection Day unfolded slowly in Milne's imagination – he did two other versions of it in the fall of 1943 – he maintained the usual run of paintings of flowers and landscapes. From time to time he also borrowed his son's toys to use as models for such paintings as *Duck and Flowers* and *Train I*, proving that significant paintings can spring from such commonplace sources. An element of joy, of sheer delight – such as children derive from their toys – is carried into these paintings, and relates them to the subject pictures that Milne was working on in the same period.

The cemetery now began to occur frequently as a subject in Milne's work, although always with a lurking wry humour that extended to the Grant Wood-like figures that were sketched in the first *Resurrection Day* painting. At this time, too, in the fall of 1943, Milne painted the first of the *Return from the Voyage* pictures, depicting Jonah's return to Toronto at Union Station, carrying in a transparent plastic bag the fish with which he had been travelling. Jonah is showing his fish to the curious, while a reporter scribbles notes and a photographer takes his picture. Was Milne suggesting that Toronto was Jonah's Nineveh, a great but wicked city doomed by the retribution of the Lord, to whom the signs of wickedness were there even in wartime? Or did he mean only that the conclusion of every trip was a deliverance?

Even though Milne's focus throughout most of 1943 was more on his indirect or studio subjects, the fall colours coaxed a few works from him, some of which were among the wettest and most fluid watercolours he had yet done. In November he painted four versions of *Rites of Autumn*, showing children burning leaves. Some sections of these paintings use the heavy wet process of a month earlier, but all are sonorous and rich in colour: dun gray or brown washes with powerful fiery reds painted into them. The piles of leaves, the line of children, the lighter houses, and the towering, massive trees overhead – all viewed between two huge tree trunks – is a composition of great architectonic strength, painstakingly designed but seemingly spontaneous.

The first fully realized *Ascensions* were painted in November 1943 – and versions continued to be done until mid-1947 – but Milne had begun to

Rites of Autumn I, *1943, watercolour, 37.8×55.6 (14⅞×21⅞)*

Rites of Autumn II, *1943, watercolour, 36.2×54.0 (14¼×21¼)*

think about them long before he began to draw them. All of them feature an ascending Christ, sometimes with a halo and sometimes without, flanked by angels (or not), most often hovering above a fictional landscape that has elements of the Uxbridge area, and sometimes of Palgrave. Christmas trees appear in some, and almost always the domed church that is the central fixture of *Snow in Bethlehem*. Christ sometimes shines from a dark cloud, or appears like a chimera in a sky crackling with northern lights. When at the end of 1943 Milne had made at least a dozen attempts at this subject, he wrote to Duncan that 'the Ascension still slips away. Don't know when it will be done, it may be laid aside for a while.'[44]

Where the idea for the *Ascensions* came from was never made clear. Milne probably did not really know himself, nor cared to know, but simply delighted in the miraculous evolution of a set of images into an original concept. He had doubtless seen Wyndham Lewis's *Crucifixion* drawings at the Picture Loan Society at about this time, and may have been influenced by them: the first of Lewis's works date from 1941, and they were shown at the Picture Loan Society in 1943.[45] Nevertheless, the *Ascensions* have roots in classical western art, perhaps in *The Transfiguration* of Giovanni Bellini or of Raphael. Furthermore, Blake's *Christ Appearing to His Apostles after the Resurrection* was exhibited in Toronto in 1935 and was illustrated in *Saturday Night* that year.[46] Milne had been studying reproductions of the Old Masters, and the progression from Raphael or Blake to a latter-day transfiguration would have been a plausible one for Milne.

Ascension I, 1943, watercolour, 55.6×37.8 (21⅞×14⅞)

Ascension XI, 1944, watercolour, 55.3×37.5 (21¾×14¾)

While his own work – treating themes of death, change, and spirituality – was driving him naturally toward this sort of subject, Milne was at a stage in his life and work where the inspiration of Raphael would have been warmly received and imaginatively acted upon. It would be typical of him to steal boldly from such a source and convert the idea to his own purposes and his own vision.

During the war years Duncan busied himself with exhibiting, promoting, selling, and cataloguing Milne's paintings and drypoints. He held regular shows at the Picture Loan Society, organized one for Hart House in 1943, and submitted paintings for official exhibitions of Canadian art abroad. In doing this he finally managed to double Milne's income to between $1,200 and $1,300 for the four years 1943–7, but this still allowed only a wafer-thin margin on which to exist with a family. Milne's novel subject matter, however (rather than his style, which was relatively constant throughout the Uxbridge period), made his paintings difficult to sell. Potential purchasers had become accustomed to his northern landscapes and flower paintings and, to judge from sales, were slow to show interest in his subject paintings. Further, his earlier work at Palgrave and Six Mile Lake had been mostly in the much more commercially viable medium of oil on canvas. Nevertheless, Milne's production was even and prolific at about seventy to eighty or more paintings a year.[47]

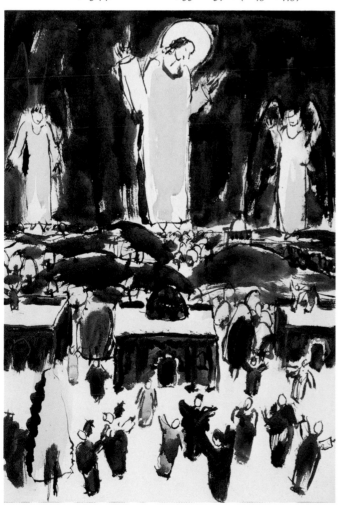

Ascension xv, *1944, watercolour, 55.6×37.8 (21⅞×14⅞)*

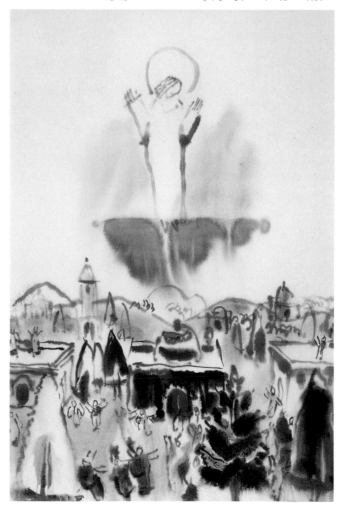

Ascension xxi, *c. 1945, watercolour, 54.9×37.2, (21⅝×14⅝)*

Canadian Flag Designs I, 1944,
watercolour, 25.4×35.6 (10×14)

This period included the relatively brief residence in Toronto of the English painter and writer Wyndham Lewis. He and his wife moved from England to Toronto in December 1940, and stayed at the Tudor Hotel on Sherbourne Street, recommended to them by Duncan, who showed Lewis's work, bought it for himself, sold it to others, and suggested portrait opportunities to Lewis. Although Milne also stayed at the Tudor, briefly in 1941, there is no evidence that he and Lewis ever met. In 1943 Duncan wrote to Milne: 'I particularly want Wyndham Lewis to meet you: he is an intelligent admirer. It would give him pleasure; and in the long run might not be without repercussions when he returns to England.'[48] Lewis knew of and envied Milne's special relationship to Duncan. In a letter to a potential British patron he wrote (and then cancelled): 'Duncan has great admiration for Milne ... and has dedicated himself among other things to keeping Milne going and trying to get his works known...The gist of it is that I am afraid I cannot rely on Duncan for much more help as he has Milne to keep.'[49] Duncan showed Milne's work to Lewis in 1941 and he had been 'most enthusiastic.'[50] Lewis once wrote about Milne's paintings: 'The drawings of David Milne would attract great interest, anywhere that visual expression was appreciated. The finest of Milne's watercolours are unique achievements in their way. I wish specimens of the very best of these painters could be seen in Europe. Jackson, Milne, and Schaefer would make a powerful trio.'[51]

Duncan attempted – at first promisingly, and then unsuccessfully – to interest Curt Valentin of the Buchholz Gallery in New York in Milne's work. Plans for a National Film Board production on Milne and his painting, which Graham McInnes wanted to make, were also stalled. Duncan, an excellent photographer, made better progress in cataloguing and photographing Milne's paintings; he made several hundred tiny photographs and began the process of sticking them on large, gray, squared-off cards, sorting them in chronological order. He also entered Milne's work into various society and other exhibitions throughout this period. More visibility came as the result of an invitation to Milne in 1945 to design a cover for a special Canadian issue of the London publication *Studio*, which he did with efficiency and flair.[52] Using the composition of a recent painting of a young maple tree, he gave the design a heraldic treatment that was both striking and highly suitable.

As the war drew to an end and there was the prospect of better and more normal times, Milne's work continued on as usual and his position in the Canadian art world was increasingly recognized. In the summer or fall of 1945 Milne drew and painted about thirty designs for a Canadian flag. The idea had come to him while he was doing the *Studio* commission. Milne's flag designs were efficient and bracing, the references to Britain and the crown were strong, and the red maple leaf was always the centre piece. After the many stylizations the maple leaf was later subjected to, Milne's design still stands as one of the happiest, with its muscular yet graceful shape, owing something to the tripartite white lily of Quebec, resting comfortably between heraldic emblem and inviting realism. Milne forwarded his hopeful prototypes to an unknown government department, but they were returned without comment.

On the marketing front Duncan mapped a strategic plan in his mind and, with careful insistence, attempted to persuade the National Gallery of Canada and the Art Gallery of Toronto to purchase Milne's work. In March 1945 he wrote to H.O. McCurry, the director of the National Gallery, in forthright terms:

Canadian Flag Designs IX, 1944,
watercolour, 25.4×35.6 (10×14)

Canadian Flag Designs X, 1944,
watercolour, 12.7×17.2 (5×6¾)

Is the Gallery willing to dig up $500 for that picture [*Boston Corners*]? It was painted in December, 1917, twenty-seven years ago. It is twenty-one years since the Gallery has shown any interest in acquiring anything of Milne's except some drypoints. 'It is later than you think'.

This belated desire to achieve a fine Milne representation is dislocating some of my patiently calculated long-range planning, and has put me into a state of considerable mental confusion, as between Milne's financial interests and those of the Gallery. I felt very hampered over the 'Rites of Autumn' because of the expense you had voluntarily put yourself to, over the colour plates [allowing it to be reproduced in colour in *Canadian Art*, April–May 1945, p. 165] – a gesture that, I know, pleased Milne very much. And in this case I feel that the National Gallery should have this picture. If it is intelligent enough to want it now, in 1945, it shouldn't be held up for a 1955 or 1965 price, which I have firmly decided any one else WILL be, on that particular picture.

As I told you over the phone, I have sometimes bought what I consider strategic Milnes, beyond what I could, or should, hope to keep – buying them at prices as high as, or higher than, I can conveniently get at the moment, allowing them thus to be seen, without having to turn down another purchaser, keeping full control over their final destination and yet providing a reasonable amount of cash in the meantime. By his own volition, Milne has been sufficiently taken advantage of in the past, for me to determine that it shall be otherwise in the future.

... The 1917 canvas [*Boston Corners*] ... is the key picture of the pre-War-Memorials lot, one of the few larger ones, and much the finest ... I have tested it on a few of the most discriminating people I know here, and have been pleased to have my opinion confirmed. Even if you hadn't reacted in the same way, I might still have given the Gallery another chance in ten years, knowing that in any case I could get for Milne a very much greater price then from anyone. The price I have quoted now is a token compromise – mostly, I'm afraid, to the advantage of the Gallery. It's absurd to realize that it's the current price of a pair of good 8×10 Thomson sketches. I think I would have no difficulty in selling it here, now, for $400. If you feel that the extra hundred is an unreasonable hold-up, you can try waiting, a few more years: blackmail, quite open, but at least on a modest scale![53]

This initiative of Duncan's pleased Milne, especially since the gallery did acquire *Rites of Autumn* for $150 and the *Boston Corners* oil for $450, the most Milne ever received for a painting in his lifetime. But he had qualms about his rather large inventory of paintings, instilled by the examples of the estates of J.W. Beatty and Emily Carr, whose executors had spilled works onto the market to pay taxes. Milne feared that at his death his paintings would not benefit his family but rather that taxes due on the deemed value of his inventory would plunge his estate into debt. While in 1934 he had wanted to keep his work together, it now seemed clear to him that the only responsible course was to sell as much as possible. Milne was vexed whenever Duncan mentioned 'holding back' paintings for public galleries or for his own collection (meanwhile not paying for them), and this contentious issue eventually caused a rupture in their relationship.

Duncan and Milne shared one belief about the several versions of nearly every subject Milne undertook. Both – but particularly Duncan – believed that one collector might be offended to know that another collector had a work that was almost identical. Milne had cautioned Alice Massey about this in 1938.[54] This is now a curious tenet; but even in Milne's time it is strange to find it counting so heavily in the process of sorting, eliminating,

or cancelling the many paintings that had been done in more than one variation. At this time and later Duncan's policy was to maintain diversity by destroying variants ruthlessly.

This attitude toward his own work was consistent with Milne's view of his drypoints. In these he worked through many inkings and combinations of plates, looking for the optimum print: once he found it, he was content to let the matter rest. Running an edition was journeyman work after that, and the various states, stages, and variations encountered on the way to the final print seemed to him to be curiosities of little worth and were never considered definitive.

In June 1946 Duncan was able to set aside his aesthetic concerns long enough to ask Milne to perform the distasteful task of signing a large number of the earlier oils that Duncan held in stock. In this massive signing spree paintings from New York through to current production were included. Milne, as usual, was reluctant, but at nine o'clock one morning Duncan shut him in the stockroom of the Picture Loan Society. At noon Milne emerged, pleased with having had the opportunity to look over his old pictures – but he hadn't signed a single one.[55] After a persuasive lunch Duncan pushed him back into the room to get on with his chore, but the perfunctory way in which Milne signed many paintings – 'MILNE' in coarse square letters, injudiciously placed in many cases – indicated his contempt for the whole exercise. In several subsequent works Milne had his revenge on Duncan by disguising or hiding his signature or the date.

Milne wrote fewer letters during the 1940s than formerly. Indeed, intimate letters about his painting became rarer as the years went by, indicating a diminution of his need to describe in letters his innermost thoughts about the work he was doing, and other attendant problems. This was no doubt because Kathleen provided a willing and sympathetic ear as he talked daily about his painting. And of course she frequently summarized his comments in her diary.

Perhaps by way of compensation, Milne began to write short essays about particular paintings: *Noah and the Ark, Supper at Bethany, Snow in Bethlehem,* and the playing-card series. He also wrote essays about particular aspects of his work, about the annual flower picture, about his method of producing colour drypoints, and the various devices revealed in, and the ideas behind, his paintings. In February 1943 he wrote to Duncan that he had in mind publishing a periodic limited-edition newsletter, possibly including drawings and drypoints, for a coterie of subscribing collectors, thinking that this project might free him from having to depend on chance sales.[56] The idea was never developed; but the essays written in preparation for it, such as those cited above, are a useful aid in understanding Milne's intentions, and may have spurred him to write his autobiographical essays in 1947.

In October 1946 Kathleen resumed her daily notes documenting Milne's drive and dedication. For these she obviously relied heavily upon Milne's own comments and descriptions. She occasionally quoted Milne's reaction to a work, or his intentions for further treatment of a painting:

Oct. 31 Waterfront picture, coal piles, smoke stack, buildings. Done on wet paper – colour mostly green – blue grey. Drawing slight, loose, simple. Sky, smoke, cloud & foreground treated alike. Interest achieved by use of slight line, small areas of colour (red and blue) and areas of washed-over white. Effect soft & delicate. May be done again. Was done twice today.

Nov. 1/46 Painted Waterfront picture again. Drew Scaffolding.

Nov. 2/46 Scaffolding picture drawn yesterday. A night picture scene – Toronto street, stores, one fronted with scaffolding. Tall building vaguely shown in the upper background. Ground dark grey with small areas washed over white. Detail drawn in bright colours – red, green, black & some yellow.

(D.B.) 'It is still a little confused and noisy. Uses a slightly different grey – cerulean blue & van dyke brown instead of the usual french ultra-marine & brown. Has a rather more greenish tinge. Is a little spotty – particularly on the left – scaffolding could be a little more definite (dryer paper) and sky a little quieter.' The effect of dark washed-over ground & thin bright lines is strong & sparkling. Scaffolding 1st. version [i.e. next painting]. Composition much the same but ground black instead of grey. Harder, dryer & very hot.[57]

Kathleen's notes on Milne's paintings are a rich mine of information and reporting, describing how Milne really worked as he sometimes worried one picture along for several days, sometimes skipping to another subject or to another medium, then returning to an earlier problem. One pattern that he often repeated was that of drawing a work and thinking about it, and then painting it the next day. Whether the execution satisfied him or not, the contemplation of what was to be done, the sequence of stages in the actual painting, and the thinking out of each detail were for Milne as important to the creation of a painting as they had been thirty years earlier. The process was no different for his fantasies than for his other work: the degree of objective detachment and his aesthetic engagement seemed about the same for both.

Milne wrote to Duncan in 1944 that he was 'still cursed with the perfectionist's idea – painting over and over.'[58] The first half of the year was almost entirely devoted to repaintings of subjects already done in first draft: the *Ascension* series, Palgrave in watercolour, the playing cards, the Eaton's catalogue series, and Jonah. Having dispatched *Shrine and Saints* and *The Saint* (which was also tried in oils) to Duncan, he then asked for photographs of them to study. Later he complained to Schaefer that he was squandering energy on 'too much painting over, sometimes watercolours painted over eight or ten times,' and that he was beset with difficulties in the execution of specific works. He had done, for example, 'innumerable Ascensions this winter ... but no one successful enough to let go.'[59]

An imaginative device that animated a few pictures before it was unceremoniously dropped was the idea of propping a picture behind a glass frame and then painting the whole composition, a sort of picture within a picture. This interior framing, seen in *Frame and Glass*, was another in Milne's visual-image games, a means of creating several layers of perception and ambiguity. The glare on the glass serves as both a dazzle area and an interruption – elements that both intrigue and excite the viewer. Milne attempted the same conceit with one of the Eaton's catalogue paintings, although with less success; and one of the playing-card paintings that was handled in this way was finally cut up by Duncan and sold in sections.

In the fall of 1944, when Milne ventured to Coboconk for his annual fall camping trip, he was determined to work solely in oils and carried adequate supplies. For seven years his production in oil had been desultory and spasmodic, frequently unsuccessful and time-consuming. With this last concentration on the medium Milne's method in oil underwent

an abrupt change of character – but then proceeded without significant change until it was dropped altogether early in 1947. The most obvious aspect of these works (there are only eight of them) is the jerky drawing of the shapes in black and white, and a disregard for finish or refinement that substantially exceeds the 'rough' painting of Palgrave and Six Mile Lake. A typical example is *Earth, Sky, and Water I* – although when Milne returned to Uxbridge he repainted it in watercolour, and produced a much finer work than the original in oil. Compositionally these paintings are all competent, taut, and balanced, but the execution looks scruffy and careless, and the thought behind them is hard to detect. The amount of detail is disparate and uncomfortable and seems finicky without having a point. Several of these oils are of still lifes of the forest floor, with bracken, mushrooms, leaves, and other uninteresting debris. Two other characteristics owe something to Milne's watercolour techniques. First, the oil was applied very thinly so that often the canvas breathes through; more tellingly, the colours run into each other accidentally. The palette, instead of being limited, was amplified, as if Milne were moving toward plenitude, an all-encompassing view, rather than adhering to the spartan minimum he had favoured in the past. When he returned from Coboconk to Uxbridge in October he had developed enough momentum to attempt, with some success, a few oils of Uxbridge subjects, and the 1944 Coboconk subjects popped up through the spring and summer of 1945 in over a dozen paintings. But Milne's attention was mainly taken up by watercolour as soon as he got home.

Milne's first major preoccupation of 1945 was *Mary and Martha*, the supper at Bethany celebrating Lazarus's return from death. Milne had first thought of the subject in 1938, but its revival coincided with news of the deaths of two of his brothers, and of Emily Carr, and the selling off of the estate holdings of the painter J.W. Beatty. It also came uncannily close in time to a pencil sketch Milne had done in Coboconk in 1944 for a painting called *Funeral in October I*, an autumn scene of the Coboconk cemetery during a funeral service. Ironically, Patsy had alarmed Clarke in late 1945 by (mistakenly) reporting the death of a David Milne in Toronto, and when Milne heard about this from Clarke he instructed Duncan to inform Clarke (so that Clarke could reassure Patsy) that, like Lazarus, he was still very much alive.[60] In addition to the *Ascensions* and the Jonahs, with their unequivocal if symbolic references to death, Milne did several paintings of a widow in a cemetery with such satiric titles as *r.i.p.* and *In Loving Memory*. With his usual bantering sarcasm he suggested to Duncan that a further title might be *There, Damn You*. He injected humour into these subjects, thus keeping them from slipping over into the macabre; but the intimations of death they harboured were profoundly real to him.

The painting of the *Supper at Bethany* (Duncan called it *Mary and Martha* for some reason, perhaps thinking that it would sell more easily) consumed more than a month at the outset of 1945. Milne's first concern was with the groupings of the many figures, and the subtle contrasts of colours. He did a detailed charcoal drawing before painting it. After careful scrutiny, he painted it twice more, making changes that appear small and unimportant, such as taking out a chair, straightening a figure slightly here, or marginally fortifying a colour there. He then painted it at least twice more. At first the lone figure on the left, gazing meditatively at a painting, was intended to be one of the disciples. His separation from the others, however, reminded Milne of Christ, so he endowed him with a halo and made him the ultimate art connoisseur. Everyone else is doing what is normal –

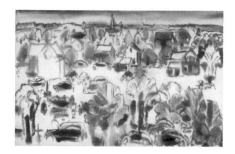

Funeral in October II, *1945, water-colour, 36.9×54.6 (14½×21½)*

chatting, telling stories, visiting with each other. What transforms the picture from a 'commonplace everyday supper party of undistinguished-looking people in present day clothes'[61] into an extraordinary pictorial statement of symbolic importance is the awareness of the people in it of being in the presence of Christ – after having seen Him raise Lazarus from death. The angels hovering near the ceiling, while difficult to mould into a pictorial unit, added an element of celestial intercession to this 'everyday' idea. Milne thought of Lazarus as 'still feeble but telling a story,'[62] while one of the disciples laughed at its humour. All the extant versions of this subject are in subdued colours applied very wet, a process that made it imperative for Milne to know exactly where each form went and how much paint to use, and to paint with unwavering certainty and speed.

Both the technique and the subject matter of *Mary and Martha* must have had some connection in Milne's mind with the *Ascension* series, for his pursuit of that subject was renewed once more, though briefly. The late winter and spring of 1945 were spent repainting fall pictures. There were several appealing night scenes of Uxbridge in the grip of winter; the Brock/Main Street subject was revived in *Green Car* and *Spring across the Way*; and still the *Ascensions* continued, now with the figure of Christ considerably reduced and the sky given more emphasis. In July and August the summer profusion of flowers drew forth a few rich and vigorous flower pictures in both oil and watercolour, such as *Penguin and Nasturtiums I* and *Monkey and Tiger Lilies*, although these perhaps lacked the tenderness and delicacy to be found in those of a year earlier or a year later. They hold up a bristly and busy face by comparison, but none are without merit. The same was true of the paintings produced from a productive trip to Coboconk in the fall of 1945, when Milne again stayed on for an extra three weeks by himself after Kathleen and little David, now four years old, had returned home.

The most noticeable change in the paintings of 1946 occurred not in method or technique but in subject matter. Milne returned to the direct painting of landscapes and flowers done in the studio, where repainting also continued. His impulse to do the fantasy pictures temporarily died – apart from the *Ascensions*, which he worked on until April 1947 – and they did not figure again in his work until five years later.

While the energetic inspiration of the landscape is abundantly evident

Mary and Martha III, *3 February 1945, watercolour, 38.1×54.6 (15×21½)*

Mary and Martha IV, *1945, watercolour, 54.6×69.9 (21½×27½)*

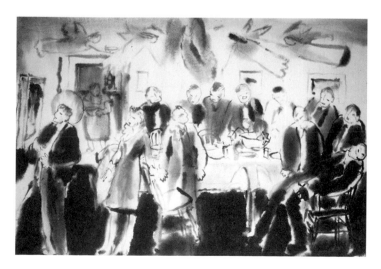

in such paintings as the *Hill Poles* and *Stump Fence* series, the year's en-
chantment was drawn from flowers. Even the marvellous bursts of flower
painting in 1935 and 1939 are surpassed by the power and sensuousness
of the 1946 work. Early in the year Milne twice repainted the *Poppies and
Lilies* of 1944. The new paintings easily equalled the originals, and when
the poppy season arrived in May, Milne produced *Candy Basket*, with an
opulent array of reds and languid browns, in both the oil and watercolour
versions. As Milne once wrote from Temagami, flowers were often an
excuse to have vases and water to capture and reflect light. That summer
the red vase from *Poppies and Lilies* was used several times, painted brown,
gray, black, green, and mauve. Abandoning rigorous economy, Milne al-
lowed a flood of opulence to permeate his work, producing an all-over
pattern that accounts for the ornate and plushy backgrounds in the *Radio*
series of five works done in May and August. The paint was applied with
supersaturated wetness, and the drawing is free and simple; but most of
all the colours pulse and flow with inspiration. In earlier works the black
and white areas acted as the combatants in Milne's pictorial duels, with
colours playing the seconds. But now he pushed colours to the fore, the
gray scale merely building toward the explosion of colour – and the range
of colours is immense. Throughout his life Milne had staunchly believed
that 'harmonizing and contrasting colours' were 'a physical, not an
aesthetic classification, [and] of minor importance in painting.'[63] In his
view the idea of considering that two colours did or did not look well
together was absurd. His intrepid use of new colour combinations through-
out the 1940s was yet another sign of the creative courage that drove him
to new fields. To appreciate the degree to which Milne achieved original
colour combinations, one has only to look at the watercolours he painted
in 1946 in a full, strong light: they fairly dance with energy and irrepressible
confidence.

Penguin and Nasturtiums I, *1945, oil, 46.1×55.9 (18¼×22)*

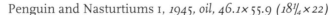

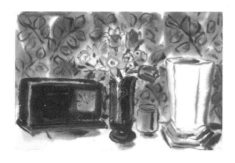

Radio with Tulips, *1946, watercolour,*
36.2×54.3 (14¼×21⅜)

Among these paintings, the superb *White Poppy* is especially alluring because it is one of Milne's painting-place pictures. The tubes and brushes, the pail of water, and the charcoal boxes that surround the vase and bouquet draw attention in a symbolic way to the artistic process, describing the function of the imagination and expressing the state of grace that art represents. The prominence given to flowers was not fortuitous. Milne liked flowers, and thought of them as a simple source of pleasure. They were allied in his mind with artists and art because art too was not essential to life (defined by him as existence), but rather an ornament to any life that wanted the thrill of aesthetic experience. 'I think artists are just naturally useless,' Milne wrote to Duncan,[64] and these works that bring together the 'useless' flowers with the materials of the 'useless' artist reinforce the spiritual importance that Milne felt both have in the lives and affairs of people.

Another proof of Milne's success in 1946 is his return to oils. Using the same subjects in which he had succeeded so brilliantly in watercolour, he found that he could at last paint them in oil, and without the hesitation and uncertainty that had plagued him in that medium for nearly ten years. Although the richness of watercolour on wet paper is impossible to translate to another medium, Milne nevertheless found that the concentrated force of his subjects, with the same range of hues – vibrant browns, the panoply of reds, tangerine orange, and Prussian blue – could be nearly as forcefully expressed in oil. Good examples are *Work Table* and *Sweet Peas and Poppies.*

White Poppy, *1946, watercolour, 36.2×54.3 (14¼×21⅜)*

The Pool, Little Bob Lake II, *1946,*
watercolour, 36.2×53.3 (14¼×21)

The concerns that dominated Milne's work in the fall of 1946 are to be found in the watercolours of three subjects: *The Pool, Little Bob Lake*, from his Coboconk trip that fall; the *Scaffolding* series, from a sketch of buildings, one under a scaffold, made on Toronto's Yonge Street at the end of October; and the *Ascension* series, to which he returned. These were attempted at least fifteen times in December alone. *The Pool* as a subject was both new and old. The idea behind the painting echoed a familiar theme – a return to the *Outlet of the Pond* compositions of 1926 and 1938, the drypoint *Still Water and Fish,* and the watercolour *Still Water*, done in 1941. But Milne's handling of the theme in 1946 was fresh – the drawing in gray and the lightly applied hues of scarlet and lemon yellow were an attempt to do more with the contrast of real trees and their reflections, and to develop more meticulously than before the contrast of fine and coarse lines. Milne returned to a yellow wash that he had used several years earlier, in *Lemon Lilies* for example, although somewhat lightened – an excellent example of the way colour solutions for one work were adapted by him for use in another. The same interplay is evident in the *Scaffolding* paintings and in most of the rejected *Ascensions* of this period, where the wet dark brown wash from the summer was used again. The *Scaffolding* subject was finally committed to oil in January in 1947 (*Scaffolding VII*); and the *Ascensions* – with all their windings and swervings, and all the experiments and unfinished attempts – were finally concluded in mid-April 1947 with a large full-sheet watercolour, *Ascension XXXIII*.

Milne's idea that many paintings of a subject in watercolour would inevitably lead to a final, perfect painting (probably in oil) was a change from his earlier goal of producing series of pictures that were related. And his continual attempts to return to painting in oils, even though few were successful, inexpicably diminished his regard for his watercolours. He wrote to Duncan that he would 'keep all versions [of watercolours] for you. However, I think there is no reason for saving them after you see them – not versions, just unsuccessful attempts.'[65] While his progress from version to version was of great interest to him, he now seemed prepared to sacrifice the cumulative impact of variations. This had a tendency to frustrate his achievement if he failed to fulfil his goal, and to crimp his production because he tended to be more severe with himself than he needed to be. Duncan certainly exacerbated Milne's tendency toward ruthlessness, and

Scaffolding I, *1946, watercolour, 36.2×54.6 (14¼×21½)*

Fair in the Park, *1947, watercolour, 36.2×54.0 (14¼×21¼)*

Open Door, 1947, *watercolour,*
36.5×54.6 (14⅜×21½)

Milne's faltering production in oils may be a result of simply trying too hard and expecting more than was reasonable.

His secluded life in Uxbridge meant that Milne could not take much part in the cultivation of his reputation, even if he had wanted to. Although his forte was obviously not the distribution or selling of his work, success clearly depended on more than just making good paintings – as Milne's career had thus far amply proved. To compound matters, the art market during the war years was especially fragile. Apart from food rationing, to which everyone was subject, Milne was quite surly about being able to procure only a coarse, low-grade Italian watercolour paper rather than the fine handmade French, Italian, or English papers he was used to. Duncan, through his purchases and sales, provided a steady flow of income, but Milne had not used his new revenues to lay in a substantial store of paper against the shortages of wartime. That was a minor inconvenience, however, compared to the chill affecting most cultural activities during the war. Art had no place in the limelight. At one point in 1943 Milne threatened to take a job in a munitions factory at nearby Ajax.[66] This drastic measure – which would have halted or wrecked his painting – may have been simply a gambit to entice Duncan to work a little harder for him. But to his credit Duncan, with his growing stature as a discriminating collector and dealer, kept Milne afloat with sales to a small but widening circle of contacts. He helped to make Milne a 'wanted' artist by carefully placing his work in major institutions and with leading patrons.

In 1946, when he was sixty-four, Milne was beginning to be conscious of his age, although his health was robust and his disposition positive. His sense of time running out led him, in early 1947, to write nine chapters, or sections, for an autobiography – an indication that his sense of self-worth had not diminished. This unfinished legacy is nearly two hundred typed pages in length. In it Milne recalled the various places where he had painted, what they had meant to him and to his work, and some of this thoughts about his painting. The sequence in which it is written is odd and perhaps wholly adventitious: Alander, Six Mile Lake – he had built one-man cabins at both these locations – his army service and work for the War Records, Dart's Lake, Mount Riga, Boston Corners, Ottawa, and New York. A few important parts of his life were not commented on – Big Moose Lake,

The Green Vase, *1947, watercolour, 36.2×54.3*
(14¼×21⅜)

Flowers and Candlesticks, *1947, watercolour, 36.2×54.6*
(14¼×21½)

Lake Placid, Temagami, and Palgrave, places where his marriage was deteriorating toward separation. Milne's writing, although straightforward, was never revised or edited. Consequently what it holds in interest is partly lost in the lack of balance and polish. There are lengthy digressions, for example, about Rattlesnake Pete's Six Mile Lake sugar bush and about Scotty Angus. The war-service section is nearly as long as all the others combined, and proves what an indelible experience it was for Milne. References to painting are general and illuminate Milne's retrospective thought rather than specific works. With his usual diffidence Milne described this extensive material to Duncan as 'pretty dry and unimportant stuff, with little of the exciting quality many of the things had for me.'[67]

Through the spring and summer of 1947 Milne painted steadily if more slowly than before. By the end of August he had accumulated about forty still lifes and Uxbridge landscapes. Such watercolours as *The Green Vase* and *Flowers and Candlesticks* punctuate the period with their richness, and prove that the quality of his work had not tailed off, even if the quantity had diminished. Milne's palette was also stretching to a dozen hues by this time, each given a place to shine, whereas he had previously tended to restrict his palette or to subdue certain colours. In the background of works like *Open Door, 1947* colours are perfused across the wall to enrich what earlier would have been a neutral or value area. A new casualness can be seen in *Elm Logs* and *Fair in the Park*, where blotches of colour seem to be cast carelessly onto the paper.

The frequently recurring theme of death in his subject paintings, particularly in the *Ascension* series, indicated a new tension and concern in Milne's life. From now on a sense of urgency in his work was never long absent. The astonishing push from the spring of 1946 to the end of that year and into the summer of 1947 was the last steady and sustained drive of Milne's career. The seventy-odd works of this period were the final high-water mark of his productivity. But despite these achievements, there was little advancement in Milne's thought. In order to jolt himself out of what had become routine, and to refresh his mind and his eyes, Milne decided, almost compulsively, that he had to transplant himself once again. In the late summer of 1947 Milne stopped painting and set out to find a new painting place. From the moment that he began to divide his time between his home in Uxbridge and his new painting ground, Milne's production began to decline.

CHAPTER FIFTEEN # Leaves in the Wind
Baptiste Lake
1947–1953

After seven years at Uxbridge Milne was impatient to move on. In September 1947 he wrote to Duncan that he was looking for a place for his family for the following summer,[1] but in fact he was searching for a new place to live and paint: Uxbridge had gone stale for him. 'Uxbridge never was much for direct painting except for flowers and still life, both of which have gone a bit thin,' he wrote to Duncan.[2] Despite his strong ties to his family, Milne wanted once more to be alone. This pattern of withdrawal had recurred throughout his life, and it is not surprising that it appeared yet again. Milne knew that concentrating solely on art, not on distracting issues raised by Duncan, not even on life with his family, was what he needed to feel comfortable with himself. He had a few minor health problems that he thought might vanish if he could relocate and live a simple, uncluttered life devoted only to his painting, with perhaps a little outdoor work.

In early September Milne boarded a train in Lindsay, Ontario, and travelled east through Fenelon Falls, Burnt River, Kinmount, Irondale, Gooderham, Tory Hill, and Cheddar, to Baptiste, a whistle stop on Baptiste Lake, thirteen kilometres (eight miles) west of the town of Bancroft, and 220 kilometres (135 miles) northeast of Toronto. This region, immediately south of Algonquin Park, is not dissimilar in aspect to the area around Six Mile Lake. Looking out the train window Milne found the countryside 'very fine – high and rough.'[3] On his first trip he went through Baptiste and spent his first night in Bancroft, where he found the hotels full, as he wrote to Kathleen:

Had a hard job to get a place to stay – an unbelievably poor (and interesting) boarding house ... Switzer's boarding house. It looked shabby, and was. Some of the boarders sat in front, a policeman in an armchair beside the door ... I knew the policeman at the door was a bad sign – trouble past, present or future, but I had to find a place for the night. The landlord and his wife and a small boy, very dirty & sleepy, were inside. They had no single rooms but offered a bed in a two-bed room, $1.20 for bed and breakfast. Said the man in the other bed was a steady boarder, carpenter working on the new high school. The people were friendly enough but the place was unbelievably shabby. The stair steps were worn almost through and unswept. The stair rail had no spindles, it was held up by a piece of rope. I left my knapsack and went in search of supper. I got a pork sandwich, coffee and pie at a Chinese restaurant, a hangout for the younger and lower set. The customers all seemed to be in their teens. The food was alright and the place seemed clean. Back to the boarding house – the landlord showed me the toilet – out at the front door then round to a corner of the back yard, no

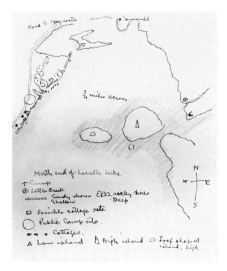

*Milne's map of Baptiste Lake, 1947, ink
and pencil, 28 × 21.6 (11 × 8½)*

light. Then I went upstairs. The carpenter was in bed but not asleep. The
bedclothes on the two beds were unbelievably worn and shabby, but there were
clean sheets. I put my pants under the pillow to protect my money, in case the
carpenter didn't turn out well. He seemed to have done the same, not sure that
his roommate would be reliable. I could see some letters sticking out under his
pillow. He lit a cigarette after the light was out and we talked for quite a while.
He was from Arnprior, a veteran of the last war, 39. He had a family of 6 boys
and one girl, the oldest ten, that's what he did in the war. He was in a low
category and didn't get overseas. I think he was putting up with the boarding
house to save money and keep the big family going. I asked about the police-
man at the door. He said that earlier in the evening a drunk had been disorderly,
he thought the policeman was there to see that he didn't get loose on the streets.
The night before a man had come in drunk and fallen down stairs. He was dead
and there had been an inquest that day. I wasn't very sleepy then. After a while
the man went to sleep, but coughed and made grinding noises with his teeth.
Toward morning I must have slept. Someone knocked, the carpenter said it
must be six o'clock. I got up too and shaved, then washed at the sink in the front
room of the place, water dipped from a pail. The carpenters were mostly
through breakfast by that time and away. I went in for mine, not bad, corn
flakes, two fried eggs, bread and butter and coffee. Evidently the place excels in
cooking and is a bit bad in housekeeping. The landlord was having his break-
fast, black coffee and a big chunk of boiled pork with lots of fat, over a pound –
nothing else. He was very friendly, offered to drive me over to the Lands and
Forests place, but I didn't wait. I mailed your letter at the post office and then
walked over to the government office. Got all the information I could use, then
came back. No train back to Baptiste and since it looked like rain, decided to get
a taxi to take me over, 8 miles $2.50. Very fine high country on the way, nothing
to be seen at Baptiste except a good store and a telegraph office and the one-
room station or storehouse, and a landing pier, and some summer places, a
small summer hotel. When you write put Baptiste, Ont. It seems there are
others in Quebec and mail sometimes goes astray.[4]

When he returned to Baptiste to explore the lake, he found that birds
and wildlife were plentiful and that the lake had a dam and a convenient
sawmill. After a brief circuit by canoe Milne settled on a point on the unin-
habited east shore of Baptiste Lake on La Valle Lake, a large bay opening to
the east through a narrows:

Then I saw this point and landed. It seems pretty good for me and I shall
probably stay here ... there is a little bay at one side, choked with driftwood, lots
of pine and stumps for fuel ... the view northwest rather good, mountain-shaped
hills (that I went to today) across the water beyond the big island. Today from
the far side it looked like a big green thunder cloud ... I think the summer
cottage up here is a good idea and should be decided on now so it could be built
when we are up next summer.[5]

From the point Milne reconnoitred the crown land nearby. A stone's throw
away, Hickey's Creek flowed into the lake and next to it was a flat area, a
potential cabin site. A little further along on the same lot, higher above the
lake and deeper into the trees, was another good spot. It was this site that
Milne bought for $10 from the Department of Lands and Forests shortly
after seeing it, so that he could build a log cabin there the following year.
He wrote to Duncan that the prospect of moving his studio to Baptiste was

'many years too late. It's a cure now. It would have been a prevention earlier.'[6] His relocation was supported by Kathleen. She saw it as a 'sign he'd become his own man again. When he left Uxbridge and built the cabin ... that was when I figured ... that he'd got himself together enough [so] he could be away again ... One of things we had in common [was] that we could get along alone.'[7]

The first Baptiste Lake painting of this trip, on which Duncan unfortunately scrawled 'Cancelled,' is the view from the point toward Blueberry Island – or High Island, as it is called in the many pictures that followed. The limpid azure-blue wash in the sky, the saturated colour, and the ungainly but original drawing of the clouds and landforms celebrate some of the magic the location held for Milne over the next few years. During the month or so that he was there in 1947 Milne stocked his artistic larder with numerous drawings, and from that time on he did practically no paintings of Uxbridge or its environs: the paintings of the winter of 1947–8, with very few exceptions, were from sketches made at Baptiste Lake. Milne had found the new place he needed to carry on his work.

But painting did not come easily, as it had generally done in the past. Although he kept himself busy, the amount of actual work Milne produced was below his standards of recent years. He found that out of doors he could only sketch in pencil, and he could paint only in his 'shelter' (or later back at his studio at Uxbridge). Increasingly he found sustained concentration difficult, and his painting time each day dwindled to two or three hours. Nearly every day Milne wrote to Kathleen to report on his chores, trips, and observations.

Made a couple of sketches from the top [of a hill] and another of the sky when I came home, but didn't get any painting done. The afternoons seem to be filled up with chores. Getting more wood and bracken. Finding a piece of iron and heating it and fixing the canoe with cement when a cut had re-opened and

High Island, 1947, *watercolour, 30.5 × 40.7 (12 × 16), 'cancelled' by Duncan*

leaked a little. Shaving and taking a bath in the shelter with hot water. Putting towel and handkerchief to soak. Looking over the drawings ... Had another good night's sleep last night, though it took a while to get my back warm. This morning when I woke there was a golden fog, the sun behind the vapour above the lake, couldn't see any shores.[8]

As he explored the country around the lake on foot and by canoe, he also sketched in pencil – natural phenomena, such as sunsets, sundogs, and other striking features of the weather:

For ten minutes the storm was a wild one. All day it has been cloudy and showery, with sudden gusts that bent the birches and even the spruces until it seemed they would break off. About the middle of the afternoon I was sitting on a rock behind and higher up than the shelter, so I could see out over the lake. The sky blue gray and the water slatey with whitecaps. The wind was shifting a little to the southwest. I thought I heard dull thunder to the northwest. I wasn't sure, it might be the booming of the driftwood washed by the waves. I had just finished the drawing when I noticed the sky changing. Both sky and water got darker than the tree-covered hills, giving an unusual look. I made a few notes of the colour.[9]

Never taciturn in his letters to Kathleen, he included odd events:

I was having some sort of mind dream, was beside a stream – not this kind of country but more open. Then I felt earthquake shocks, a number of them. As I was speculating about the earthquakes I could feel myself struggling back from sleep. Just as I awoke I heard a loud banging. I decided that the earthquake mightn't be real but the banging was, so I lit the lantern, put on my shoes and rain coat and went to look. In the evening I had been cooking the meat and when I went to bed left it on the stove. I thought maybe some animal, attracted by the odours, had got his feet burnt or at least too warm. I expected to see the whole place in ruins. But all was whole and peaceful, the meat still on the fire. I hung it up from one of the shelter poles and went back to bed. I still don't know anything about the earthquake except that – real or imaginary – it was a good one.[10]

And there was always a special anecdote for David Jr, usually about birds or porcupines. Sometimes he wrote whole letters to his son:

In the shelter, just after dark,
You are probably in bed now

Dear David,
 Last night I forgot to put a cover on the jam jar, there was only a little in it anyhow. This morning when I was lighting the fire I looked up and there was a mouse in the jam. He was standing up pawing the glass trying to get out, but the glass was too slippery. His feet had jam on them, his nose and whiskers were sticky with it. I left him until I had finished lighting the fire. By that time he was quiet, sitting down in the jam with his eyes closed. I suppose he was tired, maybe had been in there all night. I took him up outside and let him out. He ran away quickly and hid under a rock then ran out and hid under another rock down by the water, he may have been going to take a bath, though I think he would rather lick himself clean. In a little while he probably forgot all about being caught in the jar, just thought, wasn't that nice raspberry jam I tasted.

Letters from Milne to David Jr,
c. 29 May 1945 and October 1947

Very nice pictures in [your] last letter, grader across the road and things. I will make one for you of the mouse in the jam. This morning when I was standing on the rock I saw 1 heron, 3 ducks and two loons on the water out in front of me.

Mother says you have been doing some gardening, pumpkins & melons and such things. I will have a lot to see and hear about when I get home.

Mother has a birthday somewhere about this time. She should have cake & things. Will you take charge of it? You can ask her to give you a dollar or maybe a little more, not for a present – we can do that after I get home. This is for a box of chocolates and a brick of ice cream. Maybe mother can make the cake at home, with a few candles. You can sing 'Happy Birthday.'

I heard about the new clothes, but, because of the hot weather, you may not have had a chance to wear them yet.

> With love, Daddy.

I forgot, just after I had let the mouse out of the jar, another one came out of the side of the fireplace. He maybe thought it was a nice warm place to sleep last night, but when I lit the fire it got too hot.[11]

Milne stayed at his camp until mid-October. His painting was beginning to pick up a little momentum, but ice was forming on his waterpail at nights, a sign that he should soon return to Uxbridge.

This place gives me the feeling that I have been here for years. It is hard to believe that the paths have been worn so much in so short a time. The path from the shelter to the tent, with a slight detour round the ropes and then on to where I keep the canoe on the channel side – sheltered – suggests a Roman road. The one to the water at the other side is mostly over rock and doesn't show so much. The one back into the bush, the wood road, is well marked, dragging wood had broken the bushes off in a clear way. Even the path to the little creek is established and easily traceable.[12]

After spending a week at the little summer resort at Baptiste, and a few days exploring around the town of Bancroft, making drawings when he found subjects of interest, Milne headed home toward the end of October.

Soon after his return, on 5 November 1947, Milne was invited to Hart House as a special guest to give a short lecture about a retrospective exhibition of his work that Duncan had arranged. Duncan could not attend the lecture, but Milne reported to him that he 'got by all right at Hart House. Very good attendance – place seemed to be about full. Exhibition still looked good, particularly that inner wall. Had quite a talk with [Charles] Comfort and [J.W.G., 'Jock'] MacDonald. One young man talked about some art magazine – away over my head. Apparently he has seen you.'[13] This was Paul Arthur who, with his wife-to-be Catherine Harmon, would shortly publish the handsome, short-lived magazine *Here and Now*, the second issue of which (May 1948) contained a fine essay by Milne ('Feeling in Painting,' a title Milne did not like – he preferred 'Painting Day' or 'Going Painting' or 'Painter's Field Notes'), and an appreciation of Milne's work by Northrop Frye, along with ten black-and-white reproductions. Milne also reported that three of the Angus boys from Big Chute showed up, but he didn't recognize them. Charles Comfort recorded his reaction to the Hart House event in a poem:

He wore a flat tweed cap
and horn-rimmed glasses.
A short, thick-set leathery little man,
composed and articulate.

He left his coat in the Warden's office
and accompanied us downstairs to
view briefly the exhibition
of his work in the art gallery.

As we walked along the corridor
to the Great Hall,
one realized that there was no
affected characteristics in his dress
that would lead one to believe
that he was an artist.
In fact, he looked like
a healthy outdoor trades unionist.
His bald head had a dark tonsor,
Iron-grey at the sides, and all neatly trimmed.

At the head table were the Warden,
Nicholas Ignatieff, with Norman Endicott,
Arnold Wilkinson, Jock MacDonald,
Northrop Frye, Charles Comfort,
and the Chairman of the Undergraduate Art Committee.

Our guest of honour spoke simply
and honestly about the country he loved,
dwelling on the subtleties of nature.
He reminded one of David Thoreau.[14]

A month or so after this public attention Milne experienced an unfortu-
nate loss, although he did not realize it at the time: his friendship with
James Clarke was brought to an end. For more than thirty years Milne had
confided in Clarke about his artistic aims and endeavours and received
nothing but support and encouragement. They exchanged many letters,
even after Milne moved back to Canada. Milne's last letter to Clarke, writ-
ten early in 1948 (but undated), expressed thanks for Clarke's annual Christ-
mas box, which had arrived 'on the dot' in December, reported cheerfully
on his activities at Baptiste Lake, on the state of his health, and on the
forthcoming articles in *Here and Now*, a copy of which he said he would
forward. But Milne sent the letter to Douglas Duncan for posting (as he
did all his mail). Not surprisingly, it sank into Duncan's bog of procrasti-
nation and was never mailed. Milne's and Clarke's long and close friend-
ship thus ended in a sad anticlimax.

Without more concrete information one can only hypothesize about
what really ended the relationship. The news of Milne's and Patsy's sepa-
ration did not sit at all comfortably with Clarke, who continued to be friendly
to Patsy, and he was clearly in no mood to write to Milne after Milne's long
silence and his apparent failure to thank Clarke for his Christmas gift, or
to send along whatever news there was. Clarke may also have been put off
by having to write to Milne in care of Duncan. He was, after all, Milne's
best friend and a strong supporter, someone who should have been able to

Milne in a tweed cap, 1951

deal directly with his friend rather than through an intermediary. Where Clarke was concerned, Milne was obviously awkward about his domestic arrangements – assuming, rightly, that Clarke would disapprove (although Clarke himself had married for the third time in 1944). Milne never told Clarke, clearly and forthrightly, about his new situation, nor did he try to obtain Clarke's acceptance of it. Milne, of course, did not know that his letter never reached Clarke, and he allowed the long silence from Clarke to endure. The breakdown of their correspondence ultimately had severe repercussions. It drove Clarke irrevocably to Patsy's side and began his opposition to Kathleen, whom he never met, and it led to the sad disintegration of a friendship to which Milne owed so much.

About this time Milne began to lose confidence in Duncan. This may have had something to do with the level of Milne's income, which had remained at about $1,300 for 1943 and the four years following. When he stopped painting in the spring of 1948 and prepared to spend the summer building a new cabin, he forewarned Duncan:

The bogging down of painting doesn't bother me much, not as much as you, probably. There have been fallow periods before, with good effect. I don't do too much with the old faithful past. I think it would be wise to reconcile yourself to the idea of no painting at all until Sept. or Oct.[15]

And he went on to suggest that perhaps Duncan himself might take a sabbatical from Milne's affairs for the summer. He even suggested that Duncan might want to resign: 'Of course, you are not bound at all to keep on forever with such an unrewarding job.' He thought that they might try a summer with 'no plans, no help, no advice, maybe even no visits. See what an empty summer will come up with.' A year later matters had worsened instead of improved. In May 1949, after a ten-year association, Milne wrote to Duncan:

This is to acknowledge & thank you for your two checks. A little late, maybe because something has gone out of our usually pleasant relations, our visitings & our writings – too much overlapping in our activities – not good – very unfavourable for painting and deadly for human relations.[16]

And four months later Milne sent Duncan another curt note (one paragraph) that revealed that their relationship was continuing to be uncomfortable: 'Aside from your usual miracles with pictures, you can't do anything – leave it to Wyb & I. We will probably manage – if we don't get help.'[17]

Duncan was in many ways an admirable man and a true friend of artists, but for Milne the relationship with him began to be an aggravation just when he needed support and assurance. It was not easy to ignore Duncan's eccentric and procrastinating ways. As time went on his irritating practices, and his wilful disregard of reasonable requests and even specific orders, exceeded the many benefits most artists who dealt with Duncan readily admitted. Milne did not recognize or approve many of Duncan's titles for his paintings, and could not have liked Duncan's insistence on destroying so many.[18] He chafed at the idea that Duncan had such control over his affairs – his art, his finances, his correspondence, his taxes, and his obligations to his estranged wife and his family. He grew more uneasy as Duncan wrested from him increasing responsibility, especially for the paintings. Nevertheless, Duncan's response to Milne's

Milne's cabin at Baptiste Lake, interior, in 1988

Exterior of Milne's cabin at Baptiste Lake, in 1988

restiveness was to raise his annual income to $2,500 in 1949 and 1950. From Duncan's point of view, of course, he was trying to carry out the responsibilities that Milne had invited him to assume, and whatever his shortcomings, his achievements on Milne's behalf were substantial, although it is easy to belittle them when one is distanced by time or by space.

Milne's letters to Duncan were nearly always short. He never wrote to Duncan about aesthetic issues or painting matters as he had to James Clarke, Donald Buchanan, Alan Jarvis, and Graham McInnes. Although courteous and amusing in his letters to Duncan, Milne restricted his comments to business. He was particularly unhappy about Duncan's handling of his relations with Patsy. Had Duncan been able to restrict his activity to selling and exhibiting paintings, where he was reasonably adept (although George McVicar thought Duncan had 'no business sense,' an opinion he would have picked up from Milne and was to have confirmed later by Kathleen), his other services to Milne, while less than expeditiously carried out, might have been tolerated.

During this period of aggravation with Duncan, there was an even more serious worry for Milne: his health. Early in 1948 Milne reported to Duncan that he was contending with doctors:

Am on a diet. Oatmeal for breakfast. Glass of milk for lunch, oatmeal for supper, unlimited water. Not so serious as it sounds – or is. The digestive trouble the insurance examiner wished on me in the summer hadn't entirely cleared up – still a very slight indigestion, heartburn, so I went to [Dr] Mellow (here [in Uxbridge]). He was delighted, nice little case. He decided that the heart trouble had disappeared and that the indigestion wasn't much. However, just to keep me away from doctors he put me on what is practically a Ghandi diet for three days – ends tonight. If you would like further details, just write to this station.[19]

In May he wrote again:

I have had an anniversary, sort of. Just over a year since I noticed a slight dent in health, three slight dents [indigestion, heartburn, and a nervous heart]. All three

have been cured and forgotten for months at a time, but never all three at once and all have a nasty habit of coming back. None of them enough to limit activity, in fact good, steady, outdoor work seems to be the medicine. Not more than a threat so far, but a deadly one unless attended to. Anything that lasts a year calls for attention.[20]

In the first four months of 1948, at Uxbridge, Milne finished about thirty watercolours, the only paintings of the year, and all were based on his Baptiste Lake sketches. Once again they show Milne in close communion with his environment. The attention to reflections and sunsets – those insubstantial but magical subjects that had always gripped him – was again much in evidence. Milne's sense of space grew and changed as, more deliberately than before, he gave emphasis both to the two-dimensional surface of his paper and to the three-dimensional contours of his subject. The actual process of painting was now made apparent rather than being artfully disguised.

The exaggerated and unconventional shapes of *Shelter at Night I*, slopped onto the paper, reveal Milne's boldness. The bright licks of colour set every form on edge, and full advantage is taken of accidental effects produced by the watery flow of the paint itself. Milne's gentle reticence, however, may be seen in the thin, pale washes in *Sunset Mists* and *After Sunset*. In the former a peculiar antagonism exists between the fragile wash and the

Shelter at Night I, 7 October 1947, watercolour, 35.6×50.8 (14×20)

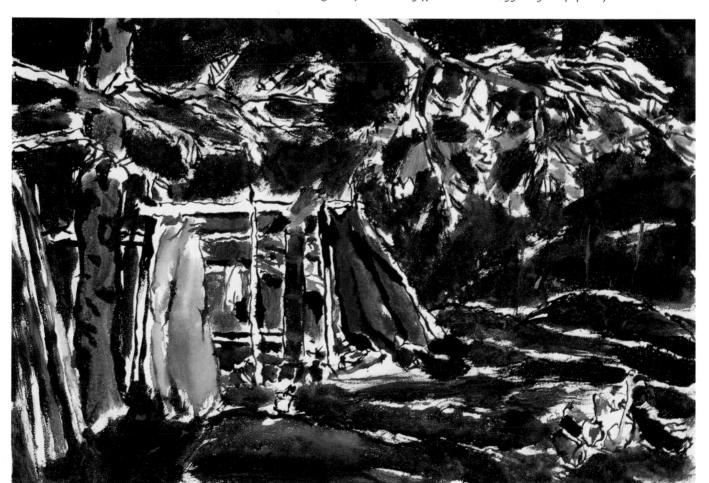

vehement handling of shapes and colours. The shapes are deceptively simple, yet the way they are organized on the sheet establishes these works as tours de force. The battle between sky and earth (to which Milne had always given his attention) reached a new synthesis: wielding the delicate against the harsh, he achieved a balance that preserved the effect and the integrity of both. These paintings, and those that followed, stretched the watercolour medium to extremes of great delicacy and great violence – and, perhaps, reflect something of the peace and anguish that Milne experienced alternately throughout his final years. In *Here and Now* Northrop Frye wrote of Milne: 'He has painted what must surely be some of the wettest watercolours, both in technique and subject-matter, ever done. In fact, rain, fog, snow and mist play an important role in his work: their function is not to blur the outlines but to soften them down so as to increase the sense of a purified visual pattern.'[21]

In late May 1948 Milne returned to Baptiste Lake to have his property surveyed, arrange for cutting and hauling logs to the cabin site, order lumber, and ready a camp for Kathleen and David – who followed shortly afterward. By the end of August, when Kathleen and David Jr returned to Uxbridge, Milne had set the piers and laid the sills, joists, and part of the rough floor of a 5×12-metre (16×22-foot) cabin. And he had established a trail overland through the bush to the road leading to Maynooth and Bancroft.

Milne's labour was far from easy. Each of the sixty-one selected logs had to be gently lowered into place after he had peeled and slightly planed it to maximize the meeting surfaces and then sealed it with oakum, a tedious job. This was exacting work and it took Milne much longer than he expected. Working alone, he managed to raise about two logs a day. By October he was close to the top of the walls, and at the end of the month he was completing the roof. When he left for Uxbridge in mid-November, all that remained to be done was finishing the floor, and setting the door and windows and masonry for the chimney. Altogether – with the survey of the land, and the acquisition of logs, lumber, windows, equipment, and materials – Milne estimated the cost of the cabin at about $350. The other tasks were completed over the next year or so, and Milne later built a small cottage for David to sleep in, a small shed for an outboard motor, and an outhouse. Into the hillside, a short distance from the door, he built a small refrigerator – a concrete box deep enough in the earth to be cool in summers and not to freeze in winter. The insulating door, made of wood and without a latch, still fits perfectly.

Today the buildings are in prime condition and are still in use by the Milne family. The black cabin, with red-trimmed windows, sits back among the trees, about fifteen metres (fifty feet) from the lake and above a huge bald scalp of granite that serves as a dock. Inside, the cabin's walls are varnished in a natural wood colour. The same natural-wood finish characterizes the bed and the table Milne built. Four windows along the lake (south) side provide ample light, while two windows in the east wall and two in the north wall give a sense of airiness. The pitch of the roof, which is not steep, adds to the sense of space. Shelves along a short wall near the door and between the south windows and the door once accommodated all the kitchen utensils and household tools. The expert craftsmanship that went into Milne's building of the cabin is still a source of delight.

As he departed for Uxbridge in the fall of 1948, after six months of

constant and back-breaking work, Milne wrote to Duncan that 'the out-door season is over for me until spring.'[22] He did no more painting until he was back at Baptiste Lake at the beginning of February 1949. Milne no longer wanted to work in Uxbridge, and he did not want to wait until spring to get back to painting, despite the cabin's unfinished state. His first paint-ing on his return was a watercolour showing the view from his cabin win-dow.

Thereafter Milne did almost all his painting at the cabin. For the next three years he normally journeyed to Uxbridge for Easter and stayed for the month of April, returning to Baptiste immediately after David's birth-day on 4 May. Kathleen and David joined him for the summer months when various work projects were scheduled. September, October, and November were generally the prime painting months. After spending Christmas and New Year's in Uxbridge, Milne would be back at Baptiste Lake for February and March.

With the move to Baptiste Lake Milne changed his painting routine. He had previously painted in both the morning and the afternoon, stopping at about four o'clock; but now he did not begin work until about noon and stopped by four. His mornings were devoted to chores: sweeping out the cabin, feeding the birds, planting an assortment of trees, washing dishes, hanging out his blankets, cooking, fetching water, and doing odd repairs. Every few days he trekked the seven kilometres (four miles) to Baptiste or the sixteen kilometres (ten miles) to Bancroft for mail, bread, and other light supplies. Normally he did his wood cutting in the late afternoon, for it had the salubrious effect of erasing all thoughts of painting from his mind, much as hoeing onions had done in Boston Corners. The evenings were spent looking at the day's work, reading, writing letters, or listening to the radio. 'Rawhide' (Max Ferguson) and Gordon Sinclair were part of Milne's staple radio fare.

To judge from Milne's fat letters to Kathleen and David, he must have spent countless hours writing to them. But unlike the lively epistles about painting written to Clarke and others in former years, these letters concen-trated almost exclusively on long, often tedious, narrations of trips to Baptiste, details of the weather, scrupulous accounts of each meal, a regis-ter of birds or wildlife seen, exactly where the wood was cut that day, what the water level in the lake was, and so forth. Occasionally Milne referred to having done a pencil sketch, or having worked with a little more or less success than the previous week; but the letters contain little that is signifi-cant about his paintings of this time.

Milne's last years were almost overwhelmed by worry and frustration. He worried about painting, about finishing the cabin, about renting or buying a house in Bancroft (in 1947 their landlord wanted to sell the house they rented in Uxbridge, but this was resolved and the Milnes stayed on until they moved to Bancroft in September 1952),[23] and about making a new will. He worried about his health, about Duncan, and about money. Milne had neither savings nor capital, and not much revenue. His short sabbatical in the summer of 1948 left a noticeable hole in his production, exaggerated by his lagging production in the months that followed. 'We had very little money,' Kathleen recalled. 'It didn't bother me at all, but it bothered *him*.'[24] Kathleen had clothes that were handed down from her mother or her friend Dorothy McVicar, but whereas she felt 'comfortable and normal' about this, Milne did not. Milne had always been a worrier, but now worrying clouded his concentration, and the difficulty in concen-

trating increased his tendency to complain. Duncan increased his annual income to about $3,500 in 1951 and 1952.

As he entered the last years of his life, Milne's personality underwent a change. He became easily agitated, suspicious, unpredictable, and capable of periodic rages. The older he got, the more difficult he was to live with. Increasingly he became the tempermental artist he had never been when he was younger. Several years after the war, when money was more available, Milne strode through Eaton's delicatessen section with Carl Schaefer, imperiously ordering exotic and expensive foods: special cheeses, clams, snails, jams, and jellies for his new cottage at Baptiste Lake. 'How about kippers?' Schaefer asked him. 'Kippers by all means,' Milne responded: 'I'll have a pair of them.'[25] Milne grew more demanding rather than less; instead of easing into his old age, he blustered his way into it.

Despite occasional good painting days at Baptiste Lake, anxiety continually crept into letters home during these last years:

The trouble, of course, after a stoppage, is to catch hold of a thread.
I haven't got back to where I was before I went home.
[The thought of going home] will probably crowd [painting] out.
Painting still far from normal.
Painting wiped out completely. Have done better and more in an afternoon than in these months ...
The pictures are a poor lot, not many and rather commonplace ...
Gradually a little more ease coming to the paintings.
We are absolutely dependent on new pictures even to keep going.
In the four days off painting, I lost hold of a lot of small threads that make up the picture, the exact amount of colour and how to put it on, how wet or dry, of small changes I had planned.
No luck with painting yet.[26]

The paintings of 1949 neither fulfilled Milne's expectations nor appeased his anxiety. Of fewer than twenty done – mostly between February and April – only a handful have any distinction. The first two versions of *Spider Bridge*, based on a quick pencil sketch when the train stopped briefly at Kinmount on a blustery day in February, were possibly painted at this time. About ten versions were done, however, and because only five were kept, the dating is uncertain.

Spider Bridge II, *1949, watercolour, 36.9 × 54.6* (14½ × 21½)

Spider Bridge III, *1950, watercolour, 36.9 × 55.6* (14½ × 21⅞)

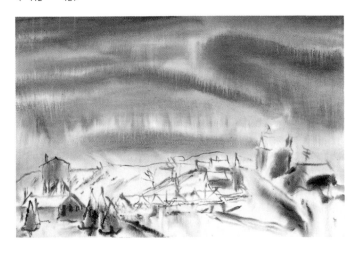

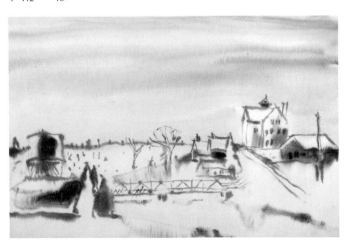

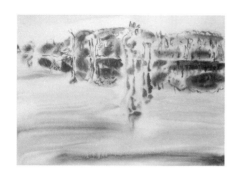

Quiet River, *1950, watercolour,*
36.5×54.3 (14⅜×21⅜)

Early in 1950 Milne made a determined push, with the result that the distinctive character of his last group of paintings was clearly and authoritatively expressed. For the next two and a half years, despite his illnesses, his works revealed unexpected freedom and apparent ease. The application and brushwork are fluid to the point of recklessness, yet never out of control. The drawing in the watercolour *York River* and a few months later in *Quiet River* is hasty but absolutely certain. They contain both a moment and all time, accidental effects that were not accidental, and a gentle submission to both the process and the subject. Most of Milne's last paintings (applying Milne's own ideal) seem to have been wished onto the paper.

The concluding three versions of *Spider Bridge* (1950) show the use Milne began to make of a single sweep of wash across the entire picture surface. This was a device he had seldom attempted before, and it required success in a single stroke: altering in any way so dominating and yet fragile a feature as the light washes was impossible after the first attempt. The fine details of the bridge, houses, and trees had to be set rapidly in place while the paper and wash were still wet. The colour motifs of orange and gray (along with the blue/gray that is found, for example, in *From the Cabin Door*) was in use for much of this time.

Versions of *Bear Camp* followed. Based on Camp Makwan on the western shore of Milne's part of Baptiste Lake, the paintings depict a variety of seasons, even though they were all painted within a month of each other in February and March 1950. The dominance of the hill shape and of the open expanse of water (reminiscent of *Across the Lake I* of 1921) creates a powerful unity, despite a multitude of small details. The singleness of purpose that Milne had sought all his life was now more manifest than ever. He played freely with the seasons and colours, and also took the liberty of moving details around – not to be disloyal to his subject, but to be true to the shapes and their relationships on the paper.

One of the finest works of 1950 is *Farm IV*. In spite of its drab colours, it has a clarity and precision that are astounding, as if the atmosphere blowing through it were pure oxygen. The orange-gray sky has a clean and

York River, *1949 or 1950, watercolour, 37.2×55.3 (14⅝×21¾)*

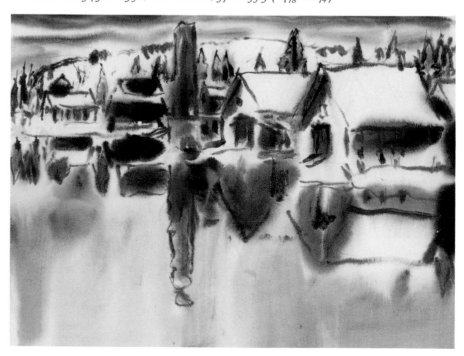

bracing quality that is almost palpable. The looseness of the paintings that followed was remarkable: in *Quiet River* the brilliant colour of the shore is embedded in the flowing lines of the river and land shapes.

Before the end of 1950 Milne started a series of paintings of the Catholic church in Bancroft. He had already turned to Bancroft for his subject matter – 'the finest painting town,' he wrote, 'I have ever seen.'[27] Its hockey arena, churches, and hillsides all found their way into his work, as did the railway station at Bird's Creek, not far out of town toward Baptiste Lake, and the farms and clearings he went past on his walks. Although these gave him subjects and good paintings, he tried desperately all year long to restart the fantasy pictures, for he felt that 'the only live interest is there.' On 26 February 1951 he wrote to Kathleen: 'I am disappointed that I haven't done any of the subject ones. They are the important thing now.'[28] But the winter of 1950–1 went by and no fantasies were accomplished: the spring, summer, and early fall were devoted to landscapes and still lifes.

Late in 1950, while he was at Baptiste Lake, Milne suffered an attack of bronchitis. He noticed that he was now beginning to tire easily, although

Bear Camp I, *1950, watercolour, 45.8 × 62.9 (18 × 24¾)*

Bear Camp II, *1950, watercolour, 47.8 × 66.1 (18½ × 26), irregular*

Bear Camp V, *1950, watercolour, 48.3 × 65.4 (19 × 25¾)*

Bear Camp VII, *1950, watercolour, 47.7 × 65.4 (18¾ × 25¾)*

earlier in the year he had walked thirty-two kilometres (twenty miles) in a day without much fatigue. One morning he awoke with cramps on the inside of both legs, for which he applied his standard remedy, Minard's Linament. Finally, in April 1951, he surrendered himself to Toronto's Western Hospital for tests and x-rays, and on 12 April Dr Bruce Vale successfully operated on him for cancer of the lower intestine, leaving Milne with a huge scar across his abdomen.

Considering his sixty-eight years, and a weight loss of nine kilograms (twenty pounds), Milne's recovery was remarkable. By 21 May he had not only gone home from the hospital to Uxbridge but had returned to Toronto, to be alone, chiefly, and to 'rest.' From his headquarters in the Ford Hotel at Bay and Dundas Streets, where he had been staying on his Toronto visits since 1945, he made forays to sketch along the waterfront, grumbling about the ripping up of Yonge Street to build the subway. With the arrival of summer he retreated to Baptiste Lake and subjected himself to a punishing amount of hard physical labour. Inability to sleep began to plague him. His dilatory sketching out of doors was undertaken more for health and recreation than as a serious occupation. Walking and sketching had always been his preferred medicine: his mind was as much in need of recuperation as his body.

Seven months after his operation, in November 1951, Milne had regained enough strength to paint again, and to readdress the problems that had concerned him before his illness and take them a step further. It is a measure of his continuing vitality as a painter that he once again delved

Farm IV, 1950, watercolour, 36.2 × 55.3 (14¼ × 21¾)

into the basic principles of his art. He retained the colour motifs of orange-gray and blue-gray and the feathery washes, with their apparent casualness, but he began to flirt with abstraction again. The results were among his most fluent works: odd and unsettling in some cases, rich and vibrant in others, but all painted with an exactitude that only unchallengeable mastery gives.

Milne began work on two small paintings, one of a storm approaching over High Island from the west; the other a view of Toronto at night as seen from his ninth-floor hospital window, sketched in April. Both subjects called upon a new extension of Milne's technique that subsequently imposed itself upon many of the late watercolours. Milne's own description of the process is revealing:

Each is done in a single operation. Everything is planned and colour prepared, brushes charged; then the paper is wet all over with a large brush. The painting is all done before the paper dries, three or four minutes, and not touched again. That doesn't make it any easier. The planning has to be done beforehand in

Storm over the Islands III, *1951, watercolour, 28×36.9 (11×14½)*

Storm over the Islands IV, *1951, watercolour, 28×36.9 (11×14½)*

Lighted Streets I, *1951, watercolour, 27.3×36.9 (10¾×14½)*

City Lights II, *18–20 November 1951, watercolour, 27.6×36.9 (10⅞×14½)*

great detail: the order in which the colours are to be applied, what brushes are to be fully charged and what with only the slightest amount of paint on them, what the effect of the diffusion, spreading and overlapping, due to the wetness of the paper. Strangely enough that doesn't make the pictures rigid, just the opposite; the whole thing is fluid, easy looking, when completely successful it looks effortless, easy. I remember talking to Cleeve Horne years ago up on Six Mile Lake. His idea was that the whole thing was chance, which is about as far away as you can get. Freedom, but not much chance; when one of them is done over a number of times there is very little difference between one version and the next – unless it is deliberate.[29]

The variations in *Storm over the Islands* (there were seven originally, but three were destroyed, probably by Milne) are so distinctly different that it

Lipstick III, *18 January 1952, watercolour, 36.2×53.7 (14¼×21⅛)*

Tempter with Cosmetics IV, *1951, watercolour, 35.6×53.3 (14×21)*

Jack Nichols's portrait of Milne, 1952, pencil

is hard to resist the thought that Milne intended a suite of paintings, works complementary to each other, rather than disposable steps toward a final and definitive work. The progression of rolling clouds and sheets of rain is less phenomenological than the progression of thought and feeling, with each new variant inspired by the one before. The carefully calculated nature of these paintings is disguised by the appearance of spontaneity, which is itself based on myriad, almost intuitive, calculations.

The five paintings of the *Lighted Streets* series, a Toronto subject, were painted concurrently with the *Storm* series, and they share not only a common technique but also a similar attention to aesthetic exploration. The night sky hangs in translucent dark gray washes and the lighted streets are punctuated by 'coloured fountains.' The sense of space, with such patent emphasis on the process of painting, is at once deeply recessive and also two-dimensional. The ambiguity of a painting's being *of something* and *of itself* was never so strong as in these last works. If any of his paintings ever made clear *how* Milne saw, rather than *what* he saw, it is these.

When he was painting in his last years, Milne frequently tested his colours by discharging his brushes tentatively on the backs of discarded sheets, and his attention was evidently drawn to these random blottings, especially in 1950. Working with a selection of them, he devised a painting called *Sketches from the Abstract*, an assortment of strange heads and figures that had begun as vague shapes and been given enough specific detail to suggest that they were derived from nature. This process of transmutation can be detected as a tendency in Milne's work from 1947 onwards. The flowing mantles of coloured wash that now began to appear in his work were obviously lifted from this articulation of his method.

All these works of the imagination primed Milne for a return to his fantasies. He had already made 'some preparation for a subject picture, no name yet – no picture yet of course, but pretty fully planned.'[30] To his diary in 1951 he committed a small pencil sketch for *Another Generation*, a work not painted until nearly a year later. And then, unaccountably, he proceeded with another version of *Jonah* or *Return from the Voyage*, which he considered unfinished from six years before in Uxbridge. Then he turned to a series of works that he thought could be called *Of Men and Angels*, or just *Salesmanship*. They depict a modern-day man in a fedora selling cosmetics to angels, who are either hovering overhead, their curiosity piqued,

Paracutin IV, *1952, watercolour, 36.9×55.3 (14½×21¾)*

Fruit of the Tree I, *1952, watercolour, 36.9×54.6 (15½×21½)*

or have already succumbed to the blandishments of the material world and are experimenting with rouge and lipstick. The angels, in various attitudes of flight, remind one of the seagulls in Milne's paintings of 1942 (the *Gulls and Lighthouse* series). The paintings are set against gossamer veils of colour – diaphanous scrims that suggest either a magical stage or a disembodied piece of heaven that has both material dimensions and an amorphous spirituality.[31]

As 1951 drew to a close Milne had accomplished more work, and had begun more paintings, than at any time in the previous four years. At the end of this year of physical and artistic recovery Milne returned to his doctor in Toronto to be tested and re-examined. Two weeks later, on 12 January 1952, he wrote to Kathleen: 'Didn't get to sleep until five o'clock this morning, not from cold, from worrying. The Toronto visit wasn't re-assuring.'[32] Whether it was the doctor's report or a meeting with Duncan that disturbed him is not known – it could have been either. But Milne must have sensed that his health was precarious, for while he was in Toronto in 1951, he visited George McVicar in his office at Connaught Laboratories, and asked him to help care for his young son in the event that he could not, so that David would have a man in his life. In March 1952 Milne suffered 'pain in the heart region.' After this he pushed his work forward with a sense of urgency.

Financial difficulties with Duncan continued to affect Milne profoundly. While Duncan had been generous in the early days and was ready to buy Milnes for his own collection if sales were slow or money was needed, the fact was that he owed Milne thousands of dollars for paintings he had acquired for himself. Getting Milne's annual income up to $3,500 in 1951 and 1952 (from $2,500) was only a half-measure. At the time of Milne's death Duncan admitted that $1,000 was 'but a fraction' of what he owed, money that was duly paid into the estate but that would have greatly increased Milne's sense of security, and that of his family, if Milne had had it during his lifetime. Milne's prickliness would have been greatly diminished had he known how many paintings Duncan had really sold and how much he, Milne, was really worth. Milne abhorred what he called Duncan's 'leave it all to me' attitude. Had Milne lived another year or two, according to Kathleen, he would have left Duncan, and taken his custom elsewhere – as other artists who knew and liked Duncan were finally forced to do.

Blue Bay, *1952, watercolour, 36.9 × 54.9* (14½ × 21⅝)

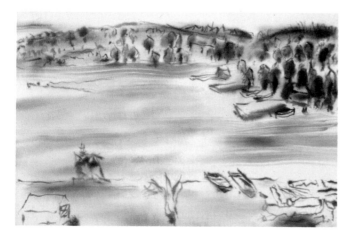

Leaves in the Wind II, *1952, watercolour, 37.2 × 54.9* (14⅝ × 21⅝)

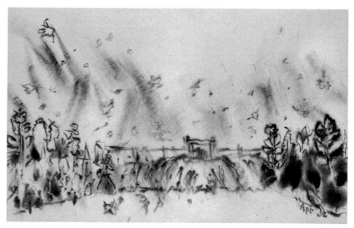

Duncan the connoisseur and critic, giving sympathetic understanding and upholding severe standards, inspired trust and respect in artists. But Duncan the absent-minded businessman, who left bills unpaid and invoices uncollected, letters unopened, cheques from collectors uncashed in quantities that boggle the mind, and remittances to artists on hold, destroyed the trust he had otherwise earned. In the end many artists were seriously deprived because of his eccentric ways.

By the early 1950s Milne was beginning to receive some of the recognition that had long been his due. In the late 1940s and into the 1950s the Art Gallery of Toronto and the National Gallery of Canada regularly began to buy Milne's works. He was one of the artists chosen to represent Canada at her first entry to the Venice Biennale in 1952, and some of his paintings were selected that year for a large Canadian exhibition in Rio de Janiero in 1953. Critics began to reassess his paintings seriously and hail them as among the most adventurous work being done in Canada – although his remarkable watercolours were (and still are) considered in the market to have less value, because of the medium, than his oil paintings.

Milne's final year of painting, 1952, was again split between landscapes and fantasy works. To the latter he added *Paracutin*, done a number of times. It was an odd choice of subject: the birth of the Mexican volcano of the same name, and his notion, with poetic licence, of how it might have appeared. The volcano erupted in 1952, having first appeared in 1943 in a field where farmers were cultivating their crops. In less than a week it

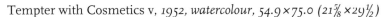

Tempter with Cosmetics v, *1952, watercolour, 54.9×75.0 (21⅞×29½)*

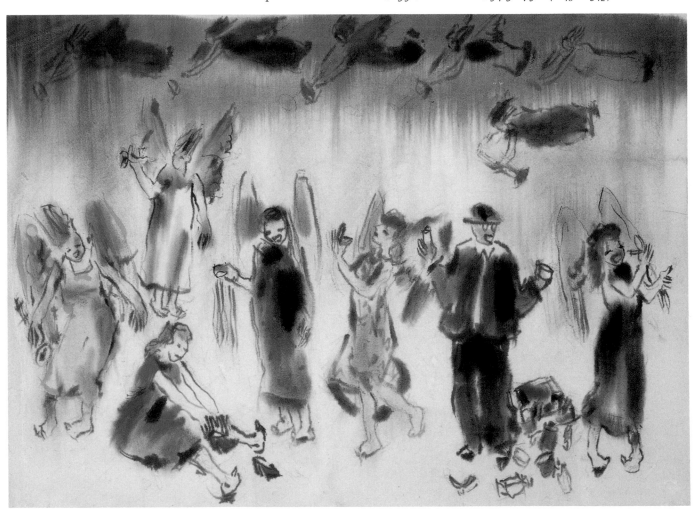

grew into a huge cone. Milne depicts a little girl running away as a rabbit gets blown out of its burrow in the ground. Strange and haunting gray-orange and blue-gray washes are used in these works, as they are in other landscapes of that year. This peculiar colour combination seems unimaginable when one describes it – until it is seen in *Shore Clearing* and in the *Blue Bay* subjects. The 1952 paintings of the Toronto waterfront (done from sketches of May 1951) have the same sharp sense of clarity, despite their depiction of smoke and haze. The blue washes, whether richly or faintly painted, have both a fragility and a strength that represent a high point in Milne's painting.

In 1952 Milne began the fall's work with two still lifes: *Sumac and Maples Leaves I* and *II*. Then he painted *Another Generation*, which he had planned for over a year, depicting lipsticked angels and a modern couple in a cemetery where the older generation (including himself) would shortly lie or already lay. The cycle of birth (*Paracutin*), life, and death, which he had been witnessing over the past decade, was one that Milne seemed here to accept with joy, humour, and understanding. Then, almost as if he sensed that the only thing missing in his imaginative world was the theme of marriage, Milne set about to do a series of works, *Fruit of the Tree*, of Adam and Eve picnicking in a garden (a Northern Ontario garden in the first versions, although later he set them in an anonymous and rather barren landscape). They are feasting on bananas, cherries, and other fruit, while the serpent approaches with an apple in its mouth.

In September 1952 the Milnes moved to Bancroft, where they bought a house at 40 Faraday Street, and a year later they moved to Hastings Street South. Milne was happier having his family closer to his Baptiste Lake studio, and was looking forward to a new surge in his painting; indeed, his work was already well-launched for the season. On 14 November, however, as he was walking from the lake to the cabin, he tried to whistle for the chickadees, as he habitually did – they often came and landed on his head or shoulder as he fed them – but his whistling failed, the first indication of a possible stroke. Luckily, a neighbour, Charles MacAllister, came by shortly afterward and rowed Milne to the north road, where he was able to get a ride or a taxi to the hospital in Bancroft. He *had* suffered a stroke, and it partly paralysed his right side. (The family later thought that the stroke may have been triggered by Milne's trying to start the outboard motor in cold, miserable weather the previous day.) The stroke brought Milne's painting career to a final, shuddering halt. Left on his easel at the cabin, unfinished, was his last work – a large, ambitious, and vastly more complicated version of a subject he had been working on a year earlier, *Tempter with Cosmetics V*.

Milne stayed in Bancroft, unable to work. On 5 January 1953 he suffered a major stroke and was taken immediately to the hospital. Then, attended by Kathleen, who sent their eleven-year-old son to stay with her brother and his family in Toronto, Milne was transferred by ambulance to the veterans' Sunnybrook Hospital in Toronto. With the aid of therapy Milne began to recover the use of his right arm, although the treatment was slow and not very effective and was not aided by his impatience. Milne tried to learn to type and write with his left hand; in a short time he was able to manage a legible if shaky scrawl, seen in handwritten titles on a number of watercolours sorted by him in 1953.

After several weeks Milne was back home in Bancroft. But on 5 March he was readmitted to Sunnybrook Hospital for observation, taken there by Duncan. Shortly after his arrival he suffered another stroke that this time

created a partial block of his vision. Again he began lengthy, uncertain attempts at therapy. As he emerged from the worst effects of that attack, he gamely asked to have watercolour brushes and paints sent to him. But he was no longer capable of extended or critical work, even though he fought stubbornly against incapacity. From his bed, when he was back in Bancroft, he spent a lot of time sorting and deciding about his paintings, but communication was difficult as his speech was seriously affected.

That summer Milne insisted on going to Baptiste Lake with his family. Kathleen cared for him while young David went off to nearby Camp Ponacka. Milne could shuffle about a little, but he spent most of his time in bed. In July he had another major stroke. He was taken to Bancroft and then by ambulance to the regional hospital in Belleville.[33] After a few weeks he was brought back to Bancroft, where Kathleen nursed him in what was by now a much weakened state: his hearing, speech, and sight were all failing. He lapsed into unconsciousness in December and was taken to the Bancroft hospital. David Milne died on 26 December 1953, two weeks short of his seventy-second birthday.

CHAPTER SIXTEEN | # Epilogue
1953 and after

MILNE'S FUNERAL was a dismal affair. Only a few people, alerted by Douglas Duncan, gathered on 28 December 1953 at the Rosar-Morrison Funeral Home on Sherbourne Street in Toronto for a short service. The day was windy and rainy, and bitterly cold. Kathleen and twelve-year-old David were there, of course, and Duncan; Vera Parsons, Milne's lawyer; the Milnes' close friends George and Dorothy McVicar; Kathleen's brother, Jack Pavey, and his wife, Wilma; Norman and Elizabeth Endicott; the painter Gordon MacNamara, a friend of Milne's and Duncan's; and George Elliott, a young writer working in advertising who was an admirer and became an acquaintance in the last years of Milne's life. J.S. McLean, the head of Canada Packers and Milne's most generous patron, was also present, giving the event some distinction. Duncan's limousine arrangements for the two Milnes and the McVicars, with whom they were staying, like so many of his practical arrangements, had fallen through, so that Kathleen and young David arrived late in a taxi. The service was accompanied by a vacuum cleaner scouring the floor in the room above. Interment followed at Mount Pleasant Cemetery, where the grave remains unmarked to this day.[1]

Duncan had insisted on the funeral arrangements, even though Kathleen had wanted to scatter Milne's ashes near the cabin at Baptiste Lake where Milne had done his last work, and where he felt at home. No announcement of the funeral was made beforehand in order to ensure, so Duncan later explained, that Patsy Milne would not turn up and plunge what was already a sad and depressing occasion further into awkwardness and gloom. This somewhat uncivil act of suppression began the myth, created by Duncan, of the mutually antagonistic 'two Mrs Milnes' (a favourite phrase of his), although Kathleen and Patsy never met.

As Patsy and David Milne had not divorced, it is not surprising that some people, especially James Clarke and Blodwen Davies who were sympathetic to Patsy, would look askance at Milne's domestic arrangements and wonder how his estate would be settled. Indeed, in Toronto in the early 1950s Milne's relationship with Kathleen belonged in the realm of scandal, or would have done if the situation had been generally known – respectable though the participants were. During the fifteen years he lived with Kathleen, Milne made matters quite clear from his point of view: he left an executed legal document that certified his paternity of David Milne Jr; he made Kathleen the executrix of his will, in which he left everything he owned – his cottage at Baptiste Lake and his paintings – to her and to their son; and he left clear instructions to Duncan and Vera Parsons that some reasonable provision should be made for Patsy as long as she lived or as long as the proceeds of sales from the pictures in his estate allowed. Patsy was the sole beneficiary of the insurance policy on Milne's life.

After Duncan and Parsons had made their calculations, Milne's estate, in 1954, was registered as having a value of $25,000: $15,000 in real estate (the cabin at Baptiste Lake) and $10,000 as the value of 811 paintings. The prints and drawings – over two thousand of them – were included *ad gratia*. While Kathleen Milne was named executrix, Duncan was still the agent for Milne's work and still controlled it physically and, for all intents and purposes, otherwise. Most of Milne's pictures were in Duncan's possession at the Picture Loan Society premises or at his family's house in Forest Hill, where he lived until 1964, when his father died. He alone would now determine what to do with the work, to whom to sell it (numerous people wanted to buy, but Duncan wouldn't sell 'to them'), and at what prices; and he continued to develop Milne's reputation and arrange exhibitions of his work. He also determined what could be provided out of sales as annual stipends to Kathleen and Patsy.

Duncan's first major task was to organize a retrospective exhibition of Milne's work for the National Gallery of Canada. The invitation to do this came from H.O. McCurry; but in 1954 McCurry retired, and Alan Jarvis (Duncan's friend and lover of former years) was appointed director of the gallery, less than a year after Milne's death. Jarvis had brought Milne's work to Duncan's attention in the first place and together they had visited Milne at Six Mile Lake in 1935. Jarvis's continuing enthusiasm for Milne's paintings led the National Gallery to purchase a significant number of works (eighteen during the three years he was director, three times the number that Duncan had sold to McCurry during the previous decade), and Duncan began to intensify his plan to ensure that the gallery had a comprehensive collection of Milne's paintings and an exhaustive collection of the drypoints in all available states. His plan for the Art Gallery of Toronto (now the Art Gallery of Ontario) to have a similar comprehensive collection was constrained by the short-sighted acquisition policies of the gallery itself, which did little to encourage Duncan's ambitions or its own. Although recent donations from the McLean family and Nora Vaughan are at last improving the Art Gallery of Ontario's Milne holdings, the Winnipeg Art Gallery can claim a better selection of Milne's work through astute purchases in 1961, when Ferdinand Eckhardt was its director. Although the Art Gallery of Ontario showed an exhibition of Milne's war art in 1935 and the retrospective exhibition in 1955, it has yet to organize a major exhibition of Milne's work.

Duncan's retrospective exhibition of 127 paintings and 38 drypoints was shown in Ottawa, Toronto, London, Vancouver, and Montreal to much acclaim in 1955 and 1956. It was nicely complemented by a smaller exhibition that he had organized in 1953 for the Western Canada Art Circuit, and which was still making the round of western cities when Milne died.

In 1958, in the wake of the retrospective exhibition, Vincent Massey, then governor general, deemed it propitious to sell most of his large holding of Milne paintings. His son Lionel, who was serving as his secretary, was put in charge of the process, and contacted Blair Laing and Duncan, and perhaps other dealers, such as Max Stern of the Dominion Gallery in Montreal. Duncan's offer for 110 canvases was $6,700. He wrote to Lionel Massey that about a quarter of the ones he had examined 'should not ethically be even offered to a purchaser – remaining, therefore, almost dead weight, to be removed from circulation in some fashion.'[2] He pointed out that this would give Vincent Massey 'a definite profit of 850%.' Duncan knew about and reminded Massey of his earlier explicit promise to give

Milne a share of the appreciated value of the canvases. And he added: 'His Excellency has stated that he feels no obligation toward Milne's dependants, but I do: the only reason I would wish to be involved in this transaction is that the inevitable margin might better be used for the benefit of the family than go into the pockets of someone like Laing or Stern.' He further noted that 240 Milnes had been itemized for insurance purposes a decade earlier: 'I should say, from the preponderence of the little ones and the very uneven quality of the 110 that I saw Sunday, that this was the first lot to be put up for sale. But I do think that a potential purchaser might well wonder how soon a further block of preferred ones might come on the market.'[3]

Massey was not moved by Duncan's entreaties, and he sold 168 paintings (two of them watercolours) to the Laing Galleries for $33,000.[4] He declined to give any portion of the proceeds to Milne's estate. Duncan, already miffed with Laing, whom he thought 'greedy and unscrupulous' from Milne's earlier troubles with Mellors Galleries, did not have a kind word to say about Vincent Massey (or Blair Laing) thereafter. When Massey's sale became known, the former director of the National Gallery, McCurry, wrote indignantly to Patsy's friend, the writer Blodwen Davies, that he had advised Massey to accept Milne's 1934 offer to sell a block of paintings as a 'mortgage on [several hundred paintings] for a sum of money to keep him painting for a period of years, perhaps 4 or 5.' But he was astonished when Massey 'sold the lot! – to a Toronto dealer of not too savoury repute. I confess I am shocked but we must not let such a miscarriage of justice prevail if it can be prevented.' McCurry knew of the plan to reimburse Milne more adequately as the pictures were sold and he deemed Massey's action to be less than honourable. He deplored the 'persecution, misrepresentation, not to say trickery, from those who had the means to make [Milne's] life a lot more liveable.'[5]

Laing's subsequent sale of the Massey Milnes, nonetheless, was another piece of marketing that helped Milne's reputation. Setting the prices at $600 for most canvases except the smallest meant putting Milne's prices up to a much higher level than Duncan's, a point of irritation to Duncan. Adding a little wicked humour to his dealing, Laing charged Duncan three times more for one Palgrave painting Duncan particularly wanted than he was charging other customers. Massey, who had paid less than $5 for each of his Milnes, told me in 1960 that he was shocked at the prices Laing was asking, considering how little Laing had paid him for them (less than $200 each on average). In about 1980 Laing told me that he was shocked at the prices that his clients were then getting for their Milnes, considering how little they had paid him for them. A decade later, however, he was selling the last of his Massey stock of Milnes for $75,000 each, nearly two and a half times more *for each painting* than he had paid for the whole stack of 168.

Duncan, of course, had first choice of the best of Milne's paintings for himself at wholesale prices, and although he was sometimes ready to re-sell what he had bought for himself to public institutions, such as the National Gallery of Canada or the Art Gallery of Toronto, he made sure that many of the finer works never got into the marketplace, a step that would have enhanced Milne's reputation in many respects. Duncan also kept Milne's prices on the low side, and Kathleen Milne was particularly irritated that Duncan was able to set prices and buy at the same time. 'I could have brained him six times a day,' she recalled later of those years

after Milne's death in a conversation with me. The purchase by the National Gallery of major paintings such as *Boston Corners* and *Billboards* for $400 or so, when other artists of Milne's generation were getting three times as much or more, rather proves her point. One time, in her frustration with Duncan, Kathleen frantically sought the help of George McVicar to confront Duncan and pull him into line. McVicar refused, and the friendship between Kathleen and the McVicars, guardians of her son, came to an abrupt end.

Since the 1955 retrospective there have been numerous exhibitions of Milne's work, some of them major. In 1962, following the suggestions of Duncan closely, I organized a small retrospective exhibition at Hart House in the University of Toronto. In 1967 a larger retrospective of Milne's work, selected by Duncan for Ralph Allen, director of the Agnes Etherington Art Centre in Kingston, Ontario, was organized as a special exhibition to mark Canada's centennial. The Vincent Massey bequest of ninety-two paintings by various artists to the National Gallery in 1968, following Massey's death at the end of 1967, drew attention to Milne again, since the bequest included twenty-six Milne canvases. After Duncan died in 1968, his entire art collection ('an accretion' was what he called it) was distributed to public galleries across Canada in lieu of estate taxes. In 1971 there was a travelling exhibition of his gift in which Milne, naturally, dominated – 152 Milne paintings and 162 drypoints were its jewels. In the same year the Milne estate mounted the first in a series of commercial exhibitions at Mira Godard's Galerie Godard Lefort, in Montreal. This exhibition was followed by regular showings at her establishments in Toronto, Montreal, and Calgary, which continue to the present. In 1980 Rosemarie Tovell, assistant curator of Canadian prints and drawings at the National Gallery, prepared a major exhibition of the Milne drypoints that had come to the gallery from Duncan, supplemented by related paintings. In Toronto in 1982, in the absence of any public initiative to mark the centenary of Milne's birth, Mira Godard mounted an exhibition of works borrowed from public institutions and from the Milne estate. In 1984 the American curator Gwendolyn Owens, who had written on the work of Maurice Prendergast, organized a fine exhibition of early Milne watercolours at the Herbert F. Johnson Museum, Cornell University, in Ithaca, New York. The estate of Frances Barwick, Duncan's sister, and her husband, Jack, was distributed in 1985, the year following Frances's death, and it also included a large number of Milnes that went into public collections. Finally, in 1991 a large retrospective (approximately one hundred and fifty paintings – the number differed at each venue) was organized by the McMichael Canadian Art Collection and the Vancouver Art Gallery and shown as well at the National Gallery of Canada. In 1995 the National Gallery mounted an exhibition of 67 of Milne's 112 war paintings, but provided no catalogue or critical assessment.

Apart from a wide variety of slim catalogues that dealt with various aspects of the artist's accomplishments, only a few substantial publications have appeared on Milne and his work in the more than forty years since his death. The catalogue for the 1955 retrospective exhibition at the National Gallery was the first, forty-eight pages in a $6\frac{1}{2} \times 8$-inch format designed by Carl Dair, with twenty-eight illustrations, eight of them in colour. It contains an incisive, clear but short essay by Alan Jarvis (five and a half pages), and a brief, largely technical, essay by Milne on his colour drypoints. Duncan oversaw the preparation of the publication for the 1955

retrospective, which Robert Hubbard, curator at the National Gallery, had organized, but was insistent on one thing:

Admittedly the purchase date of the Massey oils was important, but I won't have it made prominent in the chronology. I suppose the episode must be mentioned somewhere – but no gush. Something like: 'In 1932[sic], Milne, desperate for some cash, sold an unbelievably large number of paintings to the Hon. Vincent and Mrs. Massey, who then for some years exhibited and re-sold part of them at Mellors.' No! But I'm sure a politician like you could do better. Anyway, it was an important gesture at an urgent moment, and had snob and publicity value to Milne later, but just remember that JSM [McLean] paid a great deal more for 31 water colours once, and bought heavily both earlier, and until his death, paying out multiples of the Massey price. And I paid multiples of what McLean did – so don't be too much the courtier *in re* Her Majesty's representative. It would be better if any reference to purchasers could be omitted.[6]

In 1962 Jarvis wrote a booklet – only seven and one-half pages of text with thirty illustrations, six in colour, and two short essays by Milne – but it added little to his earlier essay.

For the catalogue of the Kingston exhibition in 1967 I contributed a substantial essay that was based largely on interviews with Duncan and on the small amount of published material available. John O'Brian wrote the first book-length study on Milne: *David Milne and the Modern Tradition of Painting* (1983). For the Edmonton Art Gallery in 1981 O'Brian also prepared an exhibition with a fine catalogue offering a shrewd exploration of Milne's New York period; the exhibition travelled to New York in 1982 and began to prompt American interest in Milne. To accompany the National Gallery's 1980 exhibition of Milne drypoints, Rosemarie Tovell prepared a *catalogue raisonné* of all the prints – etchings, lithographs, and drypoints – entitled *Reflections in a Quiet Pool: The Prints of David Milne*. Mira Godard's thematic exhibitions of Milne's work from the estate's holdings have been accompanied by modest but useful catalogues, chiefly representing the curatorial work of David Milne Jr: the New York black-and-white drawings; early Boston Corners; late Boston Corners; the Toronto year; and so on. Gwendolyn Owens wrote a fine catalogue to accompany the 1984 exhibition of Milne's work that she organized for Cornell University. The publication that accompanied the 1991 retrospective *David Milne* (1991), was edited by Ian M. Thom.

Graham McInnes had hoped to make a film on Milne for the National Film Board in the early 1940s but it was never started because of the war. However, two films on Milne have been made since. Gerald Budner completed one for the National Film Board in 1962. Entitled *The World of David Milne*, it used Milne's paintings and writings as the basis for its thirteen minutes, with an emphasis on his late watercolours and fantasies, only a passing acknowledgment of the New York years, and a total omission of the work from Palgrave and Six Mile Lake, which Duncan seems to have engineered: not one painting that had been owned by the Masseys was included, except *Painting Place III*. The writings were selected by Guy Glover and spoken by the great actor Douglas Rain.[7] One certainly gets a good sense of Milne's imaginative scope from the film, despite its brevity and the omissions. The second film on Milne was made in 1979 by Paul Caulfield. His fifty-seven-minute narrative, 'A Path of His Own,' is a wonderfully compact study of Milne, based on thoughtful research and

exposition and shots on location; the actor Les Carlson plays the part of Milne and recites some of his pithy observations. Over 135 paintings and drawings from every period of Milne's life are shown in this fine film.

In the years following Milne's death Patsy Milne stayed in Canada and led a peripatetic life that is thinly documented. The modest insurance benefit that came to her after Milne died was eventually followed by a regular allowance from the estate of $60 a month, which met most of her modest needs. She was unhappy that in 1940 Milne had revoked his 1937 will that had left everything to her: 'Even if Dave had left part of the second half [i.e., the paintings] to me I would have thought that he wanted to do what was fair, but he left it all to them [Kathleen and David Jr].'[8] Whether this was when Patsy finally learned that Milne and Kathleen had a child is unknown; and what her reaction was can only be guessed at, since she wrote nothing about it. The issue of Milne's and Patsy's childlessness, about which neither of them commented, remains closed.

For a while in the 1950s Patsy worked 'keeping house at Far Hills farm near Aurora for a bachelor farmer,' according to the writer Blodwen Davies. This was John Holden, a member of the Donald Hunter family, of the publishing giant Maclean Hunter Ltd. Finally Patsy found a small place at Mindemoya on Manitoulin Island in Georgian Bay, where she settled for her last years. Just before Milne's death, in 1952, she sought out Blodwen Davies, who had written a slim volume about Tom Thomson: 'I would like very much to ask your opinion about something that might be of interest to people in Canada – later on I mean, a sort of diary (or notes) I want to make – covering the years my husband painted in New York (and where we lived) and also in other places.'[9] With Davies's encouragement, Patsy started to write, and finally ended up with a document of forty-four typed pages that offers some worthwhile information about Milne and his life in the years they were together. Although written in the 1950s, her recollections stop in about 1940 or 1941. Her memoir has a touching, and often pathetic, tone. It concludes thus:

I have just kept on. The sun, the pine trees, and the lake, people who were kind – animals that I love – all made a pattern to help. Perhaps another might have said 'I never want to see Dave again,' after what happened to us – but I would have forgiven him anything if he had come. He meant all that was fine, and beautiful, and good, and I am glad to think that I lived with him, and the painting that was part of him. If I helped some, through the years while he was doing it – other things do not matter.[10]

Davies not only befriended Patsy but took up her cause. She wrote constantly to her, got her a lawyer, and brought her to the Milne exhibition at Hart House in March 1955, an experience that cheered Patsy up immensely. Davies also arranged to have Gerry Moses, an artist and later curator for Imperial Oil Ltd, record an interview (regrettably not an informative one) with Patsy at the National Gallery's Milne retrospective when it was shown in Toronto in October–November 1955. Davies was greatly concerned about what she thought of as the injustice done to Patsy and wanted to ensure that she had an adequate income. Davies obtained the services of a lawyer in Toronto, a Mr R. Robinson, who interceded in the courts on Patsy's behalf. Patsy was reluctant: 'I do not want to go to court if it means outsiders are there and it might also get into the papers.

I want to keep Dave's name free from criticism or stain, as it might harm the paintings in future years.'[11] The upshot, however, was that in October 1955 Patsy began to receive a regular allowance of $60 a month, although Davies's notes indicate that Vera Parsons 'said it was scandalous, $15 or so should do, but was overruled by the Official Guardian. Mr R[obinson] said he had some hot words with her about it.'[12] Davies also noted that Robinson promised to re-open the case 'if very big prices were obtained for the 800 paintings' in the Milne estate. In the early 1960s Davies helped Patsy to sell the few early Milne paintings she still had. According to Davies's notes: 'The estate [i.e., Duncan] made an attempt to claim them but the court awarded them to Mrs Milne.' This seems unlikely, since Duncan would have thought them inferior; and in any case, in 1954 he had invited Patsy to come to the Picture Loan Society and choose from the estate any work she wanted, but she had declined. In 1962 Clarke gave Patsy all the proceeds ($2,200) from the sale of his Milne paintings. In her later years, before her death in 1968, within a few months of Duncan's and a year before Clarke's, Patsy was able to spend part of each winter in Florida.

After Milne's death Kathleen Milne worked for six years, 1954–60, as a nurse at the Red Cross Outpost Hospital in Bancroft while she reared her son alone. In 1957 she sent David, then sixteen, to Pickering College in Newmarket, just north of Toronto, since she felt he needed better tutelage than the Bancroft schools provided. After leaving the hospital she worked in Bancroft for a year for Dr H.S. Johnson. In 1960 she wrote to James Clarke, asking him if she might talk to him on the telephone when she got to Toronto, where the lines were better, about a publishing idea concerning Milne. She wrote that she had often read Clarke's old letters to Milne during his last year, when he was ill, and that Milne had cherished Clarke's friendship 'above all others.' And she added that Milne felt 'close relationships would absorb too much of his time, and thought and feeling, all of which must be directed into his work. It was this, and not lack of warmth or affection that caused his withdrawal. I understand this but it seems sad to me that he could not permit himself to have the pleasure of close friendship.'[13] Clarke replied that the telephone was 'an instrument of torture' to him with his encroaching deafness and suggested that Kathleen put her proposal on paper. He also wrote, somewhat misinterpreting Kathleen's intent: 'I also regret having lost touch with Dave in later life, because the association with him and his ideals was very rewarding, but came to feel, as your letter seems to confirm, he regarded these contacts as an intrusion.'[14] On 6 June 1961 Kathleen tried again. She wrote to seek Clarke's support and assistance in arranging the publication of a biography and a collection of some of Milne's writings. She knew that Clarke held many of Milne's letters and that they would be an important part of such an undertaking. Norman Endicott, of the Department of English, University College, University of Toronto, had agreed to write a biography of Milne and help with the editing of his writings, and a more capable writer and editor would have been hard to find; he was to be assisted by the artist Gordon MacNamara as the editor of the letters. Kathleen also asked Clarke to write down, as she was going to do, as 'full and accurate a record of the years during which [we] knew' Milne as they possibly could. She added: 'You and I probably knew D. better than anyone else.'

She might have carried the day with Clarke, but for a paragraph she wrote concerning Patsy:

I don't know what she was like in earlier years, but for a long time she has been incapable of distinguishing truth from fantasy. Her stories are without end and change from day to day. Her decisions are based on the stars and unfortunately they are not constant either. I said the marriage was a tragedy and that I had always felt that she was far more sinned against than sinning – born with a character lacking in strength, then thrust into a situation and an association that would tax the strongest. I don't think she ever had a chance from the start. D. was very bitter against her until his last year when he changed and asked me to see that she was cared for – which I would have done in any case.[15]

Clarke's reply was abrupt:

From your letters I must conclude that my version of [Milne's life in the United States] would not agree with yours and your writers would slant the material I supplied toward your interpretation. This you conceived from Milne's recital which I regard as rationalizing a fact accomplished.

Nor do I believe Messrs. Endicott and MacNamara would accept Patsy's autobiography as authentic. My opinion of these papers is that they are accurate, truthful and written with a charming naiveté and are worthy of publication on their own merit ... [About] Milne's life in Canada ... I know nothing but get the impression (again from your letters) that there has been a good measure of rationalization here again ... You can see from the above why I could not accept your proposal.[16]

Clarke's sympathies were all with Patsy, and had been from 1940, when he learned from Milne, if not earlier from Patsy, of the Milnes' separation. At Patsy's suggestion Clarke shortly sent all his Milne letters, which he had treasured in a large biscuit tin, to Blodwen Davies. To her credit, Davies recognized these as being of exceptional importance, although she rather thoughtlessly separated all the letters from their envelopes in her excitement, thus making the dating of them a much harder (in some cases impossible) task than it would otherwise have been.[17]

In 1962 Kathleen moved to Toronto where she thought she would be better able to advance Milne's reputation, particularly in the matter of getting some of his letters and other writings published. To support herself during this time she lived in Duncan's father's house, where Duncan himself still resided, and provided the nursing care that the senior Duncan needed for the last two years of his life. But all editorial initiatives were checkmated. The faction that owned the papers (Patsy and Clarke, with Davies as the moving spirit) refused to give the letters over to those who controlled the copyright (Kathleen and Duncan), who refused the other side permission to publish. While Clarke agreed to consign all his Milne letters to the National Archives of Canada (then the Dominion Archives), he delegated the chore to Davies. Thwarted at not being able to publish them herself, she made the deposit in her own name in 1962, and prohibited access to these and all her other Milne papers (interviews with Patsy, Clarke, Scotty Angus, and other people who had known Milne, which she conducted with financial assistance from the Canada Council) for a period of twenty-five years.[18] She was encouraged in her course by no less an eminence than A.Y. Jackson, who in reply to her inquiry about what to do with Clarke's letters from Milne wrote:

Shortly after Milne's death two articles came out in *Canadian Art*, one by [Donald] Buchanan and the other I think by [Robert] Hubbard. They both were

covering up, giving the impression that Milne was a saint, a monastic above sex and materialism ... Milne was not a hypocrite but his followers were ... Douglas Duncan I don't think loses much on his philanthropy. [Gordon] MacNamara is a mean, selfish cuss and never does anything without a profit motive.

I can believe the Clark[e] letters are very valuable and you should not let the Milne fans have any access to them.[19]

Thus, what might be called the battle of the 'two Mrs Milnes' came to a rhetorical pitch, although if Patsy and Kathleen had actually met and discussed the matter they might have resolved it quickly enough. Their supposed contention had swollen to unusually fearsome proportions when, in 1972, I wanted to consult the original of the 1934 letter (the draft was in Milne's papers) from Milne to Alice and Vincent Massey in the Vincent Massey papers at Massey College. I knew it was an impressive document – more than twenty-five pages, to judge from the draft, and with some beautiful illustrations. What would the final version look like and what had Milne added or deleted from the draft? I wrote to the then Master of the College, the late Robertson Davies (hoping he was no relation to Blodwen, who had already been curt and unhelpful when I was casting about for material for the 1967 exhibition), and shortly afterwards met him at his College office, expecting to receive a copy, which should have been easy to find from the description I gave of it. Flanked by Douglas Lochhead, his Librarian, Davies said that even if they could find it, and they couldn't (the papers were still wholly unsorted, he said, but they would keep an eye open for the letter as they burrowed through what sounded to me like mountains of material), it would be too contentious to let me have a copy of it – in light of the copyright scrap between 'the two Mrs Milnes' over Milne's writings. Two weeks later Claude Bissell, recently retired president of the University of Toronto and a good friend, who was beginning work at Massey College on Vincent Massey's papers for the first volume of his biography of Massey, invited me to his large office (it had been Vincent Massey's when he was the first Visitor at the college), swiftly scanned the well-classified and neatly ordered shelves of Massey's papers, and pulled the letter out of its box, one marked MILNE in large capital letters. There was the twenty-nine-page letter, typed by Milne, with a two-page covering note, marginal notes, and nine splendid, fresh-as-air sketches in ink. Accompanying it were a small sheaf of other letters from Milne to the Masseys. He made copies for me forthwith.

The friendship between Patsy and Blodwen Davies made possible the sale of a group of nineteen early Milne paintings that Patsy had in her possession. Davies noted these as being with Patsy in the summer of 1954 and a year later numbered them at fourteen. Patsy had thought six or eight and was surprised there were so many; obviously she had not looked at them for some time. They had been stored and re-stored by Patsy for many years. Where she got them is not entirely certain. The probability is that they came from Florence Martin at Big Moose Lake, in whose boathouse the Milnes had stored most of their worldly goods when they left for Canada in 1929. Thoughts of retrieving their property were mentioned by Milne and Patsy from time to time but never acted on.[20] Martin was a teacher in Yonkers, New York. An undated letter from her to Patsy in the 1940s mentions that she had 'gone over the pictures again. I am sending the small ones,'[21] and Patsy remembered that she also sent a packet of early letters – Milne's love letters to Patsy from 1906–9. At least some early

drawings, a few drypoints, and a 1922 painting were still in the boathouse in the late 1950s when Martin's relatives cleaned out what remained there, destroyed Andrew McHench's plaster portrait head of Milne, and burned the remaining letters and other papers; fortunately they kept Milne's works until they decided to sell them in 1979.[22]

In May 1955 Patsy offered fourteen of her group of paintings as a gift, or for sale, to the National Gallery of Canada, which turned down her offer, probably on aesthetic grounds, although Davies claims that she begged Jarvis not to accept the paintings as a gift 'while Mrs Milne was earning her living as a servant' – she was working as a housekeeper for John Holden at the time. Following this, in 1957, Patsy made a gift of two of the paintings to the Bruce County Museum in Southampton, Ontario, near Milne's birthplace, along with other memorabilia: some of her own paintings, mostly of their cats at Boston Corners and Mount Riga; a few Milne drawings, including two of Amos Engle (*Engle Seated* and *Engle Standing*); an etching of Patsy herself by Milne (Tovell 1); a swatch of Milne's childhood kilt, the MacFarlane clan tartan; and a white mixing bowl that Patsy claimed was the one Milne often painted (and probably did), although he referred to it as the 'Massey bowl,' probably since a Christmas pudding had once arrived in it from the Masseys' Batterwood kitchen.

Robert McMichael, a Toronto businessman, was attracted to Milne's work in the early 1960s, as part of his compulsive interest in collecting Canadian art and artists, mainly works of the Group of Seven and their generation. He bought and sold and traded their paintings with entrepreneurial fervour for a time and then hit upon the idea of converting his country home and his painting collection in Kleinburg, northwest of Toronto, into a sylvan shrine to honour the Group of Seven.[23] He developed his plans, and in 1962 he tracked down James Clarke and offered to purchase Clarke's collection of Milne paintings and drypoints. Initially Clarke was not interested, but McMichael was persistent, and he finally made Clarke an offer that allowed Clarke, or so he thought, to do something for Milne's reputation and for Patsy's financial needs. 'These paintings,' Clarke wrote to Patsy in July 1962, 'will be housed and exhibited in a wonderful building in Kleinburg, Ontario. The building, land and [McMichaels'] collections of paintings of Canadian Painters has been deeded to the Metropolitan Toronto and Region Conservation Authority Foundation. Thus Dave's work will have a permanent home where it can be viewed by the public.'[24] With the assumption that his Milne paintings would belong to the public and would be continously exhibited, Clarke sold all his Milne paintings and drypoints to McMichael in 1962 for the sum of $2,200. This group consisted of at least seven canvases in oil, six watercolours, and two dozen or more drypoints that were Milne's first choice of the impressions he had pulled, one of each subject. These were the drypoints that he gave to Clarke over the years in return for Clarke's buying the etching press. Clarke put the entire proceeds from the sale into a bank account for Patsy.

McMichael clearly had a different understanding of his agreement with Clarke, for shortly nothing remained in the public collection but one watercolour (*Relaxation*) and two oil paintings (*Black* and *Valley, Lake Placid III*). On the day McMichael brought everything back from Clarke's home in Yonkers, he gave two of the drypoints to a friend.[25] Shortly thereafter he sold five oils, five watercolours, and most of the rest of the drypoints (except for a couple that he kept, McMichael told me, for his own personal

John Boyle's portrait of Milne, Imposi-
tions, 1984, oil, 55.9×76.2 (22×30)

collection and sold a few years later). Twenty-two of the drypoints were sold (or traded) for much more than McMichael paid Clarke for everything (they recently changed hands again for a total of more than $250,000).[26]

In August 1962 the Historical Board of Canada erected a historical plaque to Milne's memory in Willow Creek Park in Paisley, not far from the family home. For the unveiling Mrs John Reichert, a niece, and Stanley Milne, a nephew, were on hand with Alan Jarvis.

Milne was in the news again in 1963 when fourteen paintings that had been stolen from the Baptiste Lake cottage shortly after Milne's death were brought to an evaluation panel at the old Four Seasons Hotel on Jarvis Street in Toronto. The paintings were seized by the Ontario Provincial Police at Duncan's request and returned to Milne's estate.[27]

Milne's place in the firmament of twentieth-century painters is taking a long time to be charted and recognized. He made more of a splash in New York in the second decade of this century than American art historians have given him credit for. Had he remained in the United States, I believe that his work would now stand, as it deserves, beside that of John Marin, Marsden Hartley, Rockwell Kent, Edward Hopper, and their generation. The quality of his work quite clearly merits such a position, but history and taste are formed by markets and art critics and historians; in a sense, what they do not know does not exist. Clement Greenberg, America's foremost art critic of the twentieth century, considered Milne to be among the top three painters of his generation in North America – that is, on a par with John Marin and Marsden Hartley; in conversation with me toward the end of his life Greenberg also compared Milne's stature with that of Edward Hopper.[28] Milne is also close in sensibility to Milton Avery (1894–1965), whose sense of colour and tone is like Milne's, even and sensitive. Their aesthetic distance is also comparable, as is their sense of space and intimacy. Carl Zigrosser, an American artist and writer who had seen the Armory Show as a young man and carefully graded the achievements of the American work he saw there with a series of coloured checkmarks, gave Milne three coloured marks in his catalogue, his highest rating, and one he gave to only four other artists in the show. Late in his life Zigrosser reviewed his earlier judgments and found that they had all been pretty shrewd, except that someone named David Milne, whom he thought was so exceptional back then, had simply disappeared.[29]

As far as Americans were concerned, Milne had indeed vanished soon after his first appearance; his last American outing was shortly after the First World War, and in Boston and Philadelphia, not New York City. No initiative to develop Milne's place in the United States art market was attempted after Duncan's failed attempt to organize an exhibition at the Buchholz Gallery during the Second World War. Duncan's donation of a single watercolour to the Museum of Modern Art in New York in 1961 was hardly a peg upon which a larger strategy might have been hung.

I venture to think that Milne's originality, the fecundity of his imagination, and his exceptional creative power in translating his vision into so many images that can only be described as magical – while all the time going his own way, tenaciously and intelligently – will eventually win for him a larger audience and a more prominent place among the great painters of his time. If, as Mies van der Rohe claims, genius shows itself in energy and clarity, then Milne's work has a strong claim to more attention

than it has received so far. What persuades me most of all about the worth of Milne's achievements is that he has always been an artist's artist, a painter whom other painters have admired and respected profoundly. This book is offered in the hope, and with the conviction, that Milne's work will now begin to receive its due.

Notes

The following abbreviations are used:

DPS David P. Silcox papers, Art Gallery of Ontario, Toronto
MFP Milne family papers
NAC National Archives of Canada, Ottawa
NGC National Gallery of Canada, Ottawa
UTA University of Toronto Archives

PREFACE

1 Milne, miscellaneous notes, c. 1932
2 Milne, notes for a letter to Maulsby Kimball, 1930
3 Milne to Donald Buchanan, [c. 1936], NGC. The letter was incorporated in an article, published under Milne's name as 'Spring Fever,' *Canadian Art* 2/4 (April–May 1945): 162–5, and subsequently reprinted three times: in *Canadian Art* 1/1 (January 1958): 16–19; *artscanada* 38 (March 1982): 82–4; and *Documents in Canadian Art*, ed. Douglas Fetherling (Peterborough, Ont.: Broadview Press, 1987), pp. 93–6.
4 Milne, 'Art Definitions,' [c. 1923], MFP.
5 Milne, miscellaneous notes, 1940, MFP.
6 Ibid.
7 Ibid.
8 Ibid.

CHAPTER ONE

1 Milne to Donald Buchanan, 19 January 1937, NGC. Milne wrote that he wanted to know more about Morrice's childhood, and that such information was important in learning how certain people came to be artists. Buchanan was a curator at the National Gallery of Canada.
2 Milne to Alice Massey, 17 January 1935, NAC.
3 Milne, 'New York,' Autobiography, 1947, MFP.
4 Milne to Alice and Vincent Massey, 20 August 1934, UTA.
5 David Milne's father, William Milne, was born in 1834 in Fyvie, near Aberdeen and died on 10 June 1921 (his obituary was in the *Paisley Advocate* 15 June 1921). Mary Divortay (various spellings; Milne's brother Charles spelled it 'Devarty') was born on 12 July 1840 in Udney, not far

from Fyvie, and died on 29 May 1922. They had ten children: William (born Scotland 11 February 1862, died Milverton, Ontario, 23 August 1897) was a carriage builder who did some painting on cardboard; James (Jim) (c. 1863–31 July 1953) stayed at home (he married, but his wife, Jennie, died within a year) and was variously employed, mostly as a house painter and wallpaperer; Isabel (19 July 1865–13 March 1939), known as Belle (and as Isabella by Charles's children), was engaged for many years before she finally married Duncan McTavish and moved to Vancouver; Charles (Charlie) (31 October 1867–15 October 1944) was a teacher and businessman who moved to Morden, Manitoba; John (July 1872–January 1945) had a hotel in Hepworth (near Owen Sound, Ontario), according to Adam Esplen, in a letter to Blodwen Davies, 20 September 1961, NAC; Francis (Frank) (September 1873–January 1945) married and went to Morden, Manitoba, and then moved to Clemenson, Minnesota, in 1906 and became an American citizen; Robert (Bob) (1874–1 September 1933), a cheesemaker at Burgoyne before he went to Toronto and sold real estate and patent medicine (Patsy Milne recalled that he was an optician, which he may also have been), died from gangrene soon after his leg was amputated following an accident; Mary (29 August 1875–3 August 1877); Arthur (22 August 1880–17 August 1881); there is no birth record for David, although no birth date other than 8 January 1882 has ever been given.
6 Milne diary, 18 May 1940, MFP.
7 Milne, 'New York,' Autobiography, 1947, MFP.
8 *Paisley Advocate* 14 June 1922; a brief notice of her death also appeared on 31 May 1922.
9 Milne remembered this in his notes for his Autobiography, MFP, as being lot 6, concession A, although property records of the time contradict him. He mentions, in a draft for his Autobiography, that the log farmhouse he was born in, but had no recollection of, was a short distance east of this Milne home. The farm where he grew

up was 1.3 kilometres (three-quarters of a mile) west of Burgoyne on the south side of the road and was rented from Will Hogg. Today not a trace of the house and barn shows, except for a slightly darker patch in the alfalfa. On the west side was the Milnes' orchard, now also gone. Behind the site and up the hill is Black's bush from which Milne was able to see Lake Huron; trees several miles away along the banks of the Saugeen River now block the view. Blodwen Davies's version in her Milne notes is that Mary Milne and her many children 'lived in a log cabin at the rim of a disused gravel pit on the south bank of the [Saugeen] river. She worked in farm homes roundabout for 25¢ a day. She was a famous gardener and sold strawberries for 6 or 7 cents a quart almost all of her life, even when she moved to Paisley where her garden was famous [and] she peddled vegetables.'
10 Milne, 'Introduction,' Autobiography, 1947, MFP.
11 Ibid.
12 Ibid.
13 Ibid.
14 Milne diary, 14 May 1940, MFP.
15 Not so named because of snakes, as one local told me, but 'because it's so damned crooked.'
16 Milne diary, 14 May 1940, MFP.
17 One might expect this to be spelled 'Koepke' and sometimes it was; but for whatever reason 'Keobke' is the more usual spelling in that part of the world. Milne remembered it as 'Keopke' in his Autobiography, and noted that the family had come from Wurtemberg (now the state of Baden Wurtemberg) in Germany.
18 Milne's reference to his mother's bread, which he thought of baking and probably did, is in his diary entry of 11 January 1921, MFP.
19 Milne, 'Introduction,' Autobiography, 1947, MFP.
20 Ibid. Descendants of the Finnie family still live across and up the road. Blodwen Davies, in her research, hints strongly, but without giving sources, that Milne's childhood was an unhappy one and that he was caught in a deep conflict between

his mother and his father, who was banished to the chicken house from time to time. Milne's friend James Clarke, writing to Davies, expresses astonishment at the idea that Milne was unkind to his mother, but then accepts her surmise: 'he said very little about his early life. Still one got the impression (subsequently confirmed [i.e., by Davies]) that it was not happy. Even so it is hard to justify his neglect of his mother as he surely must have known her part in the start of his career' (Clarke to Davies, 14 November 1961, NAC). Whether this was a reaction to some comment by Patsy taken out of context or to something said by others is speculation, but there is no evidence that Milne was unhappy (any more than anyone else to whom, in those days, the switch or strap was applied when required), or that he was unfilial in his affections. In fact, Patsy mentioned that just after the First World War, and a year or two before his parents died, Milne paid the taxes, made arrangements for them, and sent packages of food and other things to his parents.

21 Milne, notes for Autobiography, 1947, MFP.
22 Ibid.
23 The date of the family's move to Paisley is not certain, but midway through 1892 or 1893 is most likely. Patsy believed it was when Milne was nine or ten years old. Milne attended the Gowanlock School for a few months at least. Adam Esplen wrote to Blodwen Davies (20 September 1961, NAC) that he and David Milne 'were in the same class in Sunday School at Burgoyne Presbyterian Church but we did not go to the same school as he was in the Gowanlock school section.' The Gowanlock records are missing for these years; Milne wrote in 1951 to try and find them when he wanted to establish his age to apply for the old-age pension. One record (according to Blodwen Davies's notes, quoting Patsy Milne) states that he began school in 1892. If the record was written in the first week of the calendar year, as was the practice then, Milne would have been just turning ten. It was about this time, or shortly after, that the Milnes moved to Paisley. Patsy confirms this, with some hesitation, in her Memoir, [c. 1958], p. 1, NAC. In an interview with C.B. Pyper in 1935 Milne noted that he began school at age ten (C.B. Pyper, 'When Canvas Is "Quick" It's the Work of Art,' review of exhibition at Mellors Galleries, Toronto, *Evening Telegram* 19 November 1935, p. 14). Had he been in school earlier, Will Hogg would not have had to teach him his ABCs, as Milne recounted in his diary entry for 14 May 1940, MFP.
24 According to Blodwen Davies in her Milne notes: 'Willie followed [Mary] to Paisley [when she moved into the new house] intending to live with her although he refused to pay for his keep. She refused to

let him live in the house so he lived the rest of his life in a brick workshop behind the house. He was only allowed in the house for dinner if there was a family gathering – as for instance when David & his bride arrived in Paisley.' Later both Jim and his father lived in the workshop, according to Davies, 'eating mainly Roman meal and raw eggs.' It is not clear where Davies got this information; Patsy does not corroborate it in her Memoir.
25 The Bible is among the artifacts at the Bruce County Museum, Southampton, Ontario.
26 Patsy Milne, Memoir, [c. 1958], p. 10, NAC.
27 Milne to Alice Massey, 'Sunday morning in Toronto' [3 March 1935], UTA.
28 Milne, notes for Autobiography, 1947, MFP.
29 In fact Milne's papers include his certificates for 1896 to 1899 inclusive, Forms I to IV, and 'honours' is noted for each one. One teacher he credited with his success was Margaret McGregor, whose descendants own an early Milne painting, and she may have encouraged him to go to New York.
30 See S. Gelman, 'The "Feminization" of the High School: Women Secondary Schoolteachers in Toronto: 1871–1930,' pp. 71–102 in *Gender and Education in Ontario: An Historical Reader*, ed. Rudy Heap and Alison Prentice (Toronto: Canadian Scholars' Press, 1991).
31 In his answer to a questionnaire in 1942, probably from *Canadian Art* or from the National Gallery of Canada; this statement was repeated in a short essay, never published, entitled 'Art Influences,' MFP.
32 In a letter of recommendation from the principal, Joseph Morgan, 27 September 1899, MFP. Morgan was a gifted classicist and ran a remarkably vigorous institution for forty years; complimentary recommendations from him were not easily come by.
33 Charles Milne, recollections written in December 1936, copy in MFP.
34 Milne, notes for Autobiography, 1947, MFP.
35 The two large volumes of *Picturesque Canada: The Country as It Was and Is*, ed. George Monro Grant (Toronto: Belden Bros, 1882), contained some 540 illustrations – wood-engravings based on paintings and, for the West, photo-engravings from photographs. Like the illustrations, the descriptive texts, by Grant, Charles G.D. Roberts, and others, presented an idealized view of the cities, towns, and regions of Canada. Another possible source of early artistic influence may be the Milnes' neighbours, the Brown family. Patsy Milne believed that the Brown from whom the Milnes rented their farm at Burgoyne – for whom William Milne worked, and from whom David Milne received his middle name – was responsible for sparking Milne's interest in drawing (see her Memoir, [c. 1958], p. 1, NAC). Blodwen Davies reported

in her Milne notes (probably retailing Patsy's information) that Brown's son, a deaf mute with high intelligence and curiosity, 'taught [Milne] to draw & paint. He made sketches & showed them to the boy & planted the seed in Milne. Brown had a very good English education ... he had, as his most precious possession, a telescope & he studied astronomy. He would set up his telescope & invite the neighbours to use it. It still exists, along with a collection of his drawings ... in Goderich.' Davies was able to confirm this determining influence with one other person who lived there then, Adam Esplen. She further reports that 'Milne often spoke to his wife [Patsy] about David Brown. He told her his association with David Brown was the origin of his interest in painting.' Both Browns, father and son, may, or may not, have been a source of inspiration. In any case there were other influences that together caught Milne's imagination and turned his thoughts toward art as a vocation.
36 Milne to Alice Massey, 'Queen's birthday' [24 May], copied with additions on 24 June, completed 26, 27 June [1938], NAC.
37 Whether Milne's illustration was used or not is unknown, since most issues, this one included, cannot be found.
38 O.E. Turnbull to Milne, 29 July 1901, MFP. We have found only two numbers of this publication: the 1902 issue is in the National Archives of Canada; the 1903 issue is in the Guelph Public Library, Guelph, Ontario.
39 Turnbull to Milne, 16 August 1901, MFP.
40 Arthur W. Wright to Milne, 23 September 1902, MFP. Copies of this publication have not been found.
41 Milne bought a camera in 1918, but seems not to have used photography in any regular way as an adjunct to his art.
42 Notes for Autobiography, 1947, MFP.
43 I was amused to hear from an elderly resident of Paisley of the unusual means of destruction of all these papers: the detritus from the Milne attic was dragged out onto the ice of Willow Creek and left to the mercy of the spring thaw.
44 Notes for Autobiography, 1947, MFP.
45 It certainly was not done – as the *Owen Sound Sun-Times* claimed in a 1962 caption, after noting the clogs – while the artist was in Holland: 'Plaque Honors Artist,' 30 August 1962, p. 13.
46 In a note written in about 1939–40, Douglas Duncan, from information given to him by Milne, mentions Margaret McGregor of Walkerton as one of Milne's early teachers.
47 Milne, 'New York,' Autobiography, 1947, MFP.
48 Ibid.
49 Until the 1970s all published references to Milne's departure for New York gave the date, incorrectly, as 1904. Milne may have caused the error; certainly he never took any steps to correct it.

50 Milne, 'New York,' Autobiography, 1947, MFP.

51 Milne to Alice and Vincent Massey, 20 August 1934, UTA.

CHAPTER TWO

1 Milne, 'New York,' Autobiography, 1947, MFP.

2 In the notes for his Autobiography, MFP, Milne merely states, 'Cigars from Rid-dells, the kindly family,' a reminder, perhaps, for an anecdote he did not elaborate upon.

3 In his Autobiography, MFP, Milne writes only of the first few months in New York. His 20 August 1934 letter to the Masseys, UTA, emphasizes the post–1910 period, but runs student and professional activities together, as if, as a student, he had attended the exhibitions at Stieglitz's 291 gallery. It did not open until some years after Milne had left the Art Students' League, and its seminal exhibitions were after 1910 – that is, after Milne's own style had been pretty well set. Milne's acceptance and growing importance as an artist are mentioned by him only in a cursory fashion.

4 Patsy Milne, Memoir, [c. 1958], p. 5, NAC.

5 Zorach was forthright about being Jewish, but held that aesthetic concerns in art were the most important issues, and in this he would have found common ground with Milne. Stieglitz, whom Milne came to know casually as the owner of the 291 gallery, was also Jewish but was reluctant to admit it, according to Benita Eisler in O'Keeffe and Stieglitz: An American Romance (New York: Penguin Books, 1992), p. 230.

6 Milne, 'New York,' Autobiography, 1947, MFP.

7 In his notes for his Autobiography, MFP, Milne also referred to it as 'the 61st St. school,' which was doubtless in the Arcade Building at 61st Street and Columbus Avenue, where a number of artists had studios.

8 How much money Milne had when he arrived in New York is not clear. Milne himself, who had paid his brothers back for the cost of his high school education, said $200 (Milne to Alice and Vincent Massey, 20 August 1934, UTA); Patsy Milne in her Memoir, [c. 1958], p. 1, NAC, reports $2,000 in total, and the second time adds that this figure included a loan from Milne's brother Jim. Milne's is a more believable figure. Clarke thought the amount was $2,000, made up from money saved and a loan from Jim Milne (Clarke, interview by Blodwen Davies, May 1961, reel 3, transcript, David Milne papers, NAC), although Clarke had just read Patsy's Memoir and may have simply been repeating her information.

9 Milne was registered as student #418, 18 November 1903, with 323 East 84th Street as his address, and as #488, 19 December (1904), with 358 West 25th Street as his address. Andrew Dasburg (1887–1979), a fellow student in both years, went on to study with Robert Henri and was later in the Armory Show with Milne. Arthur W. Crisp was on the League's Board of Control during Milne's first year. Crisp also did magazine illustrations. Milne and Crisp both served on the juries for the New York Water Color Club's annual exhibitions in 1915 and 1916. In an interview with Blodwen Davies in 1961 Patsy mentions that when she met Milne in about 1906 he was studying three days a week at the League. Milne remembered attending at night, part time, for the third year, but I have not found an official record of this.

10 Milne, notes for Autobiography, 1947, MFP.

11 Ibid.

12 Ibid. Milne went on to write: '[Chase] told a good many stories about Whistler, mostly funny, such as the one about frying the neighbours' gold fish. He admitted that some occurrences in his association with Whistler were beyond his understanding. One was when Whistler was on his way to an important business appointment – I think to deliver and be paid for a portrait – a fruit store with a sidewalk display attracted his attention, so he stopped the cab, got out and devoted himself for a long time to the picture material, even getting the proprietor to shift things around a bit. Chase couldn't understand it; it was either a pose or an indication that the man wasn't quite of sound mind. I felt that I could understand both men. One took his oranges and bananas much more seriously than the other took his fish, or even his portrait subjects.'

13 Ibid.

14 Ibid.

15 Ibid. Milne also added: 'What had lured me to New York was not the art school but the city itself. As it turned out the teaching of the Art School wasn't worth while. What I learned of art was mostly from the city, its museums and art galleries and from discussions of these with fellow students. Often after classes and Saturday mornings we went down town to see current exhibitions, not in any large body but one or two or three at a time. I don't think dealers were always entirely happy about our visits.'

16 Milne to Alice and Vincent Massey, 20 August 1934, UTA.

17 Milne, notes for Autobiography, 1947. The Homer painting of 1899, which is in the Metropolitan Museum of Art, New York, is a most disturbing painting indeed and raised considerable controversy when it was first shown.

18 Milne to Alice and Vincent Massey, 20 August 1934, UTA.

19 Milne, notes for Autobiography, 1947, MFP. Milne's opinion was shared by his friend James Clarke, himself a graduate of the Connecticut League of Art Students: 'I knew all these men and I knew their work. They were all academy men and conservative in their methods and only a few of them were radicals and they had very small followings ... I think all he [Milne] got out of the Art Students' League was the association with other people who were trying to do the same thing that he was doing. And that, of course, is a great help to an art student, to feel they are in a group, striving for the same objectives' (Clarke, interview by Blodwen Davies, 3 May 1961, reel 1, transcript, David Milne papers, NAC). Reuterdahl had one painting accepted for the Armory Show.

20 Milne, notes for Autobiography, 1947.

21 Ibid.

22 Milne to Alice and Vincent Massey, 20 August 1934, UTA.

23 Milne, notes for Autobiography, 1947, MFP.

24 Patsy Milne, Memoir, [c. 1958], p. 4, NAC.

25 Ibid., p. 5.

26 Ibid.

27 Ibid.

28 Milne reported to Patsy in 1906 that he was 'back from the North' (Milne to Patsy Hegarty, Paisley, Wednesday [5 September 1906], NAC), and in 1909 that he was 'back from the mountains.' It is likely that nearly every year until after he was married Milne made a trip home to see his family. One year his mother and sister visited him in New York. In his notes for his Autobiography Milne indicated that he was going to write about returning home via Rochester – it is not known if this was a regular route or a special occasion. The train route out of New York may sometimes have taken him at first southwest toward Philadelphia and Wilkes-Barre, where he and Engle painted in 1907 and 1908, and then north through Buffalo.

29 Patsy Milne, Memoir, [c. 1958], p. 6, NAC.

30 This date is deduced from Patsy's own account, but no record has yet been found to confirm it, despite diligent searches; she once later gave her birth date as 1894! Her first name, May, obviously derives from the month of her birth. The Archivist of New York explained to me that civic birth records were rarely kept in this period, especially in Irish Catholic communities where parish records served instead.

31 Patsy Milne, Memoir, [c. 1958], p. 8, NAC. Patsy may also have had a brother, but he is only mentioned once as being in a photograph, which we cannot now find.

32 Ibid., p. 1A.

33 The information on Patsy's family is gleaned from her Memoir, [c. 1958], NAC.

34 Patsy Milne, Memoir, [c. 1958], p. 7, NAC.

35 Ibid.

36 Ibid., p. 8.

37 Milne to Patsy Hegarty, [27 August 1909], NAC. Milne's brother, probably John, had his money tied up in a hotel, in horses,

and poultry; Milne reported that John had to pay $2,200 for one horse, so his refusal to lend Milne money was understandable.

38 Patsy Milne, Memoir, [c. 1958], p. 5, NAC. Milne recalled this culinary feat in a 1935 interview: C.B. Pyper, 'When Canvas Is "Quick" It's the Work of Art,' review of exhibition at Mellors Galleries, Toronto, *Evening Telegram* 19 November 1935, p. 14.

39 This was renumbered to 20 in about 1914. In 1975 it was still a commercial art studio over a restaurant and was advertising for an 'ARTIST – EXP'D – air brushing/ruling pen for men's wear.' The building is five storeys high and we do not know which floor the studio was on – presumably the second.

40 Milne to Clarke, [c. 18 January 1948], NAC.

41 Milne to Alice Massey, 17 January 1935, NAC. In 1900–1, when he was at the League, Engle was living at 137 West 63rd Street.

42 'Novel Hanging at Water Color Show,' review of New York Water Color Club Twenty-Fourth Annual Exhibition, *New York Sun* [c. November 1913], newspaper clipping, David Milne papers, NAC; for some of the titles of Engle's paintings, see William B. McCormick, review of New York Water Color Club Twenty-Fourth Annual Exhibition, *New York Press* November 1913, newspaper clipping, David Milne papers, NAC.

43 'Interesting Features of the Many Attractive Pictures in the Exhibition of Paintings of the Water Color Club,' review of New York Water Color Club Twenty-Third Annual Exhibition, *New York Times* 3 November 1912.

44 'Water Color Society's Exhibition,' review of New York Water Color Club Twenty-Fourth Annual Exhibition, 8–30 November 1913, unidentified newspaper clipping, David Milne papers, NAC. Milne used the same black-paper device in 1918 in Wales for the painting *Kinmel Park: The Camp at Night*, and retained a periodic interest in night subjects for most of his life.

45 Milne to Alice and Vincent Massey, 20 August 1934, UTA.

46 'Why Shouldn't a Half Moon Be Skyed,' newspaper clipping annotated 29 October 1910, David Milne papers, NAC.

47 Milne to Alice and Vincent Massey, 20 August 1934, UTA.

48 Patsy Milne, Memoir, [c. 1958], p. 8, NAC.

49 The fireplace was still there in 1975 when I poked into the building to see if anything was recognizable. Nothing else was.

50 Milne to Clarke, [25 December 1930], NAC.

51 Milne to Alice Massey, 17 January 1935, NAC.

52 Amos Engle to Milne, [c. 4 April 1921], MFP.

53 Milne to Patsy Hegarty, Friday [20], Sunday [22 August 1909], NAC.

54 Douglas Duncan, miscellaneous papers, MFP.

55 Milne to Patsy Hegarty, Friday [27 August 1909], NAC.

56 Milne to Patsy Hegarty, Friday [3 September 1909], NAC.

57 Milne to Patsy Hegarty, Wednesday [6 October 1909], NAC.

58 George Britt, *Forty Years – Forty Millions, the Career of Frank A. Munsey* (New York, 1935). Britt goes on to say: 'His temperature was low. His handclasp was fishy.' Munsey fired one of his editors for being fat; indeed, he fired anyone who was or got fat. Perhaps Milne unwittingly painted a fat man on a horse by mistake. This commission is possibly the painting that lies underneath *Embankment and Bridge*, where all that can be seen is part of a horse and the rider's uniform.

59 Milne to Spencer Kellogg, [c. 29 December 1930] (draft), MFP.

60 Milne to Donald Buchanan, 13 November 1951, NGC.

61 Milne to Clarke, 29 September 1934, NAC.

62 Engle to Milne, [c. 4 April 1921], MFP.

63 The members of The Eight were Robert Henri (he changed his name from Robert Henry Cozad as a boy, when his father skipped out of Denver after killing a man); Maurice Prendergast (1859–1924); Arthur B. Davies (1862–1928); George Luks (1866–1933); William Glackens (1870–1938); John Sloan (1871–1951); Ernest Lawson (1873–1939); and Everett Shinn (1873–1958).

64 Clarke mentioned that he and Milne knew Alfred Stieglitz; however, he also mentions that Milne helped Brancusi move one of his sculptures at 291 one day – several years before Brancusi first visited North America in 1926 (Clarke, interview by Blodwen Davies, May 1961, reel 3, transcript, David Milne papers, NAC): 'Mr Brancusi was a very small man and he was attempting to move his piece of sculpture called *The Bird* and he couldn't do it, so Dave stepped over and assisted him.' Milne may have helped Stieglitz or someone else move a Brancusi sculpture.

65 Milne to Alice and Vincent Massey, 20 August 1934, UTA.

66 See William Innes Homer, *Alfred Stieglitz and the American Avant Garde* (Boston: New York Graphic Society, 1977), pp. 295–8, for a complete listing of Stieglitz's exhibitions.

67 Twenty-five years later, ironically, Mellors Galleries in Toronto would forgo an opportunity to show Milne's paintings at the Durand-Ruel Galleries in New York, believing the cost, against the risk, to be too great. What a fine opportunity that would have been for Milne, but he never knew of the possibility. See also p. 27, and Milne's essay 'Monet,' [c. 1945], MFP, for his extended comments on Monet.

68 'Over twenty-five years ago at a Fake Show [i.e., the students' satirical exhibition] in the Art Students' League someone exhibited a masterpiece made by nailing some pieces of rock on a board and rubbing a little blue paint behind them. They called it "Rocks-well-meant." This was my introduction to Rockwell Kent; it was a fake of a coast picture by him in that

year's academy [National Academy]': Milne to Elmer Adler, 7 January 1931, Princeton University Library. Kent was a meteoric talent and it is worth remembering that he was born in the same year as Milne. Milne is wrong about the Newfoundland date, since Kent visited briefly in 1914, and then painted there in 1915–16; but he did bring back to New York stark, powerful paintings of the coast at Monhegan, Maine, early in 1907; and in 1908, across the street from Milne's studio on 42nd Street, Kent arranged a startling exhibition that was intended to shatter the artistic conventions of the National Academy. In Milne's notes for his Autobiography, MFP, there are other similar comments on Kent.

69 Milne, 'Art Influences,' an answer to a 1942 questionnaire from either *Canadian Art* or the National Gallery, NGC.

70 Milne, 'Monet,' essay, [c. 1945], MFP.

71 Ibid.

72 Ibid.

73 J. Nilsen Laurvik, 'The Fine Arts: The New York Watercolor Club Exhibition,' review of the twenty-first annual exhibition, 1910, newspaper clipping stamped 2 November 1910, Archives of American Art, microfilm reel N447.

74 'Water Color Club Excels All Former Exhibitions,' review of Eighth Annual Exhibition of the Philadelphia Water Color Club, *Public Ledger* (Philadelphia) 13 November 1910.

75 Minutes of the New York Water Color Club, 19 October 1911, Archives of American Art.

76 Milne to Alice and Vincent Massey, 20 August 1934, UTA.

77 Ibid.

78 Duncan, miscellaneous papers, MFP.

79 I have been struck by similarities in Milne's early work entitled *Pink Flowers* and Twatchman's *Wildflowers* (private collection, Boston), reproduced in Donald Goddard, *American Painting* (New York: Hugh Lauter Lavin Associates Inc., 1990).

80 Milne to Patsy Hegarty, Wednesday [6 October 1909], NAC.

81 They are discussed in the next chapter.

82 In Terry Fenton and Karen Wilkin, *Modern Painting in Canada: A Survey of Major Movements in Twentieth Century Canadian Art*, exhibition catalogue (Edmonton, Alta: Edmonton Art Gallery, 1978), p. 52, Fenton mentions that Milne studied under Maurice Prendergast. This is incorrect. Other scholars claim to see similarities between Milne and Prendergast, and while this may be so superficially, the intent in Prendergast's work seems to me to be totally at odds with Milne's. Prendergast's aim was anecdotal and illustrative. He filled all the spaces on his paper or canvases, kept to a nineteenth-century perspective, and used a wide palette. Milne's aim was aesthetic; he used space in a modernist (and novel) way, and used a strictly limited palette.

Even their subject matter was seldom, if ever, similar. Incidentally, Prendergast's middle name, Brazil, is pronounced Braz'il in Newfoundland, where his birth is registered.

83 Spuyten Duyvil is a place where Lawson frequently painted at a time when Milne was also painting there.

84 For example, compare Milne's *Train across the River* with Lawson's *Harlem River*, c. 1913–15 (Manoogian Collection).

85 Milne, notes for Autobiography, 1947, MFP.

86 Milne to Patsy Hegarty, Sunday [29 August 1909], NAC. In the early 1920s Milne could easily dispatch two or three finished watercolours or oils in a day.

87 Milne, 'Boston Corners,' Autobiography, 1947, MFP.

88 Milne's decision may also have been triggered by the success of The Eight (whose paintings sold rather well in 1908), or by a meeting with Stieglitz or Henri that triggered a response later forgotten. And he could have been inspired by a session with John Marin, a decade older than Milne, who returned from Europe briefly late in 1909 and again in early 1910 for his second exhibition at 291.

89 Patsy Milne, Memoir, [c. 1958], p. 8, NAC.

CHAPTER THREE

1 Milne purchased his paint supplies at the Montross Gallery for many years and the Montross stamp is on the back of a number of the early paintings on illustration board.

2 In conversation with the author, 1972.

3 In an early notebook, NAC, Milne gives McHench's address as 224 West 21st Street, New York; McHench moved to New Rochelle later. For comments on his portrait head of Milne, see p. 38.

4 Douglas Duncan recorded the destruction of forty-two oil paintings, which he believed ranged from 1912 to 1915, and even provided a list of them, briefly summarized. See *Catalogue Raisonné*, New York City, 1915–16, Introduction, for details.

5 This was first pointed out by John O'Brian in his book *David Milne and the Modern Tradition of Painting* (Toronto: Coach House Press, 1983), pp. 61–2.

6 Milne, 'Mount Riga,' Autobiography, 1947, MFP.

7 Patsy Milne, Memoir, [c. 1958], p. 34, NAC.

8 Milne, notes for Autobiography, MFP. See, for example, *The Pantry* for the presence of the portrait head in a painting.

9 Patsy Milne, Memoir, [c. 1958], p. 11, NAC.

10 In addition to *Black and White II* showing Potter's lions, Milne painted two other pictures of the lions that we know of, but have not yet found. They were among the paintings sent by Clarke to England in 1918 for the War Records to examine (see

Catalogue Raisonné, New York City, 1915–16, Introduction, for Clarke's list of works sent to England).

11 Whether Milne and Patsy's sudden decision to marry surreptitiously was relevant or not, Mrs Hegarty moved to California with Patsy's sister shortly afterwards, and both seem to have dropped out of Patsy's life (at least neither was ever mentioned by Milne) until the mid-1920s when Mrs Hegarty returned to New York; Patsy visited her then. Mrs Hegarty died in 1926 after being in hospital for several weeks.

12 A few years earlier, in 1909, Milne and Patsy had been contemplating buying a house in New Rochelle.

13 Patsy Milne, Memoir, [c. 1958], p. 10, NAC.

14 Ibid.

15 Ibid.

16 Ibid.

17 Ibid., p. 11.

18 Ibid.

19 Ibid., p. 8.

20 Ibid., p. 12.

21 There is some confusion about this marker in Milne's career. First, we do not know what the painting was, for it has not been found and it was not mentioned in reviews. A Milne oil with the same title was accepted at the Philadelphia Academy in 1915. The painting, although likely an oil, was catalogued at the National Academy of Design as a watercolour. It may have been the painting now known as *The Hudson from Weehawken*. However, the academy seems to have hung watercolours at its winter exhibitions, in which case the painting in question may be a watercolour, still unidentified.

22 Milne to Alice and Vincent Massey, 20 August 1934, UTA.

23 Alan Jarvis liked to quote Milne saying this. Milne wrote almost the same thing, although without the specific reference to Matisse, in his draft of a letter to H.O. McCurry, 29 May, 5 June 1932, MFP (final version dated 25 June 1932, NGC), and in an undated and unpublished essay (c. 1944) called 'Pictures Have Beginnings and Endings,' MFP: 'A picture seen while walking past an open door might be grasped completely enough to be remembered for life – if it is a good enough picture.'

24 Records of the New York Water Color Club (Archives of American Art).

25 Milne was proposed by George Dawson, the president, and seconded by John Dull, the treasurer, and Thornton Oakley, the secretary. Although elected, both Marin and Prendergast declined to join (Minutes of the Philadelphia Water Color Club, 12 January 1914, Philadelphia Museum of Art).

26 The only other Canadian artists in the exhibition were Arthur Crisp (1881–1974), who was from Hamilton, Ontario, and showed a set of decorative dining-room panels, and Edward Middleton Monigault

(1889–1922), who was from London, Ontario, and was represented by two canvases.

27 The *Reclining Figure* may be *Sleeping Woman*, done during the Milnes' honeymoon. *The Garden* may be *Canadian Garden*, also done in Paisley during the honeymoon, for it is signed. Nevertheless, Duncan did not identify any of these as Armory Show paintings and neither, presumably, did Milne. Surely Duncan would have known of, and noted, something as important as this in 1937, when he received all the Milne paintings that Clarke had been storing since 1918, and when he and Milne reviewed them. Duncan did title one painting *Columbus Circle*, but it is unsigned and is an unlikely candidate for the Armory Show.

28 Despite being chosen, Milne's *Little Figures* went only to Chicago (as number 256 in the catalogue): the whole American section was cancelled for Boston. The painting has not been identified, but may well be the one catalogued as *Fifth Avenue, Easter Sunday*, which has the same provenance as *Distorted Tree*, another strong Armory Show candidate.

29 Patsy Milne, Memoir, [c. 1958], p. 7, NAC.

30 See O'Brian, *David Milne and the Modern Tradition of Painting*, 1983, pp. 72–3.

31 Quoted by Milton W. Brown in *The Story of the Armory Show* ([New York:] Joseph H. Hirshhorn Foundation, distributed by New York Graphic Society, [1963]), pp. 132–4. One of my favourite examples of the invective hurled against modernist art at about this time was an article entitled 'A Protest against the Present Exhibition of Degenerate "Modernistic" Works in the Metropolitan Museum of Art.' These forms of art, it stated, are 'a symptom of the general movement throughout the world having as its object the breaking down of all law and order and the Revolutionary destruction of our entire social system.' The three prime motivations behind this were Bolshevism, human greed (European traffickers and worshippers of Satan were flogging new art since the old pictures were running out), mutilation of the human body and insanity following upon the 'deterioration of the optic nerve.'

32 In his memoirs, *A World of Art and Museums* (Philadelphia: Art Alliance Press, 1975), Zigrosser reviewed his early assessments and found them to be borne out accurately by subsequent developments: 'Those [among the Americans] who received three stars (the highest) were Whistler, Ryder, Robert Henri, Jo Davidson, Jerome Myers (drawings), and the following, whose names have somewhat faded away: David Milne, Van Deering Perrine, and Patrick Henry Bruce.' Zigrosser's papers, with his annotated catalogue of the Armory Show, are held at the University of Pennsylvania, Philadelphia.

33 This information is gleaned from newspaper clippings of reviews kept by Milne and now in the David Milne papers, NAC.

34 *Columbus Circle* was the name Duncan gave to a painting of the New York period that we have titled *Stores and Billboards* because we have no evidence to tie it to the Armory Show, or to this exhibition, in any way. *Stores and Billboards* is not signed, as most, if not all, of Milne's exhibited pictures were; *Columbus Circle* is more likely among Milne's missing paintings.

35 The Matisse exhibition included five drawings, forty etchings and lithographs, fourteen paintings, and eleven sculptures.

36 Milne to Alice and Vincent Massey, 20 August 1934, UTA. See note 21.

37 Clarke recalled emphatically that Miss Fitzgerald was a cousin, not an aunt, of Patsy's. Likely there were two Miss Fitzgeralds: cousin Geraldine, who accompanied Patsy to Toronto in 1918, was probably a namesake of the aunt who owned the apartment, and possibly the apartment building, at 61st Street and Columbus Avenue that the Milnes used off and on after they were married. She may be the same aunt or cousin – Geraldine Ryan after marriage – who owned the Meadowbrook estate at Tivoli on the Hudson River, or she may have belonged to a different branch of the family. Geraldine's chicken farm at Tivoli was the object of an investigative visit by Milne and Clarke early in 1924, when they tried to find out for her why she was losing money on the operation.

38 Patsy Milne, Memoir, [c. 1958], p. 14, NAC. None of the paintings shown has been identified and no names of buyers are known. Although Patsy is quite precise about the date of the exhibition, it is possible that it was in 1916: Clarke mentions in 1934 that it took place just before the Milnes left for Boston Corners in May 1916. Since both Milne and Patsy are confused about the date they left for Boston Corners (both later reported that it was 1915 instead of 1916), the 1916 date is possible for the exhibition.

39 Milne to Alice and Vincent Massey, 20 August 1934, UTA.

40 Arthur Hoeber, 'Art and Artists,' review of New York Water Color Club Twenty-Second Annual Exhibition, *Globe and Commercial Advertiser* (New York) [c. October–November 1911], newspaper clipping, David Milne papers, NAC.

41 Joseph Edgar Chamberlin, 'Beauty in Water Colors,' review of New York Water Color Club Twenty-Second Annual Exhibition, [c. October–November 1911], unidentified newspaper clipping, David Milne papers, NAC; Chamberlin usually wrote for the *New York Evening Mail*.

42 'Passing in the Art World: Opening of the Water Color Club Exhibition,' review of New York Water Color Club Twenty-

Second Annual Exhibition, [c. October–November 1911], newspaper clipping, David Milne papers, NAC.

43 'The Twenty-Second Annual Exhibition of the New York Water Color Club,' *International Studio* 45/178 (December 1911): xliii.

44 'Water Color Club Shows the Success of Narrow Frames as an Element of Attractiveness,' *New York Times* 29 October 1911, p. 15. The lead critic of the *New York Times* during these years was Elisabeth Luther Cary. While she was usually conservative in her views, she was less so than many of her colleagues at other papers. She wrote warmly of Milne, even though he was an extremist, but she was cruel to Matisse. See Brown, *The Story of the Armory Show*, p. 128 and *passim*.

45 'Art Exhibitions: Annual Show of the Pennsylvania Academy of the Fine Arts,' review of exhibition at Pennsylvania Academy of the Fine Arts, *New York Daily Tribune* 6 February 1912, p. 7.

46 Review of American Water Color Society Forty-Fifth Annual Exhibition, [c. April–May 1912], unidentified newspaper clipping, David Milne papers, NAC.

47 'Although Not Large, the American Water Color Society's Exhibit Has Interesting Individual Features,' *New York Times* 28 April 1912.

48 'Interesting Features of the Many Attractive Pictures in the Exhibition of Paintings of the Water Color Club,' review of New York Water Color Club Twenty-Third Annual Exhibition, *New York Times* 3 November 1912.

49 'Art Productions of Many Sorts Shown in International Exhibition,' *Christian Science Monitor* (Boston, Mass.) 24 February 1913, p. 8.

50 'American Pictures at the International Exhibition Show Influence of Modern Foreign Schools,' review of Armory Show, *New York Times* 2 March 1913.

51 *New York Press* November 1913, newspaper clipping, David Milne papers, NAC. Neither *Hepaticas* nor *Jack in the Pulpit* has been identified.

52 'Novel Hanging at Water Color Show,' review of New York Water Color Club Twenty-Fourth Annual Exhibition, *New York Sun* [c. November 1913], newspaper clipping, David Milne papers, NAC.

53 'The Water Color Club Exhibition,' review of New York Water Color Club Twenty-Fourth Annual Exhibition, *New York Times* 9 November 1913, p. 15.

54 Both Milne and Patsy refer to her in letters or in Patsy's Memoir as Mrs Myers (or Meyers). However, the inscription on the back of one of the paintings refers to what appears to be Rathmeyer, but could also be read as Ruth Meyer. The Blue Mountain Cemetery at West Saugerties has no Rathmeyers, but the Myers are well represented, and include a Ruth Myer.

55 Within sight of Saugerties, on the Tivoli side of the Hudson River, is Clermont, the impressive estate of the Livingston family.

Robert Livingston was a partner with Robert Fulton in the development of the steamboat; the first steamboat on the Hudson was *The Clermont*, which docked at the Livingstons' on its maiden run.

56 By about 1924 this had become nine miles.

57 See pp. 18–19.

58 'American Water Color Society,' review of American Water Color Society Forty-Seventh Annual Exhibition, [c. 16 February 1914], unidentified newspaper clipping, David Milne papers, NAC.

59 'New York Water Color Club's 25th Exhibition,' *New York Times* 8 November 1914, p. 11. The painting has the title *Molson Cottage* (not clear) written on the back, but we have retained the title *Posing* in the Catalogue Raisonné.

60 Guy Pène du Bois, 'Exhibitions in the Galleries: The New York Water Color Club,' *Arts and Decoration* 5/2 (December 1914): 67. Du Bois was the editor of this publication and also a member of the association that organized the Armory Show. He was a well-known conservative painter and an occasional critic, and was later quite bitter about the Armory Show. As a booster of Edward Hopper, who had but one small painting accepted, he may have resented Milne's generous representation there.

61 'In the Galleries,' review of exhibition at Montross Gallery, New York, 1914, *International Studio* 54/213 (November 1914): xxx–xxxii.

62 'Art at Home and Abroad' includes a review of the exhibition at the Montross Gallery, *New York Times* 18 October 1914, p. 11. The reference to a strong scientific bent in Milne's approach to painting, already noted two years earlier by the *New York Times* critic, is intriguing. In 1916 Hardesty Maratta, a pseudo-scientific manufacturer of paint from Chicago, published his theory of colour in New York, an exciting event of which Milne was undoubtedly aware. Strongly supported by Henri, Maratta also advanced his theories about harmony, colour, and proportion, and helped Henri devise a complicated and controversial palette for use in art schools. Given the scientific character in Milne's work that some critics had noticed, one might expect him to have been involved. But in fact Milne had little use for rigorous systems of colour or composition, or of any other theory. What mattered to him were the aesthetic impact and the thrill that making or seeing a painting could give. A theory could be only a guide. Henri had to admit that the system was not totally reliable and that 'you had to use your head a little' (quoted in William Innes Homer, *Robert Henri and His Circle* [Ithaca, N.Y.: Cornell University Press, 1969]).

63 Milne had exhibited a watercolour titled *Black and Green* at the New York Water Color Club in 1912. Whether it foreshad-

owed the development of Milne's work of 1915 cannot be known until the painting itself is found, but the predominance of black and green in Milne's later New York painting is very noticeable from 1912 on, and well into his painting at Boston Corners in 1916 and 1917.

64 Boston Corners Painting Note 118, 27 August 1920, NAC. These notes were typed up by Milne for each painting he did upon his return from Europe. In them he examines briefly what his goal was, whether he achieved it and how, or how he might change the painting if he were to tackle the subject again. He sometimes illustrated these notes or added written comments, such as where he had sent pictures for exhibition or if he had painted them out, something he did with dismaying frequency.

65 See Rosemarie Tovell, *Reflections in a Quiet Pool* (Ottawa: National Gallery of Canada, 1980), pp. 50–5, for further commentary on this process.

66 Milne, 'Boston Corners,' Autobiography, 1947, MFP.

67 This is Patsy's recollection; Clarke's, in a letter to Milne, [c. mid-March 1934], MFP, was unequivocal: 'I met you at the 42nd Street shop where you and Engle worked. You met Anne first at kind of a one-man show of your pictures and prints on (I think) 60th St. or thereabouts, just before the Boston Corner exploring expedition.'

68 Clarke, interview by Blodwen Davies, 3 May 1961, reel 1, transcript, David Milne papers, NAC. None of the paintings among those left in the Milne estate or discovered during our cataloguing appear to have been 'made to fit the frames' as Clarke mentions, except perhaps a few watercolours on illustration board. Furthermore, Milne usually made his own frames – and often made frames for Clarke and his associates. Maybe this scavenging was with someone else, or Clarke was the one who filled the frames.

69 Ibid. The restlessness Clarke felt about his choice of profession also came out in a letter he wrote to Milne on a train trip from New York to the Boston Corners area on 12 May 1927, MFP: 'Fordham. Once an artist lived here and was not caught in the current. He climbed out to follow the call of the spring green which is even now budding in Fordham again to beckon more artists away from the billboard zone. But there are also billboards to beckon him to swap his green for theirs. I can't say if I was more the fool for having gone south when you went north. I guess not. I guess the life and the business one goes into does not make any difference; it is more what you do with the particular piece of ground you settle on. And the very settling implies you will be wishing and wondering soon if you settled in the right field.'

70 Clarke, interview by Blodwen Davies, May 1961, reel 3, transcript, David Milne

papers, NAC. Clarke was also called Jim by his friends, but Milne could never bring himself to call him anything but 'Clarke.'

71 Clarke to Milne, 30 January 1924, MFP.

72 Clarke, interview by Blodwen Davies, 3 May 1961, reel 1, transcript, David Milne papers, NAC.

73 Ibid., reel 3.

74 Ibid. 'I believe to make it a better background for his exhibition, because the wallpaper had flowers in it, and so that interfered with the viewing of the paintings, so he painted it black with the promise that when he was finished with the apartment he would repaper it, which he did.'

75 Milne, 'Boston Corners,' Autobiography, 1947, MFP.

76 Boston Corners Painting Note 118, 27 August 1920, NAC.

CHAPTER FOUR

1 Years before, when it was part of the Commonwealth of Massachusetts, it was called Boston Corner. For practical reasons it was made part of New York State in 1853 and the name Boston Corners came to be used.

2 Milne, 'Boston Corners,' Autobiography, 1947, MFP. Clarke, who grew up in Hartford, Connecticut, had often travelled through the area and may have recommended it. Milne's knowledge of the general region of Saugerties would have predisposed him to like the area, since his most prolific painting session had been there in the summer of 1914.

3 James Clarke, interview by Blodwen Davies, 3 and 4 May 1961, reel 6, transcript, David Milne papers, NAC.

4 Patsy Milne, Memoir, [c. 1958], p. 15, NAC, states categorically that this was in 1915, a date that has been used by many others, including Milne. However, there is no doubt that 1916 is the correct year.

5 Patsy Milne, Memoir, [c. 1958], p. 15, NAC.

6 Maurice Landay, in conversation with the author, 1972.

7 Milne, 'Boston Corners,' Autobiography, 1947, MFP.

8 Ibid.

9 Patsy Milne, Memoir, [c. 1958], p. 17, NAC.

10 Ibid.

11 Milne, 'Boston Corners,' Autobiography, 1947, MFP.

12 Milne to Clarke, [c. 18 January 1948], NAC.

13 Milne occasionally took Baldwin camping and fishing up at the Riga Lakes, a good hike from Boston Corners. Patsy Milne, Memoir, [c. 1958], p. 10, NAC.

14 No examples of these posters, which were about 76.2×50.8 centimetres (36×20 inches), have ever come to light.

15 Milne, 'Boston Corners,' Autobiography, 1947, MFP.

16 Ibid.

17 Clarke, interview by Blodwen Davies, 3 and 4 May 1961, reel 6, transcript, David

Milne papers, NAC. He also added: 'Originally there was a station, freight depot and a boarding house, all to the left of Birch's [sic] store.'

18 Milne, 'Boston Corners,' Autobiography, 1947, MFP.

19 Clarke, interview by Blodwen Davies, 3 May 1961, reel 1, transcript, David Milne papers, NAC. The first sentence of the quotation is from reel 6.

20 Milne, 'Boston Corners,' Autobiography, 1947, MFP.

21 Ibid.

22 Ibid. Milne gave a similar description in a scripted radio interview with Blair Laing on CFRB, Toronto, on 16 January 1938 (typescript, MFP), just nine years before he wrote yet another version for his Autobiography.

23 Ibid. Kelly Ore Bed is on the very lip of the Berkshires, halfway up the hill from the valley floor, and east of what is now called White House Road.

24 Clarke, interview by Blodwen Davies, May 1961, reel 2, transcript, David Milne papers, NAC. The same observation was made by Patsy Milne and others.

25 Milne, 'Spring Fever,' *Canadian Art* 2/4 (April–May 1945): 162–5. In about 1944 Milne used the same phrase in a short essay on the origins of his *Snow in Bethlehem* and playing-card series, *King, Queen, and Jokers*.

26 Milne, 'Boston Corners,' Autobiography, 1947, MFP.

27 Indeed he did stop painting in order to start up his poster business, but that may not have taken as much time away from his painting as the temporary drop in production might suggest. Milne simply needed a pause of some kind to allow the ideas he had stirred up to settle a little.

28 Milne, 'Boston Corners,' Autobiography, 1947, MFP.

29 Ibid.

30 Milne to Alice and Vincent Massey, 20 August 1934, UTA.

31 These works were among those that Douglas Duncan later referred to with a shudder as 'violently coloured.'

32 I had long discussions on this subject with the master of gray paintings, Canadian artist Yves Gaucher, to whom I am indebted for this insight into the reason why Milne was so attracted to this 'value.'

33 The exact location of Meadowbrook is not certain, but it must have been close to Clermont, the Livingston family estate. Meadowbrook was the name of the place where Patsy's mother and her sisters had lived in Ireland before emigrating to the United States.

34 Many years later this experiment in using unsized canvas re-emerged naturally and effectively at Palgrave and Six Mile Lake. The raw canvas, giving a new and different quality to space, probably encouraged Milne to explore his ideas about enlarging 'empty' spaces.

35 Milne lived in Boston Corners a scant

three years in total, interrupted by his First World War service; for an additional three winters he was nearby at Mount Riga in a house lent to him initially by an artist named Howard Sherman in exchange for repairs. The house was bought in 1922 by Clarke, who also gave Milne free lodgings in exchange for upkeep of the house and other chores.

36 Patsy Milne, Memoir, [c. 1958], p. 20, NAC.

CHAPTER FIVE

1 Milne, 'Army,' Autobiography, 1947, MFP.

2 The book is in the Milne family papers.

3 Milne to James Clarke, 11 February, Kinmel Park Camp, Wales, continued on 1 March [i.e., 28 February] and Saturday [1 March 1919], Ripon Camp, England, NAC (the quotation is from text dated Saturday [1 March 1919]).

4 Patsy stayed throughout the war with a relative, probably an aunt, a Miss Collins (her mother's maiden name), at 106 West 61st Street, where the Milnes' apartment had been in 1915–16, and where another aunt, Geraldine Fitzgerald, seems also to have been residing.

5 Milne, 'War Records,' Autobiography, 1947, MFP.

6 Some of the cards to Clarke are in the David Milne papers in the National Archives of Canada, along with a few to Patsy. Milne's cards to his family were destroyed, along with his letters, in the 1950s.

7 Milne to Clarke, 3, 13, Thursday [14], 17 November [1918], NAC.

8 Milne to Clarke, 11 February, Kinmel Park Camp, Wales, continued on 1 March [i.e., 28 February] and Saturday [1 March 1919], Ripon Camp, England, NAC (the quotation is from text dated Saturday [1 March 1919]).

9 Milne to Clarke, 16 October [1918], NAC.

10 Milne to Clarke, 3, 13, Thursday [14], 17 November [1918], NAC.

11 Lord Beaverbrook (1879–1964) was born in Fredericton, New Brunswick, as Max Aitken and made his mark in England as a press baron.

12 After the war Lord Beaverbrook expected the massive collection he had commissioned to be housed in a splendid replica of Paris's Panthéon in Ottawa as a permanent memorial to the Canadian war effort; but an acrimonious quarrel broke out between him and the newly elected prime minister, Arthur Meighen, over the construction of the building, so the image of a Panthéon never graced the Ottawa skyline. While a few paintings in the War Records were skimmed off by the National Gallery and trotted out from time to time, the majority of them mouldered in storage until 1971, when they were transferred to the Canadian War Museum. The Milne paintings, however, were all carefully kept

by the National Gallery and not transferred.

13 Milne, 'War Records,' Autobiography, 1947, MFP. In March 1919 Milne told Clarke a slightly different version: 'After the armistice my thoughts began to stray to the old job. When I got the four days' leave in London early in December I made a few timid enquiries about discharge in England etc., thought of going up to Argyle House. Was told that simply wasn't done and might cost me my life, so I dropped it and went on with my sightseeing. At noon on the last day I went into the Goupil[?] galleries, more to rest my feet than to look at the pictures. There I saw some drawings of camouflaged ships that were quite freely done. Tickets on two of them stated that they had been bought for the Canadian War Records. That gave me an idea so I asked for their address. After quite a number of attempts I found the record office and Captain Watkins. Capt. Watkins outdid himself in explaining that the house was sold out – not even standing room. My impression of the talk is that he declared they couldn't use any more drawings, had never used any drawings, had nothing to do with drawings, in fact. But I wasn't going to have a carefully mapped out last half day's leave in London spoiled for nothing, so he finally suggested that if I went back to Kinmel Park for a month and made some sketches he could tell what I could do': Milne to Clarke, 11 February, Kinmel Park Camp, Wales, continued on 1 March [i.e., 28 February] and Saturday [1 March 1919], Ripon Camp, England, NAC (the quotation is from text dated Saturday [1 March 1919]). In later writings (letter to Alice and Vincent Massey, 20 August 1934, UTA, and his Autobiography, MFP) Milne gave the price of the painting of the troop ship variously as 200 or 500 guineas.

14 Clarke solicited letters from Montross, Weir, and Dawson, and also Thornton Oakley; Dawson and Oakley were both on the executive of the Philadelphia Water Color Club.

15 The fate of the pictures sent from New York is unknown: they disappeared after Konody saw them. Milne tried to retrieve them after the war, but he was unsuccessful, although he did discover that Clarke had made a rough list. He wrote to Eric Brown, director of the National Gallery, in April 1922: 'The package of drawings as I remember it (I saw it only once) was about 30×20 [inches], flat, addressed to Major Watkins at the Tudor Street Office, and contained possibly 12 to 20 water colors, no oils I think. It was sent hurriedly from New York, and, so far as I know, no catalogue or inventory was made. It naturally contained some of the most valued of my efforts and I should like in time to secure it' (6 April 1922, NGC).

16 Milne reported to Clarke in his letter of 23 January [1919], NAC, that eight works were

submitted to the War Records Office; however, ten were mounted on black card and ten are numbered on the verso.

17 The exhibition included about four hundred works. I am indebted to Maria Tippett, *Art at the Service of War: Canada, Art, and the Great War* (Toronto: University of Toronto Press, 1984), for information on the War Records program.

18 The sources are respectively: Milne to Clarke, 12 [13?], 'next night, Saturday' [14], 'Saturday again' [21], Sunday [22] December 1918, NAC; ibid.; Clarke to Milne, 10 June 1919, MFP; ibid.; Milne, 'War Records,' Autobiography, 1947, MFP; ibid.

19 Milne to Clarke, 9 April [1919], NAC.

20 Milne, 'War Records,' Autobiography, 1947, MFP.

21 Milne to Clarke, 9 April [1919], NAC.

22 Ibid.

23 Ibid.

24 Milne to Clarke, Sunday [13 November 1927], NAC.

25 Milne to Clarke, 7, Saturday [10], Thursday [15] May 1919, NAC (the quotation is from text dated 7 May 1919). Recalling this brief stint in Seaford many years later, Milne still remembered being defeated by the texture of the landscape (Milne to Clarke, 14 December 1936, NAC).

26 The papers and correspondence relating to Milne and the War Records are in the National Archives of Canada with the papers relating to that program.

27 Milne, 'War Records,' Autobiography, 1947, MFP.

28 Ibid.

29 Ibid.

30 Ibid.

31 Milne to Clarke, 24, [28, incorrectly dated Thursday (the 26th)] June, Sunday 7 [i.e., 6], Monday [7] July [1919], NAC (the quotation is from text dated 24 June [1919]).

32 Milne, 'War Records,' Autobiography, 1947, MFP.

33 Ibid.

34 Ibid.

35 Ibid.

36 Ibid.

37 Ibid.

38 Ibid.

39 Ibid. Although Milne wrote Hill 60, he probably meant Hill 70 for the reason given. Nevertheless, he did paint both Hill 60 and Hill 70. Milne learned from residents that Mount Kimmel had a maze, singing birds, and was a holiday place in the area.

40 Ibid. Even with the aid of local or military maps Milne found that it was often not possible to pinpoint certain locations, given the destruction of roads and other landmarks. Mount Sorrel was a case in point.

41 Ibid.

42 Ibid.

43 Ibid.

44 Ibid.

45 Milne to Clarke, 27 July [1919], NAC.
46 Milne, 'War Records,' Autobiography, 1947, MFP.
47 Ibid.
48 Ibid.
49 Patsy Milne, Memoir, [c. 1958], p. 24, NAC.
50 Milne, 'War Records,' Autobiography, 1947, MFP.
51 Milne to Alice and Vincent Massey, 20 August 1934, UTA.
52 Milne, 'War Records,' Autobiography, 1947, MFP.
53 Milne to Clarke, 24, [28, incorrectly dated Thursday (the 26th)] June, Sunday 7 [i.e., 6], Monday [7] July [1919], NAC (the quotation is from text incorrectly dated Thursday).
54 Milne, 'War Records,' Autobiography, 1947, MFP.
55 Milne to Alice and Vincent Massey, 20 August 1934, UTA.
56 In the fall of 1995 the National Gallery mounted an exhibition of sixty-seven of Milne's war paintings, more than half its holdings. Although it was wonderful to see these, no catalogue or other interpretive essay accompanied the show, leaving the field still open for an enterprising art historian.
57 Milne, 'War Records,' Autobiography, 1947, MFP.

CHAPTER SIX

1 Milne recalled these 'house hunting expeditions' in a letter to James Clarke, 26 September 1931, NAC, and thought that 'we might as well have tried the house [building] job there as at Big Moose later.' In fact, Milne and Clarke almost bought a house at Manitou, as Clarke remembered in a letter to Milne, [c. mid-March 1934], MFP. Milne, incidentally, was quite unwittingly proposing to do exactly what the American painter Marsden Hartley did to support his painting: run a chicken farm.
2 Clarke had also looked after Milne's interests in his absence by sending five of his paintings to the Philadelphia Water Color Club's annual exhibition in 1919.
3 Milne, 'Boston Corners,' Autobiography, 1947, MFP.
4 Milne to Clarke, [c. 17 December 1919], NAC.
5 Milne to Clarke, 9, [10] January [1920], NAC.
6 Ibid.
7 These notes, now known as the Boston Corners Painting Notes, are in the National Archives of Canada.
8 Milne to Clarke, 9, [10] January [1920], NAC.
9 Clarke, interview by Blodwen Davies, May 1961, reel 2, transcript, David Milne papers, NAC.
10 Why this pause occurred is not wholly known. Gardening, earning money, or simply taking a break (Milne holidayed in

Canada) are all possible reasons. But the record-company showcard business of 1916–17 was not revived and Milne's success with the Canadian War Records pictures did not open a market for his paintings in the United States or in Canada.
11 Milne, 'Boston Corners,' Autobiography, 1947, MFP.
12 Milne, Boston Corners Painting Note 8, 21 December 1919, NAC.
13 Milne to Clarke, 9, [10] January [1920], NAC.
14 Milne, Boston Corners Painting Note 29, 22 January 1920, NAC.
15 Milne, Boston Corners Painting Note 10, 23 December 1920, NAC.
16 Milne, Boston Corners Painting Note 18, 5 January 1920, NAC.
17 Milne, Boston Corners Painting Note 29, 22 January 1920, NAC.
18 Milne, Boston Corners Painting Note 16[a], 1 January 1920, NAC.
19 Milne, Boston Corners Painting Note 30, 23 January 1920, NAC.
20 Milne to Clarke, 9, [10] January [1920], NAC.
21 Milne to Clarke, [c. 17 December 1919], NAC.
22 Patsy Milne also exhibited a watercolour, On the Mountain, in the exhibition. That this inclusion was rightly earned is dubious – whether it was a concession to Milne cannot be guessed at – but it may speak to the general level of that particular exhibition. However, it later got her included in Chris Petteys, Dictionary of Women Artists: An International Dictionary of Women Artists Born before 1900 (Boston, Mass.: G.K. Hall, 1985), p. 498.
23 Douglas Milne, Milne's nephew and son of his brother William, recalled Milne's visit to Toronto in a letter to Blodwen Davies, 30 March 1963, NAC.
24 Milne, Boston Corners Painting Note 116, 24 August 1920, NAC.
25 Milne, Boston Corners Painting Note 118, 27 August 1920, NAC.
26 Milne, 'Boston Corners,' Autobiography, 1947, MFP.
27 Milne to Clarke, [30 September, 1 October 1920], NAC. Incidentally, Engle, who was in the west, had two watercolours – Tenage Lake, Yosemite and Mountain Pattern – in the Philadelphia Water Color Club's exhibition at the end of 1920, although he gave his address as 44 West 50th Street, New York.
28 Amos Engle to Milne, [c. 4 April 1921], MFP. This letter provides Engle's account to Milne of his post-war life.
29 Milne to Clarke, [30 September, 1 October 1920], NAC. It is impossible to interpret whether Milne had a personal reason (disguised in his letter to Clarke) for isolating himself there – to be away from Patsy – or whether he was being perfectly truthful.
30 Ibid.
31 Patsy Milne, Memoir, [c. 1958], p. 25, NAC.

That Patsy would easily accede to this arrangement strains belief, but her recollection seems to confirm Milne's excuses to Clarke, for whom Milne wanted to put a good face on the matter.
32 Kathleen Milne in conversation with the author, 1972. Patsy, in her Memoir, [c. 1958], NAC, reports that she saved a good deal of money (p. 25), so her recollections and Milne's are at odds on this point.
33 Patsy Milne, Memoir, [c. 1958], p. 24, NAC.
34 The 'Blowhole' Trail, 17 September 1920, is painted from this cleft in the hills above Boston Corners and Copake.
35 Clarke, interview by Blodwen Davies, May 1961, reel 4, transcript, David Milne papers, NAC.
36 Ibid.
37 Milne, 'Alander,' Autobiography, 1947, MFP.
38 Clarke did a little sketch of Milne's device in an undated letter to Blodwen Davies, [c. 1962], David Milne papers, NAC.
39 Patsy Milne, Memoir, [c. 1958], p. 25, NAC.
40 Ibid.
41 Milne to Clarke, [30 September, 1 October 1920], NAC.
42 Milne to Clarke, Friday [c. 21], Saturday [c. 22 January 1921], NAC.
43 Milne, 'One-Day Trip to Taconic Wilds,' Evening Post (New York) 28 April 1922. Milne had titled his essay 'To the Wilderness with a Sandwich and a Thermos Bottle.'
44 Milne to Clarke, Wednesday [c. 16], Sunday [c. 20 March 1921], NAC (the quotation is from text dated Wednesday).
45 Milne to Clarke, Thursday [27], [28?, 29 January 1921], NAC.
46 Clarke, unpublished recollection of Milne, [c. 1961], MFP.
47 Milne to Clarke, Friday Eve [11, or Thursday 10 February 1921] (incorrectly annotated as postmarked 12 October 1921), NAC.
48 Clarke to Milne, 4 April 1922, MFP.
49 Milne, Boston Corners Painting Note 78, 30 March 1920, NAC.
50 Milne, Boston Corners Painting Note 79, 2 April 1920, NAC.
51 In his letters Milne called it, casually and rather prosaically, The White Waterfall. For both aesthetic and descriptive reasons I much prefer the later title, White, the Waterfall, which Milne gave it in 1934.
52 Milne to Clarke, Thursday [21], Friday [22 April 1921], NAC.
53 Milne to Clarke, Monday [c. 28 February], Tuesday [c. 1], Friday [c. 4 March 1921], NAC.
54 Milne, 1934 sale list 12, draft, MFP.
55 Milne, 1934 sale list 12, Massey papers, UTA.
56 Clarke to Milne, 30 January 1924, MFP.
57 Milne to Clarke, 15 October 1930, NAC.
58 On 23 December 1941 (MFP) Clarke wrote to Milne: 'I guess the Alander cabin is gone because there was a big fire that burned over that part of the mountain some time back. However, it may have

escaped, fire does freak things sometime.'
In about 1942 in a letter to Milne, Clarke
dated this occurrence: 'The cabin was in
line with the big fire some years back
about 1930–32 that swept up the blow-out
back of Roberts farm where we climbed.
But I never got up to see if it was burned
or fallen in.' In a letter to Blodwen Davies,
2 August 1955, NAC, Clarke stated
unequivocally that the Alander cabin had
burned.

CHAPTER SEVEN

1 Patsy Milne, Memoir, [c. 1958], pp. 25–6,
 NAC.
2 Milne, 'Dart's Lake,' Autobiography, 1947,
 MFP.
3 This is the number of guests given by
 Milne and Patsy (her Memoir, [c. 1958], p.
 26, NAC), although I find it large, given the
 number of accommodations; however,
 there may have been a lot of children. The
 camp, first established in 1879 when the
 Darts had just married, was served by the
 railway at Dart's Landing, between Dart's
 Lake and Big Moose Lake. Dart's Landing
 was noted for its red ox that pulled a cart
 carrying freight and customers from the
 station to the camp, about two kilometres
 (just over a mile) away.
4 Milne, 'Dart's Lake,' Autobiography, 1947,
 NAC.
5 Patsy Milne, Memoir, [c. 1958], p. 26, NAC.
6 Milne, 'Dart's Lake,' Autobiography, 1947,
 MFP.
7 Milne to James Clarke, Sunday [11], [25,
 c. 26 or 27 June 1921], NAC.
8 Ibid.
9 Milne to Clarke, Sunday [13 November
 1927], NAC. Squash Pond is located about
 two kilometres (just over a mile) from the
 Glenmore Hotel.
10 Milne to Clarke, [28 June 1921], NAC.
11 Milne, 'Dart's Lake,' Autobiography, 1947,
 MFP.
12 When the same pattern is inverted, it is
 the model for the empty Palgrave skies;
 many of the landscapes at Six Mile Lake,
 such as Crystals on the Snow and Across the
 Still Lake, owe something to Across the
 Lake, and thirty years later the Bear Camp
 paintings of 1950 and 1951 were based on
 the same composition.
13 Milne to Clarke, 26 April 1930 (unfin-
 ished letter, not sent), MFP.
14 Milne, 'Mount Riga,' Autobiography,
 1947, MFP.
15 Ethan Allan had a forge and foundry at
 Mount Riga, near Salisbury, Connecticut,
 and Clarke told Blodwen Davies that part
 of the chain strung across the Hudson at
 West Point during the Revolutionary War
 came from Mount Riga (Clarke, interview
 by Blodwen Davies, 3 May 1961, reel 1,
 transcript, David Milne papers, NAC).
16 Milne, Mount Riga Painting Note 10,
 1 November 1921, NAC.
17 Milne to Clarke, 14, [15] February 1922, NAC.

18 It was still Howard Sherman's house at
 the time Milne painted it (the title is
 Douglas Duncan's). Sherman sold the
 house to Clarke in March 1922.
19 Milne, Mount Riga Painting Note 51,
 1 February 1922, NAC.
20 Milne, Mount Riga Painting Note 44,
 23 January 1922, NAC.
21 A plaster cast of The Expedition to the Land
 of Punt, from the Temple of Queen
 Hatshepsut, was presented to the
 Metropolitan Museum of Art by C.T.
 Currelly of the Royal Ontario Museum,
 Toronto, in 1906, Milne's last year at the
 Art Students' League.
22 Clarke to Milne, 13 October 1921, MFP.
23 Milne, Mount Riga Painting Note 63,
 1 March 1922, NAC.
24 Milne, Mount Riga Painting Note 55,
 8 and 9 February and 7 March 1922, NAC.
25 Milne, Boston Corners Painting Note 115,
 24 August 1920, NAC.
26 Milne, Mount Riga Painting Note 11, [3]
 November 1921, NAC
27 Milne, 'Mount Riga,' Autobiography,
 1947, MFP.
28 The number of paintings shown is not
 certain, since there was no catalogue, and
 one could interpret the evidence to
 suggest that only the paintings from
 Dart's Lake were exhibited; but that would
 be far fewer than sixty, which is most
 unlikely. Milne asked Clarke to select forty
 or fifty to supplement the ones he had
 already sent to Midjo as examples of his
 work (Milne to Clarke, 14, [15] February
 1922, NAC), then added: 'On second
 thought, 30 or 40 will be as good as 40 or
 50 because I have sent him only 25 of this
 and the last two seasons, and can send
 some more of them.' The only notice of
 the exhibition ('D.B. Milne Displays
 Original Art Exhibit,' Cornell Daily Sun
 (Ithaca, N.Y.) 16 March 1922) refers to 'a
 number of highly original landscape and
 interior designs' shown in the third floor
 exhibit room of White Hall. Milne is
 identified as being from Millertown [sic],
 New York.
29 We have no evidence that Kellogg ever
 bought any Milnes; none has been traced
 directly to him, although it would have
 been odd if he had not acquired any.
30 Patsy Milne, Memoir, [c. 1958], p. 28, NAC.
31 Ibid.
32 Ibid., p. 27.
33 Milne to Clarke, Tuesday [21 November
 1922], NAC.
34 Ibid.
35 Ibid.
36 Patsy Milne, Memoir, [c. 1958], p. 29, NAC.
37 Milne to Clarke, 'about the 20th'
 [September 1923], NAC.
38 Clarke to Milne, 6 January 1922, MFP.

CHAPTER EIGHT

1 Milne, 'Ottawa,' Autobiography, 1947,
 MFP.

2 Ibid. Milne says they were valued at
 $3,200, which suggests that there were
 close to a hundred works. When Milne
 wanted more paintings for the Art
 Association of Montreal exhibition at the
 end of the year, he rounded up a few more
 from James Clarke and from Christian
 Midjo at Cornell University.
3 Ibid.
4 In his autobiography Milne incorrectly
 calls it the Plaunt Building, which was
 nearby, just along Sparks Street.
5 Milne to Clarke, [c. 23], 30 October [1923],
 NAC.
6 Ibid.
7 Patsy Milne, Memoir, [c. 1958], p. 29, NAC.
8 Milne, 'Ottawa,' Autobiography, 1947, MFP.
9 Ibid.
10 Ibid.
11 Ibid.
12 Ibid. Sekido may have supplied Milne
 with the paper for House of Commons,
 since it is an unusual paper that Milne
 used only the one time.
13 Milne to Clarke, [c. 23], 30 October [1923],
 NAC. The notes are undated, and the
 assumption is that they were written then;
 no more appropriate date seems likely.
14 Patsy Milne, Memoir, [c. 1958], p. 29, NAC.
15 Milne to Clarke, [c. 23], 30 October [1923],
 NAC
16 Milne to Clarke, Wednesday [21 or 28
 November 1923], NAC. Milne refers to it as
 the Ottawa Art Club but probably means
 the Art Association of Ottawa.
17 Campbell Scott's Milne was Fox Hill on a
 Rainy Day, and Meister's was Woman with
 Black Umbrella.
18 Milne's Ottawa notebook of addresses,
 MFP, lists Patsy c/o Mrs Hamilton.
19 Milne to Clarke, [c. 23], 30 October [1923],
 NAC.
20 Milne, 'Ottawa,' Autobiography, 1947,
 MFP.
21 Milne to Clarke, Wednesday [21 or 28
 November 1923], NAC.
22 Milne listed 117, but 5 of those numbered
 were not sent and we do not know for
 certain that only 95 were actually hung.
 Milne mentioned the number '112' in a
 letter to Clarke ('a week before Christmas
 Eve' [c. 17], Thursday [27 December 1923],
 NAC).
23 Milne to J.B. Abbott, Monday [31
 December 1923], Montreal Museum of
 Fine Arts.
24 Ibid.
25 Review of Exhibition of Canadian Art: The
 Canadian Section of Fine Arts from the
 British Empire Exhibition, at Corporation
 Art Gallery, Rochdale, England, 1–29 May
 1926, Rochdale Observer [c. 15 May 1926],
 in Press Comments on the Canadian Section
 of Fine Arts: British Empire Exhibition, 1924
 1925, [Ottawa: National Gallery of Canada,
 1926?], NGC.
26 The National Gallery in 1924 had a budget
 of $100,000, of which 70 per cent was
 spent on acquisitions; acquisitions are less
 than 10 per cent of today's budget.

27 Most of the paintings in the Art Association exhibition were transferred to the Arts Club, but twelve were extracted and sent back to Milne on 17 January 1924. Of these five were immediately forwarded to the National Gallery for purchase, leaving possibly seven that were exhibited later in January at Hart House, University of Toronto.

28 The Ottawa Group consisted of Paul Alfred (pseudonym of Alfred Ernest Meister), Harold Beament, Frank Hennessey, F.H. McGillivray, Graham Norwell, and Yoshida Sekido. Their printed letterhead had Milne's name added by hand.

29 Possibly at the Arts and Letters Club, where MacDonald was then organizing exhibitions, or the Ontario College of Art, where he was teaching.

30 J.E.H. MacDonald to Milne, 27 July 1924, MFP.

31 Milne, 'Ottawa,' Autobiography, 1947, MFP.

32 Milne to Patsy Milne, Thursday [3 or 10 January 1924], NAC.

33 Milne to Clarke, Monday [17 March 1924], NAC. The department in question was the Department of the Interior, which included the Natural Resources Branch for which both Norwell and Beament worked.

34 Ibid.

35 Milne, 'Ottawa,' Autobiography, 1947, MFP.

36 Ibid.

37 Ibid.

38 Milne to Clarke, Wednesday [21 or 28 November 1923], NAC.

39 In 1930, when he was living in Palgrave and renewing his connections with the National Gallery, Milne sent watercolours to Brown and McCurry to let them make a selection for their personal collections. Which paintings they acquired then is not certain, but Brown took advantage of Milne's offer either then or in 1924. In later years Maude Brown, Eric Brown's widow, had two: *Pool and Posts* and *Fox Hill on a Clear Day*; McCurry's widow had no watercolours but two oils (*Rowboat on Shore I* and *Flowers from the Shore*), which were acquired through the Masseys.

CHAPTER NINE

1 Big Moose Lake is one of the larger lakes in the Adirondacks, approximately five kilometres (three miles) long and more than a kilometre (about a mile) wide. It flows out through South Bay into Moose River. Its name suggests that it was good territory for moose, big ones even, but in fact none had been seen there since the 1850s (they have only recently begun to return); the same was true of beaver, which had to be stocked in the region as early as 1906.

2 Milne to Alice and Vincent Massey, 20 August 1934, UTA.

3 The Glenmore Hotel was originally the Hotel Glennmore, established as a luxury hotel in 1904 at an elevation of 625 metres (2044 feet), the highest point of the rail system in the Adirondacks. The air of the Adirondacks, a southern lobe of the Canadian Shield, was believed to be particularly healthy, in an age when tuberculosis was prevalent. (The same claims were made for Algonquin Park in Ontario, which was established in 1895 and had the same sort of facilities, clientele, and cachet.) The Glenmore was a large four-storey building with wide verandahs and 'spacious piazzas.' Among its many amenities were riding, boating, dancing, tennis, billiards, baseball, fishing, mini-golf, regular golf at nearby Thendara, seven family cottages, and a large all-purpose store that sold 'a complete line of necessities, especially in the way of drugs and toilet articles. Meats, groceries and vegetables ...' The dancing pavilion, built over the boat storage and beside the boathouse, was served by a four-piece orchestra, six nights a week. The hotel also offered elegant dining in a 200-seat restaurant. Although early advertisements made a point of its excellent fire-protection system, it was destroyed by fire in 1950.
Hotel Glennmore and Big Moose Lake had already achieved a degree of notoriety following a sensational murder that took place there. Chester E. Gillette of Cortland, New York, drowned his pregnant sweetheart, Grace Brown, in Big Moose Lake on 11 July 1906. Theodore Dreiser's *An American Tragedy* (New York: Boni and Liveright, 1925) was based on this incident and revived interest in the place. In the novel Gillette is Clyde Griffiths, Grace Brown is Roberta, and Big Moose Lake is Big Bittern Lake.

4 The boathouse, which seems to be contemporary with the cottage and dock, was in fact built shortly after the new owners, the Collinses, bought the property from Milne in 1928.

5 James Clarke to Milne, Friday [28 March 1924], MFP.

6 Milne to Clarke, in various letters, April and May 1924, NAC.

7 Milne to Clarke, Monday [c. 21], Thursday [c. 24], Sunday [c. 27 April 1924], NAC.

8 Patsy Milne, Memoir, [c. 1958], p. 31, NAC.

9 Milne to Clarke, 'Saturday before Labor Day' [5 September 1925], NAC – but Milne was still cutting stone in mid-October, according to Patsy Milne (Memoir, [c. 1958], p. 31, NAC).

10 Milne to Clarke, Sunday [26] September [1926], NAC. When Milne complained to Clarke, sometime during that first summer, about seeing spots before his eyes, doubtless the result of too much strenuous work, Clarke replied, on 6 July 1925 (MFP), with a diagnosis and prescription that Milne may not have found reassuring: 'My dentist says that he has had two cases of "spots before the eyes" and found it to be caused by root canals being infected. He says that your spots may come from something else, but that the tissue of the eye and kidney are the first to be affected by infections from this source. The remedy is to attempt to locate the infected teeth by x-ray and then uncap and refill the canal with highly antiseptic paste. It is a hell of a job, costs money, time and pain. If your spots get worse, you had better do something if you can.'

11 Clarke to Milne, postmarked 21 October 1924, MFP.

12 Patsy Milne, Memoir, [c. 1958], p. 32, NAC.

13 Milne to Clarke, 'Another Sunday' [3 October 1926], NAC.

14 Milne to Clarke, 'Monday, a week after Easter' [20 April 1925] (incorrectly annotated as postmarked 21 April 1923), NAC.

15 Milne to Clarke, 'last week in October' [1925] (incorrectly annotated as 1927), NAC.

16 Milne to Clarke, Thursday [3 June 1926], NAC.

17 Milne to Clarke, Sunday [26] September [1926], NAC.

18 Milne to Clarke, Big Moose Lake, Sunday [c. May 1927], NAC.

19 Milne to Clarke, 'Sunday ... end of July' [24], 'next morning' [25 July 1927], NAC.

20 Ibid.

21 Milne to Clarke, Monday [25 June 1928], NAC.

22 Clarke, interview by Blodwen Davies, May 1961, reel 4, transcript, David Milne papers, NAC.

23 Milne to Clarke, Labor Day [7], 12, [13 September 1925], NAC.

24 Patsy Milne, Memoir, [c. 1958], p. 30, NAC. She noted further that Mrs Day chummed the water with bait, shamelessly and illegally, to increase her chances of success.

25 Mrs Harrison Grey Fiske (1865–1932) had a long career, not only as a great actress, but as a playwright, director, and producer. The island, which appears to be two islands and is painted that way by Milne, is in fact one, called Echo Island, but known locally as Fiske Island, or Mrs Fiske's Island.

26 Milne to Clarke, 'Another Sunday' [3 October 1926], NAC.

27 Clarke obviously urged his colleagues at Calkins and Holden to buy Milne's paintings. To date only two of the pictures sold have, we believe, surfaced: two little oils, *Snow-Covered Boulder* and *Looking toward Lake Placid*. Clarke sent the dozen pictures back to Milne in January 1927 to be signed, a task Milne readily and quickly performed, even signing both sides of one watercolour sheet he had painted on both sides, because he didn't know which side the buyer preferred. When Clarke wrote to Milne on 3 December 1926 (MFP), he enclosed cheques totalling $255 and indicated that a further $145 would be forthcoming, but to count on only $90 for sure.

28 Patsy Milne, Memoir, [c. 1958], p. 32, NAC.
29 Milne to Clarke, Monday [15 or 22], 24 December [1924], NAC.
30 Milne to Alice and Vincent Massey, 20 August 1934, UTA.
31 This feat, reported in the *Lake Placid News* 19 March 1926 as a trek of sixty-five miles, was described by Milne in a letter to Clarke, [11], 25, [26] April [1926], NAC.
32 Patsy Milne, Memoir, [c. 1958], p. 33, NAC.
33 Ibid.
34 Milne, 'Ottawa,' Autobiography, 1947. The settlement was established in 1846 by Gerrit Smith as a humanitarian project, and survived for only a few years. John Brown was there in 1849, just ten years before he was hanged for the Harper's Ferry murders in the cause of abolition.
35 Milne to Clarke, [c. 4], 8, Wednesday [11], copied before 26 [January 1928] (incorrectly annotated as postmarked 2 January 1926), NAC. In the late eighteenth century North Elba was the first settlement in the area. Lake Placid itself was not laid out as a town until 1850, although a few settlers arrived in 1804.
36 Milne to Clarke, Sunday [13 November 1927], NAC.
37 Milne to Clarke, 7 January [1927], NAC.
38 Milne to Clarke, 'Sunday before Labor Day' [5 September 1926], NAC.
39 Milne to Clarke, [9 January 1927], NAC.
40 Milne to Clarke, [18 or 19], 20, Sunday [25], Tuesday [27 January 1925], NAC. Milne goes on to add: 'It is about the method used in the Big Moose one done from the Glenmore window [*The Yard of the Glenmore Hotel*], which stands up very well.' Milne wrote to Clarke extensively about this painting.
41 Ibid.
42 Ibid.
43 Milne to Clarke, Tuesday [9 or 16], Sunday [21 June 1925], NAC.
44 Milne to Clarke, 'day before Thanksgiving' [25 November 1925], NAC.
45 Milne to Clarke, Labor Day [7], 12, [13 September 1925], NAC.
46 Milne to Clarke, 'Sunday morning in kitchen stove glade' [c. 26 July 1925], NAC.
47 Milne to Clarke, [c. 25?], Tuesday [c. 26 January 1926] (incorrectly annotated as postmarked 22 January 1927), NAC.
48 Ibid.
49 Ibid.
50 Milne to Clarke, [c. 4], 8, Wednesday [11], copied before 26 [January 1928] (incorrectly annotated as postmarked 2 January 1926), NAC.
51 Milne to Clarke, [c. 25?], Tuesday [c. 26 January 1926] (incorrectly annotated as postmarked 22 January 1927), NAC.
52 Milne to Clarke, [4, 11], 16 [July 1926], NAC.
53 Milne to Clarke, Thursday [3 June 1926], NAC.
54 Milne to Clarke, [4, 11], 16 [July 1926], NAC.
55 Milne to Clarke, 4 May [1926], NAC.
56 Milne to Clarke, 'It might be Friday' [27 August 1926], NAC.
57 Ibid.

58 Ibid.
59 Clarke to Milne, [late January and possibly early February 1926], MFP.
60 Clarke to Milne, [March or April 1926], MFP.
61 Douglas Duncan later gave the press to the artist Harold Town (1924–1990), who used it occasionally. It has now been returned to the Milne family.
62 Clarke to Milne, 13 November [1926], MFP.
63 Milne to Clarke, Tuesday [16], Wednesday [24 November 1926], NAC.
64 Milne to Clarke, 7 January [1927], NAC. Clarke later claimed that the drypoints were started in the upstairs room at Biddiecott, Mount Riga. Plates may have been scratched there, but the press was never at Mount Riga. Clarke may have been thinking of the time when Mrs Kaye's washing-machine wringer was brought over to Clarke's house in 1922.
65 Milne to Clarke, 7 January [1927], NAC.
66 The unique impression of this drypoint came to me indirectly from Patsy Milne, by way of Blodwen Davies, whose papers were given to me in 1970 by her executor.
67 Milne to Clarke, Monday [21], Wednesday [23], Thursday [24 January 1929], NAC.
68 Ibid.
69 Tovell and I refer to this subject as *Painting Place* after the title of the painting. When the drypoint was selected, a year or so later, for publication in *The Colophon* part 5 (March 1931), Milne called it *Hilltop* (see pp. 223–4).
70 Milne to Clarke, Monday [18], Wednesday [20], Thursday [21], Friday [22 February 1929], NAC.
71 Ibid.
72 Milne to Clarke, Monday [21], Wednesday [23], Thursday [24 January 1929], NAC.
73 Clarke, interview by Blodwen Davies, May 1961, reel 4, transcript, David Milne papers, NAC.
74 Ibid.
75 Ibid., reel 5.
76 Patsy Milne, Memoir, [c. 1958], p. 31, NAC.
77 A copy of this notice is among Milne's papers, MFP.
78 Two or three paintings were done at the end of 1928 at Mount Riga. We know that Milne trekked through the area then, for he stayed for a night or two at a hotel in South Egremont, Massachusetts, not far from Boston Corners in the Berkshires.
79 Big Moose Lake and Lake Placid were not the only omissions. Milne never wrote about his time in Temagami, Weston, or Palgrave, although he did refer to aspects of his life in these places in his long letter to Alice and Vincent Massey, 20 August 1934, UTA.
80 Milne to Clarke, Monday [21], Wednesday [23], Thursday [24 January 1929], NAC.
81 Milne to Carl Schaefer, 30 December 1938, NAC.
82 Clarke to Milne, 13, 'several days later,' 23 July [1927], MFP.
83 Clarke recalled that the last time he saw Milne was when he showed up unexpect-

edly at Mount Riga, where Clarke's family was holidaying at Biddiecott, for a couple of days in 1931 or 1932 (Clarke, interview by Blodwen Davies, May 1961, re: Christmas boxes and last meeting, reel 6, transcript, David Milne papers, NAC). This cannot be confirmed, and seems most unlikely; the surprise visit was probably in the spring of 1928, when Milne was at Mount Riga briefly.
84 Clarke to Milne, [February 1927], MFP.
85 Clarke, interview by Blodwen Davies, May 1961, reel 5, transcript, David Milne papers, NAC.
86 Ibid.
87 Ibid., reel 3.

CHAPTER TEN

1 Milne to James Clarke, annotated as postmarked 14 December 1929, NAC.
2 Milne to Patsy Milne, Sunday [c. 14 July 1929], NAC. He mentions that 'half the houses in Cobalt are empty because the mining is dying out.' Curators at the National Gallery may have mentioned the place to Milne, since several artists had already found Cobalt to be good painting ground. Yvonne McKague, for instance, had painted there as early as 1926.
3 Bob Hope and Lucille Ball, although still in vaudeville and the chorus line respectively, had stayed there in 1928, and James Stewart a few years later. Cary Grant, Carole Lombard, and Rita Hayworth also favoured the area with visits. Another international figure associated with Temagami was Grey Owl. From 1909 until 1912 George 'Archie' Belaney (1888–1938), an itinerant Englishman, lived with a band of Ojibway on Bear Island in Lake Temagami, honed his woodland skills, and transformed himself into an Ojibway, Grey Owl. His later international reputation as an author gave the place cachet in the 1930s.
4 Deputy Minister W.C. Cain to Milne, 2 July 1929, MFP. The required 'linen' was for the better preservation of documents.
5 Milne to Clarke, annotated as postmarked 14 December 1929, NAC.
6 Milne to H.O. McCurry, [November 1929], NGC.
7 Milne to Clarke, 24, 25 May 1929 (draft, not sent), MFP.
8 Ibid.
9 Milne to McCurry, [November 1929], NGC. Dan O'Connor was a hustling entrepreneur who first prospected in Temagami, then exploited the tourist potential of Lake Temagami by providing a boat service and by building two large hotels. His mining ventures, however, were not successful, since iron deposits there, while large, were not as accessible as larger deposits found elsewhere at the time. He died in 1933, shortly after getting in on the Porcupine gold rush. See Michael Barnes, *Temagami* (Toronto: Stoddart Publishing Co., 1992).

10 Milne to Clarke, 24, 25 May 1929 (draft, not sent), MFP.

11 Ibid.

12 Ibid.

13 The National Gallery of Canada hung one of Milne's paintings, *Flooded Prospect Shaft II*, upside down for a number of years.

14 Milne to Alice Massey, 13 September 1934, UTA. It is possible (although unlikely) that some of these paintings, if they survived a 1934 culling, were among those destroyed at Six Mile Lake in 1939 in a burning spree.

15 Milne to Clarke, 'a few days before' 1 July and copy of 21 June [1929], NAC.

16 Milne to McCurry, [November 1929], NGC.

17 Ibid.

18 Milne to Alice and Vincent Massey, 20 August 1934, UTA.

19 Ibid.

20 Milne to Clarke, Thursday [27 March 1930], NAC.

21 Milne to McCurry, 7 January 1932, NGC, and copy, UTA.

22 Milne to McCurry, [November 1929], NGC.

23 The site, located at the corner of what is today Weston Road and Coulter Avenue, close to the Humber River, was first occupied by a school (a frame school in 1849 and a brick one in 1860), and in 1892 by Walter Longstaff's pump factory, a name that survived Longstaff's business. It was sometimes called the Old Pump Works.

24 Patsy in her Memoir, [c. 1958], p. 34, NAC, recalled that they were not happy there: 'We knew no one and felt rather "lost."'

25 Milne to Clarke, Thursday [27 March 1930], NAC.

26 Milne to Alice and Vincent Massey, 20 August 1934, UTA.

27 Milne to Clarke, Friday [c. 21 February 1930], NAC.

28 Alan Jarvis, *David Milne* ([Toronto:] Society for Art Publications, McClelland and Stewart, 1962).

29 Milne, 'Feeling in Painting,' *Here and Now* 1/2 (May 1948): 57–8; reprinted in *Documents in Canadian Art*, ed. Douglas Fetherling (Peterborough, Ont.: Broadview Press, 1987), pp. 97–9.

CHAPTER ELEVEN

1 Milne to James Clarke, second and 'next' Sunday [10, 17], recopied with additions on last Sunday [24], completed Tuesday [26] April [1932], NAC.

2 Florence E. McLean and George A. Mundy, *Palgrave: The United Church and the Community* (Palgrave: Palgrave United Church, [1978]), p. 72. Reynar was reported to have made $20,000 an acre from his crop and to have said: 'It is better than golf, and more profitable than horses.' Milne mentions this enterprise in a letter to Clarke, 'last Sunday in April' [27 April 1930] (unfinished, not sent), MFP.

3 Dr Reynar had also urged the installation of sidewalks, streetlights, and the firehall.

4 McLean and Mundy, *Palgrave*, p. 84.

5 The elevator and potato shed were destroyed by fire in 1955.

6 Milne to Clarke, 'last Sunday in April' [27 April 1930] (unfinished, not sent), MFP.

7 Patsy Milne, Memoir, [c. 1958], p. 34, NAC.

8 Milne's neighbour across the road, Ollie Matson, made quite a name for himself in 1929 when he and a chum, Floyd Henderson, briefly made Palgrave's softball team unbeatable by using a loaded bat. 'They did some amazing hitting that summer and were the terror of all the pitchers,' until someone got wise to their device and they had to run for safety (McLean and Mundy, *Palgrave*, pp. 80–1).

9 The hotel, which began as the Dew Drop Inn (or O'Connor's Hotel), burned in November 1964.

10 Milne to Clarke, 'last Sunday in November' [27], 'next Sunday' [4 December 1932], NAC.

11 Milne to Clarke, Tuesday [26 August 1930], NAC.

12 Milne to H.O. McCurry, 7 January 1932, NGC, and copy, UTA.

13 At the end of 1931 the Collinses still owed $3,500 in principal and the interest on that amount (Milne to Clarke, 7, [8] December [1931], NAC). A benefit, however, was that the Collinses paid Milne in American dollars, which from time to time produced an additional amount in exchange when converted to Canadian dollars, a welcome bonus for the Milnes.

14 Patsy Milne, Memoir, [c. 1958], p. 34, NAC. Although their garden would have provided produce and fruit for preserves (rhubarb, plums, red and white currants, strawberries, and raspberries), the Milnes would have had to buy such things as meat, dairy products, and household supplies.

15 Milne to Clarke, 30 November 1931, NAC.

16 Milne to Clarke, second and 'next' Sunday [10, 17], recopied with additions on last Sunday [24], completed Tuesday [26] April [1932], NAC. The only painting that currently still has its original Milne frame is *Window*.

17 Not even one word, according to Douglas Duncan, later Milne's dealer and agent, in conversation with me, 1966. Duncan may have been indulging in hyperbole, but from a personal point of view Palgrave was indeed a misery for both Milnes.

18 Milne to Clarke, 7, [8] December [1931], NAC.

19 Milne to McCurry, 'Sunday morning' [c. 16 April 1933] (not sent), MFP. Although Milne disagreed with McCallum, he thought that one could not dismiss his support of Tom Thomson 'while he was alive' on any grounds.

20 Milne to Clarke, 7, [8] December [1931], NAC. I believe that the amount of white-lead paint Milne used both as canvas primer and as pigment may well have given him a mild level of lead poisoning and irritated the already sensitive condition of his eyes.

21 McLean and Mundy, *Palgrave*, p. 82.

22 Milne to Alice and Vincent Massey, 20 August 1934, UTA.

23 Milne to Clarke, annotated as postmarked 8 March 1934, NAC.

24 Milne to Clarke, Sunday [c. 14], Sunday [c. 21] August, copied with additions 3 October 1932, NAC.

25 Milne to Clarke, second and 'next' Sunday [10, 17], recopied with additions on last Sunday [24], completed Tuesday [26] April [1932], NAC.

26 The next suggestion in his notes is for a little playlet with a jury of ten considering a group of paintings; this may be linked in Milne's mind with his opening gambit of an article based on twelve criticisms 'actually overheard in an art ex[hibition],' which he thought it would be instructive to analyse and dissect. Then Milne suggests devoting a chapter to each of twelve paintings, considering in turn such themes as aesthetic versus representational painting and the division of aesthetics into its different parts – colour, shape, and texture. The development of texture was a subject that Milne described in great detail. He cited his attempt, in 1917, to get the sense of a veil that seemed to shroud a maple in early spring when it was about to burst into flower, and finally finding a solution in washing over part of the picture with clear water in order to portray both the shape of the tree and its incipient blooms.

27 These comments by Milne about his ideas and attitudes were preliminary to notes that he wrote for each of the paintings he sent to Maulsby Kimball. The list of paintings and the four incomplete drafts with some descriptions are referred to in the *Catalogue Raisonné* as Milne's 1930 A list.

28 Milne to Maulsby Kimball, [c. December 1930] (draft, probably to accompany A list), MFP.

29 Ibid.

30 Milne to McCurry, [c. 1930] (draft), MFP.

31 Ibid.

32 Milne to McCurry, 7 January 1932, NGC, and copy, UTA.

33 Ibid.

34 Milne to McCurry, 1 April 1932, NGC.

35 Ibid.

36 Ibid.

37 G. Blair Laing, *Morrice, a Great Canadian Artist Rediscovered* (Toronto: McClelland and Stewart, 1984), p. 88.

38 Milne to McCurry, 29 May, 5 June 1932 (draft for letter dated 25 June 1932), MFP. This was a little harsh, although perhaps not intended to be so. Milne suffered the same criticism from one of the early assessors of this project, who wrote, for the Humanities and Social Sciences Research Council, that if you've seen one Milne painting, you've seen them all.

39 Clarke to Milne, [c. 1931], MFP.

40 Vincent Massey in his memoirs, *What's Past Is Prologue: The Memoirs of the Right*

Honourable Vincent Massey, C.H. (Toronto: Macmillan, 1963), incorrectly recalls buying this painting from a gallery in Toronto – indeed the very firm, Mellors Galleries, that two years later he approached to sell his and Alice's Milne paintings.

41 Milne to Clarke, second and 'next' Sunday [10, 17], recopied with additions on last Sunday [24], completed Tuesday [26] April [1932], NAC.

42 Robert North to Milne, 10 December 1930, MFP. Hekking's term as director ended in 1931 and this may have had repercussions for Milne's proposed show.

43 No evidence can be found to confirm an exhibition. Milne described one early 1931 exhibition as 'private,' and it was likely held in Kimball's home. In an article from the *Buffalo News* of May 1932, entitled 'Fine Arts: American Artists – Marines in Oil and Line,' a reviewer mentions Milne: 'Among the most original paintings I have seen lately are those of a Canadian lumberman, David Milne. But here is a sophisticated sort of simplicity, which nevertheless expresses an unusual impression of the north woods. I wonder if he voices the feelings of men who have always seen wildest nature and never a conventional landscape' (David Milne papers, NAC). The likelihood is that the writer saw Milne's work at the Kimball home. (In fact, the author of the commentary, which discusses a few different exhibitions, may have known the Kimballs, as he mentions the paintings of Mrs Kimball, shown at the Carl Bredemeier Gallery.)

44 The Roerich Museum was the grandiose dream of Nicholas Roerich, Russian emigré, international socialite, Buddhist, and spiritualist painter, who had been nominated by friends for the Nobel Peace Prize in 1929. He believed that art and culture would bring peace to the world. A modest house converted to a museum is still maintained in his name at 319 West 107th Street in New York: it is filled with his paintings, which are reminiscent of those by the Swiss painter Ferdinand Hodler (1853–1918).

45 Spencer Kellogg to Milne, 22 December 1930, MFP.

46 Milne would have been amused, or perhaps offended, if he could have seen the plaque on one of his paintings recently, which identified the work as by 'David Milne, R.C.A.'

47 Milne, letter to the editor, 'Purchase of Work of Art by the Nation,' *Winnipeg Free Press* 18 February 1933.

48 Milne, letter to the editor, 'Should Clarify Its Position,' *Mail and Empire* (Toronto) 12 January 1933. Milne's earlier letter to the editor, 'Canadian Art,' *Mail and Empire* (Toronto) 6 January 1933, elicited a response from Wyly Grier, whose letter in reply ran in the same paper on 9 January 1933; in it he dubbed Milne the Junius

of Palgrave ('Would that the echoing solitudes, the sacred groves of the Palgrave Academy had been my alma mater!'). Milne followed up with another letter, which was published on 14 February 1933, in which he dealt with the issue of whether a layman or an artist was the better judge of art. He concluded that 'concentration makes the artist, breadth the judge.'

49 Milne to Elizabeth Wyn Wood, 7 January 1933 (copy), MFP.

50 Milne to Clarke, 4 October [1930], NAC.

51 Somewhere between eight and twelve sets of plates appear to have been used in total. Usually the raised burr of the drypoint line will flatten after being subjected to the pressure of the roller twenty to forty times to obtain a like number of copies; steel facing prolongs the ability of the plate to keep the image sharp for much longer. Some refacing was also done in Toronto at a place that Milne found but did not name. Tovell points out that Milne stopped mixing a special green and black when time pressures mounted, and used unmixed pigments instead.

52 Milne to Clarke, Wednesday [7 January 1931], NAC.

53 Milne to Clarke, 14, [15] July [1930], NAC.

54 Milne to Elmer Adler, 7 January 1932, Princeton University Library. The book is not in the National Gallery library now.

55 Bertha E. Jaques to Milne, 29 December 1930, MFP.

56 Milne to Clarke, Monday [12 January 1931], NAC.

57 Milne to Clarke, 7, [8] December [1931], NAC.

58 Self-portraits are included in *Woman at Dresser*, *Mirror*, and *Frost on the Window*, as well as indirectly in all the paintings that include a depiction of the plaster head of Milne that Andrew McHench had sculpted in 1914 (see the entry for *Interior with Paintings* in the *Catalogue Raisonné* for a list of these works). After his Palgrave years (where the only self-portrait, on the verso of *Red Elevator and Blue Sky*, is partly painted over) Milne painted himself but once more, in *Frost on the Window*, in 1935.

59 Milne to Clarke, 26 September 1931, NAC.

60 Milne, A list, second draft, c. December 1930, MFP, commenting on the painting *Lap of Earth*.

61 Milne to Clarke, 14, [15] July [1930], NAC: '*Body of the Earth* This fancy titled [drypoint] was the author [i.e., a progenitor] of both the Alander & the Sideroad [drypoints, Tovell 55 and 59]. I was conscious of the contours that suggest the thighs and belly of a woman and the two paps, though both the etching and the little picture it came from are literal drawings.'

62 Milne to Kimball, 9 March 1931, NAC.

63 Milne to Alice and Vincent Massey, 20 August 1934, UTA.

64 Milne to Clarke, second and 'next' Sunday

[10, 17], recopied with additions on last Sunday [24], completed Tuesday [26] April [1932], NAC.

65 Milne to Alice and Vincent Massey, 20 August 1934, UTA.

66 Milne had used this title in the draft of his 1934 sale list for the Masseys (MFP), but changed it for the final list (UTA) to *The House Is a Square Red Cloud*.

67 Milne, 1934 sale list 58, UTA.

68 This painting has an interesting provenance: after being purchased by the Masseys, it was acquired in 1936, as a gift from the Masseys, by the art critic Graham McInnes, who had written often about Milne and his paintings and who liked *Dark Hills and Glowing Maple* particularly. He and Milne corresponded about it (McInnes to Milne, 2 March 1938, NAC; Milne to McInnes, 13, Wednesday [15] June 1938, NAC).

69 Milne, 1934 sale list 3, for *Dark Hills and Glowing Maple*, UTA.

70 Few of Milne's drawings from this period of his life have ever been exhibited or seen: the National Gallery has two and the Art Gallery of Ontario three. The rest are held by the Milne estate. Early drawings done in New York and Paisley have been exhibited here and there, but they are quite different in kind from these swift observations and delicate impressions.

71 Milne to Clarke, 'a few days before' 1 July and copy of unlocated draft of 21 June [1929], NAC.

72 Milne to McCurry, 17 March [1932, incorrectly dated 1931], NGC.

73 Milne to McCurry, 1 April 1932, NGC.

74 Milne to Clarke, 26 September 1931, NAC.

75 Milne to McCurry, 17 March [1932, incorrectly dated 1931], NGC; Milne to Clarke, [c. August 1932] (draft, lacking pp. 1–12), p. 20, MFP.

76 Milne to Clarke, [c. August 1932] (draft, lacking pp. 1–12), p. 20, MFP.

77 Milne to McCurry, 17 March [1932, incorrectly dated 1931], NGC.

78 Milne diary, 9 October [1932], MFP.

79 Clarke, interview by Blodwen Davies, May 1961, reel 2, transcript, David Milne papers, NAC.

80 Milne to Clarke, second and 'next' Sunday [10, 17], recopied with additions on last Sunday [24], completed Tuesday [26] April [1932], NAC.

81 Milne to Clarke, 14, [18], 28 June [1934], NAC. Milne's description is of the 1930 canvas that he was repainting in 1934 at Six Mile Lake; the repainting did not survive.

82 Milne to Clarke, second and 'next' Sunday [10, 17], recopied with additions on last Sunday [24], completed Tuesday [26] April [1932], NAC.

83 Milne to Clarke, [c. August 1932] (draft, lacking pp. 1–12), MFP.

84 Ibid.

85 Ibid.

86 Milne's copy is in the Milne family papers.

87 Milne to Clarke, 29 September 1934, NAC.
88 Patsy Milne, Memoir, [c. 1958], p. 34, NAC.
89 Ibid.
90 Clarke, interview by Blodwen Davies, May 1961, reel 3, transcript, David Milne papers, NAC.
91 Milne to Alice and Vincent Massey, undated (draft of 20 August 1934), MFP.

CHAPTER TWELVE

1 Milne to James Clarke, Tuesday [16 May 1933], NAC.
2 Patsy Milne to Douglas Duncan, 17 December [1939], MFP.
3 Patsy Milne, Memoir, [c. 1958], p. 38, NAC.
4 Ibid.
5 Milne to Clarke, 11 June 1933, NAC. Milne finally told Clarke some of the unvarnished truth in a letter of 23 May 1940, NAC.
6 Milne to Clarke, 11 June 1933, NAC.
7 Milne to Clarke, Sunday [c. 8], Monday [c. 9], Tuesday [c. 10], [c. Thursday 12 October 1933], NAC.
8 Milne to Clarke, Wednesday [August 1933], NAC. Milne had also been doing eye exercises regularly.
9 Patsy Milne, Memoir, [c. 1958], p. 35, NAC.
10 Milne, 'Six Mile Lake,' Autobiography, 1947, NAC.
11 Milne to Clarke, Saturday [23 December 1933], NAC.
12 Milne, 'Six Mile Lake,' Autobiography, 1947, NAC.
13 Milne to Clarke, Saturday [23 December 1933], NAC; and Milne, 'Six Mile Lake,' Autobiography, 1947, NAC.
14 The first railway around Big Chute was built in 1919 to allow boats to circumvent a plunging 18-metre (58-foot) cataract. Port Severn was the last lock on the waterway. See Clifford and Elaine Theberge, The Trent-Severn Waterway: A Traveller's Companion (Toronto: Samuel-Stevens, 1978).
15 Milne, 'Six Mile Lake,' Autobiography, 1947, NAC. Milne made maple syrup most years he was at Six Mile Lake.
16 Patsy Milne, Memoir, [c. 1958], p. 36, NAC.
17 Douglas Duncan to the author, in conversation, 1966.
18 Patsy Milne, Memoir, [c. 1958], p. 36, NAC.
19 Ibid., p. 38. The sequence of years is not clear in Patsy's Memoir.
20 Milne to Alice and Vincent Massey, 20 August 1934, UTA. Incomplete drafts for this remarkable document are in the Milne family papers, and include several other drawings in ink.
21 Alice Massey to Milne, 17 September 1934, MFP, and copy, UTA.
22 Milne to Alice Massey, 19 September 1934, UTA.
23 As it turned out, the actual transaction was of much greater benefit to Milne's long-term well-being than Milne's original proposal would have been, for it was the pictures stored with Clarke that provided much of Milne's income for the last decade of his life, and for his family after he died.
24 Hart Massey remembered that Milne visited them at Batterwood. He may well have done so at some point (there is no record of it), but the 1935 meeting was almost certainly in Toronto. Milne was in transit from Six Mile Lake to Paisley to see his brother Jim, and he had agreed to stop in Toronto and sign a number of paintings that the Masseys intended to place with Mellors Galleries on consignment or to take with them to London.
25 These recipients included Alice Massey's parents, Mr and Mrs G.R. Parkin; Senator and Mrs J.M. Macdonnell; J. Burgon Bickersteth, warden of Hart House, University of Toronto; H.O. McCurry; Lionel and Hart Massey's French teacher, Mrs Patterson; and the Masseys' secretary, Stella Van der Voort.
26 Alice Massey to Milne, 3 October 1934, MFP, and copy, UTA.
27 Vincent Massey, What's Past Is Prologue: The Memoirs of the Right Honourable Vincent Massey, C.H. (Toronto: Macmillan, 1963), p. 88. This was a consideration that Massey seemed unable or unwilling to recall when, in 1958, he was preparing to sell most of his Milne paintings and Duncan reminded him of his undertaking, and of the neediness of Milne's dependents.
28 Alice Massey to Lionel Massey, 1934, UTA.
29 Milne to Alice Massey, 10 October 1934, NAC, and addendum, UTA. The Mellors Galleries had been established in 1932 by Arthur Laing and Robert Mellors. Mellors, an Englishman of about sixty years of age in 1934, had been in charge of the Fine Arts Gallery at Eaton's new department store on College Street. Laing was a bond salesman with an interest in art. The initiative to establish the business was Laing's. The gallery opened at 759 Yonge Street, a few steps north of Bloor Street, and was ambitious and successful despite the Depression. Paintings by Cornelius Krieghoff, Horatio Walker (whose New York dealer was N.E. Montross), and the Group of Seven were to be seen there, as were important exhibitions of the impressionists in 1935, and of other fashionable artists, largely Dutch. At first the name of the firm was legally Mellors Fine Art Limited, but Mellors Galleries was the name usually used on catalogues or in advertisements; the name was changed in 1940 to Mellors-Laing, and then shortly after to Laing Galleries. G. Blair Laing, Arthur's son, began to work in the gallery in 1935, and he subsequently inherited the business and ran it until his death in 1991.
30 Vincent Massey to Milne, 13 October 1934, MFP, and copy, UTA.
31 Milne to Alice Massey, 13 February 1935, UTA.
32 Milne to Alice Massey, 8 March 1935, UTA.
33 Alice Massey to Milne, 29 November 1934, MFP.
34 Kenneth Wells, 'A Toast to a Painter and the Woods He Paints: The Story of a Man Who Had the Courage to Answer the Call of the Wilds,' Evening Telegram (Toronto) 24 November 1934; and Wells, 'Review of Year of Art in Toronto Shows Much to Praise and Little to Regret – But Little Man What Now?' Evening Telegram (Toronto) 29 December 1934. Wells lived on a farm in Simcoe County, north of Toronto.
35 Pearl McCarthy, 'Unique Landscapes at Local Gallery,' review of Milne exhibition at Mellors Galleries, Mail and Empire (Toronto) 28 November 1934.
36 Milne to Patsy Milne, Monday [10 December 1934], NAC.
37 Graham Campbell McInnes, 'The World of Art,' Saturday Night 50/31 (8 June 1935): 8; and McInnes, 'Art,' Saturday Night 51/4 (30 November 1935): 11.
38 It is worth noting that Blair Laing, who was just out of college at the time, defensively and categorically states in his memoirs that 'at no time during the five years we were showing his paintings did we have a verbal or written contract with either Milne or Massey ... we returned all of his paintings save for two he had presented as gifts to my father and myself ... the main reason we lost him was our inability at the time to sell his pictures' (Memoirs of an Art Dealer [Toronto: McClelland and Stewart, 1979], 1: 60).
39 Milne to Alice Massey, 'Sunday morning in Toronto' [3 March 1935], UTA.
40 No one raised any questions about the propriety of buying the property of someone who was about to be appointed high commissioner in the same department.
41 William R. Watson to Mellors Galleries, 3 July 1935 (copy), Massey papers, NAC.
42 This is confirmed in later notes in the Massey papers, although the actual amount Alice Massey intended to pay is never made clear. She sent Milne $200 later, but as an 'advance' against a return from the fund, and just after Milne had sent Mellors Galleries his 1936 paintings – which the Masseys then assumed they had also purchased.
43 Milne to Alice Massey, 17 October 1935, UTA.
44 Alice Massey to Milne, 25 October 1935, MFP, and copy, UTA.
45 The records are not complete about what was given to whom and when, but it is certain that the National Gallery received three canvases, and one each went to Wells, Mellors, McInnes, and Buchanan, as well as the six mentioned in note 25. Perhaps others were given as outright gifts or sold for as little as $10 or $15.
46 Vincent Massey to A.R. Laing, 11 December 1934, UTA.
47 What was in this exhibition is unknown, since no record of it has been found. On 8 January 1937 the Varsity (Toronto), in an article titled 'Picture Theft,' p. 1, reported

that a painting had been stolen on 22 December 1936 from the exhibition of Milne's 'representative portraits,' and that the show had begun on 19 December 1936. The Toronto *Evening Telegram* reported the theft on 24 December ('Reveal Theft of Art Work at Hart House'), noting that the painting had been hung in the Sketch Room, was small, and was 'only insured for $50'; it may have been a drypoint, although this would be a high value to put on a drypoint. The exhibition was probably a group show of paintings by different artists.

48 Alice Massey to Milne, 9 September 1936, NAC.

49 Alice Massey to Milne, 15 March 1937, MFP.

50 Mellors Galleries to Alice Massey, 14 February 1938, NAC.

51 Ibid.

52 Written by Milne as a footnote on a Mellors Galleries consignment account dated 25 August 1938, which he enclosed with his letter to Alice and Vincent Massey, 1 September 1938, NAC.

53 Milne to Clarke, 26 January 1938, NAC.

54 Milne to Alice and Vincent Massey, 28, 'next day' [29] August 1938, NAC.

55 Milne to Alice Massey, 25, Thursday [27] January 1938, NAC.

56 Milne to Alice Massey, 24 February 1938, NAC.

57 Milne to Alice and Vincent Massey, 28, 'next day' [29] August 1938, NAC.

58 Alice Massey to Milne, 5 June 1938 (copy), NAC.

59 Milne to Alice and Vincent Massey, 28, 'next day' [29] August 1938, NAC.

60 Ibid.

61 Milne to Alice and Vincent Massey, 13 September 1938, and 1 September 1938, respectively, NAC.

62 Alice Massey to Mellors Galleries, 14 September 1938 (copy), NAC.

63 Milne to Clarke, 24 June 1938, NAC.

64 This is an important fact in light of later developments. See Chapter 16 for Vincent Massey's repudiation of this arrangement.

65 At 23 Forest Hill Road, just north of St Clair Avenue.

66 The Toronto portrait painter Cleeve Horne (b. 1912), who built a cottage on Crooked Lake in the late 1930s, visited Milne often and remarked on this aspect of Milne's cottage.

67 Julius Meier-Graefe, *Vincent van Gogh: A Biographical Study*, trans. John Holroyd-Reece (New York: Harcourt, Brace, 1933).

68 Milne to Maulsby Kimball, [31 December] 1935, NAC.

69 Milne, 'Six Mile Lake,' Autobiography, 1947, NAC.

70 Milne to Duncan, 19 May 1938, MFP.

71 The premises were shared, initially, with Harold Stacey, a friend of Duncan's, and Jarvis, who set up a studio there. Duncan and the Picture Loan Society gradually took over the whole space.

72 The novelist Robertson Davies later used Duncan as the model, in large part, for

Francis Cornish, a character in *What's Bred in the Bone* (Toronto: Macmillan, 1985). In the same novel Davies also used Jarvis as the basis for his character Aylwin Ross, who becomes the director of the National Gallery, as Jarvis did.

73 Milne, draft will and will, dated 10 June 1938, MFP. In this will Milne provided for payments of $50 a month to Patsy Milne in the event of his death, and made the National Gallery of Canada the recipient of the sale of his works over the years. This will was superseded by a later one that Milne executed in 1941, MFP.

74 Milne, 'Six Mile Lake,' Autobiography, 1947, NAC.

75 Ibid.

76 Ibid.

77 Milne diary, 24 September 1933, MFP.

78 Milne, 'Six Mile Lake,' Autobiography, 1947, NAC.

79 Ibid.

80 Ibid.

81 Ibid.

82 Ibid.

83 Tiger lilies planted in the 1930s were still growing there in 1995.

84 Milne, 'Six Mile Lake,' Autobiography, 1947, NAC.

85 Ibid. Dr Cotton bought a painting from the Mellors Galleries in 1936, *Trilliums and Pale Bleeding Hearts*, so Milne's arguments must have had some weight.

86 Jane Smart was the sister of Elizabeth Smart (1913–86), author of *By Grand Central Station I Sat Down and Wept* (Toronto: Popular Library, 1966). Jane visited Milne just before leaving for Spain to work with Norman Bethune during the Spanish civil war. She returned to Canada and bought a painting, *Hepaticas*, from Milne's 1936 exhibition at Mellors Galleries.

87 Graham Campbell McInnes (1912–70) was born in London, England, and raised in Melbourne, Australia. In 1933, at the age of twenty-one, he came to Canada to find his father, James Campbell McInnes, a singer, from whom his mother (the novelist Angela Thirkell) had been long divorced and whom he had not seen for fifteen years. His brother was Colin MacInness (different spelling), a well-known English novelist and writer. Graham McInnes sometimes wrote under the name G. Campbell McInnes.

88 Graham Campbell McInnes, 'The World of Art,' review of exhibition at Mellors Galleries, Toronto, *Saturday Night* 52/1 (7 November 1936): 23.

89 Graham Campbell McInnes, 'Art' (includes review of Milne exhibition at Mellors Galleries, Toronto), *Saturday Night* 51/4 (30 November 1935): 11.

90 Alan Jarvis, 'Notes on Two Canadian Artists,' *Undergraduate* (Toronto) 6 (1936): 35–7.

91 Milne, 'Six Mile Lake,' Autobiography, 1947, NAC.

92 Milne to Clarke, 20 June 1933, NAC.

93 Milne to Clarke, Wednesday [August 1933], NAC.

94 Milne to Patsy Milne, Severn Park, Tuesday [c. 5 September 1933], NAC.

95 Milne to Clarke, Wednesday [August 1933], NAC.

96 Ibid.

97 Ibid.

98 Milne, 'Six Mile Lake,' Autobiography, 1947, NAC.

99 Milne to Clarke, Wednesday [August 1933], NAC.

100 Milne to Clarke, 3 September [1933], NAC.

101 Ibid.

102 Milne, 'Six Mile Lake,' Autobiography, 1947, NAC.

103 Milne to Clarke, Sunday [c. 8], Monday [c. 9], Tuesday [c. 10], [c. Thursday 12 October 1933], NAC.

104 Where Milne ordered his painting supplies is not known, but probably from Art Metropole in Toronto (not the artists' book centre of the same name founded in Toronto in the 1970s); he used stock sizes always.

105 Milne to Clarke, 24 April [1934], NAC.

106 Ibid.

107 Milne to Donald Buchanan, fragment of a letter, [c. 1936], NGC.

108 Milne to Clarke, 24 April [1934], NAC.

109 Milne to Clarke, 14, [18], 28 June [1934], NAC.

110 Ibid.

111 Ibid.

112 Milne to Clarke, 29 September 1934, NAC. Soon after he married again, Clarke moved to 29 Shonnard Place in Yonkers; and then in 1943 to 587 Palisades Avenue in Yonkers.

113 Milne to Clarke, 28 August 1935, NAC.

114 Ibid.

115 Milne, 'Six Mile Lake,' Autobiography, 1947, NAC.

116 Milne to Clarke, 28 August 1935, NAC.

117 Milne to Buchanan, fragment of a letter, [c. 1936], NGC.

118 Milne to Alice Massey, 17 October 1935, NAC.

119 Milne to Alice Massey, 1 May 1936, NAC.

120 Milne to Alice Massey (or Buchanan or McCurry), 5 July 1936 (draft), MFP.

121 Ibid.

122 Milne to Clarke, 23 January 1936, NAC.

123 Milne to Alan Jarvis, 21 May 1936, MFP.

124 Milne, catalogue note in Mellors Galleries, Toronto, *Exhibition of Little Pictures by David B. Milne*, exhibition catalogue (Toronto: Mellors Galleries, 1936).

125 Milne's thorough exploration of some of these themes can be seen in the fact that the carton image was used in oils in 1935–7, in watercolours in 1937–8, and in drypoints in 1939, one of only five drypoints produced during his time at Six Mile Lake.

126 Milne to Alice Massey, 2 August 1937, NAC.

CHAPTER THIRTEEN

1 Milne to James Clarke, 25 November 1937, NAC.

2 Milne to Alice Massey, 2 August 1937, NAC.

3 Ibid.

4 Milne to Clarke, 26 January 1938, NAC.

5 No oils remain from 1939, only six from 1940; only a handful more, nearly all minor, remain from the subsequent six years.

6 Milne to Carl Schaefer, 16 February 1938, NAC.

7 Milne to Graham McInnes, 16 February 1938, NAC.

8 Ibid.

9 Milne to H.O. McCurry and Alice Massey, [c. 1 August 1938], NAC.

10 Milne to Donald Buchanan, 14 January 1940, NGC. Milne's comments about Eliot are interesting because they include Milne's only reference to surrealism – a movement quite separate from the world of fantasy that Milne's later paintings addressed: 'Sur-realism as practised in painting has never given me much of a thrill, but Eliot's brand does. Painters usually employ sur-realism for story telling, the nightmare, and get no further with it than any other story tellers in paint. Eliot's use is a purely aesthetic one, for contrast, shock, to keep you moving. Just at the moment when monotony threatens there is a complete change, it may be something apparently irrelevant and always unpredictable. The reader is forced on by changes, by compressions and expansions. The change of pace I was speaking of in painting is very close to this. I don't think I notice any falling off in later work, the two conversation poems – ['Sweeney Erect' and 'Sweeney among the Nightingales'] – are as delightful to me as anything earlier. Eliot's welding of meaning and music seems to me a happy one for either poetry or painting.'

11 [Elizabeth Proctor], 'Mr. David Milne Speaks on Art,' Varsity (Toronto) 19 January 1938, p. 1.

12 Ibid.

13 Milne to Alice and Vincent Massey, 4 August 1938, NAC.

14 Milne to Alice Massey, Queen's birthday [24 May], copied with additions on 24 June, completed 26, 27 June [1938], NAC.

15 Milne to McInnes, 13, Wednesday [15] June 1938, NAC.

16 Milne to McCurry and Alice Massey, [c. 1 August 1938], NAC.

17 Ibid.

18 Milne to Alice and Vincent Massey, 4 August 1938, NAC.

19 Milne to Douglas Duncan, 21 December 1938, MFP.

20 In conversation with the author, 1971.

21 Milne to Alan Jarvis, 15, 22 January 1939, MFP.

22 Milne to Alice Massey, 25, Thursday [27] January 1938, NAC.

23 On 16 January 1938 at 5:00 to 5:15 pm. The transcript is in the Milne family papers.

24 Northrop Frye, 'Canadian Art in London,'

Canadian Forum 18/216 (January 1939): 304–5.

25 Northrop Frye to Helen Frye, 21 October 1938, Northrop Frye papers, Victoria College, University of Toronto. The other artists in the Tate Gallery exhibition whom Frye thought highly of were Frederick Varley, Tom Thomson, Peggy Nicol, and Will Ogilvie.

26 Eric Newton, 'Canadian Art through English Eyes,' Canadian Forum 18 (February 1939): 344–5. The reviews Newton wrote for the Guardian and Canadian Forum were different.

27 This event, coupled with the Coronation ceremony he had heard on the radio two years earlier, may have prompted Milne's interest in playing-card figures two years later, for the royalty of the deck was not as casual a subject as Milne later claimed.

28 J.S. McLean papers, Art Gallery of Ontario, Toronto.

29 Milne to Eric Brown, 8 March 1939, NGC.

30 A.Y. Jackson to Arthur Lismer, 5 February 1939, NAC. Newton was asked by Northrop Frye to write the review for Canadian Forum; whether Frye 'primed' him or not is not known, but unlikely.

31 Gordon MacNamara related this anecdote to me.

32 Pearl McCarthy, 'Art and Artists,' Globe and Mail (Toronto) 16 December 1939.

33 Milne to Duncan, 6 May 1939, MFP.

34 Helen Frye to Northrop Frye, 1 October 1938, Northrop Frye papers, Victoria College, University of Toronto.

35 Milne to Kathleen Pavey, 30 October [1939], MFP.

36 This was Jarvis's memory of the event as he recounted it to me.

37 Milne to Kay and Carson Mark, 6, [9 or 16], 20 March, 30 April 1940, Mark family papers.

38 Milne diary, 26 April 1940, MFP.

39 Who might have provided this expense-paid trip is not mentioned in documents, but it could have been J.S. McLean. Milne's reason for not going was that he could not afford to take Kathleen Pavey, and did not want to go without her.

40 Milne to Donald Buchanan, 14 January 1940, NGC.

41 Kathleen Milne in an interview with Pat Patterson, January 1978.

42 Alfred Pavey was born in the 1870s; Bessie Louise was born in 1887.

43 Milne to Kathleen Pavey, Thursday night [June 1939], MFP.

44 In a letter to Kay, Carson, and Joan Mark, 28 December 1939, Mark family papers, Milne mentions that he and Kathleen had had a difficult time settling into their apartment and, without giving details, says that during a battle with the landlord they spent a month in the Tudor Hotel. This corresponds to a note by Duncan that Milne and Kathleen spent a month at the Tudor in the fall of 1939.

45 According to Duncan. See note 44.

46 Milne to Kathleen Milne, 13, Saturday [14 October 1939], MFP.

47 Milne to Kay, Carson, and Joan Mark, 28 December 1939, Mark family papers; and Milne to Kay and Carson Mark, 6, [9 or 16], 20 March, 30 April 1940, Mark family papers.

48 Kathleen Milne in an interview with Pat Patterson, January 1978.

49 Ibid.

50 Milne to Patsy Milne, November 1939 (copy), MFP.

51 Patsy Milne, Memoir, [c. 1958], p. 38, NAC.

52 Ibid., p. 41.

53 Patsy Milne to Duncan, 17 December [1939], MFP. Her account in her later Memoir, [c. 1958], is not substantially different: 'For some reason I cannot explain I felt greatly worried. Dave wrote, saying he was feeling nervous. Then there came a lapse between letters, and I was frantic – walking down to the Post Office at Windermere every day – hoping to hear. After three or four weeks, there was a note from Dave, in which he enclosed fifty dollars. I felt that something was wrong, and decided to go again, and see what I could do about Jim [Milne's elder brother]. [I] came back to the City [Toronto and] found a letter from Dave, and wondered why, instead of putting a "return" address on the envelope, with his name as he always did, it only said "From David B. Milne" – There were only a few lines, but the shock was so terrific, I could not think clearly. After a while I began to pack the suit-case, and I told Mrs. E[vans] I was leaving in the morning. (I did not explain why). I left for the Lake of Bays ... Each morning I walked for miles (I could not stay inside). Over and over again, I asked myself why Dave, whose life had been perfectly normal all those years, could have changed to that extent. Perhaps he found it impossible to explain to the friends who knew him so well (or even to himself) the manner in which he was living.'

54 Martin tried to reassure Patsy and helped her financially; her letters have references to astrology and numerology.

55 Florence Martin to Patsy Milne, Monday 29 [September 1941?], NAC. This letter, since it mentions Milne's son, was written slightly later than the events here related.

56 Duncan to Patsy Milne, 17 January 1940, MFP. Interestingly, every paragraph of Duncan's letter and the postscript begin with 'I' – perhaps an indication of the importance Duncan attached to his own role.

57 Duncan to Patsy Milne, 3 March 1940 (copy), MFP.

58 Duncan to Patsy Milne, 29 March 1940 (copy of postcard), MFP.

59 Patsy Milne to Duncan, 18 July [1940], MFP.

60 Patsy Milne, Memoir, [c. 1958], p. 44, NAC.

61 Duncan to Mrs Hornel, 14 February 1940 (copy), MFP.

62 Patsy Milne to Duncan, 19 February [1940], MFP.

63 Vera Parsons to Patsy Milne, 1 April

1940, MFP. The matter of Patsy's being 'unfaithful' is a mystery, and only Vera Parsons sets it out in writing. Vera Parsons, incidentally, was disliked by Patsy and others, even more than Duncan. George McVicar considered her 'as tough as a buzzard,' and Kathleen was unpleasantly surprised when she learned that Vera had a sister living in Uxbridge (where the Milnes moved in October 1940) with whom she never visited or talked. My own encounter with her, when I catalogued her Milne painting in the early 1970s, was odd. She lived on the twentieth floor at 20 Prince Arthur Avenue, Toronto, and explained that the mess in her living room was the result of vandals breaking in from the balcony after lowering themselves from the roof. This much I could accept, but when I commented in passing that her painting (a 1920 watercolour) was Milne's view of the Boston Corners valley from a high lookout he called the Blowhole, she berated me for impertinence. The scene was of Uxbridge, she said, and she had been there hundreds of times. Although I tried to point out that Milne in 1920 had probably never set foot in Uxbridge, she would have none of it, and I was turfed out without further ado, fortunately with the photograph taken and all the information I needed.

64 Duncan to Patsy Milne, 24 April 1940 (copy), MFP.

65 Patsy Milne, Memoir, [c. 1958], p. 42, NAC; Milne to Fred Fisher, October 1934, MFP.

66 Milne to Clarke, 23 May 1940, NAC.

67 Clarke to Milne, [c. 1940], MFP.

68 Clarke to Milne, [c. December 1940], MFP. The following year Clarke again sent two Christmas boxes, but, having lost Patsy's address, he sent both to Milne and asked him to forward Patsy's (Clarke to Milne, 23 December 1941, MFP).

69 Vincent Massey to Milne, 8 July 1940, telegram, MFP. One reason the Masseys may have delayed their reply was that an exhibition of Milne's paintings that they were planning for early in 1940, at the Leicester Galleries in London, was cancelled because of the war. Other exhibitions at Philadelphia and Bryn Mawr, Pennsylvania, organized by Maulsby Kimball Jr, were also cancelled at this time, for reasons unknown, but doubtless having to do with the uncertainty of wartime.

70 Milne and Kathleen Milne to Kay and Carson Mark, 2 September 1941, Mark family papers.

71 Kathleen Milne to Kay and Carson Mark, 5, 'next evening' [6], Tuesday [9] September 1941, Mark family papers.

72 Milne to Jarvis, 15, 22 January 1939, MFP.

73 Duncan records, MFP.

74 Milne diary, 29 May 1940, MFP.

75 Duncan, even more than Milne, was adamant that there not be too many variants of a painting because he was worried that one collector would resent having a painting similar to that of another collector. This led to the destruction of many good paintings. Across more than one hundred of the late watercolours that he reviewed in 1952, Duncan scrawled 'Cancelled' in black grease crayon. One may recall that in addition to the sixty-eight just mentioned, Duncan destroyed forty-two New York oils (Chapter 3, note 4), and also the wholesale burning of paintings at Six Mile Lake in 1939.

CHAPTER FOURTEEN

1 In September 1943 the Milnes moved to another rented house on Franklin Street, then on the edge of town opposite a park, where a curling rink and swimming pool now exist.

2 Kathleen Milne to Kay and Carson Mark, 5, 'next evening' [6], Tuesday [9] September 1941, Mark family papers.

3 Douglas Duncan to Milne, 12 December 1940, MFP.

4 Milne to Duncan, Saturday [21], Monday [23 December] 1940, MFP. The window was bricked in to a standard size by the owner after Milne left and is no longer 'gorgeous' although it is identifiable.

5 Ibid.

6 Kathleen Milne diary, 16 March 1941, MFP.

7 Ibid. Kathleen was in labour for thirty hours, as Milne informed Duncan by letter, Sunday [4 May 1941], MFP.

8 Milne to Kathleen Milne, Monday night [12], Tuesday [13 May 1941], MFP.

9 Milne to Duncan, 2 August 1941, MFP.

10 Milne and Kathleen Milne to Kay and Carson Mark, 2 September 1941, Mark family papers.

11 Duncan to Milne, 10 December 1941, MFP.

12 Milne to Duncan, Thursday [8 May 1941], MFP.

13 James Clarke to Patsy Milne, [c. 1941], NAC.

14 Clarke to Patsy Milne, 11 August 1942, NAC.

15 Clarke to Patsy Milne, 1 January 1944, NAC.

16 Clarke to Patsy Milne, 10 March 1944, NAC.

17 Clarke to Patsy Milne, 21 July 1944, NAC. The second Mrs Clarke had died in August 1943.

18 Duncan to Milne, 12 December 1940, MFP.

19 Kathleen Milne in an interview with the author, 1993.

20 Kathleen Milne in an interview with Pat Patterson, January 1978.

21 Ibid.

22 Kathleen Milne in an interview with the author, 1993.

23 Kathleen Milne in an interview with Pat Patterson, January 1978.

24 Milne to Clarke, 10, 24 February 1941, NAC.

25 Milne to Clarke, 10 December 1940, NAC.

26 Milne diary, 20 February 1941, MFP.

27 In his David Milne and the Modern Tradition of Painting (Toronto. Coach House Press, 1983), John O'Brian cited Benham's Playing Cards as but one possibility for Milne's interest; but the drawings Milne made, and which O'Brian did not know about when he wrote, are conclusive proof. The Introduction to Snow Crystals catches some ideas that Milne might have found attractive: 'Snow, the beautiful snow, as the raptured poet sang, winter's spotless downy blanket for forest and field, has ever challenged pen to describe, and brush to paint, its marvelous mass effects. Nor is the aesthetic urge of its very tiniest flake or smallest crystal that gently floats from heaven to earth any less compelling.'

28 Milne to Clarke, 30 June 1941, NAC.

29 Ibid.

30 Clarke to Milne, [c. 1942–3], MFP.

31 Kathleen Milne notes on paintings, 7 August 1941, MFP.

32 Milne, 'Snow in Bethlehem' essay, [c. 1944], MFP.

33 Milne, miscellaneous notes, [c. 1932], MFP.

34 Kathleen Milne notes on paintings, 21 May, 3, 7, 8, 9 September 1941, MFP.

35 Ibid.

36 Ibid.

37 Milne may have told Duncan that he had torn up thirty versions or so, and indeed he may have done so, but Kathleen Milne's detailed notes suggest that Duncan misinterpreted something Milne said.

38 Milne, 'Noah and the Ark,' essay, [c. 1941], MFP.

39 Milne to Clarke, 10 December 1941, MFP. Clarke's response: 'I can't make out from the description of the pictures whether you have gone surrealist or if you have finally taken to drink or what. I sure would like to see some of those things you describe but I can't get up there and you can't bring them to N.Y.' (Clarke to Milne, 23 December 1941, MFP). This judgment, however, was not as depressing as Duncan's straightforward dislike of the work Milne was doing.

40 Milne to Alice Massey, 9 March 1939, NAC.

41 Milne diary, 20 February 1941, MFP.

42 Milne to Duncan, 16 February 1943, MFP.

43 Milne to Clarke, [c. August 1932] (draft lacking pp. 1–12), MFP.

44 Milne to Duncan, 24 December 1943, MFP.

45 O'Brian, in David Milne and the Modern Tradition of Painting, was the first to point out that Milne probably saw Wyndham Lewis's Crucifixion drawings at the Picture Loan Society at about this time and may have been influenced by them.

46 Accompanying an article by G. Campbell McInnes, 'World of Art,' Saturday Night 51/1 (9 November 1935): 8.

47 Milne's final annual production was, of course, culled from a far larger number of paintings; his editing of his works was stiff, and Duncan's, while more eccentric, was even more so.

48 Duncan to Milne, 24 February 1943, MFP.

49 Quoted without source by Catharine

Mastin in her essay in *'The Talented Intruder': Wyndham Lewis in Canada, 1939–1945*, ed. Robert Stacey (Windsor: Art Gallery of Windsor, 1992), p. 64. Lewis's resentment of Duncan's attention to Milne may partly explain his vicious portrait of Duncan as Cedric Furber in his novel *Self Condemned* (Chicago: Regnery, 1955). Inspired by Lewis's wartime stay in Canada, the novel is venomous about his sojourn in Toronto and about Duncan (among others), who did so much to help him.

50 Duncan to Milne, 10 December 1941, MFP.

51 From an unpublished manuscript, probably for a radio broadcast, titled 'Is a Canadian Renaissance Likely?' (Wyndham Lewis papers, Cornell University, Ithaca, New York), drawn to my attention by Robert Stacey, who prepared the exceptionally fine exhibition and catalogue *'The Talented Intruder': Wyndham Lewis in Canada, 1939–1945*.

52 *Studio* 129/625 (April 1945).

53 Duncan to McCurry, 25 March 1945 (copy), MFP.

54 Milne to Alice Massey, 28, 'next day' [29] August 1938, NAC.

55 Carl Schaefer, who had dinner with Milne that evening, recounted this anecdote to me, among others pertaining to Milne and Duncan.

56 Milne to Duncan, Friday [26 February 1943], MFP.

57 Kathleen Milne notes on paintings, 31 October–2 November 1946, MFP.

58 Milne to Duncan, Good Friday [7 April] 1944, MFP.

59 Milne to Carl Schaefer, 14 April 1944, Schaefer papers.

60 Clarke to Milne, 5 November 1945, and on same leaf, Milne to Duncan, annotated by Duncan as 14 November 1945, MFP.

61 Milne, 'Supper at Bethany,' essay, 4 February 1945, MFP.

62 Ibid.

63 Milne, 'Art Definitions,' [c. 1923], MFP.

64 Milne to Duncan, annotated by Duncan as 16 August 1944, MFP.

65 Milne to Duncan, 29 December 1943, MFP.

66 Milne to Duncan, 16 February 1943, MFP; Duncan to Milne, 19 February 1943, MFP: 'As for Ajax, definitely no! But I am aware of the difficult financial situation. Give me until next week to cope with it, and I think I can.' Milne had mentioned, in regard to his finances, that since Patsy was not getting regular payments from him, he would not feel right using any part of the Big Moose mortgage income (which he usually split with her) – 'even though Patsy may be working and not in as great need as we are.'

67 Milne to Duncan, Saturday [1 March 1947], MFP.

CHAPTER FIFTEEN

1 Milne to Douglas Duncan, Tuesday [2 September 1947], MFP.

2 Milne to Duncan, 'first day of the hunting season' [8], 'next morning' [9], Wednesday [10 November 1948], MFP.

3 Milne to Kathleen Milne, [9], 'next morning at Bancroft' [10 September 1947], MFP.

4 Milne to Kathleen Milne, Wednesday [10], Thursday [11], Friday [12 September 1947], MFP.

5 Milne to Kathleen Milne and David Milne Jr, [14], Monday [15 September 1947], MFP.

6 Milne to Duncan, 'first day of the hunting season' [8], 'next morning' [9], Wednesday [10 November 1948], MFP.

7 Kathleen Milne in an interview with Pat Patterson, January 1978, MFP.

8 Milne to Kathleen Milne, Saturday [27], Sunday [28 September 1947], MFP.

9 Milne to Kathleen Milne and David Milne Jr, Sunday [21], Tuesday [23], Wednesday [24 September 1947], MFP.

10 Milne to Kathleen Milne and David Milne Jr, Sunday [5], Tuesday [7 October 1947], MFP.

11 Milne to David Milne Jr, 'In the shelter' [c. 10 October 1947], MFP.

12 Milne to Kathleen Milne, Saturday [27], Sunday [28 September 1947], MFP.

13 Milne to Duncan, Wednesday [5 November 1947], MFP.

14 Charles Fraser Comfort, 'David Milne: 5 November, 1947,' in *The Moro River and Other Observations* (Hull, Quebec, 1970).

15 Milne to Duncan, 22 May 1948, MFP.

16 Milne to Duncan, 5 May [1949], MFP, written on the way to Baptiste.

17 Milne to Duncan, 'On the way to Baptiste' [c. late November 1949], MFP.

18 Duncan destroyed sixty-eight watercolours in 1940, burned forty-two New York canvases, cancelled over one hundred watercolours, was ready in 1958 to eliminate a quarter of the Massey Milnes, and was eager to 'sterilize' the remaining New York paintings: Milne's lack of confidence was well grounded.

19 Milne to Duncan, 15 January [1948], MFP.

20 Milne to Duncan, 22 May 1948, MFP.

21 Northrop Frye, 'David Milne: An Appreciation,' *Here and Now* 1/2 (May 1948): 48.

22 Milne to Duncan, 'first day of the hunting season' [8], 'next morning' [9], Wednesday [10 November 1948], 1948, MFP.

23 When the Milnes left Uxbridge, Milne's studio was taken over by Duncan Macpherson, the celebrated cartoonist.

24 Kathleen Milne in an interview with Pat Patterson, January 1978, MFP.

25 This anecdote was related to me by Carl Schaefer, c. 1972.

26 Milne to Kathleen Milne, Thursday [9], [10 February 1950], and 2 [i.e., 3], [4] April [1950], and Saturday [19 March 1949], and Monday [25 September 1950]; Milne to Duncan, [3 January 1950], and 11 November 1950, and 28 October 1951; Milne to Kathleen Milne, Tuesday [8 April 1952], and Monday [3], Tuesday [4 Novem-

ber 1952], and Friday [24 October 1952]; all MFP.

27 Milne to Kathleen Milne, Friday [16], Monday [19 September 1949], MFP.

28 Milne to Kathleen Milne, Monday [26], Tuesday [27 February 1951], MFP.

29 Milne diary, 16–17 November 1951, MFP. Cleeve Horne remembers that once when Milne arrived at the Hornes' place on what was then Crooked Lake (now Crooked Bay in Six Mile Lake) for a visit, he had just completed a watercolour on his way there. As he landed, he passed it up from his canoe to Jean Horne and it fell accidentally into the water. Since it was freshly painted, it blurred, and Cleeve, to lighten an awkward moment, offered the comment that the soaking had created a wonderful effect. Milne was not amused.

30 Milne diary, 8 November 1951, MFP.

31 I have always seen a similarity between this aspect of Milne's work and the late 1950s veil series of the American painter Morris Louis, although the scale is entirely different and the intent of the two artists is a considerable distance apart. I discussed this with Clement Greenberg; he said that the two artists shared a keen and similar sensibility, but that Milne hadn't exploited, as perhaps he should have, what was right in front of his nose.

32 Milne to Kathleen Milne, 12 January 1952, MFP.

33 About this time word reached Milne that his brother Jim, who had been taken into a home for the aged in very poor health on 8 June, died on 31 July 1953, leaving him as the only survivor of his generation.

CHAPTER SIXTEEN

1 The location of the grave is section 43, lot 488.

2 Douglas Duncan to Lionel Massey, 1958 (copy), MFP. An amusing sidelight on Duncan's propensity to reduce the number of Milnes available: when he was torn between wanting to destroy a drypoint impression in order to keep the number of impressions of a particular state down or to suppress a small blemish, yet wanting to keep it as a curiosity for study purposes, he hit upon an eccentric solution of destroying and retaining at the same time – he perforated the offending print with his mother's sewing machine.

3 Ibid.

4 This is the amount Blair Laing mentions in his *Memoirs of an Art Dealer* (Toronto: McClelland and Stewart, 1979), 1: 64. The Laing Galleries records show an amount of $30,000; the likelihood is that the balance was in cash, a form of payment that Laing often tendered.

5 H.O. McCurry to Blodwen Davies, [c. early 1958], NAC.

6 Duncan to Alan Jarvis, 10 August 1955, NGC.

7 I once asked Kathleen Milne if Douglas Rain sounded like Milne. She laughed and

said, 'Not at all. The person whose voice is
most like Milne's is Donald Harron. His
voice has the same high, soft quality that
Milne's had.'

8 Patsy Milne, c. late 1950s, quoted in
Blodwen Davies's large notebook, DPS
papers.

9 Patsy Milne to Blodwen Davies, 28 March
1952, NAC.

10 Patsy Milne, Memoir, [c. 1958], p. 44, NAC.

11 Patsy Milne to Blodwen Davies, [c. March–
April 1954], Blodwen Davies papers, NAC.

12 Blodwen Davies, large notebook, DPS
papers.

13 Kathleen Milne to James Clarke, 25
November 1960 (copy), MFP.

14 Clarke to Kathleen Milne, 2 December
1960, MFP.

15 Kathleen Milne to Clarke, 6 June 1961
(copy), MFP.

16 Clarke to Kathleen Milne, 14 June 1961,
MFP.

17 The envelopes are in a separate box at the
National Archives of Canada. We have not
yet been successful in matching them up
with their letters and confirming the
postal dates.

18 Fortunately Dr Wilfred Smith, then the
Dominion Archivist, interpreted the
twenty-five–year period to apply from the
date that the various documents were
created, thus giving David Milne Jr and
me access to Milne's letters, while
safeguarding Davies's own material until
the end of 1987.

19 A.Y. Jackson to Blodwen Davies, 12 June
1961, NAC. MacNamara was co-owner of
the Studio Building in Toronto, where
Jackson had lived and worked as a
sometimes contentious tenant until 1955.
Jackson was also somewhat jealous of
Milne and may have seen here an
opportunity of preventing Milne's
reputation from growing.

20 In 1938 Milne wrote to Duncan that he
was 'writing at once' to Florence Martin
for letters and other things, but he seems
never to have done so.

21 Florence Martin to Patsy Milne, 23 June
[c. 1942], NAC.

22 Patsy mentions in her Memoir, [c. 1958],
p. 6, NAC, that the Milne material in the
boathouse was already destroyed.

23 One part of the gift was a provision for a
cemetery with a plot for McMichael and
his wife Signe on a little knoll, and plots
for the members of the Group of Seven
around them. Six (of what were eventually
ten) members of the group and their
spouses are, indeed, now buried there.
They are Lawren and Bess Harris; A.Y.
Jackson; Arthur and Esther Lismer;
Frederick Varley; Franz and Florence
Johnston; and A.J. and Margaret Casson.

24 Clarke to Patsy Milne, 12 July 1962, NAC.
For the first five or six years the
McMichael collection was, for provincial
administrative purpose, under the
municipality's Conservation Authority.

25 As related to me by Charles McDermott, a
friend of McMichael's, in December
1993.

26 In the Milne segment of McMichael's
reminiscences, *One Man's Obsession*
(Scarborough, Ont.: Prentice-Hall Canada,
1986), there are numerous errors of fact:
May Frances 'Patsy' Hegarty is given as
Patsy Mae Flaherty; the year Milne went to
New York is given as 1912 instead of 1903;
McMichael says that Clarke had a place in
the Adirondacks instead of the Berkshires;
and he reports that Milne died in 1945
instead of 1953.

27 The stolen pictures are all stamped, for
evidence purposes, by the Ontario
Provincial Police and identified in the
Catalogue Raisonné. News reports from the
time are listed in the bibliography there.

28 Clement Greenberg mentioned this often
to artist acquaintances, such as Jack Bush,
and in a letter to me of 18 December 1991
he wrote: 'To claim that Milne "was
arguably Canada's greatest painter" is not
extravagant ... I would class him with such
as [John] Marin and [Edward] Hopper in
my own country. But he can hold his own
anywhere.'

29 Carl Zigrosser's papers are held at the
University of Pennsylvania, Philadelphia.
See also p. 52.

Bibliography

A comprehensive bibliography will be found in *David B. Milne: Catalogue Raisonné of the Paintings.*

Agnes Etherington Art Centre, Queen's University, Kingston, Ont. *David Milne, 1882–1953*. Introduction by David P. Silcox. Exhibition catalogue. Kingston, 1967

Buchanan, Donald W. 'An Artist Who Lives in the Woods.' *Saturday Night* 50/4 (1 December 1934): 2

Carney, Lora Senechal. 'David Milne: "Subject Pictures."' *Journal of Canadian Art History* 10/2 (1987): 104–19

Caulfield, Paul, director and producer. *A Path of His Own: The Story of David B. Milne*. Film, 57 minutes. 1979. French version, *La Voie du destin*

Frye, Northrop. 'David Milne: An Appreciation.' *Here and Now* 1/2 (May 1948): 47–56. Reprinted in *The Bush Garden / Essays on the Canadian Imagination*. Toronto: Anansi Press, 1971. Pages 203–6

Galerie Godard Lefort, Montreal. *David Milne (1882–1953): A Survey Exhibition / Une exposition rétrospective*. Introduction by David P. Silcox. Exhibition catalogue. Montreal: Galerie Godard Lefort, 1971

Hill, Charles C. *Canadian Painting in the Thirties*. Exhibition catalogue. Ottawa: National Gallery of Canada, 1975. French-language edition, 1975

Jarvis, Alan H. *David Milne*. [Toronto:] Society for Art Publications, McClelland and Stewart, 1962

Marlborough Godard Gallery, Toronto. *David Milne: The Toronto Year, 1939–1940*. Introduction by David Milne Jr. Exhibition catalogue. Toronto: Marlborough Godard Gallery, 1976

Milne, David B. 'The Colour Dry-Point.' *Canadian Art* 4/4 (Summer 1947): 144–7. Reprinted in Rosemarie L. Tovell. *Reflections in a Quiet Pool*. Ottawa: National Gallery of Canada, 1980. Pages 237–8

– 'Feeling in Painting.' *Here and Now* 1/2 (May 1948): 57–8. Reprinted in *Documents in Canadian Art*. Edited by Douglas Fetherling. Peterborough, Ont.: Broadview Press, 1987. Pages 97–9

– 'Hilltop: A Drypoint in Two Colors.' In *Colophon: A Book Collectors' Quarterly* part 5 (March 1931). Unpaginated

– 'Painting a Picture on Christmas Morning.' *Canadian Art* 9/2 (Christmas–New Year 1951–2): 50

– 'Spring Fever.' *Canadian Art* 2/4 (April–May 1945): 162–5. Reprinted in *Canadian Art* 15/1 (Jan 1958): 16–19; and *artscanada* 38 (March

1982): 82–4. Also reprinted in *Documents in Canadian Art*. Edited by
Douglas Fetherling. Peterborough, Ont.: Broadview Press, 1987.
Pages 93–6

Milne, David Jr, and Nick Johnson, editor. 'David Milne: His Journal
and Letters of 1920 and 1921, a Document of Survival.' *artscanada*
30/3 (Aug 1973): 15–55

National Gallery of Canada, Ottawa. *David Milne*. Essay by Alan H.
Jarvis. Exhibition catalogue. [Corrected edition.] Ottawa: National
Gallery of Canada, 1955. Unpaginated

O'Brian, John. *David Milne and the Modern Tradition of Painting*.
Toronto: Coach House Press, 1983

– *David Milne: The New York Years, 1903–1916*. Exhibition catalogue.
Edmonton, Alta: Edmonton Art Gallery, 1981

Owens, Gwendolyn. *The Watercolors of David Milne*. Exhibition cata-
logue. Ithaca, N.Y.: Herbert F. Johnson Museum of Art, Cornell
University, 1984

Théberge, Pierre. *Gift from the Douglas M. Duncan Collection and the
Milne-Duncan Bequest*. Includes essays by Norman J. Endicott and
Alan Jarvis. Exhibition catalogue. Ottawa: National Gallery of Canada,
1971

Thom, Ian M., editor. *David Milne*. Publication accompanying exhibi-
tion. Vancouver: Vancouver Art Gallery and McMichael Canadian Art
Collection in association with Douglas & McIntyre, 1991. French-
language edition, 1991

Tovell, Rosemarie L. *David Milne: Painting Place / Un coin pour peindre*.
Masterpieces in the National Gallery of Canada no. 8. Monograph
published concurrently with exhibition of same title and date. Ottawa:
National Gallery of Canada, 1976

– *Reflections in a Quiet Pool: The Prints of David Milne*. Exhibition
catalogue. Ottawa: National Gallery of Canada, 1980. French-
language edition, *Reflets dans un miroir d'eau*, 1980

Illustrations

The illustrations in this volume are listed in the order in which they appear, with page numbers at the left; each work of art is also listed alphabetically in the Index. For further information on Milne's paintings the reader may consult David Milne Jr and David P. Silcox, *David B. Milne: Catalogue Raisonné of the Paintings*; the catalogue number (e.g., 207.73) is the last item listed for each painting. The prints and colour drypoints are identified by the numbers assigned to them in Rosemarie Tovell's catalogue raisonné of Milne's prints, *Reflections in a Quiet Pool: The Prints of David Milne* (Ottawa: National Gallery of Canada, 1980); the Tovell number is the last item listed for each drypoint. Where no photographic credit is given, the owner institution has either provided a photograph or allowed David Milne Jr and/or David Silcox to make a photograph; some black-and-white photographs of paintings are by Douglas Duncan from his negatives at the National Gallery. The following abbreviations are used:

DPS David P. Silcox papers, Art Gallery of Ontario, Toronto
MFP Milne family papers
NAC National Archives of Canada
NGC National Gallery of Canada
UTA University of Toronto Archives

The emblem reproduced at the beginning of each chapter is Milne's drawing of a young maple tree (based on his painting *Maple Leaves, 1936*), a 1944 study for a cover design for *The Studio*, April 1945. 16.5×19.1 (6½×7½). Milne estate. 603.7

i *Painting Place* (small plate), 1927, colour drypoint. Tovell 32
ii *Painting Place* (the *Colophon* edition), 1930–1, colour drypoint in an edition of 3,000 copies. Photo: Nancy Rahija. Tovell 63
1 *Painting Place I*, 28 August 1926, oil. Empire Company Limited, Stellarton, Nova Scotia. Photo: M.F. Feheley Fine Arts, Toronto. 207.73

CHAPTER ONE

4 William Milne, Milne's father, c. 1893. MFP
4 *Profile of a Man in a Straw Hat*, c. 1902, ink drawing. Mr and Mrs Donald Jack, Toronto. 101.13
5 Mary Milne, Milne's mother, c. 1893. MFP
5 Milne's map of Burgoyne, drawn from memory in 1940. MFP
6 David Milne, about age eleven, c. 1893. MFP
7 The Milne home on Orchard Avenue in Paisley, built c. 1893. DPS
7 *Dove*, c. 1902, ink drawing in Milne's copy of the New Testament. Bruce County Museum and Archives, Southampton, Ontario. 101.12
8 George A. Reid, *The Berry Pickers*, 1890, oil. Nipissing University, North Bay, Ontario
8 The Model School class, Walkerton, 1900. DPS/MFP
9 Milne and his pupils in front of their school north of Paisley, c. 1900–3. MFP
10 *David Bell's Cow*, 1902, ink drawing. Mrs Hilda Bell Stone, Scarborough, Ontario. 101.7
11 *Dutch Woman in Clogs*, c. 1902–3, oil. Private collection, Paisley, Ontario. 101.4
11 *Irish Waterfall*, c. 1901, oil. Mrs A. McCauley, Vancouver. Photo: Robert Keziere. 101.1
12 David Milne as a young man, c. 1903. NAC

CHAPTER TWO

18 May Frances Hegarty, known as 'Patsy,' Milne's fiancée. NAC
20 Amos W. Engle, Milne's painting and business partner, and Milne in New York, c. 1908. MFP
21 *Engle Seated*, 1908–11, ink drawing. Bruce County Museum and Archives, Southampton, Ontario. 604.9
22 Milne in his New York studio, c. 1909. MFP
23 *New York Girders*, c. 1906–9, watercolour. Milne estate. 604.7
23 An illustration for *Uncle Sam's Magazine*, June 1909. Photo courtesy of Library of Congress, Washington, D.C. 603.1b
25 Poster for the March *Metropolitan* magazine, c. 1909–10, colour offset lithograph. Milne estate. Photo: Nancy Rahija. 603.2
30 *Spuyten Duyvil Pastel*, c. 1909–10, pastel. Milne Family Collection. 103.8
31 *Warehouse and Barge*, c. 1906–8, oil. Milne Study Collection. 102.16
31 *White Launch*, c. 1910, watercolour. Milne Study Collection. 103.19
31 *Autumn Tints*, c. 1909–11, watercolour. Milne Study Collection. 102.52
31 *Bath House*, c. 1910, watercolour. Milne Study Collection. 103.32
32 *Van Cortlandt Park*, c. 1908–10, oil. Milne estate. Photo: John Glover. 102.29
33 *The Defiant Maple*, 1909 or 1910, pastel. Private collection, Toronto. Photo: Michael Neill. 102.54
34 *Patsy Seated*, c. 1911, etching. Milne Family Collection. Photo: Nancy Rahija. Tovell 21

CHAPTER THREE

36 *Harlem Rocks*, 27 February 1911, watercolour. Milne Study Collection. 103.50
36 John Marin, *Weehawken Series*, 1910, watercolour. Metropolitan Museum of Art, New York. Catalogue number 10.90 in Sheldon Reich, *John Marin Catalogue Raisonné* (Tucson: University of Arizona Press, 1970)
37 *Spring Foliage*, 3 May 1911, watercolour. Milne Study Collection. 103.64
37 *Blonde Rocks*, c. 1911, watercolour. Milne Family Collection. 103.10
38 *Madison Square: Spring*, 4 May 1911, etching. Milne Family Collection. Photo: Nancy Rahija. Tovell 9
38 *Apple Blossoms*, c. 1911, watercolour. Milne estate. 103.69
39 *New York Street*, c. 1911, oil. Bruce County Museum and Archives, Southampton, Ontario. 103.80
39 *Black and White I*, 1911, watercolour. Christopher Huntington and Charlotte McGill, Nova Scotia. Photo: Terry James. 103.88
39 *Black and White II*, 1911, watercolour.

Christopher Huntington and Charlotte
McGill, Nova Scotia. Photo: Terry James.
103.89

40 *Fifth Avenue*, c. 1912, watercolour. Private
collection, Vancouver. Photo: John Glover.
104.52

40 *Billboards*, c. 1912, oil. National Gallery of
Canada, Ottawa. 104.19

41 *Three Hansoms*, c. 1912, watercolour.
Private collection, Vancouver. Photo:
Robert Bos. 104.54

42 *Lady of Leisure*, c. 1912, watercolour. Milne
estate. 104.25

42 *Woman with Brown Hat*, 3 June 1912,
watercolour. Milne estate. 104.22

42 *Bronx Park, 1913*, 5 July, oil. Private
collection, London, Ontario. Photo:
Michael Neill. 105.22

43 Taddeo Gaddi, *Madonna and Child
Enthroned with Saints*, c. 1340, tempera on
wood, gold ground. Metropolitan Museum
of Art, New York

43 *St Lawrence*, c. 1912–13, watercolour.
Milne estate. 104.58

43 *Sunlight*, c. 1912, oil. Private collection,
Toronto. Photo: Michael Neill. 104.13

44 *Striped Dress*, c. 1913, watercolour. Milne
estate. 105.50

44 *Red*, 1914, oil. Milne Family Collection.
Photo: Michael Neill. 105.92

44 *Black*, 1914, oil. McMichael Canadian Art
Collection, Kleinburg, Ontario. 105.55

45 *Evening Interior*, c. 1913–14, watercolour.
Peter Chan and Debbie MacKinnon-Chan,
Calgary, Alberta. 105.46

45 *The Yellow Rocker, 1914*, oil. Private
collection, Ontario. Photo: Michael Neill.
105.66

45 *The Pantry*, 1914, oil. Milne Family
Collection. Photo: Michael Neill. 105.65

50 *Distorted Tree*, 1912, oil. National Gallery
of Canada, Ottawa. 104.68

50 Cover and two pages from Milne's copy of
the Armory Show catalogue, 1913. MFP.
Photo: Nancy Rahija

51 *Fifth Avenue, Easter Sunday*, 7 April 1912,
watercolour. Mr and Mrs Frederick
Lapham III, Shoreham, Vermont. 104.10

55 *42nd St. Library*, c. 1911–13, watercolour.
Milne estate. Photo: John Glover. 104.71

58 *The Black Couch*, 1914, oil. Private
collection, Thornhill, Ontario. Photo:
Michael Neill. 105.101

59 *Battery Park*, 1914, watercolour. Milne
estate. Photo: John Glover. 105.133

59 *Brilliant Pattern*, 1914, watercolour. Milne
estate. Photo: John Glover. 105.136

60 *Posing*, 1914, watercolour. Private
collection. Photo: Michael Neill. 105.98

60 *Stipple Pattern III*, 1914, watercolour.
Private collection, Kitchener, Ontario.
Photo: John Glover. 105.128

61 *New York Times*, 18 October 1914,
reproducing Milne's painting *Red*. Photo
courtesy of Library of Congress, Washing-
ton, D.C.

62 *Large Tree*, 1 May 1915, ink drawing. Milne
estate. Photo: Michael Neill. 601.4

62 *Bronx Hillside in Spring*, 31 May 1915, ink
drawing. Private collection, Toronto.
Photo: Michael Neill. 601.10

63 *Black Cores*, 31 July 1915, watercolour.
Milne estate. 106.38

63 *Massive Design*, 1915, watercolour. Milne
estate. 106.39

65 Milne's friend James 'René' Clarke,
advertising artist at Calkins and Holden,
New York. MFP

CHAPTER FOUR

70 Under Mountain House, the Milnes' home
at Boston Corners, in the 1970s. MFP

70 Under Mountain House, viewed from the
east, in the 1970s. MFP

71 Milne at Boston Corners. MFP

72 Milne on the porch of Under Mountain
House. MFP

73 Stationery for Milne's poster business at
Boston Corners. NAC

74 James Clarke, Patsy Milne, and Milne at
Boston Corners. MFP

75 Patsy Milne, Milne, and Anne Clarke at
Boston Corners. MFP

77 Weed Iron Mines, 1993. DPS

78 *Joe Lee's Hill*, 31 May 1916, watercolour.
National Gallery of Canada, Ottawa. 107.15

78 *Green and Mauve*, 31 May 1916, water-
colour. Milne estate. Photo courtesy of
Mira Godard Gallery. 107.14

79 *Intersected Trees*, 1916, oil. Milne estate.
107.8

80 *Drying Waterfall*, 1916, oil. Private
collection, Toronto. Photo: Michael Neill.
107.52

80 *Stream Bed in Dappled Sunlight*, 1916, oil.
Private collection, Montreal. Photo:
Michael Neill. 107.53

81 *Back Porch, the White Post*, c. 1916,
watercolour. Milne Family Collection.
107.16

81 *Porch Post*, 1934, ink drawing. National
Gallery of Canada, Ottawa

83 *Entrance to Saugerties Harbour*, 12 Sep-
tember 1916, watercolour. Mary Stewart,
Vancouver. 107.60

83 *Relaxation*, 1916, watercolour. McMichael
Canadian Art Collection, Kleinburg,
Ontario. 107.59

85 *Trees in Spring*, c. 1917, oil. National
Gallery of Canada, Ottawa. 107.83

85 *Joe Lee's House*, 6 June 1917, watercolour.
Private collection, Toronto. Photo: John
Glover. 107.85

85 *Half and Half*, 7 June 1917, watercolour.
Paul Arthur, Toronto. Photo: John Glover.
107.87

86 *Reflected Forms*, 1 November 1917,
watercolour. Art Gallery of Greater
Victoria, Victoria, British Columbia.
107.111

86 *Sunburst over the Catskills*, 8 September
1917, watercolour. Museum of Modern
Art, New York. Photo: Isaac Applebaum.
107.98

87 *Boston Corners, 1917–18*, oil. National
Gallery of Canada, Ottawa. 107.126

87 *The Catskills*, 9 September 1917, water-
colour. Private collection, Caledon,
Ontario. Photo: Michael Neill. 107.99

87 *Kelly Ore Bed*, 1917, watercolour. Private

collection, Toronto. Photo: John Glover.
107.110

87 *Village toward Evening*, 10 November
1917, watercolour. National Gallery of
Canada, Ottawa. 107.115

88 Milne in uniform with Patsy at Boston
Corners, 1918. MFP

CHAPTER FIVE

90 Milne with a walking stick. MFP

91 Milne at the Citadel, Quebec City, 1918.
MFP

94 *Kinmel Park Camp: Pte Brown Writes a
Christmas Letter*, 23 December 1918,
watercolour. National Gallery of Canada,
Ottawa. 108.7

95 *Kinmel Park Camp No. 13, Looking toward
Rhyl and the Irish Sea*, 14 December
1918, watercolour. National Gallery of
Canada, Ottawa. 108.4

95 *Kinmel Park Camp: Dinner Is Served*,
1918–19, watercolour. National Gallery
of Canada, Ottawa. 108.5

96 *Ripon in March*, 5 March 1919,
watercolour. Milne Family Collection.
108.18

96 *Ripon: South Camp from General
Headquarters*, 1 March 1919, watercolour.
National Gallery of Canada, Ottawa.
108.17

97 *Ripon: High Street*, 27 February 1919,
watercolour. Art Gallery of Ontario,
Toronto. 108.16

99 *Bramshott from the Beacons*, 29 March
1919, watercolour. National Gallery of
Canada, Ottawa. 108.28

100 *Bramshott: Interior of the Wesleyan Hut*,
4 April 1919, watercolour. National
Gallery of Canada, Ottawa. 108.30

101 *Bramshott: The London-Portsmouth Road*,
9 April 1919, watercolour. National
Gallery of Canada, Ottawa. 108.31

102 *Vimy Ridge from Souchez, Estaminet
among the Ruins*, 19 May 1919,
watercolour. National Gallery of Canada,
Ottawa. 108.43

103 *On Vimy Ridge Looking over Givenchy to
the Lens-Arras Road and Avion*, 22 May
1919, watercolour. National Gallery of
Canada, Ottawa. 108.46

103 *Entrance to Cellar Shelter in Monchy-le-
Preux*, 26 May 1919, watercolour.
National Gallery of Canada, Ottawa.
108.49

103 *Wrecked Tanks outside Monchy-le-Preux*,
24 May 1919, watercolour. National
Gallery of Canada, Ottawa. 108.48

104 *Shell Holes and Wire at the Old German
Line, Vimy Ridge*, 12 or 13 June 1919,
watercolour. National Gallery of Canada,
Ottawa. 108.65

105 *Panorama of Ypres from the Ramparts*,
July, August 1919, watercolour. National
Gallery of Canada, Ottawa. 108.84

106 *Looking toward Thélus and Thélus Wood
from a Nissen Hut under the Nine Elms*,
26 June 1919, watercolour. National
Gallery of Canada, Ottawa. 108.69

106 *Neuville-St-Vaast from the Poppy Fields*,

5 July 1919, watercolour. National Gallery of Canada, Ottawa. 108.77

107 Milne on the battlefields of France or Belgium, contemplating a skull. MFP

108 *Courcelette from the Cemetery*, 26 July 1919, watercolour. National Gallery of Canada. 108.86

109 *The Road to Passchendaele*, 30 July 1919, watercolour. National Gallery of Canada, Ottawa. 108.89

110 *German Machine Gun Posts in Thélus Cemetery*, 12 or 13 June 1919, watercolour. National Gallery of Canada, Ottawa. 108.64

110 *Camouflaged Steel Observation Post on the Souchez-Arras Road*, 14 June 1919, watercolour. National Gallery of Canada, Ottawa. 108.66

111 *Bellevue Spur and Passchendaele from Gravenstafel*, 7 August 1919, watercolour. National Gallery of Canada, Ottawa. 108.93

111 *The Sugar Refinery, Courcelette I*, 1919, watercolour. National Gallery of Canada, Ottawa. 108.105

111 *The Sugar Refinery, Courcelette II*, 24 August 1919, watercolour. National Gallery of Canada, Ottawa. 108.106

112 *Panorama of Lorette Ridge*, July 1919, watercolour. National Gallery of Canada, Ottawa. 108.83

113 *Wancourt*, 30 August 1919, watercolour. National Gallery of Canada, Ottawa. 108.109

115 A photographic self-portrait on the battlefields of France. MFP

CHAPTER SIX

120 *Track in the Fields*, 21 December 1919, oil. Milne Family Collection. 201.6

120 *Two Cedars, Boston Corners*, 24 December 1919, oil. Private collection, Toronto. 201.9

120 *Gentle Snowfall*, 30 December 1919, oil. National Gallery of Canada, Ottawa. 201.13

121 *Seated Figure*, 10 February 1920, watercolour. Mary Stewart, Vancouver. Photo: Robert Keziere. 201.46

123 *The Village in the Valley, Bare Trees*, 20 February 1920, watercolour. Mary Stewart, Vancouver. Photo: Robert Keziere. 201.57

124 *After Heavy Soft Snow*, 20 March 1920, watercolour. Whereabouts unknown. 201.78

124 *Interior with Table*, 12 August and 9 September 1920, watercolour. Private collection, Calgary, Alberta. Photo: John Dean. 201.105

124 *Figure in the House II*, 5 April 1920, watercolour. Art Gallery of Ontario, Toronto. 201.84

125 *Pink Reflections, Bishop's Pond*, 24 August 1920, watercolour. National Gallery of Canada, Ottawa. 201.113

126 *Trees Reflected, Kelly Ore Bed*, 15 August 1920, watercolour. Private collection, St Catharines, Ontario. Photo: Michael Neill. 201.107

126 *Black Reflections, Bishop's Pond*, 24 August 1920, watercolour. Private collection, Toronto. 201.114

127 Bishop's Pond (now Helck's Pond) at Boston Corners, as it is today. DPS

127 *Dark Shore Reflected, Bishop's Pond*, 1920, watercolour. Private collection, Toronto. Photo: Michael Neill. 201.130

127 *Bishop's Pond in Sunlight*, 7 October 1920, watercolour. Mrs F. Renwick Brown, Montreal. Photo: Michael Neill. 201.129

128 *Weed Iron Mines*, 27 August 1920, watercolour. National Gallery of Canada, Ottawa. 201.115

129 *Pool and Contours*, 27 August 1920, watercolour. National Gallery of Canada, Ottawa. 201.116

130 Installation of Milne's paintings in the Philadelphia Water Color Club exhibition, November–December 1920

131 Milne's map of the Alander area, 1920. NAC

131 Milne's construction drawings for the Alander cabin, 1920. NAC

132 The Alander cabin, ink drawing. MFP

132 Milne in the doorway of the Alander cabin. MFP

133 James Clarke's watercolour of Milne painting in the doorway of the Alander cabin, 1921. McMichael Canadian Art Collection, Kleinburg, Ontario.

133 *In the Cabin on the Mountain I*, c. 26 March 1921, watercolour. Private collection, St Catharines, Ontario. Photo: Michael Neill. 202.21

134 *Doorway of the Painting House, Alander*, 16 Janaury 1921, watercolour. National Gallery of Canada, Ottawa. 202.3

135 Milne at a stream, likely Ashley Brook, near the Alander cabin. MFP

135 *Drift on the Stump*, 10 or 11 February 1921, oil. Vancouver Art Gallery. 202.12

137 *White, the Waterfall*, 28 March 1921, oil. National Gallery of Canada, Ottawa. 202.22

CHAPTER SEVEN

141 *Projecting Tree, Dart's Lake*, 1 June 1921, watercolour. Agnes Etherington Art Centre, Queen's University, Kingston, Ontario. 203.1

142 *Figure in Landscape*, 1921, watercolour. Faye and Rod Willis, London, Ontario. 203.17

142 Milne and the man who posed for *Figure in Landscape*, probably his friend Christian Midjo, Dart's Camp, 1921. MFP

142 *Pond, Low Water*, 13 June 1921, watercolour. Private collection, Toronto. Photo: Michael Neill. 203.5

143 *Corner of the Porch, Dart's Camp*, 29 June 1921, watercolour. Private collection, St Catharines, Ontario. Photo: Michael Neill. 203.11

143 *Point with Flag Pole*, 20 September 1921, watercolour. Stolen from University of British Columbia, whereabouts unknown. Photo: Douglas Duncan. 203.25

143 Drawing of *Reflections at Dart's Lake I*, 1921. In Mount Riga Painting Note 22, NAC

143 *Reflections at Dart's Lake I*, 19 September 1921, watercolour. Milne Family Collection. Photo: Nancy Rahija. 203.24

144 Milne's photograph of the hill across Dart's Lake, 1921. MFP

144 *Little Reflections, Dart's Lake*, 29 September 1921, watercolour. Mr and Mrs Christopher Young, Ottawa. Photo: Douglas Duncan. 203.29

144 *Across the Lake I*, 4 October 1921, watercolour. National Gallery of Canada, Ottawa. 203.30

145 *Interior: Woman Reading*, 20 October 1921, watercolour. Robert Peters, Calgary, Alberta. Photo: John Dean. 204.2

145 *House on the Railway*, 19 October 1921, watercolour. Private collection, Toronto. Photo: Michael Neill. 204.1

146 Drawing related to *Row of Trees, Mount Riga*, 1922, ink. NAC

146 *Row of Trees, Mount Riga*, 29 October 1921, oil. Milne Family Collection. Photo: John Glover. 204.8

146 *Clarke's House after Snow*, 19 January 1922, oil. Carleton University Art Collection, Ottawa. 204.45

147 *Corner of the House II*, begun January 1922 and completed January 1926, oil. Mrs Lionel Massey, Ottawa. Photo: Michael Neill. 207.48

148 *The Hillock*, 23 January 1922. Milne Family Collection. Photo: John Glover. 204.48

150 *Wet Gray Hill*, 7 or 10 February 1922, watercolour. Art Gallery of Ontario, Toronto. 204.60

150 *Rocks in Spring*, 8 February–7 March 1922, oil. Winnipeg Art Gallery, Winnipeg, Manitoba. 204.75

151 *Melting Snow*, 7 or 10 February 1922, watercolour and ink. Milne Family Collection. 204.59

152 *House at Mount Riga*, 23 March 1922, Milne's first colour drypoint. Tovell 29

154 A detail from *Mirror*, 28 February 1922, oil. Milne Family Collection. 204.66

155 The Little Tea House at Big Moose Lake, run by the Milnes in the summers of 1922 and 1923. MFP

155 Stationery for the Little Tea House at Big Moose Lake. NAC

155 *The Blue Dragon Tabletop*, 1923, oil on wood. Milne Family Collection. 604.19

156 *The Black Cabinet*, 1922, watercolour. Winnipeg Art Gallery, Winnipeg, Manitoba. 204.89

156 *The White Cabinet*, 11 October 1922, watercolour. Jeffrey Rose, Toronto. Photo: Michael Neill. 204.88

156 *Valley at Mount Riga, October*, 25 October 1922, watercolour. Private collection, Toronto. Photo: John Glover. 204.95

156 *Clarke's House, Late Afternoon*, 2 February 1922, oil. Private collection, Ontario. Photo: Michael Neill. 204.56

157 James Clarke, *Biddiecott*, c. 1922, watercolour. Courtesy of David Clarke, New York

157 *Brown Hillside Reflected*, 18 November 1922. Private collection, Toronto. Photo courtesy of Mira Godard Gallery. 204.101

157 *Lanterns and Snowshoes*, 4 September 1923, watercolour. Milne Family Collection. 205.12

158 *Verandah at Night II*, 21 August 1923, watercolour. Private collection, Ontario. Photo: John Glover. 205.7

158 *Verandah at Night IV*, 1923, watercolour. Art Gallery of Hamilton, Hamilton, Ontario. 205.9

CHAPTER EIGHT

163 *Old RCMP Barracks II*, 1924, watercolour. National Gallery of Canada, Ottawa. 206.12

164 *House of Commons*, 7 November 1923, watercolour. National Gallery of Canada, Ottawa. 206.3

164 *Parliament Hill from Hull*, 1923, watercolour. Art Gallery of Ontario, Toronto. 206.8

165 *Figure in Black*, 1923, watercolour. Theodore D. Spieler estate, Ottawa. Photo: Douglas Duncan. 206.4

165 *Woman Reading by the Window*, 1923, watercolour. Milne estate. Photo: Douglas Duncan. 206.5

167 *Carnival Dress*, 1924, oil. Agnes Etherington Art Centre, Queen's University, Kingston, Ontario. 206.16

CHAPTER NINE

170 Milne's plans for the Big Moose Lake house, from a letter to Clarke, 1924. NAC

171 Milne's Big Moose Lake house as it stands today. DPS

172 Stone piers built by Milne. DPS

173 The stone fireplace of Milne's Big Moose Lake house. Photo: John Morris

175 *Island in the Lake*, 1925, watercolour. London Regional Art and Historical Museums, London, Ontario. 207.39

179 *Whiteface*, 1925, oil. Jennings Young, Toronto. Photo: Michael Neill. 207.6

179 *Valley, Lake Placid III*, 1925, oil. McMichael Canadian Art Collection, Kleinburg, Ontario. 207.42

180 *Black House I*, 1925, watercolour. Art Gallery of Ontario, Toronto. 207.24

181 *Tribute to Spring*, 1925, watercolour. National Gallery of Canada, Ottawa. 207.40

182 *Cottage after Snowfall I*, 28 March 1925, watercolour. Private collection, Kitchener, Ontario. Photo: John Glover. 207.21

183 *Outlet of the Pond, Morning*, 1928, oil. Private collection, Toronto. Photo: Michael Neill. 207.106

186 *Waterlilies and Indian Pipes*, 1926 or 1927, oil. National Gallery of Canada, Ottawa. 207.71

186 *Sparkle of Glass*, 1926 or 1927, oil. National Gallery of Canada, Ottawa. 207.72

189 First drawing for *Painting Place*, August 1926, pencil. NAC

189 *Painting Place I*, 28 August 1926, oil. Empire Company Limited, Stellarton, Nova Scotia. 207.73

189 *Painting Place II*, 1926–30, oil. National Gallery of Canada, Ottawa. 207.75

189 *Painting Place: Brown and Black*, c. 1926, oil. McMichael Canadian Art Collection, Kleinburg, Ontario. 207.74

189 *Painting Place III*, 1930, oil. National Gallery of Canada, Ottawa. 301.10

190 Milne's early drypoint trials, 1928. Private collection, Toronto

191 *North Elba* (fourth version), 1929, colour drypoint. Photo: Nancy Rahija. Tovell 48

CHAPTER TEN

196 Temagami in 1929. Photo courtesy of Michael Barnes

196 Temagami in 1930. Photo courtesy of Michael Barnes

197 Drawing of village of Temagami. MFP

197 *Northern Village*, 1929, oil. Private collection, Montreal. 208.1

198 *Flooded Prospect Shaft I*, 1929, oil. Private collection, Toronto. 208.5

198 *Flooded Prospect Shaft II*, 1929, oil. National Gallery of Canada, Ottawa. 208.6

199 *Riches, the Flooded Shaft*, 1929, oil. Private collection, Toronto. Photo: Michael Neill. 208.8

199 *Prospect Shaft*, 1931, colour drypoint. Photo: Nancy Rahija. Tovell 64

201 Drawing of *White Waterlilies in a Prospector's Cabin*, 1934, ink. Draft of Milne's 1934 sale list. MFP

201 *Tin Basin, Flowers in a Prospector's Cabin I*, 20–3 June 1929, oil. Private collection, Ontario. Photo: Michael Neill. 208.21

203 *Flowers and Easel*, 1929, oil. Victoria College, University of Toronto. 208.28

205 *Waterlilies and the Sunday Paper*, 1929, oil. Hart House, University of Toronto. 208.31.

207 The Weston railway bridge as it stands today

207 *The Pump*, 1929, oil. Private collection, Toronto. Photo: Michael Neill. 301.6

208 *Corner of the Etching Table*, 1930, oil. Private collection, Toronto. Photo: Michael Neill. 301.8

209 *Painting Place III*, 1930, oil. National Gallery of Canada, Ottawa. 301.10

CHAPTER ELEVEN

212 *Hills at Seeding Time*, 1930, oil. Private collection, Toronto. Photo: Joyner Fine Art. 302.7

212 *Blind Road, Plowed Ground*, 1930, oil. Private collection, Toronto. Photo: Michael Neill. 302.11

213 The Milnes' house in Palgrave, in 1973

213 *Splendour Touches Hiram's Farm*, 1932, oil. National Gallery of Canada, Ottawa. 302.199

213 *The Cold and Rain Grip Hiram's Farm*, 1932, oil. Winnipeg Art Gallery, Winnipeg, Manitoba. 302.202

214 *Window*, 27 May 1930, oil. National Gallery of Canada, Ottawa. 302.15

223 Cover of the *Colophon*, part 5, 1931. Photo: Nancy Rahija

225 *Waterfall*, 1930, colour drypoint. Photo: Nancy Rahija. Tovell 60

225 *Lines of Earth*, 1930, colour drypoint. Photo: Nancy Rahija. Tovell 58

225 *Outlet of the Pond*, 1930, colour drypoint. Photo: Nancy Rahija. Tovell 61

225 *Blind Road*, 1930, colour drypoint. Photo: Nancy Rahija. Tovell 59

226 Self-portrait, partly painted out, on verso of *Red Elevator and Blue Sky*, c. 1930, oil. Hart House, University of Toronto. 302.4

228 *Serenity*, 1931, oil. Private collection, Toronto. Photo: Michael Neill. 302.94

229 Drawing of *Light* (initially titled *Fair Weather*), 17 March 1932, ink. National Gallery of Canada, Ottawa

229 Drawing of *Serenity*, 20 August 1934, ink. UTA

229 *Village Spread Out*, 1931, oil. Art Gallery of Ontario, Toronto. 302.41

229 *Village in the Sun I*, 1931, oil. Vancouver Art Gallery. 302.95

230 *Kitchen Chimney*, 1931, oil. National Gallery of Canada, Ottawa. 302.68

230 *Chimney on Wallace Street*, 1932, oil. Private collection, Montreal. Photo: Michael Neill. 302.140

231 *The House Is a Square Red Cloud*, 1931, oil. National Gallery of Canada, Ottawa. 302.75

233 Drawing of *Framed Etching*, 17 March 1932, ink. National Gallery of Canada, Ottawa

233 *Framed Etching*, 1931, oil. Government of Canada, Department of Foreign Affairs, Ottawa. 302.43

234 *Dark Hills and Glowing Maple*, 1932, oil. Private collection, Toronto. Photo: Nancy Rahija. 302.196

235 *Flag Station*, 1931, oil. Private collection, King City, Ontario. Photo: Nancy Rahija. 302.72

238 *Barns*, 1930, oil. Whereabouts unknown. Photo: Michael Neill. 302.33

239 *Barns*, 1931, 1936, colour drypoint. Photo: Nancy Rahija. Tovell 66

239 Drawing of *Barns*, 14 June 1934. NAC

*240 *Queen's Hotel*, 1931, colour drypoint. Tovell 65

240 Drawing of *Queen's Hotel, Palgrave*, 17 April 1932, ink. NAC

*240 *Yard of the Queen's Hotel*, 1937, colour drypoint. Tovell 76

241 *Queen's Hotel, Palgrave*, 1931, oil. National Gallery of Canada, Ottawa. 302.74

*The captions for these drypoints are transposed on page 240.

CHAPTER TWELVE

246 Milne's map of Six Mile Lake, in a letter of c. 8–12 October 1933. NAC

247 *Waterlilies in the Bush*, 1933, oil. Hart Massey, Port Hope, Ontario. Photo: Michael Neill. 303.23

247 Drawing of *Waterlilies in the Bush*, 20 August 1934, ink. UTA
248 Milne's cabin at Six Mile Lake, as illustrated in a letter to James Clarke, 23 December 1933. NAC
248 *Winter Sky*, 1 January 1935, oil. Private collection, Ontario. Photo: Nancy Rahija. 304.1
250 Two pages of Milne's letter to the Masseys of 20 August 1934. UTA
251 An illustrated page of Milne's letter to the Masseys of 20 August 1934. UTA
254 Mellors Galleries, 1934 exhibition catalogue. Photo: Nancy Rahija
255 *Paper Bag*, in the February 1935 issue of *Canadian Forum*. Photo courtesy of Metropolitan Toronto Reference Library
257 Milne at his easel at Gloucester Pool, Six Mile Lake, 1936. MFP
259 Milne, Douglas Duncan, and Alan Jarvis at Six Mile Lake, 2 September 1936. MFP
259 Alan Jarvis and Milne at Six Mile Lake, c. 1936. MFP
261 Milne's painting outfit, 1936. MFP
265 Drawing for the *Undergraduate*, 1936, ink. Whereabouts of original unknown. 604.20
267 *Rock Pool*, 1933, oil. Dr Swanson, Calgary, Alberta. 303.15
268 *Rowboat on Shore I*, 1933, oil. Private collection, Toronto. Photo: Michael Neill. 303.2
268 *Alder Branch*, 1933, oil. Private collection, Coral Gables, Florida. Photo: Michael Neill. 303.29
269 Drawing of *Sugar Bush*, 20 August 1934, ink. UTA
269 *Sugar Bush*, 1935, oil. National Gallery of Canada, Ottawa. 304.11
270 *Bag of Sugar*, 1934, oil. Art Gallery of Hamilton, Hamilton, Ontario. 303.39
271 *Frost on the Window* (detail)
271 *Frost on the Window*, 1935, oil. Private collection, Montreal. Photo: Michael Neill. 304.2
272 Drawing of *Northern Lights*, 1935, ink, in a letter to James Clarke, 28 August 1935. NAC
273 Mellors Galleries, cover of 1936 exhibition catalogue with Milne's drawing of his painting *Lightning*. Photo: Nancy Rahija
273 *Northern Lights*, 1935, oil. Private collection, Montreal. Photo: Michael Neill. 304.17
273 *Lightning*, 1936, oil. Mackenzie Art Gallery, Regina, Saskatchewan. 304.78
274 *Summer Colours*, 1936, oil. McMichael Canadian Art Collection, Kleinburg, Ontario. 304.81
275 *The Time of Forest Fires*, 1936, oil. W.H. Graham, Greenbank, Ontario. Photo: Michael Neill. 304.88
276 *Bare Rock Begins to Show*, 1936, oil. National Gallery of Canada, Ottawa. 304.63
276 *Cabin Shelves*, 1934, oil. Art Gallery of Ontario, Toronto. 303.50
276 *Yellow Coat and Shelves*, 1936, oil. Milne estate. 304.75
277 *Nasturtiums and Carton II*, 1937, oil. McMichael Canadian Art Collection, Kleinburg, Ontario. 304.95
277 *Salmon Can*, 1936, oil. Hart House, University of Toronto. 304.74
278 *Raspberry Jam*, 1936, oil. National Gallery of Canada, Ottawa. 304.84
279 *Trilliums and Columbines*, 1937, oil. Murray Adaskin, Victoria, British Columbia. Photo: Robert Keziere, 305.22

CHAPTER THIRTEEN

282 *Picture on the Blackboard*, 1937, oil. Milne estate. 305.26
282 *Margaret's Picture of Wimpy and the Birthday Cake*, 1937, oil. Milne estate. Photo: John Glover. 305.25
283 *Vinegar Bottle III*, 1937, watercolour. The Honourable and Mrs J.W. Pickersgill, Ottawa. 305.36
283 *Bag of Sugar*, 1937, oil. Milne estate. 305.37
284 *Edam Cheese*, 1938, watercolour. Whereabouts unknown. Photo: Joyner Fine Art. 306.4
284 *Yellow Shoe Box*, 1937, watercolour. Mrs Eugene Hawke, Toronto. 305.41
284 *White Shoe Box*, 1937, watercolour. Mr and Mrs Thomas F. Benson, Toronto. Photo: Michael Neill. 305.42
285 Milne in his cabin at Six Mile Lake, with a version of *Cabin at Night* on the easel. MFP. Photo: Douglas Duncan
285 *Cabin at Night II*, 1938, watercolour. Private collection, Toronto. Photo: John Glover. 306.1
286 *Brook in the Sugar Bush*, 1938, watercolour. Private collection, Toronto. Photo: John Glover. 306.13
286 *Lighted Lamp*, 1937, watercolour. Private collection, Victoria, British Columbia. Photo: Bob Matheson. 305.60
287 *The Pole Line*, 1938, watercolour. Private collection, Caledon, Ontario. Photo: Michael Neill. 306.18
287 *Red Lily*, 1938, watercolour. Mr and Mrs Carl Michailoff, Toronto. Photo: Michael Neill. 306.27
287 *Zinnias to Paint*, 1938, watercolour. Private collection, Toronto. Photo: John Glover. 306.49
288 Drawing of *Cracks in the New Ice*, 15 January 1939. MFP
288 *Cracks in the New Ice*, 1939, watercolour. Milne estate. Photo: Nancy Rahija. 306.84
289 Milne in his cabin, with *The Yellow Coat* on the easel. MFP. Photo: Douglas Duncan
290 Teacher Elizabeth Cowan and her students, 1938. MFP
290 Drawing of *Goodbye to a Teacher*, 15 January 1939, ink. MFP
290 *Goodbye to a Teacher IV*, 1939, watercolour. McMichael Canadian Art Collection, Kleinburg, Ontario. 306.81
295 Alan Jarvis burning Milne paintings at Six Mile Lake, 1939. MFP
296 *Red Dress II*, 1939, watercolour. Phyllis and Alan Cohen, London, Ontario. 306.108
297 *Reading in the Cabin*, a portrait of Kathleen Pavey shortly after Milne met her, 1939, watercolour. Milne estate. 306.96
306 *United Church*, 1939, watercolour. National Gallery of Canada, Ottawa. 401.16
306 *Firehall*, 1939, watercolour. Mary Stewart, Vancouver. Photo: Robert Keziere. 401.28
307 *Stars over Bay Street*, 1939, watercolour. McMaster Museum of Art, McMaster University, Hamilton, Ontario. 401.5
307 *Stars over Bay Street*, 1941, 8 March, watercolour. National Gallery of Canada, Ottawa. 403.27
308 *Allan Gardens Drawing*, 1940, pencil. Milne estate. Photo: Nancy Rahija. 604.21
308 *St Michael's Cathedral II*, 1940, watercolour. Art Gallery of Ontario, Toronto. 401.50
309 *Parliament Buildings*, 1939, watercolour. Mr and Mrs Donald R.A. Marshall, Richmond Hill, Ontario. 401.21
309 *Brewery at Night*, 1939, watercolour. Milne estate. Photo: Douglas Duncan. 401.25
309 *Kitchen*, 31 March 1940, watercolour. Martin Ahvenus, Toronto. Photo: Michael Neill. 401.61
309 *Eggs and Milk*, 24 March 1940, watercolour. Milne estate. 401.55
310 *Hyacinths in the Window*, 1940, watercolour. Private collection, Toronto. Photo: John Glover. 401.33

CHAPTER FOURTEEN

312 Kathleen and David Milne in front of their Franklin Street home in Uxbridge, c. 1943. MFP
313 Kathleen Milne with David Jr, November 1941. MFP
313 Milne, Kathleen, and David Jr
314–15 Milne with his son. MFP
317 *Window on Main Street*, 1940, watercolour. National Gallery of Canada, Ottawa. 403.1
317 *First Snow*, 1940, watercolour. Private collection, Toronto. Photo: Michael Neill. 403.5
318 Uxbridge United Church, 1970s. DPS
318 *Red Church IV*, 1941, watercolour. Mr and Mrs Fred Schaeffer, Thornhill, Ontario. Photo: Michael Neill. 403.56
319 *Poppies*, 1941, watercolour. Art Gallery of Ontario, Toronto. 403.64
319 *Zinnias and Poppies I*, 26 August 1941, watercolour. Private collection, Mississauga. 403.69
320 *White Clouds in a Blue Sky III*, 21 February 1941, watercolour. Milne Family Collection. Photo: John Glover. 403.23
321 *Poppies and Nasturtiums*, 1941, watercolour. Carleton University Art Collection, Ottawa. 403.65
321 *Lemon Lilies*, 1941, watercolour. Private collection, Montreal. Photo: Michael Neill. 403.52
322 *Poppies and Lilies III*, 1946, watercolour. Private collection, Toronto. Photo: John Glover. 406.5

323 A page from Bentley and Humphreys's book on snow crystals, from which Milne made sketches

323 *Snow in Bethlehem II*, 11 August 1941, watercolour. Art Gallery of Ontario, Toronto. 403.59

326 A page from Benham's book on the history of playing cards, from which Milne made sketches

327 *King, Queen, and Jokers I*, 9 September 1941, watercolour. Private collection, Bancroft, Ontario. Photo: Michael Neill. 403.73

327 *King, Queen, and Jokers IV: It's a Democratic Age*, 22 January 1942, watercolour. Milne Family Collection. Photo: Nancy Rahija. 403.103

327 *King, Queen, and Jokers V: It's a Democratic Age*, 1943–4, watercolour. Art Gallery of Ontario, Toronto. 404.93

327 *King, Queen, and Jokers VIII: It's a Democratic Age*, 1943–4, watercolour. Milne estate. Photo: John Glover. 404.96

328 *Noah and the Ark and Mount Ararat I*, c. 1 December 1941, watercolour. Private collection, Toronto. 403.94

328 *Noah and the Ark and Mount Ararat III*, 15 December 1941, watercolour. E.R. Hunter, West Palm Beach, Florida. Photo: Michael Neill. 403.98

328 *Noah and the Ark and Mount Ararat IV*, 10 January 1942, watercolour. National Gallery of Canada, Ottawa. 403.100

328 *Noah and the Ark and Mount Ararat V*, 13 January 1942, watercolour. E.R. Hunter, West Palm Beach, Florida. Photo: Michael Neill. 403.101

329 Drawing of Noah, 11 June 1939, ink. MFP

329 *Prints*, 1942, watercolour. Milne Family Collection. Photo: John Glover. 403.108

330 *Wild Flowers on the Window Ledge I*, 2 May 1942, watercolour. E.R. Hunter, West Palm Beach, Florida. Photo: Michael Neill. 403.111

331 *The Saint III*, 17 June 1942, watercolour. Art Gallery of Hamilton, Hamilton, Ontario. 403.120

332 *Gulls and Lighthouse II*, 1942, watercolour. Dr Gordon R. Hall, Woodstock, Ontario. 403.129

332 *Gulls*, 1942, watercolour. Private collection, Ottawa. Photo: Michael Neill. 403.130

333 *Shrine and Saints II*, 11 March 1943, watercolour. Hart House, University of Toronto. 404.11

333 *Resurrection III*, 1943, watercolour. Art Gallery of Ontario, Toronto. 404.43

334 *Day of Judgment VI*, 1947, watercolour. University of British Columbia, Vancouver. 406.87

335 *Return from the Voyage II*, 1944, watercolour. London Regional Art and Historical Museums, London, Ontario. 404.103

335 *Return from the Voyage III*, 1944, watercolour. Milne estate. Photo: Douglas Duncan. 404.104

335 *Return from the Voyage IV*, 1944, watercolour. Milne estate. Photo: Douglas Duncan. 404.105

335 *Rites of Autumn I*, 1943, watercolour. Art Gallery of Greater Victoria, Victoria, British Columbia. 404.61

335 *Rites of Autumn II*, 1943, watercolour. E.R. Hunter, West Palm Beach, Florida. Photo: Michael Neill. 404.62

336 *Ascension I*, 1943, watercolour. National Gallery of Canada, Ottawa. 404.55

336 *Ascension XI*, 1944, watercolour. National Gallery of Canada, Ottawa. 404.75

337 *Ascension XV*, 1944, watercolour. James Coutts, Toronto. Photo: John Glover. 404.81

337 *Ascension XXI*, c. 1945, watercolour. London Regional Art and Historical Museums, London, Ontario. 405.30

338 *Canadian Flag Designs I*, 1944, watercolour. Milne estate. Photo: Nancy Rahija. 602.1

339 *Canadian Flag Designs IX*, 1944, watercolour. Milne estate. Photo: Nancy Rahija. 602.9

339 *Canadian Flag Designs X*, 1944, watercolour. Milne estate. Photo: Nancy Rahija. 602.10

343 *Funeral in October II*, 1945, watercolour. Vancouver Art Gallery. 404.132

343 *Mary and Martha III*, 3 February 1945, watercolour. McIntosh Gallery, University of Western Ontario, London, Ontario. 405.8

343 *Mary and Martha IV*, 1945, watercolour. Private collection, Vancouver. 405.9

344 *Penguin and Nasturtiums I*, 1945, oil. Inner City Products Corporation, Toronto. Photo: Michael Neill. 405.55

345 *Radio with Tulips*, 1946, watercolour. Milne estate. Photo: Douglas Duncan. 406.16

345 *White Poppy*, 1946, watercolour. National Gallery of Canada, Ottawa. 406.36

346 *The Pool, Little Bob Lake II*, 1946, watercolour. Private collection, Toronto. 406.73

346 *Scaffolding I*, 1946, watercolour. Rodman Hall Arts Centre, St Catharines, Ontario. 406.61

346 *Fair in the Park*, 1947, watercolour. Private collection, Kitchener, Ontario. Photo: John Glover. 406.121

347 *Open Door*, 1947, watercolour. Montreal Museum of Fine Arts. 406.115

347 *The Green Vase*, 1947, watercolour. Dr Peter Chan and Debbie MacKinnon-Chan, Calgary, Alberta. Photo: Michael Neill. 406.118

347 *Flowers and Candlesticks*, 1947, watercolour. M.B. Kaplansky, Toronto. Photo: Michael Neill. 406.111

CHAPTER FIFTEEN

350 Milne's map of Baptiste Lake, 1947, ink and pencil. MFP

351 *High Island*, 1947, watercolour. Milne estate. 501.1

353 Letters from Milne to David Jr, c. 29 May 1945 and October 1947. MFP

355 Milne in a tweed cap, 1951. MFP

356 Milne's cabin at Baptiste Lake, interior, in 1988. DPS

356 Exterior of Milne's cabin at Baptiste Lake, in 1988. DPS

357 *Shelter at Night I*, 7 October 1947, watercolour. National Gallery of Canada, Ottawa. 501.6

360 *Spider Bridge II*, 1949, watercolour. Mendel Art Gallery, Saskatoon, Saskatchewan. 502.14

360 *Spider Bridge III*, 1950, watercolour. National Gallery of Canada, Ottawa. 502.29

361 *Quiet River*, 1950, watercolour. Glenbow, Calgary, Alberta. 502.56

361 *York River*, 1949 or 1950, watercolour. Art Gallery of Hamilton, Hamilton, Ontario. 502.18

362 *Bear Camp I*, 1950, watercolour. Private collection, Montreal. Photo: Michael Neill. 502.22

362 *Bear Camp II*, 1950, watercolour. Mr and Mrs W.B. Harris, Toronto. 502.23

362 *Bear Camp V*, 1950, watercolour. Private collection, Montreal. Photo: Michael Neill. 502.26

362 *Bear Camp VII*, 1950, watercolour. Private collection, Vancouver. Photo: John Glover. 502.28

363 *Farm IV*, 1950, watercolour. Private collection, Toronto. Photo: Michael Neill. 502.37

364 *Storm over the Islands III*, 1951, watercolour. Art Gallery of Windsor, Windsor, Ontario. 503.23

364 *Storm over the Islands IV*, 1951, watercolour. Art Gallery of Windsor, Windsor, Ontario. 503.24

364 *Lighted Streets I*, 1951, watercolour. Private collection, Toronto. 503.16

364 *City Lights II*, 18–20 November 1951, watercolour. Mr and Mrs Murray Adaskin, Victoria, British Columbia. 503.20

365 *Lipstick III*, 18 January 1952, watercolour. Milne estate. 503.33

365 *Tempter with Cosmetics IV*, 1951, watercolour. Dr and Mrs Peter Mingie, Toronto. 503.30

366 Jack Nichols's portrait of Milne, 1952, pencil. Whereabouts unknown. Photo courtesy of the National Gallery of Canada, Ottawa

366 *Paracutin IV*, 1952, watercolour. Milne estate. Photo: Nancy Rahija. 503.49

366 *Fruit of the Tree I*, 1952, watercolour. Milne estate. 503.69

367 *Blue Bay*, 1952, watercolour. Winnipeg Art Gallery, Winnipeg, Manitoba. 503.40

367 *Leaves in the Wind II*, 1952, watercolour. Mr and Mrs A.J. Warren, Vancouver. Photo: Robert Keziere. 503.54

368 *Tempter with Cosmetics V*, 1952, watercolour. Agnes Etherington Art Centre, Queen's University, Kingston. 503.74

CHAPTER SIXTEEN

381 John Boyle's portrait of Milne, *Impositions*, 1984, oil. Collection of Stephen M. Fitterman, Toronto. Photo: Nancy Rahija

Index

Page numbers in italics indicate an illustration. Works of art are by Milne unless otherwise noted.

Abbott, J.B., 164–5
Abbott, Kay. See Mark, Kay
Aberdeen, Scotland, 113
Aberdeen-Australian Line, 90
Aberdeenshire, Scotland, 3–4, 7, 113
abstraction, 62, 199–200
Across the Bay in Spring, 289
Across the Lake, 38, 140, 143, 190, 207, 392 n12
Across the Lake I, 97, 142, *144*, 162, 184, 207, 361
Across the Still Lake, 392 n12
Adirondack Lodge, 177
Adirondack mountains, 178–9, 205
Adirondack Park, 139
Adler, Elmer, 223–4
After Heavy Soft Snow, *124*
Afternoon, Kelly Ore Bed, *122*
Afternoon Light II, 86
After Sunset, 357
Agnes Etherington Art Centre, Kingston, 374, 375
Alander cabin, 130–8, 199, 204, 391–2 n58; James Clarke's painting of Milne at, *133*; construction drawings, *131*; ink drawing, *132*; Milne in doorway, *132*
Alander Mountain, 130–1, 140; area map, *131*
Albright-Knox Art Gallery, 221
Alcove, 52
Alder Branch, *268*, 268
Alfred, Paul. See Meister, Alfred
Allan Gardens, 309
Allan Gardens Drawing, 308
Allen, Ralph, 374
American Advertising Hall of Fame, 65
American Water Color Society, 49, 60, 206
Ancram, village of, 89
Anderson Galleries, 94
Angus, Kathleen, 281
Angus, Nan, 263, 289, 292
Angus, Scotty, 247–9, 263, 265, 348
Angus boys, 353
Another Generation, 366, 369
Apple Blossoms, 38, *38*
Arcade School, New York, 14
Armory Show (1913), 30, 48, 49–53, 56, 66, 381; catalogue, *50*

Armsworth, Rodney, 171
Army and Navy Life. See *Uncle Sam's Magazine*
Arras, France, 105, 107
Art Association of Montreal. See Montreal Museum of Fine Arts
Art Directors' Club of America, 65
art galleries, New York, 15
Art Gallery of Ontario. See Art Gallery of Toronto
Art Gallery of Toronto, 206, 218, 294; Group of Seven exhibition, 218; Massey collection exhibition, 252, 256; Morrice exhibition, 237; purchase of Milne's work, 295, 338–9, 368, 372; war-paintings exhibitions, 117, 125
Arthur, Paul, 353
Art Metropole, painting supplies, 398 n104
art nouveau, 165
art prices, 165
arts, revolution of early 1900s, 25
Arts and Decoration magazine, 60
Art Students' League of New York, 14–16, 23, 36, 151, 224, 283; Engle at, 20; Fake Show, 386 n68; summer school at Saugerties, 70
Ascension series, 321, 323, 325, 333, 335, 341, 343, 346, 348
Ascension I, *336*
Ascension XI, *336*
Ascension XV, *337*
Ascension XXI, *337*
Ascension XXXIII, *346*
Asbury Park, New Jersey, 18
Ashcan school. See The Eight
Ashley, Pennsylvania, 21
Association of American Painters and Sculptors, 49–50
Atkins, Caven, 298
Attic, 191
Autumnal Tints, 21
Autumn Tints, *31*, 32

Back Porch, the White Post, 81, *81*
Back Porch, the White Post, drawing, *81*
Bag of Sugar, 270, *270*, 283, *283*
Baldwin, Leo, 72
Baldwin, Martin, 295
Baldwin house, 71
Bancroft, 349, 353, 358–9; 40 Faraday Street, 369; Hastings Street South, 369; move to, 369
Baptiste Lake, 349, 350, 353–4, 370; cabin at,

350–1, *356*, 358–9; map, *350*; painting at, 359–60; paintings stolen from, 381
Bare Rock Begins to Show, 275, *276*
Barge, 64
Barns, 238, *238*, 239, 286
Barns, drawing, *239*
Barns, drypoint, 225, 239, *239*
Barwick, Frances, 259, 374
Barwick, J.P. (Jack), 259, 374
Bash Bish Brook, 131
Bath House, *31*, 32
Batterwood, Port Hope, 252
Battery Park, 59, *59*
Battle of Amiens, 105
Battle of Mons, 105
Battle of the Somme, 102
Baxter Township, 246
Beament, Harold, 161, 166, 393 n28
Bear Camp, 361, 392 n12
Bear Cump series, 38
Bear Camp I, *362*
Bear Camp II, *362*
Bear Camp V, *362*
Bear Camp VII, *362*
Bear Island, Temagami, 196
Beatty, J.W., 219, 339, 342
Beaverbrook, Lord, 91–2, 390 n12
Beckett, Marley, 242, 245
Beckett, Peter, 245
Belaney, George 'Archie,' 394 n3
The Belfry, Hôtel de Ville, Arras, 115
Belgium, 107
Belle of Temagami (ship), 195
Belleville regional hospital, 370
Bellevue Spur and Passchendaele from Gravenstafel, 110, *111*
Bellini, Giovanni, 330; *The Transfiguration*, 336
Bellows, George, 14, 52, 54
Benham, W. Gurney, *Playing Cards, A History of the Pack and Explanations of Its Many Secrets*, 320, 326, *326*
Bennett, R.B., 220, 222
Benton, Thomas, 54
Berkshire mountains, 69
The Berry Pickers. See Reid, George A.
Bible, Allie, 215
Bickersteth, J. Burgon, 265
Biddiecott, Mount Riga, 155
Biddiecott. See Clarke, James Arthur

Bieler, André, 190
Big Chute, 247, 249, 263–4, 296, 353; railway, 397 n14; school, 281
The Big Dipper, 272
Big Moose Lake, 127, 138, 154, 155, 168, 175, 193, 393 nn1, 2; house, 170–2, *171, 172,* 182, 191; Little Tea House, 154, 157–8, 166–7, 170; mortgage money, 214, 242, 245, 249, 314, 395 n13; paintings, 127; plans for house, 170–1, *170;* real-estate venture, 169–71, 191–2, stationery for tea-house, *155;* stone fireplace, 171–2, *173;* storage of paintings at, 250, 379–80; subjects, 225
Big Moose Transportation Company, 173
Billboards, 40, 41, 44, 374
Billy's Bald Spot, lookout, 170–1, 176, 186
The Bird. See Brancusi, Constantin
Bird's Creek, 362
Bishop's Pond, Boston Corners, 76, 126, *127*
Bishop's Pond in Sunlight, 127
Bissell, Claude, 379
Black, 44, *44,* 61, 380
Black and Green, 55, 388 n63
Black and White I, 39, *39,* 54, 55
Black and White II, 39, *39,* 54, 55, 387 n10
Black and White, 1935, 265, *266*
The Black Cabinet, 155, *156*
Black Cedars, 123, 168
Black Cores, 62, *63*
The Black Couch, 58–9, *58*
Black Hills, 86
Black House I, 180, *181*
Black House II, 181
Black Reflections, Bishop's Pond, 126, *126*
Black's bush, 383 n9
Black Waterfall, 136
Blackwoods' Magazine, 245
Blake, William: *Christ Appearing to His Apostles after the Resurrection,* 336; *Songs of Experience,* 325; *Songs of Innocence,* 325
Blashfield, Edwin, 16
Blast magazine, 48
Blind Road, drypoint, 225, *225,* 396 n61 (as Tovell 59)
Blind Road, Plowed Ground, 211, *212,* 217
Blonde Rocks, 36, *37*
Bloomfield, New Jersey, 18
Blossoming Tree, 38
Blowhole trail, 131
The 'Blowhole' Trail, 391 n34
Blue Bay, 367, *369*
The Blue Dragon Tabletop, 155
Blue-Green, Black-Green, 48, 53
Blue Sky, Palgrave, drypoint, 225
Body of the Earth, drypoint, 396 n61
Bonnard, Pierre, 34, 221
The Booking Office. See Davis, Stuart
Boston Corners, 375, 389 n1; James Arthur Clarke, 66–7, 69, 114; farming enterprise, 71–2; move to, 69–70; return to, 114, 117–18; series, 87–8; subjects, 77–9; work at, 75–88, 118
Boston Corners, 87, 339, 374
Boston Corners and Fox Hill, 86
Boston Corners in January, 123
Boston Corners Painting Notes, 389 n64, 391 n7
Bouguereau, Alphonse, 26
The Boulder, 82
Boulders in the Bush, 191

Boulogne, France, 102
Box on the Porch, 184
Boyle, John, *Impositions, 381*
Bracebridge, 245–6
Brampton Conservator newspaper, 216
Bramshott, Hampshire, painting at, 98–100
Bramshott from the Beacons, 99, 99
Bramshott: Interior of the Wesleyan Hut, 99, 100
Bramshott: The London-Portsmouth Road, 99, 101
Brancusi, Constantin, 48; *The Bird,* 386 n64
Braque, Georges, 25, 295
Breakfast with Flowers, 288
Brewery at Night, 307, *309*
Brick House and Stormy Sky I, 213
Brick House and Stormy Sky II, 213
Bridgman, George B., 16–17
Brigden, Fred, 218
Brilliant Pattern, 59, *59*
Brinley, D. Putnam, 50
British Empire Exhibition, Wembley (1924), 159, 162, 165
Bronx, 61; apartment in, 47. *See also* New York
Bronx Hillside in Spring, 38, 62
Bronx Park, 1913, 42, 43–4
Bronx Park, 1914, 59
Brooker, Bertram, 218, 220
Brook in the Sugar Bush, 286, 289
Brooklyn, New York, 18
Brook Pattern. See Engle, Amos W.
Brown (farmer), 3, 384 n35
Brown, Private, 91; *Kinmel Park Camp: Pte Brown Writes a Christmas Letter,* 94–5, *94*
Brown, David, 384 n35
Brown, Eric, 92, 117, 164, 166, 206, 221, 293; National Gallery controversy, 222; purchase recommendation to National Gallery, 159, 161–2, 168
Brown, Grace, 393 n3
Brown, John, 177
Brown, Maude, 393 n39
Brown Hillside Reflected, 156, *157*
Bruce County Museum, Southampton, 380
Buchanan, Donald, 3, 24, 254–5, 264, 273, 279, 356, 378
Buchholz Gallery, New York, 338, 381
Budner, Gerald, *The World of David Milne* (film), 375
Burch, Charles, 69
Burgoyne, Ontario, 3, 5, 6, 7; map, 5
Burnt Tree, 168
Butterworth Building, Ottawa, 160–1, 163
Byng, Sir Julian, 102

Cabin at Night, version of, *285*
Cabin at Night II, 285, 287
Cabin Shelves, 274, *276*
Cadieux, Herman, 247
Caledon Hills, 211
Calkins and Holden, 64, 176, 182, 393 n27
Camblain l'Abbé, 102, *103*
Camera Work magazine, 25
Camouflaged Steel Observation Post on the Souchez-Arras Road, 110
Camp Makwan, 361
Camp Ponacka, 370

Canada: Department of External Affairs, 255; Department of the Interior, 161; Department of Lands and Forests, 350. *See also* customs officials
Canada Council, 378
Canada Packers Ltd, 293, 371
Canadian Army: Canadian Corps, 102, 105, 107, 110; 8th Canadian Reserve Battalion, 89; 1st Canadian Division, 107; 1st Central Ontario Regiment, 89; Princess Patricias, 110
Canadian Art magazine, 339, 378–9; 'Spring Fever' article by Milne, 273–4
The Canadian Boy magazine, 10
Canadian Daily Record magazine, 96
Canadian Flag Designs I, 338
Canadian Flag Designs IX, 339
Canadian Flag Designs X, 339
Canadian Forum magazine, 255, 264, 292, 293
Canadian Garden, 60, 387 n27
Canadian Group of Painters, 294
Canadian Legation, Paris, 255
Canadian National Exhibition grounds, 90
Canadian National Railway, 212
Canadian Pacific Railway, 212
Canadian Society of Painters in Water Colour, 294
Canadian War Memorial paintings, exhibition, 94
Canadian War Memorials Fund, 91
Canadian War Museum, 390 n12
Canadian War Records, 29, 39, 91–2, 125, 159, 221, 390 n13
Candy Basket, 344
Candy Box, 261, 291
Canopy Bed, 306
Carency, France, 105
Carlson, Les, 376
Carls-Rite Hotel, Toronto, 296
Carmichael, Frank, 218–19
Carnegie Institute, 28
Carnival Dress, 165, *167*
Carr, Emily, 218, 220, 339, 342; *Indian Church,* 206, 220
Cartons and Flour Bag, drypoint, 398 n125
Cary, Elisabeth Luther, 388 n44
Cassatt, Mary, 50
Casson, A.J., 218–19, 402 n23
Casson, Margaret, 402 n23
Catskill mountains, 179
The Catskills, 87
Caulfield, Paul, *A Path of His Own* (film), 375–6
Cavalier magazine, 24
Cedar Swamp, 331
Central Technical School, 296
Cézanne, Paul, 25, 26, 28, 36, 48, 52, 165, 240; *Fountains (Le Parc),* 36; *Les Grandes Baigneuses,* 25; 291 Gallery exhibition (1911), 36
CFRB Toronto, 291, 389 n22
Chamberlin, Joseph E., 54
Charles and Company, 20, 72
Chase, William Merritt, 14–15, 26, 29, 30; Panama-Pacific International Exposition, 53
Chase School, 14, 16
Chicago, 221; graphic art exhibition, 225
Chicago Society of Etchers, 225
Chickens on Lace, 307

children's art, 5, 281, 308–9, 310, 325
Chimney on Wallace Street, 230
Chinese labour battalions, 104, 106–7
Chocolates and Flowers, 307
Christ Appearing to His Apostles after the Resurrection. See Blake, William
Christian Science Monitor newspaper, 56
Christ in the Wilderness. See *The Saint*
Christmas card, *Snow in Bethlehem*, 324
Church, Frederick, 83
Churchill, Winston, 329
City Dairy, 296
City Lights II, 364
Claremont Inn, Riverside Park, etching, 36
Clarke, Anne, 64, 67, 75, 155, 250
Clarke, James Arthur, 35, 64–7, 65, 74, 75, 164, 178, 292, 356; and Alander, 131; Biddiecott, Mount Riga, 155; *Biddiecott*, 157; and Big Moose Lake, 169–71, 173–4, 191–2, 214; and Boston Corners, 69, 71–3, 117; career of, 389 n69; and correspondence with Milne, 100, 119, 124, 185; drypoint order, 207; First World War, 89, 92; and Kathleen Milne, 355, 377–8; and Patsy Milne, 304, 314–16, 371; Milne exhibition at Calkins and Holden, 176; Milne friendship ends, 354–5; Ottawa visit, 166–7; painting of Milne, 133; Palgrave, 217, 229–30, 236–7; sale of Milne paintings to Robert McMichael, 380; second marriage, 271, 316; Six Mile Lake, 246–7, 266–7, 272; storage of Milne's paintings, 193, 250; on watercolours, 282
Clarke, René. See Clarke, James Arthur
Clarke's House after Snow, 146, 147
Clarke's House, Late Afternoon, 156, 157
Classon Point Road, 28
The Clearing above Boston Corners, 122
The Cleremont (probably *Claremont Inn*), 55
Cleveland Watercolor Society, 206, 221
Cloud Curtain, 236
Clouds at the Horizon, 230
Clouds over the Village, 232, 236
Coal, 309
Cobalt, Ontario, 195–6, 394 n2
Coboconk, Ontario, 317, 331, 341–3
The Cold and Rain Grip Hiram's Farm, 213, 232
Colliers magazine, 17
Collingwood, Ontario, 3
Collins, Miss, 390 n4
Collins, Byron H., purchaser of Big Moose Lake house, 192, 214, 242, 245, 249, 314, 395 n13
Collins, Caroline. See Hegarty, Caroline
Collins, Norma, 281
The Colophon: A Book Collectors' Quarterly, 223, 224–5, 227; cover, 223
Coloured Spaghetti, 84
colours and values. See Milne, David: colours and values
Columbus Circle, 50, 53, 387 n27, 388 n34
Comfort, Charles, 353; poem, 354
Connaught Laboratories, 298, 367
Connecticut League of Art Students, 65, 385 n19
Constable, John, 137, 240
The Contemporaries, 53
Contours and Elm Trees, 252
Corcoran Gallery, 28
Cornell University, 143; catalogue by

Gwendolyn Owens, 375; exhibition, 153, 158, 162, 374
Corner of the Etching Table, 208, 210
Corner of the House II, 147–8, 147, 151, 183, 196, 208, 269, 270
Corner of the Porch, Dart's Camp, 141–2, 143
Cosmopolitan Magazine, 23
Cottage after Snowfall I, 179, 182
Cotton, Thomas H., 264
Coughlin, Father, 263
Courcelette, France, 107–8, 143
Courcelette from the Cemetery, 108, 108
Cowan, Elizabeth (Betty), 263–4, 289–91, 290, 292
Cox, Kenyon, 16, 52
Cozad, Robert Henry. See Henri, Robert
Cracks in the New Ice, 288, 289
Cracks in the New Ice, drawing, 288
Crisp, Arthur W., 49, 385 n9, 387 n26
Crooked Lake, 263
The Cross Chute, 291
cross-country skiing, 177, 216
Crucifixion. See Lewis, Wyndham
Crystals on the Snow, 392 n12
cubism, 25
Cullen, Maurice, 92
Currie, Arthur, 107
The Curtains, 157
customs officials: American, 224; Canadian, 159, 162

Dair, Carl, 374
Daniel Gallery, 26, 128, 153
Dark Hills and Glowing Maple, 232, 234, 234, 396 n68
Dark Shore Reflected, Bishop's Pond, 126, 127
Dart, Mr and Mrs William, 139–40
Dart's Lake, 127, 138, 144, 153, 154, 175; camp, 139–44, 238; paintings, 140, 238, 392 n28
Dart's Landing, 392 n3
Dasburg, Andrew, 385 n9
David Bell's Cow, 10
Davies, Arthur B., 30, 35, 49–50, 386 n63
Davies, Blodwen, 46, 66, 73; and Milne letters, 378; and Patsy Milne, 371, 373, 376–7, 378, 379
Davies, Robertson, 398 n72; and Milne papers, 379
Davis, Charles H., 29
Davis, Stuart: *The Booking Office*, 54; *On a Rainy Night*, 54
Dawson, George W., 49, 92
Day, Frank, 169–71
Day, Mrs Frank, 175, 393 n24
Day of Judgment II, 333, 335
Day of Judgment VI, 334
The Defiant Maple, 28, 32, 33, 34
Delacroix, Eugène, 28
Les Demoiselles d'Avignon. See Picasso, Pablo
Dennison, Mr and Mrs (artists), 74
Depression. See Great Depression
Derricks on the North River. See Henri, Robert
Distorted Tree, 50, 50, 52–3, 387 n28
Divortay, Mary. See Milne, Mary (mother)
Dix, John A., 39
Dominion Gallery, Montreal, 372
Dominion Square I, 165
Doorway of the Painting House, Alander, 134
Dorset, Ontario, 304

Dove, Arthur, 48
drawing, 10, 232–4; in Palgrave, 232; use of word, 84; watercolour 'drawings,' 165
Drawing Made at Boston Corners, 84
Drawing Made near the Catskill Mountains, 84
Drift on the Stump, 134, 135
Drying Waterfall, 79, 80
drypoint line, 396 n51
drypoint prints, 151–3, 178, 182, 188–91, 340; carton image, 398 n125; colour, 151–3, 189–90, 224–5; destruction of, 401 n2; orders for, 207, 223; trials, 190, 190, 394 n66; wiping process, 225–6. See also etching
du Bois, Guy Pène, 60, 388 n60
Duchamp, Marcel, 35, 48; *Nude Descending the Staircase*, 52
Duck and Flowers, 335
DuMond, Frank V., 14, 16
Duncan, Charles, 47, 48
Duncan, Douglas, 23, 28–9, 259–61, 259, 279, 287, 289, 291; and Art Gallery of Toronto, 338; and birth of David Jr, 313; and Buchholz Gallery, 338, 381; cataloguing Milne's paintings, 338; and control of Milne's estate, 372, 379; destruction of Milne's work, 294, 387 n4, 400 n75, 401 nn2, 18; exhibition, 295; financial irresponsibility of, 367–8; funeral of Milne, 371; at Lake of Bays, 301–2; and Patsy Milne, 299–304, 314–15; as Milne's agent, 292–3; and multiple versions of paintings, 339; and National Gallery of Canada, 339, 375; Picture Loan Society, 260; procrastination of, 354–5; and reputation of Milne, 347; Uxbridge, 311
Duncan, Frances. See Barwick, Frances
Durand-Ruel Galleries, New York, 27, 386 n67
Dutch Woman with Clogs, 11

Early Morning, 179
Earth, Sky, and Water I, 342
Eaton's (department store), Toronto, 206, 247, 360; catalogue series, 333, 341; Fine Art Gallery, 206, 397 n29
Eaton's College Street, 331
E.B. Eddy Mill, Hull, 163
Eckhardt, Ferdinand, 372
Edam Cheese, 284, 285
Edmonton Art Gallery, 375
Edward Bok medal, 66
Eggs and Milk, 309, 309
Egyptian convention, 60
The Eight, 26, 30, 35, 52; exhibition (1908), 30, 48; members of, 386 n63
El Greco, 295, 330
Eliot, T.S., 200, 287, 399 n10
Elliott, George, 371
Ellis Island, etching, 36, 37–8
Elm Logs, 348
Embankment and Bridge, 386 n58
Embassy Club, 307
Emily (Aunt), 166
Endicott, Elizabeth, 264, 291, 371
Endicott, Norman, 264, 291, 371, 377–8
Engle, Amos W., 20–3, 20, 35, 38, 47, 53, 60; Armory Show, 50; and Milne, 24–5, 128–9, 380; showcard business, 45; and wedding of Milne and Patsy, 45–6

– works: *Brook Pattern*, 21; *Experiment in Movement*, 21; *Floral Pattern*, 21; *The Half Moon at Night*, 21; *Mountain Pattern*, 391 n27; *Opening Overture, Century* [Theater], 21; *Rain Motif*, 21; *Rainy Night*, 21; *The Sprint*, 50; *Storm Pattern*, 21; *Sunlight*, 21; *Tenage Lake, Yosemite*, 391 n27; *Waterfall Pattern*, 21; *Wind*, 21; *Windy Night*, 50
Engle Seated, *21*, 380
Engle Standing, 380
Entrance to Cellar Shelter in Monchy-le-Preux, 103, *103*
Entrance to German Dugout in Oppy Wood, 112
Entrance to Saugerties Harbour, 83, *83*
Esplen, Adam, 384 n23
etching, 151–2, 182, 189, 190; press, 188; process, 225; supplies, 330. See also drypoint prints
Evening Interior, 45, *45*
Evening on Bay Street II, 331
Exhibition of Independent Artists (1910), 48
Experimental Farm, Ottawa, 161
Experiment in Movement. See Engle, Amos W.

Fair in the Park, *346*, 348
Fairley, Barker, 291
fantasy paintings. See Milne, David: artistic methods and devices
Farbus woods, France, 103
Farm IV, 361, *363*
Farm across the River, 228
Farm Yard, 141
Fascinating Youth (film), 176
Les Fauves, 25
Ferber, Edna, *Show Boat*, 66, 223
Ferguson, Max 'Rawhide,' 359
Fifth Avenue, 40, 41, 55
Fifth Avenue, Easter Sunday, *51*, 387 n28
Fifth Avenue and the New York Public Library Lions, etching, 36–7
Figure and Trees, 122
Figure in Black, 163, *165*
Figure in Landscape, *141*, 142
Figure in the House I, 123
Figure in the House II, *124*
Figure Sketching, 145
films on Milne, 375
Finnie family, 6
Firehall, 306, *307*
First Snow, 317
First Snow on Main Street I, 319
First Snow on Main Street II, 319
First World War, 67–8, 72; battlefield subject matter, 111–12; Engle joins up, 22–3, 88; and Milne, 89, 305
Fiske, Bouldy, 175
Fiske, Minnie Maddern, 175, 192, 393 n25
Fitzgerald, Geraldine, 53, 390 n4
FitzGerald, LeMoine, 218, 220
flag designs, 338
Flag Station, *235*, 236
Flooded Prospect Shaft I, 198, *198*
Flooded Prospect Shaft II, 198, *198*, 395 n13
Floral Pattern. See Engle, Amos W.
Flour Bag, 282
Flowers and Candlesticks, *347*, 348
Flowers and Easel, 203, *203*, 204
Flowers from the Shore, 393 n39
Flowers of the Maple, 280

Ford Hotel, Toronto, 363
42nd St. Library, 39, *55*
42nd Street studio, 21–2, 35, 206
Forum Exhibition, 49
Fosbery, Ernest, 161
Fountains (Le Parc). See Cézanne, Paul
Fox Hill, 86, 121
Fox Hill, Berkshires, 86
Fox Hill on a Clear Day, 123, 168, 393 n39
Fox Hill on a Rainy Day, 392 n17
Frame and Glass, 341
Framed Etching, 232, *233*, 255
Framed Etching, drawing, *233*
France, 115; landscape, 111; painting in, 101–13, 236
Frederick A. Keppell Gallery, 30
Free Methodist Church, 319
Fresnoy, 103
From an Upper Window, Ottawa, 163
From the Cabin Door, 361
From the Painting House I, 120
Frost on the Window, 271, *271*, 396 n58
Fruit of the Tree series, 321
Fruit of the Tree I, *366*, 369
Fry, Sherry, 50
Frye, Helen, 292, 294
Frye, Northrop, 292, 294; *Here and Now* article, 353, 358
Fulton, Robert, 23
Funeral in October II, 342, *343*
Fyvie, Scotland, 7, 113

Gaddi, Taddeo, 53–4; *Madonna and Child Enthroned with Saints*, 42, *43*
Galerie Godard Lefort, Montreal, 374
Gamble's cliff, 186
Gambles' cottage, 181
The Garden, 50, 387 n27
Gatineau Hills, 160–1
Gaucher, Yves, 389 n32
Gauguin, Paul, 25, 48, 52, 295
Gaynor, William I., 39
General Electric Company, 48
Gentle Snowfall, 120, *120*
Gentle Winter, 319
Geohegan, Walter, 66
George VI, 292
German Machine Gun Posts in Thélus Cemetery, 110
Gibson, Hiram, 211
Gibson Lake, 211
Gillette, Chester E., 393 n3
ginseng root, farm crop, 211–12
Giotto, 295
Girl with a Red Cap. See Kuhn, Walt
Glackens, William, 30, 35, 50, 56, 386 n63
Glenmore Hotel, 154, 163, 170, 191, 210, 393 n3; tearoom, 172–5
Glover, Guy, 375
Godard, Mira, 375; Milne exhibition, 374
Goldthwaite, Anne, 57
Goodbye to a Teacher, 289–90, 324, 333
Goodbye to a Teacher IV, 290
Goodbye to a Teacher, drawing, 290
Gordon, Jan, 293
Gorr Portable Etching Press, Model A, 188
Gottlieb, Adolph, 25
Gowanlock school, 7, 384 n23

Grain Elevator, drypoint, 330
Grain Elevators I, 319
Les Grandes Baigneuses. See Cézanne, Paul
Grant, George Munro, *Picturesque Canada*, 9–10
Gravenstafel, Belgium, 110, 127, 143
Gray's Bakery, 311
Great Depression, 205–6, 214
'Great White Discovery' of Milne, 134
Green and Mauve, 78, *79*
Greenberg, Clement, 381, 401 n31, 402 n28
Green Car, 343
Green Cedars, 295
Green House, 60
Green Masses. See *Joe Lee's Hill*
The Green Vase, *347*, 348
Grey Owl. See Belaney, George 'Archie'
Grier, Wyly, 222
Griffiths, Corporal S.W., 92
Ground Contours, 255
Group of Seven, 165, 206, 397 n29; burial plot, 402 n23; exhibitions, 206, 218; and McMichael, 380–1; Milne on, 218–20, 266
Guelph, Ontario, 10
Guide Boat and Reflections I, 184
Guildford, Surrey, 98
The Gulf Stream. See Homer, Winslow
Gulls, 332
Gulls and Lighthouse series, 367
Gulls and Lighthouse II, 331, *332*
Gussow, Bernard, 50
Guttman, Miss (boarder), 145

Hahn, Emanuel, 265
Haines, Fred, 206
Haines Falls, New York, 18
Half and Half, 83, *84*, 85
Half Moon (ship), 23
The Half Moon at Night. See Engle, Amos W.
Haliburton, Ontario, 305–6, 317
Hamil, Mrs, 162
Harmon, Catherine, 353
Harris, Bess, 402 n23
Harris, Lawren, 206, 218–19, 402 n23
Harron, Donald, 401–2 n7
Hart House, University of Toronto, 265, 298; exhibitions, 165, 256, 337, 353, 397–8 n47; Milne's lecture at, 353; theft from, 397–8 n47
Hartley, Marsden, 26, 48, 381, 391 n1
Harvard University, 66
Hassam, Childe, 26, 29, 52, 54
Haystack, drypoint, 207
haystack series. See Monet, Claude
Hegarty, Caroline, 19, 387 n11
Hegarty, Dennis F., 18
Hegarty, Maude, 18, 47
Hegarty, May Frances. See Milne, Patsy
Hekking, William M., 221, 396 n42
Helck's Pond. See *Bishop's Pond, Boston Corners*
Henderson, Floyd, 395 n8
Hennessey, Frank, 393 n28
Henri, Robert, 14–15, 26–7, 30–1, 35, 48, 52, 56, 385 n9, 386 n63, 388 n62; *Derricks on the North River*, 31
Hepaticas, 56, *57*, 398 n86
Herbert, Jim, 188
Herbert F. Johnson Museum. See Cornell University

Here and Now magazine, 353, 354, 358
High Island, 351
The Hillock, 148, *148*
Hill Poles, 344
Hill Reflected, Bishop's Pond, 126
Hills at Seeding Time, 211, *212*
The Hills behind Kinmel Park, Snow, 93
Hill 70, Mount Kimmel, Belgium, 107
Hillside, Autumn, 168
Hilltop, drypoint. See *Painting Place* (the
 Colophon edition), drypoint
Hirshhorn, Joseph, 265
Historical Board of Canada, 381
Hitler, Adolf, 263
Hoeber, Arthur, 54
Hogg, Will, 5, 383 n9, 384 n23
Holden, John, 376, 380
Holgate, Edwin, 218, 220
Homer, Winslow, 16; *The Gulf Stream,* 16,
 385 n17
Honey Harbour, 246
Hopper, Edward, 14, 50, 381, 388 n60, 402
 n28
Horne, Cleeve, 263, 365, 398 n66, 401 n29
Horne, Jean, 263, 401 n29
Hornell, Mrs, 303
Hotel across the Way, 191
House among the Trees, 84
House at Mount Riga, drypoint, *152*
The House Is a Square Red Cloud, 213, *231,* 396
 n66
House of Commons, Ottawa, 162, 165
House of Commons, 163, *164,* 392 n12
House on the Railway, 145, *145*
Houston, Florence and Don, 246
Hubbard, Robert, 375, 378
Hudd, Frederic, 257
Hudson, Henry, 23
The Hudson from Weehawken, 387 n121
Hudson-Fulton celebrations, 23
Hudson River valley, 21
The Hula Dancer, 289, 324
Humber River, 211
Hunter, Donald, 376
Hunter, Robert, 265, 291, 295
Hyacinths in the Window, 307, *310*

Ice Melting on the Pond, 232
Ice Melts on the Pond, 232
Ilion, New York, 19
Immortality in Queen's Park, 332
Imperial Oil Ltd, 376
Impositions. See Boyle, John
impressionism, 25, 30, 54
In a Democratic Age, working title, 329
Independent Art Association, Montreal, 221
Indian Church. See Carr, Emily
In Loving Memory, 342
Interior of the Kitchen with Patsy I, 184
Interior with Table, 124
Interior: Woman Reading, 145, *145*
International Exhibition of Modern Art (1913).
 See Armory Show
International Studio magazine, 54, 60
Intersected Trees, 79, *79*
Intervale Ski Jump, 169
In the Cabin on the Mountain I, 133
In the Cabin on the Mountain II, 162–3
Inverurie, Scotland, 113

Irish Waterfall, 11
Island in the Lake, 175, *175*

Jack in the Pulpit, 56
The Jack Pine. See Thomson, Tom
Jackson, A.Y., 92, 94, 165, 206, 218–19,
 378–9, 402 n23; on Milne, 292, 293–4
Jacobi, Otto, 206
James Wilson and Company, 255
Jaques, Bertha E., 225
Jarvis, Alan, 209–10, 259, *259,* 261, 265, 277,
 287, 291, 292, 314, 356, 372, 374; burning
 of Milne's work, 294, *295*
Jesus Creek, 247
Joe Lee's Hill, 78, *79*
Joe Lee's House, 84, *85*
Johannsen, 'Jackrabbit,' 177
John, Augustus, 53, 92, 94
John Brown's Farm, drypoint, 225
Johnson, J.S., 377
Johnston, Florence and Franz, 402 n23
Jungman, Julius, 17
Jungman's drugstore, 17–18, *19*

Kandinsky, Wassily, *Concerning the Spiritual
 in Art,* 48
Kay, Mary and George, 144–5; Mary and
 washing-machine wringer, 152, 188–9
Kellogg, Spencer, 153, 222, 265
Kelly Ore Bed, 76, 120, 126, 389 n23
Kelly Ore Bed, 87, 126
Kennedy Crater, 103, 106
Kent, Rockwell, 14, 26, 48, 224, 381, 386 n68
Kettle, H.G. (Rik), 260
Kimball, Maulsby, 153, 216, 217, 221–2, 227,
 265, 292; exhibition, 396 n43; storage of
 Milne's paintings, 250, 252
Kimball, Stockton, 265, 278
King, Mackenzie, 161, 329
King Edward Hotel, Toronto, 89
King, Queen, and Jokers I, 326, *327*
*King, Queen, and Jokers IV: It's a Democratic
 Age,* 327
*King, Queen, and Jokers V: It's a Democratic
 Age,* 327
*King, Queen, and Jokers VIII: It's a Democratic
 Age,* 327
King's Printer, 163
Kingston, Ontario, 190
Kinmel Park Camp, 90–1, 92, 390 n13;
 painting at, 93–6, 97
Kinmel Park Camp: Dinner Is Served, 95, *95*
*Kinmel Park Camp: Pte Brown Writes a
 Christmas Letter,* 94–5, *94*
*Kinmel Park Camp No. 13, Looking toward Rhyl
 and the Irish Sea,* 93, 95, *95*
*Kinmel Park Camp Seen from the Old Roman
 Camp above St George,* 96
Kinmel Park Camp: The Camp at Night, 93,
 94, 386 n44
*Kinmel Park Camp: The Middle Section of the
 Camp from the Hills above Kinmel Hall,* 93,
 96
Kinmount, Ontario, 360
Kinne, Romaine, 154, 169–70
Kitchen, 309, *309*
Kitchen Chimney, 230, *230,* 232
Kleinburg, Ontario, 380

Knickerbocker Chocolate Company, 47
Knoedler Galleries, 60
Koepke family, 6
Konody, Paul G., 92–3, 97; 'A Private's
 Drawings' in *Canadian Daily Record,* 96
Krieghoff, Cornelius, 397 n29
Kroll, Leon, 206
Kuhn, Walt, 30, 35, 49–50; *Girl with a Red
 Cap,* 56

Lady Evelyn Hotel, Temagami, 195
Lady of Leisure, 42, *42*
Laing, Arthur R., 254–5, *256,* 257–8, 292, 373,
 397 n29
Laing, G. Blair, 291, 372, 373, 397 nn29, 38;
 CFRB radio interview, 389 n22; sale of the
 Masseys' Milne paintings, 373
Laing Galleries. See Laing, G. Blair
Lake of Bays, 293, 302–3
Lake Placid, 127, 166, 168, 176–9, 348;
 painting subjects, 178; tea-house at
 Intervale Ski Jump, 169, *176;* winter
 painting, 180
Lake Placid Club, 162, 169, 176
Lake Placid, Winter Sunset, drypoint, 210
Lalanne, Maxime, *A Treatise on Etching,* 188
Landay, Maurice, 35, 70
Landay record stores, 72
A Landing among Rocks, 184
Landseer, Sir Edwin, 6
Lanterns and Snowshoes, 157, *158*
Large Tree, 62
La Salute: Dawn. See Whistler, J.A.M.
Las Maniñas (The Maids of Honour). See
 Velazquez, Diego
Laurvick, J. Nilsen, 28
La Valle Lake, 350
Lawson, Ernest, 30, 206, 386 n63, 387 n83
Leaning Gate, 141
Leaves in the Wind II, 367
Lee, Joe, 70–1, 114
Lee Pond Brook, 131
Lemon Lilies, 320, *321,* 326, 330, 331, 346
Lennox, Erma, 260
Lens, France, 105, 107
Leonia, New Jersey, 192
Lewis, Wyndham, 48, 92, 94, 400 n45,
 400–1 n49; *Crucifixion,* 336, 400 n45;
 on Milne, 338
libraries: Big Chute, 263; Lake Placid, 176;
 Toronto Central Reference Library, 320;
 Uxbridge, 312
Library Interior, 39
Liévin, France, 107
Light (initially *Fair Weather*), drawing, 229
Lighted Lamp, 286, 287
Lighted Streets series, 366
Lighted Streets I, 364
Lightning, 272, 273
Lindsay, Ontario, 349
Lines of Earth, drypoint, 225, *225*
Lipstick III, 365
Lismer, Arthur, 218–19, 291, 293, 402 n23;
 September Gale, 220
Lismer, Esther, 402 n23
lithographic prints, 62–3
Little Figures, 50, 52, 387 n28
Little Galleries of the Photo-Secession. See
 291 Gallery

Little Reflections, Dart's Lake, 142, *144*
Little Spruce Tree series, 185
Little Spruce Tree, drypoint, 190
Lochhead, Douglas, 379
London, England, 90, 115
London (England) *Morning Chronicle*
 newspaper, 92
London (England) *Observer* newspaper, 292
Longstaff, Walter, 395 n23
Longstaff Pump Works, 207
Looking toward Lake Placid, 393 n27
*Looking toward Thélus and Thélus Wood from a
 Nissen Hut under the Nine Elms*, 106
Loos, France, 107
Los Alamos, New Mexico, 287
Louis, Morris, 401 n31
Luks, George, 30, 48, 49, 128, 386 n63
Lyndhurst, New Jersey, 18

McAgy, Douglas, 265
MacAllister, Charles, 369
Macbeth Galleries, 26, 128
McCallum, James, 216
McCarthy, Pearl, 254, 291, 294
McCormick, William B., 56
MacCullough, Norah, 260
McCurry, H.O., 206, 218, 220, 221, 255, 292,
 293, 372; letter to Blodwen Davies, 373;
 letters from Palgrave, 236; and Milne's
 eyes, 216; National Gallery controversy,
 222; National Gallery purchase of Milne's
 work, 338; negotiations with, 159; purchase
 recommendation to National Gallery, 162;
 visit to Port Hope, 252
McCurry, Mrs H.O., 393 n39
MacDonald, J.E.H., 165, 206, 218–19; *The
 Solemn Land*, 220
MacDonald, J.W.G. 'Jock,' 353
McEnery, Kathleen, 56
McGillivray, Frank H., 393 n28
McGregor, Margaret, 384 nn29, 46
McHench, Andrew, 34, 35, 38, 45, 52, 217,
 380, 387 n3
McInnes, Graham, 255, 264–5, 280, 285, 288,
 291, 292, 356, 398 n87; and National Film
 Board, 338, 375
McKague, Yvonne, 394 n2
MacKenzie, Mac, 292
McLean, J.S., 293, 294, 371–2
Maclean Hunter Ltd, 376
MacLeod, Pegi Nicol, 260
McMichael, Robert, 380, 402 nn23, 26; and
 purchase from Clarke, 380–1
McMichael, Signe, 402 n23
McMichael Canadian Art Collection, 374;
 cemetery plot, 402 n23
MacNamara, Gordon, 260, 371, 377–8, 379,
 402 n19
MacPherson, Duncan, 401 n23
McVicar, Dorothy, 298, 313, 317, 359, 371
McVicar, George, 298, 313, 317, 356, 367, 371,
 374
Madison Gallery, 49
Madison Square Gardens, 36
Madison Square: Spring, etching, 36, *38*
Madonna and Child, 42, 54
Madonna and Child Enthroned with Saints. See
 Gaddi, Taddeo
Main Street, drypoint, 329–30

Main Street subjects, 329
Manchester Guardian newspaper, 292
Maratta, Hardesty, 388 n62
Marble House, 55
*Margaret's Picture of Wimpy and the Birthday
 Cake*, 281, *282*, 289, 310
Marin, John, 26, 36, 49, 52, 56, 68, 381, 402
 n28; *Weehawken Series*, 36, *36*
Mark, Carson, 287, 295, 296, 297–8, 305, 311,
 314
Mark, Kay, 287, 295, 297–8, 311, 314
Martin, Florence, 175, 301, 304, 399 nn54, 55;
 storage of Milne's paintings, 193, 250, 379
Mary and Martha, 325, 340, 342, 343
Mary and Martha III, 343
Mary and Martha IV, 343
Massey, Alice, 205, 261; and creative process,
 283; Milne's correspondence with, 288,
 291; and multiple versions of paintings,
 339–40; purchase of Milne paintings, 252,
 256–7
Massey, Alice and Vincent, 3, 39, 79, 221,
 250–1, 261, 266, 271, 292; and agreements
 with Milne, 255–9; Milne's correspondence
 with, 229, *250*, *251*, 379; 'Picture Account,'
 253
Massey, Hart, 252
Massey, Lionel, 252, 253, 372
Massey, Vincent: bequest to National Gallery,
 374; financial commitment to Milne, 372–
 3; papers, 379; sale of Milne paintings,
 372–3
Massey College, 379
The Mass in the Forest, 325
Massive Design, 61–2, *63*
Matisse, Henri, 26, 28, 34, 35, 48, 215, 221,
 295; Montross Gallery exhibition (1915), 53;
 The Red Studio, 49, 52
Matson, Dave, 215
Matson, Ollie, 213, 226, 231, 395 n8; paintings
 of his house, 241
Maugham, W. Somerset, *The Magician*, 221
Maurer, Alfred, 26, 68
Mayer, Onesime, 247
Meadowbrook estate, 70, 82, 85, 388 n37, 389
 n33
Meier-Graefe, *Vincent van Gogh*, 260
Meister, Alfred, 162, 392 n17, 393 n28
Mellors, Robert, 254–5, 261, 292, 397 n29
Mellors Galleries, 292–3, 386 n67, 397 n29;
 exhibition catalogue, *254*, 273; exhibitions,
 284, 287, 291; and Milne paintings, 253–9,
 373
Mellow, Dr, 356
Melting Snow, *151*
Menin Road, France, 114
Messines, Belgium, 107, 112
Metcalf, Willard, 29
Metropolitan magazine, 25
Metropolitan Museum of Art, 26, 36, 42, 148
Metropolitan Toronto and Region Conserva-
 tion Authority Foundation, 380
Midjo, Christian, *142*, 143, 153, 154, 162, 164,
 392 n28
Miles, Mr, 130
Miller, Miss, 46
Millerton, Ontario, 144, 152, 154, 155, 159
Milne, Arthur (brother), 4, 383 n5
Milne, Charles (Charlie) (brother), 4, 8, 9, 13,
 383 n5

Milne, David, 7, 9, *9*, 10, 24–5; aesthetic
 continuity, 324; aesthetic goals, 127, 142;
 aesthetic issues, 142, 237, 273, 345;
 aesthetic issues during Palgrave years, 227,
 231, 232; aesthetic issues in *Pool and
 Contours*, 127; anti-semitism of, 13–14;
 artistic methods and devices (see sub-entry
 below); autobiography, 347–8; beaver
 article, 143; birth, 3, 383 n15; Boston
 Corners work, 75–88, 118; Boyle portrait,
 381; burning of work, 294; and business,
 154, 157–8, 160; Christian vision, 204;
 Clarke friendship ends, 354–5; colours and
 values (see sub-entry below); commercial
 work, 23–4, 34; correspondence with
 Clarke, 100, 119, 124, 131, 158, 166, 178–9,
 185–6; as critic, 216–17, 218–19; critical
 reviews, 28, 49, 54–7, 60–1, 165, 254,
 293–4; death, 370; death, theme of, 348;
 depressions, 274–5, 280, 316; discussing
 paintings (1919–20), 119; early years, 3–11,
 6, 383–4 n20, 384 n29; essays, 340, 353;
 estate, 372; etchings of 1911, 30; exhibi-
 tions (see sub-entry below); and First
 World War, 89–90, 101–15; funeral, 371;
 health, 67, 115, 215–16, 247, 349, 356–7,
 361, 362–3, 369–70, 393 n10, 395 n20; as
 illustrator, 23–4; influence of Cézanne, 49;
 influence of Egyptian artifacts, 148–9;
 influence of McHench, 81; influence of
 Marin, 36, 49; influence of Matisse, 49;
 influence of Monet, 27–8, 36, 39, 49;
 influence of primitive and Oriental art, 38;
 letters and copyright, 378; letter writing,
 292; marriage, 130–2, 168, 195, 214, 216,
 242–4; and Patsy Milne, 17–20, 34, 45–7,
 153, 158, 161, 162, 166, 192, 254–5, 297,
 299–305; money, 70, 72, 130–1, 138, 165–
 6, 167–8, 359–60; money problems and
 approach to dealers (1920), 128; money
 problems and Duncan, 337, 356, 357;
 money problems during Great Depression,
 214–15, 249–50; money problems in New
 York, 385 n8; money problems in Ottawa,
 160; money problems during Uxbridge
 years, 316; as nationalist, 206, 329; in New
 York, 12; numbering paintings, 145, 155;
 106 West 61st Street apartment, 48, 390
 n4; onion farming, 119, 138; painting
 notes, 118, 133, 145, 149–51, 178; painting
 outfit, *261*; and Kathleen Pavey, 295–9,
 305–6; personal challenges, 185; personali-
 ty change, 360; his photograph of Dart's
 Lake, *144*; photographs of (see sub-entry
 below); reputation of, 347; sale of work, 35,
 52, 54, 78, 153–4, 165, 221, 252–3, 256,
 293, 294, 316, 373, 393 n27, 397 n42; self-
 portraits, *115*, *226*, 271–2, *271*, 396 n58;
 separation agreement, 242–3; showcard
 business, 13, 20, 35, 45, 63, 72, 73; signing
 and dating of work, 78, 118, 255, 340; sign
 painting, 173; 'Spring Fever' in *Canadian
 Art* magazine, 273–4; stationery for Boston
 Corners, 73; stolen pictures, 402 n27;
 studio of Milne and Engle, 20; subjects of,
 37, 75–6, 136, 196, 197, 266; as war artist,
 91–4, 101–15; war paintings, aesthetic
 issues of, 115; wills, 89, 371, 398 n73;
 works (see sub-entry below); writing style,
 218, 292

- artistic methods and devices: browsing pictures, 328; camouflage, 82; composition, 33–4, 79, 98, 141–2; conventions, 122–3, 135, 191; dazzle spot, 197–8, 210, 217, 229–30, 232, 250, 341; devices, 79, 134, 197, 309; direct painting, 269–70, 321, 343; divided pictures, 99; economy of means, 98, 236; fantasy paintings, 204, 280, 281, 307, 310, 321, 323, 324, 343, 368–9; flower paintings, 200–3, 231–2, 319–20; foil (visual resting place), 197, 250; hellish colour, 306–7, 309; indirect subjects, 335; interrupted vision motif, 79, 81, 93, 250, 268, 341; inventory method of painting, 141, 204; line and shape motif, 45, 79, 84–5, 121, 134, 140–1, 165, 198, 217–18, 231, 238–40, 319, 358; media, 29; memory pictures, 267, 272; mine-shaft paintings, 197–8; natural seeing, 34, 81; open-and-shut spaces, 250, 266; outlines, black and coloured, 267; progression, principle of, 285–6; reflection pictures, 127–8; religious painting, 321; repainting inside, 269–71, 343; Scotch motive, 98; serenity motif, 234; still-life painting, aesthetic issues of, 272–3; studio subjects, 335; style, 31, 38, 112, 118, 200; subject paintings, 321, 323, 337; symbols, 326; technique, 30, 32, 36–7, 43, 62, 64, 145, 149, 240; technique, dry-brush, 126, 140; technique, oil painting, 81–4, 136; technique, watercolour, 67–8, 98, 112, 319; texture, 64, 82, 217, 395 n26; woodcarving, 174
- colours and values, 29, 31–2, 38, 41, 43–5, 58–9, 63, 81–2, 85–6, 122, 145–6, 198, 284, 344, 395 n26; black, 134, 155–6, 180, 199, 204, 232, 268, 275–6; black and white, 136, 235, 307; black cores and green halos, 61–2, 67, 127, 217; blue, 236, 267, 278–9, 289, 320; blue-gray, 208, 361, 364, 369; brown, 156, 208, 326; gray, 98, 156–7, 180, 183–4, 191, 230, 268, 289, 366, 389 n32; green wash, 331; orange-gray, 361, 364, 369; reds, 43–4, 236, 267, 278–9, 289, 320, 326; value system, 140, 157, 180, 183–4, 197–8, 226, 229, 232, 234–6, 250, 266–7, 278; verdigris wash, 331, 332; violet, 306; washes, 366; white, 121–3, 134–6, 180, 199, 232, 268; yellow-beige wash, 326; yellow-ochre wash, 321; yellow wash, 330, 346
- exhibitions: American Water Color Society, 28, 49, 55; Anderson Galleries, 94; Armory Show catalogue, 50; Canadian War Memorial paintings, 94; Cornell University, 153, 158, 162, 374; Mellors Galleries, 253–5; Mira Godard (1982), 374; Montreal Museum of Fine Arts, 164–6; National Academy of Design, 53; National Gallery of Canada (1995), 391 n56; New York Water Color Club, 49, 54; 106 West 61st Street apartment, 53, 389 n74; Panama-Pacific International Exposition, 53; Pennsylvania Academy of the Fine Arts, 49; Philadelphia Water Color Club, 49; University Art Association, 265; War Records Office, 115–16. See also Armory Show
- photographs of, 313, 314, 315, 355; Alander, 135; Boston Corners, 71, 72, 74, 75; Dart's Lake, 142; First World War, 88, 90, 91; New York, 20, 22; Six Mile Lake, 257, 259, 285, 289; Uxbridge, 312, 313, 314, 315; as young man, 12
- works: Across the Bay in Spring, 289; Across the Lake, 38, 140, 143, 190, 392 n12; Across the Lake I, 97, 142, 144, 162, 184, 361; Across the Lake, drypoint, 190, 207; Across the Still Lake, 392 n12; After Heavy Soft Snow, 124; Afternoon, Kelly Ore Bed, 122; Afternoon Light II, 86; After Sunset, 357; Alcove, 52; Alder Branch, 268, 268; Allan Gardens, 309; Allan Gardens Drawing, 308; Another Generation, 366, 369; Apple Blossoms, 38, 38; Ascension series, 321, 323, 325, 333, 335, 341, 343, 346, 348; Ascension I, 336; Ascension XI, 336; Ascension XV, 337; Ascension XXI, 337; Ascension XXXIII, 346; Attic, 191; Autumnal Tints, 21; Autumn Tints, 31, 32; Back Porch, the White Post, 81, 81; Back Porch, the White Post, drawing, 81; Bag of Sugar, 270, 270, 283, 283; Bare Rock Begins to Show, 275, 276; Barge, 64; Barns, 238, 238, 239, 286; Barns, drawing, 239; Barns, drypoint, 225, 239, 239; Bath House, 31, 32; Battery Park, 59, 59; Bear Camp, 361, 392 n12; Bear Camp series, 38; Bear Camp I, 362; Bear Camp II, 362; Bear Camp V, 362; Bear Camp VII, 362; The Belfry, Hôtel de Ville, Arras, 115; Bellevue Spur and Passchendaele from Gravenstafel, 110, 111; The Big Dipper, 272; Billboards, 40, 41, 44, 374; Bishop's Pond in Sunlight, 127; Black, 44, 44, 61, 380; Black and Green, 55, 388 n63; Black and White I, 39, 39, 54, 55; Black and White II, 39, 39, 54, 55, 387 n10; Black and White, 1935, 265, 266; The Black Cabinet, 155, 156; Black Cedars, 123, 168; Black Cores, 62, 63; The Black Couch, 58–9, 58; Black Hills, 86; Black House I, 180, 181; Black House II, 181; Black Reflections, Bishop's Pond, 126, 126; Black Waterfall, 136; Blind Road, drypoint, 225, 225, 396 n61 (as Tovell 61); Blind Road, Plowed Ground, 211, 212, 217; Blonde Rocks, 36, 37; Blossoming Tree, 38; The 'Blowhole' Trail, 391 n34; Blue Bay, 367, 369; The Blue Dragon Tabletop, 155; Blue-Green, Black-Green, 48, 53; Blue Sky, Palgrave, drypoint, 225; Body of the Earth, drypoint, 396 n61; Boston Corners, 87, 339, 374; Boston Corners and Fox Hill, 86; Boston Corners in January, 123; The Boulder, 82; Boulders in the Bush, 191; Box on the Porch, 184; Bramshott from the Beacons, 99, 99; Bramshott: Interior of the Wesleyan Hut, 99, 100; Bramshott: The London-Portsmouth Road, 99, 101; Breakfast with Flowers, 288; Brewery at Night, 307, 309; Brick House and Stormy Sky I, 213; Brick House and Stormy Sky II, 213; Brilliant Pattern, 59, 59; Bronx Hillside in Spring, 38, 62; Bronx Park, 42, 43–4, 57; Bronx Pattern, 79; Brook in the Sugar Bush, 286, 289; Brown Hillside Reflected, 156, 157; Burnt Tree, 168; Cabin at Night, version of, 285; Cabin at Night II, 285, 287; Cabin Shelves, 274, 276; Camouflaged Steel Observation Post on the Souchez-Arras Road, 110; Canadian Flag Designs I, 338; Canadian Flag Designs IX, 339; Canadian Flag Designs X, 339; Canadian Garden, 60, 387 n27; Candy Basket, 344; Candy Box, 261, 291; Canopy Bed, 306; Carnival Dress, 165, 167; Cartons and Flour Bag, drypoint, 398 n125; The Catskills, 87; Cedar Swamp, 331; Chickens on Lace, 307; Chimney on Wallace Street, 230; Chocolates and Flowers, 307; Christ in the Wilderness (see The Saint); City Lights II, 364; Claremont Inn, Riverside Park, etching, 36; Clarke's House after Snow, 146, 147; Clarke's House, Late Afternoon, 156, 157; Classon Point Road, 28; The Clearing above Boston Corners, 122; The Cleremont (probably Claremont Inn), 55; Cloud Curtain, 236; Clouds at the Horizon, 230; Clouds over the Village, 232, 236; Coal, 309; The Cold and Rain Grip Hiram's Farm, 213, 232; Coloured Spaghetti, 84; Columbus Circle, 50, 53, 387 n27, 388 n34; Contours and Elm Trees, 252; Corner of the Etching Table, 208, 210; Corner of the House II, 147–8, 147, 151, 183, 196, 208, 269, 270; Corner of the Porch, Dart's Camp, 141–2, 143; Cosmopolitan Magazine poster, 23; Cottage after Snowfall, 179; Cottage after Snowfall I, 179, 182; Courcelette from the Cemetery, 108, 108; Cracks in the New Ice, 288, 289; Cracks in the New Ice, drawing, 288; The Cross Chute, 291; Crystals on the Snow, 392 n12; The Curtains, 157; Dark Hills and Glowing Maple, 232, 234, 234, 396 n68; Dark Shore Reflected, Bishop's Pond, 126, 127; David Bell's Cow, 10, 10; Day of Judgment II, 333, 335; Day of Judgment VI, 334; The Defiant Maple, 28, 33–4; Distorted Tree, 50, 50, 52–3, 387 n28; Dominion Square I, 165; Doorway of the Painting House, Alander, 134; Dove, 7; Drawing Made at Boston Corners, 84; Drawing Made near the Catskill Mountains, 84; Drift on the Stump, 134, 135; Drying Waterfall, 79, 80; Duck and Flowers, 335; Dutch Woman with Clogs, 11, 11; Early Morning, 179; Earth, Sky, and Water I, 342; Eaton's College Street, 331; E.B. Eddy Mill, Hull, 163; Edam Cheese, 284, 285; Eggs and Milk, 309, 309; Ellis Island, etching, 36, 37–8; Elm Logs, 348; Embankment and Bridge, 386 n58; Embassy Club, 307; Engle Seated, 21, 380; Engle Standing, 380; Entrance to Cellar Shelter in Monchy-le-Preux, 103, 103; Entrance to German Dugout in Oppy Wood, 112; Entrance to Saugerties Harbour, 83, 83; Evening Interior, 45, 45; Evening on Bay Street II, 331; Fair in the Park, 346, 348; Farm IV, 361, 363; Farm across the River, 228; Farm Yard, 141; Fifth Avenue, 40, 41, 55; Fifth Avenue and the New York Public Library Lions, etching, 36–7; Fifth Avenue, Easter Sunday, 51, 387 n28; Figure and Trees, 122; Figure in Black, 163, 165; Figure in Landscape, 141, 142; Figure in the House I, 123; Figure in the House II, 124; Figure Sketching, 145; Firehall, 306, 307; First Snow, 317; First Snow on Main Street I, 319; First Snow on Main Street II, 319; Flag Station, 235, 236; Flooded Prospect Shaft I, 198, 198; Flooded Prospect Shaft II, 198, 198, 395 n13; Flour Bag, 282; Flowers and Candlesticks, 347, 348; Flowers and Easel, 203, 203, 204; Flowers from the Shore, 393 n39; Flowers of the Maple, 280; 42nd St. Library, 39, 55; Fox Hill, Berkshires, 86; Fox Hill on a Clear Day, 123, 168, 393 n39; Fox Hill on a Rainy Day, 392 n17; Frame and Glass, 341; Framed

Milne, David: works (*continued*)
Etching, 232, 233, 255; *Framed Etching*, drawing, *233*; *Free Methodist Church*, 319; *Fresnoy*, 103; *From an Upper Window, Ottawa*, 163; *From the Cabin Door*, 361; *From the Painting House I*, 120; *Frost on the Window*, 271, *271*, 396 n58; *Fruit of the Tree I*, *366*, 369; *Funeral in October II*, 342, *343*; *The Garden*, 50, 387 n27; *Gentle Snowfall*, 120, *120*; *Gentle Winter*, 319; *German Machine Gun Posts in Thélus Cemetery*, *110*; *Goodbye to a Teacher*, 289–90, 324, 333; *Goodbye to a Teacher IV*, 290; *Goodbye to a Teacher*, drawing, *290*; *Grain Elevator*, drypoint, 330; *Grain Elevators I*, 319; *Green and Black Tree Shapes*, 81; *Green and Mauve*, 78, 79, 81; *Green Car*, 343; *Green Cedars*, 295; *Green House*, 60; *Green Masses* (see *Joe Lee's Hill*); *The Green Vase*, 347, *348*; *Ground Contours*, 255; *Guide Boat and Reflections I*, 184; *Gulls*, 332; *Gulls and Lighthouse*, 331; *Gulls and Lighthouse* series, 367; *Gulls and Lighthouse II*, 332; *Half and Half*, 83, 84, 85; *Harlem Rocks*, 36, *36*; *Haystack*, drypoint, 207; *Hepaticas*, 56, 57, 398 n86; *High Island*, *351*; *The Hillock*, 148, *148*; *Hill Poles*, 344; *Hill Reflected, Bishop's Pond*, 126; *Hills at Seeding Time*, 211, *212*; *The Hills behind Kinmel Park, Snow*, 93; *Hillside, Autumn*, 168; *Hilltop* (see *Painting Place* [the *Colophon* edition]); *Hotel across the Way*, 191; *House among the Trees*, 84; *House at Mount Riga*, drypoint, *152*; *The House Is a Square Red Cloud*, 213, *231*, 396 n66; *House of Commons*, 163, *164*, 392 n12; *House on the Railway*, 145, *145*; *The Hudson from Weehawken*, 387 n21; *The Hula Dancer*, 289, 324; *Hyacinths in the Window*, 307, *310*; *Ice Melting on the Pond*, 232; *Ice Melts on the Pond*, 232; *Immortality in Queen's Park*, 332; *In a Democratic Age*, working title, 329; *In Loving Memory*, 342; *Interior of the Kitchen with Patsy I*, 184; *Interior with Table*, *124*; *Interior: Woman Reading*, 145, *145*; *Intersected Trees*, 79, *79*; *In the Bronx*, 79; *In the Cabin on the Mountain I*, *133*; *In the Cabin on the Mountain II*, 162–3; *Irish Waterfall*, 11, *11*; *Island in the Lake*, 175, *175*; *Jack in the Pulpit*, 56; *Joe Lee's Hill*, 78, 79, 81; *Joe Lee's House*, 84, 85; *John Brown's Farm*, drypoint, 225; *Kelly Ore Bed*, 87, 126; *King, Queen, and Jokers I*, 326, *327*; *King, Queen, and Jokers IV: It's a Democratic Age*, 327; *King, Queen, and Jokers V: It's a Democratic Age*, 327; *King, Queen, and Jokers VIII: It's a Democratic Age*, 327; *Kinmel Park Camp: Dinner Is Served*, 95, *95*; *Kinmel Park Camp No. 13, Looking toward Rhyl and the Irish Sea*, 93, 95, *95*; *Kinmel Park Camp: Pte Brown Writes a Christmas Letter*, 94–5, *94*; *Kinmel Park Camp Seen from the Old Roman Camp above St George*, 96; *Kinmel Park Camp: The Camp at Night*, 93, 94, 386 n44; *Kinmel Park Camp: The Middle Section of the Camp from the Hills above Kinmel Hall*, 93, 96; *Kitchen*, 309, *309*; *Kitchen Chimney*, 230, *230*, 232; *Lady of Leisure*, 42, *42*; *Lake Placid, Winter Sunset*, drypoint, 210; *A Landing among Rocks*, 184; *Lanterns and Snowshoes*, 157, *158*; *Large Tree*, 62; *Leaning*

Gate, 141; *Leaves in the Wind II*, 367; *Lemon Lilies*, 320, *321*, 326, 330, 331, 346; *Library Interior*, 39; *Light* (initially *Fair Weather*), drawing, *229*; *Lighted Lamp*, 286, 287; *Lighted Streets* series, 366; *Lighted Streets I*, 364; *Lightning*, 272, *273*; *Lines of Earth*, drypoint, 225, *225*; *Lipstick III*, 365; *Little Figures*, 50, 52, 387 n28; *Little Reflections, Dart's Lake*, 142, *144*; *Little Spruce Tree*, drypoint, 190; *Little Spruce Tree* series, 185; *Looking toward Lake Placid*, 393 n27; *Looking toward Thélus and Thélus Wood from a Nissen Hut under the Nine Elms*, 106; *Madison Square Gardens*, etching, 36; *Madison Square: Spring*, etching, 36, *38*; *Madonna and Child*, 42, 54; *Main Street*, drypoint, 329–30; *Marble House*, 55; *Margaret's Picture of Wimpy and the Birthday Cake*, 281, 282, 289, 310; *Mary and Martha*, 325, 340, 342, *343*; *Mary and Martha III*, *343*; *Mary and Martha IV*, 343; *The Mass in the Forest*, 325; *Massive Design*, 61–2, *63*; *Melting Snow*, *151*; *Mirror*, detail, *154*, 396 n58; *Molson Cottage*, 388 n59; *Monkey and Tiger Lilies*, 343; *Mountain Road*, 149; *The Mountains*, 168; *Nasturtiums and Carton*, 236, 280, 284; *Nasturtiums and Carton II*, 278, *278*, 279; *Neuville-St-Vaast from the Poppy Fields*, 106; *New England House*, 151, 208; *New Shelf*, 280; *New York Girders*, 23, *23*; *New York Street*, 39, *39*; *Night on Dundas Street*, 307; *Noah and the Ark*, 310, 332, 340; *Noah and the Ark* series, 321; *Noah and the Ark and Mount Ararat I*, 328, *328*; *Noah and the Ark and Mount Ararat III*, *328*; *Noah and the Ark and Mount Ararat IV*, 328; *Noah and the Ark and Mount Ararat V*, 328; *Noah's Ark*, 325; *North Elba*, drypoint, 190; *North Elba (fourth version)*, drypoint, *191*; *Northern Lights*, 272, *273*; *Northern Lights*, drawing, 272; *Northern Village*, 196–7, *197*; *Of Men and Angels*, 366; *Old RCMP Barracks*, 168; *Old RCMP Barracks II*, 163, *163*; *Ollie Matson's House in Snow*, 213, 252; *Ollie Matson's House Is Just a Square Red Cloud*, 231; *106th St. Apartment*, 64; *On Vimy Ridge Looking over Givenchy to the Lens-Arras Road and Avion*, 103, *103*; *Open Door, 1947*, 347, *348*; *Opus 3*, 17; *Orchard in the Brown Valley*, 145; *Ore Bed Pool*, 145; *Our House and the Neighbours', Uxbridge*, 319; *Outlet of the Lake*, 191; *Outlet of the Pond*, 184, 319; *Outlet of the Pond* series, 179, 346; *Outlet of the Pond I*, 141; *Outlet of the Pond*, drypoint, 225, *225*, 319; *Outlet of the Pond, Morning*, *183*; *Painting Place*, 179, 184, 188, 189, 190, 207, 208, 292; *Painting Place I*, *1*, 186, *187*; *Painting Place II*, *187*, 208; *Painting Place III*, *187*, 208, 209, *209*, 291, *375*; *Painting Place*, drawing, *187*; *Painting Place* (the *Colophon* edition) (also known as *Hilltop*), drypoint, ii, 189, 223–4, 227, 394 n69, 396 n51; *Painting Place* (large plate), drypoint, 190, 207; *Painting Place* (small plate), drypoint, i, 188, 189, 190; *Painting Place: Brown and Black*, *187*; *Palgrave, 1939*, 306; *Panorama of Lorette Ridge*, 112, *112*; *Panorama of Ypres from the Ramparts*, 105; *The Pantry*, 45, *45*, 387 n8; *Paper Bag*, in *Canadian Forum* magazine, 255; *Paracutin IV*, *366*, 368–9;

Park Plaza, 332; *Parliament Buildings*, 307, *309*; *Parliament Buildings at Queen's Park*, 307; *Parliament Hill from Hull*, 163, *164*; *Patsy Seated*, etching, 34; *Penguin and Nasturtiums I*, 343, *344*; *Picture on the Blackboard*, 281, 282, 289, 310, 324; *Pier on the Hudson*, 13; *Pink Flowers*, 386 n79; *Pink House in Snow*, 60; *Pink Reflections, Bishop's Pond*, 125, *126*; *Pink Rock*, 140; *The Plaza Hotel*, etching, 36; *Points and Full Curves*, 54; *Point with Flag Pole*, 142, *143*; *The Pole Line*, 287, *288*; *The Pond*, drypoint, 190; *Pond, Low Water*, *142*; *Pool and Birches*, 82, 86; *Pool and Contours*, 126–7, *129*, 168; *Pool and Posts*, 168, 393 n39; *Pool in the Rocks*, 267; *The Pool, Little Bob Lake II*, 346, *346*; *Poppies*, 319, *320*; *Poppies and Glass*, 320; *Poppies and Lilies*, 333, *344*; *Poppies and Lilies III*, 322; *Poppies and Nasturtiums*, 320, *321*; *Poppies in a Paper*, 333; *Poppies in a Tin Can*, 320; *Porch Post*, 81; *Portraits from a Catalogue*, 333; *Posing*, 60, *60*, 388 n59; *Power Lines, Lake Placid*, drypoint, 190; *Prints*, 329, 330; *Profile of a Man in a Straw Hat*, 4; *Projecting Tree, Dart's Lake*, 140, 141, *141*; *Prospect Shaft*, drypoint, 199, 225; *The Pump*, 207, *208*; *Queen's Hotel*, drypoint, 225, 240; *Queen's Hotel, Palgrave*, 239, *241*, 286; *Queen's Hotel, Palgrave*, drawing, *240*; *Quiet River*, 361, *361*, 362; *Radio*, 344; *Radio with Tulips*, 345; *Ragged Shape*, 54; *Raspberry Jam*, 278, *279*, 282; *Reading*, 43; *Reading in the Cabin*, 297; *Reclining Figure*, 50, 387 n27; *Red*, 44, *44*, 52, 58–9, 61, *61*; *Red Church IV*, *318*, 319; *Red Dishes*, 298; *Red Dress II*, *296*; *Red Elevator and Blue Sky*, 226, 396 n58; *Red Lily*, 287, 289; *Red Plate*, 298; *Red Trees*, 59; *Reflected Forms*, 85, *86*; *Reflected Pattern I*, 163; *Reflected Pattern II*, 163; *Reflections II*, 83; *Reflections at Dart's Lake I*, *143*; *Reflections at Dart's Lake I*, drawing, *143*; *Reflections at Dart's Lake II*, *146*; *Reflections, Bishop's Pond*, 126; *Relaxation*, 82, 83, 380; *Resurrection* series, 321; *Resurrection III*, 333; *Resurrection Day*, 333, *335*; *Return from the Voyage*, 325, 366; *Return from the Voyage* series, 321; *Return from the Voyage II*, 335; *Return from the Voyage III*, 335; *Return from the Voyage IV*, 335; *Riches, the Flooded Shaft*, 199, *200*; *R.I.P.*, 342; *Ripon: High Street*, 97, 98; *Ripon in March*, 96, *97*; *Ripon: South Camp from General Headquarters*, 96, 98; *Ripon: The Town and South Camp from the Cathedral Towers*, 98; *Rites of Autumn*, 339; *Rites of Autumn I*, 335; *Rites of Autumn II*, 335; *Riverside Park*, 36; *The Road to Passchendaele*, 109–10, *109*; *Road to the Church*, 84; *Rock Pool*, 267, *267*; *Rocks in Spring*, 150, 151, 196; *The Roller Skater*, 55; *Roofs, Glenmore Hotel*, 210; *Roofs, Glenmore Hotel*, drypoint, 210; *Rooftops*, 213; *Rowboat on Shore I*, 267–8, *268*, 393 n39; *Row of Trees, Mount Riga*, 145, *146*; *Row of Trees, Mount Riga*, drawing, *146*; *The Saint*, 310, 330, 331, 332, 341; *The Saint III*, *331*; *St Lawrence*, 42, *43*, 54; *St Michael's Cathedral*, 333; *St Michael's Cathedral II*, 308; *St Michael's Cathedral*, drypoint, 333; *Salesmanship*, 366; *Salmon Can*, 277, *278*;

Saranac Hills series, 179; *Scaffolding* series, 346; *Scaffolding I*, 346; *Scaffolding VII*, 346; *Seaford: North Camp in a May Snowstorm*, 100; *Seated Figure, 121; Serenity*, 213, 228, 230; *Serenity*, drawing, *229; Shell Holes and Wire at the Old German Line, Vimy Ridge*, 103, *104; Shelter at Night I,* 357, *357; Shore Clearing,* 369; *Shrine and Saints*, 331, 341; *Shrine and Saints II*, 332, *333; Signs and Symbols*, 335; *Sizes and Colours*, 333; *Sketches from the Abstract*, 366; *Ski-Jump Hills with Radiating Clouds*, 180; *Ski Jump, Lake Placid*, drypoint, 190; *Sleeping Woman*, 46, 387 n27; *Snow-Covered Boulder*, 393 n27; *Snowfall, from the Painting House*, 123; *Snow from the North*, 319; *Snow in Bethlehem*, 323, 325, 336, 340; *Snow in Bethlehem II*, 323, 324; *Snow Patches*, 86; *Snow Shadows*, 55; *Soft Textures*, 84; *Sparkle of Glass*, 179, 184, 186, *186; Spider Bridge II*, 360, *360*, 361; *Spider Bridge III*, 360, *360*, 361; *Splendour Touches Hiram's Farm*, 211, *213*, 232, 236; *Spring across the Way*, 343; *Spring Comes to the Bay*, 289; *Spring Foliage*, 36, *37; Spuyten Duyvil Pastel*, 30, *30; Stars over Bay Street*, 306, 307, *307*, 319, 327, 328, 331, 332; *Stars over Bay Street, 1939*, 306, *307; Stars over Bay Street, 1941*, 307; *Stars over Bay Street*, drypoint, 306, 333; *Still Water*, 140, 319, 346; *Still Water and Fish*, drypoint, 312, 319, 346; *Stipple Pattern*, 59; *Stipple Pattern III*, 60; *Stores and Billboards*, 388 n34; *Storm over the Islands* series, 365–6; *Storm over the Islands III*, *364; Storm over the Islands IV, 364; Storm Passes Over*, 232; *Stream Bed in Dappled Sunlight*, 79, *80; Stream in the Woods*, drypoint, 207, 396 n61 (as Tovell 55); *Striped Dress*, 43–4, *44*, 45; *Stump Fence* series, 344; *Sugar Bush*, 268, *269; Sugar Bush*, drawing, *269; The Sugar Refinery, Courcelette I*, 110, *111*, 236; *The Sugar Refinery, Courcelette II*, 110, *111*, 236; *Sumac and Maple Leaves I*, 369; *Sumac and Maple Leaves II*, 369; *Summer Colours*, 274, *275; Sunburst over the Catskills*, 85, 86; *Sunlight*, 43, *43*, 44; *Sunny Morning, Kelly Ore Bed*, 122; *Sunset Mists*, 357; *Supper at Bethany* (see *Mary and Martha*); *Supper by Lamplight*, 287; *Sweet Peas and Poppies*, 345; Temagami village, drawing, *197; Tempter with Cosmetics IV*, 365; *Tempter with Cosmetics V*, 368, *369; Three Hansoms*, *41*, 42, 55; *The Time of Forest Fires*, 275, *278; Tin Basin, Flowers in a Prospector's Cabin I*, 200–1, *201; Track in the Fields*, 120, *120*, 121; *Train I*, 335; *Trees in Spring*, 84, *85; Trees Reflected, Kelly Ore Bed*, 126, *126; Tribute to Spring*, 181, *181*, 182, 281; *Tricolor*, 54, *55; Trilliums and Columbines*, 279, 280; *Trilliums and Pale Bleeding Hearts*, 398 n85; *Trilliums and Trilliums*, 279; *Trumpets* (see *Resurrection Day*); *Two Cedars, Boston Corners*, 120, *120; Two Maples*, 232; *Uncle Sam's Magazine*, 23, *23; United Church*, 306, *306*, 307, 326; *Valley at Mount Riga, October*, 156, *157; Valley, Lake Placid III*, 179, 182, 380; *Van Cortlandt Park*, 29, 32, *32*, 59; *Vapour Rising*, 121; *Verandah at Night* series, 163; *Verandah at Night II*, 158, *158; Verandah at Night IV*, 158; *Village and*

Country, 230; *Village in the Sun I*, 229, 230; *Village in the Valley*, 123, 168; *The Village in the Valley, Bare Trees, 123; The Village in White*, 230; *The Village (Palgrave)*, drypoint, 225; *Village Spread Out*, 229; *Village toward Evening*, 86, 87; *Vimy Ridge from Souchez, Estaminet among the Ruins*, 102, 103; *Vinegar Bottle*, 282, 283, 285; *Vinegar Bottle III*, 283; *Wancourt*, 113; *Warehouse and Barge*, 31, *31*; in *Watercolour Drawing*, 165; *Waterfall*, drypoint, 207, 218, 221, 225, *225; Waterlilies and Indian Pipes*, 184, 186, *186; Waterlilies and the Sunday Paper*, 204, 205, 324; *Waterlilies in the Bush*, 246, *247; Waterlilies in the Bush*, drawing, *247; Waterlilies, Temagami* (see *Waterlilies and the Sunday Paper*); *The Water Tank*, 252, 267; *Weed Iron Mines*, 77, 126, *128; Wet Gray Hill*, *150; The White Cabinet*, 66, 155, *156; White Clouds in a Blue Sky*, 332; *White Clouds in a Blue Sky III*, 320, *320; Whiteface*, 179, *179*, 180, 182; *The Whitehall Building*, etching, 36; *White Launch*, *31*, 32; *White Matrix*, 164; *White Poppy*, 344–5, *345; White Shoe Box*, 284, *284; White, the Waterfall*, 122, 136, 137, *137*, 147–8, 151, 196, 269, 270, 391 n51; *White Waterlilies in a Prospector's Cabin*, drawing, *201; Wild Flowers on the Window Ledge I*, 330, *330; Wild Flowers on the Window Ledge II*, 330; *Window*, 213, *214*, 221, 231, 291, 292; *Window on Main Street*, 311, *317*, 319; *Winter Clouds*, 280; *Winter Sky*, 248, 271; *Woman at Dresser*, 396 n58; *Woman Reading by the Window*, 163, *165; Woman with Black Umbrella*, 392 n17; *Woman with Brown Hat*, 42, *42; Work Table*, 345; *Wrecked Tanks outside Monchy-le-Preux*, 103, 105, 112; *The Yard of the Glenmore Hotel*, 394 n40; *Yard of the Queen's Hotel*, drypoint, 240; *Yellow Coat and Shelves*, 276, 278; *Yellow House*, 331; *The Yellow Rocker, 1914*, 45, *45; Yellow Room*, 56; *Yellow Shoe Box*, 283, *284; York River*, 361, *361; Zinnias and Poppies I*, *319*, 320, 326; *Zinnias to Paint*, 287, 289

- See also drawing; drypoint line; drypoint prints; etching; oil painting; watercolour; watercolour 'drawings'

Milne, David Jr, 317–18; at Baptiste Lake, 358; at Pickering College, 377; birth, 313–14; curatorial work of, 375; funeral of Milne, 371; letters to, 352–3, *353; photographs of, 313, 314, 315*

Milne, Douglas (nephew), 391 n23

Milne, Francis (Frank) (brother), 4, 383 n5

Milne, Isabel (Belle) (sister), 4, 46, 383 n5

Milne, James (Jim) (brother), 4, 7, 46, 265, 292, 299, 383 n5, 384 n24, 385 n8, 401 n33

Milne, John (brother), 4

Milne, Kathleen (Wyb) (wife), 292, 295–9, 297, 305, 311, 377–8; at Baptiste Lake, 358; daily notes, 340–1; and David Jr, 313, 318, 400 n7; Milne and marriage vows, 297; and Milne's estate, 371–3, 379; and Milne's work, 340; on money, 359; photographs of, *312, 313*

Milne, Mary (mother), 3–4, *5*, 46, 113, 383 nn5, 9; death, 3–4, 155

Milne, Mary (sister), 4, 383 n5

Milne, Patsy (wife), *18*, 34, *74, 75*, 88; after

Milne's death, 371, 376, 379–80; at Big Moose Lake, 192; at Six Mile Lake, 248–9; birth, 18, 385 n30; during First World War, 89, 113; etching of, 380; Lake of Bays, 293; marriage to Milne, 17–20, 45–7, 130, 168, 195, 214, 245; memoir, 376; on Milne, 38, 47, 52; *On the Mountain*, 391 n22; paintings of, 43–5, 46, 58, 60, 163, 184; separation, 214, 304, 311, 314–15, 355–6, 399 n53; in Weston, 205

Milne, Robert (Bob) (brother), 4, 6, 46, 383 n5

Milne, Stanley (nephew), 381

Milne, William (father), 3–4, *4*, 46, 383 n5, 384 n24

Milne, William (Willie) (brother), 4, 383 n5

Mindemoya, Manitoulin Island, 376

Mirror, detail, *154*, 396 n58

Model School, Walkerton, 8; class, *8*

modernist art, 25, 34, 56–7, 124, 237, 255, 310, 321, 323, 387 n31

Modigliani, Amedeo, 295

Molson Cottage, 388 n59

Monchy-le-Preux, France, 104–5, 107

Monet, Claude, 26, 27–8, 260, 277; haystack series, 27

Monigault, Edward Middleton, 387 n26

Monkey and Tiger Lilies, 343

Montreal, 160, 162

Montreal Crater, 103, 106

Montreal Museum of Fine Arts, 265, 392 n2; exhibition, 162, 164–6

Montross, Newman E., 30, 92, 124–5, 128

Montross Gallery, 26, 30, 35, 48–9, 52, 58, 60–1, 64, 129, 138; group show (1915), 54; Matisse exhibition (1915), 53; Milne rejected by, 153; paint supplies from, 387 n1

Moore, Private, 102–3

Morgan, Joseph, 9

Morrice, James Wilson, 3, 92, 221, 237, 253

Moses, Gerry, 376

Mountain Pattern. See Engle, Amos W.

Mountain Road, 149

The Mountains, 168

Mount Benachie, Scotland, 113

Mount Forest, Ontario, 10

Mount Forest *Confederate* newspaper, 10

Mount Kimmel, Belgium, 107, 390 n39

Mount Marcy, Lake Placid, 159–60, 176–7, 193

Mount Pleasant Cemetery, Toronto, 371

Mount Riga, 144–7, 152, 168, 178, 389–90 n35; drypoint printing, 188; painting journal, 145; Howard Sherman, 144–5; subject, 183, 394 n78

Mount Sorrel, Belgium, 107, 390 n40

Mowbray-Clarke, John, 50

Munch, Edvard, 52

Munnings, Alfred, 92, 94

Munsey, Frank, 24, 386 n58

Munsey's Magazine, 24, 30

Musée des beaux-arts de Montréal. See Montreal Museum of Fine Arts

Museum of Modern Art, New York, 381

Myers, Mrs (landlady), 57–8, 60

Myers, Jerome, 49, 50

Nabis painters, 34, 221

Nankivell, Frank, 50

Nash, Paul, 92, 94
Nasturtiums and Carton, 236, 280, 284
Nasturtiums and Carton II, 278, *278*, *279*
National Academy of Design, New York, 16, 26, 28, 48, 53
National Archives of Canada, 378; sketchbook of Milne's at, 10
National Film Board, 338, 375
National Gallery, London, 92
National Gallery of Canada, 195, 206, 250, 258; budget, 392 n26; controversy over policies, 222–3; exhibition (1995), 391 n56; Massey bequest, 374; Massey gift, 252; and Patsy Milne, 380; Milne exhibitions, 374; Milne retrospective, 372, 376; negotiations with, 159; purchase of Milne's work, 168, 221, 338–9, 368, 373; support from, 162
National Trust Company, 253, 259, 261
N.E. Montross Gallery. See Montross Gallery
Neuville-St-Vaast, Belgium, 105
Neuville-St-Vaast from the Poppy Fields, *106*
New England House, 151, 208
New Rochelle, New York, 38, 45
New Shelf, 280
New Society of American Artists in Paris, 25
Newton, Eric, 292, 293
New York, 46–7, 166, 375; art studies in, 12, 13; departure of Milne from, 67–8; as major art centre, 25–6; 18 West 37th Street, 53; Jerome Avenue, 61; 106 West 61st Street apartment, 48, 390 n4; Milne's studio at 20 West 42nd Street, 20; West 25th Street, 385 n9. See also Bronx; Yonkers
New York Daily Tribune newspaper, 55
New York *Evening Globe* newspaper, 54
New York *Evening Mail* newspaper, 54, 388 n41
New York *Evening Post* newspaper, 133, 143
New York Girders, 23, *23*
New York *Herald* newspaper, 55
New York *Press* newspaper, 56
New York Public Library, 39
New York School of Art. See Chase School
New York State Museum, Albany, 38
New York Street, 39, *39*
New York *Sun* newspaper, 56
New York Times newspaper, 54, 55–6, 57, 58, 60, *61*, 388 n44
New York Water Color Club, 28, 49, 385 n9; exhibitions, 21, 28, 55, 56, 60, 206, 386 n44; Milne's membership in, 30, 49; Milne rejected by, 153
Nichols, Jack, pencil portrait of Milne, *366*
Night on Dundas Street, 307
Noah, drawing of, *329*
Noah series, 329, *330*
Noah and the Ark, 310, 332, 340
Noah and the Ark series, 321
Noah and the Ark and Mount Ararat I, *328*, *328*
Noah and the Ark and Mount Ararat III, *328*
Noah and the Ark and Mount Ararat IV, *328*
Noah and the Ark and Mount Ararat V, *328*
Noah's Ark, 325
Normal School, Toronto, 8
North, Robert, 153, 162, 176, 221–2, 265
North Elba, drypoint, 190
North Elba (fourth version), drypoint, *191*
North Elba subjects, 177–8, 190
Northern Lights, 272, *273*
Northern Lights, drawing, *272*

Northern River. See Thomson, Tom
Northern Village, 196–7, *197*
Norwell, Graham, 161, 166, 393 n28
Nude Descending the Staircase. See Duchamp, Marcel

O'Brian, John, *David Milne and the Modern Tradition of Painting*, 375
O'Connor, Dan, 195, 197–9, 394 n9
Official Canadian War Artist, Milne as, 101–2
Of Men and Angels, 366
Ogilvie, Will, 291, 298
oil painting, 120–1, 137, 145–6, 226–7, 280, 332, 341–2, 345
O'Keeffe, Georgia, 68
Old Croken, 74
Oldmeldrum, Scotland, 113
Old RCMP Barracks, 168
Old RCMP Barracks II, 163, *163*
Ollie Matson's House in Snow, 213, 252
Ollie Matson's House Is Just a Square Red Cloud, 231
On a Rainy Night. See Davis, Stuart
106th St. Apartment, 64
Ontario (government), 196
Ontario Provincial Police, 381, 402 n27
Ontario Society of Artists, 207, 221, 222–3; exhibition, 207, 220
On the Mountain. See Milne, Patsy
On Vimy Ridge Looking over Givenchy to the Lens-Arras Road and Avion, 103, *103*
Open Door, 1947, 347, 348
Opening Overture, Century. See Engle, Amos W.
Oppy woods, France, 103, 112
Opus 3, 17
Orchard in the Brown Valley, 145
Ore Bed Pool, 145
Orillia, Ontario, 246, 266
Osterhout, Mrs (cook), 154, 157
Ottawa, 165–8, 195; move to, 159; paintings, 163; War Records paintings, 117
Ottawa Art Club, 162, 164
Ottawa Evening Citizen newspaper, 162
Ottawa Group of Artists: exhibition, 165; members, 393 n28
Ottawa Street Railway Employees Union, 160
Our House and the Neighbours', Uxbridge, 319
Outlet of the Lake, 191
Outlet of the Pond, 184, 319
Outlet of the Pond series, 179, 346
Outlet of the Pond I, 141
Outlet of the Pond, drypoint, 225, *225*, 319
Outlet of the Pond, Morning, *183*
Owens, Gwendolyn, 374, 375

Pach, Walter, 50, 54, 56
'Painted Out' postscript, 123
painting day, 1 March 1922, 149–51
Painting House (P.H.), Boston Corners, 117–20
Painting Place, 179, 184, 190, 208, 292
Painting Place paintings, 210
painting-place pictures, 345
Painting Place I, *1*, 186, *187*
Painting Place I, drawing, *187*
Painting Place II, *187*, 208
Painting Place III, *187*, 208, 209, *209*, 291, 375

Painting Place, drawing, 187
Painting Place (the *Colophon* edition) (also known as *Hilltop*), drypoint, *ii*, 189, 223–4, 227, 394 n69, 396 n51
Painting Place (large plate), drypoint, 190, 207
Painting Place (small plate), drypoint, *i*, 188, 189, 190
Painting Place: Brown and Black, *187*
painting places, 203–4
painting supplies, 103; Art Metropole, 398 n104; equipment, 103; Montross Gallery, 387 n11; Winsor and Newton, 92
Paisley, Ontario, 7–8, 11, 45–6, 125, 265, 292, 299; move to, 384 n23; Orchard Avenue home, 7; plaque in Willow Creek Park, 381; return from war, 113, 117
Paisley Advocate newspaper, 8, 9, 12, 46
palette, 34, 81, 145, 199, 265, 342, 348
Palgrave, Ontario, 210, 211, 245, 266; Albion Sideroad 25, 211; house in, 212–13, *213*; paintings, 38, 127, 227, 341; softball team, 395 n8; subjects, 225–6, 230–2; Wallace Street, 212, 231, 242
Palgrave, 1939, 306
Pallette Art, New York, 188
Panama-Pacific International Exposition, 48, 53
Panorama of Lorette Ridge, 112, *112*
Panorama of Ypres from the Ramparts, 105
The Pantry, 45, *45*, 387 n8
Paper Bag, in *Canadian Forum* magazine, 255
Paracutin IV, 366, 368–9
Paramount Studio, School for Stars, 176
Paris, Canadian Legation, 255
Park Plaza, 332
Parliament Buildings, Ottawa, 162–3, 165
Parliament Buildings, 307, 309
Parliament Buildings at Queen's Park, 307
Parliament Hill from Hull, 163, *164*
Parsons, Vera, 259, 261, 292, 301, 304, 311, 313, 317, 371, 399–400 n63; and Patsy Milne, 315, 377
Patsy Seated, etching, 34
Pavey, Alfred (Kathleen Milne's father), 296, 317
Pavey, Bessie Louise (mother), 296–7, 317
Pavey, John (Jack) (brother), 296, 371
Pavey, Kathleen (Wyb). See Milne, Kathleen
Pavey, Wilma (sister-in-law), 371
Pearson, Lester B., 257
Pearson's Weekly newspaper, 23–4
Peck (landlord, Uxbridge), 311
Penguin and Nasturtiums I, 343, *344*
Pennell, Joseph, 29–30, 36, 49, 188; Panama-Pacific International Exposition, 53
Pennsylvania Academy of the Fine Arts, 49
Pennsylvania Water Color Club, 124–5
Pepper, George, 218
Philadelphia, painters from, 26
Philadelphia Public Ledger newspaper, 28
Philadelphia Water Color Club, 29, 49, 84, 92, 138; exhibitions, 34, 129; installation of Milne's paintings, *130*; rejection by, 153
Picasso, Pablo, 25, 28, 295; *Les Demoiselles d'Avignon*, 25
Piccirilli brothers, 39
Pickering College, Newmarket, 377
Picture on the Blackboard, 281, *282*, 289, 310, 324

Picture Hire Limited, 260
Picture Loan Society, Toronto, 260–1, 291, 294, 314, 336, 377; shows, 337; 3 Charles Street West, 260–1
Pier on the Hudson, 13
Pink Flowers, 386 n79
Pink House in Snow, 60
Pink Reflections, Bishop's Pond, 125, 126
Pink Rock, 140
Pissarro, Camille, 25
planographic method, 62
Plaunt, Alan, 265
playing-card series, 325–6, 327, 329, 332, 333, 340–1, 399 n27
The Plaza Hotel, etching, 36
Points and Full Curves, 54
Point with Flag Pole, 142, *143*
The Pole Line, 287, 288
The Pond, drypoint, 190
Pond, Low Water, 142
Pool and Contours, 126–7, *129*, 168
Pool and Posts, 168, 393 n39
Pool in the Rocks, 267
The Pool, Little Bob Lake II, 346, *346*
Poppies, *319*, 320
Poppies and Glass, 320
Poppies and Lilies, 333, *344*
Poppies and Lilies III, 322
Poppies and Nasturtiums, 320, *321*
Poppies in a Paper, 333
Poppies in a Tin Can, 320
Porch Post, *81*
Port Hope, Ontario, 252, 265
Portraits from a Catalogue, 333
Port Severn, Ontario, 246, 397 n14
Posing, 60, *60*, 388 n59
post-impressionism, 165
Potter, Edward C., 39
Pound, Ezra, 287
Power Lines, Lake Placid, drypoint, 190
Prendergast, Maurice, 30, 35, 49–50, 52, 55–6, 374, 386–7 nn63, 82
Presbyterian Church, 7
Pretty Channel, 282
Princess Patricias. See Canadian Army
Prints, 329, 330
Procter, Elizabeth, 291
Profile of a Man in a Straw Hat, 4
Projecting Tree, Dart's Lake, 140, 141, *141*
Prospect Shaft, drypoint, *199*, 225
Proust, Marcel: *À la recherche du temps perdu*, 48; *Swann's Way*, 141
The Pump, *207*, 208
Pyper, C.B., 384 n23

Quebec City, 90
Queen's Hotel, drypoint, 225, *240*
Queen's Hotel, Ottawa, 160
Queen's Hotel, Palgrave, 213, 215, 216, 230, 232, 237
Queen's Hotel, Palgrave, 239, *241*, 286
Queen's Hotel, Palgrave, drawing, *240*
Queenston, Niagara Gorge, 10
Quiet River, 361, *361*, 362

radio, 263, 359
Radio, 344
Radio with Tulips, *345*

Ragged Shape, 54
Rain, Douglas, 375, 401–2 n7
Rain Motif. See Engle, Amos W.
Rainy Night. See Engle, Amos W.
Raphael, 330, 336
Raspberry Jam, *278*, 279, 282
Rattlesnake Pete (sugar-bush owner), 249, 348
Reading, 43
Reading in the Cabin, 297
realism, 52, 124
Reclining Figure, 50, 387 n27
Red, 44, *44*, 52, 58–9, 61, *61*
Red Church series, 319
Red Church IV, *318*
Red Cross Outpost Hospital, Bancroft, 377
Red Dishes, 298
Red Dress II, 296
Red Elevator and Blue Sky, 226, 396 n58
Redfield, Edward W., 30, 49
Red Lily, 287, *289*
Redon, Odilon, 52
Red Plate, 298
The Red Studio. See Matisse, Henri
Red Trees, 59
Reflected Forms, 85, *86*
Reflected Pattern I, 163
Reflected Pattern II, 163
Reflections II, 83
Reflections at Dart's Lake I, *143*
Reflections at Dart's Lake I, drawing, *143*
Reflections at Dart's Lake II, 146
Reflections, Bishop's Pond, 126
Regina Trench, France, 107–8
Reichert, Mrs John, 381
Reid, George A., 8, 27, 218–19; *The Berry Pickers*, 8, *8*, 27
Relaxation, 82, *83*, 380
Renoir, Auguste, 26
Resurrection series, 321
Resurrection III, 333
Resurrection Day, 333, *335*
Resurrection Day theme, 335
Return from the Voyage, 325, 366
Return from the Voyage series, 321
Return from the Voyage II, *335*
Return from the Voyage III, *335*
Return from the Voyage IV, *335*
Reuterdahl, Henry, 16–17, 385 n19
Reynar, Albert F., 212, 213, 395 nn2, 3
Riches, the Flooded Shaft, *199*, 200
Riddell, Jean, 13
Riddell, John (Jack), 13
Riga Lakes, overnight camping trip, 73–4
Rio de Janeiro, Canadian exhibition, 368
R.I.P., 342
Ripon, Yorkshire, painting at, 97–9
Ripon: High Street, 97, *98*
Ripon in March, *96*, 97
Ripon, South Camp from General Headquarters, *96*
Rites of Autumn, 339
Rites of Autumn I, *335*
Rites of Autumn II, *335*
Riverside Park, 36
The Road to Passchendaele, 109–10, *109*
Road to the Church, 84
Roberts, Charles G.D., 162
Roberts, Lloyd, 162
Roberts, Phil, 74

Robinson, R., 376–7
Rock Pool, 267, *267*
Rocks in Spring, *150*, 151, 196
Rodin, Auguste, 26
Roerich, Nicholas, 396 n44
Roerich Museum, New York, 222, 396 n44
The Roller Skater, 55
Roofs, Glenmore Hotel, 210
Roofs, Glenmore Hotel, drypoint, 210
Rooftops, 213
Rosar-Morrison Funeral Home, 371
Rosseau, Lake, 245
Rothermere, Lord, 91–2
Rothko, Mark, 25
Rowboat on Shore I, 267–8, *268*, 393 n39
Row of Trees, Mount Riga, 145, *146*
Row of Trees, Mount Riga, drawing, *146*
Royal Academy, London, 94
Royal Canadian Academy, 222
Royal Canadian Mounted Police, 90
Rubens, Peter Paul, 240
Rudd Pond, 155
Ruskin, John, 124
Ryan, Geraldine, 70, 82, 85, 89, 125, 166, 388 n37
Ryder, Albert Pinkham, 35, 53, 277

St Eloi craters, 107, 127
St Francis, 330–1
St Lawrence, 42, *43*, 54
St Michael's Cathedral, 333
St Michael's Cathedral II, *308*
St Michael's Cathedral, drypoint, 333
The Saint, 310, 330, 331, 332, 341
The Saint III, *331*
Salesmanship, 366
Salisbury, Connecticut, 70
Salmon Can, 277, *278*
Salon d'Automne, Paris, 25
Sanford, Edward F., Jr, 60
Saranac Hills series, 179
Saranac Lake, 176
Sargent, John Singer, 15, 26, 52; Panama-Pacific International Exposition, 53
Saturday Night magazine, 245, 255, 264, 336
Saugeen River, 4, 46
Saugeen Township, 4
Saugerties, 57, 70, 89, 166, 389 n2. See also West Saugerties
Scaffolding series, 346
Scaffolding I, 346
Scaffolding VII, 346
Schaefer, Carl, 193, 284, 292, 298, 332, 341, 360
Scott, Duncan Campbell, 162, 392 n17
Scott and Sons, Montreal, 255
Seaford, Surrey, 100
Seaford: North Camp in a May Snowstorm, 100
Seated Figure, *121*
Second World War, 305, 312, 381
Sekido, Yoshida, 161, 392 n12, 393 n28
September Gale. See Lismer, Arthur
Serenity, 213, *228*, 230
Serenity, drawing, *229*
Severn River, 246, 287
Sheeler, Charles, 35, 54, 68
Shell Holes and Wire at the Old German Line, Vimy Ridge, 103, *104*
Shelter at Night I, 357, *357*

Shepherd, F.J., 162
Sherman, Howard, 35, 125, 138, 144–5, 151, 155, 389–90 n35, 392 n18
Shinn, Everett, 386 n63
Shore Clearing, 369
Shrine and Saints, 331, 341
Shrine and Saints II, 332, 333
Signs and Symbols, 335
Simpson's (department store), Toronto, 206
Sinclair, Gordon, 359
Six Mile Lake, 246, 259, 294, 347–8; cabin, 247–8, 248; life at, 261–4; map, 246; paintings, 186, 200; Kathleen Pavey at, 297; subjects, 266; supplies, 248–9; visits from Duncan and Jarvis, 259–60, 264
Sizes and Colours, 333
Sketches from the Abstract, 366
skiing: Lake Placid, 177; Palgrave, 216; Six Mile Lake, 263
Ski-Jump Hills with Radiating Clouds, 180
Ski Jump, Lake Placid, drypoint, 190
Sleeping Woman, 46, 387 n27
Sloan, John, 386 n63
Smart, Elizabeth, 398 n86
Smart, Jane, 264, 398 n86
Smith, Doug, 281
Smith, Margaret, 281
Smith, Wilfred, 402 n18
Snake Creek, 6
Snow Covered Boulder, 393 n27
Snowfall, from the Painting House, 123
Snow from the North, 319
Snow in Bethlehem, 323, 325, 336, 340; as Christmas card, 324
Snow in Bethlehem II, 323, 324
Snow Patches, 86
Snow Shadows, 55
Soft Textures, 84
The Solemn Land. See MacDonald, J.E.H.
Somme battlefield, France, 107
Sorolla y Bastida, Joaquin, 27
Souchez, France, 103, 105
Souchez River, 103
Southam, H.S., 222
South Egremont, Massachusetts, 394 n78
Sparkle of Glass, 179, 184, 186, 186
Spider Bridge II, 360, 360, 361
Spider Bridge III, 360, 360, 361
Splendour Touches Hiram's Farm, 211, 213, 232, 236
Spring across the Way, 343
Spring Comes to the Bay, 289
Spring Foliage, 36, 37
Spring Ice. See Thomson, Tom
Spuyten Duyvil, 387 n83
Spuyten Duyvil Pastel, 30, 30
Squash Pond, 141, 173
ss *Belgic* (ship), 113
ss *Ifernistolles* (ship), 90
Stacey, Harold, 398 n71
Stamford, Connecticut, 18
Stars over Bay Street, 306, 307, 307, 319, 327, 328, 331, 332
Stars over Bay Street, drypoint, 306, 333
Stars over Bay Street, 1939, 306, 307
Stars over Bay Street, 1941, 307
Stella, Joseph, 50, 54
Stern, Max, 372
Sterner Gallery, New York, 222
Stieglitz, Alfred, 14, 36, 48–9, 68; *Camera*

Work magazine, 25; Forum Exhibition, 49. See also 291 Gallery
still-life genre, 226, 272–3
Still Water, 140, 319, 346
Still Water and Fish, drypoint, 312, 319, 346
Stipple Pattern, 59
Stipple Pattern III, 60
Stone, Tom, 206
Stores and Billboards, 388 n34
Storm over the Islands series, 365–6
Storm over the Islands III, 364
Storm over the Islands IV, 364
Storm Passes Over, 232
Storm Pattern. See Engle, Amos W.
Stormy Weather, Georgian Bay. See Varley, Frederick
Stravinsky, Igor, 287; *Rite of Spring*, 48
Stream Bed in Dappled Sunlight, 79, 80
Stream in the Woods, drypoint, 207, 396 n61 (as Tovell 55)
Striped Dress, 43–4, 44, 45
Studio magazine, 338
Stump Fence series, 344
Sturgeon Lake, Haliburton, 305
Sugar Bush, 268, 269
Sugar Bush, drawing, 269
The Sugar Refinery, Courcelette I, 110, 111, 236
The Sugar Refinery, Courcelette II, 110, 111, 236
Sumac and Maple Leaves I, 369
Sumac and Maple Leaves II, 369
Summer Colours, 274, 275
Sunburst over the Catskills, 85, 86
Sunlight, 43, 43, 44
Sunlight. See Engle, Amos W.
Sunnybrook Hospital, Toronto, 369–70
Sunny Morning, Kelly Ore Bed, 122
Sunset Mists, 357
Supper at Bethany. See *Mary and Martha*
Supper by Lamplight, 287
surrealism, 399 n10
Sweet Peas and Poppies, 345
Switzer's boarding house, 349–50
symbols. See Milne, David: artistic methods and devices

Taconic Hills, 70
Taft, William Howard, 39
Tate Gallery, 291, 292
Taylor, Henry Fitch, 50
tea-house. See Big Moose Lake, Little Tea House
Tea Lake, 296
technique. See Milne, David: artistic methods and devices
Temagami (village), 195–9, 196, 205; drawing, 197; subjects, 186, 200, 225
Temagami, Lake, 82, 195–6, 394 nn3, 9
Temagami Canoe Company, 196
Temagami Inn, 195
Tempter with Cosmetics IV, 365
Tempter with Cosmetics V, 368, 369
The Ten, 26, 29, 49; painting media of, 29
Tenage Lake, Yosemite. See Engle, Amos W.
Thayer, Raymond, 48, 53
Thélus, France, 103
Thirkell, Angela, 398 n88
Thom, Ian M., *David Milne*, 375
Thomson, Tom, 3, 165, 216, 219–21; *The Jack

Pine*, 220; *Northern River*, 220, 236; *Spring Ice*, 220; *The West Wind*, 206, 269
Thoreau, Henry David, 70, 129, 204; *Walden*, 129
Three Hansoms, 41, 42, 55
The Time of Forest Fires, 275, 278
Tin Basin, Flowers in a Prospector's Cabin I, 200–1, 201
Titian, 240
Tivoli, Hudson River, 70, 82–3, 85, 125, 166, 388 n37
topographic painting, 93
Toronto: Homewood Avenue, 297, 309; Milne and Kathleen in, 298; move to, 294–5; waterfront, 331, 363
Toronto Art Gallery. See Art Gallery of Toronto
Toronto Central Reference Library, 320
Toronto *Globe and Mail* newspaper, 245, 294
Toronto *Mail and Empire* newspaper, 222, 254
Toronto *Telegram* newspaper, 254
Torrance-Newton, Lilias, 218
Toulouse-Lautrec, Henri de, 26
Tovell, Rosemarie, 374; *Reflections in a Quiet Pool: The Prints of David Milne*, 375
Town, Harold, xiii, 394 n61
Track in the Fields, 120, 120, 121
Train I, 335
The Transfiguration. See Bellini, Giovanni
Trees in Spring, 84, 85
Trees Reflected, Kelly Ore Bed, 126, 126
Tribute to Spring, 181, 181, 182, 281
Tricolor, 54, 55
Trilliums and Columbines, 279, 280
Trilliums and Pale Bleeding Hearts, 398 n85
Trilliums and Trilliums, 279
Trumpets. See *Resurrection Day*
Tucker, Allan, 50
Tudor Hotel, Toronto, 296, 313, 338, 399 n44
Turnbull, O.E., 10–11
Turnbull-Wright Company, 10
Turner, Miss (weaving teacher), 207, 249
Turner, J.M.W., 149, 240
Twatchman, Alden, 50
Twatchman, John, 29; *Wildflowers*, 386 n79
Twin Lakes, Connecticut, 130
The Twins crater, 103
Two Cedars, Boston Corners, 120, 120
Two Maples, 232
291 Gallery, 26, 385 n3; Cézanne exhibition (1911), 36, 48; Arthur Dove exhibition (1912), 48; Marsden Hartley exhibition (1912), 48; John Marin exhibitions (1910), 48; (1911), 36, 48; Matisse exhibitions (1910, 1912), 48; Picasso exhibition (1911), 48; Younger American Artists exhibition (1910), 48. See also Stieglitz, Alfred

Udney, Scotland, 7
Uncle Sam's Magazine, 23, 23
Undergraduate magazine (University of Toronto, 1936), 265; drawing for, 265
Under Mountain House, Boston Corners, 70–3, 70, 114, 117–18, 139
United Church, 306, 306, 307, 326
United States, exhibiting in, 193
University Art Association, Milne exhibition, 265

University of Toronto, 379. See also Hart House; *Undergraduate* magazine; *Varsity* newspaper

U.S.S. (Union School Section) No. 7 Elderslie and South Saugeen, 9, *9*, 46

U.S.S. (Union School Section) No. 7 Saugeen and Arran (Gowanlock School), 7, 384 n23

Uxbridge, Ontario, 295, 306, 311–12, 357, 359; Brock Street, 311, 319, 329; Franklin Street, *312*, 400 n1; life in, 318; move from, 349, 359; painting places, 343; subjects, 342, 348

Uxbridge United Church, *318*

Vale, Bruce, 363

Valentin, Curt, 338

Valley at Mount Riga, October, *156*, 157

Valley, Lake Placid III, *179*, 182, 380

values. See Milne, David: colours and values

Van Cortlandt Park, 29, *31*, 32, 59

Vancouver Art Gallery, 374

van der Rohe, Mies, 381

van Gogh, Vincent, 48, 52, 240–1, 295

van Harvey (printer), 154, 157, 159–60, 173, 177

Vapour Rising, 121

Varley, Frederick, 92, 94, 402 n23; *Stormy Weather, Georgian Bay*, 220

Varsity newspaper (University of Toronto), 287, 291

Vaughan, Nora, 372

Vauxelles, Louis, 25

Velazquez, Diego, 240; *Las Mariñas (The Maids of Honour)*, 45

Venice Biennale (1952), 368

Verandah at Night series, 163

Verandah at Night II, *158*, *158*

Verandah at Night IV, *158*

Vermeer, Jan, 45

Vernon, Arthur, 35, 64, 74

Vernon, Cora, 74

Victor Phonograph Company, 72

Village and Country, 230

Village in the Sun I, *229*, 230

Village in the Valley, 123, 168

The Village in the Valley, Bare Trees, *123*

The Village in White, 230

The Village (Palgrave), drypoint, 225

Village Spread Out, 229

Village toward Evening, 86, *87*

Vimy Ridge, 102–4, 107, 112, 114–15

Vimy Ridge from Souchez, Estaminet among the Ruins, *102*, 103

Vincent, René, 65

Vinegar Bottle, 282, 285

Vinegar Bottle III, *283*

visual arts, in Canada, 206

Vollard, Ambrose, 260

Vuillard, Edouard, 34, 221

Wales, 90–1

Walker, Sir Edmund, 92, 117

Walker, Horatio, 35, 397 n29

Walkerton High School, 8–9

Wallace, Lucy, 53

Wancourt, France, 113

Wancourt, *113*

Ward, John E., 264

Warehouse and Barge, *31*, *31*

War Records Office, 16, 92–3, 94, 97, 101, 103, 107, 110, 117, 236, 387 n10, 390 nn12, 13, 16; exhibitions, 115–16, 316

washing-machine wringer, as a press, 152, 188–9

watercolour, 29, 134, 137, 165, 281–2, 309–10, 332, 346; abandonment of (1925–37), 181–2; renewed interest in (1937), 281

watercolour 'drawings,' 165

Waterfall, drypoint, 207, 218, 221, 225, *225*

Waterfall Pattern. See Engle, Amos W.

Waterlilies and Indian Pipes, 184, 186, *186*

Waterlilies and the Sunday Paper, 204, *205*, 324

Waterlilies in the Bush, 246, *247*

Waterlilies in the Bush, drawing, *247*

Waterlilies, Temagami. See *Waterlilies and the Sunday Paper*

The Water Tank, 252, 267

Watkins, Captain J.H., 92–3, 97, 390 n13

Watson, William, 255

Webber, Gordon, 260

Webster's Dictionary, 133

Weed Iron Mines, 126

Weed Iron Mines, 77, 126, *128*

Weehawken Series. See Marin, John

Weir, J. Alden, 29, 48, 49–50, 92

Wells, H.G., *The War of the Worlds*, 175

Wells, Kenneth, 254–5, 397 n34

Wembley exhibition. See British Empire Exhibition

Western Canada Art Circuit, 372

Western Hospital, Toronto, 296, 298, 363

Weston, Ontario, 205, 207, 243, 249; railway bridge, 207; St Alban's Avenue, 207

Weston Golf and Country Club, 208

West Saugerties, 21, 42, 48, 70, 166; summer of 1914, 57–9. See also Saugerties

The West Wind. See Thomson, Tom

Wet Gray Hill, *150*

Wherry, Sheila, 291

Whistler, J.A.M., 15, 25–6, 29, 36, 385 n12; *La Salute: Dawn*, 38; Panama-Pacific International Exposition, 53; retrospective exhibition (1910), 27, 36

The White Cabinet, 66, 155, *156*

White Clouds in a Blue Sky, 332

White Clouds in a Blue Sky III, *320*, 320

Whiteface, 179, *179*, 180, 182

Whiteface mountain, 176

The Whitehall Building, etching, 36

White Launch, *31*, 32

White Matrix, 164

White Poppy, 344–5, *345*

White Shoe Box, 284, *284*

White, the Waterfall, 122, 136, 137, *137*, 147–8, 151, 196, 269, 270, 391 n51

White Waterlilies in a Prospector's Cabin, drawing, *201*

Whitney Studio, 26

Wilde, Oscar, *The Importance of Being Earnest*, 175

Wildflowers. See Twatchman, John

Wild Flowers on the Window Ledge I, *330*, 330

Wild Flowers on the Window Ledge II, 330

Willow Creek, 7

Willow Creek Park, Paisley, 381

Wilson and Company, 255

Wilton, J.G., 9

Wimereux, France, 102, 109

Wind. See Engle, Amos W.

Windermere, Lake Rosseau, 245

Window, 213, *214*, 221, 231, 291, 292

Window on Main Street, 311, *317*, 319

Winnipeg Art Gallery, 372

Winsor and Newton, 92

Winter Clouds, 280

Winter Sky, 248, 271

Woman at Dresser, 396 n58

Woman Reading by the Window, 163, *165*

Woman with Black Umbrella, 392 n17

Woman with Brown Hat, 42, *42*

Women's Art Association, Toronto, 249, 303

Woods, Grant, 295

Woods' farm, 177

Work Table, 345

Wrecked Tanks outside Monchy-le-Preux, *103*, 105, 112

Wright, A.W., 10

Wright, Charles Lennox, 48, 53

Wright, Grace Latimer, 53

Wright, Michael, 257

Wyer, Raymond, *An Art Museum: Its Concept and Conduct*, 89

Wyeth, N.C., 49

Wyn Wood, Elizabeth, 222–3

The Yard of the Glenmore Hotel, 394 n40

Yard of the Queen's Hotel, drypoint, 240

Yellow Coat and Shelves, 276, 278

Yellow House, 331

The Yellow Rocker, 1914, 45, *45*

Yellow Room, 56

Yellow Shoe Box, 283, 284

Yonkers, New York, 193. See also New York

York River, 361, *361*

Young, Ed, 213, 230

Ypres salient, Belgium, 107, 112

Zigrosser, Carl, 52, 381, 387 n32

Zinnias and Poppies I, *319*, 320, 326

Zinnias to Paint, 287, 289

Zonnebeke, Belgium, 109

Zorach, Marguerite, 14, 38, 48, 50, 53, 56, 129

Zorach, William, 14, 38, 48, 50, 53, 56, 129, 385 n5

TYPESETTING
University of Toronto Press Incorporated

DESIGN
William Rueter, University of Toronto Press Incorporated

TYPEFACE
Scala, designed by Martin Majoor

IMAGE SCANNING
Coach House Printing

COLOUR SEPARATIONS
Herzig Somerville Limited

PRINTING
University of Toronto Press Incorporated

PAPER
Resolve Matte, 80-lb, Island Paper Mills Company

BINDING
Tri-graphic Printing (Ottawa) Limited